HAROLD E. WETHEY

THE PAINTINGS OF TITIAN

II. THE PORTRAITS

Frontispiece:

Gabriele Vendramin. Detail from Plate 136.

London, National Gallery

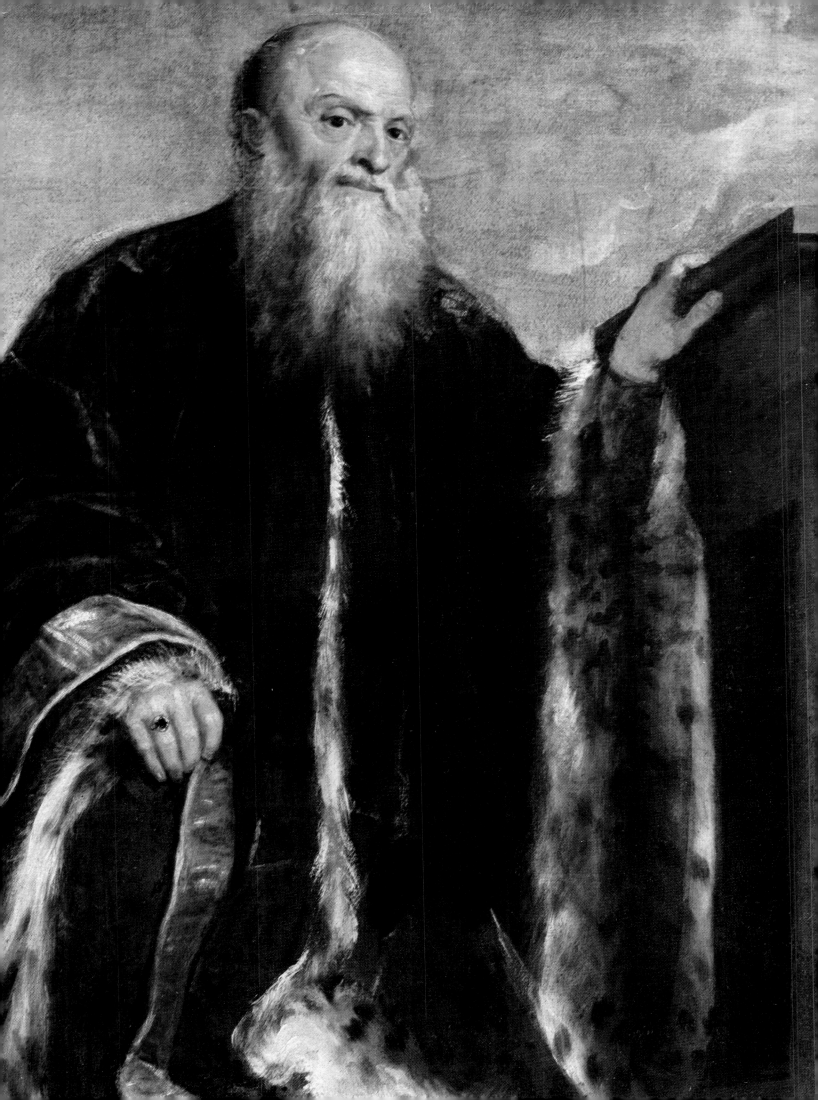

THE PAINTINGS OF
TITIAN

COMPLETE EDITION
BY HAROLD E · WETHEY

II · THE PORTRAITS

PHAIDON

© 1971 PHAIDON PRESS LTD · 5 CROMWELL PLACE · LONDON SW7

PHAIDON PUBLISHERS INC · NEW YORK
DISTRIBUTORS IN THE UNITED STATES: PRAEGER PUBLISHERS INC
111 FOURTH AVENUE · NEW YORK · N.Y. 10003
LIBRARY OF CONGRESS CATALOG CARD NUMBER: 73–81197

ISBN 0 7148 1424 5
MADE IN GREAT BRITAIN
PRINTED BY THE UNIVERSITY PRESS · ABERDEEN
COLOUR PLATES PRINTED BY THE CAVENDISH PRESS LTD · LEICESTER

CONTENTS

PREFACE

THE present work on *The Paintings of Titian* is projected in three volumes, the first of which, *The Religious Paintings*, was published in November 1969. Volume II is devoted to *The Portraits*, and the last will contain *The Mythological and Historical Paintings*. As stated in the preface of Volume I, my desire is to make the *catalogue raisonné* as complete as possible, emphasizing documentation and the histories of individual pictures, and including works known today only in literary references, as well as copies and school pieces. Connoisseurship, by which I mean the distinguishing of Titian's own hand and thus establishing a catalogue of autograph works, is a major aim in these volumes.

The portraits are arranged alphabetically by the name of the sitter, in three categories. The authentic works, which include a few items of partially workshop execution, have simple numbers. Lost works are signified by an L, as for instance, L–3, *Charles V in Armour with Baton*, whereas numbers preceded by an X denote pictures classified as works of other masters than Titian, school pieces, wrong and doubtful attributions. Traditional identifications of certain sitters have been retained with the qualification 'so-called' for the sake of convenience and also to avoid an excessive number of anonymous 'Gentlemen'. Short biographies have been included in nearly all cases excepting the very few that have no discernible connection with Titian, since not even the specialist will necessarily be familiar with many once-famous personalities. Moreover, I have kept in mind the general reader even in the biographies of popes and kings, just as I have in the introductory texts of both Volumes I and II, which I hope are intelligible to any interested person. On the scholarly side, biographies are often of significance in establishing the authenticity or the falseness of a particular work.

The illustrations in the present volume are arranged in a basically chronological order, so as to emphasize the styles of Titian's portraiture as his art developed from the Giorgionesque manner of his youth through the various phases of his career. The section of the Introduction entitled 'Titian as Portraitist' also follows the same chronological sequence. The Appendix illustrates primarily portraits by Palma il Vecchio, prints and painted copies after Titian, and works related to Titian. In the section 'Titian and Renaissance Society' a certain amount of the same material appears that is treated in greater detail in Volume I. Since not everybody who uses Volume II will necessarily have the first volume at hand, I believe it useful to include information about Titian's life and career, again with the general reader as well as the student and specialist in mind.

In preparing the catalogue I have seen every accessible picture attributed to Titian in Europe and America. Only by examination of the original can a safe opinion be made of the authorship, quality, or condition of a work of art. Exceptions are those canvases which are revealed even in photographs to be so remote from Titian that they do not merit consideration. The brief comments on the condition of pictures are the most that can be made by visual observation, when X-rays and laboratory reports recorded during cleaning are unavailable. Most scholars intentionally avoid mention of the physical state of pictures. I have endeavoured to be as thorough as possible in this matter, but I have only occasionally remarked on the condition of works not attributable to Titian, in both Volumes I

and II. The excessive importance attached to such reports by critics with museum connections has passed all reasonable bounds.

It is impossible to exaggerate the value of rechecking every aspect of Titian's works, including the sizes. A case of the significance of dimensions is the *Philip II Seated Wearing a Crown* in Cincinnati (Cat. no. 81), the size of which has been given incorrectly in every publication of the picture for forty years through 1969. Lack of a catalogue of the Cincinnati Art Museum has meant that all writers in this period have taken dimensions from someone who preceded. Yet the whole controversy about this portrait is solved by its size, which proves it to be the Barbarigo picture, just as Crowe and Cavalcaselle said it was. Many, many instances of wrong data of all kinds were discovered in the preparation of the catalogue, because I have gone to the source in every possible instance.

In any study of a great master connoisseurship is of overwhelming importance. It must be based upon a knowledge of the artist gained through an examination of undisputed works. Many of Titian's masterpieces have been known since the moment they were painted. In other cases, original contracts, authentic signatures, letters and writings of contemporaries of the master, as well as early inventories, make it possible to establish authenticity on an historical basis. Yet it is extraordinary how frequently such matters are disregarded. Instead, the opinions, not always unbiased, of earlier critics are sometimes used as a substitute. This situation is particularly true of pictures from the Spanish royal collections, although documentation is abundant. Pedro Beroqui and the present writer are exceptions in making full use of this material. In each catalogue entry I have included full documentation, every discoverable provenance, the exact date if known or the most likely one, and each previous writer's opinion, but I have also taken a clear-cut stand and have given my own precise conclusion as to Titian's participation.

Titian's fame has never wavered from his own lifetime down to the present. His works have been copied and imitated through the centuries, a fact that is well known. A case in point is the *St. Mary Magdalen in Penitence* of the types in Naples and Leningrad. Two other authentic examples exist, and the original once in the Escorial was destroyed by fire in London in 1873 (Wethey, I, 1969, Cat. no. 127), a discovery resulting from persistent research. Yet even within the last few years critics have identified it with various extant canvases. Eight other versions of the *Magdalen*, mostly Baroque copies, survive and twenty-one more are known by literary references (Wethey, I, 1969, Cat. nos. 122–129). A similar situation exists with the *Salome* of which the one original by Titian has been in the Doria-Pamphili inheritance since at least 1603. The incorrect history of this picture and its confusion with a lost *Salome* which belonged to Queen Christina in the seventeenth century was promoted by Tietze and Sestieri and thereafter accepted by all subsequent writers until 1969 (see Wethey, I, 1969, Cat. nos. 137–140). Several copies of this type of *Salome* exist, some of them still passed off as originals.

One hundred years ago art historical connoisseurship began in earnest and the struggle to clear away a morass of wrong attributions from the names of great artists was undertaken. As every scholar of Venetian art knows, Crowe and Cavalcaselle (1877) rejected a vast accumulation of Baroque copies and wrong attributions to which in their time the name of Titian had been attached. The refinement continued with the researches of Morelli and Berenson in the eighteen-nineties and the early twentieth century. Subsequently the situation has deteriorated badly and a large quantity of wrongly attributed

pictures of every description has again been gathered around the name of the master. Scholars and even the public are no longer so naive as to accept all of them. Excellent work has been done by Cecil Gould in catalogues of the National Gallery in London and by several other scholars on specific items. Alessandro Ballarin's investigations of Lambert Sustris have been especially valuable in distinguishing his work from Titian's.

Since no totally comprehensive study of Titian has been made since Crowe and Cavalcaselle's publication in 1877, it seemed to me desirable once again to attempt it, as the four-hundredth anniversary of Titian's death in 1576 approaches. In the past century many additional authentic works have reappeared. In the sphere of documentation much new significant source material has become available, for instance, the Aldobrandini inventories published by Cesare d'Onofrio and Paola della Pergola, the Borghese inventories also studied by della Pergola, and the Ludovisi inventories made available by Klara Garas. The important unpublished Odescalchi inventories, which I have investigated in connection with Titian, will be given further emphasis in Volume III. Cassiano del Pozzo's unpublished manuscript, brought to my attention by Mrs. Enriqueta Harris Frankfort, and much other documentation have been largely untapped, including the published and unpublished inventories of the Alcázar in Madrid (i.e. the Spanish royal collection), and those pertaining to the Escorial. The letters of Titian and Philip II at Simancas have been restudied and republished by Mme Annie Cloulas, and Charles Hope of Oxford has made discoveries, still unpublished, of letters relating to Titian in the Italian archives. It has been my purpose to make full use of this new material.

Crowe and Cavalcaselle dealt with nearly 860 items of all kinds, including copies, engravings, drawings, lost pictures, literary references, and wrong attributions, cataloguing as authentic only 200 paintings, of which twenty today are no longer considered by Titian. On the other hand, ten pictures they rejected have now been restored to the master's hand, and nearly 200 of the long list which they called doubtful and uncertain have disappeared altogether from the literature on Titian. My own total of accepted Titians in my first two volumes is 260. Sixty-four of these works were entirely unknown or considered lost in Crowe and Cavalcaselle's day. In addition, because of the new documentation available, and the flood of new material in the way of copies and over-optimistic attributions, I have had to deal with more than 500 items which do not appear in any guise in Crowe and Cavalcaselle's volumes. Moreover, numerous other attributions in art sales were not considered worthy of mention. Please note, those critics who state that nothing has been added to our knowledge of Titian in the century since Crowe and Cavalcaselle! The tracing of pictures to their present owners is no small task, involving hundreds of letters of enquiry. Only the collections of the major museums of Florence, Vienna, Paris, and Madrid remain unchanged, while American collections and even the Titian collection of the National Gallery in London are predominantly post-1877.

In Volume II a separate catalogue of Lost Works (Cat. nos. L–1—L–34) has been included, limited to items which for good reason must have been by Titian's hand. A large number were in the collections of Mary of Hungary and Charles V before they passed to Spain, where they were lost either in the fire of El Pardo Palace [not the Prado Museum] in 1604 or in the destruction of the Alcázar at Madrid in 1734.

Copies of Titian's portraits are less numerous than the spurious repetitions of his religious pictures.

Yet *Paul III without Cap* (Cat. no. 72) is known in at least twelve copies, obviously because his official portrait was sought by many people. My catalogue of wrongly attributed portraits comprises one-hundred and twenty-three items, many of them not even Venetian, some Roman (Cat. nos. X–16, X–17, X–33, X–34, X–80, X–107), others Central Italian (Cat. nos. X–12, X–43), and still others Flemish (Cat. nos. X–3, X–20, X–72), etc. A considerable variation of opinion continues to prevail as to the attribution of early portraits to Titian or Giorgione or Palma il Vecchio or unknown contemporaries.

After the century of connoisseurship above described, and the rediscovery of a vast amount of documentation with which to substantiate it, I have read with utter astonishment a recent critic's statement on the subject: '... the issues involved are not—except for dealers—really vital ones. The pictures about which they disagree refer in virtually every case to works which, if not by Titian himself throughout, are at any rate by his pupils or his immediate followers. ...'

By strange coincidence three important books were published within a month of my Volume I, *The Religious Paintings*, i.e. Terisio Pignatti's *Giorgione* in November 1969, Rodolfo Pallucchini's *Tiziano* and Erwin Panofsky's *Titian Problems, Mainly Iconographic*, both in December. It has been possible to consider these three scholars' opinions in connection with *The Portraits*. In the Addenda of Volume III their ideas about Titian's religious compositions will be reviewed, as well as articles and books on the same material which become available in the meantime. All three authors have made extremely valuable contributions, each of a different sort. Variations in attribution are natural and inevitable but not always equally responsible. Pignatti's handsome volume with a wealth of illustrative material is the most important study of Giorgione since J. P. Richter's fully documented monograph (1937). Nevertheless, I am not in agreement with his attributions of certain Giorgionesque portraits to the young Titian. Pallucchini's book with one large volume of text and a second volume of illustrations includes all aspects of Titian's work. The corpus of illustrative material is the largest yet published. Professor Pallucchini belongs to the group of optimistic scholars so far as attributions are concerned, but he has excluded a large number of paintings which Suida had presented as works of the master in the last edition of his monograph on Titian (1935). More than thirty portraits that Suida classified as by the artist are so far afield that they have been eliminated totally in my Volume II, while others appear in the X-catalogue. Differences between Pallucchini's opinions on portraits and my own are recorded here in Volume II, the major disagreement being his upgrading of works of Palma il Vecchio to Titian. Those concerning religious compositions will be entered in the Appendix of Volume III.

Erwin Panofsky's posthumous volume consists of the Wrightsman Lectures on Titian, delivered at the Metropolitan Museum of Art in the spring of 1966. These five lectures were devoted to a variety of iconographical problems, primarily religious and mythological. It is almost superfluous to comment that he advanced many fresh ideas from the profound depths of his humanistic mind.

In the preparation of this volume as well as in the case of Volume I and also of a previous large publication, *El Greco and His School*, my great debt to my wife, Dr. Alice Sunderland Wethey, cannot be fully estimated. As usual she has typed and retyped the manuscript, particularly catalogue entries, through several stages of development. In all of my publications she has aided in the laborious task

of reading galley and page proofs and in compiling a comprehensive and analytical Index. Still more important, she has accompanied me on several trips to Europe and has worked with me in the libraries of Rome, especially the Vatican Library, the American Academy, and the Bibliotheca Hertziana. For Volume II she did the research on a considerable number of the biographies of famous people, most notably Jacopo Strada, the della Rovere of Urbino, Giulia Varano, Giulia Gonzaga Colonna, the Turkish sultans and sultanas of the sixteenth century, Laura dei Dianti, Acquaviva the Duke of Atri, the Gonzaga of Mantua. She also prepared the genealogical table of the family of Charles V, and compiled the statistics on Crowe and Cavalcaselle's volumes, cited above. Without her constant assistance it would have been impossible to deliver the manuscript of Volume II to the publisher one year after the completion of the page proofs and Index of Volume I.

Among other scholars Charles Hope of Oxford has generously communicated his discovery of letters in the Mantuan archives regarding Titian's visits to Bologna in 1530 and 1533. His research will be published as a book on Titian's letters. Professor Ellis K. Waterhouse again came to my aid in the problem of sales catalogues (see Cat. no. 28). Dr. Emma Mellencamp, expert on Renaissance costume, has explained to me many puzzling intricacies of her specialty. By correspondence with Mme Annie Cloulas of the University of Paris at Nanterre some perplexing aspects of the patronage of Philip II were thrashed out.

Mrs. Enriqueta Harris Frankfort at the Warburg Institute in London has helped me to secure photographs of prints after Titian's pictures. Miss Caroline Westmacott of the Courtauld Institute in London searched for certain photographs which had eluded me. Thanks for help in obtaining photographs and other courtesies are also due to Professor Jan Bialostocki of Warsaw, Dr. Anna Dobrzycka of Posen, Mme Ludmila Kagané and Mme Tamara Fomiciova of the Hermitage Museum at Leningrad, Mlle Olga Nikitiouk of the Pushkin Museum in Moscow, and Mme Marianne Haraszti Takács of the Budapest Museum of Fine Arts.

The staffs of various European libraries have been particularly helpful: Wolfgang Lotz, director, and Fräulein Irmgard Schreibmüller at the Bibliotheca Hertziana, Mrs. Inez Longobardi of the American Academy, the Istituto d'Arte e d'Archeologia, and the Vatican Library, all in Rome; the Istituto di Storia dell'Arte of the Cini Foundation in Venice, the Courtauld Institute in London, and in the United States the Frick Art Reference Library in New York and Mary Rollman, expert reference librarian of the University of Michigan. Several scholars have been most generous in supplying photographs, especially Dr. Alessandro Contini-Bonacossi and Mrs. Fern Rusk Shapley of the Kress Foundation, and also the collectors, Heinz Kisters, Dr. Torsten Kreuger, Eric Lederer, and Maurice Clemént de Coppet, all in Switzerland.

Finally, to Dr. I. Grafe at the Phaidon Press I am most indebted for his expert handling of the manuscripts of both Volume I and Volume II. Mr. Keith Roberts of the same organization has contributed both his interest and unfailing encouragement.

Ann Arbor, Michigan, 12 July 1970 HAROLD E. WETHEY

INTRODUCTION

TITIAN AND RENAISSANCE SOCIETY

BY dint of sheer personal genius Titian scaled the heights of artistic achievement and rose from the humble society of an Alpine village to be knighted by the Hapsburg Emperor Charles V. Born about 1488–1490 in Pieve di Cadore, high in the Alps north of Venice, he was the son of Gregorio di Conte dei Vecelli, a local official and one-time soldier in the campaigns against Maximilian I of Austria and his invading forces.[1] The name Lucia comprises all of the information known about the mother of one of the greatest artists who ever lived.[2]

To Venice the child Tiziano Vecellio was sent to be apprenticed to Sebastiano Zuccati, a well-known master of mosaics, but he soon passed to the workshop of the leading painters of the day, the Bellini. There under the direction of Giovanni Bellini, the young Titian learned his trade according to the traditions of Renaissance workshops. Since few exact data are preserved, it can only be assumed that he arrived in Venice at the age of nine about 1497.[3] In Bellini's workshop he must have remained until 1503 or 1505. Meantime Giorgione and Titian had become friends, probably when Titian first arrived in Venice and perhaps when both were still apprenticed to the celebrated and venerable Giovanni Bellini.

The first certain work by Titian was his share in the frescoes on the German Exchange, known as the Fondaco dei Tedeschi. That was in the year 1508. Giorgione da Castelfranco, the master in charge, painted the frescoes on the river façade while Titian's compositions stood over the side portal on the street. Only fragments remain today, giving the outlines of various single figures and of the allegory of *Judith as Justice* which was Titian's major contribution.[4]

1. The arguments surrounding the date of Titian's birth are set forth in detail in Wethey, *Titian I, The Religious Paintings*, 1969, pp. 40–42. For the benefit of those who do not have volume I at hand the major facts about this and other aspects of Titian's biography are summarized here.

 Lodovico Dolce, a personal friend of Titian, writing in 1557 (edition, 1960, pp. 164, 201) stated that the artist was barely twenty when he assisted Giorgione on the Fondaco dei Tedeschi, that is in 1508. Vasari, writing in 1568, confirmed that Titian was no more than eighteen when he began to follow Giorgione. Furthermore Vasari reported that, at the time of his visit to Titian's studio in 1566, the artist was about seventy-six (Vasari (1568)-Milanesi, VII, pp. 428, 459). Vasari's account is thoroughly consistent throughout except for the statement at the start of Titian's biography that he was born in 1480. That is obviously a misprint. Vasari was frequently careless, but he could surely add and subtract.

 The diverse reports about Titian's age in letters are contradictory, since they are based on hearsay. There is considerable doubt about the accuracy of the artist's own claim of the extreme old age of ninety-five and of poverty in a letter begging for payment for his pictures, written to Philip II of Spain under date of 1 August 1571.

 The preference for a birth date in 1482 indicated by Panofsky (1969, pp. 176–179) appears to be influenced by the desire to date the picture of *St. Peter Enthroned, Adored by Alexander VI and Jacopo Pesaro* in 1503. Too much reliable evidence is ruled out in this proposal. The various theories about the date of the picture, which is generally placed about 1512, are recorded in Wethey, I, 1969, pp. 152–153, Plates 144–146.

 The belief in Titian's birth about 1488–1490 is now widely held (Dolce-Roskill, 1968, pp. 320–322; Pignatti, 1969, p. 14; Pallucchini, 1969, I, pp. 2–3).

2. The sources for the life of Titian and his relatives are Tizianello, 1622, edition 1809; Ticozzi, 1817; Cadorin, 1833; Ciani, edition 1940, pp. 448, 575–601.

3. Dolce (1557), edition, 1960, p. 201, states that Titian went to Venice at the age of nine, but he does not specify the year.

4. The scenes and figures are listed in Wethey, I, 1969, p. 8, note 45. Illustrated by prints in Zanetti, 1760, pls. 1–7; various illustrations in Richter, 1937, pls. XLII, XLIII, and LIII; also Pignatti, 1969, figs. 18–23, pls. 244–248; Wind, 1969, figs. 41–47, 51–56.

 The Fondaco compositions will be considered in detail in Wethey, *Titian III, Mythological and Historical Paintings*.

Thereafter Titian's fame grew by leaps and bounds, and in 1510–1511 he completed three scenes of the miracles of St. Anthony of Padua in the confraternity of the saint, called the Scuola del Santo at Padua.[5] In these works he became an independent master just at the time of Giorgione's death at the age of thirty-three in early October 1510.[6]

Titian next sought public recognition as painter to the Venetian state when he applied for permission to execute a battle scene in the Great Council Hall of the Ducal Palace. According to an entry in the diary of the historian Marino Sanuto, under date of 29 May 1513, he was to do the work without salary, with funds only to buy colours and to pay two helpers (*garzoni*).[7] Considerable political jockeying followed because the aged Giovanni Bellini had originally been assigned the battle picture, so that not until Giovanni's death in 1516 did Titian fall heir to the commission. However, at this point the artist's services began to be in such demand that the unpaid public commission fell into the background, and he finished then (*c.* 1518–1523) only the *Humiliation of Frederick I Barbarossa by Pope Alexander III*. The *Battle of Cadore* had to wait until 1537, when the council of state forced the artist, then world famous, to complete it. All of these frescoes were destroyed in 1577 in a devastating fire, which ruined several rooms in the Ducal Palace.[8]

During the second decade of the sixteenth century Titian's fame began to spread beyond the borders of Venice and Padua. His first journey to Ferrara to the court of Alfonso I d'Este came in 1516, and thereafter he created one of his most celebrated series of mythological works for the Alabaster Room in the d'Este Castle (1518–1523).[9] These canvases include the *Bacchus and Ariadne* now in the National Gallery in London, as well as the *Andrians* and the *Worship of Venus* in the Prado Museum at Madrid.

Meantime Titian's epoch-making *Assumption of the Virgin* (1516–1518) in the church of S. Maria dei Frari at Venice[10] served notice that here was one of the greatest masters of High Renaissance art, a man who led the way in the creation of a monumental composition that looked to the future in its power of expression. During the fifteen-twenties the painter continued to astound with the originality of his ideas on many occasions, for instance in the famous lost work, the *Martyrdom of St. Peter Martyr*.[11] Both in this composition and in the *Assumption of the Virgin* it is clear that the heroic spirit of Michelangelo's frescoes in the vault of the Sistine Chapel (1508–1512) had found an echo.

Federico II Gonzaga of Mantua, son of Isabella d'Este, sought Titian's services in the fifteen-twenties, the first tangible result of which was the charming portrait in Madrid, datable 1523 (Plates 36, 37). Several religious pictures by Titian also came his way in the twenties and thirties, as well as the celebrated lost series of eleven Roman emperors.[12] At this time the closely related families at Mantua, Ferrara, and Urbino competed for the artist's paintings. All of them ordered portraits, religious, and mythological works. Alfonso I d'Este, uncle of Federico II Gonzaga, had been Titian's patron with the

5. See Wethey, I, 1969, pp. 128–129, Plates 139–143.
6. The fullest accounts of Giorgione's life and works, including transcriptions of all documents and full bibliography, are Richter, 1937 and Pignatti, 1969.
7. Sanuto, XVI, column 316, 29 May 1513; Lorenzi, 1868, p. 161, no. 345.
8. For an outline of these events see Wethey, I, 1969, pp. 10–12. The historical frescoes will be studied in greater detail in Wethey, volume III.
9. To be studied in Wethey, volume III. See also Walker, 1956,

and Wethey, I, 1969, p. 12 for bibliography; Gould, *Bacchus and Ariadne*, 1969.
10. Wethey, I, 1969, pp. 74–76, Plates 17–19, 21–22.
11. Wethey, I, 1969, pp. 153–155, Plates 153–154.
12. The Louvre now possesses the major religious compositions by Titian which Federico II Gonzaga of Mantua first owned. They passed to Charles I of England in 1627: the *Entombment*, the *Madonna and Child with St. Catherine and a Rabbit*, *St. Jerome in Penitence*, and the *Supper at Emmaus*. See Wethey, I, 1969, Mantua in the Index. Roman Emperors, *op. cit.*, pp. 23–25.

mythological pictures for the Alabaster Room, as we have seen. He also owned the *Madonna and Child with St. Catherine and St. John the Baptist* now in the National Gallery at London and the *Madonna and Child with SS. Stephen, Jerome and Maurice* in the Louvre at Paris.[13] Alfonso's own portrait (Plate 40) soon passed to Charles V, as we shall see, and it still survives in a darkened state in the Metropolitan Museum in New York.

The next patrons of the Venetian master were Francesco Maria I della Rovere, the duke of Urbino, and his wife, Eleanora Gonzaga della Rovere, who was the sister of Federico II Gonzaga and niece of Alfonso I d'Este. Titian seemed at this period to be especially attached to the courts of Ferrara, Mantua, and Urbino, but not exclusively so, for there were also the Medici at Florence although to a far lesser degree.[14] The Urbino pictures moved to Florence a century later in 1631, when the heiress Vittoria della Rovere became engaged to Ferdinando II dei Medici. They include the portraits of the Duke and Duchess of Urbino (Plates 67–70), the *Venus of Urbino*, the nude *Magdalen*, and the *Bust of Christ*.[15]

One would have thought that Titian had reached the ultimate heights with his numerous commissions for Mantua and Ferrara in the twenties and for Urbino in the thirties. A new and greater luminary appeared on the scene, however, when Charles, King of Spain, Austria, Germany, and the Netherlands, journeyed to Bologna to be crowned Holy Roman Emperor on 24 February 1530. The rulers of Italy's principalities then vied with each other to cultivate the Emperor's favours. Those who allied themselves with the Hapsburg cause received their rewards. Marquess Federico II Gonzaga was now elevated to the rank of Duke.

It appears to have been Federico himself who arranged for Titian to come first to Mantua and thereafter to Bologna to paint the portrait of Charles V at the time of the coronation.[16] On Charles V's second visit to Bologna in 1532–1533 to meet Pope Clement VII, Titian also returned to carry out further portraits of the Emperor. At this time Francisco de los Cobos, Charles' minister, suggested that Alfonso d'Este give his master a group of paintings by Titian, which were then in the d'Este collection at Ferrara. They included a *Judith*, a *St. Michael*, and a *Madonna*, as well as the portrait of *Alfonso d'Este* himself (Plate 40), which Charles had especially admired. A series of letters in February 1533 show that the first three pictures were sent to Genoa for shipment, obviously to Spain, since the route to Brussels was overland.[17] Most curious is the fact that none of the three ever appears in the Spanish Inventories. The possibility arises that they were destroyed or lost during the voyage by sea. The portrait of Alfonso d'Este, on the other hand, was taken to Bologna, where Charles kept it hanging in his room,[18] and it is believed to be the picture still extant in the Metropolitan Museum in New York.

Titian's portraits of the Emperor prepared in January and February 1533, like the first one of 1530,

13. Wethey, I, 1969, pp. 104–105, 113, Plates 15, 35.
14. Portrait of *Ippolito dei Medici* (Plate 65).
15. For the *Bust of Christ* and the *Magdalen* see Wethey, I, 1969, p. 78, Plate 92 and pp. 143–144, 150, Plate 182.
16. A letter of 11 October 1529 from Calandra, the ducal chancellor at Mantua, to Malatesta, the Mantuan agent in Venice, expresses the desire of Federico Gonzaga to have Titian come to Mantua to do the Emperor's portrait. This letter will be published by Charles Hope of Oxford, who recently discovered it.
 Vasari's statement (Vasari (1568)-Milanesi, VII, p. 440) that Ippolito dei Medici arranged for Titian to prepare the Emperor's portrait in 1530 is therefore wrong. Vasari's determination to give a Florentine credit is consistent with his usual prejudice in favour of his native city.
17. Documents published by Gronau, 1928, pp. 244–245.
18. *Loc. cit.*, p. 245. See also Keniston, 1959, pp. 153–154.

have been lost, except the *Charles V with Hound* (Plate 55).[19] The ruler was so impressed by the master's art that, after he had reached Barcelona on 10 May 1533, he issued a decree knighting the painter. The title bestowed was Knight of the Golden Spur and Count of the Lateran Palace. The original document, which is now in the museum of the Casa di Tiziano at Pieve di Cadore, was accompanied by a golden chain. Titian's newly granted escutcheon appears upon this document and also upon his last painting, the *Pietà* now in the Accademia in Venice.[20] The highly prized golden chain of knighthood is shown in his *Self-Portraits* (Plates 1, 208, 209).

The following year Charles V ordered Titian to go to Spain to prepare portraits of the Empress Isabella and Prince Philip, then aged seven. This fact emerges in three letters of September–October 1534 written by López de Soria, Charles' ambassador at Venice, to King Ferdinand I, who was in Vienna. The ambassador urged Ferdinand to complete the special privileges allowing Titian to receive the proceeds for the cutting of wood in certain forests. Titian's brother had gone to the Austrian court for the purpose of completing the negotiations, López de Soria reported. Titian insisted that he could not leave for Spain until his brother returned to Venice. In the final letter of 4 November 1534 is included the information that Titian would soon finish a portrait of the Emperor to be sent to Ferdinand. López de Soria added that the artist would carry out portraits of the Empress and Prince Philip for the Austrian king and that they would be sent to him from Spain.[21]

Despite these promises Titian probably never intended to undertake the arduous journey to distant Valladolid. He was far too busy at home, in fact overwhelmed by commissions. Just at this time he began the *Presentation of the Virgin* (1534–1538) in the Accademia at Venice.[22] In 1536 he would send Isabella d'Este's portrait (Plate 72) to her in Mantua, and he had in preparation the *Supper at Emmaus* for her son Federico.[23] He was soon to be engaged upon the cycle of Roman Emperors for the ducal palace also at Mantua (1537–1538).[24]

Luckily for posterity Titian avoided fulfilling his agreement to undertake the difficult voyage to Spain. Otherwise he might never have had the time to create so many masterpieces in the fifteen-thirties, among them the important commissions for the Duke and Duchess of Urbino. His trips from Venice at this time were fortunately limited to his summer vacations at Cadore, his sojourns in

19. See below pages 18–22.
20. The text is published by Ridolfi (1648)-Hadeln, I, p. 181 with wrong date. See also below note 88.

The particular order and titles conferred on Titian by Charles V in 1533 clearly reflect the Emperor's new status as the officially crowned head of the Holy Roman Empire. Traditionally founded by the Emperor Constantine, the Order of the Golden Spur could be conferred by emperors as well as popes, and its holders took precedence over all others, even the wearers of the Cross of Malta. The formula of conferment read in part: 'We make and create you Knight of the Golden Militia and Count of the Lateran Audience Hall and of the Apostolic Palace, and we include you in the number and company of the other knights and counts of this kind. ... It is our will that you wear the golden chain ... and golden spurs' (Bonanni, 1724, no. 16). Frederick III of Hapsburg, great-grandfather of Charles V, on the occasion of his coronation as emperor by Nicholas V in Rome in 1452, created 265 Knights of the Golden Spur in a ceremony held on the Milvian Bridge (Bonanni, *loc. cit.*, with erroneous date of 1445), the site chosen obviously because of its association with the decisive victory of Constantine over Maxentius in A.D. 312 [the data in this item compiled by Dr. Alice Sunderland Wethey]. See note 88 below for the escutcheon.

The theories of older Spanish writers that Titian went to Barcelona to receive his knighthood and that he was also made a knight of Santiago are totally erroneous (Palomino (1724), edition, Madrid, 1947, pp. 792–793; Ceán Bermúdez, 1800, V, pp. 29–31).
21. Letters of 28 September, 1 October, 24 October, and 4 November 1534, published by Voltelini, 1890, pp. XVII–XVIII, nos. 6310–6313.
22. Wethey, I, 1969, pp. 123–124, Plates 36–39.
23. Now in the Louvre at Paris. See Wethey, I, 1969, pp. 161–162, Plates 88–89.
24. See *loc. cit.*, pp. 23–25. To be studied in greater detail in Wethey, volume III.

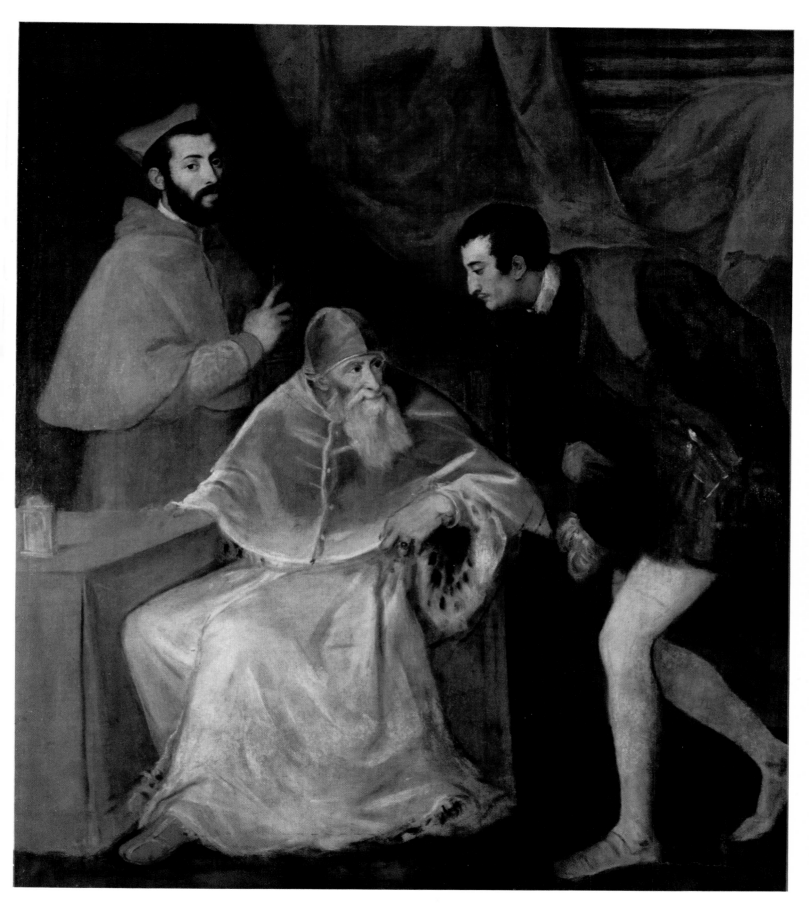

Paul III and Grandsons. 1546. Naples, Gallerie Nazionali, Capodimonte (Cat. no. 76)

Mantua, and the meeting with Charles V at Asti in May 1536 in the entourage of Federico Gonzaga of Mantua.[25] Clearly Charles V made no further attempt to persuade the artist to visit the court in Spain. Titian did at Asti make the acquaintance of the military and political advisers who accompanied the Emperor on this triumphal tour, which included Naples, Rome, Florence, and Milan.[26]

Titian had reached the very summit of the social scale of Renaissance society.[27] Honoured as a great genius, his works were sought by all of the princes of Europe. Yet the fifteen-forties were to be the busiest of his life, his commissions even more numerous than before, and his trips beyond the borders of Venice more frequent and farther-flung. He lived in luxurious style, as befitted his greatness as an artist and his social position, in the palace known as the Casa Grande in the parish of San Canciano, where he had first moved in 1531. One description of a banquet given by Titian on 1 August 1540 survives to furnish an idea of the luxury in which the artist lived at that time. In a book on *Gramatica latina* Francesco Priscianese, a famous grammarian, gave account of an evening at the Casa Grande in company with Jacopo Sansovino, Pietro Aretino, and Jacopo Nardi, a Florentine historian and translator of Livy.[28] Priscianese describes the affair as a Bacchanalian feast and states that before the dinner they spent their time looking 'at the excellent pictures of which the house was full'! They walked in the garden, spread expansively down to the lagoon opposite the island of Murano. The supper, accompanied by music, brought a copious array of delicate foods and fruits, choice wines, and lively conversation.

Exactly a year later Titian set forth for Milan, not called by the Emperor, but to seek reimbursement for his paintings.[29] The outcome took the form of an annuity of one hundred *scudi* for life. That was only the beginning of his long struggle for proper financial rewards. Later at Augsburg in 1548 Charles increased the pension to two hundred ducats annually, but the artist received not a penny until 1558, subsequent to the Emperor's death.[30] Then in an emotional state after the loss of his father, Philip II ordered payment in full for the sum due for the past several years in the amount of two thousand *scudi*. This was not the end, however, as Titian's letters to Philip continually testify, particularly the famous one of 1574, where he listed the series of celebrated religious works for the Escorial as well as the mythological paintings for which he asserted he had received no recompense.[31]

Titian's experiences with the Farnese family were even less rewarding, for it appears that he received no payment at all for any of the famous portraits of the family made at Bologna in 1543 and at Rome

25. For a fuller account of these trips and the documentation, see Wethey, I, 1969, pp. 23–28. On p. 27 the suggestion was made that Titian might have done another portrait of the Emperor at Asti. On further consideration of the matter, in view of the lack of any documentation of such a portrait, the proposal seems unlikely.

26. Letter of Titian to Aretino 31 May 1536 in Crowe and Cavalcaselle, I, pp. 407–408; also Ticozzi, 1817, p. 309. Charles V remained at Asti from 26 May until 22 June 1536 (Foronda, 1914, pp. 424–425), preparing his brief but disastrous invasion of southern France. See also Keniston, 1959, pp. 183–186.

27. See Wethey, I, 1969, pp. 13–17 for an account of the artist's personal life. In November 1525 Titian had married Cecilia, when his mistress became ill and near death, but she recovered and lived another five years. Their two sons, Pomponio born in

1524 and Orazio in 1525, were thus legitimized. Titian's daughter Lavinia (Plates 187–189, 191–192) born in 1529–1530 survived until 1561 (see Cat. nos. 59–61). Little is known about a late illegitimate daughter, born about 1548 (Wethey, I, 1969, p. 14, note 74).

28. Francesco Priscianese, *Gramatica latina*, Venice, 1540; the description of the banquet was reprinted by Ticozzi, 1817, pp. 79–80; English translation by Crowe and Cavalcaselle, II, pp. 40–41.

29. Aretino, *Lettere*, edition 1957, I, p. 193.

30. Voltelini, 1890, nos. 6343 and 6404. Full documentation cited by Wethey, I, 1969, p. 27, notes 151, 152.

31. The letter of 1574 in Crowe and Cavalcaselle, II, 1877, pp. 404–405, 539–540; Cloulas, 1967, p. 280.

in 1545–1546.³² Titian hoped to obtain the benefice of the abbey of San Pietro in Colle near Ceneda for his son Pomponio through the intervention of Paul III and Cardinal Alessandro Farnese. It is clear that he expected this benefice in place of payment for his pictures of the Farnese family. From the year 1543 until 1567 Titian continued his efforts to no avail, since the benefice was never forthcoming.³³

A detailed study of Renaissance and Baroque patronage of artists in relation to the recompense received from great families would certainly yield astonishing results. Titian himself has often been accused of avarice, without consideration of the fact that popes and rulers did not always pay artists and architects or even their mercenary troops. The soldiers, in consequence, normally sacked the cities through which they marched. The Hapsburgs, unable to pay their debts, were in a constant state of bankruptcy because of the unceasing wars in which Charles V engaged.³⁴ Nevertheless, that situation did not convince them of any need to limit their expenditures. How like modern society this aspect of the Renaissance was!

Titian's celebrated patrons, the Emperor Charles V, Pope Paul III, and Cardinal Alessandro Farnese, did, however, contribute to the spread of the artist's fame. The master moved in the highest-ranking political, ecclesiastical, and social circles, where he was treated with the reverence due to such a great genius. The sojourn at Bologna and Busseto in the spring and summer of 1543 brought him again into contact with Charles V and his numerous entourage. However, it was the pope who called Titian to Bologna.³⁵ The artist joined the suite of Cardinal Alessandro Farnese at Ferrara late in April and continued on to Bologna,³⁶ where his primary purpose was to prepare the portrait of *Paul III without Cap* (Plates 115–117). That he accomplished during the month of May, but he remained in Bologna until late July. His personal relations with Alessandro Farnese were so close that he wrote him an angry letter, when he discovered that the cardinal had departed from Bologna suddenly in July without any warnings of his intention.³⁷

Titian's next major association with the Farnese family came during those months from the autumn of 1545 until June 1546, when he was lodged in the Belvedere Palace of the Vatican. By this time popes, cardinals, bishops, and princes were no dazzling novelty to the world-famous master. Far more enthusiasm must have been aroused by the traditions of Rome, ancient, mediaeval, and Renaissance. The artist, like any visitor to the cradle of western civilization, surely spent days and weeks examining the archaeological remains of ancient Rome, not only the temples and basilicas, but the

32. See below pp. 28–32; also Cat. no. 72. Titian himself was offered the benefice of the keeper of the papal seals in 1543 at a time when it was held by his fellow artist, Sebastiano del Piombo. He refused to supplant his boyhood colleague, and later after Sebastiano's death he again rejected this sinecure. Then, however, the artist was too much involved with the offers of Charles V to shift allegiance to the Farnese (Wethey, I, 1969, p. 28 and note 158).

33. See Wethey, I, 1969, p. 30 and notes 171, 172; also Fabbro, 1967, pp. 1–18 for a summary of Titian's efforts to secure the benefice for Pomponio.

34. See John Lynch, 1964, *passim*.

35. Aretino's letter of 10 April 1543 to Cosimo dei Medici includes

the information that the pope called Titian to meet him (Gaye, 1840, II, pp. 311–312).

36. Letter of 22 April 1543 at Ferrara (Cittadella, 1868, p. 599). Titian accompanied Alessandro first to Bologna at the end of April; the meeting at Busseto took place from 21–25 June (Foronda, 1914, pp. 546–547). Thereafter Titian returned with the papal suite to Bologna. He did not go to Busseto first and then to Bologna (contrary to Crowe and Cavalcaselle, 1877, II, pp. 82–83).

37. Titian's letter of 26 July 1543 written to Alessandro Farnese after the artist's return to Venice (Ronchini, 1864, pp. 131–132; also Crowe and Cavalcaselle, 1877, II, pp. 84–85).

painted decorations in the recently explored Golden House of Nero.[38] Perhaps even more exciting to him were the works of Michelangelo, Raphael, and Sebastiano del Piombo. He could not have failed to see the frescoes of Andrea Mantegna in the chapel of Innocent VIII in the Belvedere Palace, the murals of Fra Angelico in the Chapel of Nicholas V, and the great Biblical cycle by Botticelli, Ghirlandaio, Perugino, and others on the lateral walls of the Sistine Chapel.

The remarkable fact is that the impressions of Rome had so little effect upon the great master's own work. It must be remembered, however, that he was the leader of the Venetian school, and more famous than most of those who preceded him in Rome with the possible exceptions of Raphael and Michelangelo. His art and his intellect were so fully formed that nothing would change him to any extent, then at the height of his career. Any allegation that the visit to Rome revolutionized his art is totally without justification.[39]

Several important studies relative to Titian's familiarity with antique art have been published by prominent scholars.[40] The earliest case of the inspiration of Roman sculpture is to be found in the simulated relief in the picture of *Saint Peter Enthroned, Adored by Alexander VI and Jacopo Pesaro*,[41] and sporadic occurrences can be noted throughout the artist's career. No such fundamental inspiration of Hellenistic art directed the development of Titian's painting as it did the art of Michelangelo, the sculpture of Jacopo Sansovino, and the work of numerous other Florentine and Roman masters. As early as 1533 in the document of knighthood issued by Charles V, Titian is likened to Apelles. The conjuring up the name of this most celebrated painter of antiquity, who was attached to the court of Philip of Macedonia and his son Alexander the Great, is surely a literary effusion, in which Charles V was also compared to Alexander and Augustus.[42] The attempt to draw exact parallels between Titian and Apelles, even as to their methods of painting and their use of colours, is a hyperbole which does not convince.[43] Titian was indubitably saturated with humanistic learning, knowledgeable in

38. That Titian did study the antique remains of Rome is proven by a letter of 8 December 1545, written by Titian to Charles V, concerning the portrait of the Empress Isabella (Cat. no. L–20). The first part of the letter, relative to the portrait, was quoted by Beroqui, 1925, p. 262, and 1946, pp. 63–64, as well as by Cloulas, 1967, p. 207, note 3, who noted the disappearance of the original from the Simancas Archives (E872).

The entire letter has been published in full in only one monograph on Titian, i.e., by Georges Lafenestre, 1886, p. 215. Gronau (*Titian*, 1904, p. 136) quoted one line of the letter but omitted its date and gave no bibliographical reference. For these reasons the document has escaped the attention of authors of books on Titian.

The collector, Fillon, first reproduced the letter in facsimile (1879, II, no. 2097), but he omitted the catalogue number (E 872) of the Archivo General at Simancas. The next owner, Alfred Morrison, again published the letter in facsimile, and included the Simancas catalogue number (Morrison, 1892, VI, p. 303).

The important statement in this missive regards Titian's admiration of the antique, as follows: 'I am now here in Rome called by His Holiness, and I am learning from these most marvelous antique stones, things with which my art may be worthy to paint the victories which our Lord God prepares for your majesty in the East' ('Io sono hora qui in Roma chiamatoci da N. S. et vado imparando da questi maravigliosissimi sassi

antichi cose per le quali l'arte mia devenghi degna di pingere le vittorie che Nostro Signor Dio prepara a Vostra Maesta in oriente.').

The original letter is now in the Fondation Custodia at Paris. I am much indebted to Charles Hope for information of its existence there and to Carlos van Hasselt of the Fondation for a photographic copy of the entire letter.

I must correct the former statement (Wethey, 1969, I, p. 23) that no letter survives which gives in Titian's own words his reactions to the antiquities of Rome.

39. So remarked by Saxl, 1957, p. 168. Titian's repetition of a group from Raphael's *Miraculous Draught of Fishes* in his altarpiece of the *Madonna and Child Appearing to SS. Peter and Andrew* at Serravalle (Wethey, I, 1969, p. 112, Plates 46, 48) is the one specific example of dependence on a work seen in Rome. The influence of Michelangelo on the pose and heroic scale of Titian's *Danae*, now in Naples, is also generally agreed (Wethey, *op. cit.*, p. 30).

40. Curtius, 1938; Brendel, 1955; Panofsky, 1939, 1965, and 1969; Kennedy, 1956, 1963, and 1964; and others.

41. Wethey, I, 1969, pp. 152–153, Plates 144–146; Wittkower, 1938–1939, pp. 202–203.

42. See note 20.

43. Ruth W. Kennedy in her scholarly article, 'Apelles Redivivus', 1964, pp. 167–170.

ancient and Renaissance literature like other leading masters of the High Renaissance, as his numerous mythological paintings testify. Any Renaissance man of his status was thoroughly versed in the lore of antiquity. The artist's long-distance familiarity with Michelangelo's work had been reflected in the *Assumption of the Virgin* in S. Maria dei Frari as early as 1516–1518, and in his *Martyrdom of Saint Peter Martyr* of 1526–1530.[44] After the sack of Rome in 1527 and the flight of Jacopo Sansovino and Sebastiano Serlio to Venice, the diffusion of Central Italian artistic developments was fulfilled.[45]

Titian certainly enjoyed his months in Rome, replete with unceasing activity as a painter, and himself resident in a city of inexhaustible fascination for an intellectual of the Renaissance. Before his departure the artist received the coveted honour of being declared a citizen of Rome.[46] In June 1546 on his return to Venice, stopping at Florence for the only time in his career, Titian was 'stupefied' by the artistic wonders there, according to the Florentine Vasari, no less than he had been in Rome.[47] His ties with the Farnese were ended, although he still clung to his unfulfilled hopes for a benefice for Pomponio.

His journeys were not yet over: a year and a half later he answered the call of Charles V to come to Augsburg in Southern Germany. Although a man nearing sixty, and one who had already won all of the honours for which any artist could hope, Titian remained intrepid. He set out in the depths of winter on 6 January 1548 to fight his way through the deep snows of Alpine passes. That he had the fortitude to undertake the trip on horseback is indeed testimony to the strength and audacity of men of the Renaissance. There in Augsburg the artist, accompanied by his son Orazio and other assistants, remained until October, devoting himself exclusively to portraits, the most important being those of Emperor Charles V (Plates 141–146).[48] Home again in Venice for a few weeks, he received a command from Charles to go to Milan to prepare portraits of Prince Philip, who tarried there from 20 December 1548 until 7 January 1549. Twenty-two months later the artist made a last journey abroad, again to Augsburg. This time his major surviving masterpiece is the full-length portrait of *Philip II in Armour* (Plates 174–176).[49]

On his return to Venice in mid-May 1551 Titian settled in the Casa Grande, relieved, one may imagine, that his travels had ended. His productivity during all of this period continued to be phenomenal. Portraits had taken first place for the Farnese and the Hapsburgs, although not to the total exclusion of other subjects. During the remaining twenty-six years of his life he had somewhat more time for reflection. The Hapsburgs still made great demands upon his energies and his creative imagination. After Charles V's retirement, Philip II became the artist's most insistent patron. Religious pictures issued in quantities from his brush for the monastery and church of the Escorial.[50] In addition, he created many of his most inspired compositions on mythological themes, his *poesie* for Philip II: the *Danae*, the *Venus and Adonis*, the *Diana and Actaeon*, *Diana and Callisto*, *Andromeda*, and the *Rape of Europa*.[51]

44. Wethey, I, 1969, pp. 74–76, Plates 17–19; pp. 153–155.
45. Wethey, *op. cit.*, p. 20. Giulio Romano had resided at Mantua since 1524 so that both he and his paintings and architecture at the Gonzaga court were well known to Titian (Wethey, *op. cit.*, pp. 23–25).
46. Gregorovius, 1877, p. 338.
47. Vasari (1568)-Milanesi, VII, p. 448.

48. See below pp. 35–38 and catalogue entries.
49. Further details below pp. 41–45.
50. See Wethey, I, 1969, Index, Escorial, for a list of these paintings, many of which still survive.
51. To be studied in Wethey, volume III. See also standard monographs on Titian; Panofsky, 1969; Keller, 1969.

Finally the venerable old master, whose faculties remained clear and strong until the end, died of old age in his luxurious palace, the Casa Grande.[52] The end came on 27 August 1576, when a great plague was raging in Venice. His son Orazio, aged fifty-one, was carried off by the pest two months later,[53] but Titian himself clearly died of natural causes, since his funeral services and burial took place in S. Maria dei Frari the following day. Plans for a state funeral, after the manner of the elaborate ceremonies held in Florence at the time of Michelangelo's death, had to be abandoned because of the disruption of life during this crisis, when Venice lay ravaged by the plague.[54]

52. The facts and late masterpieces contradict the malicious statement of Niccolò Stoppio that Titian was too feeble to hold a brush during his last years and that his pictures were carried out by assistants. See below, page 49.

53. Orazio died in the lazaretto at the end of October 1576 (Cadorin, 1833, pp. 95–96) and doubtless received communal burial, as was the custom with the plague-stricken.

54. Wethey, I, 1969, pp. 33–34 for further details and documentation.

CRITICAL AND CHRONOLOGICAL STUDY
OF TITIAN AS PORTRAITIST

Throughout his entire career, from the very beginning until the end, Titian engaged in portraiture. His keen observation of nature and his comprehension of human character, added to the extraordinary pictorial beauty of his canvases, have been noted by all critics. Nevertheless, Titian's art in portraits underwent a long line of evolution during his lengthy career, as it did also in the realm of religious and mythological compositions. His portraiture is examined here from the outset, when his work is difficult to distinguish from that of Giorgione, and thereafter decade by decade throughout his life, as his patronage rose to the very summit of the social scale.

VENETIAN YOUTHS AND GENTLEMEN: 1510-1520

The narrow line of demarcation between Titian and Giorgione is nowhere more vexed than in the field of portraiture, where little agreement among historians and critics has been reached. The *Youth* in Berlin (Plate 2) has become one fixed point, since all writers accept it as a certain work from Giorgione's hand about 1504–1506. The serenity of mood is subtly projected by the stillness of pose, the immobile features, and the quietly flowing outlines of the compactly moulded hair. The lavender doublet adds richness of colour to this conception of Renaissance man in his harmonious aloofness. Yet nothing about the portrait is new from the point of view of composition and design. The small parapet in the foreground which separates the viewer from the portrayed, here raised a notch at our left so the *Youth* may rest his hands upon it, had made its appearance in Antonello da Messina's *Young Man* (Berlin-Dahlem, Staatliche Gemäldegalerie) signed and dated 1474. In this and other portraits such as the *Condottiere* (Paris, Louvre) of 1475, Antonello had included only the shoulders. It remained for Giovanni Bellini and the Vivarini to carry on this tradition of portraiture and to transmit it to Giorgione. Giovanni retained the parapet but he frequently introduced the sky, making the figure dark against a pale ground. In a masterpiece which Giovanni Bellini painted after Giorgione's death, the *Fra Teodoro* (London, National Gallery), signed and dated in 1515, he increased the figure to nearly half length against a brilliant flowered curtain. Giorgione, however, retained in his portrait of the *Youth* (Plate 2) a dark setting for the lavender costume and the dark hair, and this work thus remains about as immutable and chiselled in effect as a bust by Laurana.

In Giorgione's *Self-Portrait as David*, best preserved in Wenzel Hollar's engraving (Plates 6, 7), the artist introduced a considerable change of direction. Even though he maintained the notched parapet, in this case for the special purpose of supporting the gory head of Goliath, he turned his own body into depth, sharply at an angle, and so the figure is actively engaged in the space rather than isolated from it. The shoulders and head assume a new volume and forcefulness, more suitable to the intense nature of the countenance with the determined frown and the unruly mass of heavy

hair. In the fragment of this *Self-Portrait* at Brunswick, whether by Giorgione himself or a copy,[55] shadows have notably deepened and the enveloping atmosphere is strongly felt. Here Giorgione's style has moved technically and dramatically far from the remoteness of mood and the non-atmospheric volume of the Berlin picture.

The step from Giorgione's *Self-Portrait as David* to Titian's *Gentleman in Blue in London* (Plates 3, 4) is perfectly logical and not at all wide. Titian's initials (T. V.) upon the parapet have settled the issue of authorship in a work which was long considered for stylistic considerations to be by Giorgione.[56] Here the closeness of the two masters' styles is demonstrated, yet it is possible to observe subtle differences in Titian's attitude. Even though the parapet and the position of the body are essentially the same as Giorgione's,[57] his concern for matters of texture seem greater, particularly the silken sheen of the sleeve, where the bulk of the thick quilted material stands out more boldly. Titian has maintained Giorgione's preoccupation with the atmospheric envelope, but the background is lighter again, helping thus to create the volume of the figure in the depth of space. The characterization of

55. The recent X-rays, which reveal a Giorgionesque Madonna and landscape beneath the portrait, are good evidence for the belief that the Brunswick canvas is the original and not a copy. See Müller-Hofstede, 1956, pp. 252–253; Pignatti, 1969, pp. 141–142, on the other hand, still maintains that it is a copy.

56. The mystery of the initials including a v on Venetian portraits of the early sixteenth century has been solved only to a limited degree. In the case of the *Gentleman in Blue* (Cat. no. 40) and *La Schiavona* (Cat. no. 95), both in London, the letters T V unmistakably mean TITIANVS VECELLIVS, as Gould has already demonstrated (1959, pp. 114, 121). Other variations have not been satisfactorily explained. Teniers included V V P in the right background, replacing the mirror, in his copy of Titian's *Lady at Her Toilet* then in the collection of the Archduke Leopold Wilhelm. Since he considered Titian the author of the work, he might possibly have intended them to signify VECELLIVS VENETVS PINXIT. In fact, Kenyon Cox (1913, pp. 115–120) argued cautiously for the possibility that the v in all cases refers to Titian (Vecellius).

When the *Venetian Gentleman* in Washington (Cat. no. X–109) was cleaned and X–rayed in 1962, the letters V V O came to light, but there is no agreement as to whether the picture is by Titian or Giorgione or an anonymous contemporary. The meaning here is totally elusive. On Giorgione's *Youth* in Berlin (Plate 2) V V alone appears upon the parapet. Sir Herbert Cook proposed (1907, pp. 31–32) that these letters constitute an old form for z z which would therefore mean Zorzon, the archaic Venetian form of Giorgione's name. However, no good evidence exists that the z was ever written in that way (Ferriguto, 1933, p. 331, note). Another theory published by Paola della Pergola (1955, p. 38) holds that the Berlin *Youth* is a portrait of Gabriele Vendramin, then aged twenty-four, and that the inscription should be interpreted as VENDRAMIN VENETVS. A related idea was advanced by Hermanin (1933, p. 93), who thought that the first v referred to a family name and the second to Venezia. Following in the same general direction are Morassi (1942, p. 169) and Pignatti (1969, p. 100), who concluded that a collector's mark was the most reasonable explanation.

Still other combinations of letters do occur, so it is altogether reasonable to assume that the v does not always carry the same significance. On the portrait of the so-called *Antonio Broccardo* in Budapest the v decorating the front of a cap or hat against the parapet and the three-faced head within a wreath may well be a symbolic way of identifying Vincenzo Cappello of Treviso [three faces] (Gronau, 1908, p. 431, quoting Dr. Jacobs of Berlin; accepted by Gombosi, 1937, pp. XIV, and others).

More speculative theories include those of Hartlaub (1925, p. 66) to the effect that the V V are symbols of a secret society, a theme which frequently appealed to him. Richter (1937, p. 209) preferred VANITAS VANITATUM, following an earlier proposal by Schrey (1915, p. 574).

The chief argument in favour of a variety of meanings for these mysterious initials is that they appear on unrelated pictures which cannot be associated with a single artist, collector or family. The portraits are not limited in every case to Titian and Giorgione. There are three different versions of a Venetian portrait of a *Lady* with one v, that now in Houston (?), formerly in the Quincy Adams Collection at Boston (Berenson, 1957, pl. 732) and similar works in the galleries at Budapest and Modena (Garas, 1964, pp. 75–76). Even farther removed is the mediocre portrait of *Luigi Grasso*, dated 1508, with V V (Richter, 1942, p. 223). Doubtless other examples exist in unknown private collections. Just about the only conclusion to reach is that in some way or other all of these portraits are related to Venice, inasmuch as these letters do not appear upon works of art of other schools. The v's surely do not mean the same thing in every case in view of the wide variety of male and female portraits involved (see also Gould, 1961, pp. 338–339).

57. This turn in the position of the figure occurs even more fully in the much disputed Giorgionesque *Gentleman* in Leningrad and the other version formerly belonging to the Duke of Grafton in London, dated 1512. Attributed by Berenson to Domenico Caprioli (1957, p. 52) and by Wilde to the 'Master of the Self Portraits' (1933, pp. 113–120), and by Dr. Garas to Palma il Vecchio (1966, pp. 69–93), the authorship of this handsome work, originally given to Giorgione, is still an unsolved problem.

Nevertheless, the inscription 'MDXII DOMENICO' is more reasonably identified with Domenico Mancini (active 1510–1520), a close follower of Giorgione than with Domenico Caprioli (1494–1528). See L. Venturi, 1912, pp. 136–138; Leningrad, 1958, I, p. 128.

Titian's gentleman in his mid-thirties implies confidence, maturity, and worldliness without any particular suggestion of intellectuality.

The firm ground of the London portrait disappears as one moves on to consider other works, for example the *Knight of Malta* in Florence (Plate 5), where the dream-like mood and the enveloping atmosphere, now blurred by the poor condition of the picture, predominate. Costume, along with other considerations, places the picture in the neighbourhood of 1510. The doublet cut low, revealing the white shirt, is exploited both as a contrast and as a support to the head. This design now seems to relate to Titian perhaps more than to Giorgione. The fineness of grain in characterization, the thought-involved calmness, the eyes appearing not to see, all of these are elements native both to Giorgione and to Titian in his earliest years. The costume looks ahead to *Jacopo Sannazzaro* (Hampton Court) (Plate 19) and the *Young Man with Hat and Gloves* (Garrowby Hall) (Plate 20), yet the head in each of these later pictures emerges more solidly and so the characterization has greater assertiveness. Absolute certainty that Titian is the author of the *Knight of Malta* is wanting and may always remain so.

In these same years of the Giorgione-Titian mystery belongs the celebrated *Concert* in Florence (Plates 8–10), a work which the critic Morelli in 1891 returned to Titian. The drama implied in the turn of the performer's head, the troubled look on his gaunt and superbly chiselled features, reflect the mind of the same artist who later recorded the *Man with a Glove* in the Louvre (Plates 30–32). The beseeching glance of the troubled musician is all the more telling by contrast to the older man, clearly bald though tonsured. His middle-aged face, bearing a scar, has the resignation brought by the experience of life. It is the bland indifference of the boy in his elegantly plumed hat which has caused the greatest puzzlement, to the extent that many writers explain him as the creation of a different hand, perhaps Giorgione's. That may well be so, yet his young face increases the understanding of the depth of experience felt in his companions. All three men stand as in relief against the solid wall behind them.

Near to the *Gentleman in Blue* in London, signed by Titian (Plate 3), is the *Gentleman with Flashing Eyes* at Ickworth (Plate 12), his shoulder toward the spectator, his head turned in three-quarter view to look directly out at the onlooker. In addition, cut of hair and beard are virtually identical in the two cases, enough to confirm the closeness of date. The lack of parapet in the second composition is inconsequential in view of other corresponding elements. On the other hand, the man at Ickworth strikes one as ten years younger, about twenty-five, much livelier, sure of himself in an aristocratic way. All of these contrasts Titian brings out in the subtlest manner through minute variations of surface, emphasis upon the eyes, clarity of the nose, and slight twist of the lips.

Two new details are worth noting in the Ickworth portrait: first the position of the fingers in the left hand is identical to the right hand of the *Knight of Malta* (Plate 5). Secondly, a half-medallion in the upper background is a rather curious feature which here may have an heraldic significance. In the wall behind the *Fugger Youth* (Plate 11) the artist introduced a small circular window, and similarly Titian originally placed a circular opening, with sky visible, in his signed portrait of *La Schiavona* in London (Plate 13). The *Fugger Youth* (see Cat. no. X–42) still remains a puzzle in relation to the Giorgione-Titian mystery. Its earlier acceptance as by Giorgione is now doubted, although the work is surely the picture mentioned by Ridolfi in 1648. Klara Garas still prefers its association with a *Self-*

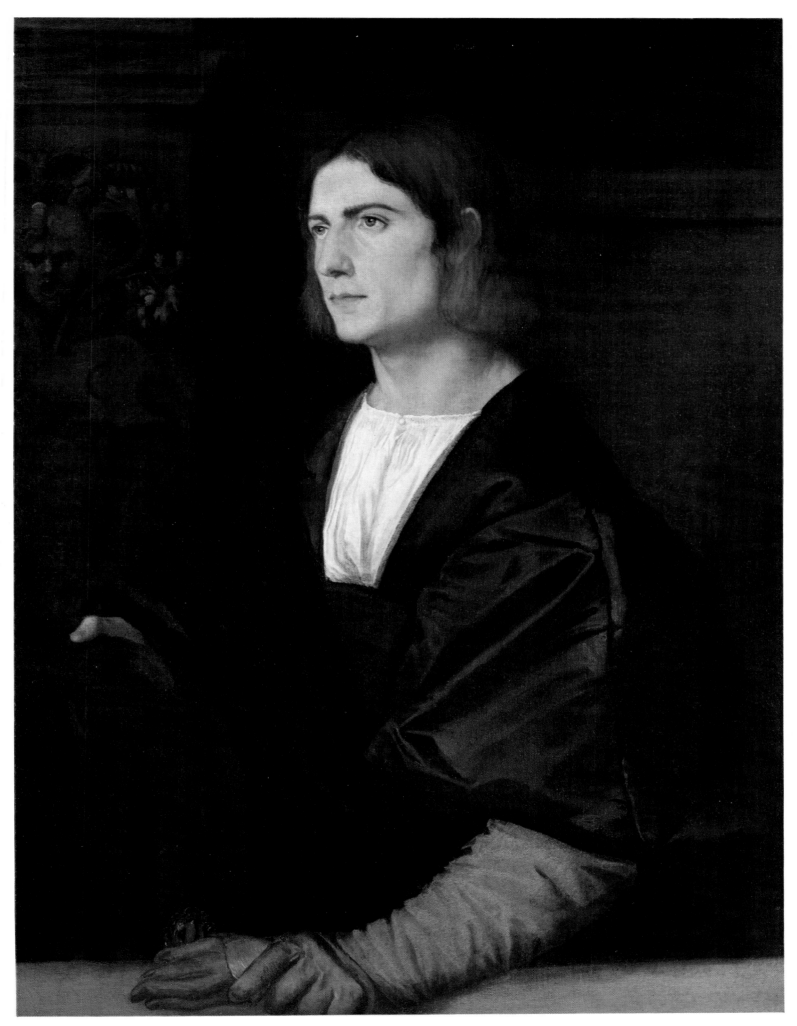

Young Man with Cap and Gloves. About 1512–1515. Garrowby Hall, Earl of Halifax (Cat. no. 115)

Portrait by Palma il Vecchio,[58] and Berenson placed it in a group of Palma il Vecchio's copies of lost Giorgiones. The Italian critics, Pallucchini and Pignatti, have turned it over without qualification to Titian. The closeness of spirit to the Ickworth *Gentleman* (Plate 12) is undeniable yet the strictly back view with head turned over the shoulder is with all probability Giorgione's invention, as in the badly damaged portrait of a *Warrior* in Vienna.[59] The *Fugger Youth*, still given to Giorgione in the Munich Gallery, is a handsome work of great spirit and originality. It borders upon Titian but does not fit easily into the general scheme of his portraiture, in which the turned back is lacking in any certain composition, during this early period.

To return to solid ground, *La Schiavona* (Plates 13–16) is not only signed by Titian but the composition adheres to the same formula as a whole group of his early portraits. Here the parapet is enlarged at the right side into a marble plaque. The profile of the same woman appears in a simulated marble relief, even though the arrangement of her hair differs. The ample body of *La Schiavona* in a rich plum-coloured dress is firmly drawn and strongly modelled, and she places the fingers of her left hand on the edge of the plaque in the same way as Giorgione's *Youth* in Berlin (Plate 2). Understandably she, too, was attributed to Giorgione at the beginning of the century, but Titian's initials on the parapet settle the authorship. Her general resemblance to the mother in Titian's fresco in the Scuola del Santo at Padua, the *Miracle of the Speaking Infant*,[60] leaves no further doubt that this is the only individual portrait of a woman to survive from the beginning of Titian's career. The earlier romantic identification of her as Queen Caterina Cornaro has gone with the snows of yesteryear, and even the present nickname, the Slavonian Woman, has little to justify it. Her far more beautiful counterpart is the *Young Lady* of the drawing in the Uffizi (Plate 17), which because of the costume is also contemporary with the frescoes at Padua. Even though large of frame, her dream-like expression and the partially closed eyes establish a remoteness of mood, so characteristic of many of Titian's early male portraits. The artist has suggested the body almost miraculously with a few lines to indicate the planes, while the head is more fully modelled. This drawing has great sensitivity as a work of art, one of the few surviving sheets which can be safely accepted as worthy of the great master. No less extraordinary in its sureness of touch is the beauty of design and of colour in *La Schiavona*. In making no attempt to

58. Garas, 1966, pp. 82–83.

59. Klauner and Oberhammer, 1960, no. 555; Pignatti, 1969, cat. no. A64, fig. 127, as a copy. The handsome portrait of a *Young Violinist* by Sebastiano del Piombo (1515) in the Rothschild Collection at Château Ferrières is another striking example of the pose with back turned (Freedberg, 1961, pp. 338–339, 370–372, fig. 456).

60. Wethey, I, 1969, Plate 140. Apology must be made for including in the section of 'Venetian Youths and Gentlemen 1510–1520' the portrait of *La Schiavona*, but hers is the only surviving female portrait in oil by Titian during the early period. Panofsky's sudden impulse to attribute to Titian the portrait of *La Vecchia* (canvas, 0·68 × 0·59 m., *c*. 1505) in the Accademia at Venice, on the grounds that the egg woman of the *Presentation of the Virgin* (1534–1538), also in the Accademia, and the maid-servant of the Prado *Danae* (1553–1554) are ugly too, is a bold idea (Panofsky, 1969, pp. 90–91), yet one of many obstacles. First is the great disparity of dates in any stylistic comparison. More important is the strong evidence in favour of Giorgione whose authorship is almost universally agreed today. *La Vecchia* is believed to be the so-called portrait of Giorgione's mother, listed in the Inventory of Gabriele Vendramin in 1569, as by Giorgione, from whence it passed to the Manfrin Collection, and later to the Accademia. *Bibliography*: Richter, 1937, p. 40 (Giorgionesque); Zampetti, 1955, pp. 54–55 (Giorgione); Pergola, 1955, p. 54 (Giorgione); Berenson, 1957, p. 84, pl. 650 (Giorgione); Moschini Marconi, 1962, pp. 124–125 (the fullest account; Giorgione); Pignatti, 1969, p. 111 (Giorgione).

Two other female portraits should be mentioned here, that is, the so-called *Violante* and the *Blonde Woman in a Black Dress*, in Vienna (Plates 222, 223). I agree with north European critics, including Panofsky (1969, p. 15), in considering them works of the coarser-grained Palma il Vecchio, who rose to unusual heights in an attempt to emulate the exquisite feminine beauty of Titian, represented by such a work as the *Flora* in the Uffizi at Florence. The Venetian writers, Pallucchini and Mariacher, and recently the Vienna Museum have elevated them to Titian. See Cat. nos. X–13 and X–115 for further explanation.

flatter her full-blown figure and rather earthy personality, Titian triumphed over his subject in creating a portrait of great pictorial beauty.

Only slightly later than these first portraits is the dashing *Gentleman in a Plumed Hat* at Petworth (Plate 18). A certain aristocratic elegance is here achieved by the projection of shoulder and the sudden turn of the head of this somewhat gaunt young fellow aged twenty-five to thirty. In his right hand he appears to hold a piece of marble as a sort of stage property to give him an active role. Even though the essential pose is connected with the *Gentleman in Blue* (Plate 3), Titian has achieved here the effect of a lively and nervously energetic individual.

In the *Young Man with Cap and Gloves* at Garrowby Hall (Plate 20) a thoughtful serious personality is projected with the head emerging in strong chiselled relief. Here, although the black costume, rose sleeves, and setting are sombre, the pictorial effect is rich, and the white shirt against the square-cut doublet is again a fine support to the head. A like intelligence, though perhaps not quite so appealing, stamps the portrait of a young scholar known as *Jacopo Sannazzaro* at Hampton Court (Plate 19). The remarkable achievement of Titian in these characterizations of young men is that he brings out the activities of the mind so superbly. They are clearly men of exceptional intelligence, clear-sighted, and seemingly idealistic as well as high born. The one who appears somewhat less sympathetic is the presumed *Lodovico Ariosto* in Indianapolis (Plate 217) but that fact may in part be explained by the lamentable condition of the canvas and the inferior quality of the photograph.

A portrait in which this clear intelligence is wanting is the *Young Man in a Red Cap, c.* 1516, in the Frick Collection at New York (Plate 22). Here we have to do with a costume piece, a male clothes model in essence, although probably not in fact. The broad, sumptuous collar of lynx fur and the red cap so dominate the composition that the head is less expressive than usual in Titian's work. Composed with the shoulders parallel to the background, it is a superbly decorative picture and beautifully drawn in all details including the gloved hand, which grips the sword, but it has less psychological and emotional impact in comparison with the other youths during these years.

Almost like a detail from a similar composition is the *Young Man in a Red Cap*, inscribed 1516, in Frankfurt (Plate 21), small in size and miniature-like in its delicacy and precision. The violet blue of the V-necked doublet contrasts with the white of the shirt, the brown hair, and the red cap. Yet the boyish face has sensitivity and an air of good breeding. The costumes of all of these pictures clearly fit into the second decade of the sixteenth century. The shirred white shirt spreads across below the neck and in most cases the doublet is cut down toward the middle of the chest or at other times straight across almost at the shoulders.

Somewhat divergent from these portraits, both in costume and composition, are two very handsome pictures which seem to fit into the last part of the second decade, *c.* 1515–1518, making them roughly contemporary with the great *Assumption* in the Frari church at Venice. The man traditionally called Titian's personal physician *Parma* (Plate 23), since the time of Ridolfi (1648), is a powerful vigorous figure, large in bulk, topped by a lion-like head of greying hair, an individual about fifty years old. His determined, somewhat professional attitude and unflinching purpose no doubt account for his presumed occupation. He looks even more like a barrister awaiting his chance to respond to an argument. The three-quarter turn of the head and general stylistic considerations point toward Titian's

early style, i.e. the emphasis upon the head and the determinedly clenched left fist. The doublet slightly opened to reveal the shirt anticipates the later *Man with a Glove* (Plate 30). For purely psychological projection, this portrait ranks very high in Titian's early production.

Also older is the Copenhagen *Gentleman* (Plate 24), probably in his mid-forties, a person of considerable elegance of bearing and certainly of high birth, although the intelligence of the sitter is again an aspect which Titian insisted upon. The background with a landscape view to one side of a curtain is a formula popularized by Giovanni Bellini in compositions of the Madonna and Child and adopted by Titian in early works, notably the *Gipsy Madonna* in Vienna, datable about 1510.[61] Here is the first instance in which Titian adjusted the same scheme to a portrait, and he even implied a parapet by the position of the closed right fist. The landscape itself is lovely and radiant, not mountainous in this instance, and enlivened by a few sheep with their shepherd, as elsewhere in the artist's career.[62] The matter of dating a picture such as the one in Copenhagen (Plate 24) is not easy, for one could argue that it is contemporary with the *Gipsy Madonna*. Nevertheless, it appears slightly later than other portraits discussed previously, because the design is broader and the modelling of the head more enveloped in light and shade. It does not emerge from the background so sharply with the almost chiselled effect of the one at Garrowby Hall, for example (Plate 20). The general style might be compared with the donor and the Dominican protector of the *Madonna and Child with St. Catherine* at La Gaida, *c.* 1515–1520.[63] Donor portraits, to be sure, are difficult of comparison since the profile position is prerequisite, yet the general suavity of presentation holds both at Copenhagen and La Gaida.

The earliest donor portraits by Titian are those of Jacopo Pesaro and Alexander VI in the *St. Peter Enthroned* at Antwerp, *c.* 1512 (Plate 27).[64] Disappointingly these donors do not help at all in dating individual portraits by Titian. Less volume is present than in the much later figure of Jacopo Pesaro and also those of his relatives included in the *Madonna and Saints* of the Pesaro altar in S. Maria dei Frari at Venice, firmly dated 1519–1526 (Plate 26).[65] The atmospheric envelope has deepened, Jacopo Pesaro looks ten to twelve years older, the brush-work is a bit freer, but no further conclusions about the portrait can be drawn.

In a positive sense these as well as other donor portraits show a consistent attitude on the part of Titian in giving an exact and convincing likeness of each individual. The stunning figure of Alvise Gozzi (Plate 28) in the altarpiece at Ancona, dated 1520,[66] is a vigorous characterization of this rugged, bald, and black-bearded churchman in his middle forties. Very alike in manner and close in date is Altobello Averoldi, donor of the Brescia altar of 1522 (Plate 25).[67] It would be obvious to any observer that Titian knew Averoldi personally, so lifelike is the rendering, even if we did not have the additional knowledge that Averoldi served as papal legate to Venice at this very time. Yet the donor portraits do not contribute to our knowledge of the artist's development, since they perforce adhere to the traditional profile formula.

61. Wethey, I, 1969, Plate 3.
62. *Madonna and Child with St. Catherine and a Rabbit* in Paris and the *Madonna and Child with St. Catherine and the Infant Baptist* in London (Wethey, I, 1969, Plates 34, 35).
63. Wethey, I, 1969, Plates 9, 11.
64. Panofsky, 1969, pp. 178–179, returns to the early date of *c.* 1503 for the Antwerp altarpiece, a position which most scholars have abandoned. For the later date see Wethey, I, 1969, p. 152, Cat. no. 132.
65. See also Wethey, I, 1969, p. 101, Cat. no. 55, Plates 28–31.
66. Wethey, I, 1969, p. 109, Cat. no. 66.
67. Wethey, I, 1969, p. 126, Cat. no. 92.

PRINCES AND MORE GENTLEMEN: 1520-1530

As Titian's career moved into the third decade of the sixteenth century, he was busy not only with altarpieces, devotional compositions, individual portraits, but also with one of his great series of mythological works, the Bacchanalia for Alfonso d'Este's Alabaster Room in the castle at Ferrara.[68] Portraits of non-Venetians in this decade reflect the artist's patronage which then extended beyond the confines of the Venetian state, for instance, those of *Alfonso d'Este, Laura dei Dianti*, and *Vincenzo Mosti*, all of Ferrara, and *Federico II Gonzaga* of Mantua (Plates 36, 40–44). These excursions were, of course, not limited to portraiture but also involved both religious and mythological works, particularly for the same two principalities.[69]

First it is convenient to consider certain canvases which relate back to earlier works of the second decade. One of the best beloved is the *Man with the Glove* in Paris, *c.* 1520–1522 (Plates 29–32), an appealing characterization of a well-born and cultivated youth of about twenty years of age. Psychologically Titian demonstrates his sympathy for youth here much as he did in the slightly more intellectual *Young Man with Cap and Gloves* at Garrowby Hall (Plate 20). The composition has changed radically now, for the subject is posed half length and in full face. The entire design adds up to a masterpiece in the subtle way Titian brings attention to the head by the V-shaped opening of the doublet which supports the round shape of the ruff-collar of the shirt. The costume has changed to the style of the fifteen-twenties, when the round collar appears to have supplanted the square-cut doublet of *Jacopo Sannazzaro*, the youth at Garrowby Hall and others (Plates 19–22). The hands, which Titian had earlier exploited for reasons of characterization and also of composition, are even more memorable here (Plates 31, 32), so adroitly placed and so beautifully drawn and painted; one might also say, so expressive of cultivated elegance.

The presumed companion of the *Man with the Glove*, known simply as a *Gentleman* (Plate 33), was once thought without any reasonable possibility to represent Pietro Aretino, to whose features there is not the remotest resemblance. Even considering the fact that the later addition of canvas at the top upsets the proper placing of the figure in the vertical space, this portrait is exceptionally uninspired for an artist of Titian's qualities of imagination. The right hand, placed upon the hip, is a pose repeated in the closely contemporary portrait of a *Gentleman* in Munich (Plate 34). Here, because of the considerably superior condition of the surface, the light and atmosphere play over the features, and the head dominates the composition to a greater degree, partly because proper space relations within the canvas have been maintained.

A most enchanting picture of the third decade is the *Federico II Gonzaga* with his white dog (Plates 36, 37), shown at the age of twenty-three in the year 1523. A cultivated Renaissance prince, for whom Titian clearly felt deep personal sympathy, he was the son of that great lady Isabella d'Este from Ferrara and her husband Francesco II Gonzaga of Mantua. Federico had spent three years (1510–1513) at

68. To be studied in Volume III. See Walker, 1956; Battisti, 1960, pp. 120–145; and Panofsky, 1969, pp. 99–102, 141–143; Gould, *Bacchus and Ariadne*, 1969. Datable *c.* 1518–1523.

69. See Wethey, I, 1969, pp. 12–13, *passim*.

the papal court in Rome during his childhood, sent there as a hostage, but treated as a favourite of Julius II. He studied later at the University of Bologna, and then succeeded his father as Marquess of Mantua in 1519, later to be elevated to duke by Charles V at the time of his coronation as Holy Roman Emperor at Bologna in 1530.

In the Prado portrait Federico is every inch a prince and not at all a warrior like his brother-in-law, Francesco Maria I della Rovere, duke of Urbino (Plate 67) or his uncle, Alfonso I d'Este of Ferrara (Plate 40). Federico's youth has an inevitable appeal as does the charming detail of the affectionate dog, on whose back the hand rests so lightly. This use of a subordinate object or person is a favourite compositional device of the artist both in religious subjects[70] and in other portraits to be considered below. The gentle expression of the face is reflected throughout the picture, even in the rich blue velvet jacket embroidered in gold, which contributes to the characterization of a Renaissance gentleman who might be the hero of Castiglione's *The Courtier*. Although Federico was made a captain of the papal armies, Titian's later portrait of him in armour (1530) showed him with the same mild countenance, to judge from a weak copy, which is the only record of the lost original (Plate 224).

Titian's likeness of the great humanist and writer *Baldassare Castiglione* (1523) in the National Gallery of Ireland (Plate 39) has survived but in such a bad state as to be nearly invisible. The silhouette of the black costume was originally more pronounced against the brown wall. Even so the darkness of the whole picture is still somewhat relieved by the landscape seen through a window or loggia at the left. The figure in back view, with the head turned over the shoulder, represents one of the rare cases of Titian's return to the Giorgionesque composition of the *Fugger Youth* (Plate 11), where, however, the pose implies an abrupt, almost startled movement. On the contrary, *Baldassare Castiglione* in the quiet elegance of his manner is very much a courtier. He too was born in the city of Mantua and had lived in Rome during the pontificates of Julius II and Leo X. Yet he was already twenty-two years old in the year of Federico Gonzaga's birth, and so a man of an older generation. A comparison is inevitable with Raphael's famous portrait of Castiglione in the Louvre at Paris, a masterpiece which has the advantage of being far better preserved. Nevertheless, Raphael's painting incorporates stronger qualities of design in the black hat and the grey-and-black costume contrasted to the light grey background.[71] This portrait, so tranquil in its harmonious drawing and in the qualities of mind expressed, has become a virtual symbol of the nature of a Renaissance humanist.

One of Titian's portraits most admired in his own day, the *Alfonso I d'Este* (c. 1523–1525), now survives in the picture in the Metropolitan Museum in New York (Plate 40), most likely the original in a faded condition rather than a copy, as sometimes believed. The deep-red velvet costume with gold sleeves and the dark cloak lined with sable have lost their original brilliancy. Nonetheless, the dynamic presentation of the man, his right hand resting upon a cannon, his left clutching a sword, carries the ambitious determination and the ruthlessness of the warrior who commanded the papal forces under Julius II and later threw in his lot with Emperor Charles V. The reason for the presence of the cannon is Alfonso's personal interest in casting that instrument of war and his enthusiasm for

70. For instance the *Salome* in the Doria-Pamphili Collection at Rome *c.* 1515. See Wethey, 1969, I, Plate 149.
71. Usually dated about 1515 because of Bembo's mention of a portrait in a letter of 1516 (Camesasca, 1956, tavola 115); Pope-Hennessy, 1966, p. 114, calls attention to the possibility of the date of 1519.

artillery in general.[72] It is still possible to imagine how this portrait looked when the colour contrasts were stronger and the silhouette of the head and shoulders stood out with greater clarity. Far removed from the dreamy youths of Titian's early portraits, this figure fills and nearly bursts from the canvas to convey a commanding personality. It is a well known fact that Charles V coveted Alfonso d'Este's portrait on his visit to Italy, and that at the suggestion of Francisco de los Cobos it was presented to the Emperor in January 1533. As already noted above, Cobos reported on 15 February that the Emperor had it hanging in his bedroom at Bologna[73] during these weeks of conference with Pope Clement VII.

A more decorative attitude toward accessories emerges for the first time in two portraits which Titian painted for the court at Ferrara during these years, one male and the other female. *Laura dei Dianti*, now in the Kisters Collection at Kreuzlingen (Plates 41–43), portrays a woman of middle-class origin who became Alfonso d'Este's mistress after the death in 1519 of his second wife, Lucrezia Borgia. The figure in three-quarter length, accompanied by the young Negro boy as servant, is presented in a brilliant gown of ultramarine velvet, relieved by white in the lower sleeves and contrasted to a pale yellow scarf over the bodice. The dark-skinned boy is even more dazzling in his costume of silk, striped with green, blue, lavender, and yellow. Titian, the great colourist, knew how to make these varied hues sumptuous and yet harmonious. The decorative richness of Laura dei Dianti's portrait is not limited to colour but is carried through in the crinkle of the silken and velvet materials. What could be more suitable than that a great painter should thus display the mistress of Duke Alfonso d'Este at her most glamorous! A woman of great charm, she ruled virtually as duchess until Alfonso's death in 1534.

This concern for the beauty of stuffs is not entirely limited to *Laura dei Dianti*, for it is present, though in a lesser degree, in the portrait of a Ferrarese courtier, *Vincenzo* or *Tommaso Mosti*, c. 1526, in the Pitti Gallery (Plate 44). Even though colours in the male costume are limited to a variety of tones of neutral blue, grey, and white, the artist makes the most of the contrasts of textures in the cloth and the fur. He also delighted in the rippling movement of the padded jacket, as the sitter rests his right arm upon the edge of a parapet. Mosti turns to look seriously at the spectator, his cap tilted to impart a jaunty elegance to the entire composition.

PORTRAITS OF THE EMPEROR CHARLES V: 1530-1533

A GREAT event in Titian's career, previously discussed, was his introduction to Charles V at Bologna at the time of the Emperor's coronation in San Petronio by Pope Clement VII. Charles' stay, a relatively protracted one of nearly five months, lasted from 5 November 1529 until 22 March 1530.[74] Vasari, who is our major source for knowledge that Titian came to Bologna, states that his portrait of the Emperor showed him completely armed ('tutto armato').[75] The Florentine writer confused the issue by placing this portrait at the same sitting when the sculptor

72. Gardner, 1906, p. 126.
73. Keniston, 1959, p. 154; Gronau, 1928, p. 245, documents VII, IX, X.
74. *Cronaca*, edition 1892, pp. 113, 234–236.

75. Vasari (1568)-Milanesi, VII, p. 440. Ridolfi's description of an equestrian portrait of Charles V done at Bologna in 1530 must be a confusion with the Mühlberg portrait of 1548 (Ridolfi (1648)-Hadeln, I, p. 170).

Alfonso Lombardi of Ferrara prepared a sketch in stucco relief, known today in bronze (Plate 52), whereas a contemporary letter establishes that occasion later during Charles' second visit to Bologna and even very specifically in late February 1533.[76] Nevertheless, confirmation of a first portrait in the early part of 1530 is provided by two letters. An unpublished letter from Calandra in Mantua to Malatesta, Gonzaga agent in Venice, under date of 11 October 1529 requests that Titian come to Mantua to portray the Emperor.[77] Secondly, the Urbino agent Leonardi writing to his master, Francesco Maria della Rovere, on 18 March 1530 states that Charles V had been slandered by the gossip to the effect that he had given Titian only one ducat for his portrait.[78]

This first work of 1530 for Charles V is lost as well as are all other early portraits except *Charles V with Hound* in the Prado (Plate 55). The latter is datable later in 1533, since he is not in armour. Engravings and also painted copies of *Charles V in Armour* do survive, but here the problems are nearly insoluble as to Titian's exact prototypes and their dates. Portraits by artists other than Titian at this same period include Barthel Beham's print of 1531 (Plate 46) and Christoph Amberger's painting in Berlin (Plate 47) showing Charles in the following year at the age of thirty-two. Amberger's representation of Charles' head is doubtless the closest to life, since we know that the ruler's extremely deformed jaw did not permit the upper and lower teeth to meet or the mouth to be closed. Nearly all artists minimized this unpleasant physical defect, but the medal in bronze (Plate 52) convincingly attributed to Alfonso Lombardi in 1533, by Dr. Ulrich Middeldorf, confirms Amberger's accuracy. Beham's splendid print, in contrast, makes the Emperor essentially handsome in presenting a strongly moulded head with a neatly trimmed and dressed beard.

In order to speculate on the appearance of Titian's first portrait of Charles V we turn to *Charles V with Drawn Sword*, in a copy attributed to Rubens *c.* 1603 (Plate 48). The armour with the disks at the shoulders, the left hand on the hip and the position of the sword are the same in related copies, and the high armoire with plumed helmet in the background surely follows Titian's original. Rubens' copy can be trusted to give a fairly accurate report of Titian's lost work of 1530, although the Fleming's technique at this period (*c.* 1603) is still rather tight.[79] His later copy, undoubtedly made in Madrid

76. Braghirolli, 1881, p. 25. Because of this confusion Crowe and Cavalcaselle and some later writers wrongly concluded that Titian did not paint Charles V's portrait at all in 1530. Dr. Pauwels, 1962, p. 163, no. 95, diameter 16·3 cm., still retained Vasari's date of 1530 for Alfonso Lombardi's bronze relief of Charles V (Plate 52). Dr. Ulrich Middeldorf assures me by letter that the attribution of this medal in the Lederer Collection at Geneva to Alfonso Lombardi is correct. He points out the similarity in style to the lost medal of Andrea Doria by Alfonso Lombardi, which is recorded in Rembrandt's drawing in Berlin (Slive, 1965, I, no. 26).

 Alfonso Cittadella called Lombardi (1497–1537) born at Ferrara, worked as sculptor and medallist, chiefly at Bologna and Mantua (Schottmüller in Thieme-Becker, 1929, pp. 345–346; Vasari (1568)–Milanesi, v, pp. 83–91; Braghirolli, 1874, pp. 8–25).

77. To be published by Charles Hope who found it in the Mantuan archives.

 The exact length of Titian's first sojourn at Bologna in 1530 has not been determined. Charles Hope believes that Titian had reached Mantua by 13 November 1529, since Federico sent instructions (unpublished letter) to his agent Malatesta in Venice

to start negotiations for the purchase of lands near Treviso which he intended to give to the painter. That would suggest Titian's presence. It is reasonable to assume that Titian actually executed Charles V's portrait in Bologna, as Vasari states, and that he remained there for the coronation festivities of 24 February 1530. A letter dated 3 March 1530 at Venice and addressed by Titian to Federico Gonzaga proves that he had reached home then. Malatesta's earlier letter from Venice to Federico of 15 January 1530 speaks of Titian in the present tense, but that fact does not necessarily imply the artist's presence in the city at that moment ('Questo mercato no spiace a Mro Ticiano': Braghirolli, 1881, p. 47).

78. Gronau, 1904, p. 13.

79. Pieter I de Jode (1570–1634), a native of Antwerp who spent a few years in Italy in the fifteen-nineties, did an engraving of *Charles V with Drawn Sword*, but it must have been derived from one of Rubens' copies since Jode never visited Spain, and therefore he could not have seen Titian's original. Jode's print is wrongly labelled *Ferdinand I*, an obvious error because Titian painted his likeness only in 1548 at Augsburg, a work also known in copies. This original was lost in the Alcázar fire of 1734 (see

during his visit there in 1628, is far more sumptuous (Plate 53); it disappeared into a private collection or was destroyed in World War II.[80] In this instance Rubens eliminated the sword and changed the head into a romantic interpretation of the king, possibly inspired by Titian's later portrait of *Charles V with Baton* (Plate 240). The armour with disks is, nevertheless, of the earlier style. Lucas Vorsterman's engraving (Plate 49) also has a head which is close to but not identical with Rubens' late interpretation. The generally high quality of this print seems to preserve for us the impressive monumental composition of Titian's original.[81]

In Giovanni Britto's woodcut (Plate 50) we may also find a reflection of Titian's first portrait of 1530, even though the position of the sword, here resting against the shoulder, has changed. The armour and the general appearance of the head, hair, and beard fit with the other likenesses of this period. Nevertheless, since Giovanni Britto's association with Titian apparently does not antedate 1536,[82] the artist may have prepared a drawing specifically for the engraver, following his own earlier sketches of 1530 or those of 1532–1533, when Titian must have painted still another portrait in armour, now lost.

Titian's portrait of *Charles V in Armour* painted at Bologna in 1530 marked the second occasion that the artist created a composition of this type. During the next two decades he had the opportunity to represent a number of Spanish and Italian leaders in their full military regalia. *Alfonso d'Avalos, the Marchese del Vasto, with Page*, now in Paris (Plate 56), is placed during the second sojourn of the Emperor and Titian at Bologna in February 1533.[83] The formula in these two portraits is so much alike that their closeness in date seems reasonable enough. The portrait of the *Charles V with Drawn Sword* by Titian, as seen through the eyes of Rubens (Plate 49), presents the figure in a little more than half length, and the body slightly turned into the depth of the picture space. Even the style of armour worn by Alfonso d'Avalos is similar, and both men wear the collar of the Knights of the Golden Fleece with the tiny pendant ram. The major variation lies in the introduction of the crimson-plumed helmet upon a high chest to give scale to the figure of Charles V on the one hand and in the presence of a small page to emphasize the bulk of d'Avalos' physique on the other hand. It is easy to imagine that Titian's original of Charles V gave the Emperor greater breadth and mass than Rubens in his early copy (1603) (Plate 48). That suspicion is confirmed by Rubens' second version (Plate 53) of the same portrait (*c.* 1628), where the design acquires new breadth and richness and the brushwork is freer, with details less precisely drawn. Here the brilliant highlights and the substantial mass of the body are much closer to Titian's own portrait of d'Avalos. The artist was to return to the representation of a military leader in armour just a few years later in his likeness of Francesco Maria I della Rovere (Plate 67).

Plate 248; Cat. no. L–16). Rubens' Inventory of 1641 lists a picture of *Ferdinand I Armed* (Lacroix, 1855, p. 271, no. 52) which is doubtless the source of Jode's print wrongly labelled as Ferdinand I.

The quality of Jode's print is very feeble, making the figure small and frail, while the shaggy hair and beard are totally lacking in elegance.

80. Müller-Hofstede, 1967, p. 45, dates this version by Rubens *c.* 1625 and does not associate it with Rubens' visit to Madrid in 1628.

81. Müller-Hofstede, 1967, pp. 39, 45, dates the Vorsterman print *c.* 1617–1618. In Wethey, 1969, I, p. 27 the author suggested that Titian might have painted *Charles V with Drawn Sword* at Asti in May 1536. However, on further consideration it seems less probable.

82. The earliest certain date of Giovanni Britto in Venice thus far established is 1536 (Mauroner, 1941, p. 62, note 7).

83. Vasari (1568)-Milanesi, VII, p. 442. There is no reason to doubt Vasari's reliability in this case.

In order to maintain a chronological sequence and in addition to consider the first works for the Emperor, the next problem concerns Titian's portraits of Charles V during the Emperor's second visit to Bologna. Federico Gonzaga had hurriedly urged Titian to come to Mantua on 7 November 1532.[84] Charles V appears to have arrived at Bologna first on 13 November.[85] After a second visit to Mantua, where he was lavishly entertained by Federico during the first part of December, Charles returned to Bologna on 13 December, and there he remained until 28 February 1533.[86] An unpublished letter recently discovered by Charles Hope reveals that on 14 January 1533 Ferrante Gonzaga at Bologna wrote to Federico to say that Titian's portrait of the Emperor had been greatly praised.[87] Unluckily this picture is lost. It must be the work for which Charles gave Titian five hundred *scudi* on the day of his departure from Bologna. It must also have been the reason why the monarch conferred upon him the title of Knight of the Golden Spur and Count of the Lateran Palace on 10 May 1533.[88] This extraordinary honour proves beyond question that Charles was delighted with his portrait. In the document of knighthood Charles speaks of his predecessors Alexander the Great and Augustus and of the Greek painter Apelles, who is reborn in Titian.

Unfortunately Titian's only surviving work done for Charles during the two sojourns at Bologna is *Charles V with Hound* now in the Prado Museum (Plate 55). All indications point to it as having been painted at Bologna in January and February 1533, following a model (Plate 54) which Jacob Seisenegger had completed there just a few weeks earlier.[89] That a great master such as Titian should have been asked to copy a work by a minor master strikes us today as stranger than it did his contemporaries. As a matter of fact both of Titian's portraits of the Empress Isabella were based upon likenesses by other artists. In this case, however, Titian never had had an opportunity to see the deceased Empress in person. Mme Annie Cloulas has argued that Charles would not have bestowed the exceptional honour of knighthood upon Titian for having copied the work of another artist.[90] True enough, but since the Seisenegger presence and precedence are inescapable, the only explanation is that the Venetian carried out at least one other portrait, now lost, of the Emperor at Bologna, as proven by Ferrante Gonzaga's letter mentioned above.

84. Braghirolli, 1881, pp. 24–25, 81.

85. Foronda, 1914, p. 368.

86. Sanuto LVII, column 334; on 28 February 1533 Charles V paid Titian and Alfonso Lombardi 500 ducats each: Braghirolli, 1881, pp. 25, 81.

87. To be published by Charles Hope in a work on Titian's letters. 'Titiano ha fatto lo imperatore tanto naturale che tutti questi lo vedono da divino'.

88. The Latin text of the diploma of knighthood was published by Ridolfi (1648)-Hadeln, I, pp. 180–182, with wrong date of 1553; Cadorin, 1833, p. 68, corrected the date; full publication by Beltrame, 1853. As previously noted, the original diploma is exhibited in the House of Titian at Pieve di Cadore. See above, note 20, and Wethey, I, 1969, p. 22, note 124.

The escutcheon that accompanies this patent of nobility is interesting and handsome. We know it from the original manuscript of the patent and from the late *Pietà* of 1576 (Wethey, I, 1969, Cat. no. 86), which Titian painted for his own tomb. An expert on heraldry would describe it approximately as: 'Argent, a fess sable; base, a chevron sable; the chief or with a double-headed eagle sable.' In other words a wide black band (the fess) occupies the horizontal centre of the shield; below on a silver ground is a black chevron; above is a black double-headed eagle on a gold ground. Thus Charles V gave his own Hapsburg eagle to Titian as the upper part of this escutcheon. The black fess is not so easily identifiable, while the black chevron on a silver ground corresponds (perhaps by coincidence) to the arms of the city of Udine [data assembled by Alice S. Wethey].

89. For a full explanation of the arguments in favour of Seisenegger as the originator of the composition, see Cat. no. 20.

90. Cloulas, 1964, pp. 219–220. An equestrian portrait of Charles V at Bologna in 1530 mentioned by Tizianello (1622, edition 1809, p. VI) and repeated by Ridolfi (1648-Hadeln, I, p. 170), never existed. Mme Cloulas (1964, pp. 214–216) thought that the Flemish portrait in the Uffizi reflected this so-called original by Titian. In a letter of 19 November 1969 Mme Cloulas wrote that she no longer believed that Titian painted any equestrian portrait of Charles V except that of 1548. The whole theory was also rejected by Müller-Hofstede (1967, pp. 40, 81).

It is logical that the full-length figure should have developed into the state portrait *par excellence* in the hands of Titian.[91] *Charles V with Hound* (Plate 55) is only a beginning, which culminated in Titian's *Philip II* (Plate 174) and the *Duke of Atri* (Plate 168). As a matter of fact, the Venetian's only portrait of the Emperor to survive from these years is by no means one of his most ingratiating efforts. Time has been unkind to this painting and the sumptuous costume, whose colour has faded badly. The green curtain behind the figure is barely visible, and the brilliancy of the silver-brocaded cloak, the golden jerkin, the grey Venetian breeches with golden stripes, and the white hose have lost much of their richness. The head (Plate 51) has suffered even more, but even so it lacks decision and force of character, in good part because the artist minimized the physical deformity of the jaw and so reduced the head to a rather summary description. Seisenegger's head of the ruler carries considerably more vigour and force of character. A comparison of the two works does, of course, demonstrate the essentially precise, linear technique of the northerner as contrasted to the softer, painterly handling of the Venetian. Consequently, however important *Charles V with Hound* from an historical point of view, the picture does not occupy front rank among the master's works.

OTHER PORTRAITS: 1530–1540

Alfonso d'Avalos, Marchese del Vasto, with Page, painted at Bologna in the winter of 1533 (Plate 56), shows this Italian military leader in full armour, in a composition very similar to *Charles V with Drawn Sword* (Plate 48), as we have already demonstrated. Later in 1539–1541 Titian represented d'Avalos again in full armour, but this time addressing his troops and accompanied by his young son (Plates 57, 58). D'Avalos had joined the conquering forces of Charles V as early as the battle of Pavia in 1525. Because of his political preëminence Titian introduced him on horseback among the spectators of the famous large picture of *Christ Before Pilate*, painted in 1543, and now in Vienna.[92]

Vasari tells us that Titian also portrayed Cardinal Ippolito dei Medici in armour,[93] but this work has disappeared without a trace. The handsome *Ippolito dei Medici* in the Pitti Gallery (Plate 65), despite its darkened and dirty condition, incorporates a breadth and grandeur through the bigness of scale which Titian was able to achieve by the way he placed the figure. The exotic nature of the plum-coloured velvet costume and the flat red hat with a flourish of greenish plumes clearly appealed to Titian's sense of the dramatic. Now that the artist's sitters came from the highest realm of the social scale, he was more and more concerned with projecting the aristocratic rank of his subject.

Surely the portrait of the Duke of Urbino in armour, *Francesco Maria I della Rovere* in the Uffizi Gallery (Plates 67, 68), carries the conviction of the power wielded by this former captain of the papal

91. Jenkins, 1947, p. 10; the full-length donor portraits of Philip the Fair and Joan the Mad in the Musée Royal at Brussels are datable about 1500; one of the earliest is, of course, *Arnolfini and His Bride* by Jan van Eyck dated 1434. See also Pope-Hennessy, 1966, pp. 171–172.

Andrea del Castagno's series of portraits of celebrated personages from the Cenacolo di Sant' Apollonia now in the Uffizi, and even Giotto's paintings of famous men do not have any direct bearing upon the development of the state portrait in the sixteenth century.

Lucas Cranach as well as Seisenegger employed the full-length figure before Titian did. In north Italy the earliest case is apparently Moretto da Brescia's full-length *Gentleman* in the National Gallery at London, dated 1526 (Gombosi, 1943, p. 35, fig. 29).

92. Wethey, I, 1969, Cat. no. 21, Plate 91.

93. Vasari (1568)-Milanesi, VII, p. 441.

forces and ally of Charles V. Titian shows him in the prime of life, though he had reached fifty-six in 1536, when this portrait was begun. His dark hair and beard belie his age, and one must conclude that Titian rolled back the years by a full decade to make this picture commemorative of the career of a man who died in 1538, the year in which the work was completed. The pen drawing in the Uffizi (Plate 66), a study in full length, is evidence of the artist's original intention. He appears to have modified the composition in order to make the duke in armour a pendant to *Eleanora Gonzaga della Rovere*, also in the Uffizi Gallery (Plates 69, 70). The duchess, seated in three-quarter length, dressed in a black costume with gold trimmings, has a rather demure dignity, which the artist considered suitable for a high-born lady. Aged forty-three when the portrait was begun, she is neither beautiful nor rejuvenated. The open window with landscape is a compositional formula which he had used earlier for the *Gentleman in a Black Beret* (Plate 24), *Baldassare Castiglione* (Plate 39), and *Count Antonio Porcia* (Plate 64).

The ideal portrait of a young woman known as *La Bella*, in the Pitti Gallery (Plate 71), was at one time incorrectly thought to represent the duchess of Urbino, but the letters of her husband referring to this picture as the 'lady in a blue dress' disprove any such theory.[94] The two compositions are contemporary, both begun in 1536. The costumes perforce are similar despite the expansive bare neck of *La Bella*, who is much more beautiful, and her lips full, in contrast to the tight little mouth of the duchess. Still Titian treated both women with considerable reserve, doubtless because of the courtly decorum of high-born ladies and the respect due to them. The artist approached these subjects on bended knee, quite unlike his attitude toward the *Flora*, for instance, the contemporary *Venus of Urbino* in the Uffizi Gallery, and the *Girl in a Fur Coat* in Vienna (Plate 73). This last-mentioned lovely young creature could scarcely be more unlike the prim middle-aged duchess, although both pictures were upon Titian's easels at the same time. The girl, as most writers agree, was the model for the *Venus of Urbino*, completed in 1536.[95] The partially nude girl, draped in a purplish fur wrap lined with sable, is in reality a study of a beautiful model rather than a portrait, properly speaking. She cannot reasonably be classified as a mythological character whom she so closely resembles, and so she is included here among the portraits of ladies. Titian was primarily concerned with a vision of youthful beauty, the delicate flesh of her neck and arms, the one naked breast, the exquisite shape of the hand upon the fur. The string of pearls at her throat, the rope of pearls in the hair, and the earrings reflect contemporary fashion. Far more lovely than *La Bella*, she is an evocation of beauty in which every detail is handled with an exquisite touch.[96]

Titian reached a climax in his recently found vocation of state-portraitist in *Doge Andrea Gritti* in Washington (Plates 74–77), apparently from the last years (*c.* 1535–1538) of a reign in which the chief of the Venetian state managed to avoid an alliance with either of the warring parties, the Hapsburg Empire and France. History tells us that he was a man of great brilliance, a consummate

94. Thausing, 1878, pp. 262–269, actually proposed that the duchess modelled both the *Venus of Urbino* and the *Girl in a Fur Coat*. Incredible as it may seem, the myth that Eleanora Gonzaga della Rovere was the model for Titian's nude *Venus of Urbino* is still popular with guides showing groups of unsuspecting tourists through the Pitti Gallery. Even Berenson in his *Venetian Painters*, edition 1906, p. 141, listed as no. 18, *La Bella*, Eleanora

Gonzaga, and no. 1117, *Venus*, the head a portrait of Eleanora Gonzaga.

95. Gronau, 1904, pp. 5–6, 10, document XXVII.

96. Comparison of the *Girl in a Fur Coat* with the mechanical variant in Leningrad (Plates 73, 265) provides an excellent demonstration of the difference in quality between a great master and his assistants.

statesman, and unswerving in determination. A glance at Titian's conception of him leaves no doubt of these qualities and even more, for the Doge seems to fulminate like Zeus about to hurl thunderbolts. His body is almost as gigantic as that of a pharaoh, but rather than appearing immobile like an Egyptian image, he has an explosive energy in his great form. The sweeping movement in the golden cloak with the curving progression of the large buttons (Plate 75) and his bursting dark-red robe contribute greatly to the power of the figure. Suida's suggestion that Titian was inspired by Michelangelo's *Moses*, which the Venetian knew in a small copy in the possession of Jacopo Sansovino,[97] is altogether plausible. What other two works express such *terribilità*! The power in the hands (Plate 77) is also common to both. On the contrary, the explanation of the pose of Andrea Gritti on the theory that he is walking is less acceptable. Standing he is, but not necessarily walking, to account for the movement in the draperies.

Titian made the huge bulk of Gritti fill the picture space in order to give him monumentality and psychological dominance. This kind of a composition is native to Mannerism of the mid-century, yet the portrait of Andrea Gritti in its essential uniqueness transcends all normal patterns of stylistic development. As early as 1527 Sebastiano del Piombo created the state symbol of *Pope Clement VII*, now in the museum at Naples. Olympian in his serenity and disdainful, *Clement VII* is one of the earlier masterpieces of its type. Titian himself in 1537–1538 carried out the series of eleven *Roman Emperors* for Federico Gonzaga of Mantua,[98] employing the same Mannerist scheme of filling the space with massive physiques. Since these Roman Emperors were reconstructed from the imagination by means of Roman coins, they lack the overpowering personality of *Doge Andrea Gritti*. The dating of this portrait *c.* 1545 after the Doge's death is possible, because the spirit of the work can be likened to a later commemoration of a national hero. Nevertheless, the compositional structure has enough parallels in the *Roman Emperors* to make the date in the last years of Gritti's reign, *c.* 1535–1538, entirely plausible.

Beside the figure of Andrea Gritti, King *Francis I* (Plate 79) of France pales, and for good reason. Pietro Aretino ordered the picture now in Paris as a gift to the king, and celebrated it in a sonnet dated 1539. Titian had never seen him, and he painted this imaginary portrait using a medal for the head. Notwithstanding these circumstances, the artist was able to instil considerable liveliness in the genial-looking face, surely at the suggestion of Aretino, who must have known Francis' reputation for numerous gallantries and the life of a *bon-vivant*. The rakish flat hat with white plume adds also to the general gaiety of mood. At the same time the design of the rose doublet and sleeves against the black jacket and sable collar reveals a like breadth of scale in the composition which characterizes other works of this period.[99] In addition to Titian's original sketch known in Italian as a *modello* (Plate 78), a third version of high quality exists in the Coppet Collection at Geneva (Plates 80, 81).

97. Suida, 1935, p. 83.
98. Braghirolli, 1881, pp. 31–37; C. and C., 1877, I, pp. 420–424; Verheyen, 1967, pp. 64–68; Wethey, I, 1969, p. 23.

99. For the sketch belonging to Lord Harewood and the second version belonging to Maurice de Coppet in Geneva, see Cat. nos. 36, 38.

TITIAN'S GALAXY OF PERSONALITIES: 1540-1545

DURING the years 1540-1545, up to the momentous trip to Rome, Titian continued to paint portraits in an ever-increasing number. Approximately twenty-five major works belong to this short period of five years, more than he had painted in the whole previous decade. No fundamental innovations are notable at this time, although the artist tended in several cases to make the composition large in scale, as he had done earlier with the *Doge Andrea Gritti* (Plate 74). The Mannerist tendency to fill the picture space and thus to monumentalize the composition continued to prevail in many cases, when the kind of personality made it desirable.

A really great portrait is the magnificently aristocratic *Benedetto Varchi* in Vienna (Plate 83) about which considerable lack of agreement prevails as to the identity of the person and the date. Since the head in the medal (Plate 84) by Domenico Poggini shows a man with ample brow and short nose, altogether similar to Varchi in the painting, it is reasonable to assume that the intellectual Florentine aristocrat is indeed to be recognized here. Garbed in black, he stands in three-quarter length with great dignity against a grey column and neutral curtain. The palatial setting and the size of the canvas add to the impressive nature of the work, but above all it is the aristocratic bearing of the man, his extremely intelligent yet kindly face, and his elegantly expressive hands which make this portrait unforgettable. Not even the hand in the lovely *Girl in a Fur Coat* (Plate 73) is so exquisitely drawn as these of *Benedetto Varchi*, whose opalescent finger nails should be noticed. Titian was obviously sympathetically inclined to the personality of Benedetto Varchi, else he could never have recorded him in so memorable a way. The date 1540 is the latest possible for this work since Varchi left Venice that year. The grandeur of presentation has convinced some critics that the painting must be placed later, *c.* 1550, yet there are no elements of style which perforce must make it later and thus eliminate Varchi as the subject. Here he has a youthful face and expression, perfectly consistent with 1540 and his age of thirty-seven.

The portrait of *Vincenzo Cappello* in Washington (Plates 88, 89) has an even more formal composition, with the Venetian admiral in three-quarter length assuming the attitude of a great leader. The tall armoire topped by the helmet and two batons gives verticality and bigness of scale, yet it is not new to Titian's repertory of settings, being a variation of the background that he had used for *Francesco Maria I della Rovere* (Plate 67). Titian intentionally made the famous leader in full armour strut somewhat pretentiously. This lack of sympathetic attitude is unusual in the work of the Venetian artist, who in this instance brings to mind the great satirical master Goya, who so devastatingly exposed the stupidity of Charles IV of Spain and his family in his portraits of them.[100] That psychological factor and the intentionally harsh contrasts between the dead white beard and the costume have caused doubts about Titian's authorship. Tintoretto's name has been suggested without consideration of date, since he produced no such portraiture for another twenty years after Cappello's death in 1541. On the other hand, Pietro Aretino's letter and poem of 1540 well document this picture as Titian's in

100. Especially the famous portrait of *Charles IV and the Royal Family* by Goya in the Prado Museum at Madrid.

precisely that year.[101] In fact, the Cappello portrait is an exceptionally large and impressive memorial to a man who held the office of chief admiral of Venice five times, and is therefore a symbol of naval might, severe, commanding, and by no means endearing. How unlike the urbane intellectual gentleman, *Benedetto Varchi*, datable in the same year 1540. Thus Titian demonstrated his ability to interpret two different personalities of widely diverse character within the same span of time.

Also placed in this year of 1540 is *Cardinal Pietro Bembo* in Washington (Plate 90), in cardinal's crimson and with his right hand raised in an expressive gesture of expounding an idea. More restrained, the gesture is essentially similar to the upraised arm of Alfonso d'Avalos addressing his troops (Plate 57). Bembo's figure fills the canvas, as does *Doge Andrea Gritti* (Plate 74), yet the purpose here is to show the cardinal as writer and teacher of ideas, not a military man of many victories. Titian considerably rejuvenated Bembo at the age of seventy, the earliest possible time for this portrait, since he became cardinal only in 1539. Moreover, Bembo's letter of 30 May 1540 must refer to it.[102] The later ruined canvas (Plate 254) in Naples, c. 1545–1546, approximates more nearly his real age, while in the profile of 1547 he truly looks the aged seer at seventy-seven (Plate 256).

For reasons of composition and pose, the fine direct study called *Titian's Friend*, in San Francisco (Plates 91, 92), fits at this time c. 1540. The inscription on the paper 'Titiano Vecellio singolare amico' is obviously apocryphal, but all the more puzzling because of the prominence of the paper. An identification as Luigi Anichini,[103] a celebrated gem-cutter and intimate friend of Titian, Aretino, and Jacopo Sansovino would be possible, but proof is wanting.

Fortunately the personality of *Daniele Barbaro*, portrayed at the age of thirty, is well known, and moreover the version in Ottawa includes his name at the top (Plate 95). As compared with the *Friend of Titian* (Plate 91), the artist varied the position of the sitter by a slight turn of the body and by the penetrating glance, very subtle elements which, nevertheless, totally transform the presence and nature of the sitter. If history had not told us so, we would know from Titian's two pictures (Plates 93–95) that Barbaro was an intellectual and an aristocrat. Daniele Barbaro not only consorted with the great humanists of his day, such as Pietro Bembo and Bernardo Tasso, but he also published an edition of Vitruvius' *Ten Books on Architecture* and served as ambassador to England for three years. By miraculous insight a great artist can tell us so much.

Pietro Aretino (Plates 96, 97, 99) was also an intellectual, a writer of plays and sonnets, but today most important to us for the historical value of his letters, which he composed principally for economic and propagandistic purposes. A man of lowly birth, he was essentially a gross character, and notwithstanding his close friendship with Titian, the artist made no effort to conceal the fact. The gigantic bulk of his body is inescapable testimony to his gluttonous appetite for food and drink. His biographers also make it clear that, at least earlier in his life, his sexual appetite for both men and women was scarcely less voracious. Still he was not entirely one of unmitigated vulgarity, as his descriptions and evaluations of works of art attest. He moved in high literary, artistic, and princely circles, a man of contrasts and contradictions. Titian made him something of a leonine character in the picture in Florence (Plate 96), Aretino's gift to Cosimo dei Medici in 1545, and also in the slightly later work

101. See Cat. no. 17. Pallucchini, 1969, p. 90, avoids the difficulties involved by rejecting the identification of the admiral as Vincenzo Cappello.

102. See data in Cat. no. 15.

103. Luigi Anichini (c. 1500–1559); for his biography see Novelli, 1961, pp. 324–325.

in the Frick Collection at New York (Plate 99). In fact, Panofsky suggested the possible influence of Michelangelo's *Moses*, chiefly because of the great mane of a beard.[104] Titian was following Mannerist methods in having the huge body fill the picture space, but he did so with a purpose, to make the huge form project the very nature of the man. We know that Aretino objected to the way the paint was splashed on the Pitti canvas, complaining that the artist was in a hurry. The Frick variant is somewhat more finished in its brushwork, as well as different in pose. Both are equally impressive in recording the appearance and nature of Aretino, the propagandist, public-relations expert of ruthless determination, willing to fawn whenever the occasion demanded.

The commanding and somewhat arrogant *Marchese Savorgnan della Torre, c. 1545* (Plate 98), in the Bankes Collection at Kingston Lacy, rises up in towering isolation, majestic in a crimson velvet robe and broad stole which cuts obliquely across the front of the body. The effect is that of a thundering personality of the sort first met in the portrait of *Doge Andrea Gritti* (Plate 74) who so dominates the space of the canvas. An interesting difference is the softness of the left hand holding the gloves in the Bankes picture. On the table lies a piece of paper, presumably a state document (which is indecipherable), indicative of the man's high estate in the Venetian government as a member of the Maggiore Consiglio. Titian's exploitation of the gigantic vision seems to have run its course in these years *c. 1535-1545*, a period which includes the *Roman Emperors* and the portraits of *Gritti, Savorgnan, Vincenzo Cappello* (Plate 88) and to a lesser degree *Cardinal Pietro Bembo* (Plate 90).

The handsome painting popularly called the *Young Englishman*, in the Pitti Gallery (Plates 100, 101), is usually dated *c. 1540-1545*, on purely stylistic considerations. The figure in black looms large in the picture space, as do the others just studied. However, the effect is totally different, for here we have not a general or high government official but a cultivated gentleman of clearly aristocratic rank and of intellectual, even poetic cast of mind. Titian achieved that characterization by the directness of the glance, straight at the spectator, a glance sympathetic, appealing, and gentle, with melting eyes, like those of a young man in love. He has none of the imperiousness of Gritti or Savorgnan nor of the overstuffed grossness of Pietro Aretino.

The qualities of design which count so much in this picture are impeccable, that is the silhouette of the black costume against a much lighter greenish-grey background without architectural setting or curtain. The long gold chain, much neutralized, is vital to the beauty of design. It relieves the plain black area of the doublet, and it is related to the general shape of the head. The small white collar and the white ruffs at the wrists are also essential to the success of the composition, thus giving accent and contrast. Many elements of this work are unique in this period, for instance, the softness of the brush particularly in the painting of the face, where beard, hair, and eyes are caressingly treated with a minimum of contrast in surfaces or in lighting. Justifiably the *Young Englishman* ranks among Titian's most beloved portraits.

The *Seigneur d'Aramon, c. 1541-1542*, in Milan (Plate 102) has some of the same qualities of design in its frontality of pose and refinement of countenance, but it never could have equalled the *Young Englishman*, even discounting the faded condition of the canvas and the totally inadequate photograph which it has been impossible to replace with a better one.

104. Panofsky, 1969, p. 10, note 9.

TWO CHILDREN: 1542

THE first member of the powerful Farnese clan to be painted by Titian, the twelve-year-old boy Ranuccio, was sent to Venice at that tender age to be prior of the Venetian chapter of the Knights of Malta. His altogether charming portrait, dated 1542, now in Washington (Plates 109, 113, 114), reveals him as a mature child of his century, dressed in a handsome costume of rose satin with a dark coat lined with sable. Titian succeeded in giving the child dignity without making him either precocious or arrogant. The standing figure in nearly three-quarter length befits his position as member of one of the most powerful of Roman families, a boy whose grandfather Pope Paul III soon succeeded in establishing the Duchy of Parma and Piacenza for the youth's father, Pierluigi Farnese. The simplicity of the composition without setting of any kind is altogether suitable for the portrait of a child whose innocence and unpretentious charm are dominant.

In another, much younger child's portrait, *Clarice Strozzi* at the age of two (Plates 106–108), painted in the same year of 1542, Titian emphasized her infancy in the way the little girl clasps her dog and feeds him a biscuit. The dancing winged cherubs upon the frieze of the low table (Plate 110) are introduced as a motive symbolic of the activities of babyhood. Although the whole design is much greater in its complexity of interrelated rectangles, the mood in general has the intimacy of the nursery. The child is, nevertheless, very richly dressed and adorned with pearls, suitable to her family's social position. By contrast, the young Ranuccio is a sympathetic boy on the verge of manhood.

TITIAN AND THE FARNESE: 1543-1546

TITIAN became the official portraitist of the Farnese pope, Paul III, after they first met at Bologna in late April 1543, when the artist arrived there from Ferrara in the train of Cardinal Alessandro Farnese.[105] *Paul III Seated without Cap* (Plate 115), now in the museum at Naples, was repeated in so many copies that no doubt remains that the pope considered it as his preferred state portrait,[106] whereas *Paul III with Cap* (Plate 118) exists in only three versions.[107] This first likeness of Paul III (Plate 115) seems to have been completed in the amazingly short time of one month, unless the small payment of two *scudi* for shipping the picture made in late May 1543 was given in advance, an unlikely supposition. At any event Aretino at Verona wrote to Titian one of his publicity letters in July 1543 with great praise for this 'miracle made by your brush in the portrait of the pontiff',[108] a work which he had probably never seen.

105. Cittadella, 1868, p. 599: letter of 22 April 1543 in Ferrara.
106. See Cat. no. 72. The most accurate replica, perhaps by Titian's shop, is the one in the sacristy of Toledo Cathedral (Plate 258) in Spain (see Cloulas, 1966, pp. 97–102, the only study of this item; also Cat. no. 72, copy 12).

Erica Tietze-Conrat in her article on the portraits of Paul III (*Gazette des beaux-arts*, 1946, pp. 73–84) rejected the portrait without cap as Titian's original of 1543, on the ground that it does not look like a work painted from life and that Paul III looks older in a miniature of 1543, reproduced in her article in fig. 7. She preferred to believe that the real author of this famous Titian was Sebastiano del Piombo or at best Titian after Sebastiano. Her extremely complex and subjective arguments have not been accepted by other critics.

107. See Cat. no. 73.
108. Aretino, *Lettere*, edition 1957, II, p. 8.

Clarice Strozzi. Detail from Plate 106

Berlin–Dahlem, Staatliche Gemäldegalerie (Cat. no. 101)

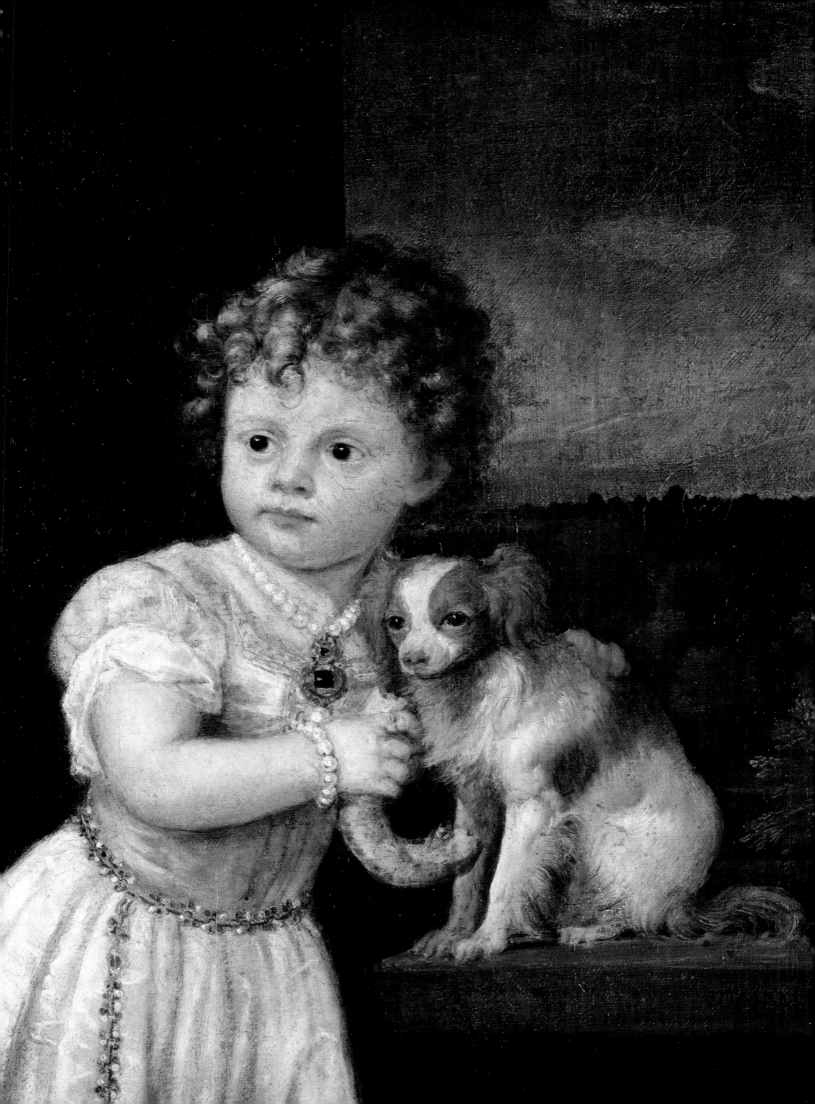

The presentation of the pope, seated in three-quarter length, follows a type well established for the portrayal of an important ecclesiastic. The most direct prototype for Titian's picture is, of course, Raphael's *Julius II* (Plate 121), which the Venetian himself was to copy later during his sojourn at Rome in 1545–1546, although obviously already known to him in 1543. Another famous example among papal portraits of this period is Sebastiano del Piombo's *Clement VII*, now also in Naples, a symbol of papal power more than a study of the man.

Titian's characterization is very direct and precise in the representation of the elderly pope, then aged seventy-five, with little attempt to flatter or glamorize him after the manner of many official likenesses of great rulers. Titian himself frequently rejuvenated his sitters, and, in his state portraits of *Charles V* (Plates 51, 142) he concealed the gross defect of the Emperor's lantern jaw. The artist probably made Paul somewhat less careworn and aged than he actually appeared, but he gave the pope dignity, even though his shoulders bend forward and his whole body is heavy with old age. The glance is shrewd and wily, the eyes piercing, leaving no doubt of Paul's political acumen and of his determination to achieve his aims in the struggle with Charles V in which he was then engaged. Titian's technical rendering of the bony hands, the wrinkled face, and the abundant white beard show an unusual insistence upon exact representation and definition of textures, which may reflect the pope's own preference for detailed rendering. The crimson velvet cape with its rich impasto of white highlights and the handling of other accessories are more typical of Titian's brushwork in this period. In the Venetian's copy after Raphael's *Julius II* (Plate 122) the softer, more illusionistic treatment of head and beard is more in keeping with his normal style, lacking the suggestion of drawing every individual hair upon his face as he did in *Paul III Seated without Cap* (Plate 115). The important fact about this magnificent state portrait is, however, the artist's ability to create a work of such psychological power that the image of the aged pope is vividly and unforgettably impressed upon the beholder. Only a few of the greatest portraitists of all time ever achieved that.

Titian accompanied the papal court from Bologna to the conferences held with Charles V at Busseto between 21 and 25 June 1543. Obviously during these few busy days of diplomatic argument over international politics and the Council of Trent, none of the famous participants had time to pose before Titian. Charles did order the master to paint a picture of the deceased Empress Isabella, using as model another artist's likeness.[109]

The major period of Titian's activity for the Farnese clan took place in Rome, as already noted, where the artist spent more than eight months, lodged in the Belvedere Palace of the Vatican, from late September or early October 1545 until early June 1546.[110] *Paul III Seated with Cap* (Plate 118) beside an open window with landscape view is generally conceded to belong to these months.

109. Aretino letter of July 1543, in *Lettere*, edition 1957, II, pp. 9–11. See also Cat. no. L–20 and Plate 150.

110. See Wethey, I, 1969, pp. 28–29. C. and C., 1877, II, pp. 112–113, also placed the departure from Venice in September. If Titian's letter to Charles V dated 5 October 1545 (Cloulas, 1967, p. 205) is correctly dated, he must have left Venice that day, but probably earlier. The possibility remains that Titian departed in September but dated his letter 5 October 1545. Cardinal Pietro Bembo's letter of 10 October 1545 from Rome to Girolamo Quirini in Venice gives details of Titian's trip to Rome by way of Pesaro and of the escort which the Duke of Urbino had supplied for the rest of the journey (Bembo, ed. 1743, II, pp. 275–276). Therefore Titian must have already arrived in Rome before 10 October (see also Wethey, I, 1969, p. 29, note 160). The speed of such a trip in five days or less, including a stop at Pesaro, seems so incredible that we should probably discredit the accuracy of the date 5 October 1545 on Titian's letter to Charles V. Panofsky, 1969, p. 185, suggests that the letter of 5 October 1545 was in reality written at Rome.

Unfortunately the wretched condition of the canvas allows few conclusions, although no reasons exist to doubt that it is the ruined original. The papal cap (*camauro*) does not increase the dignity of Paul III, and other modifications of the composition do not constitute improvements over the first version, done at Bologna (Plate 115). The larger more abundant cape conceals the stooped shoulders of the man who had reached seventy-seven years. A greater generalization of both the figure and the head seems to prevail, and the result is a less forceful characterization. The major changes in details include the paper in the right hand instead of the large purse as previously, and the additions of the cap and open window already mentioned.

As a matter of fact the Leningrad sketch (Plate 119) affords a far better idea of Paul's appearance than the ruined painting at Naples. The provenance of this picture from Titian's own house in Venice is good evidence that it is indeed an original study made in the presence of the pope. Paul III has a tired, apprehensive look, and he stoops much more. Besides, the technique is softer and more fluid than in the first likeness made in Bologna (Plate 115). One suspects that the ruined original in Naples looked essentially like the sketch, at least in colour and technique. Slight differences lie in the absence of the window in the sketch and in the position of the arms. At Leningrad the right arm rests upon the chair and the left arm is placed against the pope's body. The exact reversal of the positions of the arms in the ruined original is explained by the presence of the open window, which for reasons of design necessitates horizontal directions in the chair and the pope's arm.

The version in Vienna (Plate 120) retains all of the elements of the Leningrad sketch, and is of approximately the same size. Although the quality of this picture and the beautiful handling of the red velvet are first rate, most critics have classified it as a workshop piece. The chief reason seems to be that its history has not been traced farther back than 1816. On purely objective grounds this version is inferior to none in its technical execution. As in the Leningrad sketch, which it follows so closely, the personality of the sitter has less vitality, and he seems more tired and older than in the portrait from Bologna (Plate 115).

Titian's great work for the Farnese family, and one of the masterpieces of portraiture of all time, is the *Paul III and His Grandsons* in the museum at Naples (Plates 126–129). Here we have no conventional portrait but a dramatic presentation of family relationships, which Titian had learned to understand during his months of residence in the Belvedere Palace. The picture remains unfinished to the extent that final glazes are lacking in details, such as the hands and both the legs of Ottavio on the right, the hand of the pope which rests upon the table, and parts of the papal costume. On the contrary, the composition of the group of three and the psychological content are indeed fully conceived.

The idea of the triple portrait with the main figure seated is generally agreed to be derived from Raphael's *Leo X and His Nephews* in the Uffizi at Florence, doubtless known to Titian in the copy attributed to Andrea del Sarto, which was then in Mantua.[111] Whereas the near-sighted Leo X, magnifying glass in hand, is formally posed, as though he had momentarily arrested his examination of the book before him, his nephew-cardinals stand immobile in attendance, all heads nearly on the same level.

111. For Raphael's original see Camesasca, 1956, pl. 128; Andrea del Sarto's copy passed from the Gonzaga at Mantua to the Farnese and is now in the museum at Capodimonte in Naples.

See Rinaldis, 1911, pp. 214–218, no. 131 (attributed to Andrea del Sarto); also accepted as Andrea del Sarto's by Freedberg, 1963, II, pp. 131–133; Shearman, 1965, I, pp. 125–126.

Titian's *Paul III and His Grandsons* is a family encounter in which the suspicious old man, heavily bent with age, swings abruptly toward his grandson, Ottavio. This tall young man, then aged twenty-two, genuflects with fawning obsequiousness before the pope, who must have been well aware even then of his treacherous nature. Ottavio's profile (Plate 128) and his whole figure seem to be the very embodiment of the scheming Renaissance prince, a type we would call Machiavellian in his utter ruthlessness. His rapier-like Italian nose and his courtly bow sum up his character with a profound and scathing completeness which only a genius of the stature of Titian or Shakespeare could achieve.[112]

Ottavio was the son of the pope's son Pierluigi Farnese, who in 1545 had just been made Duke of Parma and Piacenza as the result of Paul's efforts to aggrandize his family. In 1539 Ottavio had married Margaret of Austria, illegitimate daughter of Charles V, and so belonged in the Spanish orbit. After the murder of Pierluigi by Spanish agents in 1547, Paul III reclaimed the duchy for the papacy. That did not prevent Ottavio, however, from conspiring with Ferrante Gonzaga, Charles V's governor at Milan, in an effort to succeed his father as duke of Parma and Piacenza. The plot finally succeeded after the pope's death in 1549. Nevertheless, the intrigues surrounding these men in 1546 must have been well known to Paul III.[113]

Titian has been hardly less devastating in his revelation of the pope's crafty suspicious nature, while Cardinal Alessandro Farnese (Plate 129), then twenty-six years of age, a brilliant man, an intellectual, and an experienced diplomat, is frankly understated. The purpose of the inactive and impassive look of Alessandro was to furnish contrast to his brother and grandfather. *Paul III and His Grandsons* stands as the most revealing, the most dramatic characterization of any portrait of the Italian Renaissance. Only Goya's scathing revelations of the gross stupidity of Charles IV and Queen María Luisa of Spain in *Charles IV and the Royal Family* (1800) in the Prado Museum at Madrid surpasses it for merciless satire. The Spanish royal family apparently was incapable of understanding Goya's bitter denunciation. Titian was more subtle. He observed and recorded with unerring insight, but he did not pass judgment to the extent of caricature. Paul III must have comprehended the revelations in this great work and that would explain why Titian abandoned it unfinished. No replicas or old copies of this composition, except that of Francesco Quattrocase, are known to have existed.[114]

The design of the picture, moving from the curving outline of Ottavio's figure toward his grandfather, abets the characterization. A long diagonal starts at the lower right in Ottavio's further leg and moves through the side of the pope to the hand of Alessandro. Other series of counter-movements lead from lower left to upper right. Throughout this brilliant colour composition the artist limited himself to black in Ottavio's costume, white in his hose and the pope's long-skirted surplice, and a series of tones of red in the table, the papal cape and *camauro*, the cardinal's robe, and the large red curtain in the background hung over a brown Venetian blind. The picture is a miraculous piece of subtle colour relations, particularly in the harmonious variations of the contrasting tones of red, which must be seen to be believed.

112. Panofsky's theory (1969, p. 79) that Ottavio's pose is based on a Roman relief of the Birth of Bacchus in the Vatican museum is not convincing. Titian's own powers of observation alone can explain such a brilliant projection of character through movement and pose.

113. Villari, 1910, pp. 183–184.

114. See Cat. no. 76, copy.

The handsome direct portrait of *Cardinal Alessandro Farnese* in Naples (Plate 132) appears in the Farnese inventories as Titian's work, and nothing about the picture gainsays that history. The cardinal's robes of watered silk against the darker background, now much damaged, are still brilliant, and the characterization of this sympathetic young man of twenty-five is most appealing, surely the finest record of the man in his youth. During these very years Paul III relied heavily upon him as papal legate in various diplomatic negotiations of the greatest complexity involving Francis I and Charles V. His clear intelligent glance has no trace of the arrogance which might be expected of a man of his position and influence. Titian gives us here a much more vivid idea of the young Alessandro than he does in *Paul III and His Grandsons* (Plate 129), where the face is unexpectedly placid. The bust-length figure of *Cardinal Alessandro Farnese* (Plate 130) at the Villa d'Este in Tivoli is a piece of official portraiture, by an unknown Roman artist, which shows not a trace of Titian's style or interpretation, even though the position of the head and cap is directly quoted from *Paul III and His Grandsons* (Plate 129).

The other surviving portrait of the Farnese family by Titian is *Pierluigi and Standard Bearer*, at Capodimonte in Naples (Plate 123). This son of Pope Paul III and father of Alessandro, Ranuccio, and Ottavio, is presented as the soldier of fortune and the leader of the papal military forces. The suit of armour with brilliant highlights signifies the position of the man in Paul's increasing empire, while the standard bearer adds to the martial note. From the point of view of composition the introduction of a subordinate figure is a familiar device repeatedly employed by Titian, for example in *Charles V with Hound* (Plate 55), *Alfonso d'Avalos and Page* (Plate 56), and *Guidobaldo II della Rovere and Son* (Plate 165). The rose banner supplies a major rich area of colour against the black armour. Even though the entire canvas is ruinous, Titian's original intentions are fully comprehensible. The head of Pierluigi still carries the iron determination of this man of war, in spite of the paint losses which disfigure the face. By contrast the head of *Pierluigi Farnese* in the Royal Palace at Naples (Plate 252) is wooden, and the entire composition excessively overweighted with costume. This anonymous central Italian work has been incomprehensibly assigned to Titian by some writers.[115]

A painting of extraordinary beauty is the portrait in Budapest incorrectly entitled *Vittoria Farnese* (Plate 263) and equally incorrectly attributed by a few writers to Titian. This lovely work has the quality of a great master whose name has escaped identification as completely as the name of the sitter. The recent idea that Lambert Sustris may have been the painter, if true, would show him rising to unexpected heights, for this picture is one of the masterpieces of the Italian Renaissance. A most elegant figure, dressed in a black gown, she holds the long pale tan veil with her left hand. Among other misconceptions of her, neither her costume nor her veil is indicative of mourning or widowhood. She is unequivocally a woman of aristocratic birth, representative of the high cultural and social values of the Renaissance.

115. See Cat. no. X–34.

GROUP PORTRAITS

TITIAN had essayed the group portrait early in his career, about 1510–1512, with the *Concert* in the Pitti Gallery (Plate 8), where the juxtaposition of three men of different ages and diverse character foreshadows what he was to do much later with far more dramatic emphasis in *Paul III and His Grandsons* (Plate 127). In the early composition the heads are kept upon virtually the same level, and the positions of the three men in space are not widely differentiated. Titian relied upon subtle distinctions of character in creating the highly introspective mood which was a major preoccupation here. The virtually religious spirit of the group is expressed in muted tones, which have always been regarded as very moving.

The artist's next major excursion into the realm of group portraiture was limited to two people in *Georges d'Armagnac and His Secretary Guillaume Philandrier* at Alnwick Castle (Plate 135), where the placement of the figures is remarkably like that of Sebastiano del Piombo's *Cardinal Carondolet and Secretaries* in the Thyssen-Bornemisza Collection at Lugano.[116] They differ in the background, to be sure, and in the reduction of the size of the table upon which Philandrier writes. Titian enlarged d'Armagnac, the principal actor, who dominates, while his secretary waits anxiously, almost apprehensively, for the next word. In Sebastiano's composition the large architectural background is indeed distracting to the degree that it weakens the role of Carondolet himself. Titian knew much better how to monumentalize his patron and how to subordinate setting and accessories to that purpose, with the result that d'Armagnac is an overpowering figure, almost sphinx-like in his immobility.

The so-called *Francesco Filetto and his Son* in Vienna (Plates 133, 134), originally a double portrait, was cut into two parts in the early seventeenth century.[117] In the copy (Plate 131) made before the dismemberment, the general conception is related to that of the double portrait at Alnwick Castle with the curtain at the left and landscape at the right. It is difficult to believe, however, that the landscape is faithfully reproduced here, especially the large fig leaves, so completely out of scale. The boy occupies the position of secretary, while the poses and gestures are varied to suit the new motivation of teacher-father and pupil-son. The continuity of the table across the front is comparable to the device of the parapet in early Venetian pictures of the Madonna as well as in other subjects. The two portraits of Filetto and his son (Plates 133, 134) appear today with added attributes, making the father into St. James and the boy a strange sort of St. Sebastian. Nonetheless, the figure of the man is strong and imposing, retaining enough of Titian's genius to give evidence that the original work was closely contemporary with and as fine as *Georges d'Armagnac and His Secretary* (Plate 135).

The *Vendramin Family* in the National Gallery at London (Plates 136–140) ranks among Titian's greatest masterpieces. The adoration of a relic of the Holy Cross is the theme, yet the array of portraits takes precedence over the religious motivation. The relic had been given in 1369 to Andrea

116. Gould, 1966, pp. 49–50, fig. 3; Gould prefers Raphael's *Leo X and His Nephews* as the forerunner of Titian's picture, but his insistence upon the major importance of the canted chair seems exaggerated.

117. Mentioned as two portraits on one canvas by Ridolfi (1648)-Hadeln, I, p. 192; already in two pieces in the engravings published by Teniers, 1660, pls. 81, 85.

Vendramin, who presented it to the Scuola di San Giovanni Evangelista in Venice. Its presence there gave rise to the series of pictures of *Miracles of the Holy Cross* by Gentile Bellini (1500), Carpaccio, Bastiani, and others, all of them now exhibited in the Accademia at Venice.[118] Gentile Bellini's picture commemorates the legend of a miracle which is said to have occurred not long after the relic came to Venice. The story recounts that the reliquary containing the fragment of the Cross fell into a canal but it remained miraculously suspended over the water until Andrea Vendramin could jump into the lagoon and rescue the reliquary intact.[119]

The Vendramin family's traditional devotion to the relic of the Holy Cross is thus immortalized by Titian in his magnificent group portrait. The altar displaying the reliquary stands majestically to the right above a flight of steps much in the position of the high altar in Venetian churches. Nevertheless, Titian increased the monumentality of the entire setting with steps, altar, and the Vendramin family rising impressively above the spectator. He had earlier exploited a stepped platform in the votive altar of Doge Andrea Gritti (1523–1538), a lost work which is believed to be reflected in a woodcut where Gritti's place is taken by the later Doge, Francesco Donato.[120] In this composition, however, the single donor was subordinated to a group consisting of the Madonna and saints with angels raised high to the right.

The members of the Vendramin family dominate in their votive picture with Gabriele (Plate 139), then aged sixty-three, a venerable and grey-bearded elderly man, occupying the central place of honour, closest to the altar. It is significant that Titian kept the heads of the three main worshippers on the same level, achieving thus unity and dignity. In 1547 Andrea (Plate 137), the bald man with black beard, died, so it generally has been concluded that Titian had finished the work before his death. He genuflects before the reliquary, dressed in a crimson robe lined with lynx. The broad gesture of his right arm suggests reverence but also draws attention to his attendant sons, all seven of them being his children. Leonardo, the bearded youth behind his father, born in 1523, was only twenty-four at the year of his own death in 1547. The other boys have been identified by their ages, reading left to right from the extreme left, as Bartolo, Francesco, and Luca. At the opposite side appear Federico, the little boy with the dog, Filippo, and Giovanni, utterly natural in their restlessness as opposed to their quietly kneeling older brothers at the extreme left.[121] Titian's deep understanding of human beings of all ages is brilliantly demonstrated in the *Vendramin Family*. Children's portraits are few throughout his career, yet the Vendramin boys and the little girl *Clarice Strozzi* in Berlin (Plates 106, 108) are sufficient to place him in the same category as Sir Anthony van Dyck as a painter capable of recording the artless charm of childhood.

The technical brilliancy is another aspect of the picture of the *Vendramin Family* which should not be overlooked. In photographs only large details of the heads, hands, and fur, as well as the reliquary,

118. Moschini-Marconi, 1955, nos. 56, 63, 94, 139.
119. Sansovino (1581)-Martinioni, 1663, p. 284.
120. Tietze, 1936, I, p. 134, pl. XVIII; Andrea Gritti was Doge in 1523–1538; Francesco Donato, Doge in 1545–1553.
121. The dates of the family are given as follows by Pallucchini (1969, I, p. 288): Bortolo (1530–1584), Francesco (1529–1547), Luca (1528–1601), Leonardo (1523–1547), Gabriele (1484–1552), Federico (1535–1611), Filippo (1534–1618), Giovanni (1532–1583).

Federico was twelve in 1547 so that the beginning of the picture earlier *c.* 1543, suggested by Gould, seems reasonable, since this little boy with the dog looks nearer eight or nine years old.

The dates of Andrea, given as 1481–1547 by Pallucchini, if correct, would imply that Titian rejuvenated him. He certainly does not look sixty-six in the London picture, but twenty years younger, as his children's ages also indicate.

give any idea of the freedom of the brush which so deftly suggests the form rather than describes it. Titian's development of the late style of Venetian illusionism is in its full flower now in the fifteen-forties. The brilliant red velvet robes of Andrea and his son Leonardo are contrasted to the black robe of Gabriele in the centre. The boys, dressed in black, repeat the darker tone, except for the red stockings of the little fellow with the white dog and the milder red jacket of the child at the extreme right. The result is brilliancy of the colour relations of the costumes against the pale-blue sky and the light tone of the steps and altar.

TITIAN AT AUGSBURG: 1548

THE fifteen-forties took Titian away from his home in Venice on several occasions, to which allusion was made in the section 'Titian and Renaissance Society'. After his visit to Bologna and Busseto in 1543, he had made the long trip to Rome for a stay of several months from October 1545 until June 1546, both of these sojourns already discussed. The next of his travels took him beyond the borders of Italy to the court of Charles V at Augsburg, whither he journeyed through the wintry Alpine snows of January 1548, not to return to Venice until late October.[122] Many of the portraits undertaken at this time, those of *Mary of Hungary*, *Ferdinand I*, *Christina of Denmark*, *Johann Friedrich in Armour* and others, have been lost.[123]

The great composition of *Charles V at Mühlberg* (Plates 141–144), completed during these months, is a major work of all time, sufficient in itself to immortalize Titian and his first venture to Augsburg.[124] So much has been written (Cat. no. 21) about this picture and its sources that they will not be dwelt upon here. The rearing horse may have been suggested by Leonardo's studies for the equestrian monument of Francesco Sforza,[125] but the position suggests more of a gallop than the attitude of extreme excitement of Leonardo's project, and Charles V sits easily and essentially at rest in his saddle. The nature of this work, commemorating a highly important victory at Mühlberg on 24 April 1547, is made clearly evident in the confident attitude of the Emperor as conqueror and Christian knight. The long lance accentuating the role of the victor has been shown by Panofsky to be the symbol of supreme power, borne by a Roman Emperor as illustrated in coins of Trajan and Marcus Aurelius.[126] Charles wears across his cuirass the commander's sash, the red colour of which is emblematic of the Catholic party and the Holy Roman Empire in the religious wars of the sixteenth and seventeenth centuries.

Titian placed the horse and rider in an essentially parallel relation to the landscape space. He anchored the composition to a group of trees set slightly back in the left distance. The landscape view opens as

122. For documentation see Wethey, I, 1969, pp. 31–32. Charles V first wrote to Hurtado de Mendoza in Venice 21 October 1547 asking to have Titian come to Augsburg to repair the Empress' portrait (see Cat. no. L–20).

123. See Cat. Nos. L–7, L–16, L–24, X–65.

124. See Cat. no. 21 for history, sources, and bibliography. The life-sized bronze monuments of the *Gattamelata* by Dona-

tello at Padua and *Bartolomeo Colleoni* by Verrocchio at Venice were obviously well known to Titian. Neither involved a rearing horse such as Titian introduced here.

125. For the Sforza monument see Bovi, 1959.

126. Panofsky, 1969, pp. 84–86. The same writer's statement (p. 84) that the *Charles V at Mühlberg* is 'an unceremonial portrait' seems contradictory to his own analysis.

a corridor at the right, where the light of sunset plays over the trees and mountains. The composition of this landscape, with trees cut off at the top appears earlier in Giorgione's *Pastoral Concert* (*c.* 1510) in Paris and Titian's *Bacchus and Ariadne* (*c.* 1518–1523) in London. It passed thereafter into the repertory of Renaissance and Baroque art. Velázquez's *Philip IV on Horseback* in the Prado Museum is based directly upon Titian's picture, both in the parallel position of horse and rider in relation to the picture space and in the general organization of the setting.[127] Rubens, van Dyck, and many other painters followed the example of Titian's *Charles V at Mühlberg*, a work which can justifiably be called the climactic monument in state portraiture of both the Renaissance and Baroque periods.

The brilliance of the colour and the master's technique also represent the very summit of achievement in the art of painting. The rose-coloured trappings and plume of the horse establish the dominant tone against the black steed, upon which is mounted Charles V in silvery armour, while the rose colour is repeated in the sash and in the plume on the helmet. The entire figure of Charles is a tour-de-force, particularly the armour with gleaming highlights and the tiny spots of colour which reflect both the surrounding atmosphere and the dominant rose tonality of the composition. Only Rubens with his sumptuous brushwork ever approached the sheer technical mastery here displayed. Charles personifies imperial dignity itself, and his disfiguring lantern jaw, hidden by his beard and the painter's discretion, can hardly be noted. The extent to which Titian glorified him is all the more evident on consideration of a factual description of Charles in 1529: 'a small person who stoops a little, with a small long face and pointed beard, and his mouth is always open'.[128] By 1548 Charles was every inch the Emperor in power and in deed. Titian did him an inestimable service in creating for him and for posterity this conception of the triumphant ruler, the most powerful man of his era.

A more intimate record of the man is provided by Titian in *Charles V Seated* at Munich (Plates 145, 146), a work of the same year 1548 as the equestrian monument. Even though the seated full-length pose is traditional for an important ecclesiastic or occasionally for nobility, this altogether personal record is not calculated as a state document for posterity. The golden damask cloth behind Charles is more important for its colour than as the canopy of honour, if such was the intention.[129] The red carpet provides another area of flat colour furnishing the major foil for the entirely black costume of the Emperor. That Titian's assistants painted some of the accessories can be assumed, particularly when one considers the large number of pictures undertaken by the artist during his few months at Augsburg. Nevertheless, it is unthinkable that anyone else had any part in the conception or in the design of this masterpiece. Titian was responsible for the direction of every part of it. Lambert Sustris, the Amsterdam master who accompanied Titian to Augsburg, has been credited with various parts of the execution by some critics. Sustris took over the composition in reverse for his portrait of *Erhart Vöhlin* at Cologne (Plate 245), with results which are ludicrous because of the excessive height of the background and the clumsy design of the costume. No better demonstration of the difference between Titian and a pupil could be sought than in a confrontation of these pictures. In *Charles V Seated* the rosy tint of the landscape harmonizes with the strong red of the floor in the

127. Titian's picture was hung in the Salón de los Espejos of the Alcázar (see Cat. no. 21, History) and Velázquez's in the Salón de los Reinos of the Palace of Buen Retiro at Madrid.

128. Sanuto, LI, column 371.
129. So proposed by Panofsky, 1969, p. 82.

foreground, and it does not justify the theory that Rubens repainted the background. On the other hand, the low horizon, the misty atmosphere, and the smooth outlines of the trees differ rather notably from Titian's normal handling and might therefore suggest the hand of a northern assistant. The major impression given by *Charles V Seated* is the sense of gravity, and the dignity of the tired, sickly Emperor, who was at this very time preparing for the ultimate division of his kingdom between his son, Prince Philip, and his brother, Ferdinand.

The portrait of the *Empress Isabella* in the Prado Museum (Plates 147, 149), prepared at Augsburg in the summer of 1548, followed an earlier model, perhaps by Seisenegger. The Empress had died at Toledo in Spain nine years earlier, a fact which explains the rather rigid pose and the lack of the spark of life in the serene yet sad expression of her face. The superb costume of violet-rose velvet, the rope of pearls, and the large jewelled brooch of rubies, sapphires, with the large pearl as a pendant, all of them were doubtless in the painter's possession at Augsburg. Obviously this likeness is less of a character study than others, but it has considerable decorative beauty.

The seated figure beside an open window had served in the picture of Eleanora Gonzaga, Duchess of Urbino (1536–1538) (Plate 70). In the lost portrait of *Empress Isabella Seated, Dressed in Black*, known only in copies (Plates 150, 232), the window opening contained the imperial crown. In this earlier work, securely dated in 1544–1545, where Isabella holds roses in her right hand upon her lap, her position in relation to the wall is much the same as in the Prado canvas. However, she wears an entirely different costume, which has elements in common with a rather charming picture assigned to William Scrots, in the museum at Posen (Plate 233). The complexities of the relationships are fully stated in the catalogue so there is no need to repeat them here.[130]

The double portrait of *Charles V and Empress Isabella*, painted by Titian at Augsburg in the summer of 1548, disappeared from the Spanish royal collection some time after 1636, but the composition is preserved today in a copy attributed to Rubens (Plate 151). Titian had earlier created other compositions with two people, *Georges d'Armagnac and His Secretary* (Plate 135) and *Francesco Filetto and His Son* (Plates 133, 134). In both cases, however, a major and a secondary person was involved, whereas Charles and the Empress are given equal emphasis. Both dressed in black, their figures are contrasted to red velvet upon the table and the red damask curtain behind them. The opening to a distant landscape in the right of the centre adds variety and a sense of space. The head of Charles closely resembles the contemporary *Charles V Seated* in Munich (Plate 146), while the Empress has a costume somewhat like that of her earlier lost portrait (Plate 150), although the white partlet and collar are nearer to the gown of the late Prado original (Plate 147). Since Charles had apparently taken Titian's earlier picture to Augsburg in 1547–1548 to have the nose retouched,[131] the artist appears to have used that as his primary model. Both sitters have an abstracted look, to be explained by the fact that neither was present when the artist put the picture together. One might argue also that Titian was conscious of the transitoriness of life and that the clock on the table stands specifically as a symbol thereof.[132]

130. See Cat. no. L–20. The jewels, especially the pendants vary slightly in individual portraits and copies, but these differences are not important enough to develop theories about them.
The confusions about this portrait are fully clarified by the extensive documentation, set forth in the catalogue.

131. Cloulas, 1967, p. 208.
132. Panofsky, 1969, p. 90, holds that the clock in this case signifies 'temperance and transience'.

Numerous copies of *Charles V in Armour with Baton* exist, in all of which he wears the same armour as in *Charles V at Mühlberg* (Plates 141, 242), and the face is near, both to this same original and also to *Charles V Seated* in Munich (Plate 145). The three-quarter length copy (Plate 238) signed by Juan Pantoja de la Cruz at Madrid in 1599, and inscribed "Carolus V . . . MDXLVII", is now in the Escorial. This example surely follows the lost original carried out by Titian at Augsburg in 1548 (not 1547).[133] The setting has been enlarged, yet it is safe to conclude that the figure accurately adheres to Titian's prototype. A slightly earlier copy (Plate 239) by Felipe Ariosto, datable 1587–1588, in Barcelona, is a freer adaptation in a series of Spanish rulers. The rose-coloured sash across the cuirass in this instance must have been suggested by the equestrian portrait, where it appears as symbol of the Catholic and imperial party. Finest of all is Rubens' three-quarter length copy after Titian at Detmold (Germany) in the collection of Wilfried Goepel,[134] a work in which the medallion with a figure of the Madonna on the front of the cuirass, is more clearly discernible.

Two copies by Pantoja de la Cruz were enlarged to full length, and very clumsily, from Titian's original in the Alcázar. The one in the Escorial is dated 1608 (Plate 240) and the second one, at Toledo in the Museo de Santa Cruz, 1605.[135] The destruction by fire in 1604 of the gallery of portraits in the palace of El Pardo, meant the loss of Titian's original portrait of Charles V, probably one of those painted at Bologna in 1530 or 1533.[136] For that reason Pantoja de la Cruz in 1605 and 1608 must have copied Titian's other original of 1548. Taken by Charles to Yuste on his retirement and paired with the portrait of the Empress Isabella (Plate 147), it later passed to the Alcázar (royal palace) in Madrid.[137]

The *Emperor Ferdinand I in Armour*, another of Titian's productions at Augsburg, also exists only in copies (Plate 248). However, an excellent idea of the master's portraits in armour is afforded by the handsome original representing *Giovanni Battista di Castaldo* (Plates 154–157), a magnificent picture of top quality. Just how the artist managed to accomplish so much in his stay of a few months at Augsburg is nothing short of miraculous. Certain of the canvases must have been carried back to Venice for completion there. The head of Castaldo, a weary, but powerful man of about fifty, is memorable, having much of the same spirit as the characterization of *Charles V Seated* (Plate 146). The splendour of the composition is conveyed through the sense of bulk as well as the superb decorative handling of the damascened armour. In addition, the adroit pose of this man of war contributes to the sense of dignity in a work which ranks high in Titian's portraiture.

133. Cat. no. L–5, preserved copy. The inferior German copy at Augsburg in Schloss Babenhausen is dated correctly 1548.

134. Müller-Hofstede, 1967, fig. 8. I regret the lack of a photograph of this handsome picture.

135. See Cat. no. L–5, full-length variant.

136. Calandre, 1953, p. 70. See p. 203 for further explanation of the destruction of the portrait gallery of El Pardo Palace on 13 March 1604 (not 1608).

137. Cat. no. L–5, full-length variant.

TITIAN IN VENICE: 1550-1552

BACK home from Augsburg by November 1548, Titian was obliged to make a hurried trip to Milan on 19 December to meet Prince Philip and carry out certain commissions for the twenty-one-year-old heir of Charles V.[138] The year 1550 gave him at least an opportunity to remain in the Casa Grande at Venice until late October, when he was required again to set forth for Augsburg at the Emperor's command.[139]

The imposing portrait of *Antonio Anselmi* at Lugano (Plate 158), bearing an inscription and signature with the date 1550, must have seen the light of day in the first six or eight months of the year. Half-lengths are less frequent than three-quarter length figures in these later years, but Anselmi was a humanist and scholar in the service of Pietro Bembo and Bishop Beccadelli, and therefore he did not demand a picture of more pretentious dimensions. An intellectual, as the strong penetrating glance of this man aged thirty-eight conveys, he nevertheless looms upon the canvas a powerful and commanding personality. His black costume and black beard are relieved only by the flesh colour of the face, the tiny white collar, and what remains of the red table-covering to the right. With such restricted means Titian projected a vigorous characterization.

In the early fifties the artist personally created the three-quarter length figures of the *Scholar with a Black Beard* in Copenhagen (Plate 160) and *The Knight with a Clock*, Madrid, Prado Museum (Plate 161), as well as *Johann Friedrich of Saxony*, in Vienna (Plate 159). The last mentioned was carried out during Titian's second sojourn in Augsburg in 1550-1551. All three, clothed in black, are strongly contrasted to a light greyish background. The enormous bulk of the excessively corpulent Johann Friedrich is otherwise in a special class by itself. It has been shown that the position of the body with the edge of the canvas cutting through each arm is inspired by works of the German painter, Lucas Cranach. Despite the grotesquely large body, the correspondingly small head, and the apprehensive glance of the Elector, then a prisoner of Charles V, Titian was able to endow him with a degree of dignity. The *Scholar with a Black Beard* (Plate 160) has been dated as late as 1565 by some writers. On the contrary, the clarity of draftsmanship, especially in hands and head, should be contrasted with portraits of the next decade, *Man with a Flute* (Plate 201) and *Jacopo Strada*, 1567-1568 (Plate 206), in which the technique is much more painterly and consequently the precise definition of form diminished. The *Scholar with a Black Beard* in the attitude of a lecturer, as he gestures with his right hand, recalls the portrait of *Cardinal Pietro Bembo* dated 1540 (Plate 90). Nevertheless, the light background places it about 1550.[140]

The *Knight with a Clock* (Plate 161), in the Prado Museum, fits well in the proximity of *Cardinal*

138. Titian's letter of 17 December 1548 from Venice to Granvelle, in Zarco del Valle, 1886, p. 226.

139. Titian arrived at Augsburg before 4 November 1550; see Aretino, *Lettere*, edition 1957, II, p. 383. Titian's second stay in Augsburg from November 1550 to May 1551 resulted in the full length *Philip II in Armour* to be discussed below along with problems connected with other portraits of Prince Philip.

140. The handsome portrait of a *Gentleman with a Long Beard* at Kreuzlingen (Cat. X-52) is very close indeed to the *Scholar with a Black Beard*. Yet it has not received general acceptance as the work of Titian. Despite the damaged condition and repainted hands, Paris Bordone rising to unusual heights in approaching the quality of Titian appears to be the solution. The placid expression and the modelling of the head relate to that follower of the master.

Cristoforo Madruzzo, dated 1552, at São Paulo (Plate 166), in view of the long line of the arm which reaches obliquely to the table and toward the clock in each case. There seems to be no suggestion here that the clock is anything more than a highly prized object, suitable to the rank of the gentleman.[141] The knight is a serious aristocrat, whose identity has been suggested as a member of the Venetian Cuccini family. Nothing definite has been established, on the other hand, even as to the military order to which the cross belongs.

Cardinal Madruzzo (Plate 166), by contrast, is a well known personality, member of a noble family of Trent, who joined the dominant Spanish party in the time of Charles V. Titian presented him full length, in black garb against a rose-coloured curtain, a suitably imposing figure for a great churchman. In essence this is a state portrait of a man aged forty-one, still youthful in his maturity, astute rather than domineering.

For another ecclesiastic's likeness, that of *Ludovico Beccadelli* (Plate 164), dated in the same year of 1552, Titian reverted to the more traditional format, customary for a high churchman. The bishop sits, naturally and informally, however, holding a document which is inscribed with the date of the painting as well as the title of bishop of Ravello, which he held at that time. The kindly, gentle face of this intellectual, then aged fifty-one, proves that not all Renaissance churchmen were scheming self-seeking politicians like Pope Paul III, who sent him on several diplomatic missions. The same pope also had the good judgment to appoint Beccadelli as tutor to his own grandson, the charming boy, *Ranuccio Farnese* (Plate 113), whose own sympathetic character may be in part credited to his education. In this unpretentious portrait of Beccadelli, Titian reveals his penetrating comprehension of human nature by the subtlest matters of pose of the body, as well as in the benign expression of the face.

The standing full-length portrait enjoyed particular favour with Titian and his patrons at this period in the fifteen-fifties. In addition to *Cardinal Madruzzo* (Plate 166) there are two splendid examples in *Guidobaldo II della Rovere and His Son* (Plate 165) and *Giovanni Acquaviva, Duke of Atri* (Plates 167–169) as well as others of *Philip II* of Spain to be studied shortly hereafter. In *Guidobaldo II, Duke of Urbino*, Titian returned to the composition of a large figure contrasted to a smaller one. He employed the same scheme in *Charles V and Hound* (Plate 55) and the Marchese del Vasto with his son, if the latter are isolated from the composition of the *Allocution of the Marchese del Vasto* (Plate 57). Even the portrait of *Alfonso d'Avalos, Marchese del Vasto with Page* (Plate 56) is a half-length variant of the same idea. Just how Titian restudied and varied each interpretation is particularly evident in the somewhat jaunty attitude of Guidobaldo (Plate 165), his right arm resting upon the large plumed helmet on the table and his head curiously aslant. His white hose and white doublet combined with the red-black cloak have lost some of their original elegance because of the long neglect to which the canvas was subjected. The little son in rose who tugs at his father's cloak for attention is the most charming part of the composition. Once again Titian betrays his susceptibility to the appeal of children, as he did likewise in the *Vendramin Family* (Plate 136).

141. Panofsky, 1969, pp. 88–90, proposed that the clock in Titian's portraits is a symbol of the passage of time, a *memento mori* as well as a sign of virtue. This theory is at least debatable with the possible exception of the hourglass on the table in *Paul III and His Grandsons* (Plate 127).

Considerably more dashing is the full-length *Acquaviva, Duke of Atri* (Plates 167–169) in a red velvet brigandine studded in gold. The sleeves reveal the grey chain mail against the torso covered by the velvet cloth. Even the hose and shoes repeat the same brilliant red, and the high-crowned hat is finished off with a flourish by a large plume and aigrette. The even more fantastic parade helmet lies at the left, topped with a fierce dragon, whose open mouth and licking tongue seem alive. Every detail adds a new surprise: the flowering plants in the left foreground and the large handsome hound add the spirit of a hunting picture. A far-flung landscape with hazy distances and a craggy mountain, painted in a free atmospheric illusionism, is absolutely unprecedented in Titian's portraits.[142] Nevertheless. in spite of all, the duke himself dominates this extraordinary setting, as he holds a tall military pike, yet stands confidently, even fashionably, his right arm akimbo, in a spirited, unforgettable portrait.

PORTRAITS OF PHILIP II

AMONG Titian's several portraits of Philip II, the prince in armour (Plates 174–176), in the Prado Museum at Madrid, is the unquestioned masterpiece. Certain problems merit consideration, however, in connection with the meeting in late December 1548 between Titian and Philip, the arrogant young heir of the Emperor. On his first trip beyond the borders of Spain, Philip set forth from Valladolid on 1 October 1548 and took ship the following month at Rosas, north of Barcelona. After landing in Italy at Savona and staying thereafter at Genoa for a fortnight, he continued over land to Milan. The prince's sojourn in this Spanish duchy lasted from 20 December 1548 until 7 January 1549.[143] Meantime, Titian had received instructions from Charles V to proceed to Milan to meet the prince.[144] His departure from Venice for Milan is fixed on 19 December, and it may be assumed that he remained there until 7 January, when Philip himself left for Mantua, Trent, and Augsburg.[145]

The fact that Titian prepared at least sketches for Philip's portrait during these fifteen days in Milan is fully documented. The payment of the large sum of one thousand gold *scudi*, which Philip ordered made to the artist on 29 January 1549 for 'certain portraits', is absolute proof thereof.[146] Moreover,

142. The developed illusionism of the landscape is dated after 1560 by Pallucchini (1969, p. 301), who places the portrait otherwise *c.* 1550–1555. The figure seems too completely rendered for such a late date, and the composition appears contemporary throughout.

143. Pedro Beroqui (1926, pp. 241–244; reprinted 1946, pp. 95–97) first called attention to the importance of this trip and to Titian's meeting with Prince Philip in Milan.

Philip's journey from Spain to Italy and thence to Augsburg and Brussels can be followed day by day in the account of his chronicler who accompanied him, Calvete de Estrella, edition 1873, I, *passim*. He also describes the triumphal entries to various cities and the lavish entertainments offered the prince.

Ottavio Farnese, who had married Margaret of Austria, illegitimate daughter of Charles V, paid his respects to his brother-in-law, Prince Philip, very briefly. He joined the royal party at Villafranca near Mantua (not at Genoa), and he rode with them

for ten miles to Gottolengo. The next day Ottavio left the party (Calvete de Estrella, pp. 35–109).

144. Titian at Venice wrote to Granvelle on 17 December 1548 that he would leave for Milan 'day after tomorrow' (Zarco del Valle, 1888, p. 226). Aretino also refers to this trip in a letter of December 1548 to Giovanni Onale (*Lettere*, edition 1957, II, p. 272).

145. Payments ordered for Philip's purchases at Milan are dated from 30 December 1548 until 7 January 1549. On the latter date the prince departed for Mantua, where he remained from 13 to 17 January (Calvete de Estrella, I, pp. 96–108; Beer, 1891, nos. 8367–8371).

146. On 19 January 1549, at Villafranca, Philip ordered 30 *scudi* paid to Titian (Cloulas, 1967, p. 209). This payment was followed by one thousand *scudi* on 29 January 1549 and on 30 April 1549 by fifty gold *scudi* to 'Titian's son, a Venetian painter' (Beer, 1891, nos. 8372, 8376; Cloulas, 1967, p. 209).

various literary references exist, most notably, Aretino's letter of February 1549 in which was enclosed a sonnet dedicated to Titian's portrait of the prince.[147] As usual, his sonnets are literary effusions which give no hint as to the pose or general appearance of the figure, whether in armour or in less formal regalia. In this case Aretino does speak of a gesture of royal majesty, a detail which implies a single figure of the prince: 'In gesto bel di maestà reale.'

One must assume that Aretino had seen Philip's likeness on Titian's easel in the Casa Grande, since the painting was not sent by courier from Venice to the prince in Flanders until 9 July 1549.[148] In the same letter Juan de Mendoza noted that two replicas of this work were under way and they too would be forwarded to Flanders as soon as Titian had finished retouching them. All trace of this important commission for Prince Philip has disappeared. Nonetheless, it is possible to speculate that this very portrait was the one lent to Queen Mary Tudor of England in November 1553 in connection with the marriage negotiations which ended with the wedding of Mary and Philip in Winchester Cathedral 25 August 1554. Important information about this work has been overlooked by scholars writing on Titian. In a letter of 19 November 1553 Mary of Hungary wrote that she was sending Mary Tudor a picture of Prince Philip as painted by Titian 'three years ago' and that it was considered a very good likeness at that time, but that it is no longer exact.[149] Another letter, written by Granvelle, to the imperial ambassador in England, Simon Renard, urges that it be explained to the Queen that Philip is now 'older, better formed, and has grown more beard'.[150] Even more important is the letter from Francisco de Eraso to Philip at Brussels on 21 November 1553: 'It appears that your Highness' portrait painted by Titian, the one in the *blue coat with white wolf skin* which is very good and like you, has been sent in secret to the Queen in England.'[151]

The question next arises whether the paintings in Naples and Florence (Plates 179, 180), in which Philip II wears a blue coat, might in any way reflect the first likeness of 1549. In view of his age, which appears slightly more advanced than in *Philip II in Armour* (Plates 174–176) securely dated in May 1551, the Naples and Florence versions must be later, about 1554.[152] Moreover, in these portraits the prince's cloak is lined in sable rather than white wolf-skin.

Another picture which includes a portrait of Philip can be dated early and may well have been among the pictures (*ciertos retratos*) for which he paid Titian one thousand *scudi* on 29 January 1549. That is the *Venus with Philip II as Organist* in Berlin (Plates 170, 171), where the boyish-looking curly-haired youth is indubitably Philip, albeit slightly idealized to suit the situation. The medal of Philip by Leone Leoni, the bronze bust of him in the Prado Museum, and the marble bust in the Metropolitan Museum in New York (Plate 172) are clearly the same person, leaving no reasonable doubt of the identification of Prince Philip. Other scholars, notably Berenson and Panofsky, have previously recognized the

147. Aretino, *Lettere*, edition 1957, II, p. 277; also published in Aretino, *Poesie*, edition 1930, II, p. 237; and repeated by Ridolfi (1648)-Hadeln, I, p. 183.
148. *Calendar*, IX, 1912, p. 400; Cloulas, 1967, p. 212.
 For an account of Titian's portraits of Philip II, see Wethey, *Archivo*, 1969, pp. 129–138.
149. Granvelle, 1843, IV, pp. 150–151; *Calendar*, XI, 1916, p. 367.
150. Granvelle, 1843, IV, pp. 144–145; *Calendar*, XI, 1916, p. 355.
151. *Calendar*, XI, 1916, p. 384; Cloulas, 1967, p. 218, letter of 21 November 1553, but she doubtfully associated it with the

'small portrait' by Titian's workshop which Philip acknowledged having just received in a letter to Titian under date of 18 June 1553. She has since changed her mind (letter, February 1971).
152. Another significant fact about this first and mysteriously lost portrait of Philip II is Granvelle's request to Titian in a letter of 28 April 1549 for a replica of it. Other correspondence between the two men contains references to this work, which Titian averred had come from his own hand and was shipped about 22 March 1550 (Zarco del Valle, 1888, pp. 227–229).

features of the Spanish heir in the Berlin picture.[153] Philip is endowed with a sympathetic personality here, and the thin beard is minimized to allow for a more rounded structure of the face. Even the rather tousled curly hair adds to the youthful and informal appearance. His velvet costume is, nevertheless, luxurious, consisting of a dark-red velvet jacket, golden sleeves, golden breeches and hose.[154]

After the first encounter between Titian and Prince Philip at Milan from 20 December 1548 until 7 January 1549, a year and ten months elapsed before they met again and this time at Augsburg.[155] The main reason why Charles V called the artist to his court in southern Germany seems to have been to provide further portraits of his son and heir. The major outcome is one of Titian's masterpieces, *Philip II in Armour*, in the Prado Museum at Madrid (Plates 174–176). The date of this handsome work is well established in 1550–1551 by Philip's payment, but especially by his letter of 16 May 1551 from Augsburg sent to his aunt, Mary of Hungary, at Brussels along with 'the portraits by Titian'. 'In mine in armour it is easy to see the haste with which it has been made and if there were time it would have been done over again!'[156]

Philip's statement is indeed astoundingly unappreciative of one of the greatest paintings of all time. Although the brush work is illusionistic and the highlights of the armour are somewhat splashed on to give the brilliancy of lights and reflections on steel, the modelling throughout is solid. Moreover, details of the ornament of gold damascene are all the more sparkling because of Titian's method of applying the paint. His ability to contrast the quality of materials is extraordinary, that is, to recreate the steel against the silken breeches and hose and to make the entire figure stand forth against the red-velvet covering of the table and the dimly suggested base of a column at the left.

Titian endowed the young prince, then age twenty-three, with regal dignity, which combines with other factors to make *Philip II in Armour* one of the greatest state portraits ever conceived. In fact, this work ranks second only to the master's *Charles V at Mühlberg* (Plate 141) as a symbol of royal authority and dignity. The head of the arrogant, surly young man with full, sensual lips counts for far less than the impression made by the entire composition, a phenomenon common to state portraits. Nonetheless, Titian glossed over the unpleasant aspects of Prince Philip's personality. Just how much dignity Titian bestowed upon him can be judged by contemporary descriptions of him as small in body but well proportioned. Michele Suriano, the Venetian ambassador, reported that on Philip's first journey to Italy, Germany, and the Netherlands, he was regarded as severe and intractable, 'little pleasing to the Italians, most unpleasing to the Flemish, and odious to the Germans'.[157] On the advice of Mary of Hungary and his father he changed his manners and displayed greater gentleness and humanity thereafter. Another Venetian ambassador, Federico Badoaro, described Philip at the age of thirty-one

153. Berenson, 1932, p. 568; 1957, p. 184; Panofsky, 1969, p. 122.
154. The *Venus with Philip II as Organist* in Berlin-Dahlem will be studied in greater detail in Volume III, *Mythological and Historical Paintings*. The early history of this canvas is unknown, other than the fact that it formerly belonged to Prince Pio di Savoia and was purchased by Berlin in 1915 (Bode, 1918, pp. 94–106). It has been associated with an item in the Inventory of the Prince of Savoy of 1742 described as a 'Venere a giacere con cupido ed un uomo che suona l'organo con un cagnolino del Tiziano' (Cittadella, 1868, I, p. 556). Since Philip II's daughter Catalina married Duke Charles Emmanuel of Savoy in 1585, it is

probable that Philip gave the picture to her and that it remained for several centuries in the collection of the House of Savoy. This item does not appear in the Spanish Inventory of 1600 made after Philip's death or elsewhere in the Spanish royal Inventories.
155. Titian arrived at Augsburg just before 4 November 1550 (Aretino, *Lettere*, edition 1957, II, p. 383).
156. See Cat. no. 78 for full bibliographical references. Letter of 16 May 1551: Voltelini, 1890, p. LV, no. 6443; Beroqui, 1946, p. 116, note 3; Cloulas, p. 213.
157. Gachard, *Relations*, 1855, pp. 123–128.

as short and blonde with blue eyes, more Flemish than Spanish in appearance. Even at that age he had a propensity to be melancholy, intolerant, and extremely religious.[158]

When Titian set out from Augsburg in mid-May of 1551 on his return trip to Venice, he was never to see Philip in person again. Despite that fact he supplied at least five other portraits partly from his own hand, as well as workshop replicas. Two full-length portraits, similar in general stance, to *Philip II in Armour*, differ in the costume, which consists of a blue cloak embroidered in gold and lined in sable over a light-coloured silk doublet and hose, a luxurious court outfit which it may be assumed Philip lent to the artist. The fully signed canvas at Naples (Plate 179) was surely painted by Titian with some assistance from the workshop, noticeable in the incorrectly drawn right hand, which clutches the dagger hilt, and in the weaker modelling of the legs. Philip's face is slightly older now, but, in general, contemporary with the prince's head as he appears next to his parents among the spectators (Plate 178) in the *Trinity* (La Gloria) delivered to Charles V in 1554.[159] Pompeo Leoni's full-length bronze statue of Philip II in armour, in the Prado Museum (Plate 173), was first cast in 1551, but the conventions of the bronze medium, particularly in the treatment of hair and beard, and the heroizing nature of state portraiture do not permit really close comparisons for matters of dating.[160]

In the second full-length representation of *Philip II*, in the Pitti Gallery at Florence (Plate 180), the court dress is closely similar, although not identical in details of the fabric of the doublet and breeches, the colour of which is white rather than beige as at Naples. In this version the large grey columns, which constitute a palatial setting, provide the major variation in the composition. Vasari's citation of the Pitti canvas is good evidence that Titian delivered it as his own work, even though he was assisted by the workshop in subordinate details such as the architectural setting.

The 'small portrait' of *Philip II* in the Prado Museum (Plate 177) is unquestionably the work which Titian shipped in March 1553. In his letter of acknowledgement Philip thanked the artist, and he added that 'it is as though by your hand', a clear proof that Titian acknowledged it as a workshop piece.[161] The green-black costume lined and trimmed in fur has no similarity to those in Naples and Florence, nor does the composition itself, in which Philip rests his right arm upon the table, covered in red velvet.

The two pictures of *Philip II Seated*, one of them now in Cincinnati and the other in Geneva, both show Philip holding a sceptre and in the first example he also wears a crown (Plates 181, 182). The Cincinnati version, obviously a sketch, was kept in Titian's studio until his death and must have been

158. *Loc. cit.*, pp. 40–41.

159. This picture in Naples cannot possibly be the one connected by Crowe and Cavalcaselle (1877, II, p. 210) with a letter from Titian to Philip dated 23 March 1553. On the back of the letter a note dated 18 June 1553 by Philip refers to a portrait received in Madrid. A letter from Vargas to Philip written in Venice on 24 March 1553 calls it a small portrait ('retrato pequeño'). This last letter published by Zarco del Valle, (1888, p. 231) was not known to Crowe and Cavalcaselle.

 All writers except two have continued to follow the conclusion reached by English scholars in 1877. Beroqui (1926 and 1946, p. 119) correctly connected the picture of 1553 with the small half-length likeness of Philip in the Prado Museum (Plate 177). Mme Annie Cloulas (1967, p. 218) also pointed out

the fact that the 'small portrait' shipped to Madrid could not be the large painting (1·88 × 1·00 m.) from the Farnese Collection, now in the museum at Naples. She no longer regards the 'small portrait' as the lost painting sent to Mary Tudor.

160. Plon, 1887, pp. 87–88, 287–288 [*sic*], first cast in 1551 but completed and signed by Pompeo Leoni as late as 1564.

161. See note 151. This half-length composition exists in other replicas in Genoa, Rome, and private collections; see Cat. no. 83. C. and C., 1877, II, pp. 210–211, did not distinguish accurately between these half-length pictures and the full lengths in different costumes. The lack of photographs when they wrote readily explains these confusions. They are less defensible when repeated by recent writers.

regarded as a model (*modello*) which served after his last meeting with Philip in 1551. Clearly the artist must have painted it on his last sojourn at Augsburg that year. Just as obviously the crown and sceptre were added later, either in 1554, when he became consort of Queen Mary of England and was named King of Naples and Milan, or in 1556 at Charles V's abdication. At that time Philip became ruler of the Spanish dominions and the Netherlands. The crown rather clumsily tilts as an afterthought on the head and the sceptre fits awkwardly in a changed right hand. The impression prevails that the face received retouching in beard and around the eyes to make the new king look older. The second example of this composition, now in the Kreuger Collection at Geneva (Plate 182), was painted from the start as it is today with sceptre and hand better motivated and the whole composition finished. In other words, it bears no suggestion of a sketch, but is clearly based upon the *modello* at Cincinnati, with the addition of a landscape view through the window and a beret substituted for a crown. The greatest confusion has existed about these two works because Crowe and Cavalcaselle scrambled their notes, without benefit of photographs, and made two items into one. Upon their initial error other false theories have been based.[162]

In this composition Titian returns to the well established formula of the seated figure which custom had accepted as suitable for a ruler or an important ecclesiastic. For Charles V the artist chose this convention in the picture at Munich (Plate 145), where the Emperor is revealed informally in repose rather than as Emperor or conqueror. The original conception of *Philip II Seated* was essentially the same, inasmuch as the crown and sceptre of the original sketch (Plate 181) are obviously later additions. That this work was ever projected as a companion to *Charles V Seated*, however, must be ruled out in view of the total disparity of the sizes of the two canvases. The Cincinnati picture is, as we have seen, a *modello* which may have served Titian as a general reminder for the head of Philip II in various other portraits executed after they last met at Augsburg in 1551.

In the latter part of the fifteen-fifties and until his death in 1576, the artist ceased to provide any more portraits of the Spanish royal family. The reasons are several, primarily because the artist never saw any of them again. Besides, Philip kept Titian busy with commissions for religious paintings to be placed in the church and monastery of the Escorial.[163] Moreover, the celebrated mythological compositions or *poesie*, as the artist called them, constituted a major part of his production in the last twenty years of his life, the *Danae*, the *Venus and Adonis*, the *Diana and Actaeon*, *Diana and Callisto*, the *Rape of Europa*.[164] Philip's portraits in his later life and those of his family were made by Spanish artists such as Juan Pantoja de la Cruz and Alonso Sánchez Coello.[165]

162. See Cat. no. 81 for a full account of the confusions which became further involved in Beroqui's discussion (1946, pp. 96–97) because he had the two pictures and their histories reversed. For the reasons why neither of these pictures can be the first sketch or portrait of 1548–1549 see my text page 42 and Cat. no. L–25.

163. See Wethey, I, 1969, for the religious paintings destined for the Escorial.

164. To be studied in Wethey, III, *Titian, The Mythological and Historical Paintings*.

165. See Allende-Salazar and Sánchez Cantón, 1919; Kusche, 1964.

LATE PORTRAITS: *c.* 1555-1570

DURING these years of activity for Prince Philip and Charles V, Titian continued to work for other clients, such as *Antonio Anselmi* (Plate 158) and the important cardinal from Trent, *Cristoforo Madruzzo* (Plate 166), whose likenesses were studied a few pages back. None was finer than the memorable state portrait of *Francesco Venier*, the Doge of Venice in 1554-1556 (Plates 184-186). Then in his late sixties, Venier was so ill and weak, when he occupied the highest office of the Venetian state, that he was unable to stand without the support of two men. The Doge appears tired and weary, but the artist lifted him above purely physical ills and gave him the dignity and the splendour suitable to his office. The golden brocaded robes and the golden Doge's cap against the rose curtain present a spectacle of the sumptuous pageantry of Venetian life in all its aristocratic grandeur. To emphasize the Venetian scene Titian included a rather fantastic view of the lagoons through the window. Yet none of the buildings is recognizable, and one large structure appears to be going up in flames. Whatever the intention of this detail, the Venier portrait stands very high in any list of Titian's achievements.

Portraits of women are few throughout Titian's career in comparison with the extraordinary number of those of men. The obvious fact is that kings, princes, doges, ecclesiastics, and military leaders were the important personalities of the period. Titian's galaxy of notables inevitably reflects that fact. The women who numbered among the exceptions included the Empress Isabella (Plates 147), Queen Mary of Hungary (Plate 264), Eleanora Gonzaga della Rovere and Giulia Varano, both of them Duchesses of Urbino (Plates 70, 148), and the charming little girl Clarice Strozzi (Plates 106-108).

This very rarity of female portraits gives more prominence to certain works, and explains the identification of a few as Titian's own daughter. The most enchanting of all is the so-called *Lavinia as Bride*, in Dresden (Plates 187, 189), a lovely young girl wearing a pearl necklace and pearl earrings and carrying a small white fan. Her captivating appearance in general, her lovely young face and expression, combine with the exquisite nature of the design to make this work the most appealing of Titian's portraits of women. Neither the white satin costume nor the fan makes it certain that she was portrayed as a bride during the Renaissance. Veils and white gowns appear to have been established for brides as late as the nineteenth century. As a matter of fact Queen Mary Tudor of England wore black velvet on her marriage to Prince Philip of Spain in Winchester Cathedral in August 1554.[166] The description of the wedding in Paris of Renée of France and Ercole d'Este in 1528 reveals that she selected a mantle of purple velvet lined with ermine over a robe embroidered with gold and on her head she had a royal crown.[167] When Margherita Paleologa married Federico Gonzaga in 1531 she wore white satin embroidered with silver, a white satin cap sewn with diamonds, and numerous jewels.[168] It seems obvious that a bride could wear white in Titian's day, even though it was not

166. She was heavily bedecked with jewels. See Andrés Muñoz, *Viaje de Felipe Segundo a Inglaterra*, 1554, edition Madrid, 1877, pp. 73-74; also Mellencamp, 1969, pp. 174-177, for Renaissance bridal costumes.

167. Gardner, 1906, pp. 193-194.

168. Cartwright, 1903, edition 1926, II, p. 335; Sanuto, LV, columns 41-42.

the only possible costume. The artist's clearly sympathetic attitude toward the girl constitutes an inner psychological reason for the supposition that she is an idealization of his daughter, Lavinia, who married Cornelio Sarcinelli in 1555.

The young *Venetian Girl* (Plate 194) from the Farnese Collection, now in the gallery at Naples, has been less convincingly associated with Lavinia. In age, slenderness of body, and general physical type she is similar to, if not identical with the girl in Dresden. Because Titian was engaged in commissions for the Farnese in 1545–1546 at Rome, the Naples canvas has usually been assigned to those years. The braided arrangement of the hair of the *Venetian Girl* is very like that in the painting of the *Empress Isabella* in 1548 (Plate 147). It is, however, debatable whether such a detail of feminine styles can be so narrowly dated. At any event both are handsome pictures of young ladies and unquestionably products of Titian's art in his maturity.

Lavinia with Tray of Fruit in Berlin (Plate 191) seems reasonably to be the same model as the girl in Dresden, though less charming because of the difference in pose and in the gown of golden brocade. That Titian intended her to suggest Pomona, the Roman goddess of fruits, is entirely possible and fully in the spirit of the Renaissance. Jacopo Strada, the imperial agent, did obtain a picture of this subject from Titian in 1568, and it later passed to Emperor Rudolf II.[169]

The transformation of the Berlin girl into a *Salome* (Plate 192) is less startling than it sounds. The head of St. John the Baptist replaces the fruit upon the same silver tray, and the costume becomes rose satin with white sleeves and white veil. Thus Salome's costume is less specifically that of a fashionable Venetian girl, and her jewels are reduced in quantity. Still, it must be admitted that these pictures are essentially studies of ideal feminine beauty rather than of a goddess or a Biblical anti-heroine. The results were far less successful in the hands of one of Titian's followers when a casket, presumably for jewels (Plate 193), appears upon a similar tray. Despite the illustrious history of this item, which once belonged to the Duke of Orléans, the new version is considerably inferior to the others in the technique of drawing and painting.

The latest portrait to be associated with Titian's daughter is *Lavinia as Matron* in Dresden (Plate 188). Usually dated about 1560, when the young woman was thirty, the picture has caused considerable controversy, because she shows so little resemblance to *Lavinia as Bride* (Plate 187). The inconsistency is granted, yet such an increase in avoirdupois and her loss of youth are entirely possible after five years of marriage and the birth of five children. The slight double chin and the broadened face are indeed disappointing in contrast to the sweet charming girl of five years earlier.[170] Yet this disillusioning transformation is entirely within the realm of possibility. On the contrary, outright rejection is the only answer to a coarse picture in Vienna which also purports to represent Lavinia (Plate 197) and to be by Titian's hand.

Titian continued to paint some male portraits in the fifteen-sixties, but they were few in number. He seemed to prefer the three-quarter-length figure at this time. The body of *Fabritius Salvaresio* (inscribed 1558) (Plates 199, 203) bulks large in the picture space, while the Moorish slave and the high

169. Zimmermann, 1901, p. 850; See Cat. no. 60, lost items 1–3.
170. It must be admitted that the inscription upon the canvas representing *Lavinia as Matron* (Cat. no. 61) is not by Titian's own hand and that her identification as the artist's daughter is also somewhat hypothetical.

chest help to create scale. The costume, the slave, and the precious clock establish Salvaresio's aristo-
cratic rank, yet his personality is not especially ingratiating. On the other hand, the Negro's costume
of gold cloth and rose satin, the black apparel of Salvaresio, and the greyish background produce a
handsome pictorial effect.

A similar composition, but without the accessories, recurs in the so-called *Filippo Strozzi* in Vienna
(Plate 200). The date about 1560 is reasonable for the costume as well as for the design and the style
of the painting. Nevertheless, most critics have placed the canvas about 1540 or 1550 under the im-
pression that the man might be Filippo Strozzi (died 1538). No evidence supports that identification,
and the picture itself must be dated later. In any event the portrait does not rank among Titian's best
or even certain works.

A true masterpiece, datable 1561, next appears in the three-quarter-length *Antonio Palma* in Dresden
(Plates 204, 205). He stands with the utmost dignity in a long robe of dark blue strongly silhouetted
against a light grey wall. The recurrent theme of the open window is managed with great effective-
ness here in affording contrast to the figure and the wall. The contents of the box upon the window
sill have been interpreted both as an artist's colours and an apothecary's chemicals. If the man is an
artist, the identification of him as Antonio Palma, father of Palma il Giovane, is a reasonable one. That
would explain the prominence of the palm, which here, in the absence of a halo, surely does not
identify a saint.

A more intimate spirit characterizes the *Man with a Flute* in Detroit (Plate 201), also from these
years. The paint is thinly and softly applied, and the hands are certainly unfinished. Yet the gentle,
kindly expression of the face combines with the adroit pose to create a sympathetic, if not a powerful
work. The personality seems to be that of an intellectual rather than a professional musician.

The portrait of *Jacopo Strada* (Plates 206, 207) stands in the front rank among Titian's greatest
achievements. For dramatic action, psychological perception, and pictorial beauty it belongs in the
same category as *Paul III and His Grandsons* (Plate 127). The radiant colour of the rose-satin sleeves
and the silver fur against a black jerkin contrast brilliantly with the dark-green table cover and the
light grey-brown walls. The chestnut hair and beard as well as the blue eyes, which add further rich-
ness to the colour composition, are reminders of Strada's northern parentage. Looped four times around
his neck is a heavy gold chain with a pendant showing a helmeted head in profile, probably the sump-
tuous gift of one of Strada's royal patrons. The vertical design of the architectural background, re-
cessed three times, is unmistakably Mannerist, as is the compression of the space. Jacopo Strada, the
leading antiquarian of Europe in the mid-sixteenth century, is shown exhibiting a Roman copy of the
Aphrodite Pseliumene (Aphrodite with a necklace) of Praxiteles.[171] On the table are displayed an
antique torso and several ancient coins, which likewise refer to Strada's intellectual interests and pro-
fessional activities, together with a letter with the words: 'Al Mag^co Sig^ore il Sig^or Titian Vecellio . . .
Venezia.' In the shadow behind the Aphrodite appears another antique statuette, a draped female
figure. The books in the upper recess certainly represent some of Strada's own publications on Roman
antiquities. Boschini, in 1660,[172] celebrated this work in verse:

171. Rizzo, 1932, p. 60, pl. 89. 172. Boschini, 1660, edition 1966, p. 59.

'Ma sora el tuto quel del Antiquario
Perchè tra il beli de quel bel erario
El porta el vanto, e rende stupefati.'

Strada's portrait is an eloquent memorial to this writer, humanist, and antique dealer. His enthusiasm, energy, and dynamic nature are projected by Titian in the vivid action of the pose and in the driving determination of his glance.[173] That Titian was assisted by a pupil other than in mechanical details such as the architectural setting is most improbable. The loose-tongued Niccolò Stoppio claimed at this time that Titian was too old to hold a brush and that he left the work to his young helpers.[174] The late masterpieces of Titian's last fifteen years give the lie to that statement.

TITIAN'S SELF-PORTRAITS

TITIAN painted his own portrait at various times throughout his life, but the only surviving originals date from the late years. If the doubtful romantic theory is accepted that the severed head of St. John the Baptist is a portrait of Titian in the artist's painting of *Salome* in the Doria Pamphili Collection at Rome, then an early likeness survives. The pictorial evidence is not compelling but the hypothesis has had its champions.[175] Among the lost *Self-Portraits* two were sent to Spain, the first of them shipped to Charles V in 1550. Two years later the artist presented the Emperor another, which showed himself holding a portrait of Prince Philip.[176] This unusual specimen would have been interesting and historically valuable on two counts, both for the iconography of Titian and of the young Philip II.

The earliest surviving portrait of Titian which is securely dated is Giovanni Britto's woodcut (Plate 208). Aretino's letter of July 1550 refers to it,[177] and so far as one can judge through this medium, the artist could have been about sixty to sixty-five at that time. The master carries himself with great dignity in a composition of breadth, as he appears to be sketching with his left hand (!), but that is explained by the reversal of Titian's preparatory drawing in the print.

On the basis of Giovanni Britto's woodcut the celebrated *Self-Portrait* in Berlin (Plates 209, 213) is contemporary, c. 1550. In support of that date is Titian's beard, not yet grey and the face still strong, the

173. Niccolò Stoppio, a rival dealer, wrote letters on 29 February 1568 and 9 April 1569 to Johann Jacob Fugger in which he slandered Jacopo Strada. He wrote that Titian had called Strada 'the most solemn ignoramus that can be found' (Zimmermann, 1901, pp. 850–851). Strada's numerous literary publications (see Cat. no. 100, Biography) are overwhelming evidence to the contrary, and Stoppio must be regarded as a less successful business man, who attempted to destroy his opponent's reputation.

Pope-Hennessy (1966, pp. 145–147) accepted Stoppio's account literally. However, at this very period (letter of 28 November 1568) Titian quoted Strada's judgment about the high quality of a group of mythological pictures (fables) which he offered for sale to Maximilian II (letter of Veit von Dörnberg to the Emperor in Voltelini, 1892, p. XLVII, no. 8804).

174. Zimmermann, 1901, p. 850, i.e., Niccolò Stoppio's same letter of 29 February 1568. Stoppio mentioned Emanuel Amberger as an assistant of Titian at this time. On this evidence Panofsky (1969, pp. 80–81, note 48) suggested that Amberger may have assisted Titian with Jacopo Strada's portrait. It is also difficult to see the influence of Holbein and of an Attic stele in Titian's *Jacopo Strada*.

The closest fore-runner of the Strada portrait in general conception is surely Lorenzo Lotto's *Andrea Odoni* (1527) at Hampton Court (Berenson, *Lotto*, 1955, pl. 219).

175. Illustrated in Wethey, I, 1969, Plate 149, datable about 1515. The theory is favoured by Hourticq, 1919, p. 119; Foscari, 1935, p. 22; Panofsky, 1969, p. 43.

176. See Cat. nos. L–29, L–30.

177. Aretino, *Lettere*, edition 1957, II, pp. 340–341.

body vigorous. The later period, *c.* 1562–1566 often proposed, is explained by the very free technique, which seems to represent his latest methods.[178] Yet the canvas is certainly unfinished with only the head fully rendered. The psychological penetration of this work is memorable. Titian comes through as an elderly man of emotional profundity on whom experience has weighed heavily but who remains master of himself with unbounded intellectual capacity.

In the *Trinity* (*Gloria*), delivered to Charles V in 1554, Titian is usually thought to be the aged grey-bearded man at the right edge below the head of Philip II (Plate 178). Here the artist presented himself in the guise of a seer, possibly as a prophet, and he increased his age greatly for that reason.[179] In the same fashion Nicodemus who supports Christ's body in the Prado *Entombment* (1559) bears a general resemblance to the artist.[180] Nevertheless, the character of the Biblical patriarch predominates. On the other hand, the kneeling St. Jerome in Titian's last work, the *Pietà* (1576) in the Accademia at Venice,[181] is more strictly the master as he looked in these twilight years, in a work where he is in reality as well as figuratively the donor.

Much earlier, as donor in the picture of the *Madonna and Nursing Child with Saints Andrew and Tiziano,* his thin pale face, the long nose and grey beard already give the appearance of a truly elderly man. This painting is datable about 1560.[182] Nevertheless, Paolo Veronese made Titian look distinctly younger in his huge canvas of the *Marriage of Cana* (1563) in the Louvre at Paris. In this situation, Titian at the viola da gamba is depicted with his two fellow artists, Veronese and Tintoretto, as musicians at a well-known Biblical miracle. Therefore these are not necessarily exact likenesses of any of them, but instead romantic representations.

One of the latest of the portraits that Titian painted of himself is the half-length figure in the Prado Museum (Plate 1), holding a brush in his right hand. Here about 1565–1570, he looks pale, thin and tired, much as he does as donor in the devotional composition at Cadore and in the last *Pietà*. Gone are the strength of body and vigour of personality that came through in the Berlin portrait. Still wearing his little black cap, Titian is a wraith of a man, yet assured and dignified. Colours are limited to black and greys, while the flesh tints and the white collar provide the major contrasts.

Finally the artist appears in the *Triple Mask* or *Allegory of Prudence,*[183] where Titian, Orazio Vecellio, and Marco Vecellio (Plates 211, 212) represent old age, maturity, and youth. Titian dramatized himself by means of a rather fierce expression so unlike the resignation and serenity of the Prado canvas. For sheer technical brilliancy and for psychological revelation this triple allegorical portrait has rarely been equalled. Even in the brushwork the distinction between the three ages of man is vividly revealed. In the profile of the aged Titian at the left, the features and white beard are lightly sketched in transparent pigment, yet the rose-coloured cap holds the eye, and the weary, almost sinister expression of the old painter provides a pictorial balance and a psychological pole to the young innocent youth

178. Sometimes thought to be the picture seen by Vasari in 1566, painted four years earlier (Suida, 1935, p. 113, *c.* 1560; Valcanover, 1960, II, pl. 98, 1562; Pallucchini, 1969, p. 313, *c.* 1562); Wethey, I, 1969, Fig. 1, *c.* 1566, on the basis of the style, but this date is too late.

179. Cornelius Cort's engraving (1566) of the *Trinity* includes a different portrait of Titian in the same location. Here he wears the usual cap (Foscari, 1935, fig. 22).

180. Wethey, 1969, I, Plate 77.

181. *Loc. cit.*, Plate 136.

182. Wethey, 1969, I, Cat. no. 57, Plate 47. This picture is cited by Vasari, who visited Titian's studio at Venice in 1566 (Vasari (1568)-Milanesi, VII, p. 432).

183. The extraordinary iconography of this picture is summarized in Cat. no. 107. The presumed identifications of Orazio and Marco Vecellio were first advanced by Panofsky.

at the right: youth versus care-worn advanced age. In the centre the black-bearded face of Orazio Vecellio looks confidently ahead, strong and sure, like the growling lion beneath him. In fact, the subtle way in which each animal, the meek dog beneath Marco and the aggressive wolf beneath Titian, reflects the character above, is one of the most profoundly revealing aspects of this great masterpiece. The subdued colour is, nonetheless, glowingly rich against a dark golden background. The black hair and dark skin of the central, frontal head acts as a stabilizing force with the rose and grey of Titian's profile balanced by the blonde hair and pale skin of Marco Vecellio's profile.

A handsome drawing in the Uffizi, tentatively attributed to Titian (Plate 210), represents an elderly man holding a book in his right hand and a statuette in his raised left palm. A generally similar theme with the artist supporting a drawing block and pencil exists in copies of a lost *Self-Portrait* (Plate 273).[184] The extraordinarily high quality of the drawing merits more serious consideration than it has received. The freedom of technique is perfectly consistent with the artist's methods as a painter in his last years. Moreover, the landscape at the left conforms to a compositional device which occurs repeatedly throughout his career.

Titian's greatness as a portraitist requires no further eulogy at the conclusion of this chronological examination of his major works and a consideration of the eminent patrons who sought him out. Had he limited himself to this branch of painting, as did Frans Hals throughout his life and Van Dyck during his years in England, Titian would still rank high. Yet the Venetian master stands far above the others, if only for the universality of his art, which demonstrates a profound understanding of human character, not only in his portraiture but in his religious and mythological works as well.

184. See Cat. nos. X–92—X–94. Whether Titian ever painted an original of the double portrait, *Titian and Francesco del Zuccato* (Cat. no. X–104), is uncertain. The triple portrait at Hampton Court (Cat. no. X–103) is certainly a pastiche. For the complete list of copies and versions, many of which have passed as originals by Titian, see Cat. nos. X–92—X–102.

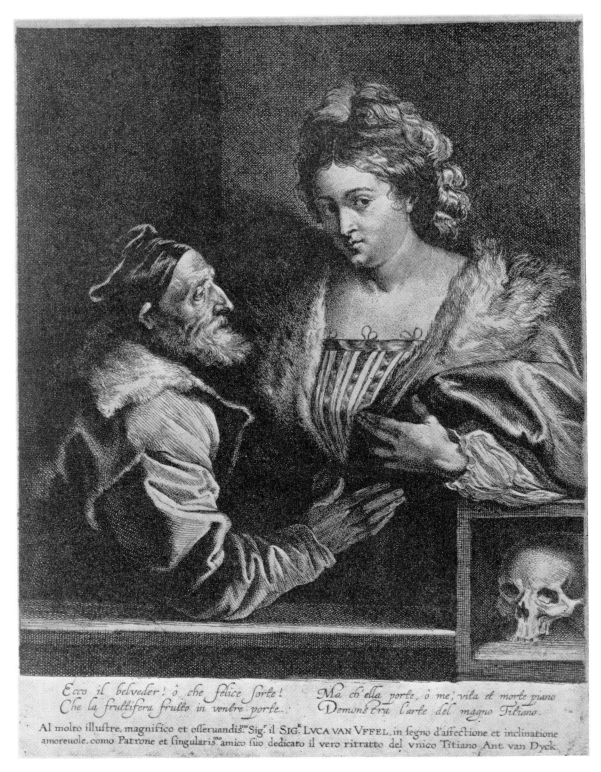

Ecco il belveder! ò che felice sorte! Ma ch'ella porte, ò me; vita et morte piano
Che la fruttifera frutto in ventre porte. Demonstra l'arte del magno Titiano.

Al molto illustre, magnifico et osseruandis.mo Sig.r il SIG.r LVCA VAN VFFEL, in segno d'affectione et inclinatione
amoreuole, como Patrone et singularis.mo amico suo dedicato il vero ritratto del vnico Titiano Ant. van Dyck.

Attributed to Sir Anthony Van Dyck: *Self-Portrait of Titian and his Mistress* (so-called). Etching.
About 1625. London, British Museum, Print Room (Cat. no. X-102)

BIBLIOGRAPHY

Gian Alberto dell'Acqua, *Tiziano*, Milan, 1955.

Gert Adriani, see: Van Dyck

Giuseppe Agnelli, 'I ritratti dell' Ariosto', *Rassegna d'arte*, XXII, 1922, pp. 82–89.

——, 'Il ritratto dell'Ariosto di Dosso Dossi', *Emporium*, LXXVII, 1933, pp. 275–282.

Duque de Alba y Berwick, *Discurso del Duque de Alba*, Madrid, Real Academia de San Fernando, 1924.

Eugenio Alberi, *Le relazioni degli ambasciatori veneti al senato*, Florence, 1839–1853.

Giuseppe Alberigo, 'Filippo Archinto', *Dizionario biografico degli italiani*, Rome, III, 1961, pp. 761–764.

——, 'Daniele Barbaro', *Dizionario biografico degli italiani*, Rome, VI, 1964, pp. 89–95.

——, 'Ludovico Beccadelli', *Dizionario biografico degli italiani*, Rome, VII, 1965, pp. 407–413.

Alcázar, Madrid Inventories (the original manuscripts are in the Archivo del Palacio, Madrid):

Inventory of Philip II (1598–1610, but mainly 1600–1602), see:

Sánchez Cantón, *Inventarios reales, bienes muebles que pertenecieron a Felipe II*, Madrid, 1956–1959, 2 vols.

Rudolf Beer, 'Inventare aus dem Archivo del Palacio', *Jahrbuch der Kunsthistorischen Sammlungen des Allerhöchsten Kaiserhauses*, Vienna, XIV, 1893, II Theil, pp. I–LXX.

Inventories of the XVII and XVIII Centuries:

Alcázar, Madrid, Inventory of 1623, unpublished manuscript, Reales oficios, legajo 26.

Alcázar, Madrid, Inventory of 1636, unpublished manuscript, folio number on every fifth page.

Alcázar, Madrid, Inventories of 1666 and 1686, see: Ives Bottineau, 'L'Alcázar de Madrid et l'inventaire de 1686', *Bulletin hispanique*, LVIII, 1956, pp. 421–452; LX, 1958, pp. 30–61, 145–179, 289–326, 451–483.

Alcázar, Madrid, Inventory of 1700 (after the death of Charles II), unpublished manuscript.

Alcázar, Madrid, Inventory of 1734 (after the destruction of the old palace by fire), unpublished manuscript.

Alcázar, Madrid, Inventory of 1747 (after the death of Philip V; the pictures were then in Buen Retiro Palace), unpublished manuscript.

Alcázar (in reality the Palacio Nuevo), Inventory of 1816 (after the Napoleonic occupation), unpublished manuscript.

Aldobrandini Collection, Rome, see:

Onofrio, 1964.

Pergola, 1960, 1962, 1963.

Federigo Alizeri, *Guida artistica per la città di Genova*, Genoa, 1846, 3 vols.

Juan Allende-Salazar and Francisco de Javier Sánchez Cantón, *Retratos del Museo del Prado*, Madrid, 1919.

Alnwick Castle, 'Catalogue of Pictures', 1930, unpublished manuscript.

See also: Newcastle-on-Tyne, 1963.

Bruto Amante, *Giulia Gonzaga, Contessa di Fondi*, Bologna, 1896.

G. E. Ambrose, *Catalogue of Pictures, the Lansdowne Collection*, London, 1897.

Ambrosiana Gallery: *Guida sommaria*, Milan, 1907; Dell'Acqua, Paredi and Vitale, *L'Ambrosiana*, Milan, 1967.

See also:

Cardinal Federico Borromeo (1625).

Galbiati, 1951.

Amsterdam: *Catalogue of Paintings, Rijksmuseum*, Amsterdam, 1960.

APC: Art Prices Current, London, I (1907–1908)–XLV (1965–1968).

Archives, see:

Alcázar, Madrid.

Archivo General, Simancas (Valladolid).

Carlo d'Arco, *Delle arti e degli artefici di Mantova*, Mantua, 1857, 2 vols.

Aretino, *Del primo (-sesto) libro de le lettere*, Paris, 1609, 6 vols.

——, *Lettere sull'arte*, edited by Ettore Camesasca and Fidenzio Pertile, Milan, 1957–1960.

——, *Poesie*, edition Lanciano, 1930, 2 vols.

See also: Innamorati, 1962.

Argote de Molina, *Biblioteca venatoria* (1582), edition Madrid, 1882.

Wart (Eduardo) Arslan, 'Giulio Licinio', Thieme-Becker, *Allgemeines Lexikon der bildenden Künstler*, XXIII, 1929, p. 194.

——, 'Un ritratto inedito di Tiziano', *Dedalo*, XI, part 2, 1930–1931, pp. 1363–1365 [*sic*].

——, *I Bassano*, Milan, 1960.

Arundel, Earl of, Collection, see:

Cust, 1911.

Hervey, 1921.

Avila y Zúñiga, *Comentario de la guerra de Alemania hecha por Carlo V . . . en el año de 1546 y 1547*, Madrid and Antwerp, 1549; also in *Biblioteca de autores españoles*, Madrid, 1852, XXI, pp. 409–449.

José M. de Azcárate, 'Noticias sobre Velázquez en la corte, *Archivo español de arte*, XXX, 1960, pp. 357–385.

Jean Babelon, 'Giannello della Torre', *Revue de l'art ancien et moderne*, XXIV, 1913, pp. 269–279.

——, *Titien*, Paris, 1950.

Nicolas Bailly (1709–1710)—Engerand, *Inventaire des tableaux du roy*, Paris, 1899.

Ludwig Baldass, 'Die Venezianer der Wiener Gemäldegalerie', *Belvedere*, V, 1924, pp. 86–96.

Ludwig Baldass, 'Ein unbekanntes Hauptwerk des Cariani', *Jahrbuch der Kunsthistorischen Sammlungen in Wien*, N.F., III, 1929, pp. 91–110.

——, 'Eine Portrait-Skizze vom jungen Tizian', *Zeitschrift für Kunstwissenschaft*, IX, 1955, pp. 193–209.

——, 'Tizian im Banne Giorgiones', *Jahrbuch der Kunst-historischen Sammlungen in Wien*, N.F. XVII, 1957, pp. 101–156.

—— and Günther Heinz, *Giorgione*, Vienna, 1964 and 1965.

Alessandro Ballarin, 'Profilo di Lamberto d'Amsterdam, Lamberto Sustris', *Arte veneta*, XVI, 1962, pp. 61–81.

——, 'Lamberto d'Amsterdam (Lamberto Sustris): le fonti e la critica', *Atti dell'Istituto Veneto di Scienze, Lettere ed Arti*, CXXI, 1962–1963, pp. 335–366.

——, 'I veneti all'esposizione, Le seizième siècle européen del Petit Palais', *Arte veneta*, XIX, 1965, pp. 238–240.

——, 'Pittura veneziana nei musei di Budapest, Praga, e Varsovia', *Arte veneta*, XXII, 1968, pp. 237–255.

——, *Tiziano*, Florence, 1968, I diamanti d'arte, no. 37.

Baltimore Exhibition: *Giorgione and his Circle*, Johns Hopkins University, 1942.

Niccolò Barbarigo, *Vita di Andrea Gritti, Doge di Venezia*, Venice, 1793.

Angel María Barcia, *Catálogo de la colección de pinturas del Sr. duque de Berwick y Alba*, Madrid, 1911.

P. M. Bardi, *Dipinti del museo d'arte di San Paolo del Brasile, esposti al palazzo reale di Milano*, Milan, 1954.

——, *Paintings from the São Paulo Museum*, New York, Metropolitan Museum of Art, 1957.

Louis Barthomieu, *Catalogue descriptif et annoté des peintures et sculptures*, Narbonne, 1923.

Adam Bartsch, *Le peintre-graveur*, Leipzig and Vienna, 1876, 21 vols.

Girolamo Baruffaldi, *Vita di Lodovico Ariosto* (1700), edition Ferrara, 1807.

Eugenio Battisti, *Rinascimento e barocco*, Rome, 1960.

E. de Beaumont, 'État de dépenses de la maison de Philippe d'Autriche', *Gazette des beaux-arts*, XXVI, 1869, I, pp. 84–89.

Rudolf Beer, 'Acten, Regesten und Inventare aus dem Archivo General zu Simancas', *Jahrbuch der Kunsthistori-schen Sammlungen des Allerhöchsten Kaiserhauses*, Vienna, XII, 1891, II Theil, pp. XCI–CCIV. See also: Alcázar.

Berthold Beinert, 'Carlos V en Mühlberg de Tiziano', *Archivo español de arte*, XIV, 1946, pp. 1–17.

Francesco Beltrame, *Tiziano Vecellio e il suo monumento*, Milan, 1853.

Pietro Bembo, *Delle lettere*, Venice, 1560, 4 vols.; also edition Verona, 1743, 5 vols (see also Giulio Coggiola).

——, *Della istoria veneziana*, Venice, 1590. Frontispiece, the Bartolozzi print after Titian.

R. H. Benson, *The Holford Collection*, London, 1924; 2nd edition, London, 1927, 2 vols.

Bernard Berenson, *Venetian Painters of the Renaissance* London, 1894 and 1906.

——, 'De quelques copies d'après des originaux perdus de Giorgione', *Gazette des beaux-arts*, 3 période, XVIII, 1897, pp. 274–278.

——, *Study and Criticism of Italian Art*, London, 1901, and later editions, 1908, 1912, 1920, 1930.

——, *North Italian Painters of the Renaissance*, London and New York, 1907.

——, *Catalogue of the John G. Johnson Collection*, Phila-delphia, 1913.

——, *Pictures in the Collection of P. A. B. Widener*, Phila-delphia, 1916.

——, 'Un portrait de Titien à Budapest', *Gazette des beaux-arts*, 5 période, XIII, 1926, pp. 153–162.

——, 'While on Tintoretto', *Festschrift für Max J. Fried-länder*, Leipzig, 1927, pp. 224–243.

——, *Italian Pictures of the Renaissance*, Oxford, 1932.

——, 'Ristudiando Tintoretto e Tiziano', *Arte veneta*, I, 1947, pp. 22–26.

——, *Lotto*, Milan, 1955.

——, *Italian Pictures of the Renaissance, Venetian School*, London, 1957, 2 vols.

——, *Italian Pictures of the Renaissance, Florentine School*, London, 1963, 2 vols.

——, *Italian Pictures of the Renaissance, Central Italian and North Italian Schools*, London, 1968.

Berlin, Staatliche Gemäldegalerie, see: Bode, 1904. Irene Kühnel-Kunze, 1931, and 1963.

Giorgio Bernardini, 'I dipinti del Museo Civico di Pavia', *Rassegna d'arte*, I, 1901, pp. 149–152.

Pedro Beroqui, 'Adiciones y correcciones al catálogo del Museo del Prado', *Boletín de la Sociedad Castellana de Excursiones*, VI, 1913–1914, pp. 466–473.

——, *El Museo del Prado. Notas para su historia*, Madrid, 1933.

——, *Tiziano en el Museo del Prado*, Madrid, 1946 (first published in a series of articles in the *Boletín de la Sociedad Española de Excursiones*, XXXIII–XXXV, 1925–1927).

A. Bertolotti, 'Speserie segrete e pubbliche di Papa Paulo III', *Atti e Memorie delle R R Deputazione di Storia Patria per le provincie dell'Emilia*, III, 1878, pp. 169–212.

——, *Artisti veneti in Roma*, Venice, 1884.

Besançon: *Besançon, le plus ancien musée de France*, Paris, 1957.

Richard J. Betts, 'Titian's Portrait of Filippo Archinto in the Johnson Collection', *Art Bulletin*, XLIX, 1967, pp. 59–61.

G. C. Bevilacqua, *Insigne pinacoteca della nobile veneta famiglia Barbarigo della Terrazza*, Venice, 1845.

Jan Bialostocki, 'The Empress Isabelle and Guillem Scrots', *Oud Holland*, LXIX, 1954, pp. 109–115.

—— and Michal Walicki, *Malarstwo Europejskie W. Zbiorach Polskich*, Krakow, 1955.

Charles Blanc, *Le trésor de la curiosité tiré des catalogues des ventes*, Paris, 1857–1858, 2 vols.

Leslie Blanch, *The Wilder Shores of Love*, New York, 1954.

E. Maurice Bloch, 'Rembrandt and the López Collection', *Gazette des beaux-arts*, VI series, XXIX, 1946, pp. 175–189.

Wilhelm Bode, *Beschreibendes Verzeichnis der Gemälde im Kaiser Friedrich Museum*, Berlin, 1904.

——, 'Portrait of a Venetian Nobleman by Giorgione in the Altman Collection', *Art in America*, I, 1913, pp. 225–234.

——, 'Venus mit dem Orgelspieler', *Amtliche Berichte Berliner Museen*, XXXIX, 1918, pp. 94–106.

Max von Boehn, *Giorgione und Palma*, Leipzig, 1908.

Ferdinando Bologna, 'Un doppio ritratto di Tiziano inedito', *Arte veneta*, XI, 1957, pp. 65–70.

——and Raffaello Causa, *Fontainebleau e la maniera italiana*, Naples, 1952.

——and G. Doria, *Mostra del ritratto storico napoletano*, Naples, 1954.

P. Filippo Bonanni [Buonanni], *Catalogo degli ordini equestri e militari*, third edition, Rome, 1724 (unpaged).

Lucien Bonaparte, *Choix de gravures à l'eau-forte d'après les peintures . . . de Lucien Bonaparte*, London, 1812.

Giuseppe Maria Bonomi, *Il quadro di Tiziano della famiglia Martinengo-Colleoni*, Bergamo, 1886.

K. G. Boon, 'Jan Vermeyen', Thieme-Becker *Künstler-lexikon*, XLIII, 1940.

Bordeaux: *La femme et l'artiste de Bellini à Picasso*, Catalogue by Gilberte Martin-Méry, Bordeaux, 1964.

Tancred Borenius, *Catalogue of the Pictures at Doughty House*, London, I, 1913.

——, 'The Venetian School in the Grand-Ducal Collection, Oldenburg', *Burlington Magazine*, XXIII, 1913, pp. 25–35.

——, *The Picture Gallery of Andrea Vendramin*, London, 1923.

——, *Catalogue . . . of Harewood House*, Oxford, 1936.

——, 'Gems of Painting', *Burlington Magazine*, LXXI, 1937, p. 41.

——, 'An Unknown Work of Titian's Last Phase', *Burlington Magazine*, LXXX–LXXXI, 1942, pp. 133–134.

——, and Lionel Cust, *Catalogue . . . of Northwick Park*, London, 1921.

Borghese Collection, see: Pergola, 1964 and 1965.

Cardinal Federico Borromeo, *Il museo del cardinale Federico Borromeo* (1625), edited by Luca Beltrami, Milan, 1909.

A. Boschetto, *Giovan Gerolamo Savoldo*, Milan, 1963.

Marco Boschini, *La carta del navegar pitoresco*, Venice, 1660; also new annotated edition by Anna Pallucchini, Venice, 1966.

——, *Le minere della pittura . . . di Venezia*, Venice, 1664.

——, *Le ricche minere della pittura*, Venice, 1674; 'Breve instruzione, Premessa a *Le ricche minere*', reprinted in Anna Pallucchini's edition of *La carta del navegar pitoresco*, Venice, 1966, pp. 701–756.

——, *I gioieli pittoreschi, virtuoso ornamento della città di Vicenza*, Venice, 1676.

Boston: Museum of Fine Arts, *Summary Catalogue of European Paintings*, Boston, 1955.

Giovanni Bottari, *Raccolta di lettere*, Rome, 1754–1773, 7 vols.; edition by Stefano Ticozzi, Milan, 1822–1825, 8 vols.; see also Gualandi.

Ives Bottineau, *L'Art de cours dans l'Espagne de Phillippe V, 1700–1746*, Bordeaux, 1960.

See also: Alcázar, Madrid, Inventories 1666, 1686.

Arturo Bovi, *L'opera di Leonardo per il monumento Sforza a Milano*, Florence, 1959.

Willelmo Braghirolli, 'Alfonso Cittadella scultore del secolo XVI', *Atti e memorie della R. Accademia Virgiliana*, 1874–1878.

——, 'Tiziano alla corte dei Gonzaga di Mantova', Mantua, 1881; estratta dagli *Atti e memorie della R. Accademia Virgiliana*, 1881.

Karl Brandi, 'Zur Ikonographie Karls V', *Kaiser Karl V*, Munich, 1941, II, pp. 416–426.

Pietro Brandolesi, *Pitture, sculture, architetture . . . di Padova*, Padua, 1795.

Brantôme (Pierre de Bourdeilles, abbé et seigneur de), *Les vies des grands capitaines*, 1604; in *Oeuvres complètes*, Paris, 1858.

Wolfgang Braunfels, 'Tizians Augsburger Kaiserbildnisse', *Kunstgeschichtliche Studien für Hans Kauffmann*, Berlin, 1956, pp. 192–207.

——, 'Tizians Allocutio des Avalos und Giulio Romano', *Studien für Otto Förster*, Cologne, 1960, pp. 108–112.

——, 'Die Inventio des Künstlers', *Festschrift Heydenreich*, Munich, 1964, pp. 20–28.

——, 'Ein Tizian nach Cranach', *Festschrift für Herbert von Einem*, Berlin, 1965, pp. 44–48.

Braunschweig: *Katalog der Fidei Kommiss Galerie des Gesamthauses Braunschweig-Lüneburg*, Hannover, 1905.

Carlo del Bravo, 'Una copia del Tiziano', *Arte veneta*, XXI, 1967, p. 223.

Otto J. Brendel, 'Borrowings from Ancient Art in Titian', *Art Bulletin*, XXXVII, 1955, pp. 113–125.

Maurice Brockwell, *Catalogue of Pictures at Doughty House*, London, III, 1915.

Bridgewater: *Catalogue of the Bridgewater and Ellesmere Collections*, London, Bridgewater House, 1907.

Mario Brunetti, 'Tiziano ritrattista di Sultani', *Rivista di Venezia*, XIV, 1935, pp. 123–124.

——, 'Una strana interpretazione del Concerto della Galleria Pitti', *Rivista di Venezia*, XIV, 1935, pp. 119–124.

——, 'Una figlia sconosciuta di Tiziano', *Rivista di Venezia*, XIV, 1935, pp. 175–184.

William Buchanan, *Memoirs of Painting*, London, 1824, 2 vols.

Budapest, Museum of Fine Arts, see:
Térey, 1924.
Pigler, 1937 and 1967.
Garas, 1965.

Buen Retiro Palace, Madrid, see: Alcázar, Madrid, 1747.

Ludwig Burchard, 'Zwei Papstbildnisse Tizians', *Jahrbuch der preuszischen Kunstsammlungen*, XLVI, 1925, pp. 121–129.

——, *Catalogus Rubens*, Amsterdam, 1933.

——, *Loan Exhibition of Works by Peter Paul Rubens*, London, Wildenstein Gallery, 1950.

W. Bürger (pseudonym of Théophile Thoré, French critic), *Trésors d'art exposés à Manchester en 1857*, Paris, 1857.

Bryson Burroughs, 'The Portrait of Alfonso d'Este by Titian', *Metropolitan Museum Bulletin*, XXII, 1927, pp. 97–101.

J. Byam Shaw, *Paintings by Old Masters at Christ Church Oxford*, London, 1967.

C. and C., see: Crowe and Cavalcaselle.

Giuseppe Cadorin, *Dello amore ai veneziani di Tiziano Vecellio delle sue case in Cadore e in Venezia*, Venice, 1833.

——, *Nota dei luoghi dove si trovano opere di Tiziano*, San Fior di Conegliano, 1885.

Luis Calandre, *El palacio del Pardo*, Madrid, 1953.

Calendar of Letters, Despatches, and State Papers, Spanish, London, IX, 1912; XI, 1916.

Maurizio Calvesi, *Le incisioni dei Carracci*, Rome, 1965.

Juan Christoval Calvete de Estrella, *Voyage de ... Don Philippe*, Brussels, 1873–1884, 5 vols.

E. Calzini, 'Tiziano e i duchi d'Urbino', *Rassegna bibliografica dell'arte italiana*, VIII, 1905, pp. 79–90.

Cambridge, Fitzwilliam Museum, see: Goodison and Robertson, 1967.

Ettore Camesasca, *Tutta la pittura di Raffaello*, Milan, 1956, 2 vols.

Camesasca and Pertile, see: Aretino, 1957–1960.

Giuseppe Campori, *Raccolta di cataloghi ed inventari inediti*, Modena, 1870.

——, 'Tiziano e gli Estensi', *Nuova Antologia*, XXVII, 1874, pp. 581–620.

Giordana Canova, *Paris Bordon*, Venice, 1964.

——, 'Note a Paris Bordon', *Arte veneta*, XIX, 1965, pp. 152–154.

Carlo Capasso, *Paolo III*, Messina, 1924, 2 vols.

Lorenzo Cardella, *Memorie storiche dei cardinali*, Rome, 1792–1797, 9 vols.

Valentín Carderera, 'Ensayo histórico sobre los retratos de hombres celebres desde el siglo XIII hasta el XVIII (1841)', published in *Boletín de la Real Academia de la Historia*, XXXIV, 1899, pp. 201–257.

Vicente Carducho, 'Diálogos de la pintura' (1633), in Sánchez Cantón, *Fuentes literarias para la historia del arte español*, II, Madrid, 1933.

Carlos V: See Charles V.

Gaspare Caro, 'Alfonso d'Avalos, Marchese del Vasto', *Dizionario biografico degli italiani*, Rome, IV, 1962.

Natale Carotti, 'Landi', *Enciclopedia italiana*, XX, 1933, pp. 491–492.

Nolfo di Carpegna, *Catalogo della quadreria di Villa d'Este a Tivoli*, Rome, c. 1955.

W. H. Carpenter, *Pictorial Notices Concerning a Memoir of Sir Anthony Van Dyck with a Descriptive Catalogue of Etchings Executed by Him*, London, 1844.

Julia Cartwright, *Isabella d'Este*, London and New York, 1903, and later editions.

——, *Beatrice d'Este*, London, 1899 and 1928.

——, *The Perfect Courtier, Baldassare Castiglione*, London, 1908 and later editions.

——, *Christina of Denmark*, New York, 1913.

Auguste Castan, 1867, see: Granvelle.

Giorgio Castelfranco, 'Tiziano', *La reforma literaria*, XV, 1936–1937, pp. 1–11 (essay on the 1935 exhibition).

Giuseppe Castellani, 'Varano', *Enciclopedia italiana*, XXXIV, Rome, 1935, pp. 989–990.

Arturo Castiglioni and Carlo Calcaterra, 'Fracastoro', *Enciclopedia italiana*, XV, 1932, pp. 829–830.

Raffaello Causa, *IV mostra di restauri, catalogo*, Naples, 1960.

——, 'Per Tiziano: un pentimento nel Paolo III con i nipoti', *Arte veneta*, XVIII, 1964, pp. 219–223.

Giovanni Battista Cavalcaselle, 'Spigolature tizianesche', *Archivio storico dell'arte*, IV, 1891, pp. 3–8.

Juan Agustín Ceán Bermúdez, *Diccionario histórico de los más ilustres profesores de las bellas artes en España*, Madrid, 1800, 6 vols.

G. F. Cecconi, *Roma sacra e moderna*, Rome, 1725.

Pico Cellini, 'Per una revisione di attribuzione a Tiziano', *Arte antica e moderna*, IV, 1961, pp. 465–469.

Charles I of England:
 See van der Doort, 1639.
 'Pictures Belonging to King Charles I at His Several Palaces, Appraised and Most of Them Sold by the Council of State. Order of March 23, 1649' (n.d., c. 1650), Manuscript no. 79A, Victoria and Albert Museum, London.
 'The Inventory of the Effects of Charles I, 1649–1652', Harley Manuscript, no. 4898, British Museum.
 'Pictures, Statues, Plate and Effects of King Charles I, 1649–1651', London, Public Records Office, no. LR 2/124.
 See also Cosnac, 1885, Appendix, 'Estat de quelques tableaux exposés en vente à la maison de Somerset May 1650', pp. 413–418.
 W. L. F. Nuttall, 'King Charles I's Pictures and the Commonwealth Sale', *Apollo*, 1965, pp. 302–309.
 R. Symonds, Diary: 'Notes on Painting', 1650–1652, British Museum, Egerton Mss., no. 1636, folio 105.
 Pictures Belonging to King Charles I (Victoria and Albert Library), c. 1660, from St. James' Palace.

Charles V, Holy Roman Emperor:
 Charles-Quint et son temps, Ghent, Musée des Beaux-Arts, 1955.
 Carlos V y su ambiente, Exposición homenaje en el IV centenario de su muerte, Toledo, 1958.
 Inventory of 1561: Rudolf Beer, 'Archivo General de Simancas', *Jahrbuch der Kunsthistorischen Sammlungen des Allerhöchsten Kaiserhauses*, Vienna, XII, 1891, II Theil, pp. CLXVI–CLXXVII.
 See also:
 Cronaca (1529–1530), edition 1892.
 Gachard, 1855.
 Pinchart, 1856.
 Foronda y Aguilera, 1914.
 Sánchez Loro, 1958.

Chatsworth:
 S. Dodsley, 'Catalogue of Pictures at Chatsworth', 1761.
 Arthur Strong, *Masterpieces in the Duke of Devonshire's Collection of Pictures*, London, 1901.
 'Catalogue of the Paintings in the Collection of the Duke of Devonshire', 1933.

Jean Chesneau, editor, *Le voyage de Monsieur d'Aramon*, Recueil de voyages, VIII, Paris, 1887.

Chicago: *Paintings in the Art Institute*, 1961.

Hugh Chisholm, 'Granvella', *Encyclopaedia Britannica*, eleventh edition, 1910, XII, pp. 361–362.

Christina, Queen of Sweden:
'Inventario della Regina Cristina', 1662–1663, Riksarkivet, Stockholm, Azzolino-samlingen, XLVIII, K441.
See also:
Geffroy, 1855.
Granberg, 1896, 1897.
Odescalchi Archives, Rome.
Stockholm, 1966.
Waterhouse, 1966.

Alphonsus Ciaconius (or Ciacconio, i.e., Alonso Chacón, 1530–1599), *Vitae et res gestae pontificum romanorum et S. R. E. Cardinalium ab initio nascentis Ecclesiae usque ad Urbanum VIII*, Rome (1601), edition 1677, 4 vols.

Ciani, *Storia del popolo cadorino*, 1856 and 1862, edition Treviso, 1940.

Emmanuel Antonio Cicogna, *Delle iscrizioni veneziane*, Venice, 1824–1853, 6 vols.

——, *Saggio di bibliografia veneziana*, Venice, 1847.

Cincinnati: *Guide to the Collections of the Cincinnati Art Museum*, 1957.

Niccolò Cipriani, *La galleria palatina nel Palazzo Pitti a Firenze, repertorio illustrato*, Florence, 1966.

Luigi Napoleone Cittadella, *Notizie . . . relative a Ferrara*, Ferrara, 1868.

Gustave Clausse, *Les Farnèses peints par le Titien*, Paris, 1905.

Cleveland: *Venetian Tradition, Catalogue of the Exhibition*, by Henry S. Francis, Cleveland Museum of Art, 1956.

Annie Cloulas, 'Charles-Quint et le Titien. Les premiers portraits d'apparat', *L'Information d'histoire de l'art*, IX, no. 5, 1964, pp. 213–221.

——, 'Le portrait de Paul III conservé a Tolède: original ou copie?', *Mélanges de la Casa de Velázquez*, II, 1966, pp. 97–102.

——, 'Documents concernant Titien conservés aux archives de Simancas', *Mélanges de la Casa de Velázquez*, III, 1967, pp. 197–288.

Giulio Coggiola, 'Per l'iconografia di Pietro Bembo', *Atti del Reale Istituto Veneto*, LXXIV (serie 8, XVII, part 2), 1914–1915, pp. 473–514.

Luigi Coletti, *All the Paintings of Giorgione*, Italian edition, Milan, 1955; English edition, New York, 1961.

C. H. Collins Baker, *Catalogue of the Petworth Collection of Pictures*, London, 1920.

——, *Catalogue of the Pictures at Hampton Court*, London, 1929.

Sir Sidney Colvin, 'A Portrait by Titian', *Burlington Magazine*, XXV, 1917, p. 87.

M. G. Constant, 'Rapport sur une mission scientifique aux archives d'Autriche et d'Espagne, *Nouvelles archives des missions scientifiques et littéraires*, Paris, XVIII, 1909, pp. 359–385.

Sir Herbert Cook, 'Three Unpublished Italian Portraits', *Burlington Magazine*, I, 1903, pp. 185–186.

——, 'The Portrait of Antonio Palma by Titian', *Burlington Magazine*, VI, 1904–1905, pp. 451–452.

——, 'The True Portrait of Laura dei Dianti by Titian', *Burlington Magazine*, VII, 1905, pp. 449–455.

——, 'Some Venetian Portraits in English Possession', *Burlington Magazine*, VIII, 1905–1906, pp. 338–344.

——, 'Notes on the Study of Titian', *Burlington Magazine*, X, 1906–1907, pp. 102–108.

——, *Giorgione*, London (1900), edition 1907.

——, 'Venetian Portraits and Some Problems', *Burlington Magazine*, XVI, 1909–1910, pp. 328–334.

——, *Reviews and Appreciations*, London, 1912.

Copenhagen: *Royal Museum of Fine Arts, Catalogue*, Copenhagen, 1951.

Couché, see: Orléans Collection.

Kenyon Cox, 'On Certain Portraits Generally Ascribed to Giorgione', *Art in America*, I, 1913, pp. 115–120.

Cronaca del soggiorno di Carlo V in Italia (1529–1530), edited by Giuseppe Romano, Milan, 1892.

Sir Joseph Archer Crowe and Giovanni Battista Cavalcaselle, *History of Painting in North Italy*, London, 1871, 2 vols.; edition London, 1912, 3 vols. (with notes by T. Borenius).

——, *Life and Times of Titian*, London, 1877, 2 vols.; edition 1881, same pagination; Italian edition, *Tiziano, La sua vita e suoi tempi*, Florence, 1877–1878, 2 vols.

——, *Raffaello*, Florence, 1882–1885.

Crozat Collection, see: Stuffmann, 1968.

Maud Cruttwell, *Guide to the Paintings in Florentine Galleries*, London, 1907.

L. Curtius, 'Zum Antikenstudium Tizians', *Archiv für Kulturgeschichte*, XXVIII, 1938, pp. 235–238.

Lionel Cust, 'Venetian Art at the New Gallery', *Magazine of Art*, XVIII, 1895, pp. 208–211.

——, 'Notes on the Collection Formed by Thomas Howard, Earl of Arundel', *Burlington Magazine*, XIX, 1911, pp. 278–286, 323–325.

Conte Tullio Dandolo, *Panorama di Firenze. La esposizione nazionale del 1861 e la Villa Demidoff a San Donato*, Milan, 1863.

Ireneo Daniele, 'Georges d'Armagnac', *Enciclopedia cattolica*, I, 1948, pp. 124–126.

Randall Davies, 'An Inventory of the Duke of Buckingham's Pictures at York House in 1635', *Burlington Magazine*, X, 1906–1907, pp. 376–382.

Hugo Debrunner, 'A Masterpiece by Lorenzo Lotto', *Burlington Magazine*, LIII, 1928, pp. 116–127.

Bernhard Degenhard, 'Zur Graphologie der Handzeichnung', *Kunstgeschichtliches Jahrbuch der Biblioteca Hertziana*, Leipzig, I, 1937, pp. 223–283.

dell'Acqua, see: Acqua.

James Dennistoun, *Memoirs of the Dukes of Urbino, 1440–1630*, London, 1851, 3 vols.; second edition (with notes by Edward Hutton), London, 1909, 3 vols.

Jean Denucé, *De Antwerpsche Konstkamers. Inventarissen . . . 16 en 17 Eeuwen*, The Hague, 1932.

Detroit:
　Catalogue of a Loan Exhibition of Paintings by Titian, Detroit, Institute of Arts, 1928.
　Catalogue of Paintings, Institute of Arts, Detroit, 1944.
　Catalogue . . . Edgar B. Whitcomb, Detroit, Institute of Arts, 1954.

Devonshire, see: Chatsworth.

G. Dionisotti, 'Pietro Bembo', *Dizionario biografico degli italiani*, Rome, VIII, 1966, pp. 133–151.

Dodsley, see: Chatsworth.

Lodovico Dolce, *Dialogo della pittura intitolado l'Aretino*, 1557, edition by Paola Barocchi, Bari, 1960, in *Trattati d'arte del Cinquecento*; edition by Mark W. Roskill, New York, 1968.

Lamberto Donati, 'Due immagini ignote di Solimano I', *Studi orientalistici in onore di Giorgio Levi della Vida*, Rome, 1956, pp. 219–233.

G. Doria and F. Bologna, *Mostra del ritratto storico napoletano, Catalogo*, Naples, 1954.

Doria-Pamphili Gallery, Rome:
　Catalogo sommario, Rome, 1967.
　See also:
　　Onofrio, 1964.
　　Pergola, 1959, 1960, 1962, 1963.
　　Torselli, 1969.

Giovanni Drei, *I Farnese. Grandezza e decadenza*, edited by G. A. Tassoni, Rome, 1954.

Dresden: *Venezianische Malerei*, Dresden, 1968 (exhibition). See also: Posse, 1930.

Dublin: Thomas MacGreevy, *Catalogue of Pictures of the Italian School*, National Gallery of Ireland, 1956.

Dulwich: *Catalogue of the Pictures*, revised by Sir Edward Cook, London, 1926.

Luitpold Dussler,' Tizian-Ausstellung in Venedig', *Zeitschrift für Kunstgeschichte*, 10, 1935, pp. 237–239.

——, *Sebastiano del Piombo*, Basle, 1942.

——, 'Review of Rodolfo Pallucchini, Tiziano', *Pantheon*, XXVIII, 1970, pp. 549–550.

Lazare Duvaux, *Livre journal* (1748–1758), Paris, 1873, edited by Louis Courajod.

Duveen Pictures in Public Collections in America, New York, 1941.

Dyck, see: Van Dyck.

George H. Edgell, 'A Recently Acquired Portrait by Titian', *Bulletin, Museum of Fine Arts*, Boston, XLI, 1943, pp. 40–42.

Patricia Egan, 'Concert Scenes in Musical Paintings of the Renaissance', *American Musicological Society*, XIV, 1961, pp. 184–195.

Herbert von Einem, 'Karl V und Titian', *Arbeitsgemeinschaft für Forschung des Landes Nordrhein Westfalen*, Heft 92, 1960, p. 22; also in *Karl V der Kaiser und seine Zeit*, Cologne 1960, pp. 67–93.

Oscar Eisenmann, *Katalog der Königlichen Gemälde-Galerie zu Cassel*, Cassel, 1888.

Giulio B. Emert, *Fonti manoscritti inedite per la storia dell'arte nel trentino*, Florence, 1939.

Enciclopedia italiana, Rome, 1929–1939, 35 vols; Appendix, 1938–1961, 5 vols.

Eduard R. V. Engerth, *Gemälde*, Kunsthistorische Sammlungen, I, *Italienische, Spanische und Französische Schulen*, Vienna, 1884; II, *Niederländische Schulen*, Vienna, 1892.

El Escorial, 1563–1963, Madrid, 1963, 2 vols.

Espasa-Calpe, *Enciclopedia universal ilustrada*, 'Diego Hurtado de Mendoza', Madrid, XXVIII, 1925, part I, pp. 754–756.

Exposition de l'Ordre de Malte, Paris, Bibliothèque Nationale, 1929.

Celso Fabbro, 'Un ritratto inedito di Tiziano', *Arte veneta*, VI, 1952, pp. 185–186.

——, 'Tiziano, i Farnese e l'Abbazia di San Pietro in Colle nel Cenedese', *Archivio storico di Belluno, Feltre e Cadore*, XXXVIII, nos. 178–179, 1967, pp. 1–18.

——, 'Documenti relativi a Tiziano nei suoi rapporti con Carlo V e Filippo II a Simancas', *Archivio storico di Belluno, Feltre e Cadore*, XXXIX, 1967, pp. 87–95.

Cornelius von Fabriczy, *Medaillen der italienischen Renaissance*, Leipzig, n.d. [c. 1900].

A. Fano, *Sperone Speroni*, Padua, 1909.

Louis Farges, 'Aramon' in *La grande encyclopédie*, Paris, 1886, 31 vols.

Farnese Inventories, see:
　Campori, 1870.
　Filangieri di Candida, 1902.
　'Fondi Farnese, Farnesiana, nos. 1176–1177', Archivio di Stato, Naples. Inventories 1626, 1651, 1668.

Elena Fasano Guarini, 'Giovan Francesco Acquaviva d'Aragona', *Dizionario biografico degli italiani*, I, Rome, 1960, pp. 192–193.

Philip Fehl, 'Realism and Classicism in the Representation of a Painful Scene: Titian's Flaying of Marsyas', *Czechoslovakia Past and Present*, The Hague, 1969, II, pp. 1387–1415.

Ferrara: *Catalogo della esposizione della pittura ferrarese del cinquecento*, Ferrara, 1933.

Pasquale Nerino Ferri, *Catalogo riassuntivo della raccolta di disegni antichi e moderni posseduti dalla R. Galleria degli Uffizi di Firenze*, Rome, 1890–1897.

Arnaldo Ferriguto, *Attraverso i misteri di Giorgione*, Castelfranco, 1933.

Cardinal Fesch: *La collection du Cardinal Fesch*, Rome, 1845, 2 vols.

C. Ffoulkes and A. Venturi, 'Il ritratto di Pietro Aretino del Tiziano', *L'Arte*, VIII, 1905, p. 386.

A. Filangieri di Candida, 'Spigolature del vero personaggio rappresentato nel preteso ritratto del Cardinal Passerini nella R. Galleria Nazionale di Napoli', *L'Arte*, IV, 1901, pp. 128–134.

——, 'La Galleria Nazionale di Napoli', *Le gallerie nazionali italiane*, V, Rome, 1902, pp. 208–354 (Farnese inventories).

Benjamin Fillon, *Inventaires des autographes et documents historiques*, Paris, 1879. 3 vols.

Giuseppe Fiocco, *Pordenone*, Padua, 1943.

——, 'Un Tiziano dimenticato?', *Arte veneta*, I, 1947, p. 293.

——, 'Il ritratto di Sperone Speroni dipinto da Tiziano', *Bollettino d'arte*, XXXIX, 1954, pp. 306–310.

Oskar Fischel, *Tizian*, Klassiker der Kunst, Stuttgart, third edition, 1907; fifth edition, 1924.

——, 'Two Unknown Portraits by Titian', *Art in America*, XIV, 1925–1926, pp. 187–195 (both wrong attributions).

Fitzwilliam Museum, Cambridge, see: Goodison and Robertson, 1967.

Florence, *Mostra del cinquecento toscano*, Palazzo Strozzi, 1940.

Florence, Pitti Gallery, see:

 Gotti, 1875.

 Cipriani, 1966.

 Francini-Ciaranfi, 1956 and 1964.

 Jahn-Rusconi, 1937.

Florence, Uffizi:

 Catalogo dei dipinti, Florence, 1927.

 Catalogo topografico illustrato, Florence, 1929–1930.

 See also:

 Ferri, 1890–1897.

 Salvini, 1964.

José M. Florit, 'Inventario de los cuadros y objetos de arte en la quinta real llamada La Ribera en Valladolid', *Boletín de la Sociedad Española de Excursiones*, XIV, 1906, pp. 153–160.

T. H. Fokker, *Catalogo sommario dei quadri della Galleria Doria Pamphili*, Rome, 1958.

Tamara Fomiciova, *Tiziano Vecellio* (in Russian), Moscow, 1960.

——, 'I dipinti di Tiziano nelle raccolte dell'Ermitage', *Arte veneta*, XXI, 1967, pp. 57–70.

Vincenzo Forcella, *Iscrizioni delle chiese e d'altri edifici di Roma*, Rome, 1869–1884, 14 vols.

Foronda y Aguilera, *Estancias y viajes del emperador Carlos V*, Madrid, 1914.

Lodovico Foscari, 'Autoritratti di maestri veneziani', *Rivista di Venezia*, XII, 1933, pp. 247–261.

——, *Iconografia di Tiziano*, Venice, 1935.

R. Foulché-Delbosc, 'Le portrait de Mendoza', *Revue hispanique*, XXIII, 1910, pp. 310–313.

Anna Maria Francini-Ciaranfi, *La Galleria Palatina (Pitti)*, Florence, 1956 and 1964.

Frankfort, see: Harris.

Frankfurt:

 Katalog der Gemäldegalerie . . . zu Frankfurt, Frankfurt, 1900.

 Städelsches Kunstinstitut, Verzeichnis der Gemälde, Frankfurt, 1966.

Sidney J. Freedberg, *Painting of the High Renaissance in Rome and Florence*, Cambridge (Mass.), 1961.

——, *Andrea del Sarto*, Cambridge, 1963.

——, *Painting in Italy, 1500–1600*, London and Baltimore, 1971.

Frank E. Washburn Freund, 'Leih-Ausstellungen in amerikanischen Museen', *Cicerone*, XX, 1928, pp. 253–258.

——, 'Paintings by Titian in America', *International Studio*, May, 1938, p. 39.

Frick Collection:

 Frick Collection, New York, 1949.

 Frick Collection, New York, 1968.

Max Friedeberg, 'Über das Konzert in Palazzo Pitti', *Zeitschrift für bildende Kunst*, N.F., XXVIII, 1917, pp. 169–176.

Gustavo Frizzoni, *Collezione di quaranta disegni scelti dalla raccolta del Senatore Giovanni Morelli*, Milan, 1886.

——, 'Serie di capolavori dell'arte italiana nuovamente illustrati', *Archivio storico dell'arte*, V, 1892, pp. 9–25.

Lili Fröhlich-Bum, 'Die Zeichnungen Tizians', *Jahrbuch der Kunsthistorischen Sammlungen in Wien*, N.F., II, 1928, pp. 194–198.

Roger E. Fry, 'Titian's Ariosto', *Burlington Magazine*, VI, 1904–1905, pp. 135–138.

——, 'Pietro Aretino by Titian', *Burlington Magazine*, VII, 1905, pp. 344–347.

——, 'La mostra di antichi dipinti alle Grafton Galleries di Londra', *Rassegna d'arte*, X, 1910, pp. 25–39.

Paola Fuchs, 'La coperta con l'Impresa d'Amore dipinta da Tiziano per il ritratto di Sperone Speroni', *Dedalo*, IX, 1928–1929, pp. 621–633.

Louis P. Gachard, *Retraite et mort de Charles Quint au monastère de Yuste*, Brussels, 1855, II, pp. 90–93 (Charles V's Inventory of 1556).

——, *Relations des ambassadeurs vénitiens sur Charles-Quint et Philippe II*, Brussels, 1855.

——, and Eugène Piot, *Collection des voyages des souverains des Pays-Bas*, Académie Royale des Sciences, des Lettres et des Beaux Arts de Belgique, Brussels, 1882, IV.

Giovanni Galbiati, *Itinerario . . . della Biblioteca Ambrosiana, della Pinacoteca*, Milan, 1951.

Rodolfo Gallo, 'Per il San Lorenzo martire di Tiziano', *Rivista di Venezia*, XIV, 1935, pp. 155–174.

P. B. Gams, *Series episcoporum*, Leipzig, 1931.

Klara Garas, *Italian Renaissance Portraits*, Budapest, 1965.

——, 'Giorgione e Giorgionismo au XVII siècle', *Bulletin du Musée Hongrois des Beaux-Arts*, no. 25, 1964, pp. 51–80; no. 28, 1966, pp. 69–93.

——, 'The Ludovisi Collection of Pictures in 1633', *Burlington Magazine*, CIX, 1967, pp. 287–289, 339–348.

Edmund G. Gardner, *The King of Court Poets, A Study of the Work, Life and Times of Lodovico Ariosto*, New York, 1906.

Giacomo Gatti, *Descrizione delle più rare cose di Bologna*, Bologna, 1803.

Giovanni Gaye, *Carteggio inedito d'artisti*, Florence, 1839–1840, 3 vols.

Auguste Geffroy, *Notices et extraits des manuscrits . . . dans les bibliothèques ou archives de Suède, Danemark et Norvège*, Paris, 1855.

Giuseppe Gerola, *Il supposto ritratto del Fracastoro dipinto dal Tiziano*, Istituto Veneto, 1910, pp. 1–9, reprint.

——, 'Madruzzo', *Enciclopedia italiana*, Rome, XXI, 1934, pp. 854–855.

Felton Gibbons, *Dosso and Battista Dossi*, Princeton, 1968.

Giacinto Gigli, *Diario Romano (1608–1670)*, published by G. Ricciotti, Rome, 1958.

Creighton Gilbert, *Major Masters of the Renaissance*, Brandeis University, Waltham, 1963.

Gaetano Giordani, *Cronaca della venuta e dimora in Bologna del Sommo Pontifice Clemente VII per la coronazione di Carlo V*, Bologna, 1842.

Paolo Giovio, *Elogia virorum bellica virtute illustrium*, edition Basel, 1575.

Bernardo Giustinian, *Historia cronologica dell'origine degl' ordini militari e di tutte le religioni cavalleresche*, Venice, 1692.

Gustav Glück, 'Original und Kopie', *Festschrift für Julius Schlosser*, Vienna, 1927, pp. 224–242.

——, 'Bildnisse aus dem Hause Habsburg',
 'I, Kaiserin Isabella', *Jahrbuch der Kunsthistorischen Sammlungen in Wien*, N.F., VII, 1933, pp. 183–210;
 'II, Königin Maria von Ungarn', *ibid.*, N.F., VIII, 1934, pp. 173–198;
 'III, Kaiser Karl V', *ibid.*, N.F., XI, 1937, pp. 165–178.

——, and August Schaeffer, *Die Gemäldegalerie. Alte Meister*, Vienna, 1907.

Ludwig Goldscheider, *Five Hundred Self-Portraits*, London, 1937.

V. Golzio, *La galleria e le collezioni della R. Accademia di San Luca*, Rome, 1939.

György Gombosi, 'Tizians Bildnis der Victoria Farnese', *Jahrbuch der preuszischen Kunstsammlung*, XLIX, 1928, pp. 55–61 (includes all data).

——, 'Il ritratto di Filippo II di Tiziano nella Galleria Corsini', *Bollettino d'arte*, serie 2, VIII, 1929, pp. 562–564.

——, *Palma Vecchio*, Klassiker der Kunst, Stuttgart-Berlin, 1937.

——, 'Über venezianische Bildnisse, *Pantheon*, XIX, 1937, pp. 102–110.

——, *Moretto da Brescia*, Basle, 1943.

Angel González Palencia and Eugenio Mele, *Vida y obras de Don Diego Hurtado de Mendoza*, Madrid, 1941–1943, 3 vols.

J. W. Goodison and G. H. Robertson, *Catalogue of Paintings*, Fitzwilliam Museum, Cambridge, 1967.

St. John Gore, 'Five Portraits', *Burlington Magazine*, C, 1958, pp. 351–352.

——, 'Pictures in National Trust Houses', *Burlington Magazine*, CXI, 1969, pp. 238–258.

Aurelio Gotti, *Le gallerie e i musei di Firenze, discorso storico*, Florence, 1875, pp. 382–386: inventory of pictures brought from Urbino to Florence in 1631.

Cecil Gould, *The Sixteenth-Century Venetian School*, London, National Gallery, 1959.

——, 'The Lady at the Parapet', *Burlington Magazine*, 103, 1961, pp. 335–340.

——, 'Lorenzo Lotto and the Double Portrait', *Saggi e memorie di storia dell'arte*, Venice, V, 1966, pp. 45–51.

——, *Titian*, London, 1969.

——, *Raphael's Portrait of Pope Julius II*, London, National Gallery, 1970.

——, 'The Raphael Portrait of Julius II', *Apollo*, 92, no. 103, 1970, pp. 187–189.

Olaf Granberg, *La galerie de tableaux de la Reine Christina de Suède*, Stockholm, 1897; also Swedish edition, Stockholm, 1896.

——, *Inventaire général des trésors d'art en Suède*, Stockholm, 1911–1913, 3 vols.

Granvelle:
 Papiers d'Etat du Cardinal Granvelle, Paris, 1843, IV, p. 150.
 Auguste Castan, 'Monographie du Palais Granvelle à Besançon (with inventory)', *Mémoires de la Société d'Emulation de Doubs*, 4 série, II, 1867 (i.e. 1866), pp. 109–139.
 Letters of Granvelle, see: Zarco del Valle, 1888.
 See also:
 Levêque, 1753.
 Chisholm, 1910.

Algernon Graves, *A Century of Loan Exhibitions, 1813–1912*, London, 1914, III.

——, *Art Sales*, London, 1921, 3 vols.

Padre Gregorio de Andrés, 'La biblioteca de don Diego Hurtado de Mendoza', *Documentos para la historia del monasterio de San Lorenzo el Real de El Escorial*, Madrid, 1964, pp. 237–401.

Ferdinand Gregorovius, 'Alcuni cenni storici sulla cittadinanza romana', *Atti della Reale Accademia dei Lincei, Memorie della classe di scienze morali, storiche e filologiache*, serie III, I, 1877, pp. 314–346.

George Gronau, 'L'art vénitien à Londres à propos de l'exposition de la New Gallery', *Gazette des beaux-arts*, 3 période, XIII, 1895, pp. 427–440.

——, 'Tizians Bildnisse türkischer Sultaninnen', *Beiträge zur Kunstgeschichte F. Wickhoff gewidmet*, Vienna, 1903, pp. 132–137.

——, 'Titian's Portrait of the Empress Isabella', *Burlington Magazine*, II, 1903, pp. 281–285.

——, *Titian*, English edition, London, 1904.

——, 'Die Kunstbestrebungen der Herzöge von Urbino', *Jahrbuch der königlich preuszischen Kunstsammlungen*, XXV, 1904, Beiheft, pp. 1–33. Italian edition: *Documenti artistici urbinati*, Florence, 1936, pp. 1–8, 85–113. Extract of the Inventory of 1631 also published earlier: see Gotti, 1875.

——, 'Tizians Bildnis des Pietro Aretino in London', *Zeitschrift für bildende Kunst*, N.F., XVI, 1905, pp. 294–296.

——, 'Il ritratto di Giovanni delle Bande Nere attribuito a Tiziano', *Rivista d'arte*, III, 1905, pp. 135–141.

——, 'Zwei Tizianische Bildnisse der Berliner Galerie: I, Das Bildnis des Ranuccio Farnese; II, Das Bildnis der Tochter des Roberto Strozzi', *Jahrbuch der königlich preuszischen Kunstsammlungen*, Berlin, XXVII, 1906, pp. 3–12.

——, 'Di due quadri del Tiziano poco conosciuti', *Rassegna d'arte*, VII, 1907, pp. 135–136.

——, 'Tizians Selbstbildnis in der Berliner Galerie', *Jahrbuch der königlich preuszischen Kunstsammlungen*, Berlin, XXVIII, 1907, pp. 45–49.

George Gronau, 'Kritische Studien zu Giorgione', *Repertorium für Kunstwissenschaft*, XXXI, 1908, pp. 403–426, 503–521.

——, 'Giorgione', Thieme-Becker, *Künstler-Lexikon*, XIV, 1921, pp. 86–90.

——, 'Über einige unbekannte Bildnisse von Tizian', *Zeitschrift für bildende Kunst*, N.F. XXXIII, 1922, pp. 60–68.

——, 'Concerning Titian's Picture at Alnwick Castle', *Apollo*, II, no. 9, 1925, pp. 126–127.

——, 'Alfonso d'Este und Tizian', *Jahrbuch der Kunsthistorischen Sammlungen in Wien*, N.F., II, 1928, pp. 233–246 (with documents).

——, 'Über ein Jugendbildnis der Kardinals Alessandro Farnese', *Cicerone*, XXI, 1929, pp. 41–48.

——, in W. R. Valentiner, *Das unbekannte Meisterwerk*, Berlin, 1930.

——, 'Gian Paolo Pace', Thieme-Becker, *Künstler-Lexikon*, XXVI, 1932, p. 117.

——, 'Un ritratto del Duca Guidobaldo di Urbino dipinto da Tiziano', *Miscellanea di storia dell'arte in onore de I. B. Supino*, Florence, 1933, pp. 487–495.

——, 'Titian's Ariosto', *Burlington Magazine*, LXIII, 1933, pp. 194–203.

——, 'Some Portraits by Titian and Raphael', *Art in America*, XXV, 1937, pp. 93–104.

Lucio Grossato, *Affreschi del cinquecento in Padova*, Milan, 1966.

Orlando Grosso, *Catalogo delle gallerie di Palazzo Rosso, della pinacoteca di Palazzo Bianco e delle collezioni di Palazzo Comunale*, Genoa, 1931.

Michelangelo Gualandi, *Nuova raccolta di lettere*, Bologna, 1844–1856, 3 vols.

Camillo Guerrieri-Crocetti, 'Sperone Speroni', *Enciclopedia italiana*, XXXII, 1936, p. 343.

Guida sommaria . . . della Biblioteca Ambrosiana, Milan, 1907.

Jean Guiffrey, 'Collection de M. le baron de Schlichting', *Les Arts*, no. 50, February, 1906.

Detlev von Hadeln, 'Zum Datum der Bella Tizians', *Repertorium für Kunstwissenschaft*, XXXII, 1909, pp. 69–71.

——, 'Tizians Bildnis des Dogen Niccolò Marcello in der Pinakothek des Vatikans', *Repertorium für Kunstwissenschaft*, XXXIII, 1910, pp. 101–106.

——, 'Tizians Bildnis der Laura dei Dianti in Modena', *Münchner Jahrbuch*, VI, 1911, pp. 65–72.

——, 'Beiträge zur Tintorettoforschung', *Jahrbuch der königlich preuszischen Kunstsammlungen*, Berlin, XXXII, 1911, pp. 25–58.

——, 'Domenico Campagnola', Thieme-Becker, *Allgemeines Lexikon der bildenden Künstler*, V, 1911, pp. 449–451.

——, 'Damiano Mazza', *Zeitschrift für bildende Kunst*, N.F., XXIV, 1912–1913, pp. 249–254.

——, 'Über Zeichnungen der früheren Zeit Tizians', *Jahrbuch der königlich preuszischen Kunstsammlungen*, Berlin, XXXIV, 1913, pp. 224–250.

——, Review of Hetzer's *Die frühen Gemälde*, in *Kunstchronik*, N.F., XXXI, 1920, pp. 931–934.

——, *Zeichnungen des Tizian*, Berlin, 1924.

——, 'Some Little-Known Works by Titian', *Burlington Magazine*, XLV, 1924, pp. 179–181.

——, *Venezianische Zeichnungen der Hochrenaissance*, Berlin, 1925.

——, 'An Unknown Titian Portrait', *Burlington Magazine*, XLIX, 1926, p. 234.

——, *Titian's Drawings*, London, 1927.

——, 'Two Unknown Works by Titian', *Burlington Magazine*, LIII, 1928, pp. 55–56 (both are forgeries).

——, 'Ein Gruppenbildnis von Tizian', *Pantheon*, III, January 1929, pp. 10–12, illustration.

——, 'Dogenbildnisse von Tizian', *Pantheon*, VI, 1930, pp. 489–494.

——, 'Das Problem der Lavinia Bildnisse', *Pantheon*, VII, 1931, pp. 82–87.

——, 'Tizians Bildnis des Giovanni Francesco Acquaviva', *Pantheon*, XIII, 1934, pp. 16–17.

Maurice Hamel, 'Le portrait d'Isabelle d'Este', *Gazette des beaux-arts*, 3 période, XXIX, 1903, pp. 104–106.

Harley Manuscript, no. 4898, London, British Museum, 'The Inventory of the Effects of Charles I, 1649–1652'.

Enriqueta Harris (Frankfort), 'Cassiano del Pozzo on Diego Velázquez', *Burlington Magazine*, CXII, 1970, pp. 364–373.

G. Hartlaub, *Giorgiones Geheimnis*, Munich, 1925.

Frederick Hartt, *Giulio Romano*, New Haven, 1958, 2 vols.

Francis Haskell, *Patrons and Painters*, New York, 1963.

Louis Hautecoeur, *Ecole italienne et école espagnole*, Musée National du Louvre, Paris, 1926.

Walter Heil, 'A Portrait by Titian', *Bulletin, Detroit Institute of Arts*, IX, no. 1, 1927, pp. 14–15.

Fritz Heinemann, *Tizian*, Munich, dissertation, 1928.

——, *Giovanni Bellini e i Belliniani*, Venice, 1962, 2 vols.

——, 'Die Ausstellung venezianischer Kunst in Stockholm', *Kunstchronik*, XVI, 1963, pp. 61–68.

——, 'Über unbekannte oder wenig bekannte Werke Tizians', *Arte veneta*, XXI, 1967, pp. 210–213.

Rudolf Heinemann, *Sammlung Schloss Rohonz*, Lugano, 1958.

Julius S. Held, 'Flora, Goddess and Courtesan', *Essays in Honor of Erwin Panofsky*, New York, 1961, pp. 201–218.

Philip Hendy, *Some Italian Renaissance Pictures in the Thyssen-Bornemisza Collection*, Lugano, 1964.

Federico Hermanin, *Il mito di Giorgione*, Spoleto, 1933.

Mary F. S. Hervey, *The Life, Correspondence and Collections of Thomas Howard, Earl of Arundel*, Cambridge, England, 1921.

Erich Herzog, *Die Gemäldegalerie der staatlichen Kunstsammlungen Kassel*, Cassel, 1969.

Theodor Hetzer, *Die frühen Gemälde Tizians*, Basel, 1920.

——, 'Vecellio, Tiziano', Thieme-Becker *Künstler-Lexikon*, XXXIV, 1940, pp. 158–171.

——, *Tizian. Geschichte seiner Farbe*, Frankfurt, 1948.

——, 'Tizians Bildnisse', *Aufsätze und Vorträge*, Leipzig, 1957, I, pp. 43–74.

G. F. Hill, *Medals of the Renaissance*, Oxford, 1920.

G. F. Hill and Graham Pollard, *Renaissance Medals from the Samuel H. Kress Collection at the National Gallery of Art*, London, 1967.

Juliana Hill, 'An Identification of Titian's Allegory of Prudence', *Apollo*, XIII, 1956, pp. 40–41.

Arthur Hind, *Van Dyck, His Original Etchings and His Iconography*, Boston, 1915.

——, *Print Collectors Quarterly*, V, 1915, pp. 3–36.

Ursula Hoff, *Catalogue of European Paintings Before Eighteen Hundred*, Melbourne, 1961.

Cornelius Hofstede de Groot, *Die Urkunden über Rembrandt, Quellen-Studien*, III, 1906, pp. 116–118.

W. H. Hollstein, *Dutch and Flemish Engravings and Woodcuts*, Amsterdam, 1949.

Sir Charles Holmes, 'The School of Giorgione at the Grafton Galleries', *Burlington Magazine*, XVI, 1909–1910, pp. 72–74.

——, 'La Schiavona by Titian', *Burlington Magazine*, XXVI, 1914–1915, pp. 15–16.

——, 'The Inscription upon Titian's Portrait of Franceschi', *Burlington Magazine*, LV, 1929, pp. 159–160.

Niels von Holst, 'La pittura veneziana tra il Reno e la Neva', *Arte veneta*, V, 1951, pp. 131–140.

G. J. Hoogewerff and J. Q. van Regteren Altena, *Arnoldus Buchelius Res Pictoriae, Quellenstudien*, XV, The Hague, 1928.

Louis Hourticq, *La jeunesse de Titien*, Paris, 1919.

——, *Le problème de Giorgione*, Paris, 1930.

Thomas C. Howe, 'Two Paintings by Titian', *Bulletin of the California Palace of the Legion of Honor*, V, 1947, pp. 34–39.

R. H. Hubbard, *European Paintings in Canadian Collections*, Toronto, 1956.

——, *Catalogue of Paintings and Sculpture*, The National Gallery of Canada, Ottawa, 1957.

Sir Abraham Hume, *Notices of the Life and Times of Titian*, London, 1829.

John Hunt, 'Jeweled Neck Furs . . .', *Pantheon*, XXXI, 1963, pp. 151–157.

Diego Hurtado de Mendoza, *Algunas cartas escritas 1538–1552*, edited by Alberto Vázquez and R. Seldon Rose, New Haven, 1935.

Indianapolis: *Paintings from the Collection of G. H. A. Clowes*, Memorial Exhibition, John Herron Art Museum, Indianapolis, 1959.

G. Innamorati, 'Pietro Aretino', *Dizionario biografico degli italiani*, IV, 1962, pp. 89–104.

Emil Jacobs, 'Das Museum Vendramin und die Sammlung Reynst', *Repertorium für Kunstwissenschaft*, 46, 1925, pp. 15–38.

Michael Jaffé, 'The Dukes of Devonshire', in Douglas Cooper, *Great Family Collections*, London and New York, 1965.

——, 'The Picture of the Secretary of Titian', *Burlington Magazine*, CVIII, 1966, pp. 114–126.

A. Jahn-Rusconi, *La Reale Galleria Pitti*, Rome, 1937.

Anna Jameson, *Companion . . . to Celebrated Private Galleries*, London, 1844.

Marianna Jenkins, *The State Portrait*, New York, College Art Association, 1947.

Princess Juana, Inventory, 1573: 'Inventarios de la Infanta Juana', *Memorias de la Real Academia Española*, XI, 1914, pp. 315–380.

Philippe Jullian, 'La fausse abbaye de Fonthill et les collections de l'extravagant William Beckford, *Connaissance des Arts*, March, 1963, pp. 94–103.

Karl Justi, 'Verzeichnis der früher in Spanien befindlichen jetzt verschollenen oder ins Ausland gekommenen Gemälde Tizians', *Jahrbuch der königlich preuszischen Kunstsammlungen*, Berlin, X, 1889, pp. 181–186 (an out-of-date and incomplete account).

——, 'Das Tizianbildnis des Königlichen Galerie zu Cassel', *Jahrbuch der königlich preuszischen Kunstsammlungen*, Berlin, XV, 1894, pp. 160–174.

——, 'Die Bildnisse des Kardinal Hippolyt von Medici in Florence', *Zeitschrift für bildende Kunst*, N.F., VIII, 1897, pp. 34–40.

——, *Miscellaneen aus drei Jahrhunderten*, Berlin, 1908.

Ludwig Justi, *Giorgione*, Berlin, editions 1908 and 1926, 2 vols.

Madlyn Kahr, 'Titian, The Hypnerotomachia Poliphili Woodcuts and Antiquity', *Gazette des beaux-arts*, 6 période, LXVII, 1966, pp. 119–127.

Kansas City: *Handbook of the Collection of the William Rockhill Nelson Gallery of Art*, Kansas City, 1959.

Harald Keller, *Tizians Poesie für König Philip II von Spanien*, Wiesbaden, 1969.

Francis M. Kelley, 'Note on an Italian Portrait at Doughty House', *Burlington Magazine*, LXXV, 1939, pp. 75–77.

Hayward Keniston, *Francisco de los Cobos, Secretary to the Emperor Charles V*, Pittsburgh, 1959.

Ruth W. Kennedy, 'Tiziano in Roma', *Il mondo antico nel Rinascimento*, Florence, 1956 [published 1958,] pp. 237–243.

——, *Novelty and Tradition in Titian's Art*, Northampton, 1963.

——, 'Apelles Redivivus', *Essays in Memory of Karl Lehmann*, New York, 1964, pp. 160–170.

Friedrich Kenner, 'Die Portratsammlung des Erzherzogs Ferdinand von Tirol', *Jahrbuch der Kunsthistorischen Sammlungen des Allerhöchstens Kaiserhauses*, XIX, 1898, pp. 6–146.

Friderike Klauner, 'Spanische Porträts des 16. Jahrhunderts', *Jahrbuch der Kunsthistorischen Sammlungen in Wien*, N.F., XXI, 1961, pp. 123–158.

——, and Vinzenz Oberhammer, *Katalog der Gemäldegalerie*, Teil I, Vienna, 1960.

——, V. Oberhammer, and G. Heinz, *Neuerworben 1955 bis 1966*, Vienna, 1966.

See also: Oberhammer.

Hermann Knackfuss, *Tizian*, Leipzig, 1921.

Kress Collection: *Kress Collection, Paintings and Sculpture*, Washington, National Gallery of Art, 1959 (illustrations only).

See also:
 Suida and Shapley, 1956.
 Shapley, 1968.

Irene Kühnel-Kunze, Staatliche Museen, Berlin, *Die Gemäldegalerie, Die italienischen Meister, 16. bis 18. Jahrhundert*, Berlin, 1931.

——, *Verzeichnis der ausgestellten Gemälde des 13. bis 18. Jahrhunderts im Museum Dahlem*, Berlin, 1963.

Maria Kusche, *Juan Pantoja de la Cruz*, Madrid, 1964.

Lacroix, 1855, see: Rubens.

Georges Lafenestre, *La vie et l'oeuvre de Titien*, Paris, 1886; later edition, Paris, n.d., 1907 or 1909.

——, 'Les portraits des Madruzzi par Titien et G. B. Moroni', *Revue de l'art ancien et moderne*, XXI, 1907, pp. 351–360.

——, and Eugène Richtenberger, *La peinture en Europe, Venise*, Paris, c. 1910.

Sir Joseph Larmor, 'Francis I', *Encyclopaedia Britannica*, eleventh edition, 1910, IX, pp. 934–935.

Jan Lauts, *Isabella d'Este*, Hamburg, 1952.

Victor Lazareff, 'Ein Bildnis des Vincenzo Cappello von Tintoretto', *Jahrbuch der preuszischen Kunstsammlungen*, XLIV, 1923, pp. 172–177.

Alfonso Lazzari, 'Il ritratto del Mosti di Tiziano nella Galleria Pitti', *Arte veneta*, VI, 1952, pp. 173–175.

Leganés: 'La gran colección de pinturas del Marqués de Leganés', edited by José López Navio, *Analecta calasanctiana*, Madrid, no. 8, 1962, pp. 261–330.

Leningrad, Hermitage: *Catalogue of Paintings* (in Russian), Leningrad, 1958.
 See also:
 Somof, 1899.
 Liphart, 1912.

Antonio de León Pinelo, *Anales de Madrid reinado de Felipe III, años 1598 a 1621*, edition 1931.

Pompeo Leoni: Marqués de Saltillo, 'La herencia de Pompeyo Leoni', *Boletín de la Sociedad Española de Excursiones*, XLII, 1934, pp. 95–121.
 See also: Plon, 1887.

Archduke Leopold Wilhelm, 'Inventar', 1659, published by Adolf Berger, *Jahrbuch der Kunsthistorischen Sammlungen des Allerhöchsten Kaiserhauses*, Vienna, I, 1883, II Theil, pp. LXXXVI–CXIV.

François B. Lépicié, *Catalogue raisonné des tableaux du roy*, Paris, 1752–1754, 2 vols.

Pierre Levêque, *Mémoires pour servir à l'histoire du Cardinal de Granvelle*, Paris, 1753.

Cesare A. Levi, *Le collezioni veneziane*, Venice, 1900.

Alphons Lhotsky, *Festschrift des Kunsthistorischen Museums zur Feier des fünfzigjährigen Bestandes*, Zweiter Teil, *Die Geschichte der Sammlungen*, Vienna, 1941–1945, 2 vols. (with continuous paging).

E. de Liphart, *Il catalogo delle gallerie imperiali dell' Ermitage*, St. Petersburg, 1912.

Gian Giuseppe Liruti, *Notizie delle vite e opere scritte da litterati da Friuli*, Venice, 1762.

Conte Pompeo Litta and Passerin, *Celebri famiglie italiane*, Milan, 1819–1923, 16 vols.

Kurt Löcher, *Jakob Seisenegger*, Linz, 1962.

Charles Loeser, 'Tiziano e Tintoretto'; in *I disegni degli Uffizi in Firenze*, Florence, 1922, vol. I (in 10 volumes, directed by Giovanni Paggi).

Giovanni Paolo Lomazzo, *Trattato dell'arte de la pittura*, Milan, 1584 (photographic reprint, Hildesheim, 1968).

London:
 Catalogue of the Pictures at Grosvenor House, London, 1913.
 Exhibition of Italian Art, Royal Academy, 1930.
 Exhibition of Works by Holbein and Other Masters of the Sixteenth Century, Royal Academy, 1950–1951.
 Flemish Art 1300–1700, Royal Academy, 1953–1954.

Roberto Longhi, 'Giunte a Tiziano', *L'Arte*, XXVIII, 1925, pp. 40–45; reprinted in *Saggi e ricerche, 1925–1928*, Florence, 1967, pp. 9–18.

——, 'Cartella Tizianesca', *Vita artistica*, II, 1927, pp. 216–226; reprinted in *Saggi e ricerche, 1925–1928*, Florence, 1967, pp. 233–244.

——, *Precisioni nelle gallerie italiane*, Rome, 1928.

——, *Viatico per cinque secoli di pittura veneziana*, Florence, 1946.

——, *Officina ferrarese*, Florence, 1956.

——, 'Tiziano: Tre ritratti', *Paragone*, no. 215, 1968, pp. 58–64.

L. Loostrøm, *Konstsamlingarna, På Säfstaholm*, 1882.

Juan José López Sedano, *El parnaso español*, Madrid, 1768–1778, 9 vols.

Manuel Lorente Junquera, 'Il ritratto del connestabile di Borbone di Tiziano', *Arte veneta*, VII, 1953, pp. 164–166.

Giovanni Battista Lorenzi, *Monumenti per servire alla storia del Palazzo Ducale di Venezia*, Venice, 1868.

Louvre Museum, see:
 Villot, 1874.
 Bailly-Engerand, 1899.
 Hautecoeur, 1926.

Lovere: *Catalogo dei quadri*, Accademia Tadini, Lovere, 1929.

Ludovisi Collection, see: Garas, 1967.

Frits Lugt, *Les dessins italiens dans les collections hollandais*, Paris, 1962.

Alessandro Luzio, 'Federico Gonzaga ostaggio alla corte di Giulio II', *Archivio della Real Società Romana di Storia Patria*, IX, 1886, pp. 509–582.

——, 'Arte retrospettiva: i ritratti d'Isabella d'Este', *Emporium*, XI, 1900, pp. 344–359, 427–441; expanded in *La galleria dei Gonzaga*, Milan, 1913.

——, *La galleria dei Gonzaga*, Milan, 1913.

John Lynch, *Spain under the Hapsburgs*, Oxford and New York, 1964.

Madrazo: *Catálogo de la galería de cuadros del Excm. Sr. D. José de Madrazo*, Madrid, 1856.

Pedro de Madrazo, *Catálogo de los cuadros del Real Museo de Pintura*, Madrid, 1843; editions 1854, 1872, 1873, and 1910.

——, *Viaje artístico de tres siglos por las colecciones de cuadros de los reyes de España*, Barcelona, 1884.

Madrid, see:
 Alcázar
 Madrazo
 Prado Museum
 Sánchez Cantón

Karl Madsen, 'Købet af an Tizian', *Samleren*, III, 1926, pp. 133–139.

Denis Mahon, 'Notes on the Dutch Gift to Charles II', *Burlington Magazine*, XCI, 1949, pp. 303–305, 349–350; XCII, 1950, pp. 12–18, 238.

Francesco Malaguzzi-Valeri, 'Un quadro di Tiziano', *Rassegna d'arte*, I, 1901–1902, pp. 41–43.

——, 'Un intéressant portrait de Charles-Quint', *Gazette des beaux-arts*, 4 période VII, 1912, pp. 237–239.

Vittorio Malamani, *Memorie del Conte Leopoldo Cicognara*, Venice, 1888, 2 vols.

Malta: *The Order of St. John of Malta with an Exhibition of Paintings by Mattia Preti*, Valetta, 1970.

Carlo Cesare Malvasia, *Felsina pittrice*, Bologna, 1678, 2 vols.

Manchester:
 European Old Masters, Manchester City Art Gallery, 1957.
 Between Renaissance and Baroque: European Art 1520–1600, Manchester, 1965.
 See also Bürger, 1857.

Conte Fabio di Maniago, *Storia delle arti friulane*, Venice, 1819.

Bertina Suida Manning, 'Titian, Veronese, and Tintoretto in the Collection of Walter B. Chrysler, Jr.', *Arte veneta*, XVI, 1962, pp. 49–60.

Conte Francesco di Manzano, *Annali del Friuli*, vol. VII, 1879.

Gregorio Marañon, *Antonio Pérez*, Madrid, 1948, 2 vols.

Henri Marceau and Barbara Sweeney, *John G. Johnson Collection, Catalogue of Italian Painting*, Philadelphia, 1966.

'Margaret of Austria', *Encyclopaedia Britannica*, eleventh edition, 1910, XVII, pp. 703–704.

Giovanni Mariacher, 'Il ritratto di Francesco I di Tiziano per la corte di Urbino', *Pantheon*, XXI, 1963, pp. 210–221.

——, *Palma il Vecchio*, Milan, 1968.

P. J. Mariette, 'Abecedario ... Titien Vecelli' (1720), *Archives de l'art français*, Paris, X, 1858–1859, pp. 301–340.

Guillaume de Marillac (d. 1573) and Antoine de Laval (d. 1631), 'Vie du Connetable Charles de Bourbon', in *Choix de chroniques et de mémoires*, Paris, 1836, pp. 124–184; ['Sac de Rome', par Jacques Buonaparte, *ibid.*, pp. 185–215 (sixteenth-century account)].

Paul Martin, *Arms and Armour from the 9th to the 17th Century*, English edition, Rutland, 1968.

Domenico Martinelli, *Il ritratto di Venezia*, Venice, 1684 (based on Boschini).

Jusepe Martínez, 'Discursos praticables' (1675) in Sánchez Cantón, *Fuentes literarias para la historia del arte español*, II, Madrid, 1934.

Alberto Martini, 'Spigolature venete', *Arte veneta*, XI, 1957, pp. 53–64.

Mary of Hungary (sister of Charles V), Inventories:
 Brussels Inventory 1556: Alexander Pinchart, 'Tableaux et sculptures de Marie d'Autriche reine douairière de Hongrie', *Revue universelle des arts*, III, 1856, pp. 127–146.
 Cigales Inventory 1558: Present number at Simancas, Legajo 1017, folios 143V–145V, dated Cigales, 19 octubre 1558; published by Rudolf Beer, 'Acten, Regesten und Inventare aus dem Archivo General de Simancas', *Jahrbuch der Kunsthistorischen Sammlungen des Allerhöchsten Kaiserhauses*, Vienna, XII, 1891, II Theil, pp. CLVIII–CLXIV; the section relating to portraits published by Claudio Pérez Gredilla in *Revista de archivos, bibliotecas y museos*, VII, 1877, pp. 250–252.

Frank J. Mather, Jr., 'An Exhibition of Venetian Paintings', *The Arts*, X, 1926, p. 312.

——, 'An Enigmatic Venetian Picture at Detroit', *Art Bulletin*, IX, 1926, pp. 70–75.

——, *Venetian Painters*, New York, 1936.

——, 'When was Titian Born?', *Art Bulletin*, XX, 1938, pp. 13–25.

E. Mauceri, *La regia pinacoteca di Bologna*, 1935, p. 166.

Fabio Mauroner, *Le incisioni di Tiziano*, Venice, 1941.

August L. Mayer, 'Bildnis des Herzogs Federigo II von Mantua', *Die Galerien Europas*, VIII, 1913, p. 574.

——, 'Zwei unbekannte Gemälde aus Tizians Spätzeit', *Belvedere*, V, 1924, pp. 184–185.

——, 'Tizianstudien', *Münchner Jahrbuch*, II, 1925, pp. 267–268.

——, *El Greco*, Munich, 1926.

——, 'An Unknown Portrait of Titian's Middle Period', *Apollo*, III, 1926, pp. 63–64.

——, 'Versteigerung der Sammlung von Heyl', *Pantheon*, VI, 1930, p. 482.

——, 'Ein unbekanntes Doppelporträt von Tizian', *Pantheon*, VIII, 1931, p. 346.

——, 'Zur Giorgione-Tizian Frage', *Pantheon*, X, 1932, pp. 369–380.

——, 'Anotaciones a algunos cuadros del Museo del Prado', *Boletín de la Sociedad Español de Excursiones*, XLII, 1934, pp. 291–299.

——, 'A propos d'un nouveau livre sur le Titien', *Gazette des beaux-arts*, 6 période, XVIII, 1937, pp. 304–311.

——, 'Two Pictures by Titian in the Escorial', *Burlington Magazine*, LXXI, 1937, p. 178.

——, 'Beiträge zu Tizian', *Critica d'arte*, III, 1938, pp. 30–32.

——, 'Quelques notes sur l'oeuvre de Titien', *Gazette des beaux-arts*, 6 période, XX, 1938, pp. 289–308.

Richard B. K. McLanathan, 'Dipinti veneziani acquistati negli ultimi anni dal Museo di Belle Arti di Boston', *Arte veneta*, IV, 1950, pp. 162–164.

Christian von Mechel, *Verzeichnis der Gemälde der kaiserlich-königlichen Bilder-Gallerie in Wien*, Vienna, 1783; French edition, Basle, 1784.

Emma H. Mellencamp, 'A Note on the Costume of Titian's Flora', *Art Bulletin*, LI, 1969, pp. 174–177.

H. Mendelsohn, *Das Werk der Dossi*, Munich, 1914.

Luigi Menegazzi, *Il Museo Civico di Treviso*, Venice, 1964.

G. Mentz, *Johann Friedrich der Grossmütige*, Jena, 1903–1908.

Marcantonio Michiel, *Notizie d'opere di disegno* (*c.* 1532); edition Jacopo Morelli, Bassano, 1800; edition G. Frizzoni, Bologna, 1884; edition Theodor Frimmel, Vienna, 1888; edition G. C. Williamson, London, 1903.

Milan, Ambrosiana Gallery, see:
Galbiati, 1951.
Guida sommaria, 1907.

Milan, Brera Gallery, see: Modigliani, 1950.

Oliver Millar, 'Notes on British Painting from Archives', *Burlington Magazine*, XCVII, 1955, pp. 255–256.

H. Mireur, *Dictionnaire des ventes d'art*, Paris, 1912, 7 vols.

Ettore Modigliani, *Catalogo della Pinacoteca di Brera*, Milan, 1950.

E. W. Moes, 'Een Brief van Kunsthistorische Beteekenis', *Oud Holland*, XII, 1894, pp. 238–240.

Bruno Molajoli, *Notizie su Capodimonte, Catalogo delle gallerie e del museo*, Naples, 1958, and later editions.

Pompeo Molmenti, *La storia di Venezia nella vita privata*, Bergamo, 1910–1912, 3 vols.

François Monod, 'La galerie Altman au Metropolitan Museum de New York', *Gazette des beaux-arts*, 5 période, VIII, 1923, pp. 179–198.

Montpensier: *Catálogo de los cuadros y esculturas . . . Duques de Montpensier*, Seville, 1866, Suplemento, 1867.

Antonio Morassi, *Giorgione*, Milan, 1942.

——, 'Ritratti del periodo giovanile di Tiziano', *Festschrift W. Sas-Zaloziecky zum 60 Geburtstag*, Graz, 1956, pp. 125–131.

——, *Titian*, Milan and New York, 1964.

——, 'Titian', *Encyclopaedia of World Art*, XIV, New York, 1967, pp. 132–158.

Giovanni Morelli (Lermolieff), *Le opere di maestri italiani nelle gallerie di Monaco, Dresda e Berlino*, Bologna, 1886 (translated from the German edition, Leipzig, 1880).

——, *Kunstkritische Studien*, Leipzig, 1890–1893, 3 vols.

——, *Italian Painters*, edition London, 1892, 1893, 2 vols.

——, *Della pittura italiana*, Milan, 1897.
See also Richter and Morelli.

Jacopo Morelli and Gustav Frizzoni, see: Marcantonio Michiel, edition Bologna, 1884.

J. Moreno Villa, 'Cómo son y cómo eran unos Ticianos del Prado', *Archivo español de arte y arqueología*, IX, 1933, pp. 113–116.

Gaetano Moroni, *Dizionario di erudizione storico-ecclesiastico*, Venice, 1840–1879, 103 vols., plus indices in 6 vols.

Alfred Morrison, *Catalogue of the Collection of autograph Letters . . .*, London, 1883–1892, 6 vols.

Sandra Moschini Marconi, *Gallerie dell'Accademia di Venezia, Opere d'arte dei secoli XIV e XV*, Rome, 1955; *Opere d'arte del secolo XVI*, Rome, 1962.

Andrea da Mosto, *I dogi di Venezia*, Milan, 1960.

Mostra del cinquecento toscano in Palazzo Strozzi, Florence, 1940.

Mostra di Tiziano. Catalogo delle opere, edited by Gino Fogolari, Venice, 1935.

Mostra dei Vecellio a Belluno, edited by Valcanover, Belluno, 1951.

Cornelius Müller-Hofstede, 'Das Selbstbildnis von Giorgione in Braunschweig', *Venezia e l'Europa*, Venice, 1956, pp. 252–253.

Justus Müller-Hofstede, 'Bildnisse aus Rubens' Italienjahren', *Jahrbuch der Staatlichen Kunstsammlungen in Baden-Württemberg*, II, 1965, pp. 89–153.

——, 'Rubens und Tizian: Das Bild Karl V', *Münchner Jahrbuch der bildenden Kunst*, XVIII, 1967, pp. 33–96.

J[enny] Müller-Rostock, 'Ein Verzeichnis von Bildern aus dem Besitze des van Dyck', *Zeitschrift für bildende Kunst*, N.F., XXXIII, 1922, pp. 22–24.

Eugène Müntz, *Le musée de portraits de Paul Jove*, Paris, 1900; also in *Mémoires de l'Académie des Inscriptions et Belles-Lettres*, Paris, XXXVI, 1898, pp. 249–343.

Munich: *Alte Pinakothek*, Munich, 1958.
See also: Reber, 1895.

Michelangelo Muraro, 'Il memoriale di Zuan Paolo da Ponte', *Archivio veneto*, XLIV–XLV, 1949, pp. 77–88.

Lodovico A. Muratori, *Annali d'Italia*, Rome, 1752–1754, 12 vols.

Newcastle-on-Tyne: *Noble Patronage*, Exhibition of Alnwick Pictures, 1963.

New York:
Frick Collection, see under Frick.
Knoedler and Co., 1938: *Venetian Paintings of the XV and XVI Centuries*.
Metropolitan Museum, see: Wehle, 1940.
World's Fair: Catalogue of Paintings and Sculpture, *Masterpieces of Art*, New York World's Fair, New York, 1939 and also 1940.

G. B. Niccolini, *Filippo Strozzi*, Florence, 1847.

G. Nicodemi, 'La biblioteca, gli arazzi, e le opere d'arte passate dalla Trivulziana al Castello Sforzesco', *Emporium*, 82, 1935, pp. 3–37.

Nicolas de Nicolay, *Le navegationi et viaggi nella Turchia* (1567), edition Venice, 1580.

Benedict Nicolson, 'Venetian Art in Stockholm', *Burlington Magazine*, CV, 1963, pp. 32–33.

Pierre de Nolhac, 'Les collections de Fulvio Orsini', *Gazette des beaux-arts*, 2 période, XXIX, 1884, pp. 427–436.

Carl Nordenfalk, 'Tizians Darstellung des Schauens', *Nationalmuseum Arsbok*, 1947–1948 (1950).

Christopher Norris, 'Titian: Notes on the Venice Exhibition' *Burlington Magazine*, LXVII, 1935, pp. 127–131.

Northbrook: Jean P. Richter and W. H. James Weale, *A Descriptive Catalogue of the Pictures Belonging to the Earl of Northbrook*, London, 1889.

Northwick, see: Borenius and Cust, 1921.

M. A. Novelli, 'Luigi Anichini', *Dizionario biografico degli italiani*, III, 1961, pp. 324–325.

Vinzenz Oberhammer, *Die Gemäldegalerie des Kunsthistorischen Museums zu Wien*, Vienna, 1959.

——, 'Christus und die Ehebrecherin, ein Frühwerk Tizians', *Jahrbuch der Kunsthistorischen Sammlungen in Wien*, N.F., XXIV, 1964, pp. 101–136.
See also: Klauner and Oberhammer.

Lodovico Oberziner, *Il ritratto di Cristoforo Madruzzo di Tiziano*, Trent, 1900; (review of book), *Rassegna d'arte*, I, 1901, p. 80.

Odescalchi Archives, Palazzo Odescalchi, Rome:

'Contratto fatta fra l'Illustrissimo Signore Principe Livio Odescalchi ed it Signore Marchese Pompeo Azzolino con l'inventario de' mobili esistenti nel Palazzo del Marchese Ottavio Riario alla Lungara, 1692' [Inventory of Queen Christina's possessions], vol. II, M2, folios 465V–471.

'Nota dei quadri della Regina Cristina di Svezia divisi in ogni classe d'autori' [no date, probably before her death in 1689], v, BI, no. 16.

'Inventari Bonarum Heredita Clare Memoriae Ducis D. Liviis Odescalchi', November 1713, vol. v, D2.

'La compra dei quadri da noi fatta a nome delle serenissima A. R. del Duca d'Orleans, Regente di Francia dall' Eccmo. Signore Don Baltasar Odescalchi Duca di Bracciano, 2 settembre 1721', vol. v 1, no. 18.

Karl Oettinger, 'Die wahre Giorgione Venus', *Jahrbuch der Kunsthistorischen Sammlungen in Wien*, N.F., XIII, 1944, pp. 113–137.

Ugo Ojetti, 'Della quadreria Giovanelli', *Dedalo*, VI, 1925–1926, pp. 133–136.

Harald Olsen, *Italian Paintings and Sculpture in Denmark*, Copenhagen, 1961.

——, *Federico Barocci*, Copenhagen, 1962.

Cesare d'Onofrio, 'Inventario dei dipinti del Cardinal Pietro Aldobrandini, compilato da G. B. Agucchi nel 1603', *Palatino*, VIII, 1964, pp. 15–20, 158–162, 202–211.

Johannes A. F. Orbaan, *Documenti sul barocco in Roma*, Rome, 1920.

G. Oreste, 'Gerolamo Adorno', *Dizionario biografico degli italiani*, Rome, 1960, pp. 297–298.

Orléans Collection:

Louis François Dubois de Saint Gelais, *Description des tableaux du Palais Royal*, Paris, 1727.

J. Couché, *Galerie des tableaux du Palais Royal*, Paris, 1786–1788, 1808.

Champier and Sandoz, *Le Palais Royal*, Paris, 1900.

Casimir Stryienski, *La galerie du Régent*, Paris, 1913.

Sergio Ortolani, 'Le origini della critica d'arte a Venezia', *L'Arte*, XXVI, 1923, pp. 1–17.

——, 'Restauro d'un Tiziano' (Paul III), *Bollettino d'arte*, serie IV, XXXIII, 1948, pp. 44–53.

Angela Ottino della Chiesa, *Accademia Carrara*, Bergamo, 1955.

W. Young Ottley, *Collection of the Marquess of Stafford*, London, 1818.

Leandro Ozzola, 'Isabella d'Este di Tiziano', *Bollettino d'arte*, XXIV, 1930–1931, pp. 491–494.

——, 'Un presunto ritratto di Tiziano', *Bollettino d'arte*, XXV, 1931, pp. 172–173.

Francisco Pacheco, *Arte de la pintura* (1638), edition by Sánchez Cantón, Madrid, 1956, 2 vols.

Rodolfo Pallucchini, *Sebastian Viniziano*, Venice, 1944.

——, *I dipinti della Galleria Estense*, Rome, 1945.

——, *La giovinezza del Tintoretto*, Milan, 1950.

——, 'Una mostra di pittura veneziana a Londra', *Arte veneta*, VII, 1952, pp. 209–210.

——, *Tiziano, Conferenze*, I, Bologna, 1953; II, Bologna, 1954.

——, 'La mostra del centenario a Manchester', *Arte veneta*, XI, 1957, pp. 257–258.

——, 'Un nuovo ritratto di Tiziano', *Arte veneta*, XII, 1958, pp. 63–69.

——, 'Studi Tizianeschi', *Arte veneta*, XV, 1961, pp. 286–295.

——, 'Il restauro del ritratto di gentiluomo veneziano . . . di Washington', *Arte veneta*, XVI, 1962, pp. 234–237.

——, *Tiziano*, Florence, 1969, 2 vols.

Roberto Palmarocchi, 'Benedetto Varchi', *Enciclopedia italiana*, Rome, XXXIV, 1935, pp. 991–992.

Antonio Palomino, *El parnaso español pintoresco laureado con las vidas de los pintores y estatuarios eminentes españoles*, Madrid, 1724; modern edition, Madrid, 1947.

Erwin Panofsky, 'Eine tizianische Allegorie', *Hercules am Scheidewege*, Hamburg, 1930, pp. 1–9.

——, 'Titian's Allegory of Prudence, A Postscript', *Meaning in the Visual Arts*, Garden City, 1955, pp. 146–168.

——, 'Classical Reminiscences in Titian's Portraits', *Festschrift für Herbert von Einem zum 16 Februar 1965*, Berlin, 1965.

——, *Problems in Titian, Mostly Iconographic*, New York, 1969.

——, and Fritz Saxl, 'A Late Antique Religious Symbol in Works by Holbein and Titian', *Burlington Magazine*, XLVII, 1926, pp. 177–181.

Ermalao Paoletti, *Il fiore di Venezia*, Venice, 1837–1840, 4 vols.

El Pardo Palace, Madrid, 'Inventario de las pinturas', 1614–1617, Legajo 27, Archivo del Palacio Real, Madrid.

Paris, 1929: *Exposition de l'Ordre de Malte*, Paris, Bibliothèque Nationale, 1929.

Paris, 1954: *Chefs d'oeuvre vénitiens*, Musée de l'Orangerie, Paris, 1954.

Paris, 1965–1966: *Le seizième siècle européen, peintures et dessins dans les collections françaises*, Paris, Louvre, 1965–1966.

Parnaso español, III–IV, 1770; IX, 1782.

See also: López Sedano.

Gustav Parthey, *Wenzel Hollar*, Berlin, 1853.

Andrea Pasta, *Le pitture notabili di Bergamo*, Bergamo, 1775.

Ludwig Pastor, *History of the Popes*, St. Louis, 1891–1953, 40 vols.

H. Pauwels, *La toison d'or. Cinq siècles d'art et d'histoire*, Bruges, 1962.

Giuseppe Pavanello, 'Pietro Lando', *Enciclopedia italiana*, XX, 1932, p. 494.

Wilbur Peat, 'Ariosto by Titian', *Bulletin, Herron Art Institute*, Indianapolis, XXXIV, 1947, pp. 3–5.

Giovanni de Pellegrini, 'Letter about Mr. Julius Wernher's Titian', *Burlington Magazine*, II, 1903, pp. 267–268.

R. A. Peltzer, 'Tizian in Augsburg', *Das schwäbische Museum, Zeitschrift für Bayerisch-Schwaben, seine Kultur, Kunst und Geschichte*, II, 1925, pp. 31–45.

Antonio Pérez: 'Inventario . . . de . . . las casas', Antonio Márquez, 1585, no. 989 (Archivo de Protocolos, Madrid), *Memorias de la Real Academia Española*, X, 1910, pp. 324–327.
See also: Marañon, 1948.

A. Ritter von Perger, 'Studien zur Geschichte d. K. K. Gemäldegalerie im Belvedere zu Wien', *Berichte und Mittheilungen des Altertums-Vereins zu Wien*, Vienna, VII, 1864, pp. 101–163.

Paola della Pergola, *Galleria Borghese, I dipinti*, Rome, I, 1955; II, 1959.

——, *Giorgione*, Milan, 1955.

——, 'L'Inventario del 1592 di Lucrezia d'Este', *Arte antica e moderna*, II, 1959, pp. 342–351.

——, 'Gli inventari Salviati', *Arte antica e moderna*, III, 1960, pp. 193–200.

——, 'Gli inventari Aldobrandini' (Inventario del 1611; Inventario del 1626), *Arte antica e moderna*, III, 1960, pp. 425–444.

——, 'Gli inventari Aldobrandini del 1682', *Arte antica e moderna*, V, 1962, pp. 316–322; VI, 1963, pp. 61–87, 175–191.

——, 'L'Inventario Borghese del 1693', *Arte antica e moderna*, VII, 1964, pp. 219–230, 451–467; VIII, 1965, pp. 202–217.

Fidenzio Pertile, see: Aretino, 1957–1960.

Philip II, see: Alcázar, Madrid.

J. G. Philips and Olga Raggio, 'Ottavio Farnese', *Metropolitan Museum Bulletin*, XII, 1953–1954, pp. 233–240.

Walter Alison Philips, 'Clement VII', *Encyclopaedia Britannica*, eleventh edition, 1910, vol. VI, pp. 485–486.

Sir Claude Phillips, *The Later Works of Titian*, London, 1898.

——, *The Earlier Works of Titian*, London, 1906.

——, 'The Titian of the Cassel Gallery', *Burlington Magazine*, XXI, 1912, pp. 128–136.

Duncan Phillips, *The Leadership of Giorgione*, Washington, 1937.

Giovanni Battista Picotti, 'Medici', *Enciclopedia italiana*, Rome, XXII, 1934, pp. 694–702.

Andor Pigler, *Catalogue of the Museum of Fine Arts* (in Hungarian), Budapest, 1937.

——, *Katalog der Galerie alter Meister*, Budapest, 1967, 2 vols.

Terisio Pignatti, *Giorgione*, Venice, 1969.

Alexander Pinchart, 'Tableaux et sculptures de Charles V', *Revue universelle des arts*, III, 1856, pp. 225–239 (includes Charles V's Brussels Inventory of 1556; also published by Gachard; see besides: Mary of Hungary).

José M. Pita Andrade, 'The Dukes of Alba', in *Great Family Collections*, edited by Douglas Cooper, New York, 1965, pp. 267–288.

Eugène Plon, *Leone Leoni et Pompeo Leoni*, Paris, 1887.

Stephen Poglayen-Neuwall, 'Tizianstudien', *Münchner Jahrbuch*, N.F., IV, 1927, pp. 59–70.

Antonio Ponz, *Viage de España*, Madrid, I–XVIII, 1772–1794, also edition, Madrid 1947, I vol.

John Pope-Hennessy, *The Portrait in the Renaissance*, New York, 1966.

——, *Raphael*, London, 1970.

A. E. Popham, *Italian Drawings Exhibited at the Royal Academy* (1930), London, 1931.

Hans Posse, *Königliche Museen zu Berlin, Die Gemäldegalerie des Kaiser-Friedrichmuseums*, Berlin, editions 1909 and 1913.

——, *Die staatliche Gemäldegalerie zu Dresden. Katalog der alten Meister*, Dresden, 1930.

Philip Pouncey, 'The Miraculous Cross in Titian's Vendramin Family', *Journal of the Warburg Institute*, II, 1938–1939, pp. 191–193.

Cassiano del Pozzo, 'Legatione del Signore Cardinale [Francesco Barberini] in Spagna', 1626, Vatican Library, MS. Barberini latino, 5689.

Prado Museum, Madrid:
Catálogo de las pinturas, Madrid, 1963 (and numerous earlier editions).
'Inventario general de los cuadros', 1857, manuscript in the Prado Museum Library.
See also:
Madrazo.
Sánchez Cantón.

Prague Castle, see: Rudolf II.

Lucia and Ugo Procacci, 'Il carteggio di Marco Boschini con il Cardinale Leopoldo de' Medici', *Saggi e memorie di storia dell'arte*, IV, 1965, pp. 87–114.

Prodromus zum Theatrum Artis Pictoriae (1735), see: Stampart.

Lina Putelli, *Tiziano Vecellio da Cador*, Turin, 1966 (novellized booklet).

Mario Quattrucci, 'Antonio Anselmi', *Dizionario biografico degli italiani*, Rome, III, 1961, p. 377.

Romolo Quazza, 'Giulia Gonzaga', *Enciclopedia italiana*, XVII, 1933, p. 544.

H. P. R., 'A Purchase of Early Prints', *Museum of Fine Arts, Bulletin*, Boston, XLVI, 1948, pp. 82–91.

F. von Ramdohr, *Über Mahlerei und Bildhauerarbeit in Rom*, Leipzig, 1787.

Richard H. Randall, Jr., 'A Mannerist Jewel', *Bulletin of the Walters Art Gallery*, XX, No. 1, October 1967, pp. 1–3; also in *Apollo*, N.S. LXXXVII, no. 73, March, 1968, pp. 176–178.

Carlo Giuseppe Ratti, *Instruzione di quanto può vedersi di più bello in Genova*, Genoa, 1780, 2 vols.

Aldo Ravà, 'Il camerino delle antigaglie di Gabriele Vendramin', *Nuovo archivio veneto*, N.S. XXII, 1920, tomo XXXIX, pp. 155–181.

Brian Reade, *Costume of the Western World. The Dominance of Spain*, London, 1951.

Franz von Reber, *Katalog der Gemäldegalerie*, Munich, 1895; also English edition.

George Redford, *Art Sales*, London, 1888, 2 vols.

Corrado Ricci, 'Ritratti Tizianeschi', *Rivista del R. Istituto d'Archeologia*, I, 1929, pp. 249–264.

George M. Richter, 'Two Titian Self Portraits', *Burlington Magazine*, LVIII, 1931, pp. 161–168.

——, 'The Three Different Types of Titian's Self Portraits', *Apollo*, XIII, 1931, pp. 339–343.

——, 'A Clue to Giorgione's Late Style', *Burlington Magazine*, LX, 1932, pp. 123–130.

——, 'Unfinished Pictures by Giorgione', *Art Bulletin*, XVI, 1934, pp. 272–290.

——, 'An Ideal Portrait of Lavinia by Titian', *Apollo*, XXVI, 1937, pp. 222–223.

——, *Giorgio da Castelfranco*, Chicago, 1937.

——, 'Lost and Rediscovered Works by Giorgione', *Art in America*, XXX, 1942, pp. 141–157, 211–224.

J. P. Richter and Giovanni Morelli, *Italienische Malerei der Renaissance im Briefwechsel (1876–1891)*, edited by Gisela Richter, Baden Baden, 1960.

J. P. Richter and James Weale, *Descriptive Catalogue of the Collection Belonging to the Earl of Northbrook*, London, 1889.

Charles Ricketts, *Titian*, London, 1910.

Ridolfi (1648)-Hadeln, *Le maraviglie dell'arte* (Venice, 1648), edition Berlin, 1914–1924, 2 vols.

Aldo de Rinaldis, *Guida del Museo Nazionale di Napoli*, II, Pinacoteca, Naples, 1911; second edition, 1927–1928.

Fritz Rintelen, 'Tizians Porträt des Antonio Anselmi', *Jahrbuch der königlich preuszischen Kunstsammlungen*, XXVI, 1905, pp. 202–204, illustration.

Giulio Emanuele Rizzo, *Prassitele*, Milan-Rome, 1932.

Keith Roberts, 'Allegory of Prudence', *Burlington Magazine*, CVIII, 1966, p. 490.

Giles Robertson, *Vincenzo Catena*, Edinburgh, 1954.

——, 'The Giorgione Exhibition in Venice', *Burlington Magazine*, XCVII, 1955, pp. 272–277.

——, *Giovanni Bellini*, Oxford, 1968.

J. C. Robinson, 'The Gallery of Pictures by Old Masters Formed by Francis Cook', *Art Journal*, XLVII, 1885, pp. 133–137.

Louise Roblot-Delonde, 'Les portraits d'Isabelle de Portugal, épouse de Charles V', *Gazette des beaux-arts*, LI, 1909, pp. 435–454; reprinted in *Portraits d'Infantes*, XVI siècle, Paris, 1913, pp. 56–59.

Amadio Ronchini, 'Delle relazioni di Tiziano coi Farnesi', *Deputazioni di storia patria per le provincie modanesi e parmesi, Atti e Memorie*, Modena, II, 1864, pp. 129–146.

Max Rooses, *L'Oeuvre de P. P. Rubens*, Brussels, 1886–1892, 5 vols.

G. Roscoe, *Vita e pontificato di Leo X*, Italian translation from English and notes by Count Luigi Bossi, Milan, 1817, 6 vols.

Patricia Rose, 'Christina of Denmark by Michael Coxie', *Allen Memorial Art Museum Bulletin*, Oberlin, XXI, 1963, pp. 29–51 (admirable article).

Roskill, see: Dolce.

Ettore Rossi, 'Abdul-Hamid I', *Enciclopedia italiana*, Rome, I, 1929, pp. 46–47.

——, 'Murad III', *Enciclopedia italiana*, XXIV, 1934, p. 47.

——, 'Selim II', *Enciclopedia italiana*, XXXI, 1936, p. 324.

——, 'Solimano I', *Enciclopedia italiana*, XXXII, 1936, p. 76.

——, 'La sultana Nûr Bûnû' (Cecilia Venier-Baffo), *Oriente moderno*, XXXIII, 1953, pp. 433–441.

Rothermere Collection: P. G. Konody, *Works of Art in the Collection of Viscount Rothermere*, London, 1932.

Rubens' Inventory 1640:

Paul Lacroix, 'Catalogue des tableaux et objets d'art qui faisaient partie du cabinet de Rubens', *Revue universelle des arts*, I, 1855, pp. 269–279.

W. Noel Sainsbury, *Original Unpublished Papers Illustrative of the Life of Sir Peter Paul Rubens*, London, 1859, pp. 236–245.

Jean Denucé, *De Antwerpsche 'Konstkamers', inventarissen van Kunstverzamelingen te Antwerpen in de 16ᵉ en 17ᵉ Eeuwen*, The Hague, 1932, pp. 56–71.

Emperor Rudolf II, see:

Perger, 1864.

Zimmermann, 1905.

Vincenzo Ruffo, 'Galleria Ruffo nel secolo XVII in Messina', *Bollettino d'arte*, X, 1916, pp. 21–64, 95–128, 165–192.

William N. Sainsbury, *Original Unpublished Papers Illustrative of the Life of Sir Peter Paul Rubens*, London, 1859.

Luigi Salerno, *Roma communis patria*, Bologna, 1968.

Roberto Salvini, *La galleria degli Uffizi, Catalogo dei dipinti*, Florence, 1964.

Charles Samaran, 'Georges d'Armagnac et Guillaume Philandrier, peint par Titien. Deux portraits identifiés', *Monuments et mémoires*, Académie des Inscriptions et Belles Lettres, Fondation Eugène Piot, Paris, LV, 1967, pp. 115–129.

Francisco J. Sánchez Cantón, *Catálogo de las pinturas del Instituto de Valencia de Don Juan*, Madrid, 1922.

——, *Fuentes literarias para la historia del arte español*, I–V, Madrid, 1923–1941.

——, *Inventarios reales, bienes muebles que pertenecieron a Felipe II*, Madrid, 1946–1949, 2 vols.

——, *Los retratos de los reyes de España*, Barcelona, 1948.

——, *Catálogo de las pinturas*, Museo del Prado, Madrid, 1963 (and earlier editions).

See also:

Alcázar, Madrid.

Allende-Salazar and Sánchez Cantón, 1919.

Domingo Sánchez Loro, *La inquietud postrimera de Carlos V*, Cáceres, 1958, II (Charles V's Yuste Inventory of 1558).

San Diego: *Fine Arts Gallery, Catalogue*, San Diego, 1960 (or 1961?).

Fert Sangiorgi, 'Sul Guidobaldo II del Bronzino', *Antichità viva*, VIII, 1969, pp. 25–27.

Francisco de Borja de San Román, 'Alonso Sánchez Coello', *Academia de Bellas Artes . . . de Toledo*, 1936.

Francesco Sansovino, *Delle cose notabili che sono in Venetia*, Venice, 1651.

——, *Venetia*, Venice, 1581; edition Venice, 1604, with additions by Stringa; edition Venice, 1663, with additions by G. Martinioni.

Padre Francisco de los Santos, 'Descripción de San Lorenzo del Escorial', 1657 y 1698, in Sánchez Cantón, *Fuentes literarias para la historia del arte español*, Madrid, II, 1933, pp. 225–319.

Marino Sanuto, *Diarii*, 1496–1533, published Venice, 1879–1903, 58 vols.

Natalino Sapegno, 'Lodovico Ariosto', *Dizionario biografico degli italiani*, Rome, IV, 1962, pp. 172–188.

Sarasota, Ringling Museum, see Suida, 1949

Simona Savini-Branca, *Il collezionismo veneziano nel '600*, Padua, 1964.

Fritz Saxl, *Lectures*, London, 1957.

Francesco Scannelli, *Il microcosmo della pittura*, Cesena, 1657.

Emil Schaeffer, 'Cristofano dell' Altissimo', in Thieme-Becker, *Künstler-lexikon*, I, 1907, pp. 352–353.

——, 'Ein Bildniss des Vincenzo Cappello', *Monatshefte für Kunstwissenschaft*, I, part II, 1908, pp. 1117–1118.

——, 'Noch einmal das Bildniss des Vincenzo Cappello', *Monatshefte für Kunstwissenschaft*, II, 1909, pp. 158–160.

——, 'Ein Bildnis des Hieronymo Fracastoro von Tizian', *Jahrbuch der königlich preuszischen Kunstsammlungen*, XXXI, 1910, pp. 130–138.

——, 'Bildnisse der Caterina Cornaro', *Monatshefte für Kunstwissenschaft*, IV, 1911, pp. 12–19.

Alfred Scharf, 'Rubens' Portraits of Charles V and Isabella', *Burlington Magazine*, LXVI, 1935, pp. 259–266.

George Scharf, *Catalogue raisonné or List of the Pictures at Blenheim Palace*, London, 1862.

Eberhard Freiherr Schenk zu Schweinsberg, 'Zwei unveroeffentlichte Bildnisse des Antonio Moro', *Oud Holland*, LXXV, 1960, pp. 92–99.

Paul Schubring, 'A Surmise Concerning the Subject of the Venetian Figure Painting in the Detroit Museum', *Art in America*, XV, 1926, pp. 35–40.

——, *Die Kunst der Hochrenaissance in Italien*, Berlin, 1936.

Fritz T. Schulz, 'Jacopo Strada', Thieme-Becker, *Künstler-Lexikon*, XXXII, 1938, pp. 145–147.

Arnaldo Segarizzi, 'Una lotteria di quadri nel secolo XVII', *Nuovo archivio veneto*, N.S., XXVIII, 1914, pp. 172–187.

Count Antoine Seilern, *Flemish Paintings and Drawings at 56 Princes Gate*, London, 1955.
Addenda, 1969.

——, *Italian Painters at Princes Gate, Addenda*, 1969.

Pietro E. Selvatico, *Di alcuni abbozzi di Tiziano . . . nella galleria del Conte Sebastiano Giustiniani Barbarigo*, Padua, 1845.

Charles Seymour, Jr., *The Rabinowitz Collection of European Paintings*, Yale University, 1961.

Jean Seznec, *The Survival of the Pagan Gods*, New York, 1953.

Fern Rusk Shapley, *Paintings from the Samuel H. Kress Collection. Italian Schools XV–XVI Century*, London, 1968.
See also: Suida and Shapley.

John Shearman, 'Titian's Portrait of Giulio Romano', *Burlington Magazine*, CVII, 1965, pp. 172–177.

——, *Andrea del Sarto*, Oxford, 1965.

Padre Joseph de Sigüenza, 'Historia de la orden de San Gerónimo', 1599, in Sánchez Cantón, *Fuentes literarias para la historia del arte español*, I, 1923, pp. 325–448.

Simancas, Archivo General, see:
Beer, 1891.
Cloulas, 1967.
Fabbro, 1967.

Oswald Sirèn, *Dessins et tableaux de la renaissance italienne dans les collections de Suède*, Stockholm, 1902.

——, 'Pictures of the Venetian School in Sweden', *Burlington Magazine*, VI, 1904–1905, pp. 59–70.

——, 'Tizians porträtt av Konung Filip II av Spanien', *Arsbok*, Nationalmusei, Stockholm, X, 1928, pp. 41–47.

——, *Italienska Tavlor och Teckningar*, Stockholm, National Museum, 1933.

Seymour Slive, *Drawings of Rembrandt*, New York, 1965.

I. A. Smirnova, *Titian and Venetian Portraits, Sixteenth Century* (in Russian), Moscow, 1964.

Angelo Solerti, 'Il ritratto dell' Ariosto di Tiziano', *Emporium*, XX, 1904, pp. 465–476.

A. I. Somof, *Catalogue de la galerie des tableaux*, St. Petersburg, 1899.

Emilio Spagni, 'Una sultana veneziana', *Nuovo archivio veneto*, XIX, 1900, pp. 241–248.

Annemarie Spahn, *Palma Vecchio*, Leipzig, 1932.

Giuseppe Spezi, *Lettere inedite del Cardinale Pietro Bembo*, Rome, 1862.

Marion H. Spielmann, *The Iconography of Andreas Vesalius*, London, 1925.

Marquess of Stafford:
Catalogue raisonné of the Pictures . . . Marquess of Stafford, in the Gallery of Cleveland House, London, 1808.
Engravings of the most Noble Marquess of Stafford's Collection of Pictures in London, by William Young Ottley and P. W. Tomkins, Esq., engraver, London, 1818.
Catalogue of the Collection of Pictures . . . Marquess of Stafford at Cleveland House, London, 1825, I.
Catalogue of Pictures in the Gallery at Stafford House, London, 1862.
See also: Bridgewater.

Franz von Stampart and Anton von Prenners, 'Prodromus zum Theatrum Artis Pictoriae' (1735), edited by Heinrich Zimmermann, *Jahrbuch der Kunsthistorischen Sammlungen des Allerhöchsten Kaiserhauses*, Vienna, VII, 1888, II Theil, pp. VII–XIV, plates 1–30.

Wolfgang Stechow, 'Rembrandt and Titian', *Art Quarterly*, V, 1942, pp. 135–146.

——, *Catalogue of European and American Paintings and Sculpture*, Oberlin College, 1967.

Alfred Stix, 'Tizians Diana und Kallisto in der Kaiserlichen Gemäldegalerie in Wien', *Jahrbuch der Kunsthistorischen Sammlungen des Allerhöchsten Kaiserhauses*, Vienna, XXXI, 1913–1914, pp. 335–346.

J. Stockbauer, *Die Kunstbestrebungen am Bayerischen Hofe unter Herzog Albert V. und seinem Nachfolger Wilhelm V.*

Quellenschriften für Kunstgeschichte, Vienna, VIII, 1874. 'Jacob Strada', pp. 29–52; 'Nicolo Stoppio', pp. 53–69.

Stockholm:

O. Sirèn, *Catalogue descriptif des collections de peintures du Musée National*, Stockholm, 1928.

Konstens Venedig, Exhibition, National Museum, 1962–1963.

Christina Queen of Sweden, Exhibition, National Museum, 1966.

Storffer, *Gemaltes Inventarium der Aufstellung der Gemälde-galerie in der Stallburg*, Vienna, 1720–1733, 3 vols.

Sir Robert Strange, *A Descriptive Catalogue of a Collection of Pictures*, London, 1769.

Arthur Strong, *Masterpieces in the Duke of Devonshire's Collection of Pictures*, London, 1901.

Margret Stuffmann, 'Les tableaux de la collection de Pierre Crozat', *Gazette des beaux-arts*, VI période, LXXII, 1968, pp. 13–135.

Wilhelm Suida, *Genua*, Leipzig, 1906.

——, 'Unbekannte Bildnisse von Tizian', *Belvedere*, I, 1922, pp. 168–174 (unacceptable attributions).

——, 'Rivendicazioni a Tiziano', *Vita artistica*, II, 1927, pp. 206–215.

——, 'Tizians Bildniss des Mons'or d'Aramont', *Belvedere*, VIII, 1929, pp. 7–8.

——, 'Un second Homme aux Gants de Titien', *Gazette des beaux-arts*, VI période, III, 1930, pp. 83–84.

——, 'Einige Bildnisse von Tizian', *Belvedere*, XI, 1934–1935, pp. 101–102.

——, 'New Light on Titian's Portraits', I, *Burlington Magazine*, LXIV, 1934, pp. 272–278; II, *idem*, LXVIII, 1936, pp. 281–283.

——, *Titien*, French edition, Paris, 1935.

——, 'Epilog zur Tizian-Austellung in Venedig', *Pantheon*, XVIII, 1936, pp. 102–104.

——, 'Titian's Earliest Portrait of Aretino', *Burlington Magazine*, LXXV, 1939, pp. 113–115.

——, 'Titian's Portrait of Martino Pasqualigo', *Art Quarterly*, II, 1939, pp. 326–330.

——, 'Titian Portraits, Originals and Reconstructions', *Gazette des beaux-arts*, 6th series, XXIX, 1946, pp. 139–152.

——, *Catalogue of Paintings in the John and Mable Ringling Museum of Art*, Sarasota, 1949.

——, 'Miscellanea Tizianesca', I, *Arte veneta*, VI, 1952, pp. 27–41.

——, 'Miscellanea Tizianesca', II, *Arte veneta*, X, 1956, pp. 71–81.

—— and Fern Rusk Shapley, *Paintings and Sculpture from the Kress Collection* (acquired 1951–1956), Washington, National Gallery of Art, 1956.

Giorgio Szabo Kákay, 'Giorgione o Tiziano', *Bollettino d'arte*, XLV, 1960, pp. 320–324.

R. R. Tatlock, 'An Uncatalogued Titian', *Burlington Magazine*, XLVII, 1925, p. 222.

David Teniers II, *Theatrum pictorium*, Antwerp, 1660.

G. von Térey, *Catalogue of the Budapest Museum of Fine Arts* (in Hungarian), Budapest, 1924.

Moritz Thausing, 'Tizian und die Herzogin Eleanora von Urbino', *Zeitschrift für bildende Kunst*, XIII, 1878, pp. 257–269, 305–315.

Theatrum pictorium, see: Teniers.

Henry Thode, *Tintoretto*, Leipzig, 1901.

Théophile Thoré, see: Bürger.

Stefano Ticozzi, *Vite dei pittori Vecelli di Cadore*, Milan, 1817.

Thieme-Becker, 'Anton Goetkint', *Künstler-Lexikon*, XIV, 1921, p. 317.

Hans Tietze, *Tizian*, Vienna, 1936, 2 vols.

——, 'Die öffentlichen Gemäldesammlungen in Kanada', *Pantheon*, XVIII, 1936, pp. 180–184.

——, 'Titian's Pasqualigo Portrait in Washington', *Art in America*, XXVII, 1939, p. 181.

——, *Four Centuries of Venetian Painting*, Toledo, Museum of Art, 1940.

——, *Tizian Gemälde und Zeichnungen*, London, 1950 (also an English edition).

——, 'Titian's Portrait of King Francis I', *Connoisseur*, 126, 1950, pp. 83–85.

Hans Tietze and Erica Tietze-Conrat, 'Tizian Studien', *Jahrbuch der Kunsthistorischen Sammlungen in Wien*, N.F., X, 1936, pp. 137–192.

——, *The Drawings of the Venetian Painters*, New York, 1944.

——, 'I ritratti Spilembergo a Washington', *Emporium*, CXVII, 1953, pp. 99–107.

Erica Tietze-Conrat, 'Titian's Workshop in his Late Years', *Art Bulletin*, XXVIII, 1946, pp. 76–88.

——, 'Titian's Portrait of Paul III', *Gazette des beaux-arts*, 6th series, XXIX, 1946, pp. 73–84.

——, 'The Iconography of Michele Sanmichele', *Gazette des beaux-arts*, 6th series, XXIX, 1946, pp. 378–382.

——, 'Das Skizzenbuch des Van Dyck als Quelle für die Tizianforschung', *Critica d'arte*, XXXII, 1950, pp. 425–442.

Filippo Titi, *Descrizioni delle pitture, sculture e architetture . . . in Roma*, Rome, 1763.

Tizianello, *Vita dell'insigne pittore Tiziano Vecellio*, 1622, edition Venice, 1809.

Elena Berti Toesca, 'Per la mostra di Tiziano a Venezia, quadri di Tiziano all'Accademia di San Luca', *Bollettino d'arte*, N.S., XXVIII, 1934–1935, pp. 440–445.

Elias Tormo y Monzó, *Trenta y tres retratos de las Descalzas Reales*, Madrid, 1944.

Giorgio Torselli, *La Galleria Doria*, Rome, 1969.

Pompilio Totti, *Ritratti et elogii di capitani illustri*, Rome, 1635.

Giuseppe Treccia, *Catalogo della Pinacoteca Comunale di Verona*, Bergamo, 1912.

E. G. Troche, 'Venetian Paintings of the Renaissance in the M. H. De Young Memorial Museum', *Art Quarterly*, XXVIII, 1965, pp. 91–103.

K. Tscheuschner, 'Über den Tizian no. 172 der Dresdener Galerie', *Repertorium für Kunstwissenschaft*, XXIV, 1901, pp. 292–293.

Joseph Tupinier (Henri Baraude), *Lopez, agent financier et confident de Richelieu*, Paris, 1933.

Uffizi, see: Florence.

Filippo Ugolini, *Storia dei conti e duchi d'Urbino*, Florence, 1859, 2 vols.

Maurice Vaes, 'Le séjour de Van Dyck en Italie', *Bulletin de l'Institute Historique Belge de Rome*, 1924, pp. 178–181.

Francesco Valcanover, *Tutta la pittura di Tiziano*, Milan, 1960, 2 vols.

——, *L'opera completa di Tiziano*, Milan, Classici dell'arte, no. 32, 1969.

Conde Valencia de Don Juan, 'Bilderinventar der Waffen, Rüstungen, Gewänder und Standarten Karl V in der Armeria Real zu Madrid, *Jahrbuch der Kunsthistorischen Sammlungen des Allerhöchsten Kaiserhauses*, XI, 1890, II Theil, pp. CCXLII–CCXLVIII, Taf 24.

——, *Catálogo histórico-descriptivo de la Real Armería de Madrid*, Madrid, 1898.

Wilhelm R. Valentiner, 'A Portrait by Titian in the Cincinnati Museum', *Art in America*, II, 1914, pp. 159–163.

——, *The Widener Collection*, Philadelphia, 1923.

——, 'A Combined Work by Titian, Giorgione, and Sebastiano del Piombo', *Bulletin, Detroit Institute of Arts*, VII, 1926, pp. 62–65.

——, 'Once More the Venetian Three-Figure Painting in Detroit', *Art in America*, XVI, 1926, pp. 40–45.

——, *Das unbekannte Meisterwerk*, Berlin, 1930 (also English edition, text only).

——, 'Pieter Bruegel, a Painter of the People, and Antonio Moro, a Painter of the Court', *Art in America*, XIX, 1931, pp. 101–121.

——, *The Henry Goldman Collection*, New York, 1942.

Abraham van der Doort, *Catalogue of the Collections of Charles I (1639)*, edited by Oliver Millar, Glasgow. The Walpole Society, XXXVII, 1958–1960. See also: Charles I of England.

Sir Anthony Van Dyck, see: Michael Jaffé, *Van Dyck's Antwerp Sketchbook*, London, 1966, 2 vols.

——, 'Italian Sketchbook', 1622–1627, original manuscript now in the British Museum, published by Lionel Cust, London, 1902; Gert Adriani, *Van Dycks Italienisches Skizzenbuch*, Vienna, 1940.

Giorgio Vasari, *Le vite dei più eccellenti pittori, scultori, ed architetti (1568)*, edition by Gaetano Milanesi, Florence, 1875–1885, republished Florence, 1907; edition by Paola Barocchi, vols. 1–2, Florence, 1966, 1967.

Alberto Vázquez and R. Selden Rose, *Algunas cartas de Don Diego Hurtado de Mendoza*, New Haven, 1935.

Vatican: *Guida alla Pinacoteca vaticana*, Rome, 1933.

Cesare Vecellio, *Habiti antichi et moderni*, Venice, second edition, 1598.

Adolfo Venturi, *La galleria Crespi in Milano*, Milan, 1900.

——, 'Cronaca', *L'Arte*, XIV, 1911, p. 394.

——, *Studi del vero attraverso le raccolte artistiche d'Europa*, Milan, 1927.

——, 'Ancora della Biblioteca di Sir Robert Witt', *L'Arte*, XXXI, 1928, pp. 193–214.

——, *Storia dell'arte*, Milan, IX, part 3, 1928; IX, part 4, 1929; IX, part 5, 1932; IX, part 7, 1934.

——, 'Doppio ritratto di Tiziano', *L'Arte*, XXXV, 1932, p. 46, figs, 1–2.

——, 'L'esposizione della pittura ferrarese del rinascimento' *L'Arte*, XXXVI, 1933, pp. 367–390.

Lionello Venturi, 'Saggio sulle opere d'arte italiana a Pietroburgo', *L'Arte*, XV, 1912, pp. 121–146.

——, *Giorgione e il giorgionismo*, Milan, 1913.

——, 'Nella collezione Nemes', *L'Arte*, XXXIV, 1931, pp. 250–266.

——, *Pitture italiane in America*, New York, 1931; English edition, New York, 1933.

——, 'Contributi a Tiziano', *L'Arte*, XXXV, 1932, pp. 481–497.

——, 'Tre ritratti inediti di Tiziano', *L'Arte*, XL, 1937, pp. 55–56 (all are wrong attributions).

——, *The Rabinowitz Collection*, New York, 1944, pp. 50–51.

——, 'Tre pitture venete della collezione Rabinowitz', *Arte veneta*, I, 1947, pp. 20–21.

——, *Giorgione*, Rome, 1954.

——, 'Giorgione', *Encyclopedia of World Art*, New York, VI, 1962, pp. 330–339.

Ridolfino Venuti, *Roma moderna*, Rome, 1745; another edition, 1766.

Egon Verheyen, 'Jacopo Strada's Mantuan Drawings', *Art Bulletin*, XLIX, 1967, pp. 62–70.

——, 'Der Sinngehalt von Giorgiones Laura', *Pantheon*, XXVI, 1968, pp. 220–227.

George Vertue, *Note Books (1713–1756)*, vols. I–VI, edition Walpole Society, London, XVIII–XXIX, 1930–1947.

Giorgio Viani, *Memorie della famiglia Cybo e delle monete di Massa*, Pisa, 1808.

Vienna:
 Kunsthistorisches Museum, see:
 Michel, 1783.
 Engerth, 1884.
 Glück and Schaeffer, 1907.
 Wilde, Baldass and others, 1938.
 Klauner and Oberhammer, 1960.
 Klauner, Oberhammer, and Heinz, 1966.
 Sezession Galerie:
 Austellung der Meisterwerke italienische Renaissance-Kunst, Sezession Galerie, 1924.

Luigi Villari, 'Farnese', *Encylopaedia Britannica*, eleventh edition, 1910, IX, pp. 183–184.

Fédéric Villot, *Notices des tableaux . . . Musée National du Louvre*, Paris, 1874.

Conde de la Viñaza, *Adiciones al diccionario histórico de los más ilustres profesores de bellas artes en España de Juan Agustín Ceán Bermúdez*, Madrid, 1889.

Hans Vogel, *Katalog der Staatlichen Gemäldegalerie zu Kassel*, Kassel, 1958.

H. Vollmer, 'Favray', Thieme-Becker, *Künstler-Lexikon*, XI, 1915, pp. 310–311.

——, 'Liotard, Jean Etienne', Thieme-Becker, *Künstler-Lexikon*, XXIII, 1929, pp. 263–264.

Hans von Voltelini, 'Urkunden und Regesten aus dem K. und K. Haus-, Hof- und Staats-archiv in Wien', *Jahrbuch der Kunsthistorischen Sammlungen des Allerhöchsten Kaiserhauses*, Vienna, XI, 1890, II Theil, pp. I–LXXXIII; XIII, 1892, II Theil, pp. XXVI–CLXXIV; XV, 1894, II Theil, pp. XLIX–CLXXIX.

von: Names with 'von', see the patronymic.

G. F. Waagen, *Treasures of Art in Great Britain*, London, 1854, 3 vols.

——, *Galleries and Cabinets of Art in Great Britain*, London, editions 1838 and 1857.

John Walker, *Bellini and Titian at Ferrara*, New York, 1956.

Washington:
 Corcoran Gallery:
 Illustrated Handbook of the W. A. Clark Collection, Corcoran Gallery of Art, 1928.
 National Gallery:
 Preliminary Catalogue of Paintings and Sculpture, National Gallery of Art, Washington, 1941.
 Paintings and Sculpture from the Samuel H. Kress Collection, Washington, 1956 and 1959.
 Summary Catalogue of European Paintings and Sculpture, Washington, 1965.
 See also: Shapley, 1968.

Ellis K. Waterhouse, 'Paintings from Venice for Seventeenth-century England', *Italian Studies*, VII, 1952, pp. 1–23.

——, *Italian Art and Britain*, London, 1960.

——, 'Queen Christina's Italian Pictures in England', *Queen Christina of Sweden. Documents and Studies*, Stockholm, 1966.

H. B. Wehle, *Catalogue of Italian, Spanish and Byzantine Paintings*, New York, Metropolitan Museum, 1940.

Evelyn Wellington, *Catalogue of the Collection at Apsley House*, London, 1901.

Paul Wescher, *A Catalogue of Italian, French, and Spanish Paintings, XIV–XVIII Century*, Los Angeles, 1953.

Dorothea Westphal, 'Antonio Palma', Thieme-Becker, *Künstler-Lexikon*, XXVI, 1932, pp. 171–172.

Harold E. Wethey, *El Greco and His School*, Princeton, 1962, 2 vols.

——, *The Paintings of Titian, Complete Edition. Volume I, The Religious Paintings*, London, 1969.

——, 'Los retratos de Felipe II por Tiziano', *Archivo español de arte*, XLII, 1969, pp. 129–138.

——, and A. S. Wethey, 'Herrera Barnuevo and His Chapel in the Descalzas Reales', *Art Bulletin*, 1966, pp. 15–34.

Franz Wickhoff, 'Les écoles italiennes au musée de Vienne', *Gazette des beaux-arts*, 3 ième période, IX, 1893, pp. 5–18, 130–147.

——, Review of G. Gronau's *Titian*, in *Kunstgeschichtliche Anzeigen*, 1904, pp. 113–117.

Karl Wilczek, 'Ein Bildniss des Alfonso Davalos von Tizian', *Zeitschrift für bildende Kunst*, LXIII, 1929, pp. 240–247.

——, *Katalog der Graf Czernin'schen Gemäldegalerie*, Vienna, 1936.

Johannes Wilde, 'Wiedergefundene Gemälde aus der Sammlung des Erzherzogs Leopold Wilhelm', *Jahrbuch der Kunsthistorischen Sammlungen in Wien*, N.F. IV, 1930, pp. 245–266.

——, 'Ein unbeachtetes Werk Giorgiones', *Jahrbuch der preuszischen Kunstsammlungen*, LII, 1931, pp. 91–100.

——, 'Die Probleme von Domenico Mancini', *Jahrbuch der Kunsthistorischen Sammlungen in Wien*, N.F., VII, 1933, pp. 97–135.

——, 'Zwei Tizian Zuschreibungen des 17. Jahrhunderts', *Jahrbuch der Kunsthistorischen Sammlungen in Wien*, N.F., VIII, 1934, pp. 161–172.

——, 'Über einige venezianische Frauenbildnisse der Renaissance', *Hommage à Alexis Petrovics*, Budapest, 1934, pp. 206–212.

——, in *Katalog der Gemäldegalerie*, Vienna, 1938.

——, 'Titian's St. Catherine', in *Addenda to Count Seilern's Collection*, London, 1969, V, pp. 4–6.

Edgar Wind, *Bellini's Feast of the Gods*, Cambridge (Massachusetts), 1948.

——, *Giorgione's Tempesta*, Oxford, 1969.

Rudolf Wittkower, 'Transformation of Minerva in Renaissance Imagery', *Journal of the Warburg Institute*, II, 1938–1939, pp. 195–205.

Rudolf Wittkower, 'L'Arcadia e il Giorgionismo', *Umanesimo europeo e umanesimo veneziano*, edited by Vittore Branca, Venice, 1963, pp. 473–484.

Charles Yriarte, *Autour des Borgia . . . Etudes d'histoire et d'art*, Paris, 1891.

Pietro Zampetti, *Giorgione e i Giorgioneschi*, Venice, 1955.

——, *Jacopo Bassano, Catalogo della mostra*, Venice, 1957.

Antonio Maria Zanetti, *Varie pitture a fresco dei principali maestri veneziani*, Venice, 1760.

Manuel R. Zarco del Valle, 'Unveröffentlichte Beiträge zur Geschichte der Kunstbestrebungen Karl V. und Philipp II.', *Jahrbuch der Kunsthistorischen Sammlungen des Allerhöchsten Kaiserhauses*, VII, 1888, pp. 221–237.

J. Zarnowski, 'L'atelier de Titien: Girolamo Dente', *Dawna Sztuka*, 1938, pp. 103–130.

Federico Zeri, *La Galleria Spada in Roma*, Florence, 1954.

Heinrich Zimmermann, 'Zur richtigen Datirung eines Portraits von Tizian in der Wiener kaiserlichen Gemälde-Gallerie', *Mittheilungen des Instituts für oesterreichische Geschichtsforschung*, Innsbruck, 1901, VI, Ergänzungsband, pp. 830–857.

——, 'Das Inventar der Prager Schatz- und Kunstkammer vom 6. Dezember 1621,' *Jahrbuch der Kunsthistorischen Sammlungen des Allerhöchsten Kaiserhauses*, Vienna, XXV, 1905, II Theil, pp. XIII–LI.

CATALOGUE RAISONNÉ

Arranged alphabetically by subject; pictures of the same subject appear chronologically.
Dimensions are cited in all cases height×width.

1. **Giovanni Francesco Acquaviva d'Aragona, self-styled Duke of Atri** Plates 168, 169

Canvas. 2·304×1·532 m.

Cassel, Staatliche Gemäldegalerie.

Signed in capitals on the rock to the right of the cherub: TITIANVS FECIT

About 1552.

The red velvet costume decorated with gold consists of slashed trunks and an upper part over the body called a brigandine (i.e. cloth over iron rings or plates of metal). Fine chain mail forms the sleeves. The fantastic head gear, also red, the red hose, the slashed red velvet shoes likewise embroidered in gold, and the spectacular red helmet at the left combine to create a brilliant colour composition against the illusionistic landscape, which is effective though faded. The cherub and the large white hound with yellow ears, which is nearly identical with the animal in the *Boy with the Dog* (*c.* 1565) in the Rotterdam museum add further unusual elements to an altogether exceptional combination. Because of the hound Hetzer dated the Acquaviva portrait in Titian's late period.

The identification of this man as Giovanni Francesco Acquaviva is very tentative, since it rests primarily on the fact that an Acquaviva portrait by Titian existed. In August 1552 Pietro Aretino wrote to Acquaviva referring to Titian's portrait and again in December to the Duchess of Atri (*Lettere*, edition 1957, II, pp. 404–405, 418–420). It is a puzzling circumstance that Aretino refers to the Duchess as Susanna, since no Susanna occurs in the Acquaviva genealogies compiled by Litta (1819–1923, vol. x). When Aretino wrote, the legitimate Duchess was Isabella Spinelli, wife of Giannantonio Donato Acquaviva and daughter of the Count of Cariati. The wife of the self-styled Duke was Camilla Caracciolo, daughter of the Prince of Melfi, another Neapolitan exile at the French court (Litta, vol. x, tav. IV, v). Hadeln discovered another portrait purporting to be Acquaviva (Cat. no. X–1), and he consequently rejected the identification of the Cassel picture.

Biography: Son of Giulio Antonio Acquaviva d'Aragona (Cat. no. X–2), the self-styled Duke of Atri (*c.* 1510–1569)

was a Neapolitan driven into exile by the Spanish along with his father in 1528. Both father and son lived chiefly in Paris thereafter, supported by pensions from Francis I, Henry II and Catherine dei Medici, but Giovanni Francesco visited the court of Pope Paul III (Cat. no. 72) during 1547–1548. At this time he may have journeyed to Venice, or possibly that visit was made about 1551–1552. In 1554 Acquaviva was again recorded in Paris, where Henry II made him a cavalier of the Order of St. Michael (Fasano Guarini, 1960, pp. 192–193). He died in Paris in 1569.

Condition: The landscape has faded slightly but the picture is generally well preserved.

Possible source: Collection of Sir Anthony van Dyck, Inventory 1644, 'Il Duca di Sforza di Milano con un cane' (Müller-Rostock, 1922, pp. 22–24).

History (as reconstructed by Justi, 1894, pp. 161–162): De la Chataiqueraye, Paris (catalogue of 1732); Prince de Carignan, Paris (sale, 30 July 1742); Duc de Tallard, Paris (sale, 29 May 1756; Mariette in 1720 identified the sitter as Dieudonné de Gozon in vol. x, p. 329; Blanc, 1857, I, p. 79); Hoet purchased it for William VIII of Hesse, founder of the Cassel Gallery; 1806, taken to Paris; returned in 1817.

Bibliography: See also above; C. and C., 1877, II, pp. 427–428 (Titian); Justi, 1894, pp. 160–174; Phillips, 1912, pp. 128–136 (Titian); Knackfuss, 1921, p. 106 (suggests he is Guidobaldo II [della Rovere] of Urbino); Fischel, 1924, pl. 170 (Titian); Hadeln, 1934, p. 16 (unknown sitter); Suida, 1935, pp. 110, 116, pl. 198 (unknown sitter); Tietze, 1936, II, p. 291 (Titian); Hetzer, 1940, p. 166 (Titian, *c.* 1560); Pallucchini, 1954, II, p. 56 (Titian, *c.* 1550); dell'Acqua 1955, pl. 142 (Titian); Berenson, 1957, p. 184 (Titian, 1552); Vogel, 1958, p. 159 (Titian); Valcanover, 1960, II, pl. 40–41 (Titian); *idem*, 1969, no. 332 (Titian, unknown gentleman); Pallucchini, 1969, p. 301, figs. 391–393 (Titian, *c.* 1550–1555); Herzog, 1969, p. 76, pl. XV.

Giovanni Francesco Acquaviva, see also: Cat. no. X–1.

73

Amico di Tiziano, see: Friend of Titian, Cat. no. 39.

2. **Antonio Anselmi** Plate 158

Canvas. 0·76×0·635 m.

Lugano, Thyssen Bornemisza Collection.

Inscribed on the back: ... ONIVS. ANSELMVS. ANN. 38. 1550 ...

TITIANVS. F.

Dressed in black, Anselmi once rested his arm upon a red table, now eliminated. Blue highlights on the sleeves and collar and the tiny white ruff now provide the only contrasts to the black hair and beard and the dark costume and background. Anselmi gives the impression of a well-born intellectual with a clear, direct glance, self-assured, rather handsome, but not arrogant.

Biography: Antonio Anselmi (1512–c. 1568), a Bolognese scholar, spent ten years (1537–1547) as secretary to Pietro Bembo (Cat. no. 15), after whose death he passed into the service of Bishop Ludovico Beccadelli (Cat. no. 13), a man who had also been in Bembo's entourage. Anselmi was in correspondence with major literary figures of his day as well as being a poet himself. Pietro Aretino's letters to Anselmi are dated 1537–1548 (*Lettere*, edition 1957, I, p. 38, II, pp. 162, 256–257, 300). The inscription on this portrait shows that he was born in 1512 and rules out the former hypothesis placing his birth at the end of the fifteenth century (Quattrucci, 1961, p. 377). Furthermore, the portrait clearly represents a young man, not someone past the half-century mark.

Condition: Cut down on all sides, particularly the lower edge, removing the hand; cleaned in 1960; very dark but otherwise well preserved.

History: W. von Dirksen, Berlin, who purchased it from a Berlin dealer in 1904; F. Steinmeyer, Lucerne, 1924 (Fischel, 1924, pl. 165); Haberstock, Berlin, 1929; purchased by Thyssen-Bornemisza in 1929.

Bibliography: See also above; Rinteln, 1905, pp. 202–204 (first published the portrait); Fischel, 1924, p. 168 (Titian); Suida, 1935, pp. 110, 174 (Titian); Tietze, 1936, II, p. 295 (Titian); Berenson, 1957, p. 187 (Titian); Heinemann, 1958, no. 421 (Titian); Valcanover, 1960, II, pl. 39 (Titian); Hendy, 1964, p. 107 (Titian); Valcanover, 1969, no. 333 (Titian); Pallucchini, 1969, p. 293, figs. 352–353 (Titian, 1550).

3. **Seigneur d'Aramon (Gabriel de Luetz)** Plate 102

Canvas. 0·74×0·74 m.

Milan, Castello Sforzesco, Council Room.

Signed at the left of the arrows: TITIANVS F

A partially defaced inscription at the top reads: MONSOR DE ARAMON...IMBASATOR DE [FRANCIA] A CONSTANTINOPOLI 1541–1542.

With the simplest means Titian has created a sympathetic portrait of an intelligent aristocrat. The golden arrows, which must have an heraldic significance, the chain, and the white collar afford the major contrasts to the grey and black costume and the green curtain behind the figure.

Biography: During a rather adventurous career the Seigneur d'Aramon (c. 1500–1554), from a village near Nîmes, visited Venice at least three times, in January 1541, February 1542, and for fourteen days in 1547. On the last two occasions he was *en route* with a legation to Constantinople on behalf of Francis I in an attempt to induce Rustem Pasha, the Turkish Grand Vizier, to attack Hungary and to send his fleet to North Africa. The strategy was part of the struggle of the French against the Hapsburg empire of Charles V. Aramon apparently remained in the Near East until 1553. The journal of his voyage and diplomatic efforts has been published and his biography reconstructed (Farges, 1886; Chesneau, 1887, pp. I–LI, 2–4).

Condition: Slightly darkened; the inscription must be a later addition because of its crowded position and the fact that Aramon was a Seigneur (lord) and not an ecclesiastic (monsignore).

History: Prince Trivulzio, Milan; bequest to the Castello Sforzesco in 1928 (Nicodemi, 1935, p. 37).

Bibliography: See also above; Suida, 1929, pp. 7–8 (initial publication of the picture); *idem*, 1935, pp. 84, 172 (Titian); Tietze, 1936, II, p. 300 (Titian); Pallucchini, 1953, p. 202 (Titian); Berenson, 1957 (omitted); Valcanover, 1960, I, pl. 165A (Titian): *idem*, 1969, no. 232 (Titian); Pallucchini, 1969, pp. 277–278, fig. 267 (Titian, c. 1541–1543).

4. **Archbishop Filippo Archinto** Plate 162

Canvas. 1·15×0·89 m.

Philadelphia, John G. Johnson Collection.

About 1558.

The unorthodox nature of this picture, in which the transparent curtain is drawn over the figure leaving only the

episcopal ring on the right hand and half of the right eye fully visible, immediately puzzles every observer. The explanation recently offered by Richard J. Betts seems reasonable, i.e. that it refers to the fact that Archinto was prevented from assuming his post as archbishop of Milan by the curia, which he had planned to purge. Thus the bishop shows his ring of authority but is veiled because he was unable to exercise his authority. Betts draws the parallel to St. Paul's difficulties in Corinth and sees Archinto's inspiration in the Apostle's words: 'And if our gospel is also veiled, it is veiled only to those who are perishing. In their case, the god of this world has blinded their unbelieving minds, that they should not see the light of the gospel of the glory of Christ, who is the image of God.' These events place the portrait in the year 1558, when Archinto was obliged to retire to Bergamo, where he died on 21 June 1558 (Betts, 1967, pp. 59–61).

Technically the painting is a tour-de-force in the rendering of the figure visible beneath a veil. Professor Ruth Kennedy's theory that Titian was inspired in this technical trick by the classical story of the painter Parrhasios appears much less to the point than the events of Archbishop Archinto's own life (Kennedy, 1964, p. 168). Her belief that the Philadelphia version served as a cover for the other portrait without the veil in the Metropolitan Museum (see Variant below) also fails to convince, if only because the latter picture is inferior in quality.

Biography: Filippo Archinto (1495–1558), Milanese by birth, took a doctorate in law at Pavia. Closely associated with the Spanish, he was sent by the Milanese to the Spanish capital at Valladolid in 1527, to Barcelona in 1529, and to the coronation of Charles V at Bologna in 1530. At Rome Paul III persuaded him in 1535 to enter the papal service, and he became governor of the city. Three years later he was made Bishop of Borgo San Sepolcro, although he never resided there. His career, continuing to be political, included a visit to the Council of Trent in 1546 and his later appointment as papal nuncio at Venice (1554–1556). A bitter controversy over his nomination as bishop of Milan in 1556 and his inability to occupy the see resulted in his spending the last months of his life in Bergamo (Alberigo, 1961, pp. 761–764).

Condition: Cleaned in 1950; well preserved.

History: Archinto family, Milan (sale, Paris, Hôtel Drouot, 18 May 1863, no. 59, as by Titian); purchased by Italico Brass, Venice, who owned it 1863–1909. John G. Johnson, Philadelphia, 1909.

Bibliography: See also above; Litta, 1850, I, 'Archinto',

tav. IV following (Titian); Berenson, 1913, I, pp. 126–127 (Titian, c. 1554–1556); Fischel, 1924, p. 185 (Titian, c. 1554); Suida, 1935, p. 109 (Titian); Tietze, 1936 and 1950 (omitted); Zarnowsky, 1938, pp. 103–108 (Girolamo Dente); Berenson, 1957, p. 190 (Titian); Valcanover, 1960, II, p. 71; *idem*, 1969, no. 402 (attributed); Marceau and Sweeney, 1966, p. 76, no. 204 (Titian); Betts, 1967, pp. 59–61 (Titian); Pallucchini, 1969, p. 303 (Titian and Orazio Vecellio).

VARIANT:

New York, Metropolitan Museum of Art (Plate 163); canvas, 1·18×0·94 m.; Workshop of Titian or Leandro Bassano.

The unusual circumstance about this portrait is the fact that both it and the veiled bishop now in Philadelphia were in the possession of the Archinto family at Milan until 1863. The Metropolitan example carried an attribution to Leandro Bassano and the other to Titian. The considerable disparity in quality between the two works explains the separate attributions, although the pose is identical. The workshop of Titian is a reasonable classification for the Metropolitan Museum example, yet the possibility that it is a later copy by Leandro Bassano cannot be ruled out.

Condition: Cleaned in 1949.

History: Archinto family, Milan (sale, Paris, 18 May 1863, no. 4, as by Leandro Bassano); acquired by Italico Brass, Venice, 1863–1900; Benjamin Altman, New York, c. 1900–1913; bequest to the Metropolitan Museum in 1913.

Bibliography: See also above; Monod, 1923, p. 191 (Titian, 1545–1546); Fischel, 1924, p. 184 (Titian, c. 1554); Suida, 1935, pp. 109, 174 (Titian, c. 1554–1556); Tietze, 1936 and 1950 (omitted); Zarnowsky, 1938, pp. 103–108 (Girolamo Dente); Wehle, 1940, p. 194 (later than the Philadelphia version); Duveen, 1941, pl. 160 (Titian); Berenson, 1957, p. 189 (Titian, 1554–1556); Valcanover, 1960, II, p. 71 (attributed); *idem*, 1969, no. 392 (workshop); Betts, 1967, pp. 59–61 (possibly Leandro Bassano); Pallucchini, 1969, p. 302, fig. 398 (Titian and workshop).

5. Pietro Aretino

Plate 96

Canvas. 1·08×0·76 m.

Florence, Pitti Gallery.

1545.

In a letter of October 1545 Aretino wrote scathingly of this picture, which he called a sketch, not a finished work, suggesting that Titian was not paid highly enough to do better (*Lettere*, edition 1956–1957, II, pp. 107–108). It is

true that the highlights are seemingly slashed on with abandon, but Titian knew exactly the effect he wanted. The broad brown velvet cloak with rose satin lining is placed over a golden brown garment, upon which appears a gold chain, the gift of King Francis I. The effect of filling the picture space with the figure is characteristic of Titian's style at the period and not solely due to the massive bulk of Aretino's body.

Biography: See Cat. no. 6.

Condition: The canvas is dry and dirty.

History: Aretino's gift to Cosimo I dei Medici in 1545.

Bibliography: See also above; Vasari (1568)-Milanesi, VII, p. 445; C. and C., 1877, II, pp. 109–110; Gronau, *Titian*, 1904, p. 127 (Titian); Suida, 1935, pp. 88, 169 (Titian); *Mostra di Tiziano*, 1935, no. 62 (Titian, 1545); Tietze, 1936, II, p. 289 (Titian); Jahn-Rusconi, 1937, p. 302 (Titian); Paris, 1954, no. 54 (Titian); dell'Acqua, 1955, pl. 119 (Titian); Valcanover, 1960, I, p. 193 (Titian); Francini Ciaranfi, 1964, p. 53, no. 54 (Titian); Valcanover, 1969, no. 246 (Titian); Pallucchini, 1969, p. 282, figs. 293–294 (Titian, 1545); Panofsky, 1969, p. 10, note 9 (possible influence of Michelangelo's *Moses*).

REPLICA:
Newcastle, Pennsylvania, Arthur Kohn; canvas, 0·99× 0·762 m. This replica of the Pitti portrait, which seems to have rather exaggerated white highlights, may be a later copy.

History: Captain Manners, ninth duke of Rutland (?); International Art Gallery, London, in 1937.

6. Pietro Aretino Plate 99

Canvas. 1·02× 0·857 m.

New York, Frick Collection.

About 1548.

In its present state this portrait is much more impressive than the version in the Pitti Gallery; even the pose is freer, the figure less bulky, and the head more sympathetic.

Biography: Pietro Aretino (1492–1556), son of a shoe-maker, came from a humble background at Arezzo, but he managed to obtain an education there and at Perugia, before he passed to Rome under the patronage of Agostino Chigi (1517). Closely associated with artists, writers, and humanists in Rome, his literary career as writer of plays, poetry and satirical tracts grew rapidly. After 1522 he lived at various ducal courts, particularly at Mantua under the patronage of Federico II Gonzaga (Cat. no. 49). From 1527, however, he settled in Venice, where he became an intimate friend of Jacopo Sansovino and Titian. His collected letters are a primary source of documentation for many works of the great Venetian painter (Innamorati, 1962, pp. 89–104; Aretino, *Lettere*, edition 1956–1957).

Condition: Well preserved and conserved; slightly cut down at the lower edge; a wax seal of the Chigi on the stretcher.

History: Perhaps the picture done for Francesco Marcolini (cited by Vasari (1568)-Milanesi, VII, p. 445); mentioned in the 1692 Inventory of Cardinal Flavio Chigi (New York, Frick Collection, 1968, II, p. 259); Palazzo Chigi, Rome (Cecconi, 1725, p. 178; Titi, 1763, p. 357); remained there until 1904; Colnaghi, London, 1905; purchased by Frick, 1905.

Dating: A letter, dated Venice, 15 September 1551, from Aretino's publisher Francesco Marcolini to the former praises a portrait of Aretino by Titian and speaks of it as having been painted in the past (Bottari, 1822, V, pp. 253–256). However, Aretino's grey beard in the Frick portrait implies a date no earlier than 1548, when Pietro himself stated that he had just stopped dyeing it (Aretino, *Lettere*, 1609, IV, pp. 127–128, 200).

Bibliography: See also above; C. and C., 1877 (unknown to them); Cavalcaselle, 1891, p. 2 (Titian); Morelli, 1892, I, p. 309; 1897, p. 314 (Titian); Gronau, *Titian*, 1904, p. 127 (Titian); *idem*, 1905, pp. 294–296 (Titian, 1548); Ffoulkes and Venturi, 1905, p. 386 (not Titian); Fry, 1905, pp. 344–347 (Titian); L. Venturi, 1931, pl. 383; 1933, pl. 517 (Titian); Suida, 1935, pp. 88, 169 (Titian, 1538); Tietze, 1936, II, p. 303 (Titian); Mayer, 1937, pp. 307–308 (Titian, *c.* 1548); dell'Acqua, 1955, pl. 125 (Titian, after 1548); Valcanover, 1960, II, pl. 11 (Titian); New York, Frick Collection, 1968, II, pp. 256–261 (exhaustive bibliography and study); Valcanover, 1969, no. 310 (commonly attributed): Pallucchini, 1969, p. 290, fig. 337 (Titian, post 1548).

ENGRAVED PORTRAITS:
1. In the edition of Aretino's letters, *Le lettere di M. Pietro Aretino*, Venice, 1538. Suida's theory (1935, p. 88) that the engraving is based on the Frick portrait, which should therefore be dated 1538, cannot be accepted. In the engraving Aretino is presented in profile, unlike the painting, and his costume is also entirely different, although he has the long abundant beard worn in both the Frick and the Pitti pictures.

2. An engraving by Pieter de Jode, after a lost portrait attributed to Titian, is incorrectly identified in the print as representing Pietro Aretino (illustration in Suida, 1936, p. 281, pl. IIC).

3. W. Hollar, after a picture in the Van Verle Collection, Antwerp (Parthey, 1853, nos. 1346–1348).

LITERARY REFERENCES:

1. Bologna; Vasari mentions a portrait of Pietro Aretino painted at Bologna (i.e. 1532–1533). It is difficult to find any support for Panofsky's theory that Aretino gave this picture to Ippolito dei Medici (Vasari (1568)-Milanesi, VII, p. 442 and note 1; also Panofsky, 1969, p. 10 note 9).

2. Como, Paolo Giovio Collection; on 11 March 1545 Giovio wrote to Aretino requesting a coloured drawing, if he could not send a portrait on canvas, for use by his engraver (Müntz, 1898, p. 283; Bottari, 1822, V, pp. 282–283). The tradition that Aretino provided Giovio with his own portrait by Titian is based on a letter of Count Giovio, written more than two centuries later on 8 September 1780 (Müntz, 1898, p. 342).

3. Mantua, Gonzaga Collection; Titian presented to Federico Gonzaga a portrait of Aretino and one of Girolamo Adorno according to his own letter of 22 June and Federico's acknowledgement of it on 8 July 1527. In a letter of 6 October 1527 sent to Federico Gonzaga, Aretino himself took credit for the gift of his own portrait (Aretino, *Lettere*, edition 1957, I, p. 17; also d'Arco, 1857, I, p. 99).

VARIANTS KNOWN IN SALES CATALOGUES (perhaps actually only one or two items):

1. Cheltenham, Lord Northwick, *Pietro Aretino*, half length in black (sale, 10 April 1860, p. 26, no. 359).

2. London, Robert Fagan and Charles Grignon (sale, London, Squibb, 29 May 1806, p. 8, by Titian).

3. London, Earl Grosvenor and Welbore Ellis Agar (sale, London, Peter Coxe, 27 June 1807, no. 50, by Titian).

4. London, Lansdowne House, Marquess of Lansdowne (sale, London, Peter Coxe, 20 March 1806, no. 4, by Titian).

Pietro Aretino, see also Cat. no. X–6.

7. **Ariosto** (so-called) Plate 217

Canvas, 0·596 × 0·47 m.

Indianapolis, Indianapolis Museum of Art.

About 1512.

The features of this gentleman by no means closely resemble those of Ariosto, which are well known from paintings,

prints, and medals (see Fry, 1904–1905, pp. 136–138; Gronau, 1933, pp. 194–203; also Cat. no. X–7).

Tietze's attempt (1940, no. 65) to associate this picture with a portrait of Ariosto by Titian cited by Ridolfi (Ridolfi (1648)-Hadeln, I, p. 162) is totally unconvincing, since in that canvas, once in the Renieri Collection at Venice, Ariosto is described as presented 'in a majestic manner with garments of black velvet lined in fur'. In the present portrait the gentleman wears a red doublet with fur at the shoulders, and the simplicity of the bust-length figure can hardly be described as majestic. The costume with the square cut neck would suggest an early date, and if the man is really Ariosto that would mean about 1516, when Titian first went to Ferrara. However, Ariosto was then forty-two years old, whereas the sitter here is surely ten years younger. All these considerations throw something more than doubt upon the possibility that Ariosto is represented in the Indianapolis portrait.

Biography: See Cat. no. X–7.

Condition: Badly damaged by an accident in the museum, when water leaked over the canvas.

History: Anonymous sale (Campbell), London, Sotheby's, 29 January 1930, no. 52A (*APC*, IX A, 1929–1930, no. 3867, a gentleman by Titian); Mr. and Mrs. Booth Tarkington, Indianapolis, 1938–1948; gift to the museum in 1948.

Bibliography: See also above; Tietze, 1940, no. 65 (Ariosto by Titian); *idem*, 1950, p. 376 (same opinion); Peat, 1947, pp. 3–5 (Ariosto by Titian); Berenson, 1957, p. 186 (Ariosto (?) by Titian); Valcanover, 1960, I, pl. 63 (Ariosto by Titian); Valcanover, 1969, no. 72 (commonly attributed; presumed portrait of Ariosto); Pallucchini, 1969, p. 251, fig. 119 (Ariosto by Titian, c. 1516).

LOST PICTURES (Ariosto by Titian, known only in literary references):

1. Venice, Renieri Collection; Ariosto in black velvet lined in fur by Titian (Ridolfi (1648)-Hadeln, I, p. 162). C. and C., 1877, I, p. 200, note, assumed it to be the picture in the National Gallery, London, now given to Palma il Vecchio. Tietze attempted to identify it with the work now in Indianapolis (Cat. no. 7).

2. Venice, Giovanni Antonio Moschini in 1840 bequeathed a copy of Titian's *Ariosto* to Dr. Agostino Quintavalle (Cicogna, IV, 1834, p. 694).

Ariosto, see also: Gentleman in Blue, Cat. no. 40; Venetian Gentleman, Cat. no. X–110.

7

8. **Cardinal Georges d'Armagnac and His Secretary Guillaume Philandrier** Plate 135

Canvas. 1·04×1·143 m.

Alnwick Castle, Duke of Northumberland.

1536–1538.

The bishop, entirely in black garb, is seated before a grey stone wall, while a gold-coloured pilaster with heraldic ornament finishes the picture at the left. The dark-bearded secretary at the right, dressed in a black coat over a red doublet and red sleeves, rests his arms upon the table covered with a light green cloth. The blue of the sky remains clear and strong, whereas the trees have darkened. The rather stony character of the bishop comes across in his stolid pose, perhaps to be judged as thought-immersed, while the secretary awaits the next word with a cautious, even apprehensive look.

The composition of this picture certainly implies that Titian was familiar with Sebastiano del Piombo's *Cardinal Carondolet and his Secretaries* (now in the Thyssen Bornemisza Collection at Lugano), painted at Rome in 1511–1512, a sketch of which the artist may have seen. Gould, however, considers Raphael's *Leo X and Nephews* the real source of Titian's picture at Alnwick, since Andrea del Sarto's copy was then at Mantua, where the Venetian would have seen it (Gould, 1966, pp. 49–50). Nevertheless, I find it difficult to see any similarity between the two works.

The identity of d'Armagnac was established and the history of the picture reconstructed in exhaustive detail by Jaffé (1966, pp. 114–126). Samaran added an important study of d'Armagnac's career and published a portrait of him in the archiepiscopal palace at Rodez, which further confirms the identification. The same scholar explained the meaning of the heraldic objects upon the pilaster in the left background, i.e. the sheaf of wheat, which is found in d'Armagnac's escutcheon, and the crown above it, which refers to his descent from the counts of Rodez and d'Armagnac. Since the bishop was an ambassador of Francis I, Samaran demonstrates that the pomegranate refers symbolically to the treaty of Nice between Charles V and Francis I (Samaran, 1967, pp. 115–129). The logical date for the picture is 1536–1538, when d'Armagnac was French ambassador at Venice.

Biography: Georges d'Armagnac (1500–1585), bishop of Rodez, archbishop of Tours and later of Toulouse, was elevated to the rank of cardinal in 1551. Although he served as French ambassador to Venice (1536–1538) and later to Rome, he was as much a humanist as a politician, and he collected one of the great libraries of his time (Jaffé, *op. cit.*; Samaran, *op. cit.*; Daniele, 1948, pp. 124–126).

Condition: Cleaned, relined, and X-rayed in 1965–1966.

History: Purchased in France for the Duke of Buckingham by Balthasar Gerbier and shipped from Boulogne to England in November 1624; listed in the Buckingham Collection at York House in the Inventory of 1635 (Davies, 1906–1907, p. 380: 'A picture of the French Ambassador Enditeing'); mentioned in the Northumberland Collection at Suffolk House in 1652 as 'Titian: a Senator and His Secretary'; at Alnwick Castle in 1671 in the Inventory by Symon Stone as Titian's 'Duke of Florence and Machiavil'; Syon House, Guildford, as Venetian School, in 1940; taken to Albury Park during World War II; moved to Alnwick Castle in 1966 (history reconstructed by Jaffé, 1966, pp. 114–119, from the Northumberland archives and elsewhere).

Bibliography: See also above; Jaffé, 1966, pp. 114–126 (Titian; with complete data); Samaran, 1967, pp. 115–129 (Titian); Valcanover, 1969, no. 202 (traditional attribution); Pallucchini, 1969, pp. 272–273, fig. 244 (Titian, c. 1538–1539).

COPIES:

In addition to the five items listed below Professor Jaffé has examined and published several others (Jaffé, 1966, pp. 114–120) and has traced the influence of Titian's original on the English school.

1. Kimbolton Castle; canvas, 1·09×1·155 m., as the 'Grand Duke and Machiavel' (Jaffé, 1966, p. 118).
2. London, British Museum, corridor outside the director's office; English copy, eighteenth century, canvas, 1·23×1·56 m.; from Montague House as 'Cosimo de' Medici and His Secretary' (Jaffé, 1966, pp. 117–118).
3. Nivaagard (Denmark), Statens Museum for Kunst; canvas, 0·93×1·11 m. (Berenson, 1957, p. 189).
4. New York, Jacob Reder; 'Senator and Secretary' (photograph, Courtauld Institute, London); Jaffé, 1966, p. 119 (copy, full account).
5. Paris, Musée du Louvre, Dépot de la Récuperation; canvas, 1·07×1·016 m., English copy, seventeenth century; formerly Paul A. Jurschewitz, then published by A. Venturi, 1932, p. 46 (as Alfonso d'Este I by Titian); Mayer, 1931, p. 346 (Titian); Jaffé, 1966, p. 119 (English copy, seventeenth century).

9. **Alfonso d'Avalos, Marchese del Vasto, with Page**
 Plate 56

Canvas, 1·10×0·84 m.

Paris, Marquis de Ganay.

1533.

The standing figure accompanied by a small secondary attendant appears in other portraits by Titian, notably *Charles V with Hound* (1533) in the Prado (Cat. no. 20) and *Guidobaldo II of Urbino with his Son* in London (Cat. no. 91). It has been suggested that the page is d'Avalos' son Francesco, born in 1530 (Braunfels, 1930, pp. 109–110) on comparison of the child's head with the page in the *Allocution of the Marchese del Vasto* (Cat. no. 10) in the Prado. On the contrary, the ugly face of the page in this picture of 1533 may even be that of a dwarf as Panofsky thought (1969, p. 74, note 43). The characterization of d'Avalos, who was essentially a despicable person, is sympathetic and undoubtedly flattering. Most effective in the portrait are the gracious pose and the exquisite painting of the black armour inlaid with gold ornament. Fate has been kinder to this canvas than to the majority of Titian's portraits.

The shoulder-length woodcut of d'Avalos reproduced in Paolo Giovio's *Elogia* (1575, p. 335) does not follow Titian's work, as the armour is entirely different. The identification of the Paris portrait as d'Avalos has not been challenged, since he is obviously the same person as illustrated by Giovio and also in a labelled miniature from the series of portraits formerly at Ambras Castle near Vienna (Wilczek, 1929, see below).

Biography: Alfonso d'Avalos (1502–1546), Marchese del Vasto e di Pescara, was born at Ischia, son of the previous holder of the Vasto title and cousin of the famous Marchese di Pescara, husband of Vittoria Colonna, from whom he inherited the second title. He joined the imperial forces of Charles V, became one of the commanders at the battle of Pavia (1525) and was subsequently made captain general of the imperial forces in Italy. Taken prisoner by Andrea Doria after a serious defeat in the Gulf of Salerno in 1528, he persuaded Doria to defect to the forces of Charles V. Among the several military campaigns in which he took part was the expedition to Tunis (1535). Three years later Charles appointed him governor of Milan and commander of the forces in Italy. His intolerance, arrogance, as well as his avariciousness and corrupt administration led the Emperor to recall him to Madrid; he died shortly afterwards in 1546 (Caro, 1962, pp. 612–616). The order of the Golden Fleece, the collar of which he wears in Titian's portrait, was bestowed upon him in 1532 (Pauwels, 1962, p. 40).

Condition: Exceptionally well preserved.

Dating: Painted at Bologna in 1533 (Vasari (1568)-Milanesi, VII, pp. 441–442); accepted by Wilczek, Tietze, and Panofsky; Doria-Bologna proposed 1543 at Busseto, but that meeting between Charles V and Paul III was too brief for portraits; 1536 is proposed by Mayer (1938, p. 294), Pallucchini (1953, I, p. 177), and Shearman (1965, p. 173), who argues for the date 1536 at Asti, as Titian's letter to Aretino speaks of meeting d'Avalos there in May (Ticozzi, 1817, p. 309).

History: King Stanislas of Poland (according to tradition); Count Potocki, Paris, until 1925; Comtesse de Béhague, Paris, 1925–1939; her bequest to her nephew, the present owner.

Bibliography: See also above; Wilczek, 1929, pp. 240–247 (major article); Suida, 1935, p. 168 (Titian); Tietze, 1936, II, p. 306 (Titian); Doria and Bologna, 1954, pp. 15–16 (Titian); Berenson, 1957, p. 190 (Titian); Valcanover, 1960, I, pl. 144 (Titian); Panofsky, 1965, p. 191 (Titian); Valcanover, 1969, no. 231 (Titian); Pallucchini, 1969, p. 272, fig. 242 (Titian, c. 1536–1538); Panofsky, 1969, p. 74, note 43 (Titian, 1532–1533).

10. Alfonso d'Avalos, Marchese del Vasto, Allocution of
Plates 57, 58

Canvas. 2·23 × 1·65 m.

Madrid, Prado Museum.

1539–1541.

The subject of a general addressing his troops has many precedents in ancient and Renaissance history, and in pictorial representation, especially on ancient Roman monuments. Panofsky in his exhaustive study of this picture proposed that d'Avalos wished to commemorate his personal feat in persuading his mutinous soldiers to advance against the Turks in the Hungarian campaign of 1532 (Panofsky, 1965, pp. 195–197; 1969, p. 76). The boy at d'Avalos' side is Francesco Ferrante (1531–1571), his son, who holds his father's helmet. The general's lifted right arm conforms to standard rhetorical gesture while the baton in the left hand indicates his rank as a military leader.

The elevated position of Alfonso d'Avalos is natural enough for this subject, yet numerous proposals have been advanced regarding classical Roman models, such as the Aurelian relief on the arch of Constantine, and others on the columns of Trajan and Marcus Aurelius, as well as Giulio Romano's *Allocution of Constantine* in the frescoes of the Vatican, and Roman coins (Panofsky, 1965, pp. 191–195 with illustrative material). The costumes and setting are, however, entirely Renaissance in design.

Condition: Badly damaged, perhaps in the fire at the Escorial in 1671; old restorations; darkened and dirty. The colour,

blackened and muddy, retains some brilliancy only in the red drapery over the Marchese's shoulder and in the red velvet over the back of the man who lifts the sword. The crowd of soldiers with pikes is barely discernible.

History: Aretino reported to the Marchese del Vasto in a letter of 20 November 1540 that the picture was in preparation, and with another letter of 22 December 1540 he dispatched Titian's *modello* [lost] of the picture. On 15 February 1541 Aretino wrote to Girolamo Martinengo requesting the loan of a suit of armour for the painter to follow (Aretino, *Lettere*, edition 1957, I, pp. 161–163, 176–177, 180–181); said to have come from the Gonzaga Collection at Mantua (although it does not appear in their inventories) according to the catalogue of the collection of Charles I of England (van der Doort, 1639, Millar edition 1960, p. 15, no. 8, 'a Mantua peece done by Tichin'); purchased for Philip IV of Spain at the sale of Charles I's pictures at Somerset House, May 1650 (Cosnac, 1885, no. 243, Le Marquis du Guast; Charles I, LR 2/124, folios 171–172); Alcázar, Madrid, Inventory 1666, no. 535, in the 'pieza de la torre en el cuarto alto'; Escorial, 1667, or perhaps this item was a copy (Padre de los Santos, edition 1667, folio 100ᵛ); Beroqui suggested that it was the original and that it was returned to Madrid after the Escorial fire of 1671; Alcázar, Madrid, Inventory 1686, no. 762, in the 'pieza de las bóvedas que cae debajo el despacho de verano'; Inventory 1700, no. 419 (Bottineau, 1958, p. 311); Inventory 1734, no. 42 (said to be *bien tratado*, i.e., well treated, therefore not damaged at that time); Inventory 1747, no. 12; Palacio Nuevo, Antecamara del Infante don Gabriel in 1772; Cuarto del Infante don Antonio (Ponz, 1776, tomo VI, 58); Prado Museum, 1828 (Beroqui, 1946, p. 60).

Bibliography: See also above; C. and C., 1877, II, pp. 27, 51–53; Allende-Salazar and Sánchez Cantón, 1919, pp. 39–41 (Titian); Beroqui, 1925, pp. 251–259; *idem*, 1946, pp. 53–61 (Titian); Suida, 1935, pp. 47, 80, 169 (Titian); Tietze, 1936, II, p. 299 (Titian); Berenson, 1957, p. 187 (Titian); Valcanover, 1960, I, pl. 158 (Titian); Braunfels, 1960, pp. 108–112; Prado catalogue, 1963, no. 417; Morassi, 1964, pl. 21 (colour reproduction); Panofsky, 1965, pp. 188–189; Valcanover, 1969, no. 218 (Titian); Pallucchini, 1969, p. 276, fig. 257 (Titian, *c.* 1540–1541); Panofsky, 1969, pp. 74–77.

COPIES:

1. London, Collection of Charles I; a copy of 'the Allocution of the Marquis del Guast done by Peter Oliver', a miniature now in the Royal Library. (van der Doort, 1639, Millar edition, 1960, pp. 104, 214, 233).
2. Naples, Museo di Capodimonte; two large copies,

2·86×2·48 m., much restored, in the *armeria* of the museum. In one of them Charles V appears as the chief figure (Rinaldis, 1927, p. 341, from the d'Avalos Palace in Naples; C. and C., 1877, II, p. 445; Bologna and Doria, 1954, p. 16). Another small copy in storage.
3. Toledo, Museo de Santa Cruz; variant in which d'Avalos holds a crucifix in his right hand and lilies in his left; a monogram reads: Pᴼvᴇs; canvas, 2·58×1·93 m.; on loan from the Prado Museum; perhaps the copy formerly in the sacristy of the Carmelitas Descalzos (Ceán Bermúdez, 1800, V, p. 41; Allende-Salazar and Sánchez Cantón, 1919, p. 40, illustrated; Beroqui, 1946, pp. 60–61 (copy); Charles V, 1958, p. 115, no. 141, pl. 109).

11. **Daniele Barbaro**　　　　　　　Plate 95

Canvas. 0·857×0·711 m.

Ottawa, National Gallery of Canada.

1544–1545.

Barbaro, as a young man aged thirty-one, makes a handsome appearance with his black beard and intelligent expression. Colours are limited to black against a green-black background. The Ottawa version, by general agreement superior to the repetition at Madrid (Cat. no. 12), includes an inscription at the top: DANIEL BARBARUS

Biography: Born of a noble Venetian family, Daniele Barbaro (1514–1570) studied the classics, philosophy, and science at the University of Padua, where his fellow students included Bernardo Navagero and Ludovico Beccadelli (Cat. no. 13). He also knew other celebrated humanists of his day, such as Pietro Bembo (Cat. no. 15), Bernardo Tasso and Cardinal Alvise Cornaro. After a period as Venetian ambassador to England (1548–1551), he was appointed successor to Giovanni Grimani as patriarch of Aquileia, but Grimani outlived him and Barbaro never occupied the see. His appointment, however, resulted in the obligation to attend the Council of Trent. Barbaro's fame rests chiefly on his commentaries on Aristotle, his translation with commentaries of Vitruvius' *I dieci libri d'architettura* (1566) and *La practica della prospettiva* (1567), the last being his most original work (Alberigo, 1964, pp. 89–95).

Condition: In a good state of preservation.

History: Aretino's letter to Paolo Giovio of February 1545 heaps praise upon this portrait, which had just been sent by Titian to the bishop at Como (*Lettere*, edition 1957, II, pp. 47–48); collection of Paolo Giovio, Como, until 1905 (L.

Venturi, 1932, pp. 482–484); private collection, Vienna; Sackville Gallery, London, from which acquired by Ottawa in 1928.

Bibliography: See also above; C. and C., 1877, II, p. 107 (reference to Aretino's letter only); L. Venturi, 1933, pl. 518 (Titian, 1545); Suida, 1935, pp. 89–90 (Titian); Tietze, 1936, II, p. 304 (Titian original); Hubbard, 1956, pp. 14–15 (Titian); *idem*, 1957, p. 41 (Titian); Valcanover, 1960, I, pl. 190 (Titian); *idem*, 1969, no. 249 (Titian); Pallucchini, 1969, p. 102 (not autograph).

ANOTHER VERSION:
Unknown location, formerly Vienna, Count Lancko-ronski (Suida, 1935, p. 172).

12. **Daniele Barbaro** Plates 93, 94
Canvas. 0·81×0·69 m.
Madrid, Prado Museum.
1545.

Identical in pose to the Ottawa portrait (Cat. no. 11). Both the quality and state of preservation are slightly less impressive here; nevertheless, the attribution to Titian is valid.

Condition: Much darkened and dirty; undoubtedly suffered in the fire of the Alcázar in 1734.

History: The portrait of Barbaro in the van Uffel Collection at Antwerp, engraved by Hollar in 1650, when belonging to the Van Verle (Parthey, 1853, no. 1359) might be the Prado example (Ridolfi (1648)-Hadeln, I, p. 198); Alcázar Inventory 1666, in the 'Pasillo que llaman de la Madona', no. 639, 'un hombre con un libro en la mano, de Ticiano'; Inventory 1686, no. 189 (Bottineau, 1958, p. 146); Inventory 1734, no. 127, simply 'un hombre medio cuerpo, original de Ticiano' (uncertain identification).

Bibliography: See also History; Madrazo, 1873, p. 89, no. 481 (Titian); C. and C., 1877, II, p. 446 (Pordenone); Allende-Salazar and Sánchez Cantón, 1919, pp. 64–65 (Barbaro by Titian); Beroqui, 1926, pp. 245–246; *idem*,1946, pp. 99–101 (Titian); Suida, 1935, pp. 89, 172 (Titian); Tietze, 1936, II, p. 299 (a replica of the Ottawa picture); Berenson, 1957, p. 187 (Titian); Valcanover, 1960, I, pl. 191 (Titian; replica of the Ottawa portrait); Prado catalogue, 1963, no. 414 (old no. 682) (Titian); Valcanover, 1969, no. 336 (Titian); Pallucchini, 1969, p. 283, figs. 298–299 (Titian, *c.* 1545).

13. **Ludovico Beccadelli** Plate 164
Canvas. 1·11×0·985 m.
Florence, Uffizi.
Signed on the paper and dated 1552.

Aretino's letter of October 1552 and the sonnet describing the portrait (*Lettere*, edition 1957, II, pp. 411–412) place the date accurately and verify the inscription, which includes the date, in Beccadelli's hands. Then bishop of Ravello and papal legate to Venice (1550–1554), Beccadelli is seated against a grey-green wall, and he wears a dark-red hood which has lost colour to the point that it is nearly as black as his flat black hat. The inscription upon the paper reads: 'Julius P P III. Venerabili frati Ludovico Epo. Ravellen apud Dominum Venetorum nostro et Apostolicae Sedes nuntio, cum annum ageret LII Titianus Veccilius [*sic*] faciebat Venetus MDLII Mense Juli . . .'

Biography: Born of an old Bolognese family, Ludovico Beccadelli (1501–1572) studied in Padua in the circle of Pietro Bembo (Cat. no. 15). He accompanied Cardinal Gasparo Contarini to Rome and to Venice (1535–1536), to Nice in 1538, to Spain, and later to Regensburg. After Contarini's death in 1542 he became vicar general at Reggio d'Emilia. Under Paul III (Cat. no. 72) he was appointed tutor to his grandson Ranuccio Farnese (Cat. no. 31), who prevailed upon the pope to appoint Beccadelli bishop of Ravello in 1549. Sent on various ecclesiastical missions including the Council of Trent, he succeeded as archbishop of Ragusa in 1555 and finally as bishop of Prato ten years later, a post which he held until his death in 1572 (Alberigo, 1965, pp. 407–413).

Condition: In general very dirty and obscured by old varnish; a fine crackle over the entire surface.

History: Bequeathed by Cardinal Leopoldo dei Medici in 1675.

Bibliography: See also above; C. and C., 1877, II, pp. 216–217; Italian edition, II, pp. 170–171; Suida, 1935, pp. 109, 174 (Titian); Tietze, 1936, II, p. 290 (Titian); Berenson, 1957, p. 186 (Titian); Valcanover, 1960, II, pl. 47A (Titian); Salvini, 1961, p. 67, no. 1457 (sometimes called an old copy); Valcanover, 1969, no. 347 (Titian); Pallucchini, 1969, pp. 297–298, fig. 376 (Titian, 1552).

14. **La Bella** Plate 71
Canvas. 0·75×0·69 m.
Florence, Pitti Gallery.
1536.

The mention of her as 'a lady in a blue dress' in the duke of Urbino's letter of 2 May 1536 proves that she is not the duchess, Eleanora Gonzaga, as Thausing proposed in 1878. Berenson adopted the suggestion in 1906, but in 1932 he reverted to the traditional title. *La Bella* has such an impersonal look and attitude that an ideal portrait is the most reasonable classification. The vivid green-blue dress with changing hues of red and violet against golden brown sleeves and the golden hair and gold chain provide richness of colour, which constitutes the most interesting part of the picture.

Condition: In a relatively good state.

History: A lady in a blue dress mentioned in a letter of 2 May 1536 from the duke to his agent Leonardi at Venice; brought from Urbino to Florence by Vittoria della Rovere in 1631 (Gronau, 1904, pp. 5, 18).

Bibliography: See also above; C. and C., 1877, I, pp. 391–392 (Titian at his best); Thausing, 1878, pp. 310–315 (Eleanora Gonzaga the model); Gronau, *Titian*, 1904, p. 290 (Titian, 1536); Berenson, 1906, p. 141 (portrait of Eleanora Gonzaga); Hadeln, 1909, p. 69; Ozzola, 1930–1931, p. 494 (as a portrait of Isabella d'Este!); *Mostra di Tiziano*, 1935, no. 26 (Titian); Suida, 1935, pp. 90, 168 (Titian); Tietze, 1936, II, p. 289 (Titian); Jahn-Rusconi, 1937, p. 301 (Titian); Pallucchini, 1953, I, pp. 176–177 (Titian); Berenson, 1957, p. 185 (Titian, *c.* 1536); Valcanover, 1960, I, p. 68 (Titian); Francini Ciaranfi, 1964, p. 53, no. 18 (Titian); Valcanover, 1969, no. 177 (Titian); Pallucchini, 1969, p. 270, fig. 226 (Titian, *c.* 1536).

COPIES:

Unimportant later copies; among them were one in the Cook Collection at Richmond, Surrey (no. 144), and another called Eleanora Gonzaga in the Stillwell sale, New York, American Art Association, 1–3 December 1927, no. 477, formerly Italico Brass, Venice; canvas, 0·915 × 0·723 m.

15. **Cardinal Pietro Bembo** Plate 90

Canvas. 0·943 × 0·765 m.

Washington, National Gallery of Art, Kress Collection.

About 1540.

In a brilliant red cardinal's robe and cap Bembo makes a powerful, impressive figure, his hand raised in a gesture of expounding. Titian considerably rejuvenated his subject, who must have been about seventy, since he became cardinal only in 1539. In the profile portrait by contrast (Cat. no.

X–11) Bembo has a long grey beard at the age of seventy-seven, the year of his death.

Biography: Son of a diplomat, Pietro Bembo (1470–1547), one of the great humanists of the Renaissance, had a long and unusually diversified career even for his period. Perhaps best known as author of the romantic love poem, *Gli Asolani* (1505), in which he glorified the court of Catherine Cornaro at Asolo after her retirement as Queen of Cyprus, Bembo had previously edited classical authors for Aldo Manuzio at Venice (1501). Later he spent some years at the courts of Urbino and Ferrara and acted as secretary of Leo X in Rome, where he collected antiques. After 1522 he settled in a handsome palace at Padua with his mistress, la Morosina, who bore him three children notwithstanding the fact that he held ecclesiastical benefices. In 1539 he was created cardinal by Paul III (Cat. no. 72), given the title of Bishop of Gubbio, and later elevated to the bishopric of Bergamo. Bembo continued, however, in Padua as his major residence. He died in Rome in the Palazzo Baldassini on the Campo Marzio on 18 January 1547. An excellent account of his life with full bibliography was published recently by Dionisotti (1966).

Condition: The left arm is invisible and the right hand partially sketched in; nevertheless, the work is in excellent condition.

Portraits: In addition to Titian's portraits, Bembo is figured on a medal by Valerio Belli (1532) and another attributed to Benvenuto Cellini (Fabrizy, [*c.* 1900], p. 97). The fantastic identification of him as Priapus in Giovanni Bellini's *Feast of the Gods* in Washington, has not been accepted by most scholars (Wind, 1948, pp. 42–43).

The portraits of Bembo have been the subject of an exhaustive article by Giulio Coggiola (1914–1915, pp. 473–514), a study which has eluded art historians. The lost representation of *Bembo as a Young Man*, assigned to Raphael when Marcantonio Michiel saw it in the scholar's own house at Padua about 1530 (Michiel, edition Frizzoni, 1884, p. 18; Coggiola, p. 476), does not concern us here. No evidence exists for the theory that Titian first portrayed the writer about 1515 at the age of forty-five (Coggiola, pp. 484–485). The painter did include Bembo along with Andrea Navagero, Jacopo Sannazzaro, Lodovico Ariosto, Fra Giocondo, and other notables in the mural in the Ducal Palace representing the *Humiliation of Emperor Frederick Barbarossa before Pope Alexander III*, a work completed in 1523 but totally destroyed in the fire in the Sala del Gran Consiglio of the Ducal Palace in 1577 (Sansovino, 1581, p. 18; also Ridolfi (1648)-Hadeln, I, p. 157). This portrait of Pietro Bembo at the age of fifty-three is not preserved even in prints or copies.

The other documents which survive in connection with Titian's portraits of Bembo include the letter of 30 May 1540, in which the writer in Rome asked his friend Girolamo Querini at Venice to thank the artist for his second portrait (Bembo, 1560, II, p. 133), saying that he had intended to pay for it but, since it was a gift, he would try to do Titian some service in return. This letter cannot refer to the profile portrait (Cat. no. X–11) of which many prints and copies exist, inasmuch as that one is datable 1547.

History: Gian Lorenzo Bernini; Barberini Collection, Rome, until 1928: Barberini Inventory of 1631 (Orbaan, 1920, p. 497, 'un ritratto d'un cardinale alto palmi 3½ incerca di mano di Titiano, havuto del cavalier Bernini'); Ramdohr (1787, p. 286) possibly includes Bembo's portrait in his reference to 'zwei Brustbilder aus Tizians Schule' in the Barberini Palace; still there in 1881 (Vasari (1568)-Milanesi, note by Milanesi, VII, 1881, p. 455); Colnaghi, London, 1928; Charles Schwab, New York, before 1936—until 1942 (sale, New York, Parke-Bernet, 3 December 1942, no. 32, as Titian); Samuel H. Kress Foundation, 1942.

Bibliography: See also above; C. and C., 1877, II, pp. 28–29 (Titian, 1540); Morelli, 1890, I, p. 406 (doubtful attribution); *idem*, 1897, pp. 314–315 (copy); Venturi, IX, part 3, 1928, p. 142 (Titian; confuses one picture as two separate works); Suida, 1935, p. 87 (Titian); *idem*, 1936, p. 281 (Titian); Tietze, 1936, II, p. 304 (Titian, 1540); *idem*, 1950, p. 403 (Titian *modello*); Berenson, 1957, p. 192 (Titian); Washington, National Gallery, 1959, pl. 193 (Titian); Valcanover, 1960, I, pl. 159 (Titian); Shapley, 1968, pp. 180–181 (Titian); Valcanover, 1969, no. 209 (Titian); Pallucchini, 1969, p. 274, fig. 251 (Titian, *c.* 1540).

VARIANT:
Florence, Bargello, mosaic, 0·84×0·64 m., dated 1541, signed Francesco e Valerio Zuccati; possibly after Titian's design (Coggiola, 1914–1915, pp. 512, 514, illustration; Suida, 1935, p. 87; Valcanover, 1960, I, p. 104, pl. 220B); *idem*, 1969, no. 225 (designed by Titian, executed by the Zuccati).

16. **Cardinal Pietro Bembo** Plate 254

Canvas. 1·19× 1·00 m.

Naples, Gallerie Nazionali, Capodimonte (in storage).

Ruined original.

About 1545–1546.

The compositional elements, showing a seated ecclesiastic beside a window with landscape view, are clearly related to

the master's work, *c.* 1545, but the condition of the Naples canvas is so ruinous that it is difficult to be certain whether it is an original or a copy.

Condition: Damaged and extensively repainted; restored in 1960.

History: The portrait of a cardinal by Titian, as described in the Farnese Inventory at Parma in 1680, is probably the present item (Campori, 1870, p. 236, 'braccia 2, once 1½ × braccia 1, once 9½, i.e. about 1·29×1·00 m.).

Bibliography: See also History; C. and C., Italian edition, 1878, II, pp. 422–423 (Titian, 1540); Rinaldis, 1911, pp. 134–136, no. 70; Suida, 1935, p. 87 (Titian); Tietze, 1936 (not listed); Berenson, 1957, p. 188 (Titian, after 1548, repainted); Valcanover, 1960, I, p. 88, II, pl. 10 (Titian, 1545–1546); *idem*, 1969, no. 261 (Titian, 1545–1546); Pallucchini, 1969, p. 284, fig. 305 (Titian, 1545–1546).

COPY:
Bergamo, Galleria Carrara, canvas, 1·00×0·90 m.; much weaker and later than the Naples version; illustrated by Coggiola (1914–1915, p. 514, no. 3; Morelli, 1897, p. 315, copy); gift of Marcantonio Foppa in 1673 (Pasta, 1775, p. 33).

LOST ITEMS:
1. Rome, Cardinal Pietro Bembo; a letter of 30 May 1540 from Bembo in Rome to Girolamo Querini in Venice asks that Titian be thanked for his second portrait of Bembo (Bembo, 1560, II, p. 133; also 1743, II, p. 248).
2. Rome, Fulvio Orsini, Inventory 1600, no. 52, portrait of Cardinal Bembo by a pupil of Titian (Nolhac, 1884, p. 433).

Cardinal Pietro Bembo, see also: Cat. nos. X–9 and X–11.

17. **Vincenzo Cappello** Plates 88, 89

Canvas. 1·41× 1·18 m.

Washington, National Gallery of Art, Kress Collection.

1540.

The composition of this picture is studied in the text, page 25. The date 1540 eliminates Tintoretto from consideration since this period corresponds to his earliest activity, to which time Pallucchini (1950, pp. 71–116) has assigned a number of highly debatable attributions. Titian's authorship is supported by Aretino's letter and poem, dated Christmas 1540 (*Lettere*, edition 1957, I, pp. 177–178), in

which he praises the master's portrait of Vincenzo Cappello. The Washington picture appears to be the source of the mediocre print by Tobias Stimmer published in Paolo Giovio's *Elogia* (edition 1575, p. 329), although the author gives no source.

Biography: Vincenzo Cappello (1467–1541), a Venetian admiral, was elected *generale de mar* five times, on the last occasion shortly before his death at the age of seventy-four. He also served as Venetian ambassador to Henry VII of England and to the popes Adrian VI and Clement VII. A statue of him stands over the main door on the exterior of S. Maria Formosa in Venice, the church in which are located his tomb and epitaph.

Condition: Well preserved; cleaned in recent years.

History: Possibly from the collection of Domenico Ruzzino, Venice (Ridolfi (1648)-Hadeln, I, p. 200); William Beckford, at Fonthill Abbey, Bath, England (Inventory, 1844, as a Spanish admiral by Tintoretto; Shapley, 1968, p. 182); Beckford's son, the Duke of Hamilton, Hamilton Palace (sale, 1882, no. 410, as Tintoretto; Jullian, 1963, p. 98); H. Bingham Mildmay, London, 1882–1893 (sale, London, Christie's, 24 July 1893, no. 73, as Tintoretto; bought by Agnew); Earl of Rosebery, 1893–1939 (sale, London, Christie's, 5 May 1939, no. 45, illustrated as Giorgione); Samuel H. Kress Collection, 1954; National Gallery, Washington, since 1957.

Bibliography: See also above; Berenson, 1894 and 1906, p. 136 (as Venier by Tintoretto); Thode, 1901, p. 80 (Tintoretto); Berenson, 1957, p. 189 (Titian); Suida and Shapley, 1956, pp. 182–185 (Titian); Valcanover, 1960, I, pp. 88, 102, pl. 215A (uncertain attribution); Shapley, 1968, pp. 181–182 (Titian; full account); Valcanover, 1969, no. 631 (attributed); Pallucchini, 1969, p. 90 (Tintoretto).

OTHER VERSIONS:
1. Leningrad, Hermitage (storage); canvas, 1·49×1·15 m., copy of Titian; Stroganoff Collection (engraved in that collection in 1807). *Bibliography:* Lazareff, 1923, pp. 172–176 (Tintoretto); Berenson, 1927, pp. 226–229 (Vincenzo Cappello, copy of Titian); *idem*, 1947, p. 24 (copy of Titian); Hermitage catalogue, 1958, no. 7759 (school of Titian); Fomiciova, 1967, p. 70, no. 12 (copy).
2. New York, Walter P. Chrysler, Jr.; canvas, 1·35×1·15 m.; formerly Schnackenberg, Munich (Suida, 1935, pp. 85, 169, pl. 143, Titian). B. Manning (1962, pp. 49–50) identifies the Chrysler portrait as the one mentioned by Aretino in 1540, rather than the Washington picture. The inscription reads: QVINQVIES DVX. She sees five

batons (perhaps there are three) as representing his appointment five times as commander of the Venetian fleet.
3. Unknown location; canvas, 1·155×1·149 m.; formerly Falkirk, Dunmore Park, Earl of Dunmore (Waagen, 1857, p. 454, as Tintoretto), sale London, Sotheby's, 28 November 1956, no. 19 (*APC*, XXIV, 1956–1957, no. 986; with history confused with the former Hermitage version.

PARTIAL COPY
Florence, Uffizi; head only, copied by Cristofano dell' Altissimo, 1552–1554 (Schaeffer, I, 1908, p. 1117, illustration; Lazareff, 1927, pp. 173–174, illustration).

RELATED WORK:
Paris, Louvre; Nicola Cappello by Palma il Giovane; canvas, about 1·17×0·92 m.; formerly Schlichting Collection, Paris, before 1906. *Bibliography:* Guiffrey, 1906, no. 50, February, pp. 1–2 (Andrea Doria by Titian); Schaeffer, 1909, II, pp. 158–160 (Vincenzo Cappello by Titian; dated 1540); Lazareff, 1923, pp. 173–174 (Vincenzo Cappello by Titian); Fischel, 1924, pl. 211 (Vincenzo Cappello by Titian); Berenson, 1924, pp. 226–231 (Nicola Cappello by Palma il Giovane); Berenson, 1947, pp. 23–24 (Nicola Cappello by Palma il Giovane).

18. **Giovanni Battista di Castaldo** Plates 156, 157
Canvas. 1·195×0·986 m.

Dortmund, Becker Collection.

1548.

The identification of Castaldo in the painting rests upon the engraving and the account by Totti (Totti, 1635, pp. 245–246, engraved portrait). He is described as large in physique with fair complexion, red hair, and blue eyes. Titian's portrait also shows a reasonable likeness to Castaldo in Annibal's medal of him (Plate 155). Hans Tietze's identification of the medallion worn by Castaldo as the portrait of Fernando Francesco d'Avalos is not confirmed by Annibale Fontana's medal of d'Avalos (Hill and Pollard, 1967, no. 442). Since the helmet is unmistakably *all'antica*, the profile may represent an ancient Roman emperor. Neither of the Hapsburgs, Charles V or Ferdinand I, can be recognized here.

Biography: Giovanni Battista Castaldo (died 1562), a Neapolitan soldier in the entourage of Fernando Francesco d'Avalos, Marchese di Pescara, at the battle of Pavia, took part in that Spanish victory over the French in 1525. He remained in the service of Charles V, engaging in the campaign against Soliman the Turk at Vienna and in other wars. Charles V named him Marchese di Cassano of Lombardy (Totti, *op. cit.*).

Condition: Well preserved.

History: Said to be from the Imperiale Collection, Genoa, but it is not in the Imperiale Inventory of 1661 (Luzio, 1913, pp. 306–307); Becker, 1967, no. 93, colour print.

Bibliography: See also above; Vasari (1568)-Milanesi, VII, p. 450 (reference to a portrait of Castaldo by Titian at Augsburg); Tietze, 1950, p. 390, pls. 181–182 (Titian; then at the Schaeffer Gallery, New York); Pallucchini, 1954, II, p. 39 (Titian, 1548; then in Geneva); Valcanover, 1960, II, pl. 28; *idem*, 1969, no. 294 (Titian at Augsburg, 1548); Pallucchini, 1969, p. 290, fig. 336 (Titian, *c.* 1548).

COPY:

Kassel-Wilhelmshöhe, Loewenberg Collection; canvas, 0·455×0·35 m.; copy reduced in size and labelled 'le seigneur Jean Baptiste'; attributed somewhat doubtfully to Antonio Moro (Schenk, 1960, p. 93).

19. **Count Baldassare Castiglione** Plate 39

Canvas. 1·24×0·97 m.

Dublin, National Gallery of Ireland.

Inscribed at the upper right: COMES BALDASSAR CASTI-LIONVS 1523.

The landscape through an open window is familiar in Titian's portraits, but the picture has lost colour so much that the black costume against the dark brown wall can scarcely be distinguished. Castiglione's right arm rests upon a high chest as he turns his head over his left shoulder toward the spectator. Two visits to Venice in 1517 and 1523 gave the humanist an opportunity to meet Titian, who must have painted the portrait on the second occasion. In spite of the damaged condition of Titian's likeness, it is safe to say that Raphael's renowned portrait of Castiglione in the Louvre, Paris, is finer as well as better preserved.

Biography: The celebrated humanist and writer (1478–1529), one of the great figures of the Renaissance, having been reared in Mantua, served as emissary of the Duke of Urbino and later of the Marquess of Mantua, during the pontificates of Julius II, Leo X, and Clement VII. His fame today rests upon the treatise, *Il libro del cortegiano*, first published in 1528, wherein he described the court at Urbino as an idealization of aristocratic Renaissance society. After his wife's death he became an ecclesiastic and was appointed papal legate to Spain in 1525; he died at Toledo four years later (Cartwright, 1908).

Condition: Darkened, dirty, heavily varnished, and in generally bad condition.

History: Vincenzo Imperiale, Genoa, Inventory of 1661 (Luzio, 1913, p. 307, Titian); purchased by Christina of Sweden: Inventory of 1662, no. 55; Inventory 1689, no. 64, as by Giulio Romano (Campori, 1870, p. 317; Granberg, 1896, p. 125).
Odescalchi Collection, Rome: Inventory, 1713, folio 76ᵛ, no. 147 (Tintoretto!); Nota dei quadri della Regina Christina, no. 54 (Titian); Baldassare Odescalchi, Duke of Bracciano, sale to Duc d'Orléans, 1721, folio 4, no. 43 (Titian); Orléans Collection, Paris, 1721–1798 (Dubois de Saint Gelais, p. 461; Buchanan, 1824 I, p. 115); Coxe sale, London, 23–24 April 1807, no. 57; Lord Mansfield at Scone (Hume, 1829, p. 99); Sir Hugh Lane; bequest to the Dublin Gallery, 1918; always to Titian since 1721.

Bibliography: See also History; C. and C. (unknown to them); Suida, 1935, p. 87 (Titian); Gronau, 1937, pp. 101–104 (Titian); Dublin, 1956, no. 782 (Titian); Berenson, 1957, p. 185 (Titian; restored); Valcanover, 1960, I, pl. 119A (Titian); *idem*, 1969, no. 133 (commonly attributed); Stockholm, 1966, p. 482; Pallucchini, 1969, p. 262, fig. 187 (Titian, before 1529).

20. **Charles V with Hound** Plates 51, 55

Canvas. 1·92×1·11 m.

Madrid, Prado Museum.

Documented 1533.

Charles' silver brocade coat with sable collar and lining, golden jerkin and black hat, his grey Venetian breeches with golden stripes, and the grey-white hose make a very beautiful costume. The reddish-grey floor and the neutral-green curtain (much darkened) in the left background provide a reticent setting for the dignified figure. Charles grasps his dagger hilt with its long fringe with his right hand, and he holds the dog's collar in his left. Much controversy has raged about every aspect of this picture, which is the earliest preserved portrait of Charles V by Titian. The first likeness, painted at Bologna at the time of Charles' coronation in February 1530 has been lost. Titian's presence at the coronation was incorrectly doubted by Crowe and Cavalcaselle (1877, I, p. 366), an opinion still held by some recent writers (Einem, 1956, pp. 67–68). Nevertheless, Vasari was unquestionably correct in his statement (Vasari (1568)-Milanesi, VII, p. 440) that Titian met and painted the emperor at Bologna in 1530, a fact proved by a letter from Leonardi to Francesco Maria II della Rovere, Duke of Urbino, on 18 March 1530 stating that Charles V had

been slandered by the story that he had paid Titian only one ducat for his portrait (letter published by Gronau, 1904, p. 13). Charles stayed at Bologna from 5 November 1529 until 22 March 1530 (*Cronaca*, edition 1892, pp. 113, 234). For further details about the lost portrait of 1530, see pp. 18–20 and note 77.

The reasons for believing that *Charles V with Hound* originated in Bologna in 1533 rather than in 1530 rest upon descriptions of the dog and the emperor's costume in the late fall of 1532 and the fact that the portrait of 1530 showed him in armour. A report to the Venetian State on 7 November 1532, sent from Verona, says that Charles had arrived accompanied by a large racing dog (Sanuto, LVII, column 217; 'Veniva sopra uno caro con uno cane grande corso, quale se diceva lo imperator farlo cussi portar'). A few days earlier on 1 November 1532 Charles' costume is described at Bassano as consisting of a cloak of silver brocade lined with sable and white hose (Sanuto, LVII, column 194: 'Soa Maestà vene vestita di sagio (saio) et robon di brocato d'arzento, fodrato di zebelini et calzato, li bolzegini bianchi'). However, the description of his garments on 24 February 1530 at Bologna seems to involve the same outfit: 'una vesta di brocato di argiento rizzo sopra rizzo alla francesa fodrata di una bellissma fodra di zibellini con il sayo dil medesimo drappo di argiento et zippone con calze bianche et scarpe di veluto bianco' (*Cronaca*, edition 1892, p. 211).

The existence of Jacob Seisenegger's portrait of Charles V in the same costume and pose (Plate 54) and, accompanied by the same dog, first received general attention as a result of Glück's article (1927, pp. 224–242), when he, followed later by other German writers (Löcher, 1962, pp. 32–40), pointed out with glee that Titian must have copied the Austrian's portrait. The date 1532 and monogram of the artist seem to establish Seisenegger's priority (also Panofsky, 1969, pp. 182–184).

On this second visit Charles entered Bologna on 13 November 1532 and remained there until 28 February 1533, except for a visit to Mantua during the first two weeks of December (see Foronda, 1914, p. 368; Sanuto, LVII, columns 332–334). Titian apparently did not arrive until January (see Introduction, p. 21). A letter from Girolamo Negrino to the Duke of Mantua dated 28 February 1533 states that Charles V gave to Alfonso Lombardi and Titian five hundred *scudi* each for their portraits of him just before his departure (Braghiroli, 1881, p. 25; Beroqui, 1946, p. 51). Vasari (Vasari (1568)-Milanesi, V, pp. 88–89) had mistakenly placed this episode in 1530. Ten days later Titian, still at Bologna, wrote that he would not stop at Mantua on his return trip to Venice since the duke was absent, but he promised to send a copy of his portrait of Charles V (Braghirolli, 1881, pp. 25–26; C. and C., 1877, I, pp. 456–

457). That picture, now lost, must have shown Charles V in armour (see Cat. no. L–3) and it surely did not involve *Charles V with Hound*.

Some critics have found it difficult to accept the proposition that Titian copied a virtually contemporary portrait by a rather obscure young Austrian painter. Nordenfalk (1947–1948, pp. 55–56) pointed out that Titian had earlier developed the composition of a main figure accompanied by a secondary person, for instance, *Laura Dianti and Negro Servant* (Plate 41) and *Salome* with servant in the Doria Pamphili Collection at Rome (Wethey, I, 1969, plate 149). More convincing was the objection of the French scholar, Annie Cloulas, that Charles' bestowal of knighthood upon Titian on 10 May 1533 could not have been awarded because he copied a work of Seisenegger, as the Emperor never honoured any other painter in that way. She argued that, on the contrary, Seisenegger must have repeated Titian's original (Cloulas, 1964, pp. 219–220).

This puzzling situation may never be resolved to everyone's satisfaction. Certainly Charles V did not knight Titian for that one work. The artist had already carried out one portrait in armour at Bologna in 1530. He surely had also added still another composition in the nature of a state portrait at Bologna in 1533. See the Introduction, p. 21.

Biography: See Cat. no. 21.

Condition: The colours have darkened greatly by time and as a result of the damage caused by the numerous travels to which the picture has been subjected. Its location in the Galería de Mediodía of the Alcázar at the time of the fire of 1734 indicates the probability of damage, since this part of the palace was rapidly destroyed (Bottineau, 1960, pp. 485–487). Cleaned partially in 1966.

History: Charles V with Hound must have been shipped directly to Spain within a short time, since no copies of it were ever made in Italy. Rubens, who was so fond of making replicas of Titian's works, never saw it in Italy, and he could only have had an opportunity to examine it in Madrid in 1603.

This portrait is not recorded in the Inventories of Mary of Hungary and Charles V. First mention: Alcázar, Guardajoyas, Madrid, Inventory 1600, no. 173 (Philip II, II, p. 230); 1623 Philip IV's gift to Prince Charles of England on his visit to Madrid; English Inventory 1623–1624 (Sainsbury, 1859, p. 355, no. 6); Charles I of England, London (van der Doort, 1639, edition Millar, 1960, p. 4, no. 12 'brought from Spaine ... by Techian'); offered for sale after Charles I's execution: R. Symonds' Diary, 1650–1652 (Egerton Mss., 1636, folio 105); shown at Somerset House, 1650 (Cosnac, 1885, p. 417; 'Pictures Belonging

to King Charles', p. 6, no. 13, sold for £150); purchased by Philip IV of Spain; Alcázar, Madrid, Galería de Mediodía, 1666, no. 611; Inventory 1686, no. 287 (Bottineau, 1958, p. 158); Inventory 1700, no. 98; Inventory 1734, no. 43 (after the fire in the Alcázar); Buen Retiro, Philip V, 1747, no. 13; Palacio Real, Pieza de Comer, 1776 (Ponz VI, Del Alcázar, 46); Prado Museum, catalogue, 1821 (Beroqui, 1946, p. 52).

Bibliography: See also above; Madrazo, 1843, p. 164, no. 765; 'Inventario general', 1857, p. 156, no. 765; C. and C., 1877, I, pp. 368–370 (thought Charles I of England had a replica); Gronau, *Titian*, 1904, pp. 102–104, 303 (painted at Bologna in 1530 or 1533); Allende-Salazar and Sánchez Cantón, 1919, pp. 29–30; Suida, 1935, pp. 46, 80–81, 168 (Titian, after Seisenegger); Tietze, 1936, II, p. 299 (Titian, 1532–1533); Jenkins, 1947, pp. 14–15; Beroqui, 1946, pp. 49–53 (thorough account); Berenson, 1957, p. 187 (Titian, 1533); Valcanover, 1960, I, pl. 132; Prado catalogue, 1963, no. 409; Pope-Hennessy, 1966, pp. 171–172 (Titian, after Seisenegger); Valcanover, 1969, no. 158 (Titian, 1533); Pallucchini, 1969, p. 266, figs. 208–209 (Titian, 1532–1533).

21. Charles V at Mühlberg Plates 141–144

Canvas. 3·32 × 2·79 m.

Madrid, Prado Museum.

Not signed.

Documented in 1548.

Titian's portrait of Charles V, in commemoration of his victory over the German Protestants at Mühlberg on 24 April 1547, is one of the epoch-making paintings of all time. It established the model for the state equestrian portrait, which other great masters such as Velázquez and Van Dyck followed. The imperial dignity of the victor, supremely confident upon the charging horse, carries impressively. The face itself, kindly treated by the artist in his minimizing of the emperor's ugly, protruding jaw, is far less important in totality of effect than his regal bearing. In composition the work adheres to Renaissance methods in the placing of horse and rider parallel to the background and in the establishment of space by the coulisse of trees to the left and in the diminishing sizes, as the trees merge into the distance at the right. The atmospheric light and the blue sky, streaked with yellow and rose, still survive to a considerable degree even though the fire in the Alcázar of 1734 severely damaged the colours. Most beautiful is the painting of the armour with its gleaming highlights and reflections, of the rose-coloured commander's sash across the chest, and of the darker rose plume in the helmet. The same rose returns in the trappings and the plumes upon the horse, thus establishing a warm rich tonality throughout the entire picture. The explanation of a rose-coloured or red sash is that it stands as a symbol of the Holy Roman Empire, Spain, and the Catholic parties in the religious wars of the sixteenth and seventeenth centuries (Martin, 1968, pp. 107 and 123).

Charles appears on the same horse and in the same armour that he wore at the scene of the battle at Mühlberg in 1547 (Aretino, *Lettere*, edition 1957, II, p. 212; 'su lo stesso cavallo e con le medesime arme che aveva al di che vince'). A handsome outfit, made three years earlier in Germany by Desiderius Colman, this armour is still preserved (Plate 242) in the Real Armería at Madrid. An image of the Madonna appears engraved in a mandorla upon the breastplate and a figure of St. Barbara on the back of the cuirass, a devotional custom which seems to have been introduced into Charles' suits of armour after he was crowned Holy Roman Emperor at Bologna in 1530 (Valencia de Don Juan, 1898, pp. 60–61). The emblem of the Burgundian Order of the Golden Fleece hangs from a rose-coloured ribbon placed around his neck over the armour.

Various symbolic meanings have been suggested in connection with *Charles V at Mühlberg*. Aretino in a letter of April 1548 proposed that allegorical figures of Religion and Fame (*Lettere*, edition 1957, II, pp. 212–213) should accompany the emperor, but Titian wisely failed to heed his counsel. Avila y Zúñiga in 1549 (edition 1852, p. 444), an eye-witness in describing the victory, reported that Charles paraphrased Julius Caesar's words 'I came, I saw, and I conquered' to 'I came, I saw, and God conquered' (Vine, y ví, y Dios venció). Although the story may not be literally true, it does confirm the thoroughly religious attitude of Charles and his deep-seated Catholicism. Whether Charles V is intended to represent the Christian knight and defender of the faith, the new Constantine the Great, has been debated by Braunfels, von Einem and Panofsky (see below, Bibliography).

The numerous suggestions which have been advanced as sources of Titian's composition range from Dürer's print of *The Knight, Death and the Devil* to Burgkmair's drawing and print of Maximilian I on horseback and to Leonardo's studies of the rearing horse for the monument of Francesco Sforza. Various earlier Italian equestrian portraits such as Donatello's bronze *Gattamelata* at Padua and Verrocchio's *Bartolomeo Colleoni* at Venice were obviously familiar to Titian, yet he effectually established the type with the rearing horse, which was to be followed by later painters of the Renaissance and Baroque periods.

Biography: Charles V (1500–1558), Holy Roman Emperor,

THE FAMILY OF CHARLES V

Names in capitals are those of persons portrayed by Titian

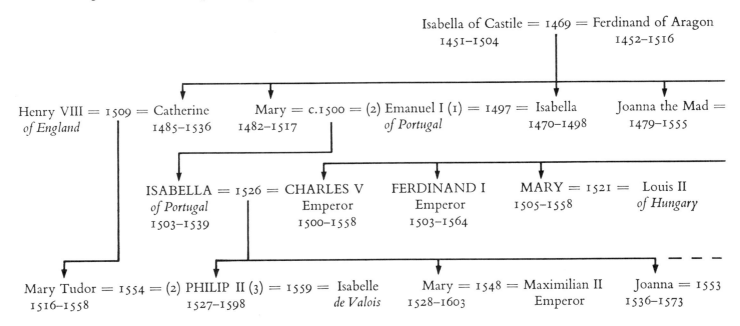

ruler of Austria, Germany, the Netherlands, Naples and Sicily, Spain and her American possessions, was the son of Philip the Fair of Burgundy and Joanna the Mad of Castile. Through his mother he inherited the Spanish dominions of his grandparents Ferdinand of Aragon and Isabella of Castile, as well as Naples, while the northern empire came from his Hapsburg grandfather Emperor Maximilian I (1459–1519) and his grandmother, Mary of Burgundy. Born at Ghent and educated as a Fleming, he first visited Spain in 1516 on the death of Ferdinand. On a later, more extended sojourn he married his cousin Isabella of Portugal (Cat. no. 53) in a splendid ceremony at Seville in 1526. The three surviving children of this remarkably happy marriage were his successor Philip II (Cat. no. 78), Maria, who became the wife of her cousin the Emperor Maximilian II, and Joanna, long the widow of the Prince of Portugal. Two natural children also had notable careers. Margaret of Austria (Cat. no. L–23), born before his marriage, became Duchess of Parma as the wife of Ottavio Farnese (Cat. no. L–14), and later regent of the Netherlands. Don John of Austria (1545–1578), born some years after the death of the Empress, achieved lasting fame as the leader of the victorious naval battle against the Turks at Lepanto in 1571.

High points in a career filled with international events and crises included Charles' defeat of Francis I of France at Pavia in 1525, by virtue of which the Emperor's hegemony over Italy was established. The assault on Rome in 1527 by his mercenary troops under the Constable Charles de Bourbon (Cat. no. X–14) and the subsequent sack were regarded by Charles V himself as the blackest moment of his reign. Three years later his former enemy, Pope Clement VII, was to crown him Holy Roman Emperor amid lavish celebrations at Bologna on 24 February 1530, ten years after his coronation at Aix-la-Chapelle. Thereafter Charles' determination to dominate Europe led to ceaseless wars and constant travels in Italy, Spain, Germany and the Netherlands, as well as campaigns against the Turks. At last tired and ill, he abdicated in 1556, leaving the Spanish dominions and the Netherlands to his son, Philip II, and the Austro-German empire to his brother, Ferdinand I. He departed for Spain and his chosen refuge in the Jeronymite monastery at Yuste, a remote spot in the southwest not far from Plasencia. There he died on 21 September 1558 (Brandi, 1939; Lynch, 1964).

Charles V was physically unimpressive, though fair-complexioned and golden-haired in his youth. He was short and slight with a face disfigured by a lantern jaw so abnormal that his teeth did not meet, making it impossible for him to chew his food. Early portraits clearly show this grotesque defect but later artists such as Titian minimized the shape of the jaw with the aid of a beard. In 1529 he was

Emperor Maximilian I = 1477 = Mary of Burgundy
1459–1519 1457–1482

496 = Philip the Fair John = 1497 = (1) Margaret of Austria (2) = 1501 = Philibert
 1478–1506 1478–1497 1480–1530 *of Savoy*

Emanuel I = 1518 = (1) Eleanor (2) = 1530 = FRANCIS I Catherine = 1526 = John III Isabella = 1515 = Christian II
of Portugal 1498–1558 *of France* 1507–1578 *of Portugal* 1501–1526 *of Denmark*

Prince John MARGARET of Austria Don Juan of Austria DOROTHEA CHRISTINA
of Portugal (*natural daughter*) (*natural son*) *Countess Palatine* *Duchess of Milan*
 1522–1586 1545–1578 1520–1562 *and Lorraine*
 1522–1590

described as a 'small person, who stoops a little, with a small long face and pointed beard and his mouth is always open ... however, he has an excellent and gracious manner ... a man of exemplary life' (Sanuto, LI, column 371). Later in 1551 Marino Cavallo, the Venetian ambassador, described him as in bad health, suffering from the gout and asthma to the extent that he was not expected to live long. At this point he was extremely religious, attending Mass twice a day, and was said to abstain from all vices (Alberi, serie I, col. II, pp. 211–214).

Condition: The condition of the figure of Charles V is excellent despite various mishaps to the picture. When the portrait was hung out-of-doors to dry just before Titian left Augsburg (on 16 September 1548), a strong wind blew it against a tree, ripping the canvas, particularly on the back of the horse. A letter, undated but signed by the German painter Christopher Amberger, states that he repaired the injured spots in Titian's presence because the Venetian was about to depart (Beinert, 1946, pp. 16–17). After the devastating fire of the Alcázar in 1734 it was described as 'in extremely bad condition' (see below, History); the ripped canvas at upper left and right presumably dates from that time. Recently cleaned in 1966–1967.

History: The artist was at work upon the equestrian portrait

in April 1548 (Aretino, *Lettere*, edition 1957, II, p. 212). In a letter to Granvelle written from Augsburg 1 September 1548 Titian says he will leave six pictures with Fochari [Fuggers] among them 'quello grande di sua cesarea maesta a cavalo' (Zarco del Valle, 1888, p. 222). On September 16 Titian departed from Augsburg (*loc. cit.*, p. 223).

At Brussels in the collection of Mary of Hungary, sister of Charles V, Inventory 1556 (Beer, 1891, p. CLXIII, no. 55; Pinchart, 1856, p. 139, no. 2; Pérez Gredilla, 1877, p. 250); shipped to Cigales near Valladolid with her belongings in 1556; her collection inherited by Philip II in 1558 (Granvelle, edition 1843, IV, pp. 510–511); Casa del Tesoro, Alcázar, Madrid, Inventory 1600, no. 336 (Philip II, edition 1956, II, p. 250, valued at 200 ducats); taken to El Pardo after the fire there of 1604; El Pardo Palace, 1614–1617 (Inventory, legajo 27, folio 2v); Alcázar, Pieça Nueva, 1626 (Cassiano del Pozzo, folio 48); Alcázar, in the 'pieza nueva', newly enlarged (Carducho, 1633, edition 1933, II, p. 109); still in the same room in 1636 (Inventory, folio 14v, 'se trujo del Pardo para poner en esta pieça'); Galería de los Espejos (same room redecorated under Velázquez), Inventory 1666; Inventory 1686, no. 57; Inventory 1700, no. 1 (Bottineau, 1958, p. 38–39); Inventory 1734, no. 1091; after the fire which destroyed the Alcázar, the pictures were taken to the Convento de San Gil: 'otro sin marco ni bastidor de tres varas y quarta de ancho y quatro varas de

alto maltratado en sumo grado retrato a caballo del Señor Carlos Quinto original de Ticiano'; Inventory 1747, folio 219; 1776, in the King's dining room of the new palace (Ponz, tomo VI, Del Alcázar, 35); Real Palacio, Madrid, Inventory 1816, no. 1 (pictures taken to the Real Academia de San Fernando); removed to the Prado Museum in 1827.

Bibliography: See also above; Avila y Zúñiga, 1549, p. 63 (describes the picture); Cassiano del Pozzo, 1626, folio 48 ('un bellissimo paese'); Ridolfi (1648)-Hadeln, I, pp. 170, 180 (confused references); Madrazo, 1843, p. 144, no. 685; 'Inventario general', 1857, p. 135, no. 685; C. and C., 1877, II, pp. 178–179; Allende-Salazar and Sánchez Cantón, 1919, p. 31; Suida, 1935, pp. 97, 107, 170; Janson, 1935-1936, p. 27; Tietze, 1936, I, p. 182, II, p. 299; Beroqui, 1946, pp. 90–94; Beinert, 1946, pp. 1–17; Jenkins, 1947, p. 15; Braunfels, 1956, pp. 193–207; Einem, 1960, pp. 73-79; Prado catalogue, 1963, no. 410 (old no. 685); Pope-Hennessy, 1966, pp. 173–176; Valcanover, 1969, no. 289; Pallucchini, 1969, p. 289, figs. 329–330; Panofsky, 1969, pp. 84–87.

COPY OF HEAD ONLY:
London, Count Seilern, since 1936, copy by Rubens, canvas, 0·75×0·555 m.; formerly Prince Belosselsky, Russia; this copy by Rubens was engraved by Theodor van Kessel. *Bibliography:* Rubens' Inventory, edition 1855, p. 272, no. 79, as a copy by Van Dyck; Sainsbury, 1859, p. 238, no. 79; Seilern, 1955, pp. 23–24, no. 13, pl. XXX; Müller-Hofstede, 1967, pp. 71–72, fig. 36.

COMPLETE COPIES:
1. London, Lord Northbrook (formerly), canvas, 0·863× 0·724 m.; sale, London, Sotheby's, 16 June 1930, no. 98 £44 to A. Field (Waterhouse, 1966, p. 374, no. 65). *History:* Queen Christina at Antwerp, Inventory 1656 (Denucé, 1932, p, 178); Christina at Rome, Inventory 1689 (Granberg, 1897, no. 34); Odescalchi Collection, Rome (Inventory 1692, folio 470ᵛ, no. 14; Inventory 1721, sale to Duke of Orléans, folio 4, no. 19); Duke of Orléans, Paris (Dubois de St. Gelais, 1727, p. 463; Couché, 1786–1788, pl. XX, 2 pieds 8 pouces × 2 pieds 5 pouces i.e. (0·813×0·737 m); J. J. Angerstein, London, 1798 (Buchanan, 1824, I, p. 115, no. 21); Samuel Rogers, London (Jameson, 1844, p. 403, as Titian's study); Roger's sale, 2 May 1856, no. 619, bought by Thomas Baring, Lord Northbrook (Waagen, 1857, p. 95; C. and C., 1877, II, p. 179, as a small Spanish copy; Richter and Weale, 1889, no. 217).
2. Parma, Palazzo del Giardino (formerly), Farnese Collection, Inventory 1680, canvas, 4 *braccia* 5 *once* × 4 *braccia* 6 *once* (c. 2·60×2·59 m.). *Bibliography:* Scanelli, 1657, p. 222; Campori, 1870, p. 243 (called Titian).

3. Toledo (Spain), Duchess of Lerma, canvas, 3·07×2·45 m. (Plate 244) (Carlos V, 1958, p. 113, no. 136); Spanish copy (?); Antonio Pérez's inventory in 1585 contained a picture which may be this item (Pérez 'Inventario', 1585, folio 473; edition 1910, p. 324; Marañon, 1948, I, pp. 58–59). It was probably Pérez' picture that was described in a letter of 4 September 1581 from the imperial envoy in Madrid, Khevenhüller, to Emperor Rudolf II, 'auch Caroli V imperatoris conterfet zu ross, gar guet ... das Gemälde mit den Pferden, die er für Erzherzog Karl Gekauft habe, senden' (Voltelini, 1892, p. CXXVI, no. 9214).
4. Unknown location, weak copy, S. Hartvell, Antwerp, 1934; J. Leger and Sons, London, 1934 (photographs: Courtauld Institute, London, and Frick Art Reference Library, New York).

22. **Charles V Seated** Plate 145
Canvas. 2·05×1·21 m.
Munich, Alte Pinakothek.
Signed at the lower right upon the wall: TITIANVS F
Dated upon the upper part of the wall in large numerals: MDXLVIII

In this intimate portrait of Charles V at the age of forty-eight, already old and sickly, Titian did not emphasize his ill health but presented a dignified psychological study of the man rather than the Emperor and conqueror at Mühlberg (Plate 141). This masterpiece is by far the most personal, most profound, and most sympathetic record of Charles, who throughout his career was usually portrayed in armour as the symbol of power rather than as a human being. Essentially the same figure was repeated in the double portrait with the Empress Isabella, a lost work, known today in Rubens' copy (Plate 151).
The full-length seated figure is a type of composition established by Melozzo da Forlì and Raphael for portraits of ecclesiastics and previously adopted by Titian himself in his portraits of *Paul III* (Plate 115) and *Paul III with His Grandsons* (Plate 127). Veronese, El Greco in his painting of *Cardinal Juan Niño de Guevara* in the Metropolitan Museum at New York, and later Velázquez as well as Rubens continued this tradition (Müller-Hofstede, 1967, pp. 66–67). Lambert Sustris, Titian's pupil repeated the composition, reversed, in his picture of *Erhart Voehlin* in Cologne (pl. 245), a work which forcibly demonstrates the difference between master and pupil.
The conception of this handsome portrait of the dignified Charles V, dressed in black, can only be the work of Titian himself. The brilliant red carpet, the gold damask wall-covering, and the green-grey architecture supply a fine decorative foil to the black figure. The landscape, seen here

as from an open loggia, is entirely consistent with the Venetian tradition of the view through an open window. The rosy tinted landscape establishes an harmonious colour relation with the red of the floor, and does not imply repainting by Rubens as Morelli first suggestd, an idea seized upon by some subsequent critics. During these busy months in Augsburg Titian's assistants undoubtedly carried out minor details under the master's direction. The treatment of the landscape differs enough from Titian's normal style to justify the theory of the intervention of an assistant (see Introduction, p. 36). Nevertheless, the whole conception of this great picture is Titian's, and it is a mistake to limit his share to the head and right hand.

Condition: A vertical crease, visible at each side of the picture, shows where the canvas has been enlarged or bent over the stretcher in earlier years. Original size given as 2·05×1·14 (Munich, 1958, p. 103, no. 632). Some repainting but by no means as extensive as some critics maintain.

History: Said to have been in the Fugger Collection at Augsburg in 1650 (Holst, 1951, p. 131); collection of the Elector of Bavaria at Schloss Schleissheim in 1748 (Braunfels, 1956, p. 197, note 27).

Bibliography: See also above; Vasari (1568)-Milanesi, VII, p. 449 (portraits at Augsburg); C. and C., 1877, II, pp. 179-180 (head by Titian, rest repainted); Morelli, 1891, p. 80 (signature authentic; landscape recalls Rubens); Reber, 1895, no. 112 (Titian); Gronau, *Titian*, 1904, p. 287 (Titian); Ricketts, 1910, p. 118 (repainted by Rubens); Fischel, 1924, p. 153 (Titian); Suida, 1935, pp. 107, 170 (Titian); Tietze, 1936, I, pp. 181-182, II, p. 302 (Titian); Pallucchini, II, 1954, pp. 36-37 (Titian, poorly preserved); Braunfels, 1956, pp. 196-198 (Titian, perhaps aided by Lambert Sustris); Berenson, 1957, p. 188 (Titian, 1548); Valcanover, 1960, II, pl. 21 (Titian); Einem, 1960, pp. 79-81 (head and hands by Titian); Pope-Hennessy, 1966, pp. 173-174 (Titian); Müller-Hofstede, 1967, pp. 66-67 (head and right hand by Titian); Valcanover, 1969, no. 290 (Titian); Pallucchini, 1969, p. 289, figs. 331-332 (Titian and Lambert Sustris); Panofsky, 1969, pp. 82-83 (landscape perhaps by Sustris).

COPY:

Vienna, Kunsthistorisches Museum, no. 510, kept in storage, panel, 0·20×0·16 m.; recorded in the Prague Inventory 1718, no. 32; poor small copy, formerly claimed to be Titian's sketch (C. and C., 1877, II, p. 180, copy by Teniers; Engerth, 1884, I, pp. 362-363).

Charles V, see also: Cat. nos. L-3—L-6 and X-18, X-20.

23. The Concert Plates 8-10
Canvas. 1·09×1·23 m.
Florence, Pitti Gallery.
About 1510-1512.

Famous as this work is, relatively little has been written about the subject matter. Although the portrait nature of the composition is recognized by all, the intention of the painter must have been far deeper. In a sense the dramatization of the three men may be regarded as an early phase of the kind of psychological characterization with which Titian presented *Paul III and His Grandsons* (Plate 127), where pose and movement reveal the struggle for power in the violent feud then raging within the Farnese family (see Cat. no. 76).

On the other hand, the mood of *The Concert* is calm and reflective, yet stirring to the imagination as to the meaning and significance of this group. That the 'Three Ages of Man' is an underlying idea appears obvious: youth is represented by the boy aged about fifteen, maturity by the black-robed performer, and old age by the bald and tonsured chorister, who holds a viola da gamba. In another composition even the title is given as the *Three Ages of Man*, a work in the Pitti Gallery, formerly attributed to Giorgione, now chiefly to a follower (Zampetti, 1955, p. 95). Patricia Egan has interpreted the theme of these pictures as a development of *Musica naturalis*, evolved from the iconography of a composition such as Pintoricchio's *Allegory of Music* in the Borgia Apartments of the Vatican Palace (Egan, 1961, pp. 190-191). She also hints at the subject of Music as the passage of time, a concept which strikes one as the essential key to the whole mystery. The obvious theme of this picture is Music, here presented as essential to the life of civilized man from youth to old age. That every gentleman should be versed in music is clearly set forth by Baldassare Castiglione in his description of the ideal Renaissance society (*The Courtier, c.* 1508-1515). From antiquity, but even more so in the Renaissance, music was regarded as an accomplishment not only of the perfect gentleman but even of warriors, and perforce essential to young lovers.

The wonderfully expressive figure in the centre of Titian's *The Concert* appears to pause and to turn his head in response to the older man, who touches him upon his back. The boy, perhaps the singer in this group, wears unmistakably male attire of the sixteenth century, and the popular confusion in regarding him as a girl comes from unfamiliarity with the period. The long bobbed hair reaching to the neck is most familiar in the male portraits of Giovanni Bellini, Giorgione, and early Titian (see Plates 2, 3, 6, 11, 12, 18-22), while the cut of the costume closely resembles

that of the young man in the double male portrait in the Palazzo Venezia at Rome (Zampetti, 1965, p. 81) and that of the lutenist in Giorgione's *Pastoral Concert* in Paris.

The spirituality of this group and, above all, if one may say, the soulful expression of the man playing the clavicembalo are unforgettable and notably increased by the contrast between the serious glance of the oldest man and the bland face of the boy. These men of three different ages interact upon each other to produce the total emotional effect. Since Ridolfi's time the dominant personality has been called an Augustinian monk because of his black robe, which may, however, be only a cassock worn at ecclesiastical functions. He does not appear to have a shaven head or a monastic cowl. The man to the right is undeniably a monk in a white chorister's robe. Then why is the boy in secular garb, with a plumed hat, which he could not wear in church? One could escape this dilemma by suggesting that a rehearsal is about to begin. On the other hand, if, as it seems likely, this picture is primarily symbolic, the secular garb merely emphasizes youth and freedom from the trials of life. Some quite unconvincing proposals have been advanced in an attempt to identify these men. Most fantastic was the statement that the performer is Giovanni Spinetti (!), who invented the spinet in 1502 [*sic*] (Schubring, 1936, p. 69), an instrument known for at least a century before that date. Another theory, advanced by Friedeberg, that the celebrated Flemish composer Verdelotto, choir master of St. Mark's, is shown here with Ubretto, a singer in the same church, is unacceptable because Vasari describes a double (not triple) portrait by Sebastiano del Piombo (see Cat. no. X–113).

Attribution: Early assigned to Giorgione from the time of its first mention by Ridolfi in 1648, the picture has been among the most debated in the problem of distinction between Giorgione and Titian. Morelli in the past century first held the latter to be the more likely painter. Since then the pendulum has swung back and forth, with Titian clearly in the lead among critics of the past thirty years. The youth in the plumed hat is the one really Giorgionesque figure in *The Concert* by virtue of his remote expression and possibly also because of the costume, which, however, is rarely a safe guide to dating or attribution. In the bibliography below each writer's opinion is noted.

Condition: Badly patched and smeared in several places, most prominently on the right side of the chorister's cape. A horizontal crease runs through the top, cutting through the plumes of the boy's hat. Superficially cleaned in 1902; never X-rayed.

History: Paolo del Sera, Venice, in 1648 (Ridolfi (1648)-

Hadeln, I, p. 99, Giorgione); purchased from him in 1654 by Cardinal Leopoldo dei Medici, who owned it until his death in 1675; thereafter in the Medici collections and the Pitti Gallery.

Boschini in his poem of 1660 gives a free romantic account of this picture which does not constitute an accurate description, yet it must be the present work, at that time in Sera's collection (Boschini, 1660, edition 1966, p. 397).

Bibliography: See also above; C. and C., 1871, II, pp. 144–147 (Giorgione); Morelli, 1886, p. 158 (Titian); Richter and Morelli, 1876–1891, edition 1960, p. 152 (early Titian); Morelli, 1891, II, p. 75, note (Titian); Gronau, *Titian*, 1904, pp. 19–21, 291 (Giorgione, finished by Titian); Cook, 1907, pp. 49–52 (Giorgione, *c.* 1507); L. Venturi, 1913, pp. 150–151 (Titian); Ridolfi-Hadeln, 1914, I, p. 99, note 2 (Titian); Friedeberg, 1917, pp. 169–176 (Sebastiano del Piombo); Hetzer, 1920, pp. 133–138 (anonymous!); Justi, 1926, I, pp. 219–224, II, no. 41 (Giorgione); Heinemann, 1928, pp. 27–29 (Giorgione, finished by Titian); Hourticq, 1930, pp. 114–127 (Sebastiano del Piombo); Richter, 1934, pp. 285–286 (Giorgione and Titian); Suida, 1935, pp. 30, 156 (Titian); Brunetti, 1935, pp. 119–124 (about the identification of the people as Luther and Calvin); Schubring, 1936, p. 69 (Giorgione); Tietze, 1936, I, pp. 85–87, II, p. 288 (Titian); Richter, 1937, pp. 216–217 (Giorgione, much repainted); Hetzer, 1940, p. 162 (nearer to Titian than to Giorgione); Pergola, 1955, pl. 103 (Titian); Berenson, 1957, p. 185 (Titian; the head at the left by Giorgione); Valcanover, 1960, I, pl. 45 (Titian); L. Venturi, 1962, p. 338 (Giorgione); Francini Ciaranfi, 1964, p. 56, no. 185 (Titian); Baldass and Heinz, 1964, p. 171 (Titian alone); Gould, 1966, pp. 49–50 (attributed to Titian, *c.* 1511); Valcanover, 1969, no. 42 (Titian and collaborators); Pallucchini, 1969, p. 241, figs. 69–71 (Titian and collaborators, *c.* 1511–1512); Pignatti, 1969, p. 118, cat. no. A11 (entirely Titian).

COPIES:
1. London, John Sadler (formerly); identified as youthful portraits of Leo X, Paul III, and Giorgione!; formerly Earl of Kinnoull, Scotland.
2. Rome, Doria Pamphili Gallery; mediocre copy, canvas, 0·82×0·96 m. (Richter, 1937, pl. LXV; Fokker, 1958, cat. no. 154; photo Anderson 3032).

24. **Laura dei Dianti** Plates 41–43
Canvas. 1·19×0·93 m.
Kreuzlingen, Heinz Kisters.
Signed in red on the metal arm-band: TICIANVS F
About 1523.

Since its recent cleaning this masterpiece is resplendent in its brilliant colour, leaving no doubt that Titian himself painted it. Against the dark background the ultramarine dress of velvet, the white sleeves, and light yellow scarf over the bodice are dazzling in themselves, but even more so by contrast with the costume of the small blackamoor, in silk of striped green, blue, lavender, and yellow. The colours throughout maintain harmonious relationships despite their variegated range.

Ridolfi's description of the portrait of the 'Duchess' with an Ethiopian slave seems to be based upon Aegidius Sadeler's print, since the lady does not wear black velvet as the writer states. He does not indicate which Duchess she was, i.e. Lucrezia Borgia or Laura dei Dianti (Ridolfi (1648)-Hadeln, I, p. 161). The nineteenth-century writers, Campori, Crowe and Cavalcaselle, and Charles Yriarte decided in favour of Lucrezia Borgia until Karl Justi presented arguments to the contrary in his article in 1899 (reprinted 1908). He pointed out that in another passage Ridolfi states that Cesare d'Este (grandson of Laura) presented Titian's portrait of Laura dei Dianti to Emperor Rudolf II of Austria in 1599 (Ridolfi (1648)-Hadeln, I, pp. 195–196). The picture appears in the Inventory of 1599 of Rudolf's possessions in the castle at Prague and in Inventories thereafter of the castle until it was looted from Prague by the armies of Queen Christina in 1648. Moreover, there is a copy still in Stockholm as a result of the acquisition of the original by Queen Christina. It is surely this original that is still preserved today in Switzerland.

Biography: Almost nothing is known of Laura dei Dianti's origins except that she was the daughter of a hat-maker of Ferrara. She became mistress of Alfonso I d'Este (Cat. no. 26) after the death of his second wife Lucrezia Borgia in 1519 and bore him two sons, Alfonso and Alfonsino, who were described in their father's testament as natural sons of an unmarried woman: 'nati da se soluto, e da una donna soluta' (Muratori, 1752–1754, II, p. 418). Consequently the story that circulated after Alfonso's death in 1534 that she had become his duchess may not be true. However, Laura was called wife and duchess in Ferrara from that time onward. Her marriage to the duke was accepted as fact by Aretino (letter of October 1542 to Laura Estense) and by Vasari, who spoke of Titian's portrait of her: 'Similmente ritrasse la Signora Laura, che fu poi moglie di quel duca; che è opera stupenda' (Vasari (1568)-Milanesi, VII, p. 435; see also Justi, 1908, II, pp. 169–179). Her death is recorded in 1573 (Cittadella, 1868, pp. 170–171; C. and C., 1877, I, p. 266).

Condition: A photograph in the Witt Library of the Courtauld Institute in London shows the canvas during restoration in 1957. Losses were greatest in the right sleeve and the blouse, which now have puckers that seem to be the work of the restorer. The scarf has also been modified by the addition of a fine pattern, seen in Sadeler's engraving.

History: D'Este Collection, Ferrara; Cesare d'Este's gift to Rudolf II in 1599 (Ridolfi (1648)-Hadeln, I, pp. 195–196, confuses Emperors Ferdinand II and Rudolf II); Prague Inventory c. 1599: 'Eine Türkin mit einem kleinen Mor, von Titian' (Perger, 1864, p. 105); Prague Inventory 1621: no. 860, 'Ein Türkin mit einem kleinen mor, vom Tician (Orig.)' (Zimmermann, 1905, p. XXXVIII); in 1648 taken from Prague by the Swedish army; Queen Christina of Sweden, Königmarck, 1648, no. 217, also Inventories 1652 (Geoffroy, 1855, p. 184); Antwerp, 1656 'Une fille avecq un morion' [little moor] (Denucé, 1932, p. 179); and Rome, Palazzo Riario, 1662, no. 21 (Stockholm, 1966, p. 482). Rome, Inventory of Queen Christina 1689, no. 30 (Campori, 1870, p. 342; Granberg, 1897, p. 36, no. 38, appendix, no. 30); Cardinal Azzolinio, Rome, 1689; Prince Odescalchi, Rome, Inventory 1692, folio 466v, no. 30; 'Nota dei quadri', no. 42; Inventory, Prince Livio Odescalchi, 1713, folio 85v, no. 197, original by Titian, formerly Queen of Sweden's; folio 43, nos. 99–103, five copies of the same after Titian; sale of Baldassare Odescalchi to Duke of Orléans, 1721, folio 1v, no. 15; Orléans Collection, Paris, 1722–1798 (Dubois de Saint Gelais, 1727, p. 474; Couché, 1786–1808, pl. XVIII); Walkuers, Brussels, 1792; London, Bryan sale, 14 February 1800, no. 35; Earl of Suffolk, before 1824 (Buchanan, 1824, I, p. 114, no. 35, p. 157); Edward Gray, Harringay House, 1824–1839; J. H. Smyth Pigott, Brockley Hall: sale, 10 October 1849, no. 20 (Waterhouse, 1966, p. 374, no. 63); J. Dunnington Fletcher, 1849–1876; Cook Collection, Richmond, 1876–1954; Rosenberg and Stiebel, New York, 1955–1956.

Bibliography: See also above; Vasari (1568)-Milanesi, VII, p. 435; Ridolfi (1648)-Hadeln, I, p. 161; C. and C., 1877, I, pp. 185–191 (wrongly identified the lady as Lucrezia Borgia); Yriarte, 1891, p. 122 (as Lucrezia); Campori, 1874, pp. 612–614 (calls her a sultana); Cook, 1905, pp. 449–450; idem, 1912, pp. 80–87 (Titian's original portrait of Laura dei Dianti); Justi, 1908, II, pp. 169–179 (originally published in 1899, pp. 183–192, as Laura dei Dianti); Hadeln, 1911, pp. 65–72 (as a copy); Borenius, 1913, I, pp. 168–169 (Titian's Laura dei Dianti); Tietze, 1936, II, p. 307 (as a copy; apparently considered it an original after the cleaning in 1954); Gombosi, 1937, p. 106 (Titian); Berenson, 1957, p. 190 (Titian, c. 1523, restored); Valcanover 1960, I, p. 97, pl. 205a (uncertain); idem, 1969, no. 118 (Titian); Pallucchini, 1969, p. 262, figs. 188–189 (Titian, c. 1528–1530).

COPIES:

1. Antwerp, Dr. Benoit Roose (1966), canvas, 1·17×0·95 m. formerly van Dirksen sale, Lepke Galleries, Berlin, 28–29 April, 1931, no. 119.

2. Cardiff, Wales, Williams' Collection (formerly); sale, London, Christie's, 29 November 1935, no. 141 (photograph, London, Courtauld Institute).

3. Cologne, L. Malmedé (1966); canvas, 1·17×0·95 m., a good copy, apparently the picture once owned by Baron Lipperheide, Berlin (Cook, 1905, p. 455, copy); said to have come from the Torlonia Collection, Rome. The same as item no. 1(?).

4. Modena, Galleria Estense, canvas, 1·105×0·95 m., labelled Lodovico Carracci in the museum; sometimes believed to be the copy by Lodovico Carracci, made before the original was sent to Emperor Rudolf II in 1599. It was placed in the Tartaglione Collection at Modena by Malvasia (1678, I, p. 492). This dark, weak copy is totally lacking in the brilliancy of the original now at Kreuzlingen. *Bibliography:* Hadeln, 1911, pp. 65–72 (insisted that it was Titian's original); Pallucchini, 1945, p. 187, no. 432.

5. Rome, Galleria Borghese, Head of Laura Dianti, canvas, 0·34×0·25 m. (Pergola, 1955, I, p. 133, no. 238, illustrated; photo G.F.N. no. E32753); formerly Rome, Sciarra Collection, sale 1899 (Justi, 1908, II, p. 172, copy).

6. Rome, Galleria Doria-Pamphili, free copy omitting the Negro slave and substituting St. Helena's cross (photograph, G.F.N., Rome, no. 41517).

7. Rome, Galleria Spada, canvas, 0·28×0·203 m.; Laura dei Dianti transformed into Salome, in a red dress and blue stole.

8. Västeras, Sweden, Lansresidenst (on loan from the Stockholm Museum), canvas, 1·17×0·91 m.; a simplified copy presumably made in the middle of the seventeenth century, when Queen Christina owned the original (Cook, 1905, p. 455, copy; *idem*, 1912, p. 86, illustration); formerly belonged to King Gustav III (died 1792) (Justi, 1908, II, p. 179).

9. Venice, Palazzo Giustiniani, Count Luigi Sernagiotti (formerly) (Justi, 1908, II, p. 172, copy; Cook, 1905, p. 455, copy).

10. Miscellaneous copies listed by Pallucchini, 1945, p. 187, and Pergola, 1955, p. 132.

PRINT:

Aegidius Sadeler (1570–1629), probably engraved at Prague, where he served Rudolf II in the early seventeenth century (Justi, 1908, II, pp. 175–178; Hadeln, 1911, p. 69, illustration).

LITERARY REFERENCE:

Rome, Odescalchi Collection, Inventory, 1713, five copies (folio 43, nos. 99–103; see also History, above).

25. Giacomo Doria Plate 86

Canvas. 1·155×0·977 m.

Luton Hoo (Bedfordshire), Wernher Collection.

Signed: TICIANVS F

Workshop of Titian.

About 1540.

The generally dull quality of this item gives rise to considerable doubt that Titian had much to do with its execution. Even the signature is shaded in a way not common in Titian's works, although it does occur on the signed *Man with a Glove* (Cat. no. 64). In this case the effect may be due to retouching. At the right appears the inscription GIACOMO DORIA Q[ONDAM?] AVGVSTINI.

Biography: The escutcheon at the upper left identifies a member of the Genoese rather than the Venetian branch of the family. Giacomo Doria was presumably the younger brother of Giovanni Battista Doria, who became Doge of Genoa in 1537 (Pellegrini, 1903, pp. 267–268).

Condition: Darkened but fairly well preserved with the usual retouches.

History: Principe d'Angri, Naples (?); bought by Sir Julius Wernher about 1902.

Bibliography: See also above; Cook, 1903, p. 185 (Titian, *c.* 1523; first publication); Gronau, *Titian*, 1904, p. 282 (Titian, *c.* 1560); London, 1930, p. 210, no. 374 (Titian); Suida, 1935, pp. 86, 172 (Titian); Tietze, 1936, II, p. 293 (Titian, *c.* 1540); Mayer, 1937, p. 183 (a studio replica of an original which is still in a Genoese [*sic*] collection); Pallucchini, 1953, I, pp. 202, 212 (Titian, 1540–1545); Berenson, 1957, p. 187 (Titian, signed); Waterhouse, 1960, no. 59 (Titian); Valcanover, 1960, I, pl. 160A (Titian); *idem*, 1969, no. 217 (Titian, *c.* 1540); Pallucchini, 1969, pp. 273–274, fig. 249 (Titian, *c.* 1540).

26. Alfonso I d'Este, Marquess and Duke of Ferrara
Plate 40

Oil on canvas. 1·27×0·984 m.

New York, Metropolitan Museum of Art.

About 1523–1525.

The duke wears a dark-red costume with gold-brocaded sleeves and a dark cloak lined with sable, as he rests his right hand upon a cannon. The gold cord about his neck ends in a square-cut sapphire and large pearl, and a sapphire ring adorns the first finger of the left hand. The energy

and determination which the pose and the expression project have the psychological substance that reveals the hand of a great master. Technically the work is also clearly superior, although the canvas has deteriorated.

Biography: Alfonso I d'Este (1486–1534) was the son of Ercole I d'Este, whom he succeeded as duke in 1505, and brother of the celebrated Isabella d'Este (Cat. no. 27). He engaged in numerous wars throughout his career and was appointed commander of the papal forces of Julius II in 1508 during the war of the League of Cambrai against Venice. After later struggles against Popes Julius II, Leo X and Clement VII, Alfonso was confirmed in his possessions by Emperor Charles V. He married Lucrezia Borgia, then aged twenty-one in 1501, who retired from Rome to Ferrara, and at her death in 1519 left her husband four children. Subsequently Alfonso formed a liaison with Laura dei Dianti (Cat. no. 24). Alfonso's true claim to fame lies in his patronage of the great poet Lodovico Ariosto (Cat. no. 7) and of Titian. For Alfonso Titian created one of his greatest series of mythological pictures (1518–1523) to decorate the Alabaster Room in the castle at Ferrara (to be studied in Vol. III) (Cartwright, 1903, *passim*; Gardner, 1906, *passim*).

Condition: Somewhat darkened and faded.

Dating and documentation: The date is uncertain but this is definitely Titian's first portrait of Alfonso I d'Este. A letter of Alfonso to his Venetian agent Theobaldo, dated 29 September 1519, protests at Titian's delay in finishing 'quella nostra pictura' (Campori, 1874, p. 88). Generally thought to refer to the mythological paintings, it might concern the first portrait.
Lodovico Dolce, a friend of Titian, wrote in 1557 that Alfonso paid Titian three-hundred *scudi* for his portrait. He also tells the story that Michelangelo admired the picture on his visit to Ferrara in 1529 (Dolce, *Dialogo della pittura*, edition 1960, p. 159). This detail is repeated by Vasari and by Aretino in his play *La Cortegiana*, Act III, Scene VII (Gronau, 1928, p. 236; Dolce, edition 1960, Barocchi's note p. 449).

Presumed History: Collection of Alfonso I d'Este until 1533; gift to Emperor Charles V in January 1533 (Gronau, 1928, pp. 244–245, documents about the gift); shipped to Spain via Genoa and Barcelona in March 1533 (Keniston, 1959, p. 154); Alcázar, Madrid, Inventory 1666, Galería del Mediodía, no. 612, 200 ducats, wrongly described as the 'Duke of Urbino' with his arm upon a cannon ('el Duque de Urbino con una mano sobre un tiro de Artillería de mano de el Ticiano'); Alcázar, Inventory 1686, no. 288; Inventory 1700, no. 99, 150 doubloons (Bottineau, 1958, p. 159). It is most likely that this picture was among the many gifts in 1704 to the Duc de Gramont, the French ambassador.

Certain History: Comtesse de Vogüé, Château de Commarin near Dijon until about 1925 (*New York Times*, 8 June 1927); purchased from A. S. Drey, Munich, by the Metropolitan Museum in 1927.

Bibliography: See also above; Campori, 1874, pp. 601–604 (mistakenly thought it was the picture still preserved in the Prado Museum, Madrid, now known to represent Federico II Gonzaga (see Cat. no. 49); Mayer, 1925, pp. 279–282 (Titian, *c.* 1529); Burroughs, 1927, pp. 97–101 (Titian, *c.* 1523–1525); Gronau, 1928, pp. 237–246 (definitive study with documents); Suida, 1935, pp. 44, 79, 161 (Titian); Tietze, 1936, II, p. 303 (indecisive opinion); Wehle, 1940, pp. 192–193 (Titian, *c.* 1523–1525); Berenson, 1957, p. 189 (Titian, 1534; thus confusing it with the second portrait); Valcanover, 1960, I, p. 81 (doubtful attribution); *idem*, 1969, no. 116 (doubtful); Pallucchini, 1969, p. 261, fig. 184 (probably a copy).

Alfonso I d'Este, see also: Cat. no. L–10.

27. Isabella d'Este, Marchioness of Mantua, in Black
Plate 72

Canvas. 1·02 × 0·64 m.

Vienna, Kunsthistorisches Museum.

About 1534–1536.

Her black costume is trimmed with a broad grey fur-piece, against which are placed the blue sleeves decorated with white and gold. The *balzo* (rolled headdress) of light tan upon her chestnut hair stands out from the dark background of the picture. Titian painted this portrait using as a model a younger likeness of Isabella by Francesco Francia, a fact which explains the stilted, lifeless attitude. In 1534 Isabella was sixty.

The pattern of gold embroidery on the sleeves is said to have been designed by Niccolò da Correggio, who was inspired by Leonardo da Vinci's interlaced designs. Isabella d'Este gave her sister Beatrice permission to use the same pattern on a gown worn at the wedding of Bianca Sforza and Emperor Maximilian (Cartwright, 1899, edition 1928, pp. 208–209; *idem*, 1903, edition 1926, II, pp. 355–357).

Biography: Isabella d'Este (1474–1539), daughter of Ercole I d'Este and Eleanora of Aragon, was born and reared at Ferrara. At the age of sixteen she married Francesco II

Gonzaga (1466–1519), heir to the Marquisate of Mantua. One of the great ladies of the Renaissance, Isabella was patroness of humanists, scholars, writers, and artists. In her earlier years she employed Andrea Mantegna, Lorenzo Costa, and Francia, and later she sought the works of Giorgione and Titian. Her brother Alfonso I d'Este (Cat. no. 26) became one of Titian's first great patrons when the Venetian provided the three mythological pictures (1518–1523) for the Alabaster Room in the castle at Ferrara. Her son Federico II Gonzaga (1500–1540) (Cat. no. 49) was Marquess and later Duke of Mantua, while her daughter, Eleanor Gonzaga, became Duchess of Urbino (Cat. no. 87). Among the humanists and writers who frequented Isabella's court were Pietro Bembo (Cat. no. 15) and Baldassare Castiglione (Cat. no. 19) (Cartwright, 1903; Lauts, 1952).

Condition: Damage to the canvas is discernible on the forehead, chin, and the blouse.

Documentation: That the portrait by Francia, painted in 1511, when Isabella was thirty-seven, served Titian as model in 1534–1536, was demonstrated with scholarly finality by Luzio (1900, pp. 427–434; in expanded form, 1913, pp. 219–230), who published several letters including the one of 29 May 1536, in which Isabella acknowledges the arrival of her likeness by Titian. A later reference occurs in a letter from Pietro Bembo to Girolamo Quirino on 24 December 1543: 'Ho fatto molto caro che messer Tiziano abbia ben finita la figura di Madonna Isabella . . .' (Spezi, 1862, p. 65).

History: Gonzaga Collection, Mantua (not in the Inventory of 1627; see Luzio, 1913, pp. 89–136); Archduke Leopold Wilhelm, Vienna, Inventory 1659, no. 367 (Berger, 1883, p. cvii).

Bibliography: See also above; Teniers, 1660, pl. 75; Stampart, 1735, pl. 14; Engerth, 1884, I, pp. 355–357 (Titian's Isabella d'Este; a thorough study); C. and C., 1877, I, pp. 385–388, 457–458 (letters of 1534 and 1536 in Italian and in English translation); Gronau, *Titian*, 1904, pp. 275–276 (Titian); Fischel, 1924, p. 67 (Titian); Ozzola, 1931, pp. 391–394 (not Isabella d'Este); Suida, 1935, pp. 82, 168 (not Isabella d'Este; workshop of Titian); Tietze, 1936, II, p. 317 (Isabella by Titian, 1534–1536); Tietze and Tietze-Conrat, 1936, pp. 139–140 (same opinion); Klauner and Oberhammer, 1960, p. 137, no. 712 (Isabella d'Este by Titian); Valcanover, 1960, I, pl. 139; *idem*, 1969, no. 174 (Isabella d'Este by Titian); Pallucchini, 1969, p. 270, fig. 225 (Isabella d'Este by Titian, 1534–1536).

COPY:
Cordoba, Museo de Bellas Artes (Plate 230); canvas, 1·06× 0·86 m., mediocre copy of the picture in Vienna, patched, darkened, and heavily varnished; formerly in the Prado Museum, Madrid.
History: Probably the item listed in the Alcázar, Madrid, Galería del Mediodía, Inventory 1666, no. 584; Inventory 1686, no. 262; Inventory 1700, no. 73 (Bottineau, 1958, p. 154). *Bibliography:* Madrazo, 1873, p. 92, no. 495; *idem*, 1910, p. 86, no. 451 (copy); Allende-Salazar and Sánchez Cantón, 1919, pp. 32–33 (copy).

LOST COPY BY RUBENS:
History: Rubens' Inventory 1640, no. 57, 'Isabella d'Este in black' (Lacroix, 1855, p. 271). *Bibliography:* Engerth, II, 1884, edition 1892, pp. 400–401; Rooses, 1890, IV, pp. 198–199, no. 971; Luzio, 1900, p. 432, print by Vorsterman, p. 428.

Isabella d'Este, see also: Cat. nos. L–11, and X–31, X–32.

28. Falconer (Gentleman with a Falcon) Plate 38
Canvas. 1·09×0·94 m.
Omaha, Joslyn Art Museum.
Signed at the left: TITIANVS F
About 1520.

The picture has been so much repainted that only the composition, admittedly original in idea, can be credited to Titian.

Condition: Overcleaned, darkened, and much repainted.

Probable History: Prince de Carignano, Paris, sale, 1743, no. 42 (Mireur, 1912, VII, p. 289); Louis François de Bourbon, Prince de Conti, 1743–1777, 3 *pies* 6 *pouces* × 2 *pies* 9 *pouces*, sale, Paris, 8 April 1777, no. 92 (Mireur, *loc. cit.*, p. 290). *Certain History:* Earl of Carlisle, *c.* 1811–1895 (Waagen, 1854, II, p. 278; Cust, 1895, p. 211, Titian); E. F. Milliken, sale, New York, 14 February 1902, no. 26, bought in (also *Connoisseur*, II, 1902, p. 277); Milliken sale, 23 May 1903, no. 78 (*Connoisseur*, VI, 1903, p. 188); Edward Simon, Berlin, *c.* 1903–1921; Duveen & Co., New York; Erickson, New York, *c.* 1930–1942; Wildenstein Galleries, New York; purchased by the Joslyn Museum from Wildenstein, 1942.

Bibliography: See also History; C. and C., 1877, II, pp. 18–20 (Titian); Gronau, *Titian*, 1904, p. 307 (Titian); L. Venturi, 1931, pl. 380; 1933, pl. 512 (Titian); Suida, 1935,

pp. 90, 168 (Titian); Tietze, 1936, II, p. 303 (Titian, c. 1525; then owned by Erickson); *idem*, 1950, p. 391 (Titian, restored); Berenson, 1957, p. 189 (Titian); Valcanover, 1960, pl. 118A (Titian, c. 1525); *idem*, 1969, no. 123 (Titian, c. 1525); Pallucchini, 1969, p. 261, fig. 185 (Titian, c. 1525–1528).

OTHER VERSIONS:

1. Venice, Valentino Benfatto (Zanotto, *Guida*, 1863, addenda, reference given by C. and C., 1877, II, p. 20).
2. Washington, Robert Guggenheim (formerly); very poor copy, canvas, 0·953×0·775 m., destroyed by fire. *History:* Le Brun sale, Paris, 1810 to Sir Thomas Baring (Buchanan, 1824, II, p. 253, as Titian): sold privately to Holford in 1843 (C. and C., 1877, II, p. 461, Titianesque); Holford sale (London, 5 July 1927, no. 100, as Andrea Schiavone); later to Contini-Bonacossi Collection, Florence, as by Sebastiano del Piombo.

For the history of this item and its separation from the Joslyn Museum picture I am indebted to the scholarly generosity of Ellis K. Waterhouse.

3. London, Lord Chesham (formerly), exhibited at Leeds, 1868, no. 255; said to have come from the Averoldi Collection, Brescia; perhaps the same item was sold in London, Sotheby's, 21 May 1952: canvas, 1·167×0·89 m. (*APC*, XXIX, 1951–1952, no. 3003).

29. Cardinal Alessandro Farnese Plate 132

Canvas. 0·99×0·79 m.

Naples, Gallerie Nazionali, Capodimonte.

1545.

Only the lamentable state of preservation can explain the hesitation of some critics to accept this portrait as by Titian's hand. The red watered-silk of the robes in this three-quarter-length portrait stand out brilliantly against the curtain, now turned black-and-brown. A direct, forceful characterization adds to the effectiveness of the handsome colour. On the back of the canvas appear a Farnese lily and the legend 'C. S. Angelo', i.e. Cardinal Sant'Angelo in Foro Piscium, the title bestowed upon him by his grandfather in 1534.

Biography: Cardinal Alessandro Farnese (1520–1589), son of Pierluigi Farnese (Cat. no. 30) and Girolama Orsini, grandson of Pope Paul III (Cat. no. 72), was one of the great churchmen of the sixteenth century. He studied at the University of Bologna, became Cardinal di Sant'Angelo in Foro Piscium at the age of fourteen and later held several bishoprics. His title subsequently changed to that of Cardinal of SS. Lorenzo e Damaso, that of Sant'Angelo passing to

his younger brother Ranuccio (Cat. no. 31). Alessandro served as papal legate on various occasions, including an attempt to settle the state of war between Francis I of France (Cat. no. 37) and Emperor Charles V (Cat. no. 21). Aspiring to the papacy himself, but unsuccessfully, Cardinal Alessandro Farnese became the first and major patron of the Jesuits and was the prime force in the building and decoration of the church of the Gesù and the Jesuit College in Rome. In the realm of domestic architecture his major project was the Farnese Castle at Caprarola (Cardella, 1793, IV, pp. 136–140; Moroni, XXIII, 1844, pp. 211–213; Pastor, XI, 1923, *passim*; Drei, 1954, *passim*). His natural daughter Clelia was celebrated as one of the great beauties of her time (see Cat. no. L–13).

Condition: Dirty and extremely damaged, particularly the upper background, which is blistered and ruinous; partially cleaned in 1960.

History: Palazzo Farnese, Rome; shipped from Rome to Parma in 1662, Inventory, no. 66, 'Un ritratto in tela del cardinal S. Angelo testa busto e mani, mano di Titiano' (Filangieri di Candida, 1902, p. 269, no. 65); Palazzo del Giardino, Parma, Inventory 1680, 'Un quadro alto br. 1 on. 11, largo br. 1, on. 5 e 1/2, Ritratto del Cardinale S. Angelo con berretta in capo tiene li guanti nella sinistra e la destra in ombra con sopra panno verde, di Tiziano' (Campori, 1870, p. 234); taken to Naples, Palazzo di Capodimonte, in the mid-eighteenth century; sent to Palmero in 1798; returned to Naples after the fall of Napoleon in 1815; in the Palazzo Reale, Naples, until 1831, 'Tela. Ritratto di Cardinal Santangelo con guanti in mano, Tiziano Vecellio...' (Filangieri di Candida, 1902, p. 342, no. 16; Rinaldis, 1911, p. 140; 1927, p. 323).

Bibliography: See also above; Vasari (1568)-Milanesi, VII, p. 446 (portrait of Cardinal Alessandro, painted at Rome 1545–1546); Ridolfi (1648)-Hadeln, I, p. 178 (wrong data: a portrait painted in Rome in 1548!); C. and C., 1877, II, p. 89 (uncertain); Rinaldis, 1911, pp. 139–140; *idem*, 1927, pp. 321–322 (Titian); Serra, 1935, p. 561 (uncertain; bad condition); Suida, 1935, pl. 150b (Titian); *Mostra di Tiziano*, 1935, no. 58 (Titian, 1543); Tietze, 1936, II, p. 302 (doubtful); Pallucchini, 1954, II, p. 26 (Titian, 1546); Berenson, 1957, p. 189, no. 133 (partly by Titian); Valcanover, 1960, II, pl. 3 (Titian); *idem*, 1969, no. 260 (commonly attributed); Pallucchini, 1969, p. 286, fig. 311 (Titian, c. 1546).

COPY:

Late copy in the upper gallery of the Palazzo Farnese, Rome (1966).

LOST PORTRAIT:
Parma, Palazzo del Giardino, Inventory 1680, 'Un quadro alto on. 10 e 1/2 largo on. 7 e 1/2 in tavola. Ritratto del Cardinale S. Angelo con berretta in capo, di Tiziano' (Campori, 1870, p. 230).

Cardinal Alessandro Farnese: see also Cat. X–33.

30. **Pierluigi Farnese and Standard Bearer** Plate 123

Canvas. 1·06×0·95 m.

Naples, Gallerie Nazionali, Capodimonte.

1546.

A magnificent picture despite its lamentable condition, it shows Pierluigi in black armour standing against a rose banner, which is held by a young soldier. Titian painted the portrait either at Piacenza *en route* from Rome to Venice in 1546 or later the same year, when Pierluigi visited Venice. Since the artist's sojourn at Busseto in 1543 afforded little time for painting, that date for this picture must be excluded.

Biography: Pierluigi Farnese (1503–1547) was the son of Cardinal Alessandro Farnese, then aged 35, later to become Pope Paul III (1534–1549; see Cat. no. 72); his mother was a young woman thought to have been of a noble Roman family, the Ruffini. At the age of sixteen Pierluigi married Girolama Orsini, by whom he had several children: Vittoria (1519; Cat. no. X–35); Cardinal Alessandro (1520; Cat. no. 29); Ottavio (1524; Cat. no. L–14); Ranuccio (1530; Cat. no. 31); and Orazio (1531). The pope aggrandized the family fortunes by making Pierluigi Duke of Castro (1528) and later Duke of Parma and Piacenza (1545). In 1547 by connivance of Ferrante Gonzaga, the governor of the Spanish duchy of Milan in the name of Charles V, Pierluigi was murdered in his castle at Piacenza. This member of the Farnese clan, a soldier of fortune, ruthless in his ambitions, acted as agent of his father the pope in creating the Farnese empire (Drei, 1954, pp. 17–80).

Condition: Ruinous with blistered surfaces and extensive losses of paint; conservation measures taken in 1960.

History: Probably the portrait at Caprarola, 1626–1660: Inventory 1626, folio 68, 'un quadro mezzano del Duca Pier Luigi farnese' in the Camera dello Studio; in the same room, Inventory 1651, folio 17ᵛ; in 1668, not there (Fondo Farnese, nos. 1176–1177, Naples, Archivio di Stato); Palazzo Farnese, Rome, *c.* 1660–1662; sent from Rome to Parma, Inventory 1662, no. 84 (Filangieri di Candida, 1902, p. 269, no. 44; Rinaldis, 1911, p. 149); Palazzo del Giardino,

Parma, Inventory 1680, settima camera (Campori, 1870, pp. 233–234); brought to Naples *c.* 1738; taken by the French in 1799, recovered in Rome in 1800 (Filangieri di Candida, 1902, p. 306); sent to Sicily in 1806 from the Palace of Francavilla in Naples (Filangieri di Candida, 1902, p. 231); brought back from Palermo to Naples in 1815 after the fall of Napoleon (Filangieri di Candida, 1902, p. 237).

Bibliography: See also History; C. and C., 1877, II, pp. 130–131 (Titian 1546); Clausse, 1905, pp. 124–128 (Titian, 1546); Rinaldis, 1911, pp. 147–149; 1927, pp. 332–334; Suida, 1935, pp. 105, 169 (Titian); *Mostra di Tiziano*, 1935, no. 67 (Titian, 1546); Tietze, 1936, II, p. 302 (Titian, 1546); Pallucchini, 1954, II, pp. 28–29 (Titian, 1546, at Piacenza); Berenson, 1957, p. 189 (Titian); Valcanover, 1960, II, pl. 7 (Titian, 1546, at Venice); *idem*, 1969, no. 271 (Titian, 1546, at Venice); Pallucchini, 1969, p. 286, fig. 313 (Titian, 1546–1547).

Pierluigi Farnese: see also Cat. nos. X–34 and L–15.

31. **Ranuccio Farnese, as Knight of Malta**
 Plates 109, 113, 114

Canvas. 0·897×0·736 m.

Washington, National Gallery of Art, Kress Collection.

Signed at the right below the shoulder: TITIANVS F

1542.

The superb quality of this portrait identifies it as the picture by Titian mentioned in a letter of 22 September 1542 from Gian Francesco Leoni of Padua to Cardinal Alessandro Farnese. Leoni writes that the Bishop of Brescia will take the picture to the cardinal in Rome, and that he believes that Titian might be persuaded to enter the Farnese service at the papal court (copy of the letter in the files of the National Gallery, Washington; see also History). The former classification of this canvas as a copy, because of its dirty condition, is now generally rejected, in recognition of the pictorial and psychological splendour of Ranuccio Farnese's portrait.

Ranuccio is also recognizable in a fresco by the Zuccari in the Farnese castle at Caprarola, where he appears in the scene in which Paul III designates Pierluigi commander of the papal forces.

Biography: Ranuccio Farnese (1530–1565), son of Pierluigi Farnese (Cat. no. 30) and Girolama Orsini, grandson of Pope Paul III (Cat. no. 72), was sent to Venice in 1542 as prior of the Knights of Malta in that city, a fact indicated

by the Maltese cross upon his cloak in Titian's portrait. His grandfather elevated him to the rank of Cardinal of Santa Lucia in Sicily at the age of fifteen, and not long thereafter he took the title of Cardinal of Sant'Angelo in Foro Piscium, which had previously belonged to his elder brother Cardinal Alessandro Farnese (Cat. no. 29). Various bishoprics were conferred upon him, among them Naples, Bologna, and Ravenna. In spite of the nepotism with which he was favoured his good character and excellent education made him well liked by his contemporaries (Cardella, 1793, IV, pp. 282–284; Drei, 1954, pp. 14, 34, 63; Pastor, XI, 1923, *passim*).

Condition: Somewhat darkened; slight scrubbing of the surface around the mouth and chin; cleaned in 1949–1950.

History: Painted in Venice in 1542 (letter of 22 September 1542 in Ronchini, 1864, p. 2); Farnese Collection, Rome; sent to Parma at an unknown date; Farnese Collection, Palazzo del Giardino, Parma, Inventory 1680, 'ritratto di un giovane vestito di rosso con sopra veste nera, sopra della quale la croce di cavaliere di Malta, tiene nella destra un guanto, di Tiziano' (Campori, 1870, p. 239); in the mid-eighteenth century the Farnese Collection was transferred to Naples; probably 'un ritratto di giovane, in tela, di Tiziano' at Palazzo Francavilla, 1802 (Filangieri di Candida, 1902, p. 304, no. 34); the portrait may have been stolen during the political disruption of the Napoleonic period; shortly before 1885 taken to England from Naples (Robinson, 1885, p. 136); Sir George Donaldson, London; Cook Collection, Richmond (Borenius, 1913, p. 170, no. 143); Contini-Bonacossi Collection, Florence, 1945 (?); Samuel H. Kress Collection, 1948.

Bibliography: See also above; Van Dyck's 'Italian Sketchbook' (perhaps folio 108); C. and C., 1877, II, pp. 75–77 (with wrong identification); Clausse, 1905, pp. 293–302 (incorrect data); Gronau, 1906, pp. 3–7 (Ranuccio identified; by Titian); Fischel, 1907, p. 99 (copy); Borenius, 1913, no. 143 (Titian); Berenson, 1932, p. 574 (copy); Suida, 1935, pp. 92, 169 (Titian); Tietze, 1936, II, p. 307 (undecided); Kelley, 1939, pp. 75–77 (Titian, portrait of Ranuccio); Suida, 1951, pp. 114–115 (Titian); *idem*, 1952, pp. 38–39; Pallucchini, 1953, I, pp. 209, 212 (Titian, 1542); Berenson, 1957, p. 192 (studio of Titian); Valcanover, 1960, I, pl. 167 (Titian); Pope-Hennessy, 1966, pp. 279–280 (Titian); Shapley, 1968, pp. 182–183 (Titian); Valcanover, 1969, no. 227 (commonly attributed); Pallucchini, 1969, p. 277, figs. 264–265 (Titian, 1541–1542).

COPIES:
1. Berlin-Dahlem, Staatliche Gemäldegalerie; panel, 0·20×

0·14 m. (Plate 112), inscribed on the back, 'n⁰ iso mano del Salviato', attributed by Gronau to Francesco Salviati, who spent two years in Venice in 1539–1541 before Titian painted the original (Gronau, 1906, pp. 3–7); if painted by Salviati, Francesco saw it in Rome, while Giuseppe settled in Venice in 1539 and remained until his death in 1575 (Thieme-Becker, XXIX, 1935, p. 367); given by Meyer to El Greco! (Mayer, 1926, no. 356); Wethey, not El Greco (Wethey, 1962, II p. 202, no. X-168); Valcanover, Salviati (1969, under no. 224); Pallucchini, El Greco (1969, p. 277).
2. Florence (formerly), Mr. Brauer (Suida, 1951, p. 114).

32. **Farnese Gentleman** (so-called) Plate 228
Canvas. 1·05×0·84 m.
Pommersfelden, Schönborn Collection.
Titian (?).
About 1526.

The escutcheon, said to be of the Farnese, at the upper left is the reason for the identification of the sitter as a member of that family. However, the identification of the escutcheon is entirely conjectural, and the attribution to Titian is not secure. It has not been possible to locate a copy of the print cited by Suida.

Condition: Scrubbed, dirty, and scarred, a fact visible in the inadequate photograph.

History: 1776 mentioned at Pommersfelden; engraved by I. Vandergucht (1660–1725) as Cesare Borgia, an obviously incorrect title.

Bibliography: Arslan, 1931, pp. 1363–1365 (Titian, c. 1537); Suida, 1935, pp. 91, 169 (print inscribed: 'Apud Dominum Valettum Neapoli', i.e. Valetta, Malta?), pl. 140b (Titian); Tietze, 1936 (not listed); Pallucchini, 1953, I, p. 150 (Titian, c. 1525); Berenson, 1957, p. 190 (Titian; German sitter); Valcanover, 1960, I, pl. 118b (Titian); *idem*, 1969, no. 126 (generally attributed); Pallucchini, 1969, p. 260, fig. 178 (Titian, c. 1524–1526); Dussler, 1970, p. 550 (not Titian).

33. **Francesco Filetto and His Son** (presumed)
 Plates 133, 134
Canvas. Fragments, 0·83×0·62 m. and 0·89×0·67 m.
Vienna, Kunsthistorisches Museum.
About 1538–1540.

The old copy now in Ankara (Plate 131) proves that the two fragments originally made one picture of the famous orator and his son. After the dismemberment of the painting

sometime in the seventeenth century, the separated figures were transformed into a St. James and a youth with an arrow. The expressions of the faces are splendidly projected despite the vicissitudes of the original canvas. Ludwig Burchard is given credit for correctly associating this fragmented work with *Filetto and His Son* (Wilde, 1928, pp. 226–227), a picture which Vasari saw in the Giustiniani Collection at Venice (Vasari (1568)-Milanesi, VII, p. 455). Doubt that the man is Filetto has been expressed because the Vienna figure does not closely resemble the man in a portrait labelled 'Franc. Philetus Doctor', attributed to Bernardino Licinio, in the Palazzo Rosso at Genoa (illustrated by Grosso, 1931, p. 240), The ages and costumes are clearly different, but this fact does not strengthen Ferdinando Bologna's identification of another really mediocre portrait as Titian's *Filetto* (see below).

Condition: Very little of Titian's original paint survives in these much damaged and repainted canvases. Left hand of the son as well as the arrows are later additions, c. 1600.

Dating: Contemporary with *Georges d'Armagnac and His Secretary* dated 1536–1538 (Cat. no. 8).

History: Collection of Matteo Giustiniani, Venice, seen by Vasari in 1566 (Vasari (1568)-Milanesi, VII, p. 455); Archduke Leopold Wilhelm, Vienna, 1659, already cut into two pieces (Teniers, 1660, pl. 81, the boy; pl. 85, Filetto); Stallburg Castle (Storffer, 1720, p. 224).

Bibliography: See also above; Ridolfi (1648)-Hadeln, I, p. 192 (Titian; copies Vasari); Mechel, 1783, p. 17, no. 4; C. and C., 1877, II, pp. 76–78 (mistakenly identified the figures as Ranuccio Farnese and his tutor Gian Francesco Leoni); Fischel, fifth edition, 1924, pls. 124–125 (St. James and a Youth, Titian, c. 1540); Clausse, 1905, pp. 292–299 (repeats Crowe and Cavalcaselle); Tietze, 1936, II, p. 316 (Filetto by Titian, c. 1550); Bologna, 1957, p. 69 (wrongly identifies another picture as Filetto and son rather than the Vienna portraits; this work, dated 1552, cannot possibly be accepted as by Titian; see Cat. no. X-36); Klauner and Oberhammer 1960, pp. 138–139, nos. 714, 715 (Filetto and son by Titian); Valcanover, 1960, II, pls. 8, 9 (follows Bologna in rejecting identification; Titian); *idem*, 1969, nos. 286, 287 (Titian; still rejects identification); Pallucchini, 1969, p. 288, figs. 326, 327 (Titian, c. 1545–1548; rejects identification).

COPIES:
1. Ankara, German Embassy, on loan from the Staatliche Gemäldegalerie, Berlin, since 1905 (Plate 131); canvas, 0·89×1·075 m., shows the two figures together before the original canvas was cut into two parts and modified by the elimination of the landscape behind the boy. Mentioned by Crowe and Cavalcaselle (1877, II, p. 78), Gronau, 1906, pp. 4–5, and Pallucchini, 1969, p. 288, as in storage at the Berlin Museum. The picture was purchased from the Solly Collection in 1821 (Archives, Berlin Museum).
2. Blenheim Palace (formerly); copy of Filetto and Son by Teniers (sale, 7 August 1866, no. 111, as St. Aloysius Gonzaga, and no. 115, as St. James; C. and C., 1877, II, p. 78).
3. Merion (Pennsylvania), Barnes Foundation; copy (photograph, Frick Library, New York).

34. **Andrea dei Franceschi** Plate 63
Canvas. 0·819×0·635 m.
Detroit, Institute of Arts.
About 1532.

This version of Franceschi's portrait includes the left hand holding a paper with a defaced inscription. Although the face is somewhat less wrinkled than in the Washington picture, the works seem close together in date. The superior quality of the Detroit painting makes it the best candidate for an original, whereas the Washington canvas is unmistakably inferior (Plate 61) and the triple portrait at Hampton Court a pastiche (Plate 275).

Biography and Dating: Andrea dei Franceschi (1472–1551), born in 1472 (Sansovino (1580)-Martinioni, 1663, p. 64), became chancellor of Venice in 1529, aged fifty-seven, at which time, Berenson suggested, he might have had Titian paint his portrait (Berenson, 1927, p. 235, and 1947, p. 30). On the other hand, the fragmentary inscription on the Washington version (Cat. no. 35) suggests the year 1532. Franceschi appears among the spectators (Plate 62) in Titian's *Presentation of the Virgin* (Wethey, I, 1969, Cat. no. 87). Although the identification of these portraits as Andrea dei Franceschi is not completely proven, it is likely to be correct.

Condition: Well preserved, but darkened; cut down slightly on the right side.

History: Possibly the portrait of Franceschi seen in the house of Count Vidman, Venice (Ridolfi (1648)-Hadeln, I, p. 201), although it is uncertain which version this might be; Frederick II of Prussia until 1806; confiscated by the French; Viardot Collection, Paris, until 1910 (sale, Paris, Hôtel Drouot, 27 June 1910, no. 16, as Tintoretto); Duveen, New York, until 1929; Whitcomb Collection, Detroit; bequest to the Institute of Arts in 1953.

Bibliography: See also above; Fischel, 1924, p. 277 (uncertain attribution); Charles Holmes, 1929, p. 16 (dates it *c.* 1545 when Andrea was 73); Suida, 1935, pp. 88, 168 (Titian); Tietze, 1936, II, p. 286 (Titian, *c.* 1540); Berenson, 1947, pp. 30–31 (Titian); Tietze, 1950, p. 371 (replica of Titian by a follower of Tintoretto); Pallucchini, I, 1953, p. 174 (Titian, superior to the Washington version); Detroit, 1954, p. 107 (Titian, *c.* 1540); Berenson, 1957, p. 184 (Titian, 1532); Valcanover, 1960, I, p. 101 (doubtful attribution); *idem,* 1969, no. 156 (commonly attributed); Pallucchini, 1969, p. 266, fig. 207 (Titian and workshop, *c.* 1532).

35. Andrea dei Franceschi Plate 61

Canvas. 0·65 × 0·51 m.

Washington, National Gallery of Art.

A fragmentary inscription reads: TIS
 OLX

Workshop of Titian.

About 1532.

The inscription has been interpreted by Sir Charles Holmes as AETATIS...ANNO LX, making Franceschi sixty years old in 1532. His costume is a brilliant red, indicative of his office as chancellor or as magistrate of the Council of State, when combined with the black stole (Vecellio, 1598, p. 81; information supplied by Dr. Emma Mellencamp).

Condition: Reduced in size, it probably originally included the hands. The bluish goatee and the bluish strands of hair at both temples are clearly repaint.

History: Earl of Wemyss, Lord Elcho, Gosford House, East Lothian, before 1877 (C. and C., 1877, II, pp. 64–65); Duveen, London, 1927; Mellon Collection, Washington; gift to the National Gallery in 1937.

Bibliography: C. and C., 1877, II, pp. 64–65 (Titian); Berenson, 1927, p. 233 (Titian); Poglayen-Neuwald, 1927, p. 59 (workshop); Holmes, 1929, pp. 159–160 (Titian); Tietze, 1936, II, p. 287 (mentioned under Detroit version); Washington, 1941, p. 196, no. 35 (Titian); Berenson, 1947, p. 30 (Titian); Tietze, 1950, p. 403 (Titian); Pallucchini, I, 1953, p. 174 (Titian); Berenson, 1957, p. 192 (Titian); Valcanover, 1960, I, p. 101 (doubtful attribution); *idem,* 1969, no. 155 (commonly attributed; 1532); Pallucchini, 1969, p. 266 (under Detroit version; copy).

Andrea dei Franceschi, see also: Cat. nos. X–39 and X–103.

36. Francis I Plate 78

Canvas. 1·003 × 0·825 m.

Leeds, Harewood House, Earl of Harewood.

Titian's Sketch.

About 1538.

Although the king is hatless, this version may be Titian's preliminary sketch for the Louvre portrait (Cat. no. 37), since the picture is known to have come from the artist's own collection.

Condition: Cut down and retouched, apparently by Lenbach; rather dirty.

History: Titian's house, the Casa Grande; Barbarigo Collection, Venice, from 1581; in their palace in the Piazza di San Polo in 1648 according to Ridolfi (Ridolfi-Hadeln, I, p. 200; also Savini-Branca, 1964, p. 186); passed to the Giustiniani-Barbarigo Collection, Padua (cited there by Selvatico, 1875, pp. 6–9, 14, size 1·14 × 0·95 m.); owned by the painter Franz von Lenbach, *c.* 1892–1911; London, Agnew Brothers, 1911–1919; bought by Lord Lascelles, sixth Earl of Harewood.

Bibliography: See also History; C. and C., 1877, I, pp. 383–384 (Titian, study for Louvre picture); Fischel, 1924, p. 90; Suida, 1935, p. 84, pl. 203A (study for Louvre picture); Tietze, 1936, II, p. 306 (under Paris); Borenius, 1936, p. 34, no. 67 (Titian); Hetzer, 1940, p. 164 (weak variant); Tietze, 1950, p. 84 (reworked); Berenson, 1957, p. 186 (Titian in great part); Valcanover, 1960, I, p. 103, pl. 219A (weak replica); Mariacher, 1963, pp. 213–214 (inferior to other two versions); Valcanover, 1969, no. 197 (commonly attributed); Pallucchini, 1969, p. 272 (under Louvre version; Titian, sketch).

COPY:

Munich, Alte Pinakothek, storage, panel, 0·243 × 0·19 m. (photo 30/174).

LITERARY REFERENCE:

Lomazzo's praise of Titian's skill in painting the effects of light upon armour in portraits of Francis I and Emperor Ferdinand I of Austria (Lomazzo, 1548, libro IV, cap. XV; see Cat. no. L–16) does not necessarily mean that he had ever seen either work, since he is not known to have visited France or Austria. As a matter of fact this one reference to Francis I in armour is not sufficient to conclude that such a picture ever existed (Mariacher, 1963, pp. 214–215). Lomazzo could have seen a number of other portraits of men in armour by Titian.

37. Francis I Plate 79

Canvas. 1·09×0·89 m.

Paris, Louvre.

1539.

The fine decorative qualities of this portrait, which include
the rose doublet and sleeves, black jacket with fur collar,
and black hat with a white plume, leave no doubt of Titian's
authorship, although he never saw the king. The fact that
Benvenuto Cellini's medal served as the artist's model for
the head explains the profile position of the black-bearded
king. Minor details consist of a dagger hilt in Francis'
right hand and a locket containing a full-length female
figure, which may represent Eleanor of Austria, sister of
Charles V, the king's second wife, whom he married in
1530.

Biography: Francis I, 1494–1547, King of France (1515–1547)
is too celebrated to require a lengthy biography here.
In relation to Italy he lost out to Charles V on his defeat at
Pavia in 1525, although the struggle for European domina-
tion continued. His greatest claim to fame as a major
Renaissance prince lies in his patronage of artists, writers,
and humanists, the most celebrated being Leonardo da
Vinci (Lamor, 1910, pp. 934–935).

Condition: Darkened and dirty but well preserved; cleaned
in 1755 (Bailly-Engerand, 1899, p. 77).

History: Commissioned by Pietro Aretino as a gift to Francis
I, a fact recorded in the following poem by Aretino which
includes the date 1539; not mentioned in Aretino's letters.

> E basta a me, che Tiziano Apelle
> . . .
> per carità dell' amicizia nostra
> dipinto m'abbia con mirabil far
> la immagine sacra dell' Altezza Vostra
> . . .
> Di Vinegia il decembre a non sò quanti,
> nel trentanove ch' ha fame, e non sete,
> Pietro Aretino, che aspetta i contanti
> (Aretino, *Opere burlesche*, edition 1863, Libro III,
> p. 383; Aretino, *Poesie*, edition 1930, I, p. 98).

Collection of Francis I, Fontainebleau; Versailles, Le
Brun Inventory, 1683, no. 130; Versailles, 1695; Hôtel
d'Antin, Paris, 1715; Versailles, 1737; Lépicié, 1752, p. 33
(full history in Bailly-Engerand, 1899, pp. 76–77).

Bibliography: See also above; Vasari (1568)-Milanesi, VII,
pp. 437, 450; Ridolfi (1648)-Hadeln, I, p. 192; Louvre cat.
no. 1588, inv. no. 753; Villot, 1874, p. 287, no. 469; C. and

C., 1877, I, pp. 383–385 (Titian); Gronau, *Titian*, 1904, pp.
126, 284; Fischel, 1924, p. 91; Suida, 1935, pp. 84, 169;
Tietze, 1936, II, p. 306 (1538–1539); Berenson, 1957, p. 190;
Valcanover, 1960, I, pl. 145; Mariacher, 1963, pp. 210–
220; Valcanover, 1969, no. 188 (Titian): Pallucchini, 1969,
p. 272, fig. 243 (*c.* 1538).

38. Francis I Plates 80, 81

Canvas. 1·07×0·90 m.

Geneva, Maurice Clément de Coppet.

About 1539.

Almost identical with the Louvre portrait, this version
appears in photographs and colour reproductions to be of
good quality.

Condition: Somewhat better preserved than the other two
versions (Cat. nos. 36–37).

History: Proposed as the picture in the collection of the
Duke of Urbino, acquired in 1539 (Gronau, 1904, p. 10;
Vasari (1568)-Milanesi, VII, p. 443); listed in the della
Rovere Inventory, 1631, no. 23, but it did not go to Florence
as part of the dowry of Vittoria della Rovere on her engage-
ment to Ferdinand II dei Medici (Gronau, 1904, p. 10);
said to have been in the collection of the Dukes of Mont-
pensier at Seville and sold by them in London in 1883
(Mariacher, 1963, p. 215); this picture does not appear,
however, in the Montpensier catalogue of 1866–1867, but
rather a miniature portrait of Francis I, King of Naples
(see Montpensier, 1867, p. 10, no. 823).

Bibliography: See also History; C. and C., 1877, II, p.
383 (lost; 1536, for the duke of Urbino); Tietze, 1950,
pp. 83–85 (Titian; first publication); Pallucchini, 1953,
I, p. 180 (Titian; superior to Louvre picture); Berenson,
1957 (not listed); Valcanover, 1960, I, pp. 88, 103 (attri-
buted, doubtful, original lost); Mariacher, 1963, pp. 210–
221, illustration (Titian); Valcanover, 1969, no. 198 (Titian);
Pallucchini, 1969, p. 272 (under Louvre picture; replica by
Titian).

39. Friend of Titian Plates 91, 92

Canvas. 0·902×0·724 m.

San Francisco, De Young Memorial Museum.

About 1540.

The title is based on the inscription upon the paper held by
the gentleman: 'Di Titiano Vecellio singolare amico.'

Borenius' suggestion that he be identified as Francesco Zuccato (del Mosaico) does not accord with other portraits associated with the famous mosaicist. This direct, earnest study seems worthy of the master.

Condition: Somewhat repainted, particularly the hand.

History: Lord Lansdowne, c. 1854–1930 (Waagen, 1854, II, p. 151); sale, Christie's, London, 1 February 1924, lot no. 4 (apparently bought in); sale Christie's, London, 7 March 1930, no. 75, to Frank Sabin (*APC*, 1929–1930, IX, no. 5483); Frank Sabin, London, to 1936; Mrs. E. S. Borthwick Norton, sale, Christie's, London, 15 May 1953, no. 87; Koetser, London; Kress Foundation, 1954; in San Francisco since 1955.

Bibliography: See also above; Jameson, 1844, p. 311; C. and C., 1877 (not listed); Ambrose, 1897, p. 113 (Titian); Wilde, 1934, p. 164 (Titian, c. 1540); Suida, 1935, p. 172, pl. 185 (Titian); Borenius, 1937, p. 41 (Titian, 1540); Tietze, 1936, II, p. 295 (Titian, c. 1550); Pallucchini, 1954, II, p. 55 (Titian); Berenson, 1957, p. 190 (Titian); Gore, 1958, p. 352 (Titian); Valcanover, 1960, II, pl. 46b (Titian); Troche, 1965, pp. 97–98 (Titian); Shapley, 1968, pp. 184–185 (Titian, c. 1550; full account); Valcanover, 1969, no. 337 (Titian, 1550); Pallucchini, 1969, p. 294, figs. 354–355 (Titian, c. 1550).

40. Gentleman in Blue (formerly called Ariosto)

Plates 3, 4

Canvas. 0·812 × 0·663 m.

London, National Gallery.

Signed on the parapet: T. V.

About 1512.

The initials T. V. on the parapet are reasonably interpreted as an abbreviation of Titianvs Vecellius, but the full name Titianus, which appeared here before the cleaning of 1949, was demonstrated to be a later amplification. Titian's authorship is now universally accepted and the arguments for an ascription to Giorgione have been abandoned.
The traditional identification of the man as Ariosto has also been rejected on comparison of his features with assured portraits of the poet (see Cat. no. X–7). H. L. Cook and others held the theory that he might be a member of the Barbarigo family whose portrait Vasari praised highly as done in Giorgione's style when Titian was eighteen. However appealing this suggestion, no concrete evidence supports it, especially since Vasari states that the Barbarigo picture was signed 'in ombra' by Titian (Vasari (1568)-

Milanesi, VII, p. 428). Vasari probably meant a signature with shadowed letters (see Cat. no. 25). Gould tentatively proposed that a Self-portrait of the artist in his youth should be considered on the basis of the pose and Rembrandt's adoption of it (1640) as well as Van Dyck in his *Self-portrait with a Flower*. That is indeed a highly reasonable theory. Discussion of the style of this portrait will be found in the text.

Condition: Cleaned in 1949; the former inscription TITIANVS V. was covered in 1949, leaving the initials T. V. which appear to be Titian's original signature. Generally well preserved except for the parapet which is restored (Gould, 1959, p. 114).

History: Engraved by Perysn at Amsterdam in 1639 (Bloch, 1946, p. 183, fig. 8); Alfonso López, a Spanish-born international agent principally in the employ of Richelieu, had this and other pictures at Amsterdam. The possibility that he purchased them in Amsterdam sales seems reasonable (Hofstede de Groot, 1906, pp. 116–118). The theory that López acquired the so-called *Ariosto* from the van Uffeln Collection in April 1639 at the time that he bought Raphael's *Castiglione* at their sale in Amsterdam has been advanced by others (Hoogewerff and van Regteren Altena, 1928, p. 99, note). Sandrart also engraved the so-called *Ariosto* at Amsterdam (Stechow, 1942, pp. 136, 145) when it was already in López's possession according to the legend on the print. The later sale of López's collection apparently took place in Paris in December 1541 rather than in Amsterdam as sometimes believed (Bloch, 1946, pp. 178–179). A letter written by Claude Vignon or Jacopo Stella in November 1641 to François Langlois, then in London, states that the López sale would take place in December (no place mentioned), and that included was Titian's famous *Ariosto*. He asks that Van Dyck in London be told about this picture and he requests that his regards be given to Rembrandt in Amsterdam and to others in Holland (Bottari, 1822, IV, p. 446); the letter was republished with comments by Moes (1894, pp. 238–240). These remarks seem to eliminate Amsterdam as the location of the sale and to place it in Paris where López was living after 1540 (Tupinier, 1933, pp. 11–12).
Sir Anthony Van Dyck, who died in London on 9 December 1641, must have ordered shortly before his death the purchase of Titian's *Ariosto* because it appears in the Van Dyck Inventory of 1644 (Müller-Rostock, 1922, pp. 22–24; this author mistakenly dated the Inventory earlier and thought that López had bought it from Van Dyck, whereas the reverse order is correct).
No final proof exists that the London picture is the same, but the probability is very great (Gould, 1959, p. 115), despite a hiatus in the history of the portrait until it reappears

in Lord Darnley's collection at Cobham Hall before 1824; sold in 1904 to Sir G. Donaldson, from whom the National Gallery purchased it that year (Gould, 1959, p. 115).

Bibliography: See also above; Waagen, 1854, III, p. 19 (Titian); C. and C., 1877, I, pp. 197–201 (Titian); Solerti, 1904, pp. 470–476 (Ariosto by Titian); Fry, 1904–1905, pp. 136–138 (Ariosto by Titian); Cook, 1907, pp. 68–73 (Giorgione; signed later by Titian); Hetzer, 1920, p. 11 (follower of Sebastiano del Piombo!); L. Justi, 1926, II, pp. 329–331 (follower of Giorgione); Suida, 1935, pp. 31–32, 156 (Titian); Richter, 1937, pp. 224–225 (Giorgione; finished and signed by Titian); Tietze, 1936, II, pp. 294–295 (Titian); Berenson, 1957, p. 187 (early Titian); Gould, 1959, pp. 114–117 (Titian); Valcanover, 1960, I, pl. 34 (Titian); Pope-Hennessy, 1966, pp. 138–139 (Titian); Valcanover, 1969, no. 16 (Titian, *c.* 1510); Pallucchini, 1969, p. 236, fig. 29 (Titian, *c.* 1510–1511).

COPIES:
1. Brescia, Tosi Collection; mediocre copy of the head only (C. and C., 1877, I, p. 201, note; Solerti, 1904, p. 472, illustrated).
2. London, Butler Johnstone; previously Munro Collection (C. and C., 1877, I, p. 201, note).
3. Mentmore, Lord Rosebery; poor copy, formerly Manfrin Collection, Venice (Waagen, 1854, III, p. 19, as Titian); C. and C., 1877, I, p. 201, note, mediocre copy; photograph in the Frick Art Reference Library, New York.
4. Vicenza, Museum; copy with variations (C. and C., 1877, I, p. 201, note); not listed in recent catalogues of the museum.

41. Gentleman with Flashing Eyes Plate 12

Canvas. 0·765 × 0·628 m.

Bury St. Edmunds, Ickworth, National Trust.

About 1512

The Giorgionesque character of this fine portrait is undeniable, but the composition is close to Titian's signed portrait in London (Plate 3) and the spirited expressiveness of the characterization is also notable.

The medallion in the upper-left background recalls the use of a circular window in Giorgione's *Fugger Youth* (Plate 11) and in the underpaint of Titian's *La Schiavona* (Plate 13). For further discussion see the Introduction in the section 'Venetian Youths and Gentlemen'.

Condition: Restored in 1970–1971; until then much repainted; cut down at the left.

History: Early history uncertain; *Head of a Monk* (!) by Titian mentioned at Ickworth in 1838 (Waterhouse, 1960, p. 40, no. 71).

Bibliography: Cook, 1910, p. 333 (Palma il Vecchio); Cook, 1912, pp. 122–123 (Palma il Vecchio); London, 1930, p. 214, no. 384 (Titian); Spahn, 1932, p. 174 (follower of Giorgione); Berenson, 1932, p. 569 (Titian); Pallucchini, 1953, I, p. 104 (Titian); Zampetti, 1955, p. 180 (Titian); Berenson, 1957, p. 186 (early Titian); Valcanover, 1960, I, pp. 94–95 (doubtful attribution); Waterhouse, 1960, p. 40, no. 71 (Titian, with reservations); Gore, 1969, p. 246 (attributed to Titian); Mariacher, 1969, p. 100 (traditionally Giorgione; wrongly located in London); Valcanover, 1969, no. 68 (reservations; much repainted); Pallucchini, 1969, pp. 251–252, fig. 120 (Titian, *c.* 1516–1518).

42. Gentleman in a Plumed Hat Plate 18

Canvas. 0·71 × 0·635 m.

Petworth (Sussex), Petworth House, on loan from H.M. Treasury.

About 1515.

This dashing figure is the product of Titian's lively imagination in his youth, when he gave flourish to the pose and an aristocratic air to the sitter. The clarity of the features recall the performer in *The Concert* (Plate 8).

At the left the object held in his hand appears to be a chunk of marble, although it may have been a book originally. See further discussion in the Introduction.

Condition: Badly in need of conservation. The abraded face and neck have retouched sections; slashes in the canvas on the man's face are crudely patched, and the lower left area is totally repainted.

History: Probably acquired by George Wyndham, third Earl of Egremont (1751–1837).

Bibliography: Waagen, 1854, III, p. 34 (Titian; perhaps this picture which he describes as a man with a pen and places at Petworth); Collins Baker, 1920, no. 298 (North Italian, *c.* 1520); Morassi, 1956, pp. 126–127 (Titian, *c.* 1510); Manchester, 1957, no. 63 (Titian); Berenson, 1957, p. 190 (early Titian); Pallucchini, 1957, p. 257 (Titian); Waterhouse, 1960, p. 39, no. 69 (Titian, *c.* 1515–1520); Valcanover, 1960 (omitted); Morassi, 1964, p. 18 (early Titian); Gore, 1969, p. 250 (Titian); Valcanover, 1969, no. 18 (commonly attributed, *c.* 1510); Pallucchini, 1969, p. 251, pl. 118 (Titian, *c.* 1516).

43. Gentleman in a Black Beret

Plate 24

Canvas. 0·80 × 0·66 m.

Copenhagen, Royal Museum of Fine Arts.

About 1515–1518.

The general composition is related to the portraits by Giorgione and Titian in his early maturity. The half-length format with or without a ledge in the foreground and the distant landscape are familiar elements in Venetian portraiture of the first three decades of the sixteenth century. Yet the elegance of pose of this gentleman, entirely garbed in black, and the style of the portrait suggest a mature date. The landscape corresponds most closely to that in Titian's *Madonna and Child with St. Anthony* in the Uffizi (Wethey, I, 1969, Plate 10). The attribution of the Copenhagen portrait has wandered in the past, but Titian's authorship is well established today.

Condition: Generally excellent, with normal crackle and few losses.

History: Giovanni Domenico Bossi's collection; sold by him in 1828 to Count Gustaf Trolle-Bonde of Säfstaholm (as Titian); sold to Ny Carlsberg Glyptotek, 1912; lent to the Royal Museum since 1922.

Bibliography: Loostrφm, 1882, pp. 19, 21, 95; Sirèn, 1902, p. 87 (Bernardino Licinio); *idem*, VI, 1904–1905, p. 60 (probably Titian); Granberg, 1912, II, p. 20 (Cariani); Suida, 1935, pp. 32–33, 157, pl. 30 (Titian); Tietze, 1936 (not listed); *idem*, 1950, p. 368 (Titian, *c.* 1513–1514); Berenson, 1957, p. 184 (Titian, early); Baldass, 1957, pp. 116–117 (Titian); Copenhagen, 1951, no. 709 (Titian); Valcanover, 1960, I, pl. 57 (Titian); H. Olsen, 1961, p. 94 (Titian, *c.* 1510); Baldass and Heinz, 1965, p. 174, no. 37 (early Titian); Valcanover, 1969, no. 49 (Titian, *c.* 1514); Pallucchini, 1969, p. 242, fig. 73 (Titian, *c.* 1512–1514).

44. Gentleman

Plate 33

Canvas. 1·18 × 0·96 m.

Paris, Louvre.

About 1520–1522.

The identification by Hourticq as Pietro Aretino's portrait which the latter sent to the Duke of Mantua in 1527 has not been accepted, because of the obvious lack of resemblance to Aretino at any stage in his life. The sympathetic face with small goatee and very red eyes, the right hand on the hip, and a wallet in the left hand are the identifying features of one of Titian's less interesting early portraits, the attribution

of which has never been questioned. This picture would be more likely to represent Girolamo Adorno, who died in 1523 at the age of either thirty-three or forty, rather than the very young *Man with the Glove* as Hourticq proposed (see Cat. no. 64).

Condition: The picture has darkened; canvas has been added at the top and at the right; the left side was formerly folded under; cleaned in 1799 (Bailly-Engerand, 1899, p. 79).

History: Assumed to have come from the Gonzaga Collection at Mantua, but without proof; Louis XIV, Le Brun's Versailles Inventory 1683, no. 247; Paillet, 1695; Hôtel d'Antin, Paris, 1715; Lépicié, 1732, p. 37; Hôtel de la Surintendance, Paris; Jeaurat's Inventory 1760; Rameau's Inventory 1784 (full history in Bailly-Engerand, 1899, p. 79).

Bibliography: See also above; Villot, 1874, p. 290, no. 472 (Titian); C. and C., 1877, II, p. 421 (Titian); Hourticq, pp. 207–211 (as Aretino); Suida, 1935, pp. 34, 161 (Titian); Tietze, 1936, II, p. 306 (Titian); Mayer, 1937, p. 291 (Titian; posthumous portrait of Girolamo Adorno); Berenson, 1957, p. 190 (Titian); Valcanover, 1960, I, pl. 107 (Titian, *c.* 1523); *idem*, 1969, no. 113 (Titian, *c.* 1523); Pallucchini, 1969, p. 258, fig. 169 (Titian, *c.* 1523–1524).

45. Gentleman

Plate 34

Canvas over wood. 0·89 × 0·74 m.

Munich, Alte Pinakothek.

About 1520–1522.

The dark-haired man in a black costume with white shirt stands against a slightly lighter greenish background. In his left hand he holds a sword, while his right arm rests against his hip in a pose similar to the portrait of an unknown man in the Louvre (Cat. no. 44). The former identification as Pietro Aretino has long been abandoned.

Condition: Well preserved.

History: Düsseldorf Gallery (as Pietro Aretino); Hof-garten-galerie, Munich, 1806; to the Alte Pinakothek in 1836 (Reber, 1895, p. 224, no. 1111, Titian).

Bibliography: See also above: C. and C., 1877, II, p. 425 (Titian); Morelli, 1891, II, p. 78 (Titian); Ricketts, 1910, pp. 46, 180 (Titian); Hetzer, 1920, p. 66 (Titian); Suida, 1935, pp. 34, 161 (Titian); Tietze, 1936, II, p. 301 (Titian, *c.* 1520); Brussels, 1948, p. 19 (Titian); Berenson, 1957, p. 188, no. 517 (early Titian); Munich, 1958, p. 103, no. 517

(Titian); Valcanover, 1960, I, pl. 106 (Titian); *idem*, 1969, no. 93 (Titian, 1520); Pallucchini, 1969, p. 258, fig. 166 (Titian, *c.* 1520–1522).

46. Gentleman Plate 35

Canvas. 0·94×0·72 m.

Berlin-Dahlem, Staatliche Gemäldegalerie.

Signed at the left centre: TICIANVS F

About 1525–1530.

Formerly attributed to Tintoretto until the discovery of a presumed signature at the left centre, the picture remains conjectural as to author and date. If by Titian, it is one of his minor efforts. The generally dark colour, comprising a black costume against a dark green ground, is provided with bits of contrast in the white and red ornament on the sleeves.

Condition: In a generally satisfactory state.

History: Purchased from the Solly Collection in 1821; later in the Royal Palace, Berlin.

Bibliography: Van Dyck, 'Italian Sketchbook', folio 104v. (labelled Titian); Posse, 1913, I, p. 177, no. 301 (Titian); Kühnel-Kunze, 1931, p. 485, no. 301 (Titian); Suida, 1935, pp. 91, 161 (Titian); Tietze, 1936, II, p. 284 (Titian, *c.* 1540); Berenson, 1957, p. 184, no. 301 (Titian); Munich, 1958, p. 103, no. 517 (Titian); Valcanover, 1960, I, pl. 119B (Titian); Kühnel-Kunze, 1963, p. 112, no. 301 (Titian, *c.* 1525); Valcanover, 1969, no. 124 (Titian, 1525); Pallucchini, 1969, p. 260, fig. 179 (Titian, *c.* 1524–1526).

47. Gentleman with a Book Plate III

Canvas. 0·97×0·765 m.

Boston, Museum of Fine Arts.

Signed (?) at the lower left beneath the book: TICIANVS Titian (?).

About 1540.

An inscription on the back names the sitter as Giovanni Paolo Baglione of Perugia, who died in 1520, a date far too early for this picture. Neither can he possibly be Guidobaldo II della Rovere, Duke of Urbino (Cat. no. 91), an idea advanced by Edgell and McLanathan, since his features do not correspond. The general pose of the figure is reminiscent of the *Daniele Barbaro* in Ottawa (Plate 95), yet the emphasis on costume exceeds the usual restraint in Titian's works.

Condition: somewhat darkened.

History: Oneta family at Genoa; Giuseppe Oneta e Lanza, Palermo; C. M. Majorca Montillaro, Conte di Francavilla, Palermo; Trotti and Company, Paris; Agnew and Sons, London; Frederick Platt, Long Island; purchased by Boston in 1943 (history by McLanathan, 1950, p. 162).

Bibliography: Suida, 1935, pp. 90, 169 (Titian); Edgell, 1943, pp. 40–42 (Titian); McLanathan, 1950, p. 162 (Titian, *c.* 1540–1545); Tietze, 1950, p. 368 (Pace); Berenson, 1957, p. 184 (Titian, signed); Valcanover, 1960, II, p. 103, pl. 216B (doubtful attribution); *idem*, 1969, no. 250 (Titian, 1545–1550); Boston, 1955, p. 63, no. 43.83; Pallucchini, 1969, pp. 222–223 (anonymous).

Gentleman, see also: Cat. nos. X–44—X–58.
 Also see:
 Fracastoro (so-called), Cat. no. X–38.
 Man, Cat. nos. 63–64 and X–72.
 Scholar, Cat. no. 96.
 Venetian Gentleman, Cat. nos. X–110, X–111.
 Young Englishman, Cat. no. 113.
 Young Man, Cat. nos. 115–117, X–118—X–121.

48. Girl in a Fur Coat Plate 73

Canvas. 0·95×0·63 m.

Vienna, Kunsthistorisches Museum.

About 1535

It is generally thought that *La Bella* (Cat. no. 14) and the *Venus of Urbino* represent this same model. The purplish-black cloak lined with brown fur provides a contrast to the exquisite flesh. For further discussion see the text, p. 23 and the related picture in Leningrad (Cat. no. X–59).

Condition: Somewhat cut down; noticeable crackle over the entire surface. It measured 1·194×0·61 m. when in the collection of Charles I of England (see History).

History: Collections of Pompeo Leoni and the Conde de Villamediana in Spain were the sources of Charles I's purchases there (Carducho, 1633, edition 1933, p. 109); Charles I of England (van der Doort, 1639, edition Millar, 1960, p. 16, no. 12 'an Itallion Woeman's picture, houlding with both hands a furred gown upon her naked shoulders; which ju M bougth in Spaine'; sale of Charles I's collection, 1650: 'Tytzians Mrs after Ye Life by Tytsian', sold to Mr. Murray on 23 October 1650 for £100 (Harley MS. 4898, folio 229); first mention in Austria at Stallburg

Castle in 1730 (Storffer, 1720–1733, II, no. 16); Belvedere Palace, Vienna, in the nineteenth century.

Bibliography: See also above; Stampart, 1735, pl. 11; Mechel, 1783, p. 27, no. 46; C. and C., 1877, I, pp. 393–394 (Titian); Thausing, 1878, pp. 262–269 (proposed Eleanora Gonzaga as the model!); Engerth, 1884, I, pp. 357–359 (Titian); Gronau, *Titian*, 1904, pp. 277–278 (Titian); Suida, 1935, pp. 90, 168 (Titian); *Mostra di Tiziano*, 1935, no. 27; Tietze, 1936, II, p. 317 (Titian); Pallucchini, 1953, I, p. 177 (Titian); Valcanover, 1960, I, pl. 140 (Titian); Klauner and Oberhammer, 1960, p. 136, no. 711 (Titian); Valcanover, 1969, no. 179 (Titian); Pallucchini, 1969, p. 270, fig. 227 (Titian, *c.* 1535–1537).

COPIES:

1. By Rubens; London, Eustace Hoare; canvas, 0·927× 0·692 m. (London, Royal Academy, 1953–1954, no. 196, lent by R. F. W. Cartwright; photograph, Courtauld Institute, London).
2. London, Dulwich College, Gallery, no. 198; inferior English copy; canvas, 0·89×0·635 m. (Dulwich, 1926, pp. 117–118, no. 98).

Giulio Romano, see: Romano, Cat. no. 86.

49. Federico II Gonzaga, Duke of Mantua Plates 36, 37
Panel. 1·25×0·99 m.
Madrid, Prado Museum.
Inscribed on the belt: TITIANVS F
About 1523.

On the whole, the portrait ranks among Titian's finest. The ultramarine velvet jacket, now only slightly faded, predominates, with the white-and-yellow curly-haired dog taking second place. The silhouette remains strong against a bluish-grey background, while the duke's red breeches and the blue-green table cover count only as minor contrasts. The chain of beads about Gonzaga's neck is a rosary with a tiny suspended cross. The former identification of the subject as Alfonso d'Este has been abandoned, since it has been demonstrated that the features are clearly those of Federico II Gonzaga.

Biography: Federico II Gonzaga (1500–1540) was the son of Francesco II Gonzaga and the celebrated Renaissance lady, Isabella d'Este Gonzaga (Cat. no. 27), and brother of Eleanora Gonzaga della Rovere (Cat. no. 87), Duchess of Urbino. As a child he was sent as hostage to the Emperor Maximilian and later to Francis I of France. He spent three years in Rome (1510–1513), again as hostage, but well liked by Julius II, who housed him in the Belvedere Palace. Federico became a highly cultured and elegantly mannered Renaissance courtier, having studied at Bologna, as well as at Rome (Luzio, 1886, pp. 509–582). He succeeded as Marchese of Mantua in 1519 on his father's death and was elevated to Duke by Charles V in 1530. The Hapsburg ruler was entertained at Mantua at the period of his coronation at Bologna in the winter of 1530. Federico, the art patron, called Giulio Romano (Cat. no. 86) to Mantua and sought Titian's services, among the major commissions being the series of eleven Roman emperors. (Cartwright, 1903, *passim*).

Condition: Cleaned in 1966, bringing out nuances of tones in the background and upon the figures of the duke and the dog. Escaped damage in the Alcázar fire of 1734 (Inventory 1734, no. 90).

Dating: In a letter dated at Venice on 11 August 1523 Braghino, an agent of Federico Gonzaga, refers to a portrait which he will send immediately (C. and C., 1877, I, pp. 282, 442; Braghirolli, 1881, p. 45). Although the sitter is not specified, it may well be the Prado portrait of Federico himself, who appears to be in his early twenties. Moreover, Titian's first visit to Mantua took place in February of that year. The later lost portrait of 1530 of the duke in armour (Braghirolli, 1881, p. 9) obviously is not involved here. See below Literary Reference, no. 1.

History: The portrait in the Gonzaga Collection at Mantua, Inventory 1627 (Luzio, 1913, p. 108, no. 250) may be this item, since it was not acquired by Charles I of England who bought a large number of these pictures. Marqués de Leganés, Madrid, Inventory 1655, after his death, 'otro retrato de un Duque de Ferrara con su perro . . .' (Léganes, edition 1965, p. 270, no. 15); Alcázar, Inventory 1666, no. 571, Galería de Mediodía; same location Inventory 1686, no. 249 (Bottineau, 1958, p. 152); Inventory 1700, no. 60; Inventory 1734, no. 90; Philip V, Inventory 1747, no. 21; Palacio Nuevo, Madrid, 1772, no. 21, Antecámera del Infante don Luis; in 1794 in the Pieza de la librería (as Tintoretto!) (Beroqui, 1946, p. 42); taken to the Prado Museum in 1821 as Federico Gonzaga (Beroqui, 1933, p. 144).

Bibliography: See also above; Vasari (1568)-Milanesi, VII, p. 442 (refers to a portrait of Federico); *Catálogo del Museo del Prado*, 1821, no. 499); Madrazo, 1843, no. 926 (wrongly identified as Alfonso d'Este); Prado, 1857, p. 194, no. 926 (panel, as Alfonso d'Este); C. and C., I, 1877, pp. 189–190 (Alfonso d'Este); Gronau, *Titian*, 1904, p. 302 (as Federico Gonzaga, *c.* 1525); Justi, 1908, II, pp. 153–166 (Ercole II

d'Este); Allende-Salazar and Sánchez Cantón, 1919, pp. 25–27 (Federico Gonzaga, son of Isabella d'Este, 1530); Suida, 1935, pp. 45, 79, 161 (Titian, 1530–1540); Tietze, 1936, II, p. 99 (Titian); Beroqui, 1946, pp. 41–45 (Titian; with history of the picture); Pallucchini, 1953, I, pp. 148–149 (Titian, c. 1525–1528); Berenson, 1957, p. 187 (Titian, 1531); Valcanover, 1960, I, pl. 115; Prado catalogue, 1963, no. 408 (Federico Gonzaga, 1531); Valcanover, 1969, no. 122; Pallucchini, 1969, p. 261, fig. 186 (Titian, c. 1525–1528).

ATTRIBUTION:

Bristol, Tennessee, Walter Farris; canvas, 1·60×1·20 m. Without knowledge of the original picture it is difficult to decide whether any direct connection with Titian can be assumed. Photographs suggest a somewhat hard technique. In this three-quarter-length portrait Federico Gonzaga, dressed in a long black cloak, rests his left arm against the table with green cover at our right, while holding a small paper in his left hand and clutching with his right hand the hilt of a dagger in its sheath. Because he is older than in the Prado canvas, Mayer associated this work with Federico's letter of 17 June 1540, in which he promised the Duke of Bavaria a portrait of himself and of his wife, but Federico's death in October of the same year makes it unlikely that Titian ever carried out this commission (Braghirolli, 1881, pp. 37, 67–68). *History:* Cardinal Broschi, Bologna; von Nemes Collection, Budapest (sale, Munich, Müller, Cassirer and Helbing, 16 June 1931, no. 31); Oberlander Collection, Reading, Pennsylvania (sale, New York, Parke-Bernet, 25–26 May 1939); Houston Collection (sale, New York, Parke-Bernet, 29 April 1943, no. 53). *Bibliography:* Mayer, 1913, p. 574, illustration (Titian); Fischel, 1924, p. 283 (school of Titian); L. Venturi, *L'Arte*, 1931, p. 266 (Titian); Suida, 1935, pp. 45, 161, under pl. LXVIII (workshop).

LITERARY REFERENCES:

1. Portrait of Federico II Gonzaga in armour, dated 1530. An unpublished letter, discovered by Charles Hope in the Mantua archives, was written by Federico Gonzaga to Alfonso d'Este from Mantua on 16 April 1529. In it Federico refers to a portrait of himself which Titian is painting. It seems logical that this is the portrait in armour which is again mentioned on 5 February 1530 (Braghirolli, 1881, p. 9).

Bust of Federico Gonzaga (fragment) (Plate 224), Madrid, Duke and Duchess of Alba; canvas, 0·66×0·50 m. This badly damaged fragment may be a copy of Titian's lost original of 1530 (Barcia, 1911, p. 144, no. 159, Duke of Ferrara, copy after Titian; Berenson, 1957, p. 188, as by Titian, representing Federico Gonzaga).

2. Federico II Gonzaga and his wife, Margherita Paleologa, two portraits ordered as gifts for the duke of Bavaria (Braghirolli, 1881, pp. 37, 67–68, letter of 17 June 1540); probably never executed by Titian.

Granvelle, see:

Antoine Perrenot, Cat. no. 77.
Nicholas Perrenot, Cat. no. X–82.
Madame Granvelle, Cat. no. L–18.

50. **Andrea Gritti, Doge of Venice** Plates 74–77

Canvas. 1·333×1·032 m.

Washington, National Gallery of Art, Kress Collection.

Signed at upper right near the shoulder: TITIANVS E. F.

Datable 1535–1538.

At the upper left appears the legend: ANDREAS GRITTI DOGE DI VENETIA, an identification which is fully confirmed by medals and other portraits. Doubt about the authenticity of the signature has arisen because of the unusual form E.F. after the artist's name instead of EQVES CAESARIS F. (knight of the Emperor made it) as on the picture of *Christ Before Pilate* dated 1543, now in Vienna (see Vol. I, Cat. no. 21). Nevertheless the technical examination by Modestini during the cleaning of the picture indicates that the signature is authentic, and so it must be concluded that Titian varied this feature. Since the painter was knighted by Charles V in 1533, the portrait of Gritti is usually dated subsequent to that year and before the Doge's death in 1538.

The sweeping movement of the cloak and the curve of the row of large buttons, added to the bulk of the figure, and the domineering intensity of the glance endow this great masterpiece with overwhelming conviction. The pose led Suida to suggest the influence of Michelangelo's *Moses*, with which Titian must have been familiar in a drawing or small copy, presumed to have been taken to Venice by Jacopo Sansovino. The massive physique fills the space of the canvas, as did Titian's contemporary evocations of *Roman Emperors* (1537–1539; see Vol. I, pp. 23–25, 82) as well as the later portraits of Pietro Aretino (1545; see Cat. nos. 5, 6). The monumental phase of Titian's style (c. 1535–1550) is perfectly consistent with his development at that period under Central Italian inspiration. Nevertheless, the failure of Crowe and Cavalcaselle to understand Roman Mannerism and its reflection in Ventian art led them to reject the heroic phase of Titian's art, seen here, and also later as in the handsome *Madonna and Child* in Munich (see Vol. I, Cat. no. 53).

Biography: Andrea Gritti (1455–1538), member of a patrician family of Venice, was for several decades a commanding figure in Venetian affairs. An extended visit on private business to Constantinople in his early forties gave him the opportunity to gain the friendship of Turkish court officials and even that of Sultan Bajazet and so to learn in detail the organization of the Turkish government. Still there when war broke out in 1487 between the Venetians and the Turks, he was able to provide Venice with full information on Turkish military and naval strength. Thereafter he turned his exceptional intellectual, administrative, and diplomatic abilities to public and military life, taking part in major engagements opposing both the imperial forces of Maximilian and the French. Captured by the latter in 1513 and taken as prisoner to Paris, he adroitly persuaded Louis XII to sign a peace treaty with Venice. His reign as doge (1523–1538) was noteworthy for the maintenance of peace for Venice and the avoidance of alliance either with the Hapsburg empire of Charles V or the French imperialism of Francis I (Barbarigo, 1793).

Condition: Despite the loss of glazes and some darkening of pigment, the psychological and pictorial effect of the portrait is undiminished; cleaned in 1955.

History: Not from Mantua; Charles I of England; his insignia, the CR with a crown, is said in the Czernin catalogue to have been on the back of the picture but it is no longer visible; however, a label with inscription still survives: 'Bought for his Majesty in Italy 1626' (van der Doort, 1639, Millar edition, 1960, p. 21, no. 5); sale after death of Charles (LR 2/124, 1649, folio 9v; Cosnac, 1885, p. 414; Harley MS. no. 4898, folio 152, no. 36: 'Gritto. Doge de Venatia done by Tytsian' ; sold to Mr. Jackson, 23 October, 1652, £40); Prince Kaunitz-Rietberg (died 1794); sold by his heirs, 13 March 1820, no. 178; Czernin Collection, Vienna, 1820–1936 (Wilczek, 1936, p. 88); Knoedler's, New York, 1953–1954; Samuel H. Kress Collection, purchase 1954.

Bibliography: See also above; C. and C., 1877, I, p. 301 (Pordenone); Gronau, *Titian*, 1904, p. 278 (Titian, after 1540); Berenson, 1906, 1932, and 1957, p. 189 (Titian); Hadeln, 1930, p. 490 (Titian); *Mostra di Tiziano*, 1935, no. 31 (Titian); Suida, 1935, pp. 83, 162 (Titian, after 1533); Tietze, 1936, p. 315 (noncommittal; about 1540); Mayer, 1937, p. 308 (probably by Palma Giovane and not a portrait of Gritti!); Tietze-Conrat, 1946, p. 81 (Titian); Suida and Shapley, 1956, pp. 178–181 (Titian); Pallucchini, 1953, I, pp. 204–205 (perhaps not Gritti); Valcanover, 1960, I, pl. 164A (Titian); Nutthall, 1965, p. 308; Shapley, 1968, pp. 179–180 (Titian); Valcanover, 1969, no. 214

(commonly attributed); Pallucchini, 1969, p. 282, figs. 295–297 (Titian, *c.* 1545).

LOST COPY

By Rubens; Inventory 1640 (edition 1855, p. 272, no. 60); type unspecified.

51. **Andrea Gritti, Doge of Venice** Plate 234

Canvas. 1·022×0·807 m.

New York, Metropolitan Museum of Art (in storage).

Workshop replica.

About 1535–1538.

Partially based on the Washington picture, it is at best a workshop replica. Acceptance of this work as by Titian's own hand by several critics has not led to its being exhibited at the museum. The inscription, ANDREAS GRITTI VENETAR DUX, which was formerly on a parapet on the lower edge, has been lost.

Condition: Perhaps unfinished and somewhat repainted.

History: Titian's estate in the Casa Grande (Ridolfi (1648)-Hadeln, I, p. 200; Savini-Branca, 1964, p. 186); Giustiniani-Barbarigo Collection, Padua (Selvatico, 1875, p. 14, size 1·20×1·00 m.; *Catalogue ... du prince Giustiniani*, n.d., p. 36, no. 38); Von Heyl, Darmstadt (not in the sale, 1930); Friedsam Collection, New York; bequeathed to the Metropolitan Museum in 1931.

Bibliography: See also History; C. and C., 1877, I, pp. 299–300 (Titian); Fischel, 1924, pl. 95 (Titian); Hadeln, 1930, pp. 489–494 (Titian); L. Venturi, 1931, pl. 382 (Titian); Suida, 1935, p. 88 (Titian, sketch); Tietze, 1936, II, p. 303 (possibly workshop); Wehle, 1940, pp. 194–195 (Titian); Tietze-Conrat, 1946, p. 81 (Titian sketch, repainted); Pallucchini, 1953, I, p. 205 (uncertain); Berenson, 1957, p. 189 (Titian); Valcanover, 1960, I, p. 102 pl. 215B (workshop); *idem*, 1969, no. 216 (workshop); Pallucchini, 1969, p. 274, fig. 250 (Titian, *c.* 1538–1540).

VARIANT:

Kenosha (Wisconsin), Margaret Allen Whitaker (Plate 235); canvas, 0·85×0·66 m., workshop of Titian, mid-sixteenth century. A more precise, somewhat harder rendering, after the portrait in the Metropolitan Museum (Plate 234), it includes more buttons, and the patterns of the brocades have been modified. *History:* Altamira, Madrid; Madrazo, Madrid (Madrazo, 1856, no. 264, size: 0·83× 0·65 m.); Marqués de Salamanca, Madrid; Baron de

Cortés, Madrid (as Tintoretto; Moreno photo); Trotti and Company, Paris, 1909, purchased by Nathan Allen in 1911; inherited by Mrs. Whitaker. *Bibliography:* See also above; Suida, 1935, pp. 83, 162, pl. 73 (Titian; with wrong provenance); Tietze, 1936, II, p. 291 (Titian); Tietze-Conrat, 1946, p. 81, note 44 (Titian); Pallucchini, 1953, I, pp. 204, 212 (Titian, 1540); Berenson, 1957, p. 186 (Titian); Valcanover, 1960, I, pl. 161A (Titian; confused with another portrait of Gritti, see Cat. no. X–62); *idem,* 1969, no. 210 (doubtful attribution); Pallucchini, 1969, pp. 82–83, 274 (workshop, completed by Pomponio!! [undoubtedly Orazio is meant]).

Andrea Gritti, Doge of Venice, see also: Cat. no. X–62.

52. **Diego Hurtado de Mendoza** (incorrectly called)
 Plate 60
Canvas. 1·78×1·14 m.
Florence, Pitti Gallery.
About 1530–1535.

The entirely black costume of the full-length gentleman and the pink-and-grey architectural setting are without any question Titian's own invention and execution. Reference to poetry would explain the pseudo-antique relief at the lower left, where there are three figures: a draped old woman (?) stands at the extreme left, a central partially nude figure seated holds a lyre (?), and a standing nude youth at the right dances and plays a recorder. Professor Philip Fehl's suggestion of the contest between Apollo and Marsyas as the subject may be correct, but the seated man playing the lyre would be Apollo (Fehl, 1969, p. 1388, note 6). Tietze saw here dependence upon Marcantonio's print *Quod Ego* (Bartsch 352), an idea which is much too far fetched.
See Cat. no. L–19 for the discussion of the lost portrait of Diego Hurtado de Mendoza, who was large and powerful in physique, a fact which eliminates the identification of the present work in the Pitti Gallery.

Condition: Darkened and covered with old varnish; the costume of the man has been rubbed at an early period.

History: Inventory of 1637, as the portrait of Minerbetti (Donato Minerbetti) by Titian (Jahn-Rusconi, 1937, pp. 308–309, no. 215).

Bibliography: See also above; C. and C., 1877, II, pp. 49–50 (Titian, but not Hurtado de Mendoza); Gronau, *Titian,* 1904, p. 292 (Titian, but not Hurtado de Mendoza); *Mostra di Tiziano,* 1935, no. 43 (Titian, 1541); Tietze, 1936, II,

p. 289 (Titian, *c.* 1545–1550, sitter unknown); Berenson, 1957, p. 185, no. 215 (as a full-length man), no. 494 (called Hurtado de Mendoza; this number is an error); Valcanover, 1960, I, pl. 162 (Titian); Francini Ciaranfi, 1964, p. 9, no. 215 (Titian); Valcanover, 1969, no. 247 (Titian, *c.* 1540–1545); Pallucchini, 1969, pp. 99, 131, 134, 275, fig. 256 (Mendoza by Titian, *c.* 1541).

53. **Empress Isabella** Plate 147
Canvas. 1·17×0·98 m.
Madrid, Prado Museum.
Documented 1548.

Resplendently gowned in violet-rose velvet, which is trimmed with broad bands of embroidery and sewn with pearls, the Empress sits with great dignity beside an open window, through which is visible a fine distant landscape capped by the blue mountain peaks of Cadore. A neutral grey wall and a dark red-brown curtain provide the background at the left. To her luxurious costume are added a rope of pearls and the large brooch of pearls, rubies, and blue sapphires upon her breast. Her left hand holds a prayer-book, while her pale drawn face gives the impression that she is deeply immersed in thought. The rigidity of pose and the general lack of animation of the entire figure are explainable by the fact that Titian never saw his sitter, who had died nine years earlier. The artist's earlier portrait of the Empress, done in 1544–1545, in which the composition and pose are very similar, undoubtedly served as the model for this picture. We know that Charles took that work, the *Empress Isabella, Seated, Dressed in Black* (Plate 150), on his journey from Brussels to Augsburg in 1547 in order to have the painter retouch the nose (see Cat. no. L–20).
The handsome velvet gown and the jewels of the Prado portrait were most probably lent to Titian at this time. On the other hand, the Empress is shown standing in three-quarter length wearing a similar gown and coiffure, but different jewels, in a painting attributed to the workshop of Jacob Seisenegger (Löcher, 1962, no. 129; Glück, 1933, p. 203, fig. 160). It may be therefore that Titian knew the costume only through a similar portrait by Seisenegger, since the latter had visited Spain in 1538–1539. At that time, when Seisenegger prepared portraits of Isabella's daughters, he may well have painted the Empress also (Löcher, 1962, p. 11).

Biography: Empress Isabella (1503–1539) was the daughter of King Manuel of Portugal and Queen María, a daughter of Ferdinand and Isabella of Spain. She married her first cousin, Charles V, at Seville on 11 March 1526. During

the long absences of Charles in the Netherlands, Germany, and Italy she served as regent of Spain. That this marriage, arranged solely for reasons of political power, was exceptionally happy among the crowned heads of Europe is demonstrated by Charles' devotion to her, by his commissioning her portrait after her death, and by the fact that he never remarried. Her first and only surviving son, Philip II, was born at Valladolid in 1527. Her daughter Mary (1528–1603) married her cousin Maximilian II and became Empress of the Holy Roman Empire; the other daughter Juana (1535–1573) was in 1553 the bride of her cousin Juan of Portugal, heir to the crown of Portugal, but he died a few months later and she remained a widow, serving as regent of Spain for Charles V after her mother's death.

Condition: Somewhat dull and faded; cleaning and varnish would improve the canvas.

History: Titian's letter, dated 1 September 1548 at Augsburg, to Granvelle says that the portrait of 'la imperatrize sola' is ready (Zarco del Valle, 1888, p. 222); Charles V's Inventory 1556, Brussels, the Empress, paired with a portrait of Charles V armed (Gachard, 1855, II, p. 92); Yuste Inventory 1558 after the death of Charles V, 'pintura entera de la emperatriz' (Sánchez Loro, 1958, II, p. 507, no. 411); the theory that this portrait was the item in Mary of Hungary's Inventory seems to me mistaken (see Cat. no. L–4).
A portrait of the Empress wearing a string of pearls and jewels ('una sarta de perlas y dos joyeles'), paired with a portrait of *Charles V in Armour with Baton*, in the Inventory of 1573 of Princess Juana, founder of the Convent of the Descalzas Reales, Madrid, daughter of Charles V (*Princess Juana*, pp. 363–364, nos. 33, 34); this item may have been lent to her by Philip II or it might have been a copy of the Yuste portrait; Philip II Inventory 1600, nos. 392, 393, *Empress Isabella* 'con una sarta de perlas' paired with *Charles V in Armour with Baton*, both lent to Empress Maria (died 1603), daughter of Charles V, widow of Maximilian II of Austria, then living in a palace adjoining the Descalzas Reales, Madrid (Philip II's Inventory, edition 1956, pp. 254–255).
Alcázar, Madrid, portraits of the *Empress Isabella* and *Charles V* in 1633 (Carducho, edition 1933, p. 108, by Titian); Alcázar, Madrid, Galería de Mediodía, Inventory 1636, folio 18ᵛ, *Empress Isabella* 'vestido morado con una sarta de perlas', paired with *Charles V in Armour with Baton* 'en la una mano un baston y sobre un bufete la celada', there called copies after Titian; *Empress* by Titian, 1¼ × 1 *varas* (1·04 × 0·835 m.) in the Galería del Mediodía, Alcázar, Inventory 1666, no. 604, paired with no. 605, *Ferdinand I* brother of Charles V. This change must have been made by Velázquez, who in the 1650's reorganized the arrange-

ment of the pictures in the Alcázar; Inventory 1686, no. 280, by Titian, paired with Titian's portrait of Ferdinand I, no. 281; Inventory 1700, no. 91, 1¼ × 1 *varas*, paired with Ferdinand I, no. 92; Inventory 1734, after the fire in the Alcázar, no. 88 or 89, undamaged, a woman by Titian; Inventory 1747, Philip V, no. 616, 'una señora con un libro', school of Titian (Bottineau, 1958, p. 157); Inventory 1814 in Royal Palace, Madrid; taken to the Prado Museum in 1821.

Bibliography: Prado catalogues, 1821 and 1823, no. 351; 'Inventario general', Prado, 1857, p. 183, no. 878; C. and C., 1877, II, pp. 103–105 (wrongly dated 1544); Allende-Salazar and Sánchez Cantón, 1919, pp. 34–36; Fischel, 1924, p. 140 (wrongly dated 1544); Glück, 1933, pp. 208–210 (wrongly dated 1544); Suida, 1935, pp. 83, 170 (wrongly dated 1544); Tietze, 1936, II, p. 300 (Titian); Beroqui, 1946, pp. 61–72 (important account); Pallucchini, 1953, pp. 35–36 (Titian, 1548); Bialostocki, 1954, pp. 109–115; Berenson, 1957, p. 187 (Titian, 1548); Valcanover, 1960, II, pl. 25 (Titian, 1548); Prado catalogue, 1963, no. 415 (old no. 878); Valcanover, 1969, no. 291 (wrong date of 1544); Pallucchini, 1969, pp. 121–122, 289, fig. 333 (Titian, 1548).

COPY:

Madrid, Instituto de Valencia de Don Juan; canvas, 1·24 × 0·97 m.; mediocre copy in reverse (Sánchez Cantón, 1922, pp. 19–21).

Empress Isabella, see also: Cat. nos. L–6 and L–20.

54. **Johann Friedrich, Elector of Saxony, Seated**

Plate 159

Canvas. 1·035 × 0·83 m.

Vienna, Kunsthistorisches Museum.

1550–1551.

The sitter's black costume with a narrow white ruff at the neck and wrists, a broad collar of brown fur, and his considerable bulk fill most of the picture space. The light grey-green background furnishes a splendid contrast to the figure and to the neutral grey-brown chair, on the arm of which he rests his right hand, holding a round black hat. The forcefulness of the portrait is partially explainable by the crowded picture space as well as by the apprehensive look upon the black-bearded countenance, placed like a peak upon the summit of the bulky figure.
Suida, Braunfels, and other German historians have shown convincingly that Titian must have followed a prototype by Cranach, or if not, that he was influenced by the portraits

of the German artist, who sojourned in Augsburg at the same time as the Venetian, from November 1550 to February 1551. The position of the figure of Johann Friedrich and the way in which the edge of the canvas cuts across the two arms are indeed very much after the manner of Cranach.

Biography: Kurfürst Johann Friedrich (1503–1554) ruled at Wittenberg and led the Protestant forces against Charles V, who defeated and captured him at Mühlberg on 19 May 1547. He was held prisoner until 1552 (Mentz, 1903–1908).

Condition: Well preserved.

Dating: Titian and Johann Friedrich were both at Augsburg in 1550.

History: One of two portraits, the other armed, in the possession of Mary of Hungary when she left Brussels for Spain: Inventory 1556, 'otro retracto del dicho Duque de Sajonia' (Pinchart, 1856, p. 140, no. 10; also edition by Pérez Gredilla, 1877, p. 251); Madrid, Alcázar, Contaduría, 1600, portrait of the Duke of Saxony dressed in black, 1·25 × 1·02 *varas* (1·04 × 0·85 m.), evaluated at eight ducats, no artist mentioned, for which reason this portrait may have been a copy; El Pardo Inventory 1614 (says Beroqui, 1926, p. 239, note 1 and also 1946, p. 93, note; I cannot find such an item); Alcázar, Madrid, 1626, in the Bóvedas, Duke of Saxony by Titian (Cassiano del Pozzo, 1626, folio 121); Alcázar, 1633, Duke of Saxony by Titian (Carducho, edition 1933, p. 109); gift of Philip IV to the Marqués de Leganés (see below, copy 2; also Justi, 1889, p. 185, no. 42); Leganés Inventory, 1655, portrait of the Duke of Saxony by Titian (edition 1965, p. 270, no. 16); undoubtedly purchased by Archduke Leopold Wilhelm from the Leganés estate since the portrait was copied by Teniers c. 1660 (see below, copy 1), but not in the *Theatrum pictorium*; Stallburg Castle, Austria (Storffer, 1720, I, p. 269).

Bibliography: See also above; Vasari (1568)-Milanesi, VII, p. 450 (Titian, portrait of Duke of Saxony when prisoner); C. and C., 1877, II, pp. 181–183 (Titian); Mechel, 1783, p. 25, no. 39 (Titian); Engerth, 1884, pp. 367–368 (Titian); Gronau, *Titian*, 1904, p. 277 (Titian, 1548 or 1550); Wickhoff, 1904, p. 117 (Rubens after Titian); Suida, 1935, pp. 96–97, 109, 170 (influence of Cranach); *Mostra di Tiziano*, 1935, no. 73 (Titian, 1550); Tietze, 1936, II, p. 316 (Titian); Berenson, 1957, p. 192 (Titian, 1548); Valcanover, 1960, II, pl. 29 (Titian); Klauner and Oberhammer, 1960, p. 141, no. 719 (Titian); Pope-Hennessy, 1966, p. 178 (Titian, based on Cranach); Valcanover, 1969, no. 338 (Titian); Pallucchini, 1969, p. 296, fig. 367 (Titian, 1550–1551).

COPIES:
1. Blenheim Palace (formerly); Marlborough sale, 26 July 1886, no. 119, as a portrait of John Frederick, copy by Teniers (C. and C., 1877, II, p. 183, note).
2. Madrid, Alcázar, Inventory 1636, 'Pieza en que su magestad negocia en el cuarto bajo de verano': 'Duke of Saxony, seated, dressed in black; a copy of Titian, the original of which his majesty gave to the Marqués de Leganés (folio 30vv).
3. Rubens' copy made in 1628 at Madrid, but it is not specified whether this was the portrait in armour or the other one in black (Pacheco, 1638, edition 1956, I, p. 153); later in Rubens' estate, Inventory 1640 (edition 1855, p. 271, no. 54; also Sainsbury, 1859, p. 237, no. 54).

Johann Friederich, Elector of Saxony, see also: Cat. no. X–65.

55. **Julius II** (after Raphael) Plate 122

Panel. 0·99 × 0·82 m.

Florence, Pitti Gallery, Sala di Venere.

1545–1546.

The attribution of this picture to Titian has been occasionally challenged, yet most critics believe that it is the work mentioned by Vasari as Titian's copy of Raphael's *Julius II*. The latter was hanging in S. Maria del Popolo at the time of the Venetian's visit to Rome in 1545 (Vasari (1568)-Milanesi, IV, p. 338). Morelli decided early that this work was the one by Titian that Vasari mentioned (Morelli, 1897, p. 55). The expression of the face is tired and introspective, and the brushwork soft as compared with the prototype by Raphael, whose original (see Gould, 1970) is now in the National Gallery in London (Plate 121).

Biography: Julius II, Giuliano della Rovere (1443–1513) started life as a Franciscan, son of a modest family. He advanced rapidly in the ecclesiastical hierarchy when his uncle became Sixtus IV (1471–1484). Named cardinal in 1471, he subsequently held various bishoprics, among them Bologna and Avignon. As pope (1503–1513) he rose to great heights as a patron of arts and letters, especially in commissioning Raphael to paint the celebrated rooms in the Vatican Palace, Bramante to rebuild the Vatican and St. Peter's, and Michelangelo to carry out the decoration of the vault of the Sistine Chapel as well as to carve his tomb. No Renaissance pope surpassed Julius II in his desire to rebuild and beautify Rome; his patronage of the arts has tended to overshadow his less than admirable political and military intrigues (Pastor, VI, 1902, *passim*).

Condition: Long vertical cracks in the wood at each side about six inches from the edge; although the surface is in fair condition over the face and hands, blistered paint somewhat mars the hood; the background is smudged and black.

History: The Duke of Urbino owned Titian's copy of Raphael's portrait of Julius II (Vasari (1568)-Milanesi, VII, p. 444); in 1631 brought to Florence by Vittoria della Rovere on her engagement to marry Ferdinand II dei Medici; Medici Inventories of 1691 and 1694 as Titian (Gronau, 1904, p. 12).

Bibliography: See also above; C. and C., 1877, II, p. 476 (lost); C. and C., 1884–1891, II, p. 112 (by Giovanni da Udine); Burchard, 1925, pp. 121–128 (Titian); Berenson, 1932, p. 570 (Titian); Suida, 1935, pp. 82, 104 (Titian); Tietze, 1936, II, p. 289 (Titian); Jahn-Rusconi, 1937, pp. 226–227 (after Raphael); Francini Ciaranfi, 1956, p. 53, no. 79 (Titian); Berenson, 1957, p. 185 (Titian); Valcanover, 1960, II, p. 64 (attributed); *idem*, 1969, no. 269 (commonly attributed); Pallucchini, 1969, p. 284, fig. 304 (Titian, 1545–1546); Gould, *Apollo*, 1970, p. 189 (Titian).

56. **Knight of Malta** Plate 5

Canvas. 0·80×0·64 m.
Florence, Uffizi.
Titian (?).
About 1510.

An inscription, probably of the eighteenth century, on the back of the picture reads 'Giorgio da Castelfranco detto Giorgione', yet the present-day tendency has moved toward an attribution to Titian during his early Giorgionesque period. Even more than in some other cases, any decision of this sort is an act of faith, resting upon the mood projected by the portrait and the subjective reaction of the critic.

The cross upon the doublet clearly indicates that the sitter was a Knight of Malta. He was formerly identified as Stefano Colonna without explanation (von Boehm, 1908, p. 60), but the portrait of this same gentleman by Bronzino dated 1546 (Berenson, 1963, fig. 1452) proves that he belonged to a later generation, and his armour shows no Cross of Malta.

In his right hand the Uffizi knight holds a rosary, the lowest bead of which is inscribed with the numerals XXXV, probably his age. Against the square-cut white shirt a jewelled Cross of Malta is suspended upon a rope of gold. The greenish-black costume, the hair, and the beard are very dark, to the degree that details have disappeared. A pattern of opened pomegranates on the brocaded stuff of his doublet must have either an heraldic or a symbolic significance.

Condition: Very darkened and much abraded; also covered with a fine crackle; cut down slightly on all sides.

History: Paolo del Sera, Venice, 1654; probably purchased from him as Titian by Cardinal Leopoldo dei Medici, who owned it until his death in 1675; 1677 in the Tribuna of the Uffizi; Inventory of the Uffizi, 1704, no. 1863; later at Poggio a Caiano; returned to the Uffizi on 2 August 1798 (history in Uffizi, 1927, p. 94, no. 942).

Bibliography: C. and C., 1871, II, p. 154 (Giorgione or follower); Morelli, 1892, pp. 248–249 (Giorgione); Cruttwell, 1907, p. 28, no. 622 (Giorgione); von Boehm, 1908, p. 60 (Giorgione); L. Venturi, 1913, p. 150 (Titian); Florence, Uffizi, 1927, p. 94, no. 942 (Giorgione); Suida, 1935, p. 157 (Titian); Tietze, 1936, II, p. 290 (nearest to Giorgione); *idem*, 1950 (omitted); Richter, 1937, p. 217 (probably late Giorgione); Oettinger, 1944, p. 136 (early Titian); Zampetti, 1955, p. 118, no. 50 (Titian); Berenson, 1957, p. 84 (Giorgione); Valcanover, 1960, I, p. 94 (attributed to Titian); *idem*, 1969, no. 66 (Titian); Salvini, 1964, p. 70, no. 942 (Titian, *c.* 1518); Baldass and Heniz, 1964, p. 171, cat. no. 45 (Titian); Pignatti, 1969, p. 118, no. A12 (early Titian); Pallucchini, 1969, p. 247, fig. 97 (Titian, *c.* 1515).

57. **Knight of Santiago** Plate 87

Canvas. 1·395×1·175 m.
Munich, Alte Pinakothek.
Titian (?).
1542 (?).

In a black costume with broad fur collar against a medium-grey background, the man wears a heavy, elaborately worked double gold chain over a lighter chain, on which is suspended the red cross of the Knights of Santiago. In his right hand he holds a large pilgrim's staff indicative of that same Spanish military order, while his left grasps a gilded sword. The suggestion in the Munich Catalogue (1958) that he holds a marshall's staff appears less probable. The breadth and the grandeur of spirit in the interpretation of a Spanish nobleman are impressive, yet doubt remains that Titian is involved here.

An inscription at the upper right seems to have been wrongly restored since it is not readily decipherable or translatable: ANNVM AGENS (?) XXXXII. It may refer to the date of the picture rather than to the age of the gentleman, who appears older.

Condition: Damages to the canvas have been crudely repaired, but none of them occurs in a critical position.

History: Lebrun Collection, Paris, in 1809; purchased in 1815 for Crown Prince Ludwig of Bavaria.

Bibliography: C. and C., 1877, II, p. 453 (Tintoretto; restored); Morelli, 1891, II, p. 79 (unknown master); Reber, 1895, p. 225, no. 1115 (Titian); Gronau, *Titian*, 1904 (omitted); Ricketts, 1910, pp. 120, 180 (Titian; 'among the finest portraits'); Fischel, 1924, p. 165 (Titian); Suida, 1935 (not listed); Tietze, 1936 (omitted); Berenson, 1957, p. 188 (Titian); Munich, 1958, p. 103, no. W.A.F. 1085 (Titian); Valcanover, 1960 (omitted); Morassi, 1967, p. 143 (Titian); Pallucchini, 1969, fig. 673 (Titianesque painter).

58. Knight with a Clock Plate 161

Canvas. 1·22 × 1·01 m.

Madrid, Prado Museum.

About 1550–1552.

This three-quarter-length figure in black against a much lighter grey-brown background has a strong silhouette in fine Renaissance style. The light-grey cross has been said incorrectly to be that of the Knights of Malta. The former identification of the sitter as Giannello della Torre (born about 1500), a clock-maker to Charles V and Philip II, has been abandoned. A member of the Cuccini family (compare Veronese's picture of the family in Dresden) at least shows some similarity in physical type, although beards are deceptive. The clock must have been in Titian's possession, since it is also identifiable in the portrait of Eleanora Gonzaga della Rovere, Duchess of Urbino (Plate 69), in the Uffizi.

Condition: The state of preservation is superior to most of Titian's portraits in the Prado Museum, for even the rosy flesh-tints survive with clarity. However, some clumsy old retouching of the highlights on the lining of the cloak disfigures the left side of the canvas. Escaped damage in the Alcázar fire of 1734 because it was located in the 'Bóvedas'.

History: Possibly a gift of Prince Niccolò Ludovisi to Philip IV in 1637: Ludovisi Inventory of 1633, no. 19, 'Un Ritratto d'un Huomo, che tiene la mano sopra un orologgio alto palmi cinque [1·17 m.] mano di Titiano' (Garas, 1967, p. 340). First cited in Madrid, Alcázar, Escalera del Zaguanete, Inventory 1666, no. 672 (as by Tintoretto); Inventory 1686, no. 845 in entrance to the 'Bóvedas' (Bottineau, 1958, p. 317); Inventory 1734 (unidentifiable); Inventory of Philip V, 1747, no. 28 (as by Titian); probably transferred to the Prado Museum in 1827.

Bibliography: See also above; Madrazo, 1843, p. 159, no. 740 (Titian); 'Inventario general', Prado, 1857, p. 150, no. 740; C. and C., 1877, II, p. 420 (Titian); Babelon, 1913, pp. 269–279 (Giannello della Torre); Allende-Salazar and Sánchez Cantón, 1919, pp. 54–56 (member of the Cuccini family); Fischel, 1924, p. 166 (Titian, *c.* 1550); Suida, 1935, pp. 111, 172 (Titian); Tietze, 1936, II, p. 299 (Titian); Beroqui, 1946, pp. 168–169 (member of the Cuccini family); Pallucchini, II, 1954, pp. 54–55 (Titian, *c.* 1550); Berenson, 1957, p. 187 (Titian); Valcanover, 1960, II, pl. 45 (Titian, *c.* 1550); Prado catalogue, 1963, no. 412 (old nos. 28 and 740); Valcanover, 1969, no. 331 (Titian, 1550); Pallucchini, 1969, p. 296, fig. 368 (Titian, 1550–1552).

59. Lavinia as Bride (so-called) with a Fan Plate 187

Canvas. 1·02 × 0·86 m.

Dresden, Staatliche Gemäldegalerie.

About 1555.

No one has questioned Titian's authorship of this enchanting picture of a young girl in white holding a fan. The arguments have concerned her identification as Lavinia and as a bride. Hadeln (1931) was right in insisting that neither proposal can be proven and that both are essentially romantic theories. The other pictures of a rather ideally beautiful young girl, all theoretically Lavinia, do have a basic similarity in physical type and mood (Berlin and Madrid, Plates 191 and 192). However, Lavinia cannot be excluded as the possible model, since Ridolfi, although as late as 1648, so designates her (Ridolfi-Hadeln, I, p. 194; see Cat. no. 60), to be sure wrongly called 'Cornelia, Titian's daughter'. The major objection to the Lavinia theory is that *Lavinia as Matron* (Plate 188) has expanded in bulk and coarsened in feature, but again this is not entirely improbable as she had a baby every year.

As for the girl being depicted as a bride, she is clearly posed on some festive occasion. White was not necessarily the required colour for a sixteenth-century wedding, yet it does not altogether exclude the possibility. Morelli was mistaken in his statement that only a bride carried that type of fan, since it occurs in several of Cesare Vecellio's costume plates (see Mellencamp, 1969, for a discussion of Venetian bridal costume). Morelli (1893) published Lavinia's marriage contract in full. Crowe and Cavalcaselle's speculation that Lavinia's portrait now in Dresden is the work sent to Philip II in 1559, according to his letter of 22 September, has little to recommend it. Not only is the year too late but Titian describes her as dressed in yellow (not white) (C. and C., 1877, II, pp. 137, 516; Cloulas, 1967, pp. 238–239).

Condition: in a seemingly good state.

History: Alfonso II d'Este of Ferrara (Scanelli states that he read Titian's letter to Alfonso d'Este sending a portrait of his most beloved. She is described as walking, her head turned, and carrying a fan: 'nell'atti di sodamente caminare con gratia e convenevole decoro scuopre piu di meza faccia e sta riguardando leggiadramente con ventaglio in mano'; Scanelli, 1657, pp. 222–223); purchased by the Dresden Gallery from the ducal collection at Modena in 1746.

Bibliography: See also above; Van Dyck's 'Italian Sketchbook', 1622–1627 (Adriani edition, 1940, pl. 104ᵛ, labelled Titian); C. and C., 1877, II, pp. 137–138 (Titian, Lavinia as Bride); Morelli, 1893, pp. 230–232 (Lavinia as Bride; Titian, 1550); Gronau, *Titian*, 1904, p. 286 (Titian, 1555; Lavinia); Fischel, 1924, pl. 177 (Lavinia as Bride; Titian, 1555); Posse, 1929, I, p. 87 (Titian; not Lavinia); Hadeln, 1931 (Titian, *c.* 1550; neither Lavinia nor a bride); Suida, 1935, pp. 112, 173 (Titian; Lavinia); Tietze, 1936, II, p. 287 (Titian; not Lavinia); Pallucchini, 1954, II, p. 64 (Titian, 1555; not Lavinia); Berenson, 1957, p. 184 (Titian, Lavinia?, *c.* 1553); Valcanover, 1960, II, pl. 61; *idem,* 1969, no. 383 (Titian, *c.* 1555; not Lavinia): Pallucchini, 1969, p. 303, fig. 399 (Titian, *c.* 1555; not Lavinia).

COPIES:

1. Cassel, Gemäldegalerie (in storage); canvas, 0·99× 0·79 m.; cited in Inventory 1749, no. 227. *Bibliography:* Eisenmann, 1888, p. 292, no. 452 (copy); Katalog, 1929, no. 490 (copy).
2. Vienna, Kunsthistorisches Museum; canvas, 0·99× 0·79 m.; by Rubens, early seventeenth century, when the original was still in the d'Este collection at Modena; Lavinia, dressed in white, carries a light tan fan with a red edging and stands against a green-grey background. *Bibliography:* Archduke Leopold Wilhelm, Vienna, 1659, Inventory no. 69; Engerth, II, 1884, pp. 403–404, no. 1182 (Rubens); Rooses, 1890, IV, pp. 308–309, no. 1125 (Rubens, after Titian, painted in Italy).

Lavinia, see also: **Venetian Girl,** Cat. nos. 112, X–71.

60. **Lavinia** (so-called) **with a Tray of Fruit** Plate 191
Canvas. 1·02×0·82 m.
Berlin-Dahlem, Staatliche Gemäldegalerie.
About 1555.

Both Tietze and Panofsky suggested an identification with the picture of 'Pomona', the Roman goddess of fruits (see Lost Items, no. 1), but more generally the traditional identification as Lavinia has prevailed. However, the ideal nature of the work, for which Titian's daughter probably served as inspiration, cannot be denied, since it is not, strictly speaking, a portrait. The golden-brown dress and white scarf stand out against a dark-red curtain at the left and the distant landscape at the right. Upon the silver tray she carries a variety of fruits and two sprigs of roses.

Condition: The paint is considerably crackled; somewhat better preserved than the Prado *Salome* (Wethey, I, 1969, Plate 192; see also below, Variants, no. 1).

History: Probably one of the three Lost Items (see below); purchased by the Berlin museum from Abbate Celotti, Florence, in 1832.

Bibliography: See also above; C. and C., 1877, II, pp. 139–141 (Titian, 1550); Morelli, 1893, p. 233 (Lavinia by Titian); Gronau, *Titian*, 1904, p. 285 (Lavinia by Titian); Posse, 1909, I, p. 172, no. 166 (Titian); Hadeln, 1931, pp. 86–87 (Titian; not Lavinia); Kunze-Kühnel, 1931, p. 484, no. 166 (Titian); Suida, 1935, pp. 112, 171 (Titian); Tietze, 1936, II, p. 284 (Titian); Pallucchini, 1954, II, pp. 64–65 (Titian, *c.* 1550; not Lavinia); Berenson, 1957, p. 184 (Titian); Valcanover, 1960, II, pl. 63 (Titian, *c.* 1555; not Lavinia); *idem,* 1969, no. 386 (Titian); Wethey, I, 1969, p. 160, Cat. no. 141, variant 1; Pallucchini, 1969, p. 304, fig. 407 (Titian, *c.* 1555–1558, not Lavinia); Panofsky, 1969, p. 80, note 48 (perhaps Pomona).

VARIANTS AND COPIES:

1. London, Mrs. Abbott; *Lavinia with Casket* (so-called) (Plate 193); canvas, 1·185×0·94 m.; workshop or copy, sixteenth-century? The composition, so clearly a variant of the Berlin picture, differs in the green costume, instead of golden-brown, as well as in the object held. In a photograph the technique appears smooth and perfunctory in a way characteristic of copies. *Condition:* The picture has obviously been restored excessively. That might explain the bad drawing of the right hand. *History:* Chevalier de Lorraine; Duc d'Orléans Collection, Paris (Dubois de St. Gelais, 1727, p. 472, Titian; Couché, 1786–1788, II, pl. 12, Titian); Lady Lucas, later Countess de Grey (Buchanan, 1824, I, p. 113, from the Orléans Collection; Waagen, 1854, II, p. 85, hard and inferior to the Berlin picture); Francis de Grey, seventh Lord Cowper, Panshanger (C. and C., 1877, II, pp. 140–141); by inheritance Baroness Lucas, Wrest Park (sale, London, Christie's, 26 May 1922; *APC,* I, 1921–1922, p. 312, no. 83); Mrs. Abbott, London (sale, Sotheby's, 6 July 1966, no. 118, bought in; sale 10 July 1968, no. 108, withdrawn). *Bibliography:* See also above; Bürger, 1857, p. 77 (Titian); C. and C., 1877, pp.

140–141 (not entirely by Titian; restored); Wethey, I, 1969, p. 160, Cat. no. 141, variant 2 (copy).

2. London, Earl of Malmesbury, replica (Gronau, *Titian*, 1904, p. 285).

3. Madrid, Prado Museum; *Lavinia as Salome*, by Titian (Plate 192), *c.* 1550–1555, canvas, 0·87×0·80 m.; damaged by fire in 1734, restored 1968; the same composition as *Lavinia with a Tray of Fruit* (see Wethey, I, 1969, p. 160, Cat. no. 141, Plate 192 [*sic*]).

4. Paris, Georges Encil (Pallucchini, 1969, p. 304; as in Montreal: a variant perhaps autograph). I have been unsuccessful in verifying this item either in Paris or Montreal.

LOST ITEMS: *A Young Woman with a Tray of Fruit*
1. Jacopo Strada, agent of Maximilian II and later of Rudolf II, in 1568 obtained a picture of *Pomona* by Titian, which is described as follows: 'una belissima donna ritratta con varii frutti che le vengono presentati' (Zimmermann, 1901, p. 850). The painting is undoubtedly the work which appears as a *Young Woman with a Tray of Fruit* at Prague Castle: Inventory *c.* 1619, folio 37b (Perger, 1864, p. 107); Inventory 1621, no. 1025 (Zimmermann, 1905, p. XLII). The Prague collection was seized by the Swedes in 1648 and passed to Queen Christina: Queen Christina's collection, Antwerp Inventory 1656 (Denucé, 1932, p. 178; see also Panofsky, 1969, p. 80, note 48). It is not cited in Christina's later inventories.

2. *Lavinia with a Tray of Melons.* This subject, recorded in Van Dyck's 'Italian Sketchbook' (edition 1940, pl. 116v), is also known reversed in W. Hollar's engraving dated 1650 (Adriani, 1940, p. 83). C. and C., 1877, II, p. 141, note, say correctly that the print was derived from a picture in the Van Veerle Collection (Parthey, 1853, no. 1511). Ridolfi (1648-Hadeln, I, p. 198) places it apparently earlier in Jan Van Uffel's house at Antwerp, identified as Titian's daughter: 'Cornelia [*sic*] figliuola di Titiano che tiene un bacille, entroui due meloni'. The costume in the Hollar print consists of pseudo-classical drapery, unlike the contemporary dress of other versions.

3. *Lavinia* (wrongly *Cornelia*) *with a Basket of Fruit*, Venice, Niccolò Crasso in 1648 (Ridolfi (1648)-Hadeln, I, p. 194).

LITERARY REFERENCE:
Lavinia (1549). In a letter of 26 April 1549 written at Modena Argentina Rangone de' Pallavicini asked Titian to finish the picture of Lavini [*sic*] (Gaye, 1840, II, p. 375).

61. **Lavinia as Matron** (so-called) Plate 188
Canvas. 1·03×0·865 m.
Dresden, Staatliche Gemäldegalerie.
About 1560.

Inscribed: 'Lavinia TIT. V. F. AB. E. O. P.' (Lavinia, daughter of Titian, painted by him). It is most doubtful that the inscription came from Titian's own hand, and hence the picture cannot be regarded as signed. On the whole, this portrait does not occupy an important position among Titian's creations.

Biography: Lavinia (*c.* 1529/1530–1561), daughter of Titian and his wife Cecilia, married Cornelio Sarcinelli of Serravalle in 1555. She died in 1561 on the birth of her sixth child. Several writers (see below, Bibliography) have strangely dated the portrait of *Lavinia as Matron* well after her death (Cadorin, 1833, pp. 56–57, 96–97; Morelli, 1893, pp. 230–232; Wethey, I, 1969, pp. 14, 32).

Condition: Relined in 1826.

History: In Ferrara originally; taken to Modena by Cesare d'Este (?); purchased by Dresden from the ducal collection at Modena in 1746 (Posse, 1929, I, p. 87).

Bibliography: Morelli, 1893, pp. 232–233 (Lavinia by Titian, *c.* 1570); C. and C., 1877, II, pp. 267–269 (Titian, Lavinia, 1560); Fischel, 1924, pl. 214A (Titian, Lavinia, 1565); Posse, 1929, I, p. 87 (Titian, Lavinia); Hadeln, 1931, pp. 83–85 (Titian, Lavinia, 1565); Suida, 1935, pp. 113–174 (Titian, Lavinia); Tietze, 1936, II (Titian, *c.* 1558); Berenson, 1957, p. 184 (Titian); Valcanover, 1960, II, pl. 97 (Titian, *c.* 1560, Lavinia); *idem*, 1969, no. 455 (Titian, Lavinia?); Pallucchini, 1969, pp. 317–318, fig. 485 (Titian, *c.* 1565, Lavinia?).

Lavinia as Matron, see also: Cat. no. X–70.

62. **Cristoforo Madruzzo, Cardinal and Bishop of Trent** Plate 166
Canvas. 2·10×1·09 m.
São Paulo (Brazil), Museum of Art.
Inscribed: Anno MDLII aetatis suae XXXVIIII. Titianus Fecit.
1552.

This impressive full-length portrait presents Madruzzo in a long black cloak and black hat, standing against a red velvet curtain, which he appears to be pulling back. On the table with green-velvet covering are a clock and papers, upon which appears the inscription. The small tricorne hat, worn by ecclesiastics, is the only reference to his position as churchman, a fact which suggests that Madruzzo preferred to be shown in his more important role as statesman. A

masterpiece among Titian's works, Madruzzo's portrait is less known than many other canvases because it remained so long in private hands at Trent and even now at São Paulo is less accessible than works in European and American museums.

Biography: Cristoforo Madruzzo (1511–1577), born of a noble family of Trent, became bishop there in 1539 and was raised to the rank of cardinal four years later. An astute politician who joined the Spanish party, he served Charles V in the negotiations which brought the great Church Council to Trent in 1545 rather than to Bologna as Paul III had preferred. He succeeded the Duke of Alba as Spanish governor of Milan for two years in 1556–1557 (Gerola, 1934, pp. 854–855). His epitaph in Sant'Onofrio at Rome gives the date of his death as 5 July 1577 at the age of sixty-six (Forcella, XIII, 1879, p. 263).

Condition: Well preserved; slightly cut down at the right side; cleaned in 1956 establishing the correct inscription with the date 1552.

Dating: The date 1552 appears twice, upon the clock and in the inscription on the paper, which includes the age of Madruzzo as thirty-nine. Both dates are essentially in agreement with the record of his epitaph in Rome (see above, Biography). When Titian made his first trip to Augsburg in 1548, he stopped at Ceneda just north of Venice, where Count Girolamo della Torre gave him a letter of introduction to Cardinal Madruzzo (C. and C., 1877, II, p. 502), then at Augsburg with Charles V and his court. The first meeting between the artist and the cardinal must therefore have taken place in Germany. If Titian had already painted Madruzzo at Venice in 1542, it is unlikely that he would have needed an introduction to him in 1548. Consequently, an earlier proposal that the picture should be dated during a visit of the sitter to Venice from 15 February to 15 March 1542 must be ruled out. The date of the letter, published as 10 July 1542 (Oberziner, 1900, p. 12 and 1901, p. 80) and used to prove that Titian had finished the portrait then, must have been mis-read or illegible. Since the date 1552 appears twice on the picture, the letter published by Oberziner cannot have a date of 1542. The numerals were doubtless hard to read or badly faded so that Oberziner misinterpreted them.

Vasari, in listing the portrait of the cardinal of Trent, has been misquoted as saying that the picture was painted in 1541, a date which refers solely to the portrait (Cat. no. L-19) of Diego Hurtado de Mendoza (Vasari (1568)-Milanesi, VII, p. 445).

History: Castello del Buon Consiglio, the bishop's residence, Trent in 1599; inherited by the Roccabruna family in the seventeenth century; by bequest to Baron Gaudenti della Torre, in his possession in 1735 (Emert, 1939, pp. 125, 138); 1855 by inheritance to Valentino de' Salvadori, Trent (history compiled by Oberziner, 1900 and also 1901, p. 80); Trotti and Company, Paris, *c.* 1905; James Stillman, Paris and New York, before 1907; Mrs. Avery Rockefeller, New York, 1942; purchased by the São Paulo Museum in 1950.

Bibliography: See also above; Ridolfi (1648)-Hadeln, I, p. 184 (Titian visited the cardinal of Trent on the return from Augsburg; cardinal wanted his portrait); C. and C., 1877, II, p. 186 (Titian; the picture then in the Salvadori palace at Trent); Morelli, 1891, II, p. 86 (Moroni); Gronau, *Titian*, 1904, p. 128 (Titian); Lafenestre, 1907, pp. 351–360 (Titian, seen at Trent in 1888); Fischel, 1924, pl. 109 (Titian, 1541–1542); Suida, 1935, pp. 81, 170 (Titian); Tietze, 1936, II, p. 304 (Titian); Pallucchini, 1953, I, p. 207 (Titian, 1542); Bardi, 1954, p. 27 (Titian, 1542); dell'Acqua, 1955, p. 120 (Titian, 1552); Bardi, 1957, pl. 9 (Titian, dated 1552); Berenson, 1957, p. 190 (Titian, signed); Valcanover, 1960, I, pl. 163 (Titian); *idem*, 1969, no. 227 (Titian, 1542?); Pallucchini, 1969, p. 297, figs. 373–375 (Titian, 1552).

63. Man with a Flute Plate 201

Canvas. 0·978 × 0·76 m.

Detroit, Institute of Arts.

Signed on the table at the left: TITIANVS F.

About 1560–1565.

The gentleman here represented may not necessarily have been a professional musician but rather an aristocrat fond of the flute. According to Baldassare Castiglione's conception, the Renaissance courtier was a highly versatile person with some musical accomplishments; but wind instruments were considered less suitable for a gentleman since a performer's face is distorted. To draw any dogmatic conclusion as to the sitter's rank is perhaps unnecessary. The colour is low-keyed in black and greys, the paint thinly applied in the technique of Titian's late canvases.

Condition: Cut down at the lower edge, eliminating part of the left hand; generally good condition; the signature has been restored.

History: Baron von Stumm, Berlin (as Andrea Schiavone); van Diemen and Co., Berlin; acquired by Detroit in 1927.

Bibliography: Hadeln, 1926, p. 234 (Titian, *c.* 1560); Detroit, 1926, no. 226 (Titian); Mather, 1926, p. 312 (Titian); Heil,

1927, pp. 14–15 (Titian, *c.* 1560); Detroit, 1928, no. 20 (Titian); L. Venturi, 1931, pl. 390; *idem*, 1933, no. 529 (Titian, *c.* 1565); Suida, 1935, pp. 114, 182 (Titian, late); Tietze, 1936, II, p. 286 (Titian, late); Detroit, 1944, p. 134, no. 226, acquisition 27.385 (Titian); Berenson, 1957, p. 184 (Titian); Valcanover, 1960, II, pl. 94 (Titian); *idem*, 1969, no. 431 (Titian); Pallucchini, 1969, p. 312, fig. 459 (Titian, 1561–1562).

VARIANT:

Althorp, Earl Spencer; canvas. 0·788×0·61 m., called Ignatius Loyola (!), the same man in half length; Manchester, 1857, no. 250 (perhaps Titian); Royal Academy, Italian Exhibition, 1930, no. 373.

Man, see also: Cat. no. X–72.
 Also see:
 Falconer, Cat. no. 28.
 Fracastoro (so-called), Cat. no. X–38.
 Gentleman, Cat. nos. 40–47 and X–44—X–58.
 Scholar, Cat. no. 96.
 Venetian Gentleman, Cat. nos. X–110, X–111.
 Young Englishman, Cat. no. 113.
 Young Man, Cat. nos. 115–117, X–118—X–121.

64. Man with the Glove
Plates 29–32

Canvas. 1·00×0·89 m.

Paris, Louvre.

Signed at the lower right: TITIANVS F.

About 1520–1522.

The identity of the sitter remains unknown, although the picture is universally regarded as one of Titian's most remarkable, primarily because of the appealing expression and the clear-cut features of the cultivated young man of aristocratic bearing, but also because of the design. Nothing could be simpler than the natural pose of the half-length figure and the centring of attention upon the head by the long V-shaped opening of the jacket and the round collar. The extraordinary beauty of the painting of the hands and in particular the grey gloves, which have given the title to the picture, could escape no one. He rests his left arm upon the stone at our right, where appears Titian's signature. Hourticq's attempt to identify the sitter as Girolamo Adorno, a Genoese nobleman who served as ambassador of Charles V at Venice in 1522–1523, fails completely, because Adorno died in 1523 at the age (and here contemporary accounts differ) of either thirty-three or forty (Oreste, 1960, I, pp. 297–298). Clearly the man with the glove is no more than eighteen or twenty.

On 22 June 1527 Titian wrote a letter to the Duke of Mantua saying that he was sending a gift of two portraits, one of Pietro Aretino and the other of Girolamo Adorno. A letter of thanks on 8 July shows that the pictures had arrived at Mantua (letters published by C. and C., 1877, I, pp. 317–319, 443–444). Unfortunately neither of these works can be proved to have survived until the present day.

August L. Mayer proposed an identification of the young man as Giambattista Malatesta (Mayer, *Gazette*, 1938, p. 290), an agent of the Duke of Mantua, whose letters of 1523 mentioning a portrait have been published (C. and C., 1877, I, pp. 282–283, 441–442). However, the letters do not say whose portrait is involved, much less that it is Malatesta's. See the portrait of *Federico Gonzaga* (Cat. no. 49, Dating).

Condition: Very darkened and covered with thick varnish. A note by Rameau in 1788 that it is badly relined and should be returned to original smaller size; 1789 restored by Martin 'etait intercepté par la crasse et beaucoup de re-peints, réparé avec soin et difficulté' (Bailly-Engerand, 1899, p. 79). The shading on the signature may or may not be due to retouching.

Possible History: Gonzaga Collection, Mantua, Inventory 1627, no. 324, called 'un Giovinetto' by Titian (Luzio, 1913, p. 116). Charles I of England, sale of 1651, no. 234, 'A picture of a Man done by Tytsian', £40 (Harley Manuscript 4898, folio 504); Inventory 1649–1651, folio 166ᵛ, no. 235, 'A Man by Tytsian' £40 (LR 2/124).

Certain History: Jabach, Paris; Louis XIV, Le Brun's Inventory of Versailles, 1683, no. 248, as by Titian; Paillet, 1695; Hôtel d'Antin, Paris, 1715; Versailles, 1737; Lépicié, 1752, p. 37; Hôtel de la Surintendance, 1760 (Jeaurat) (full history Bailly-Engerand, 1899, pp. 78–79).

Bibliography: See also above; Villot, 1874, p. 290, no. 473; C. and C., 1877, II, p. 421; Hourticq, 1919, pp. 202, 206–214; Hadeln, 1920, pp. 931–934 (rejects Hourticq's proposal); Suida, 1935, pp. 34, 161; *Mostra di Tiziano*, 1935, no. 7 (Titian, 1510–1520); Tietze, 1936, II, p. 306; Berenson, 1957, p. 190; Valcanover, 1960, I, pls. 108–109; *idem*, 1969, no. 114; Pallucchini, 1969, pp. 258–259, figs. 170–171 (Titian, *c.* 1523–1524).

65. Niccolò Marcello, Doge of Venice
Plate 105

Canvas. 1·03×0·90 m.

Rome, Pinacoteca Vaticana.

About 1542.

The profile position of this earlier Venetian doge (1473–1474) is clearly based upon a fifteenth-century prototype, probably a portrait by Gentile Bellini located in the Sala del Gran Consiglio of the Ducal Palace before the destruction of the room by fire in 1577. The face is lined and consciously precise in the manner of that period. Against a blue-black background Marcello wears a golden-brown brocaded cloak with red lining and a red velvet robe.

Biography: Niccolò Marcello (1397–1474) was elected doge in 1473 at the age of seventy-six, and died a year and four months later. He is said to have started the tradition that the doge should wear robes made of cloth of gold. His tomb by Pietro Lombardo is now in SS. Giovanni e Paolo, transferred from the destroyed S. Marina (Paoletti, 1839, II, p. 244).

Condition: The hands are darkened and in poor condition; the face, cloak and background are better preserved.

History: From the Aldobrandini Collection, Bologna (C. and C., 1877, I, p. 113); acquired by Leo XII (1823–1829).

Bibliography: C. and C., 1877, I, pp. 112–113 (Titian); Hadeln, 1910, pp. 101–106 (Titian, 1542; the major study of the picture); Vatican, 1933, pp. 229–230, no. 445; Suida, 1935, pp. 83, 173 (Titian); Tietze, 1936, II, p. 308 (Titian); Berenson, 1957, p. 190 (Titian's copy of Gentile Bellini); Valcanover (omitted); *idem*, 1969, no. 229 (Titian); Pallucchini, 1969, p. 275, fig. 254 (Titian and workshop, *c.* 1540–1542).

66. Cardinal Ippolito dei Medici Plate 65

Canvas. 1·38 × 1·06 m.

Florence, Pitti Gallery.

1533.

The sumptuous costume of plum-coloured velvet, the greenish plumes in his red hat, and the black beard stand against a dark ground. The Hungarian garb, mentioned by both Vasari and Ridolfi, refers specifically to Ippolito's participation in the defence of Hungary against the Turks, subsequent to which the portrait was painted at Bologna.

Biography: Ippolito dei Medici (1511–1535), natural son of Giuliano, Duc de Nemours, was taken by his uncle Leo X to Rome when a baby. Later Clement VII made him cardinal in 1529, provided him with benefices which enabled him to live in sumptuous style in a palace in the Campo Marzio. His principal military achievement was participation in the Hungarian campaign against the Turks. His sudden death

of unknown causes at Itri near Gaeta is often suspected to have been caused by poison (Picotti, 1934, p. 699).

Condition: The darkened dirty state and the numerous repairs in the canvas leave much to be desired.

History: Painted at Bologna in 1533 (Vasari (1568)-Milanesi, VII, p. 441); taken by the French to Paris in 1799–1815.

Bibliography: See also above; Ridolfi (1648)-Hadeln, I, pp. 172, 197; C. and C., 1877, I, pp. 376–378 (Titian); Justi, 1897, pp. 35–37 (Titian); Gronau, *Titian,* 1904, p. 291 (Titian; at Venice 1532 or at Bologna 1533); Suida, 1935, pp. 48, 83 (Titian); *Mostra di Tiziano,* 1935, no. 32 (Titian, 1533); Tietze, 1936, II, p. 289 (Titian, 1532–1533); Jahn-Rusconi, 1937, p. 308 (Titian); Berenson, 1957, p. 185 (Titian, 1533); Valcanover, 1960, I, pl. 133 (Titian, 1532–1533); Francini Ciaranfi, 1964, p. 40, no. 201 (Titian); Valcanover, 1969, no. 160 (Titian); Pallucchini, 1969, p. 266, fig. 206 (Titian, 1532–1533).

COPY:

Paris, Louvre; panel, 0·64 × 0·55 m. *Bibliography:* Bailly-Engerand, 1899, pp. 77–78; Villot, 1874, p. 292 (copy); C. and C., 1877, I, pp. 378–379, note (copy).

LOST:

1. *Ippolito dei Medici in Armour,* by Titian. *Bibliography:* Vasari (1568)-Milanesi, VII, p. 441; Ridolfi (1648)-Hadeln, I, p. 173.
2. Rubens' lost copy, Inventory 1640, no. 38 (Lacroix, 1855, p. 271; C. and C., 1877, I, p. 379, note); type unspecified.

67. Vincenzo or Tommaso Mosti Plate 44

Panel transferred to canvas. 0·85 × 0·66 m.

Florence, Pitti Gallery.

About 1526.

The varying dates assigned to this picture have ignored the inscription on the back, with the year 1526, a perfectly reasonable time for the origin of the portrait. The biography of the sitter written by Lazzari also leaves some problems unsolved (see below). Various tones of blue-grey and white are subtly managed with contrasts in textures of fur and cloth, in a work which has a new decorative complexity, combined with elegance in this characterization of a young courtier.

Biography: An inscription formerly on the back of the panel was copied before the transfer to canvas: DI TOHMASO

MOSTI IN ETA DI ANNI XXV L'ANNO MDXXVI. TITIANO DACADORE PITTORE. Lazzari proposed that the sitter was Vincenzo Mosti, favourite of Alfonso I d'Este (Cat. no. 26), rather than Tommaso, a priest and brother of the more prominent courtier of the period at Ferrara. Vincenzo first came to the duke's attention because of his exploits in the battle of Ravenna in 1512, when he must have been at least twenty-two. The inscription, however, places the man's birth in the year 1501. If true, Vincenzo could scarcely have distinguished himself in battle at the age of ten. Lazzari makes no reference to the discrepancy. The only safe conclusion is that the certain identity of this man of the Mosti family has yet to be established.

Condition: In need of cleaning.

History: Bequest of Cardinal Leopoldo dei Medici in 1674.

Bibliography: See also above; C. and C., 1877, I, p. 303 (much restored); Gronau, *Titian*, 1904, p. 292 (Titian, 1516!); Arslan, 1930–1931, p. 1365 (Titian, 1526); *Mostra di Tiziano*, 1935, no. 20 (Titian, 1526); Suida, 1935, pp. 33, 161 (Titian); Tietze, 1936, II, p. 289 (Titian, 1520); Jahn-Rusconi, 1937, p. 310, no. 495 (Titian); Hetzer, 1940, p. 161 (Titian, perhaps 1515!); Pallucchini, 1953, I, p. 141 (Titian, 1520); Berenson, 1957, p. 185 (Titian, 1526); Valcanover, 1960, I, pl. 88 (Titian, 1520); Francini Ciaranfi, 1964, p. 110, no. 495 (Titian); Morassi, 1964, pl. 9 in colour; Valcanover, 1969, no. 95 (Titian); Pallucchini, 1966, p. 259, fig. 172 (Titian, *c.* 1523–1525).

68. Niccolò Orsini (so-called) Plate 202

Canvas. 0·876×0·71 m.

Baltimore, Museum of Art, Epstein Collection.

About 1561.

The inscription inscribed in gold letters: TITIANI OPVS MDLXI is certainly a later addition since the artist did not sign in this fashion, although gold letters do not exclude authenticity. His normal signature is TITIANVS F. Only occasionally did Titian use gold letters; for example on the important *Entombment* in the Prado Museum at Madrid he expanded the signature in gold to read TITIANVS VECELLIVS OPVS AEQVES CAES. (datable 1559; see Wethey, I, 1969, no. 37, Plates 76, 202). Nevertheless, the attribution of the Baltimore portrait to Titian is acceptable, even if the identification of the sitter as an Orsini is highly doubtful. He wears a crimson doublet and a black coat trimmed with white fur.

Another portrait, identified as Nicola Ursini (canvas, 0·94×0·75 m.), when in the collection of Sir Robert Strange

in 1769, showed the man seated, resting one hand upon his helmet (Strange, 1769, no. 77).

Condition: Somewhat abraded and the front of the costume damaged; cut down in length by nineteen cm. since the sale of 1794; cleaned in 1962.

Possible History: Duke Orsini by Titian in the Orsini Palace, Rome, in 1745 (Venuti, 1745, I, p. 382).

Certain History: Count Nicola Ursini, canvas, 42×28 inches; collection of Sir L. Dundas (sale London, 29 May 1794; Graves, 1921, III, p. 210); Henry Metcalf, London (sale, London, Christie's, 15 June 1850, no. 35); Herman de Zoete, Pickhurst Mead, England (sale Christie's?, 1855); Charles Brinsley, Marlay Mullingar, Ireland; Canon J. L. White-Thompson, archdeacon of Canterbury, Bromford Manor, Exmouth, North Devon (sale, London, Christie's, 1 February 1924, no. 43; *APC*, III, 1923–1924, no. 1588, as an anonymous sale); Jacob Epstein, Baltimore, purchased from Knoedler & Co., London, in 1925; lent to the Baltimore Museum of Art from 1929; bequest to the museum in 1951.

Bibliography: Mayer, 1924, p. 184 (Titian, 1561); Tatlock, 1925, p. 222 (Titian, 1561); Detroit, 1928, no. 22 (Titian); Berenson, 1932, p. 568 (Titian, 1561); Suida, 1935, pp. 113, 116, 182 (Titian, 1561); Tietze, 1936, II, p. 284 (Titian, 1561); *idem*, 1950, p. 367 (Titian); New York, 1938, no. 18 (Titian); Berenson, 1957, p. 184 (Titian, 1561); Valcanover, 1960, II, pl. 95; *idem*, 1969, no. 434 (Titian); Pallucchini, 1969, p. 311, fig. 456 (Titian, 1561).

69. Antonio Palma Plate 205

Canvas. 1·38×1·16 m.

Dresden, Staatliche Gemäldegalerie.

Datable 1561.

Unquestionably one of Titian's great portraits, the painting shows the gentleman in a dark-blue robe standing against a grey wall, to the left of which appears a distant view of a sunset landscape. The inscription, surely not from Titian's own hand, reads: MDLXI . . . NATVS AETATIS SVAE XLVI TITIANVS PICTOR ET AEQVES CAESARIS. The general conclusion that we have here the portrait of a painter and that the palm refers to his name has been contested. Another proposal, that the open box on the window sill is that of an apothecary and that he appears in the guise of his patron saint because of the palm, supposedly of martyrdom, strikes one as rather far-fetched (Tscheuschner, 1901, pp. 292–293). Final proof of the sitter's identity is wanting because of the lack of any other portrait of Antonio Palma.

Biography: Antonio Palma (1510/1515–1575), nephew of Palma il Vecchio and father of Jacopo Palma il Giovane, was a pupil of Bonifazio Veronese, whose workshop he continued after his master's death. Very little is known about either the life or works of Antonio Palma (Westphal, 1932, pp. 171–172).

Condition: Somewhat darkened, but in good condition.

History: Posse states that the portrait came from the Casa Marcello, Venice (Posse, 1929, p. 88, no. 172); Inventory Guarienti at Dresden, 1753, no. 432.

Bibliography: See also above; C. and C., 1877, II, pp. 423–424 (Titian; much retouched); Gronau, *Titian*, 1904, pp. 199, 287 (Titian); Cook, VI, 1905–1906, pp. 451–452; *idem*, 1912, pp. 75–79 (major study; Antonio Palma by Titian); Suida, 1935, pp. 113, 182 (Titian, late); *Mostra di Tiziano*, 1935, p. 179, no. 88 (Titian); Tietze, 1936, II, p. 287 (Titian, 1561); Berenson, 1957, p. 184 (Titian, 1561); Valcanover, 1960, II, pl. 96 (Titian); Dresden, 1968, no. 104, colour frontispiece; Valcanover, 1969, no. 435 (Titian); Pallucchini, 1969, p. 311, fig. 457 (Titian, 1561).

70. **Parma the Physician** (so-called) Plate 23
Canvas. 0·88 × 0·75 m.
Vienna, Kunsthistorisches Museum.
About 1515–1518.

The somewhat hard lines in the face and neck may be due to retouching or to the man's corpulence. To the black costume are contrasted the white hair, the red doublet, a white V at the neck, and the dark-brown background. The strong psychological motivation of the presumed physician, conveyed through the attitude of body as well as the head, should leave no doubt of Titian's authorship. The composition in half length with the head in a three-quarter position occurs in several portraits of Titian's early period (see Plates 12, 18, 19, 24).

Biography: The tradition that this portrait represents Parma, who was Titian's own physician, is passed on by Ridolfi in the mid-seventeenth century at the time the picture was in the della Nave collection at Venice. No further information about the proposed identification or the physician is available.

Condition: reasonably satisfactory, although considerably darkened.

History: Bartolomeo della Nave (Venice (Ridolfi (1648)-

Hadeln, I, p. 169, as the physician Parma by Titian); presumably sold to the Duke of Hamilton, 1636 (Waterhouse, 1952, unidentifiable); Archduke Leopold Wilhelm, Vienna, Inventory 1659, no. 15; Stallburg (Storffer, 1720, II, p. 230).

Bibliography: See also History; Teniers, 1660, pl. 57 (Titian); Mechel, 1783, p. 27, no. 47; C. and C., 1877, II, pp. 425–426 (uncertain attribution); Engerth, 1884, pp. 366–367 (Titian); Morelli, 1892, p. 308, note 8 (Titian); *idem*, 1897, p. 313, no. 4 (Titian); Wickhoff, 1893, pp. 135–136 (Campagnola); Gronau, *Titian*, 1904, p. 276 (Titian, c. 1511); Cook, 1907, p. 148 (Giorgione); Fischel, 1924, pl. 305 (Titian); Suida, 1935, pp. 33, 156 (Titian); Tietze, 1936 (omitted); Pallucchini, 1953, I, pp. 145–146 (Titian); Berenson, 1957, p. 191 (Titian); Baldass, 1957, pp. 150–152 (Titian); Valcanover, 1960, I, pl. 85 (Titian); Klauner and Oberhammer, 1960, p. 134, no. 708 (Titian); Valcanover, 1969, no. 96 (Titian; portrait of a man); Pallucchini, 1969, p. 254, figs. 136–137 (Titian, 1518–1520; not Parma).

71. **Martino Pasqualigo** Plate 103
Canvas. 0·793 × 0·635 m.
Washington, Corcoran Gallery.
Signed at the left by the shoulder: TICIANVS F
Titian and workshop.
About 1545–1546.

Inscribed at the top: MARTINVS PASQVALIGO STATVARIVS VENETVS. The restrained and seemingly uninspired character of this portrait may be explainable either by the condition of the canvas or by the intervention of the workshop. A picture in the Vendramin Collection at Venice in 1627 inscribed MARTINO DAL SFRISO (Borenius, 1923, pl. 29) probably represented this same youth but it obviously is not the Washington portrait.

Biography: Martino Pasqualigo (c. 1524–1580), a young sculptor and assistant of Leone Leoni, accompanied his master from Milan to Venice in 1545. On his refusal to return to Milan, Leoni hired an assassin to murder him but he escaped with severe wounds in the face. Although Aretino was angered by this outrage, he wrote a conciliatory letter to Leoni in April 1546 (Aretino, *Lettere*, edition 1957, II, pp. 159–160; Cadorin, 1833, pp. 47–48; Plon, 1887, pp. 30–35; Camesasca, 1957–1960, pp. 355–356, 398–399).

Condition: Darkened and cut down on all sides, particularly the lower edge, where the left hand is partly missing.

History: Bortolo da Fino, Venice (Ridolfi (1648)-Hadeln, I, p. 201; Martino scultore by Titian; *loc. cit.,* II, p. 201 *(sic)*: portrait of Martino Pasqualigo by Titian); possibly the Chigi Palace, Rome (Suida, 1946, p. 142); gift of Senator William Andrews Clark to the Corcoran Gallery in 1925 (Washington, 1928, p. 54, no. 2175).

Bibliography: See also above; Suida, 1939, pp. 326–330 (Titian; first major article); *idem,* 1946, p. 31, pl. 29; Tietze, 1939, p. 181 (Titian, *c.* 1543–1544); Pallucchini, 1954, II, p. 62 (workshop of Titian); Berenson, 1957, p. 192 (partly by Titian); Valcanover, 1960, II, pl. 46A (Titian); *idem,* 1969, no. 375 (Titian and assistant); Pallucchini, 1969, p. 301, fig. 395 (Titian and workshop).

72. **Paul III without Cap** Plates 115–117

Canvas. 1·06×0·85 m.

Naples, Gallerie Nazionali, Capodimonte.

1543.

This major portrait of Paul III has rarely been questioned as Titian's work and is certainly the artist's first picture of the pope, painted at Bologna in the spring of 1543. The numerous copies of this work prove that it, rather than the *Paul III with Cap (camauro)* (Cat. no. 73), was regarded as the official portrait of the pope by the sitter and his family.

The precise representation of the head in the detailed drawing of hair and beard and the exact modelling of the face with full impasto indicate the attention given by the artist in the desire to please the sitter. The strong white highlights upon the rose-coloured cape are fully in the style of Titian at this period. In general, the figure seated in a chair had become the established formula for papal portraits from the time of Raphael. However, the psychological power that the artist was able to project, through the slope of the shoulders, the positions of the hands as well as by the alert penetrating glance of the wily old man, surpasses all others save Titian's *Paul III and Grandsons* (Cat. no. 76).

Biography: Paul III (1468–1549), earlier Cardinal Alessandro Farnese, son of Pierluigi I and Giovannella Caetani, born in Rome, rose rapidly in the ecclesiastical hierarchy during the pontificate of Alexander VI Borgia, who made him a cardinal in 1493. As the result of a liaison with an unnamed woman from 1502–1513 he had four children: Costanza (1502?), Pierluigi (1503; see Cat. no. 30), Paolo (1504), and Ranuccio (1509); his eldest son established the Farnese dynasty. The future Paul III managed to stay in favour with Julius II della Rovere, Leo X dei Medici, and some-

what less so with Clement VII dei Medici, whom he succeeded as pope in 1534.

During the pontificate of Paul III (1534–1549) the struggle for the domination of Europe between Francis I of France and Charles V of the Spanish and Hapsburg empire continued unabated, and so did the rebellion of the Protestant states in Germany. The pope attempted to play one side against the other to his own benefit, but he finally swung to the victorious Hapsburg faction.

His recognition of the need for reform within the church was the major positive achievement in a reign dominated by political intrigue and a ceaseless desire for personal, family, and papal aggrandizement. Under him the Council of Trent was convened with the support of Charles V and opposed by France. As an art patron Paul III initiated the construction of the Palazzo Farnese in Rome, which was completed after his death by Cardinal Alessandro Farnese (Cat. no. 29). He engaged Michelangelo to paint the *Last Judgment* in the Sistine Chapel as well as the *Conversion of St. Paul* and the *Crucifixion of St. Peter* in the Cappella Paolina of the Vatican (Moroni, XXIII, 1844, pp. 193–198; Pastor XI, 1923; Capasso, 1924; Drei, 1954).

Condition: Exceptionally well preserved, far better than any other Farnese portrait in Naples, thus indicating the importance attached to it by the Farnese family in earlier periods; restored in 1959.

Documentation: Painted at Bologna in late April and May 1543. On 22 May 1543 Titian was paid two *scudi* and 20 *bol* for shipment of the picture (Bertolotti, 1878, III, pp. 186–187; elsewhere drawing on other archives Bertolotti, 1884, pp. 18–19 gives the date of payment for shipment as 22 September 1543. The later date may be an error or it may involve another document due to a delay in payment and a new request for it).

The payment for shipment in May is supported by a document in the Archivio di Stato in Rome dated 27 May 1543 (first published by Crowe and Cavalcaselle, Italian edition, II, p. 12, note 2 and repeated from them by Venturi, IX, part 3, 1928, p. 145): '1543. A di 27 maggio, ducati doi d'oro in oro pagati a Bernardino Della Croce per tanti ne ha dati a M^ro. Tiziano pittore venetiano per far portare el quadro del ritratto di Sua Santità ch' ha fatto'. 'E più a di 10 luglio detto ducati cinquanta d'oro in oro a M^ro. Titiano pittore quali Sua Santità gli dona per sue spese in tornare a Venezia'.

On 8 July 1543 (according to Bertolotti, 1878, pp. 186–187) Paul III made an advance payment of fifty *scudi* for the expenses of Titian's trip back to Venice. The date is 10 July 1543 elsewhere (see above). No further sum was paid to the artist. Titian did not actually return to Venice until the

end of July, as demonstrated by a letter of the 26th of the month to Cardinal Alessandro Farnese (Ronchini, 1864, pp. 131–132; C. and C., 1877, II, p. 85).
A letter of Pietro Aretino from Verona in July 1543 praises the miracle of Titian's portrait of Paul III. Since he had never seen the picture, the letter must be regarded as his usual publicity stunt on behalf of Titian (*Lettere*, edition 1957, II, p. 8; III, p. 488).

History: Palazzo Farnese, Rome, in the *guardaroba* of Cardinal Alessandro Farnese, the portrait done at Bologna (Vasari (1568)-Milanesi, VII, p. 443); Palazzo del Giardino, Parma, Inventory 1680, 'Ritratto di Paolo III sopra una carega di velluto cremisi, vestito di bianco, tiene la destra con anello in dita appoggiata ad una borsa di simile velluto, di Tiziano' (Campori, 1870, p. 233); taken to Naples or Portici in the mid-eighteenth century; sent to Palermo from the palace at Portici in 1798 (Filangieri di Candida, 1902, p. 320, no. 7; Rinaldis, 1911, p. 138; *idem*, 1927, p. 325); returned to Naples after the fall of Napoleon in 1815 (Filangieri di Candida, 1902, p. 237).

Bibliography: See also above; C. and C., 1877, II, pp. 86–87 (Titian, 1543); Clausse, 1905, pp. 72–77 (as the replica painted for the Cardinal of Santa Fiore); Rinaldis, 1911, pp. 136–139; *idem*, 1927, pp. 323–325 (Titian); Venturi, 1928, p. 293 (Titian, 1543, perhaps not from life!); *Mostra di Tiziano*, 1935, no. 57 (Titian, 1543); Suida, 1935, p. 104 (Titian, 1543); Tietze, 1936, II, p. 302 (Titian, 1543); Tietze-Conrat, 1946, pp. 73–84 (Titian after a model by Sebastiano del Piombo or by the latter!); Pallucchini, 1953, I, pp. 211–212, II, pp. 23–26 (Titian, 1543; rejects theory of Tietze-Conrat); Berenson, 1957, p. 189 (Titian, 1543); Valcanover, 1960, I, pls. 168–169 (Titian, 1543); Causa, 1960, pp. 62–64, no. 19 (Titian, 1543); Valcanover, 1969, no. 236 (Titian, 1543); Pallucchini, 1969, p. 278, figs. 272–274 (Titian, 1543).

LOST SECOND VERSION:
Rome, Cardinal Santa Fiore (Guido Ascanio Sforza, son of Costanza Farnese), grandson of Paul III (Vasari (1568)-Milanesi, VII, p. 443: replica by Titian of the Bologna portrait). Cloulas, 1966, suggests that it might be the version in Toledo Cathedral (see below, copy no. 12).

COPIES (Paul III without Cap):
1. Alnwick Castle, Duke of Northumberland; panel, exhibited at Newcastle, 1929 (photo, Courtauld Institute, London); from the Altieri and Camuccini collections, Rome; purchased by Northumberland in 1856 (C. and C., 1877, II, p. 91, small scale faithful copy). Exhibited at the British Institution in 1856 (Graves, 1914, III, p. 1319, no. 46); Waagen, 1857, p. 468 (not Titian).
2. Aquila, Marchese Persichetti; a copy by Paris Bordone (Pastor, XI, 1923, p. 30, note 2).
3. Beverly Hills, California, Gene Kelley; panel, 0·349× 0·273 m. (Plate 259), wrongly attributed to El Greco (hitherto unpublished). Perhaps the same as Literary Reference, no. 1, below.
4. Florence, Pitti Gallery; canvas, 1·39×0·91 m., nearly full length and thus unlike the Naples original; the hard technique suggests a Roman copy (C. and C., 1877, II, p. 9, copy, seventeenth century; Wickhoff, 1904, p. 114, Paris Bordone; Tietze, 1936, II, p. 302, confused with the version of *Paul III with Cap*, Cat. no. 73; Francini Ciaranfi, 1964, p. 8, no. 326, Venetian copy; Cipriani, 1966, p. 16, Venetian school).
5. New York, N. B. Spingold (Tietze-Conrat, 1946, p. 80, fig. 6); formerly Lord Northwick (Waagen, 1854, II, p. 203, Titian; Northwick, 1859, p. 91, no. 990; C. and C., 1877, II, p. 91, school piece, repainted).
6. Rhöndorf (Bonn), Estate of Dr. Konrad Adenauer; canvas, 1·03×0·86 m.; A grotesquely bad copy, wrongly attributed to El Greco (Wethey, 1962, II, no. X–190); purchased by Heinz Kisters, Kreuzlingen, 1969.
7. Rome, Galleria Spada; canvas, 1·19×0·957 m. (Plate 260) (C. and C., 1877, II, p. 91, eighteenth century; Zeri, 1954, pl. 201, p. 146, Scipione Pulzone?).
8. Rome, Museo di Palazzo Venezia, in storage, Appartamento Cybo, no. 920 (old no. 588); panel, 0·385×0·285 m. (Plate 261); gift of Prince Torlonia, 1892 (G.F.N., photo no. E23475).
9. Rome, Italian Embassy to the Holy See, Palazzino di Pio IV; canvas, 1·18×0·93 m. (Plate 262); dark red hood against a deep green background; very precise, perhaps Flemish copy, late sixteenth century (?).
10. Rome, Castel Sant'Angelo, Hall of Psyche and Cupid; canvas, *c.* 0·76×0·76 m.; bust only; bad modern copy.
11. Stresa, Isola Bella, Borromeo Collection; canvas, *c.* 1·30×0·98 m., hard perfunctory copy, sixteenth-seventeenth century.
12. Toledo, Cathedral sacristy; canvas, 1·06×0·82 m. (Plate 258); vivid reds; Titian's workshop; gift of Cardinal Pascual de Aragón in 1674 (*Carlos V*, 1958, pl. 120, copy; Cloulas, 1966, pp. 97–102, Titian).
13. Turin, Galleria Sabauda, in storage; copy (C. and C., 1877, II, p. 91, follower of Bassano).

COPIES KNOWN ONLY IN LITERARY REFERENCES:
1. Parma, Palazzo del Giardino in 1680, 'Un quadro alto on. 8 e 1/2, largo 6 e 1/2 in tavola. Ritratto di Paolo 3° simile a quello che è nella Camera de' ritratti segnato no. 59 di Titiano' (Campori, 1870, p. 206).

2. Parma, Palazzo del Giardino in 1680, 'Un quadro alto br. 2 on. 2, largo 1 on. 2. Ritratto di Paolo 3º a sedere con la destra appoggiata ad una borsa di velluto cremesi. Da Tiziano. Copia del Gatti' (Campori, 1870, p. 294) (Bernardino Gatti of Parma, 1495–1575). Size *c.* 1·40 × 1·10 m.

3. Rome, Fulvio Orsini, *Paul III*, type unknown (Nolhac, 1884, p. 431, no. 1).

4. Urbino, Duke of Urbino; portrait of Paul III by Titian (Vasari (1568)-Milanesi, VII, p. 444).

73. **Paul III with Cap** (*camauro*) Plate 118

Canvas. 1·08 × 0·80 m.

Naples, Gallerie Nazionali, Capodimonte.

Titian (ruined original).

1545–1546.

Since Paul III looks older and more bent with age than in the portrait without cap (*camauro*) (Cat. no. 72), nearly all critics have identified the present portrait as Titian's second of the pope, painted at Rome in 1545–1546. The general pose is essentially the same in both cases; he holds a purse in his right hand in the first portrait and a sheet of paper in the second. The open window with landscape view has also been added in the later version. Despite the lesser vitality of the *Paul III with Cap* and the ruinous condition of the paint surface, no reason exists to doubt Titian's authorship.

Condition: Photographs taken during the relining and restoration in 1948 show that little remains of the original painted surface. Scrubbed in the hand and in the white surplice down to the canvas itself (Ortolani, 1948, pp. 44–53).

History: Rome, Palazzo Farnese; Parma, Palazzo del Giardino, Inventory 1680 (Campori, 1870, p. 234); taken to Naples in the mid-eighteenth century.

Bibliography: See also History; Vasari (1568)-Milanesi, VII, p. 446 (perhaps Paul III in 1545–1546); C. and C., 1877, II, p. 91 (possibly a damaged original); Wickhoff, 1904, p. 114 (Paris Bordone!); Rinaldis, 1911, pp. 140–141 (workshop); *idem*, 1928 (omitted); Suida, 1935, p. 104 (Titian); Tietze, 1936, II, p. 302 (studio replica); Tietze-Conrat, 1946, pp. 76–84 (Titian); Ortolani, 1948, pp. 44–53 (detailed study; Titian, in Rome, 1545–1546); Pallucchini, 1954, II, p. 26 (Titian, prototype for the Leningrad picture); Berenson, 1957, p. 189 (Titian, before 1549); Valcanover, 1960, II, pl. 2 (Titian, in Rome); *idem*, 1969, no. 267 (commonly attributed); Palluchini, 1969, p. 285, fig. 308 (Titian, 1546).

74. **Paul III with Cap** (*camauro*) Plate 119

Canvas. 0·978 × 0·787 m.

Leningrad, Hermitage Museum.

1545–1546.

The provenance of this version from Titian's own house lends support to Tietze-Conrat's proposal that it is the artist's preparatory sketch (*modello*) for both the Naples and Vienna pictures (Cat. nos. 73, 75). Purely stylistic evidence is less reliable because of the condition of the canvas.

Condition: Considerably repainted.

History: Titian's house, Venice, until 1581; Barbarigo Collection, Venice, 1581–1850 (Bevilacqua, 1845, p. 3, no. 1); Barbarigo sale, 1850, sold to Russia (Levi, 1900, p. 286, no. 1; Savini-Branca, 1964, p. 186).

Bibliography: C. and C., 1877, II, p. 90 (Titian and assistant); Venturi, 1928, p. 145 (Titian); Suida, 1935, p. 170 (Titian); Tietze, 1936, II, p. 291 (uncertain); Tietze-Conrat, *Gazette*, 1946, pp. 73–84 (sketch for the Naples picture, 1543); Tietze, 1936, II, p. 291 (uncertain); Tietze-Conrat, 1946, pp. 73–84 (Titian's sketch for the Naples picture, 1543); Pallucchini, 1954, II, p. 26 (Titian, second version); Berenson, 1957, p. 186 (Titian, late); Leningrad, 1958, no. 122 (atelier of Titian); Valcanover, 1960, II, p. 64 (attributed, doubtfully); *idem*, 1969, no. 272 (doubtful); Pallucchini, 1969, p. 285, fig. 309 (Titian, 1546).

75. **Paul III with Cap** (*camauro*) Plate 120

Canvas. 0·89 × 0·79 m.

Vienna, Kunsthistorisches Museum.

1545–1546.

Better in state of preservation than the Naples version, this picture seems at least equal in quality to it and to the Leningrad example. The handling of pigment conforms to Titian's technique in the fifteen-forties as seen in other authentic works in the same museum. Strangely enough this version has been rejected even by Suida and Tietze, both Viennese critics, possibly for subjective reasons.

Condition: Satisfactory.

History: In the Kunsthistorisches Museum since 1816 (Krafft, 1854, p. 87, no. 4).

Bibliography: C. and C., 1877, II, p. 91 (a Venetian copy, late sixteenth century); Engerth, 1884, pp. 368–369 (school

repetition of the original); Clausse, 1905, p. 83 (copy of the Naples picture by a follower); Suida, 1935 (omitted); Tietze, 1936 (omitted); Tietze-Conrat, 1946, pp. 73–84 (workshop replica); Pallucchini, 1954, II, p. 26 (Titian's replica of Leningrad picture; rejects Tietze-Conrat's theory); Berenson, 1957, p. 192 (Titian in great part); Klauner and Oberhammer, 1960, p. 140, no. 718 (Titian); Valcanover, 1969, no. 273 (workshop, 1546); Pallucchini, 1969, p. 285 (replica).

76. **Paul III and His Grandsons** Plates 126–129

Canvas. 2·00 × 1·73 m.

Naples, Gallerie Nazionali, Capodimonte.

1546.

In this masterpiece, perhaps the greatest psychological portrait of all time, the dissensions rife between Paul III and his overambitious grandson Ottavio are clearly revealed. The elderly pope, bent with age, turns quickly and looks suspiciously at the obsequious Ottavio, who at that very time was scheming with the old man's opponents. It would be impossible to imagine a posture more revealing of feigned reverence than that of the bowing Ottavio or a face more Machiavellian, with all that the word implies. Cardinal Alessandro Farnese, the great churchman and art patron, then twenty-six, standing quietly and impassively at the left, provides a foil to the explosive situation before him. Various writers have concluded with good reason that Titian had been witness to a violent scene between Paul III and Ottavio, and for that reason the picture may have displeased the pope. That fact would explain why the artist left the canvas without finishing the last details.

Raphael's group portrait of *Leo X and His Nephews c.* 1517 (Florence, Uffizi) is the major forerunner of Titian's *Paul III and His Nephews (Grandsons)*; the seated pope is accompanied by two much younger men in both cases. Whereas Raphael portrayed each person independently and grouped the two cardinals symmetrically on either side of Leo X, Titian revealed the potentially explosive drama of a family intrigue. In other words, he combined portraiture and narrative in a profoundly revealing way. To achieve that purpose and in keeping with the later development of the Venetian school, posture and movement are exploited in a composition of great freedom, wherein balance is achieved in part by the composition of the colour.

A brilliant symphony of reds is orchestrated in the varying tones of the pope's cape and cap, in Alessandro's cardinal's robes, the red velvet table covering, and the large crimson curtain in the background. Ottavio's black costume, his white hose, and the pope's white surplice furnish the major

contrasts. The utmost virtuosity is displayed in the brilliance and dexterity of the application of paint as well as in the subtle variations of colour relationships. White highlights, so typical of Titian's mature work, are applied over the pope's costume with scintillating effects.

Biography: The biographies of Paul III Farnese and Cardinal Alessandro Farnese are sketched elsewhere (Cat. nos. 72, 29). Ottavio (Cat. no. L–14), grandson of the pope and the second son of Pierluigi Farnese (Cat. no. 30) and his wife Girolama Orsini, was born in 1524. At the age of fifteen he was married off to Margaret of Austria (Cat. no. L–23), natural daughter of Emperor Charles V, his senior by two years and already at fifteen the widow of the murdered Alessandro dei Medici. This political marriage led to Ottavio's assumption of the title of Duke of Parma and Piacenza in a struggle for power between Charles V and Paul III, who gave these papal estates to his own son Pierluigi Farnese (Pastor, XI, 1914, pp. 322–336; XII, 1914, pp. 229–234, 369–374). Ottavio succeeded to them after the murder of his father through the connivance of Charles V and Ferrante Gonzaga, the emperor's governor of Milan.

Condition: Recent X-rays have shown that Titian painted directly upon the canvas without preparatory studies and that he changed details as he proceeded. The first version of Cardinal Alessandro's head was abandoned and the location shifted to the right. This entire figure was carried to virtual conclusion, whereas Ottavio's head alone is complete. His body exists mainly in underpaint, and the details, most notable in the right hand holding his cap, were never added. The pope's head and his surplice lack the final layers of paint, yet Titian's conception of this figure and indeed of the entire picture is so fully realized that nothing essential to its pictorial beauty or psychological projection is wanting (Causa, 1964, pp. 219–223).

History: Painted in Rome in 1546; Palazzo Farnese, Rome; sent to Parma, date unrecorded; Palazzo del Giardino, Parma, Inventory 1680 (Campori, p. 237, no. 4: Ottavio wrongly identified as Pierluigi); taken to Naples in the mid-eighteenth century; sent to Palermo in 1798 for safekeeping (Filangieri di Candida, 1902, p. 320, no. 12).

Bibliography: See also History; Vasari (1568)-Milanesi, VII, p. 446 (Vasari's text is ambiguous, but he describes *Paul III and His Grandsons* quite specifically in a letter of 12 February 1547 to Benedetto Varchi; quoted by Milanesi, in note 2); Van Dyck, 'Italian Sketchbook', *c.* 1621–1627, folio 108ᵛ; Ridolfi (1648)-Hadeln, I, p. 178; C. and C., 1877, II, pp. 123–126; Gronau, *Titian,* 1904, pp. 137–139, 294; Rinaldis, 1911, II, pp. 144–147; idem. 1927, pp. 329–330.

no. 129; Fischel, 1924, pl. 127; Suida, 1935, pp. 104–105; *Mostra di Tiziano*, 1935, no. 65; Tietze, 1936, I, pp. 177–178, II, p. 302; Berenson, 1957, p. 189; Molajoli, 1958, p. 46; Valcanover, 1960, II, colour plate and pl. 1; Causa, 1964, pp. 219–223 (X-rays); Pope-Hennessy, 1966, pp. 148–149; Valcanover, 1969, no. 268; Pallucchini, 1969, p. 284, figs. 306–307; Panofsky, 1969, pp. 78–79.

COPY:
Parma, Palazzo del Giardino; copy by Francesco Quattrocase, *c.* 1670; canvas, *br.* 3 *on.* 8½ × *br.* 3 *on.* 2½ i.e. about 2·37×2·04 m. (Campori, 1870, p. 272, last item). The copy in storage in the Naples Museum is probably this picture (Rinaldis, 1911, p. 158).

77. Antoine Perrenot, Cardinal Granvelle Plate 153

Canvas. 1·12×0·883 m.

Kansas City (Missouri), William Rockhill Nelson Gallery.

Titian and workshop.

About 1548.

The cursive inscription 'Titianus di Cadore' on the paper beside the clock at the right cannot be regarded as autograph since it does not correspond to Titian's numerous authentic signatures.

The identification of Cardinal Granvelle in this picture is confirmed by Suavius' engraving (*Charles V*, 1955, p. 54) and by Antonio Moro's portrait of him in Vienna (Valentiner, 1931, p. 110, illustrated). The latter work is more brilliantly painted than the one in Kansas City, a fact which lends support to the belief that Titian himself had very little to do with this item. The total lack of white highlights or any suggestion of the Venetian's technique other than on the rose-coloured table covering implies the hand of a German or Flemish assistant. Nevertheless, the characterization of the Cardinal is well projected. The black costume against a neutral background is relieved only by the white collar, white cuffs and the rose colour of the table. The Cardinal wears gold rings set with garnet stones on the left hand holding the book, and he carries gloves in the right hand.

Biography: Antoine Perrenot, Cardinal Granvelle (1517–1586), was the son of Nicolas Perrenot, chancellor of Charles V (see Cat. no. X–82). After completing his studies at Padua and Louvain he became bishop of Arras in 1540. Soon propelled into the affairs of the Hapsburg empire through his father's influence, he attended the Council of Trent and served as ambassador of Charles V on several occasions, among them the negotiations for the marriage of Prince Philip with Queen Mary of England. Later he

became prime minister to Margaret of Parma during her regency of the Netherlands. His continued prominence under Philip II is shown by his mission to Rome, which brought about the Holy League between Spain, Venice, and the papacy and resulted in the victory of Lepanto over the Turks in 1571. At this period he served as Spanish viceroy to Naples (1570–1575), and thereafter continued as a most valuable international diplomat until his death (Hugh Chisholm, 1910).

Condition: Somewhat repainted; formerly on a smaller frame as demonstrated by ridges in the canvas about eight centimetres from the left side vertically and others about four centimetres from the upper edge horizontally.

History: Reference to 'a portrait' without further specification has been most doubtfully assumed to have been one of the Cardinal himself (letter 4 November 1548, Cardinal Granvelle to Titian: Zarco del Valle, 1888, pp. 223–224); presumed to have been in the Granvelle Palace at Besançon; Comte de Cantecroix, nephew of Cardinal Antoine Perrenot (Levêque, 1753, I, pp. 190–191). *Certain History:* Claudius Tarral, Paris (sale, London, Christie's, 11 June 1847, no. 45); C. R. Beauclerk, London; Robert T. Parker, London; Captain T. A. Tatton, Cuerdon Hall, Preston (sale, London, Christie's, 14 December 1928, no. 58, as Daniele Barbaro; *APC*, VIII, 1928–1929, no. 3505); Frank Sabin, London, 1928 [history in part reconstructed by Gronau, 1930, pl. 23]; bought by the Kansas City Gallery in 1930.

Bibliography: See also History; C. and C., 1877, II, pp. 184–185 (literary reference); Gronau, 1930, pl. 23; Valentiner, 1931, p. 110 (Titian); L. Venturi, 1933, pl. 521 (Titian); Wilde, 1934, pp. 166–167 (Titian, *c.* 1548); Suida, 1935, pp. 109, 170 (Titian, repainted); Tietze, 1936, II, p. 291 (Titian); Berenson, 1957, p. 187 (as signed!; 1548–1549); Kansas City, 1959, p. 68 (Titian, 1548–1549); Valcanover, 1960, II, pl. 27 (Titian); *idem*, 1969, no. 292 (Titian, 1548); Pallucchini, 1969, p. 290, fig. 335 (Titian, 1548).

RELATED WORKS
Toledo, Museo de Santa Cruz, no. 109 (lent by the Prado Museum, Madrid); panel, 1·11×0·815 m., copy by Ferdinand Frösch, 1879, of Antonio Moro's reversed composition in Vienna (*Carlos V*, 1958, p. 80, no. 48, pl. 106).

78. Philip II in Armour (full-length) Plates 174–176

Canvas. 1·93×1·11 m.

Madrid, Prado Museum.

Not signed.

Documented 1550–1551.

The full-length portrait shows the prince dressed in armour damascened with gold and wearing greyish-white hose and breeches. The helmet lies upon a table covered with dark red velvet. Prince Philip, aged twenty-three, then the heir apparent to Charles V, is shown at his most attractive in full youth in a portrait that Titian certainly painted in the presence of the model. In technical brilliancy this state portrait ranks among Titian's greatest achievements. The armour gleams, and the subtleties of nuances in tone created by reflected lights and the damascened gold are indescribable. The entire figure projects the regal status of the prince, whereas his surly arrogant young face has been softened to assuage what could have been a shocking revelation of his unpleasant character. The Venetian illusionistic technique, i.e. form, suggested rather than described, has not been carried far enough to veil the precise shapes of the armour and other objects. Yet Philip, so accustomed to the precision of Flemish art, remarked upon the supposed lack of finish of this masterpiece. On sending the portrait to Brussels to his aunt, Mary of Hungary, in the charge of the Duke of Alba, Philip wrote from Augsburg on 16 May 1551, 'It is easy to see the haste with which it has been made and if there were time it would have been done over again' (Voltelini, 1890, p. LV, no. 6443; Cloulas, 1967, p. 213: 'Con esta van los retratos de Ticiano que vuestra alteza me mandó que le enbiase, y otros dos qu'el me dió para vuestra alteza; al mio armado se le parece bien, la priesa con que le ha hecho y si ubiero mas tiempo, yo se le hiziera tornara hazer. El otro le a dannado un poco al barniz, aunque no en el gesto, y esto se podra allá adreçar, y la culpa no es mia sino de Ticiano').

The parade armour worn by Philip in this painting consists only of the cuirass, while the gauntlets and plumed helmet lie upon the table. In the Real Armería this suit, with only a few pieces missing, still exists, there attributed to the famous Colman atelier of Augsburg, where various sets of armour were executed for Philip in the years 1549–1554 (Valencia de Don Juan, 1898, pp. 74–75).

Biography: Philip II (1527–1598), the son of Emperor Charles V and the Empress Isabella, was born at Valladolid on 21 May 1527. At the age of seven the Emperor placed him under the tutelage of Martínez Siliceo, a professor of the University of Salamanca, later archbishop of Toledo. The young prince learned to speak fluent Latin, then the principal international language, as well as Spanish, French, and Italian.

At the age of sixteen Philip married his cousin, Mary of Portugal, who died in 1545 leaving an infant son, the ill-fated, insane Don Carlos (1544–1568), whom Schiller and Verdi turned into a romantic hero.

On 1 October 1548 Philip set forth from Spain upon the first of several foreign journeys. Arriving at Savona on 25 November, he began a rapid triumphal tour across north Italy. In Milan he met Titian, called there to paint the young prince's portrait, thus initiating the long series of commissions that were to end only with the artist's death. He continued on over the Alps to Augsburg and thence to Brussels to meet his father Charles V. In June 1549 the Emperor and his son travelled back to Augsburg, where at the Diet of Augsburg plans were made for Philip to inherit Spain, the Netherlands, and America, whereas Ferdinand, Charles' brother, was to succeed as Emperor of Germany and Austria. In June 1551 Philip returned to Spain as regent, there to remain until his departure for England, where he married Mary Tudor, his senior by eleven years, in a ceremony at Winchester Cathedral on 25 August 1554. A year later he departed for Brussels, returning once again to England for less than four months in 1557. Mary Tudor's death, childless, on 17 November 1558 put an end to the fantastic hope of uniting the British and Spanish empires under a single Catholic ruler.

Meantime, after Charles V's abdication in 1556, Philip II succeeded to his dominions as earlier agreed. In August 1559 the new king returned to Spain for the first time in five years, and there he remained for the rest of his life. At the age of thirty-two he took a third wife, the French Princess Isabelle de Valois, chosen for political reasons, as was customary. During this period Titian's activity for Philip II continued and even increased as the monarch made plans for building the great monastery and palace of the Escorial (begun 1563). At the death of Isabelle de Valois at the age of twenty-three in 1568, Philip was still without a male heir but his final and fourth marriage with his niece, Ana of Austria (1570) resulted in the birth of his successor, Philip III. Never a sympathetic character, Philip II ruled as absolute monarch after his father's death, inflexible, vengeful, and cruel in his political dealings, and yet fanatically pious (*Escorial, 1563–1963*, 1963).

Condition: Somewhat darkened. The present height of the canvas includes an increase by about eight centimetres to fit a frame, probably made after the fire of 1734.

History: See also above; the portrait was painted during Titian's second trip to Augsburg between 4 November 1550 and May 1551. It was completed before 16 May, as demonstrated by the letter quoted above. That fact is confirmed by payments to Titian on 19 December 1550 of sixty *escudos de oro* and on 6 February 1551 of two hundred *scudi* plus thirty *scudi* for colours (Beaumont, 1869, pp. 84–89; Beer, 1891, p. CXLVIII, no. 8408; Cloulas, 1967, pp. 209–210; the last item is omitted by Beer, but is recorded in the documents at Simancas, Estado, Libro 71, folios

91–91ᵛ). On 5 May 1551 another payment to Titian of one thousand *scudi* and on 13 May two hundred *scudi* to his son (Beroqui, 1946, p. 116; Cloulas, 1967, p. 211). On 15 May 1551 Philip also ordered an annual payment of two hundred *escudos de oro* to Titian (Beer, *loc. cit.*, no. 8418; Cloulas, 1967, p. 211).

The full-length portrait of Philip II armed and in white hose is described in the following royal inventories: Alcázar, Madrid, in Guardajoyas, Inventory 1600 (Philip II, edition 1956, II, pp. 235–236, no. 213, valued at 100 ducats); Alcázar, Pieça en que duerme su Magestad ... de verano, Inventory 1636 (folio 36); Alcázar, Galería de Mediodía, Inventory 1666, no. 573, value 250 ducats; Inventory 1686, no. 251, '2¼ *varas* de alto' [i.e. 188 m.], Inventory 1700, no. 62 (Bottineau, 1958, pp. 152–153); Inventory 1734, no. 45 (after the fire of 1734: 'bien tratado'); Inventory 1747, no. 14, 'Felipe armado' (wrongly called 'Felipe tercero'); in the Royal Palace, Madrid in 1776 (Ponz, tomo VI, Del Alcázar, 46); taken to the Prado Museum probably in 1827.

Bibliography: See also above; Vasari (1568)-Milanesi, VII, p. 448 (portraits); Madrazo, 1843, p. 165, no. 769; 'Inventario general', Museo del Prado, 1857, p. 157, no. 769; C. and C., 1877, II, pp. 204–211; Allende-Salazar and Sánchez Cantón, 1919, p. 58; Suida, 1935, pp. 107–108; Tietze, 1936, II, p. 299; Beroqui, 1946, pp. 112–118 (detailed study of Philip); Jenkins, 1947, p. 16; Pallucchini, 1954, II, p. 53; Berenson, 1975, p. 187; Valcanover, 1960, II, pls. 43–44 (Titian, 1551); Prado catalogue, 1963, no. 411 (old no. 769); Pope-Hennessy, 1966, pp. 178–179; Valcanover, 1969, no. 345 (Titian, 1551); Pallucchini, 1969, p. 296, fig. 369 (Titian, 1551).

COPIES:

1. Chatsworth, Duke of Devonshire, canvas, 1·78×1·04 m., copy by Rubens datable 1628 (Plate 241). The drawing and details are more precise than in Titian's original in the Prado Museum. The red-velvet table covering as well as the greyish-white hose and breeches appear solider and harder in surfaces. In the Chatsworth picture numerous losses of paint are detectable throughout. *Bibliography:* Pacheco, 1638, edition 1956, I, p. 153 (Rubens' copy in 1628); Rubens' Inventory 1640, edition 1855, p. 272, no. 61; Sainsbury, 1859, p. 238, no. 61; in the Devonshire Collection as early as 1722 when the Comte de Caylus admired it (reproduced by Blanc, 1857, I, p. cxxiii); C. and C., 1877, II, p. 210 (replica by Orazio or Cesare Vecellio); Chatsworth catalogue in manuscript, 1933, no. 664; Vertue, *Notebooks* (1713–1756), edition 1930–1947, III, p. 112, IV, pp. 7, 79; Burchard, 1950, pp. 32–33 (Rubens, 1603); Jaffé, 1965, p. 159 (Rubens, 1603); Müller-Hofstede, 1967, p. 54 (Rubens, 1603).

2. Cheltenham, Lord Northwick (formerly); sale 26 July 1859, p. 101, no. 1085; C. and C., 1877, II, p. 210 (Spanish copy).

3. Dowdeswell, canvas, 2·082×1·245 m., weak copy, probably the same as Copy 5, below.

4. Paris, Musée des Arts Décoratifs, no. 979, panel, 0·355× 0·203 m., probably a Spanish copy. Even the subject is unidentified here, but the label 'Peyre, no. 7' suggests the provenance.

5. Unknown location, formerly London, Seale Haynes Collection, canvas, 2·083×1·245 m., sale, 16, 18 April 1904 (*Connoisseur*, IX, 1904, p. 125); *purported history:* Emperor Rudolf II; Bonaparte brought it from Spain; collection of King Louis Philippe.

79. **Philip II** (full length) Plate 179

Canvas. 1·88×1·00 m.

Naples, Gallerie Nazionali, Capodimonte.

Signed at the lower right: TITIANVS EQVES. C. F.

Titian and workshop.

About 1554.

The precision in the painting of the details of the costume, particularly the sleeves, may be explained by the assistance of an able northern pupil. To the prince's beige doublet and hose are added a royal-blue jacket lined with fur and completed by handsome blue sleeves embroidered in gold. The figure is silhouetted against a dark-brown background and a pale rose-coloured floor. The link design of the chain with Golden Fleece does not conform to the official collar, the pattern of which is based on the flint-and-steel of Burgundy. In his left hand the prince holds his gloves, while his right hand rests upon the hilt of the dagger, the scabbard of which is adorned with a tassel.

Dating: On the basis of Philip's age and by comparison with other portraits of him this work is datable about 1554. Crowe and Cavalcaselle proposed a date of 1553 because of a letter from Titian to Philip dated 23 March on the back of which is reference to the arrival of a portrait (C. and C., 1877, II, pp. 210–211, 506). It is difficult to see why the Naples picture, formerly in the Farnese Collection, should be this item shipped to Madrid. Moreover, the portrait of 1553 is the half-length version now in the Prado Museum (Cat. no. 83). Nevertheless, nearly all writers have accepted Crowe and Cavalcaselle's suggestion, despite the fact that a different letter from Vargas at Venice to Philip dated 24 March 1553 qualifies the picture shipped at this time as a 'small portrait' (Zarco del Valle, 1888, p. 231; Cloulas, 1967, p. 218; see also my text, note 159). This second

letter about the same picture was unknown to Crowe and Cavalcaselle in 1877.

Condition: Restored in 1962; the general condition of the canvas is satisfactory.

Probable history: Although no artists are cited, Titian's *Philip II* from the Farnese Collection is probably the following: Inventory of Odoardo Farnese, Caprarola, 1626, Camera dello studio, 'un quadro grande di filippo 2' (Naples, Archivio di Stato, 1176–1177, folio 68); 1651, in the Stanza dello Studio, 'un quadro grande di filippo 2' (*loc. cit.*, folio 17ᵛ); 1668, in the same room and same words (*loc. cit.*, folio 68). On the contrary, Rinaldis (1911, p. 154; 1927, p. 337) tentatively identified the Naples portrait with an item in the Palazzo del Giardino, Parma, in 1680, 'un quadro alto braccia 1 on 11, largo braccia 1 on 5½ [about 0·70 × 0·67 m.], Ritratto di Filippo II re di Spagna di ...' (no artist given; Campori, 1870, p. 271); however, the small size of this picture eliminates such a possibility. It is not known whether the Caprarola portrait was ever sent to Parma.

Bibliography: C. and C., 1877, II, pp. 210–211, 506 (Titian); Gronau, *Titian*, 1904, p. 294 (Titian); Ricketts, 1910, pp. 102, 183 (Orazio Vecellio); Rinaldis, 1911, pp. 151–154; 1927, pp. 335–337, no. 127 (Titian); Mayer, 1925, pp. 268–270 (copy); *Mostra di Tiziano*, 1935, no. 75 (workshop, *c.* 1553); Suida, 1935, pp. 108, 170 (Titian and workshop); Tietze, 1936, II, p. 302 (the best workshop replica); Pallucchini, 1954, II, p. 59 (Titian); Doria and Bologna, 1954, pp. 17–18 (Titian); Berenson, 1957, p. 189 (Titian, 1553); Valcanover, 1960, II, pl. 48, p. 56 (Titian); Morassi, 1964, pl. 27 (Titian, 1553; colour reproduction); Valcanover, 1969, no. 354 (workshop); Pallucchini, 1969, p. 298, fig. 380 (Titian, 1553); Panofsky, 1969, p. 82, note 56 (workshop).

COPIES:
1. Monticello, Illinois National Art Foundation (since 1963); hard copy attributed to Orazio Vecellio, canvas, 1·89 × 1·10 m.; Wanamaker sale, American Art Association, 28 March 1935, no. 61; formerly Sedelmeyer, Paris; Kress Foundation, no. K 1534, since 1948 (Shapley, 1968, p. 190).
2. Unknown location, canvas, 1·78 × 0·89 m.; formerly Blenheim Palace (Scharf, 1862, p. 51, as a copy of the Naples portrait; C. and C., 1877, II, p. 211, follower of Titian; Blenheim sale, 7 August 1886, no. 262).
3. Vienna, Kunsthistorisches Museum; canvas, 1·78 × 0·97 m., good copy (Klauner, 1961, p. 135, illustrated).

VARIANT:
Unknown location; canvas, 1·17 × 0·84 m.; formerly Lord Carlisle at Castle Howard (C. and C., 1877, II, p. 211, as a partial copy of the Naples picture); sale, London, Sotheby, 6 May 1926, no. 8, to Barlow and Hampton. Variant in three-quarter length (photo at Courtauld Institute, London).

80. **Philip II** (full-length) Plate 180
Canvas. 1·85 × 1·03 m.
Florence, Pitti Gallery.
Titian and workshop.
About 1554.

After the cleaning of 1964 the picture has gained so notably that Titian's supervision and share in painting the portrait must have been greater than usually presumed. Especially the head has vigour of expression and richness in paint textures. The grey architectural setting and large grey columns, which differ from the plain background of the Naples version, are altogether unusual in the artist's work. The solidity and precision of the architecture suggests the hand of a German assistant. The costume also deviates from other versions in that the prince wears white shoes, white hose, and a pale-blue silk jacket lined with sable. The general quality seems better than that of the picture in Naples.

Condition: see above.

History: Vasari (1568)-Milanesi, VII, p. 450, as sent to Cosimo I dei Medici by Titian.

Bibliography: See also History; C. and C., 1877, II, p. 211 (replica); Ricketts, 1910, pp. 120, 183 (Orazio Vecellio); Gronau, *Titian*, 1904, p. 291 (Titian); Mayer, 1925, p. 270 (follower of Titian); Suida, 1935, p. 108 (workshop); Tietze, 1936 (not listed); Pallucchini, 1954, II, p. 60 (replica of the Naples portrait); Berenson, 1957, p. 185 (Titian); Valcanover, 1960, II, p. 66 (workshop); Francini Ciaranfi, 1964, p. 11 (Titian); Valcanover, 1969, no. 593 (attributed); Pallucchini, 1969, p. 298 (derivation from Naples version of 1553).

81. **Philip II Seated Wearing a Crown** Plate 181
Canvas. 1·092 × 0·952 m.
Cincinnati, Art Museum.
About 1551, repainted 1554–1556.

This sketch (*bozzetto*) appears to have been executed in the presence of the sitter, and therefore it would have been painted either at Milan in December 1548 or at Augsburg in 1550–1551. The latest possible date seems likely, because

Philip looks older than in early portraits. The crown is clearly a subsequent addition, and the position of the right arm and sceptre also imply modifications at the same time. The earliest date at which a crown would be applicable was subsequent to Philip's marriage to Queen Mary Tudor of England in August 1554. Two years later, on his father's abdication in January 1556, he became ruler of Spain and the American dominions, the Netherlands, and the Spanish possessions in Italy, including Milan, Naples, and Sicily. Mayer's theory that the picture might be dated 1559 and associated with García Hernández's letter dated 22 September (Mayer, 1925, p. 269) must be rejected, because that portrait of a girl dressed in yellow probably represented Lavinia and certainly not Philip II (letter in C. and C., 1877, II, p. 517; Cloulas, 1967, p. 239).

Many theories have been put forward about *Philip II Seated Wearing a Crown*. Beroqui (1946, p. 97) felt certain that this work was the sketch executed by Titian at Milan in December 1548 and paid for by Philip on 29 January 1549 (see Cat. no. L–25). Moreover, he confused the two versions of *Philip II Seated*, misled by the description of Crowe and Cavalcaselle (1877, II, pp. 206–208).

Crowe and Cavalcaselle visited the Barbarigo Collection in Padua, where they saw the picture now in Cincinnati, but they must also have seen the Habich Collection in Cassel, which contained the second version. At a period when photographs were not available, they somehow scrambled their notes. They describe the Barbarigo-Cincinnati version giving the dimensions correctly as 1·14×0·95 m. (today 1·092×0·952), but they say that he wears a beret and is seated beside a window with landscape view. These last two details apply, however, to the version now in Geneva (formerly Habich Collection, Cassel); the size of this smaller canvas is 0·96×0·75 m. To me a simple and logical explanation is that they had seen both pictures during years of research and later forgot, as one does when dealing with hundreds of items. In other words they telescoped the two pictures into one.

Tietze-Conrat (1946, p. 82) thought they were describing the portrait in which Philip II wears the beret, now in Geneva, but they mention by name only the Barbarigo-Cincinnati picture. Panofsky recently (1969, pp. 82–83, note) proposed two other alternatives, either that the Cincinnati portrait may have shown Philip with a beret, which since the 1870's was changed to a crown, or that Crowe and Cavalcaselle saw a third lost picture, which was really the one earlier in Padua. Both ideas seem to me to assume the absolute infallibility of Crowe and Cavalcaselle, who were great scholars but after all only human. They give a confused erroneous description of the Barbarigo-Cincinnati picture, but their correct dimensions prove that they saw this version.

Condition: Somewhat retouched, probably by Lenbach.

History: Casa Grande, Titian's house; still in the artist's possession at his death; Barbarigo Collection, Venice (Ridolfi (1648)-Hadeln, I, p. 200); Barbarigo-Giustiniani Collection, Padua (Selvatico, 1875, pp. 6–9, 114; the dimensions, 1·14×0·95 m. prove that this picture is the one now in Cincinnati); Franz von Lenbach, the painter, Munich, c. 1892–1911; Sir Hugh Lane, Dublin, 1911–1913; Agnew and Co., London, 1914; Emery Collection, Cincinnati (Ohio), 1914–1927; gift to the Cincinnati Art Museum in 1927.

Bibliography: See also above; C. and C., 1877, II, pp. 206–208 (as Titian's earliest sketch); Valentiner, 1914, pp. 159–163 (Titian); Fischel, 1924, p. 159 (Titian, c. 1550); Mayer, 1925, pp. 268–269 (Titian); L. Venturi, 1933, pl. 523 (Titian); Suida, 1935, p. 108 (Titian, 1554 or 1556); Tietze, 1936, II, p. 286 (Titian, c. 1554); Tietze-Conrat, 1946, p. 82 (Titian's *bozzetto*); Beroqui, 1946, p. 97 (Titian, datable 1549; he confuses the history with that of the Geneva version, Cat. no. 82); Pallucchini, II, 1954, pp. 60–61 (Titian); Cincinnati, 1957, pp. 38, 41 (Titian); Berenson, 1957, p. 184 (c. 1555, unfinished); Valcanover, 1960, II, pl. 42 (Titian); *idem*, 1969, no. 391 (Titian, c. 1554); Pallucchini, 1969, p. 300, fig. 388 (Titian, c. 1554); Panofsky, 1969, pp. 82–83, note (proposes a possible third lost version); Wethey, *Archivo*, 1969, pp. 136–137.

COPY:

Göteborg, Sweden, private collection; weak copy of the Cincinnati picture, but the crown is replaced here by a black beret (Sirèn, 1928, pp. 41–47). Even though the version by Titian now in Geneva (Cat. no. 82) also shows the king wearing a cap, the details of the copy unmistakably depend upon the Cincinnati portrait. Neither Panofsky nor Tietze-Conrat knew this copy and it was unknown to Crowe and Cavalcaselle as well.

82. **Philip II Seated, Wearing a Cap** Plate 182

Canvas. 0·96×0·75 m.

Geneva, Dr. Torsten Kreuger.

About 1556.

The seated pose is traditional in portraits of rulers or important ecclesiastics, as in the larger canvas of *Charles V Seated* at Munich (Plate 145) or Titian's *Paul III* at Naples (Plate 115). In spite of numerous and varied theories the Geneva picture, based upon Titian's sketch in Cincinnati (Plate 181), is essentially a finished work with an added landscape seen through the window. This particular version

could never have been considered a companion to *Charles V Seated*, as sometimes proposed, because of the great disparity in sizes of the two canvases and the fact that one is full length and the other three-quarter length.

Condition: Well preserved.

Certain History: Habich Collection, Cassel, until 1892; Georges Combez, Paris; Hermann Rasch, Stockholm, 1936.

Bibliography: C. and C., 1877, II, pp. 207–208 (this picture, although not mentioned, is described and confused with the Cincinnati version, Cat. no. 81); Fischel, 1924, p. 158 (Titian, *c.* 1550); Mayer, 1925, p. 269 (Titian); Sirèn, 1933, pl. 100 (Titian); Suida, 1935, pp. 108, 170 (Titian); Tietze, 1936, II, p. 309 (Titian, *c.* 1554); Zarnowsky, 1938, pp. 103–130 (extravagant attribution to Girolamo Dente di Tiziano); Beroqui, 1946, p. 97 (Titian, 1549; the history confused with that of Cat. no. 81 in Cincinnati); Tietze-Conrat, 1946, p. 82 (Titian); Pallucchini, 1954, II, p. 61 (Titian); Berenson, 1957 (omitted); Valcanover, 1960, II, pl. 49 (Titian); *idem*, 1969, no. 377 (doubtful attribution); Pallucchini, 1969, p. 300, fig. 389 (Titian, *c.* 1554, derived from Cincinnati picture); Panofsky, 1969, pp. 82–83, note (proposes a possible lost version to explain the confusion of Crowe and Cavalcaselle).

83. **Philip II** (half length) Plate 177

Canvas. 1·03 × 0·82 m.

Madrid, Prado Museum.

Workshop.

1553.

Shown in slightly more than half length, Philip appears in a dark-green-black costume lined and trimmed in fur and rests his right hand upon the red-velvet cover of the table. The hard linear quality of the drawings suggests the hand of one of Titian's German assistants. This opinion is supported by a remark on arrival of the picture in Philip's letter of 18 June 1553 to Titian in which Philip described a portrait as like one of the master's own hand, 'es como cosa de vuestra mano' (C. and C., 1877, II, p. 506; Beroqui, 1946, p. 119, note 1; Cloulas, 1967, p. 219). Another letter from Philip to Vargas, the Spanish ambassador at Venice, dated 18 (or 28) June 1553, makes the same comment (Zarco del Valle, 1888, p. 232; Cloulas, 1967, p. 219). This same picture when shipped by Francisco de Vargas from Venice to Philip had been qualified as a 'small portrait' (*retrato pequeño*) in a letter dated 24 March 1553 (Zarco del Valle, 1888, p. 231; Cloulas, 1967, p. 218). Beroqui earlier correctly associated the letter with this half-length portrait,

while Crowe and Cavalcaselle's belief that it referred to the large Naples portrait in full length (Cat. no. 79) has been incomprehensibly accepted by most critics.

Condition: Darkened and dirty.

History: Possibly at Aranjuez in 1600 (Beroqui, 1946, p. 119); Alcázar, Cuarto bajo de verano, 1636 (Inventory, folio 31); Alcázar, Inventory 1666, no. 313 (hung with A. Moro's *Mary Tudor*); Alcázar, Inventory 1686, no. 764; Alcázar, Inventory 1700, no. 421; Inventory of Philip V, 1747, no. 25 (Bottineau, 1958, p. 312); Royal Palace, 1772 and 1794, Antecamara del Rey; Royal Palace, 1794, Pieza de la Librería (Beroqui, 1946, pp. 121–122); probably taken to the Prado Museum in 1839.

Bibliography: Madrazo, 1843, p. 135, no. 649; 'Inventario general', Prado, 1857, p. 126, no. 649 (school of Titian); Allende-Salazar and Sánchez Cantón, 1919, pp. 58–59 (copy of lost original); Mayer, 1925, p. 270 (copy, perhaps by Sánchez Coello); Beroqui, 1946, pp. 118–121 (workshop of Titian); Pallucchini, 1954, II, p. 60 (copy); Valcanover, 1960, II, p. 66 (copy); Prado catalogue, 1963, no. 452 (workshop, 1551–1553); omitted by Suida, Tietze, and Berenson; Valcanover, 1969, under no. 356 (quotes Meyer's attribution to Sánchez Coello); Pallucchini, 1969, under the Naples portrait, pp. 298–299 (classifies it as a copy along with those cited here below).

COPIES:

1. Genoa, Palazzo Rosso; canvas, 1·00 × 0·76 m., unattributed in Inventory of 1717; mediocre copy of the same composition as the examples in the Prado Museum at Madrid and in the National Gallery at Rome (see below, copy no. 3). *Bibliography:* Grosso, 1931, p. 38 (workshop of Titian); Valcanover, 1960, II, p. 66 (copy attributed to Van Dyck); *idem*, 1969, under no. 356 (copy attributed to Van Dyck); Alinari photo no. 15414.

2. Hampton Court Palace; Flemish copy, hard, of poor quality; probably in Charles I's collection at Whitehall (van der Doort, 1639, Millar edition, 1960, p. 32); Gombosi proposed that this northern copy was the original from which Titian reproduced the example at Rome! *Bibliography:* Gombosi, 1929, pp. 562–564.

3. Rome, Galleria Nazionale; Palazzo Barberini; canvas, 1·08 × 0·78 m.; mediocre copy with green-black costume and white fur. *Bibliography:* C. and C., 1877, II, p. 211, note (copy); Fischel, fifth edition, 1924, pl. 162; Mayer, 1925, p. 270 (copy); Suida, 1935, p. 108 (workshop); Carpegna, 1954, p. 59, pl. 76 (copy); Pallucchini, 1954, II, p. 60 (copy); Valcanover, 1960, II, p. 66 (workshop); *idem*, 1969, no. 356 (workshop); Pallucchini, 1969, pp. 135, 298 (copy).

4. Unknown location; copy, three-quarter length, 1·067×
0·825 m.; Morton sale, London, Christie's, 8 June 1928, no.
112; formerly Jeremiah Harman in 1844; lent to Manchester
Exhibition, 1857; Lord Stanhope, 1857, sale, London,
Christie's, 8 June 1928 (*APC*, VII, 1927–1928, no. 8731).
Bibliography: Waagen, 1857, p. 181 (Titian); C. and C.,
1877, II, p. 211 (copy).

Philip II, see also: Cat. no. L–25.

84. **Philip II, Allegorical Portrait of** Plate 183
(Allegory of the Victory of Lepanto).

Canvas. 3·25 × 2·74 m.

Madrid, Prado Museum.

Titian and workshop.

Signed in cursive letters upon the paper on the column:
Titianus Vecelius eques. Caes. fecit

Datable 1573–1575.

The inscription 'Maiora tibi' suggests that triumphs also
await the child Prince Ferdinand (born in December 1571)
held by Philip, a prophecy which was never realized, since
the boy died aged seven in 1578. The captive Turk, his
turban on the floor, the rose flag, shield, arrows, and chains,
as well as the large drum and the green flag with crescents
at the left, all symbolize the defeat of the Turkish forces at
Lepanto in 1571 by members of the Holy League, i.e.
Spain, Venice, and the papacy. Jusepe Martínez (1675,
edition 1934, p. 41) may have been chauvinistic in his
statement that Sánchez Coello not only supplied Titian
with Philip's portrait, but also created the entire compos-
ition. The mention of 'your painter Alonso' in Titian's
letter of 22 December 1574 must refer, however, to a
portrait of Philip to be used as model and probably a draw-
ing containing the main ideas for the allegory (C. and C.,
1877, II, pp. 539–540; Cloulas, 1967, p. 80). In general,
the extremely dull character of this allegorical machine is
more reflective of the uninspired mentality of an Alonso
Sánchez Coello than of the brilliant imagination of a
great artist such as Titian. The placing of the table in the
centre, the rows of columns in perspective, the clumsy angel,
and the iconographic paraphernalia at the left now add
up to a monotonous composition. Nevertheless, it was
highly praised by Cassiano del Pozzo on his visit to Madrid
in 1626: 'un quadro stupendissimo e grande e straordinario
... paese, marina et una battaglia navale' (Pozzo, 1626,
folio 48). Consequently it must be presumed that the
seascape with a naval battle and the colour were brilliant
before the severe damage in the fire of 1734 (see below:
History). This picture, commemorating Philip's greatest

military achievement, was hung in the Royal Palace as a
pendant to his father's great victory at Mühlberg (Plate 141).

Condition: Badly damaged in the Alcázar fire of 1734;
much darkened and repainted. The grotesquely bad head
of the angel must be entirely a restoration after 1734.
In the background the ships on the sea are shown amidst
heavy smoke and gunfire, while the deep-blue sky still
retains a suggestion of its original richness. In 1625–1626
Vicente Carducho enlarged the picture from 2·98×1·95 m.
to the present size. Moreno Villa had the theory that the slave
was added entirely by Carducho (documents published by
Moreno Villa, 1933, pp. 113–115). A large rectangular
patch in the upper centre may be a section added by Car-
ducho or even later after the fire of 1734. Nearly a metre of
additional canvas is discernible along the right, i.e. the
two columns there. The cut goes through the dog's front
legs and head. Here the difference in paint surface is detect-
able. The bases of the two added columns differ in the
foliate ornament from Titian's at the left. The composition
is indeed better with the Turk at the left eliminated as
Moreno Villa suggested. Only a thorough technical examin-
ation in the laboratory, including X-rays, can establish
exactly which parts were added by Vicente Carducho.
However, the Turk does belong to the original composition,
for the El Pardo Inventory of 1614–1617, folio 5, specifically
mentions him: 'y debajo de un bufete rendido el gran
Turco y atadas las manos'. It seems likely that the details
at the left, including shield, flag, and drums, are indeed among
Carducho's additions to the picture.

History: Agatone, agent of Guidobaldo II della Rovere,
Duke of Urbino, described it in a letter of 9 May 1573 after
having seen it in Titian's studio, and reported that he had
ordered a copy (unknown) for his master (Gronau, 1904,
p. 29); shipped from Venice in September 1575 according
to a letter of 24 September (Zarco del Valle, 1888, p. 235;
Cloulas, 1967, p. 281); Madrid, Alcázar, Casa del Tesoro,
Inventory 1600 (Philip II, edition 1956, II, p. 251, no. 340);
Madrid, El Pardo Palace, Sala de Antecamara, taken there
after the fire of 1604 (Inventory 1614–1617, legajo 27, folio
2ᵛ); Alcázar, Salón Nuevo, 1626, room enlarged (Azcárate,
1960, p. 360); same room, 1633 (Carducho, edition 1933,
pp. 108–109; no mention of Carducho's additions to
the picture); Alcázar, Pieça Nueva (same room), Inventory,
1636, folio 14 (after); Alcázar, Salón de los Espejos, 1666;
Alcázar, 1686, no. 63 (Bottineau, 1958, pp. 40–41); Buen
Retiro Palace, 1700, no. 4; Alcázar Inventory, 1734, no. 62
(fire of 1734: 'maltratado', i.e. badly damaged); Inventory
of Philip V, 1747, no. 152; Royal Palace, Madrid, Cuarto
del Rey in 1776 (Ponz, VI, Del Alcázar, 35); taken to the
Prado probably in 1839.

Bibliography: See also above; Madrazo, 1843, p. 187, no. 854; 'Inventario general', Prado, 1857, p. 178, no. 854; C. and C., 1877, II, pp. 396–399, 403–405; Gronau, *Titian*, 1904, pp. 29–30; Allende-Salazar and Sánchez Cantón, 1919, pp. 60–61; San Román, 1931, pp. 41, 51 (cited a lost drawing of the subject by Sánchez Coello, in the painter's inventory); Suida, 1935, pp. 100, 116–117, 182 (entirely Titian); Tietze, 1936, II, p. 298 (mainly workshop); Beroqui, 1946, pp. 163–164; Berenson, 1957, p. 188 (as commissioned in 1571); Valcanover, 1960, II, pl. 131 (heavily restored); Prado catalogue, 1963, p. 701, no. 431; Valcanover, 1969, no. 509 (workshop); Pallucchini, 1969, p. 327, fig. 536 (partly workshop); Panofsky, 1969, pp. 72–74; Harris, 1970, p. 372.

LOST COPIES:

1. Copy ordered by Agatone, agent of Guidobaldo II della Rovere (see above).
2. Copy, canvas, 2½ *varas* square (2·08 m.), by Blas del Prado, Inventory of the palace of La Ribera, Valladolid in 1606 (Florit, 1906, p. 156).
3. Madrid, Collection of Antonio Pérez, favourite and later disgraced minister of Philip II. The inventory of his estate dated 1585 describes the picture: 'Otro quadro grande en que está el rey N.S. con su hijo, y un ángel acaba a darle una palma y el turco a los pies atados' (Pérez, Inventario, 1585, folio 472). Since no artist is mentioned, it might be the copy by Blas del Prado which later appears in the royal collection, i.e. copy 2 above.

85. Count Antonio Porcia e Brugnera Plate 64
Canvas. 1·15×0·90 m.
Milan, Brera Gallery.
Signed below the hand in capitals: TITIANVS
About 1535.

Porcia, dressed entirely in black with white at the cuffs and wearing a gold chain and elaborate pendant, stands against a dark brown background. His gloved right hand rests upon the handle of his sword. In the landscape seen through the open window are visible mountains against heavy clouds and a river, at the edge of which are moored boats. The painting of the head is particularly fine; a sheen seems to cover the face and the highlights on the nose and the eyes add brilliance.

Biography: The genealogy of the Porcia family has been published by Frizzoni, but nothing of Antonio's life is known beyond his approximate dates (*c.* 1508–1585).

Condition: Heavily varnished and much darkened; the landscape hardly visible; the signature is raggedly restored.

History: From Castello Porcia, near Pordenone; by inheritance to Principe Alfonso Porcia, Milan, 1830–1840; by inheritance to Eugenia Vimercati, Milan; likewise to Duchessa Eugenia Litta Visconti Arese, who donated it to the Brera in 1891 (Frizzoni, 1892, pp. 20–21).

Bibliography: Frizzoni, 1892, pp. 20–25 (Titian; initial publication); Gronau, *Titian*, 1904, p. 293 (Titian, *c.* 1540–1543); Fischel, 1924, p. 92 (Titian); *Mostra di Tiziano*, 1935, no. 34 (Titian); Suida, 1935, pp. 86, 171 (Titian, 1535); Tietze, 1936, II, p. 300 (Titian); Modigliani, 1950, p. 48, no. 180 (Titian); Berenson, 1957, p. 188 (Titian); Valcanover, 1960, I, pl. 146A (Titian); *idem*, 1969, no. 199 (Titian); Pallucchini, 1969, p. 273, fig. 248 (Titian, *c.* 1538–1540).

86. Giulio Romano Plate 82
Canvas. 1·02×0·87 m.
London, Mark Oliver.
About 1536.

This handsome portrait, recently rediscovered and published by John Shearman, shows Giulio Romano displaying a large sheet of paper, on which is drawn a central-plan church, which the artist must obviously have considered one of his major architectural designs. Shearman's conclusion that it was a project for the Gonzaga pantheon, later built as Santa Barbara, carries conviction.

The portrait is a direct study of one great artist by another with emphasis upon his professional activities and upon the characterization of the head. Colours are limited to tones of grey and black with the subtle variations of which only a very great master is capable. The fact that the pose of head and shoulders closely follows Giulio Romano's *Self-Portrait* in the Uffizi (Hartt, 1958, fig. 537) has caused some wonderment, yet Titian did occasionally follow an established model when requested to do so (see *Charles V*, Cat. no. 20, and *Empress Isabella*, Cat. no. 53).

Biography: Giulio Romano (1500–1546) was Raphael's principal assistant and heir to that artist's Vatican commissions after the early death of his master in 1520. From the beginning his activities embraced both painting and architecture. His natural brilliance and his great reputation in Rome induced Federico Gonzaga to call him to Mantua in 1524, where he remained until his death (Hartt, 1958).

Condition: Recently cleaned, removing old repaint and the later background with fluted pilaster and the dome of St. Peter's (Shearman, 1965, p. 173).

Dating: Probably painted at Mantua during Titian's visits there in 1536 or 1538, when he was involved with the Gonzaga commissions for Roman Emperors (Wethey, 1969, I, pp. 23–25).

History: Probably Giulio Romano's collection, Mantua; Gonzaga Collection, Mantua, recorded in the Inventory of 1627, no. 50, no author named (dell' Arco, 1857, II, p. 153; Luzio, 1913, p. 94); Charles I of England (van der Doort, 1639, Millar edition, 1960, pp. 45, 203 (as a Self-portrait by Giulio Romano); exhibited for sale at Somerset House in May 1650 (Cosnac, 1885, p. 417, 'Le portraict de Julio Romano, par Tissian ... £25'); sale of Charles I, 23 October 1651 to Grinder (LR/124, folio 166, no. 233, then as Titian); probably purchased by George, seventh Lord Kinnaird, in the late eighteenth century; Lord Kinnaird sale, London, Christie's, 21 June 1946, no. 79, as Titian; Anonymous sale, London, Sotheby's, 20 November 1957, no. 95 (history reconstructed by Shearman, 1965, pp. 172–173).

Bibliography: See also above; Berenson, 1907, p. 296 (Torbido, portrait of an architect, collection of Lord Kinnaird); Shearman, 1965, pp. 172–177 (the definitive study of the picture); Manchester, 1965, pp. 72–73 (Titian); Valcanover, 1969, no. 185 (traditional attribution); Pallucchini, 1969, p. 273, figs. 246–247 (Titian, *c.* 1540–1542).

COPIES:

1. Athens (Georgia), University of Georgia (since 1961); canvas, 0·594×0·451 m., portrait of Giulio Romano inscribed: —ROMANᴼ MC—M. An Uffizi pastel portrait follows this type. Mrs. Shapley suggests that all preserved portraits may reflect a lost original. *Bibliography:* Shearman, 1965, p. 172 (for comparative material); Shapley, 1968, pp. 190–191 (copy, perhaps after Titian).
2. Basel, Dr. Ernst Rothlin (in 1947); canvas, 0·46×0·38 m. (Suida, 1935, p. 186, pl. 315B).

87. Eleanora Gonzaga della Rovere, Duchess of Urbino
Plates 69, 70

Canvas. 1·14×1·22 m.

Florence, Uffizi.

Documented 1536–1538.

The solemn Duchess, the wife of Francesco Maria I della Rovere (Cat. no. 89), seated beside an open window with landscape view, is presented in one of the favourite compositional devices of Titian and the Venetian school. Forty-three years of age in 1536, she has retained little of the beauty for which she was known in her youth. Her rich black costume with gold braid and gold bows provides a sharp silhouette against the grey wall and the green covering of the table. Held in the fingers of her right hand is a sable or marten's fur with a gold-and-jewelled head, a luxurious article of dress widely adopted by the great ladies of the sixteenth century (Reade, 1951, p. 17). It served as neck-warmer during the cold months in the great unheated stone palaces of that period (Hunt, 1963, pp. 151–157; Randall, 1967, pp. 176–178). That any symbolism is intended by the little white-and-tan dog and by the clock is doubtful. Both have been declared to be representative of fidelity, but appear rather to have the sole purpose of enlivening the setting. Titian's portrait was praised by Aretino in his sonnet included in a letter of 7 November 1537 (*Lettere*, edition 1957, I, p. 77; also quoted by Ridolfi (1648)-Hadeln, I, p. 174).

Biography: Eleanora Gonzaga (1493–1550), daughter of Francesco II Gonzaga of Mantua and the celebrated Isabella d'Este (Cat. no. 27), was married at the age of sixteen in 1509 to Francesco Maria I della Rovere of Urbino (Cat. no. 89). Her role in history was obscure as compared with that of her famous mother, since there was no important sequel in Urbino to the patronage of arts and letters that distinguished the reigns of Federico and Guidobaldo I. She administered her husband's estates during his long absences on military campaigns, and she was mourned as the 'good duchess' on her death in 1550 (Ugolini, 1859, II, pp. 170–171, 191–196, 258–263).

Documentation: See Cat. no. 89.

Condition: In exceptionally good condition.

History: At Pesaro in 1538, later at Urbino; brought to Florence in 1631 by Vittoria della Rovere on her engagement to Duke Ferdinand II dei Medici, Inventory, no. 345 (Gronau, 1904, p. 9).

Bibliography: See also above; C. and C., 1877, I, pp. 413–416; Gronau, 1904, pp. 9–10, 18; Gronau, *Titian*, 1904, p. 92; Suida, 1935, pp. 48, 82, 167; Tietze, 1936, II, p. 290; Pallucchini, 1953, p. 179; Berenson, 1957, p. 185; Valcanover, 1960, I, pl. 143; Salvini, 1964, p. 70, no. 919; Valcanover, 1969, no. 187; Pallucchini, 1969, p. 271, fig. 232; Panofsky, 1969, p. 88.

88. Francesco Maria I della Rovere, Duke of Urbino
Plate 66

Bistre ink on white paper. 240×142 mm.

Florence, Uffizi, Gabinetto delle Stampe e dei Disegni, no. E 20, 767.

This niche-shaped drawing, which is squared off, is by common agreement regarded as Titian's study for the portrait in the Uffizi, painted in 1536. The evidence here of a full-length figure is confirmed by the picture itself (Cat. no. 89), which obviously was cut down to form a pendant to the canvas representing the duchess (Cat. no. 87). This pen drawing has the vigour and decisiveness of a rapid study for the composition, a sheet which may have been sent to the duke for his approval.

History: Probably the collection of the duke of Urbino; Mariano Urbinelli; Giuseppe Coradini in 1693, according to the note accompanying the drawing: as follows: 'ritratto di Francesco Maria pº della Rovere Duca quarto di Urbino di mano di Titiano Eccᵐᵒ pittore quale fu donato a me Giuseppe Coradini dal sig Mariano Urbinelli son haverli io fatto fare le cornigie et altro come qua si vede tutto costa grossi tredici in circa da tenerse gran conto, che così decidere Pregate a dio per me'; purchased by Giovanni Morelli from Glück, who said it had belonged to Prince Staccoli Castracano of Urbino (Richter and Morelli, edition 1960, p. 222); Giovanni Morelli's collector's mark on the drawing; bought by the Uffizi from Morelli's estate in 1908.

Bibliography: See also above; Frizzoni, 1886, pl. 27; Loesser, 1922, pl. 5 (Titian); Hadeln, 1924, pp. 49–50, pl. 11; Fröhlich-Bum, 1928, p. 197, no. 33; Popham, 1931, p. 73, no. 264 (preparatory study); Tietze and Tietze-Conrat, 1936, pp. 186 and 191, no. 25; *idem*, 1944, p. 317, no. 1911 (Titian's preparatory study); Hetzer, 1940, p. 167 (not Titian); Valcanover, 1960, I, p. 69; *idem*, 1969, under no. 186 (Titian's preparatory study); Panofsky, 1969, p. 89, note (Titian; with the suggestion that it might have been a scheme for a memorial portrait after the duke's death in 1538); Pallucchini, 1969, p. 332, fig. 567 (Titian's study).

89. Francesco Maria I della Rovere, Duke of Urbino
Plates 67, 68

Canvas. 1·143 × 1·00 m.

Florence, Uffizi.

Signed at the lower left: TITIANVS F.

Documented 1536–1538.

Francesco Maria I, dressed in dark armour, stands against a red velvet curtain, but above the shoulders the background is greenish-grey. The military equipment is completed by three batons at the upper right and the helmet at the left, which is topped by a dragon and plume, finished with a great flourish, and similar in style to the helmet of the Duke of Atri (Plate 168). The serious and sympathetically interpreted countenance as well as the brilliant handling of the painter's brush place the picture high among the artist's achievements.

The preparatory drawing, in full length, is preserved in the Uffizi (Plate 66). Even without this evidence it is obvious from the abruptness of the lower section of the composition that the canvas was cut down to make the portrait a pendant to Titian's picture of the Duchess, Eleanora Gonzaga della Rovere (Plate 70).

Biography: Francesco Maria I della Rovere (1480–1538) was appointed heir by his uncle Guidobaldo I da Montefeltro, on whose death in 1508 he became duke of Urbino. In the following year he married Eleanora Gonzaga (Cat. no. 87), daughter of Francesco II, marquess of Mantua, and Isabella d'Este (Cat. no. 27). Their son, Guidobaldo II della Rovere (Cat. no. 91), born in 1514, succeeded his father as duke of Urbino in 1538. The family fortunes had reached their height earlier during the pontificate (1503–1513) of Julius II (Giuliano della Rovere; see Cat. no. 55). Later, during the ascendancy of the imperial forces of Charles V, Francesco Maria allied himself with the Spanish against the French, and, thus engaging in a military career, managed to keep his possessions intact. His sudden illness and death within a month in September-October 1538 was formerly ascribed to poison, introduced in his ear by his barber (!), but modern medicine might diagnose a virus infection (Dennistoun, II, edition 1909, pp. 314–483, III, p. 71; Litta, vol. IX).

Documentation: Eulogized by Aretino in his sonnet of 1536 (Aretino, *Poesie*, edition 1930, II, pp. 208–209; also quoted by Dennistoun, edition 1909, III, p. 470); a letter of Francesco Maria, 17 July 1536, mentions the loan of his armour for the portrait (Gronau, 1904, p. 18); the picture arrived in Pesaro by 14 April 1538, according to a letter of Giovanmaria della Porta to the Duchess Eleanora praising this portrait and the Duchess's (Gronau, 1904, p. 19).

Condition: Dirty and darkened, but generally well preserved; exaggerated highlights on the right arm must be restorations; enlarged by about seven centimetres at the top and cut down at the lower edge from a full-length composition (see Cat. no. 88).

History: At Pesaro in 1538; later at Urbino; brought to Florence in 1631 by Vittoria della Rovere on her engagement to Ferdinand II dei Medici: Inventory, no. 323 (Gronau, 1904, p. 10).

Bibliography: See also above; universally accepted as Titian; Vasari (1568)-Milanesi, VII, p. 444; C. and C., 1877, I, pp. 411–413; Gronau, 1904, pp. 9–10, 17–18; Gronau, *Titian*, 1904, pp. 92, 289; Suida, 1935, pp. 79, 82, 167; *Mostra di Tiziano*, 1935, no. 25; Tietze, 1936, II, p. 290; Berenson, 1957, p. 185; Valcanover, 1960, I, pl. 142; Salvini, 1964, p. 70, no. 926; Valcanover, 1969, no. 186; Pallucchini, 1969, p. 271, pl. 231; Panofsky, 1969, pp. 88–89, note 1.

90. **Giulia Varano della Rovere, Duchess of Urbino**

Plate 148

Panel. 1·13×0·87 m.

Florence, Pitti Gallery, State Apartments.

1545–1547.

In Aretino's letter of October 1545 (*Lettere*, edition 1957, II, p. 92) to Giulia Varano, the first wife of Guidobaldo II della Rovere, Duke of Urbino, he refers to the monogram G G, which signifies Giulia and Guidobaldo. These letters appear embroidered on the sleeves and across the bodice of the rose velvet costume. The major reservation in accepting the identification as Giulia Varano lies in the fact that she was twenty-two in 1545, whereas the lady represented here seems much older. Nevertheless, the monogram and the velvet dress are important historical evidence, as is also the provenance of the picture from Urbino, where it was identified as Giulia Varano in 1631.

Aretino implies that Titian painted the picture solely from Guidobaldo's description of his wife, but it appears reasonable that another portrait must have been supplied to guide the artist. The pose, repeating exactly that of Eleanora Gonzaga (Plate 70), Giulia's mother-in-law, was certainly requested of the artist. The flowers in her hand resemble those in Titian's lost portrait of the Empress Isabella (Plate 150), a work which the artist also created from an earlier prototype. Both portraits, as well as that of Isabella d'Este (Plate 72), copied from Francesco Francia, have an unaccustomed rigidity and lack of psychological impact. The dominant rose tonality, established by the rose velvet costume, undoubtedly accounts for the attribution of the picture to Rubens by Wilde, followed by Tietze. This theory does not appear valid even if the portrait had been painted in Rubens' early years during his Italian sojourn. The stylistic elements are not compelling, and Rubens would have had to go to Urbino to see Titian's portrait of the lady.

Biography: Giulia Varano (1524–1547) was designated heiress of Camerino by Pope Clement VII dei Medici (1523–1534) on the death in 1527 of her father Giovanni Maria Varano, the last of his dynasty. Thereupon Camerino was subjected to widespread devastation by Rodolfo Varano, natural son of Giovanni Maria. In 1534 Giulia was hastily married, in spite of her extreme youth, to Guidobaldo II della Rovere, ten years her senior. The accession to the papal throne of Paul III Farnese, who had wanted Giulia and her inheritance for Ottavio Farnese his grandson, brought the interdict to Camerino and excommunication to Giulia and her mother. By 1542 Guidobaldo II was forced to surrender his rights to the Duchy of Camerino, which passed first to Ottavio Farnese and then in 1545 directly under the rule of the Holy See.

Probably never beautiful, Giulia was called in her own day 'molto cattolica, elemosiniera, letterata', but not 'bella', She died prematurely in 1547 at the age of 23 from a sudden illness, survived by a daughter Virginia, who ultimately became the wife of Federico Borromeo and sister-in-law of S. Carlo Borromeo (Ugolini, 1859, II, pp. 247–250, 286–287; Castellani, 1935, pp. 989–990).

Condition: Face retouched; the landscape through the open window very darkened; possibly damaged by fire.

Documentation: In November 1545 Duchess Giulia Varano of Urbino wrote impatiently to Titian, sending at the same time some sleeves he had asked for, and hoping that he would not delay longer in finishing 'our portraits' (Gronau, 1904, p. 100). Then in February of 1547 one of the courtiers of Urbino furnished Titian a dress of the Duchess, adding that 'a handsomer one would have been sent if he had not wanted one of crimson or pink velvet' (Dennistoun, Hutton edition, 1909, III, p. 391, note).

History: In the Urbino collection in 1623 (Dennistoun, edition 1909, III, p. 488, no. 91); brought from Urbino to Florence by Vittoria della Rovere in 1631 on her engagement to Ferdinand II dei Medici, Inventory, no. 323 (Gronau, 1904, p. 10).

Bibliography: Vasari (1568)-Milanesi, VII, p. 444); C. and C., 1877, II, p. 107 (apparently consider it lost); Gronau, 1904, pp. 10, 21–22 (Titian); Gronau, *Titian*, 1904, p. 292 (Titian); Wilde, 1930, pp. 261–262 (copy by Rubens); *Mostra di Tiziano*, 1935, no. 69 (Titian, 1547); Suida, 1935, pp. 49, 186 (Titian); Tietze, 1936, II, p. 289 (Rubens); Jahn-Rusconi, 1937 (not listed); Mayer, 1937, p. 306 (damaged original); Tietze, 1950, p. 374 (Rubens); Berenson, 1957, p. 185 (partly by Titian, 1547); Valcanover, 1960, II, pp. 53, 64 (copy); *idem*, 1969, no. 595 (copy); Pallucchini, 1969, p. 344, fig. 623 (Rubens or a Flemish copy after Titian).

91. Guidobaldo II della Rovere, Duke of Urbino, and His Son Francesco Maria II
Plate 165

Canvas. 2·00 × 1·143 m.

Anonymous private collector.

About 1552–1553.

The composition of a full-length figure accompanied by a smaller figure has an ample precedent in Titian's work, for instance, *Charles V with Hound* (Cat. no. 20), and *Alfonso d'Avalos and Page* (Cat. no. 9). Yet the figures lack the dignity usually to be expected in the artist's portraits, although the child has a certain charm in the way he tugs at his father's first finger to attract attention. Guidobaldo's black cloak with a reddish tinge is worn over white hose and a white doublet with gold buttons. The boy's long rose-coloured dress with white collar and cuffs is floor-length. In the blue-black armour at the left decorative patterns of gold inlay provide accent and contrast. Of the two batons, one gold and the other black, the latter is furled with a banderole bearing the letters S R E S U R F (Sanctae Romanae Ecclesiae Signifer Urbis Romae Praefectus, i.e. Prefect or Standard Bearer of the Holy Roman Church of the city of Rome). This title refers to the duke's appointment as captain-general of the papacy in January 1553 (Dennistoun, edition 1909, III, pp. 103–104).

Aretino's reference to a portrait of Guidobaldo in a letter of March 1545 (*Lettere*, edition 1957, II, p. 57) obviously cannot apply to the present work, in which the son Francesco Maria II, born 1549, is included. It must be the portrait recorded in Guidobaldo's letters of 1552 (Gronau, 1904, p. 22). The apparent age of the child confirms this belief.

Biography: Guidobaldo II della Rovere (1514–1574), the son of Francesco Maria I (Cat. no. 89) and Eleanora Gonzaga (Cat. no. 87), succeeded as duke of Urbino on the death of his father in 1538. He had married Giulia Varano (Cat. no. 90) in 1534, when she was only ten years old, in order to obtain the duchy of Camerino, thereby thwarting temporarily the plans of the Farnese family. In 1542 Paul III forced him to give up his rights to Camerino, which the pope thereupon bestowed upon his grandson, Ottavio Farnese. On the death of Giulia, who was survived by only one daughter Virginia, in 1547, Guidobaldo quickly swung to the papal camp by marrying Vittoria Farnese (Cat. no. X–35), granddaughter of the pope, a few months later that same year. By Vittoria he had a son Francesco Maria II, his successor, and two daughters, Isabella and Lavinia, while less is known about his two natural daughters (Ugolini, 1859, II, pp. 251, 252, 273, 369). He was made a Knight of the Golden Fleece by Philip II in 1559 (Pauwels, 1962, p. 41).

For Guidobaldo Titian painted the celebrated *Venus of Urbino*, now in the Uffizi at Florence, as well as a number of portraits. During the artist's journey to Rome in September 1545, he stopped at Pesaro to visit the duke, who provided him with an escort for the rest of the trip to the papal court (Wethey, I, 1969, pp. 28–29, and p. 29, note 160).

Condition: Heavily varnished and darkened; repairs in the once-torn canvas visible in Guidobaldo's nose. The figure of the child is better preserved. The black curtain, which serves as background, may have been dark red originally.

History: Said to have belonged to the Malaspina family (Elizabetta della Rovere, sister of Guidobaldo II, to whom the portrait may have been given, married Alberigo I Cybo Malaspina, marquess of Massa and Carrara (see Ugolini, 1859, II, p. 254; Viani, 1808, pp. 32–40); Abbate Celotti, Venice until 1837; Prince Demidoff, Villa at San Donato, Florence, 1837–1870 (Dandolo, 1863, p. 203, illustrated); sale, Paris, 3–4 March 1870, no. 187 (Mireur, 1912, VII, p. 291); Duke of Westminster, 1870–1959 (exhibited London, Grosvener House, 1913, no. 23); Westminster sale (Sotheby's, London, 24 June 1959, no. 17; *APC*, XXXVI, 1959–1960, no. 4914); purchased by the Matthiesen Gallery, London.

Bibliography: See also History; Valcanover, 1960, II, p. 56 (lost); Stockholm, 1962–1963, no. 95 (Titian, 1552); Nicolson, 1963, p. 32 (Titian); Heinemann, 1963, p. 66 (Titian); Valcanover, 1969, no. 348 (lost); Pallucchini, 1969, p. 90 (not Titian).

Guidobaldo II della Rovere, see also: Cat. nos. X–86 and X–87.

92. Fabritius Salvaresio
Plate 199

Canvas. 1·12 × 0·88 m.

Vienna, Kunsthistorisches Museum.

Inscribed (not signed) on the tablet at the left: MDLVIII FABRICIVS SALVARESIVS ANNVM AGENS L. TITIANI OPVS

1558.

Here again Titian employed a favourite arrangement in the introduction of a subordinate figure, in this case a Negro page, who offers flowers to Salvaresio. The high chest in the background also appears in somewhat different form in the famous portrait of Jacopo Strada at Vienna (Cat. no. 100) and the one of Vincenzo Cappello in Washington (Cat. no. 17).

Biography: Nothing is known of Salvaresio beyond what is given in the inscription on his portrait, that he was fifty years old in 1558.

Condition: Cut down considerably at the lower edge and to the right; recent tests have shown that the picture is not extensively overpainted, contrary to former belief.

History: Archduke Leopold Wilhelm, Vienna, 1659, Inventory no. 32; Stallburg (Storffer, 1720, I, p. 265).

Bibliography: Teniers, 1660, pl. 89; Stampart, 1735, pl. 8; Mechel, 1784, p. 26, no. 41; C. and C., 1877, II, pp. 266–267 (wrongly state that the Negro slave is missing in the print); Engerth, 1884, p. 369, no. 520; Gronau, *Titian*, 1904, p. 275 (Titian, damaged); Suida, 1935, pp. 79, 113, 174; Tietze, 1936, II, p. 317 (Titian); Berenson, 1957, p. 191 (Titian, 1558); Valcanover, 1960, II, pls. 92, 93; Klauner and Oberhammer, 1960, p. 143, no. 721; Valcanover, 1969, no. 397 (Titian, 1558); Pallucchini, 1969, pp. 138, 176, 306, fig. 424 (Titian, 1558).

93. **Jacopo Sannazzaro** (so-called) Plate 19
Canvas. 0·84×0·71 m.
Hampton Court Palace, Royal Collection.
About 1512.

This most handsomely portrayed young man recalls in clarity and directness the central figure of *The Concert* (Plate 8). The head and shoulders are silhouetted against the blue-green background while the black costume with a brown fur collar is given contrast by the white shirt, the dark green table, and the red book in the right hand. An unacceptable identification of the sitter was suggested by Collins Baker (1929, p. 143, no. 149), who put forward the name of Jacopo Sannazzaro (1458–1530), the celebrated Neapolitan poet, author of the *Arcadia* (1504), a man over fifty at the time Titian painted this work. Another quite absurd identification of this elegant young intellectual has been Alessandro dei Medici, Duke of Florence. This bastard mulatto son of Lorenzo dei Medici (1492–1519), notorious as a vicious libertine, who was married in 1536 to Margaret, natural daughter of Emperor Charles V and was murdered in 1537, is clearly not the young intellectual seen here. The statement of Crowe and Cavalcaselle that the picture was engraved by Pieter de Jode as Giovanni Boccaccio is an outright error, which others followed, until it was rectified by Denis Mahon (1950, pp. 12–13).

Condition: Very darkened and heavily varnished.

History: Reynst Collection, Amsterdam (Jacobs, 1925, p. 31, no. 134); Dutch gift to Charles II; James II, catalogue no. 440, as Giorgione (Mahon, 1950, p. 12).

Bibliography: See also above, C. and C., 1877, II, p. 465 (they state that it was wrongly identified as Alessandro dei Medici and in too bad condition to judge); Gronau, *Titian*, 1904, pp. 43, 279 (Titian, *c.* 1511); Fischel, 1924, p. 23 (Titian, *c.* 1511); Collins Baker, 1929, p. 143, no. 149 (Titian); Suida, 1935, pp. 33, 157 (early Titian); Mahon, 1950, p. 12 (Titian); Pallucchini, 1953, I, p. 145 (Titian, *c.* 1518–1520); Berenson, 1957, p. 186 (early Titian); Valcanover, 1960, I, pl. 87 (Titian, *c.* 1518–1520); Waterhouse, 1960, p. 23, no. 20 (Titian, *c.* 1511–1512); Valcanover, 1969, no. 94 (commonly attributed, 1518–1520); Pallucchini, 1969, p. 254, figs. 134–135 (Titian, 1518–1520).

94. **Francesco Savorgnan della Torre** Plate 98
Canvas. 1·232×0·965 m.
Kingston Lacy, H. J. Ralph Bankes.
About 1545.

The large scale of the figure in relation to the picture space clearly places this work *c.* 1540–1545 contemporary with the likeness of *Cardinal Pietro Bembo* in Washington (Plate 90) and the slightly later portraits of *Pietro Aretino* (Plates 96, 99). The earliest appearance of this powerful Mannerist style was in the series of *Roman Emperors* painted for the Duke of Mantua in 1536–1538 (see Volume I, pp. 23–25). The Bankes canvas, which has been seen by relatively few scholars, ranks among Titian's masterpieces and is considered further in the text (see p. 27).

Biography: Francesco Savorgnan della Torre (1496–1547), a Venetian patrician and member of the Maggior Consiglio, appears to be the reasonable candidate for the person here represented. The former proposal that the sitter was Girolamo Savorgnan, a military leader who died in 1529, has been abandoned (Fabbro, 1952, p. 186).

Condition: Small paint losses and scars on the canvas which apparently have never been repaired.

Probable History: Palazzo Savorgnan del Torre at San Geremia, Venice, until 1810; sold to Marescalchi of Bologna (Fabbro, 1952, pp. 185–186).
Certain History: Palazzo Marescalchi, Bologna; purchased by Henry Bankes about 1820.

Bibliography: Waagen, 1857, p. 378 (Titian); C. and C.,

1877, II, pp. 20–21 (Titian; probably not Girolamo Savorgnan, died 1529); Suida, 1935, p. 85 (Titian, *c.* 1540); Tietze, 1936 and 1950 (omitted!); Fabbro, 1952, pp. 186–187 (Titian; the major article); Berenson, 1957, p. 186 (Titian); Valcanover, 1960, I, pl. 160B (Titian); Waterhouse, 1960, pp. 43–44, no. 83 (Titian); Valcanover, 1969, no. 280 (commonly attributed, 1543–1547); Pallucchini, 1969, p. 281, fig. 289 (Titian, *c.* 1545).

95. La Schiavona Plates 13–16

Canvas. 1·194×0·965 m.

London, National Gallery.

Signed on the parapet: T V

About 1511–1512.

Upon the grey marble parapet with bluish and reddish veins, the initials T V appear at the left. There can be no doubt of the fact that the letters are Titian's monogram (Titianus Vecellius). The lady's dress is plum-coloured, her sleeves lined in white, and her belt dark greenish-blue. The medium-grey veil over her hair has gold stripes, which are repeated in the necklace of gold thread.

That the profile portrait of the same lady on the parapet at the right reflects Titian's knowledge of antique reliefs and coins has been suggested by Dr. Otto Brendel with every degree of plausibility (Brendel, 1955, p. 116). As frequently observed, this profile with double chin closely resembles the mother in the Paduan fresco of the *Miracle of the Speaking Infant* (Wethey, I, Plates 139, 140). Sir Herbert Cook's theory that the London picture represents Catherine Cornaro, whose portrait by Giorgione Vasari records in the house of Giovanni Cornaro (Vasari (1568)-Milanesi, IV, p. 99), has been abandoned as there is no resemblance to the lady's features. Moreover, Catherine Cornaro died in 1510 at the age of fifty-six, much older than the very plump Mediterranean woman under consideration. The earliest mention of the subject as La Schiavona (the Slavonian woman) occurs in a letter of 1641 (Gould, 1959, p. 122), where the picture is identified as the work of Titian, whose authorship is now unanimously accepted.

Condition: X-rays reveal that the square parapet was not in the artist's first scheme but perhaps a subordinate figure such as a page. Further, an elliptical opening with sky and clouds visible was first planned and then overpainted (Plate 13) (Gould, 1961, pp. 335–340).

History: Count Alessandro Martinengo and descendants, Brescia, before 1640 to 1817 or later; Martinengo family, Brescia (Sala engraving as there in 1817); Francesco Riccardi, a Martinengo relative, Bergamo, in 1877 (Bonomi, 1866;

C. and C., 1877, II, p. 58, note); Crespi Collection, Milan, 1900–1911/12); H. L. Cook, Richmond (England), 1914–1942; gift to the National Gallery by his son in 1944 in memory of his father.

Bibliography: See also above; C. and C., 1877, II, p. 58, note (probably early Titian); Bonomi, 1886 (Titian); Berenson, 1897, pp. 278–281; *idem*, 1901, edition 1930, pp. 84–85 (copy of Giorgione); A. Venturi, 1900, p. 133 (Licinio); Malaguzzi, 1901–1902, pp. 41–43 (Titian); Gronau, *Titian*, 1904, p. 293; *idem*, 1908, pp. 512–513 (early Titian); Cook, 1907, pp. 74–81 (Catherine Cornaro by Giorgione); Holmes, 1914–1915, pp. 15–16 (Titian); Wilde, 1934, p. 211 (Giorgione); Suida, 1935, pp. 15, 155 (early Titian); Richter, 1937, p. 236 (Giorgione, finished by Titian); Berenson, 1957, I, p. 187 (early Titian); Gould, 1959, pp. 120–123 (full account); *idem*, 1961, pp. 335–340 (Titian alone; detailed analysis); Valcanover, 1960, I, pl. 33 (early Titian); Pope-Hennessy, 1966, p. 138 (Titian); Valcanover, 1969, no. 17 (Titian, 1510); Pallucchini, 1969, p. 238, figs. 50–51 (Titian, *c.* 1511).

96. Scholar with a Black Beard Plate 160

Canvas. 1·135×0·935 m.

Copenhagen, Royal Museum of Fine Arts.

About 1550.

The gesture of the right hand, as though addressing an audience, is usually associated with a portrait of a scholar. It occurs in Titian's *Cardinal Bembo* at Washington (Cat. no. 15) and in El Greco's presumed *Giovanni Battista Porta* at Copenhagen (Wethey, 1962, fig. 32). The general presentation of the figure in three-quarter length and filling the picture space belongs to the same category as Titian's portrait (Plate 96) of Pietro Aretino (1545). Harald Olsen proposed a possible identification of the sitter with Apollonio Massa, whose bust by Vittoria is in the Seminario Patriarcale at Venice. The attribution to Titian is widely accepted, yet some reservations, because of the stilted effect of the sitter, are inevitable.

Condition: Extensive paint losses in the left background; darkened and heavily varnished throughout; the beard is scrubbed.

History: Purchased from the van Dieman Gallery, Berlin, 1926.

Bibliography: See also above; Madsen, 1926, pp. 133–139; *Apollo*, V, 1927, pp. 8–10; *Mostra di Tiziano*, 1935, no. 92 (Titian. *c.* 1560); Norris, 1935, p. 131, no. 92 (a great

portrait by Titian); Suida, 1935, pp. 114, 182 (Titian); Tietze, 1936, II, p. 291 (Titian, *c.* 1565); *idem*, 1950, p. 376 (not Titian); Copenhagen, 1951, no. 711 (Titian); Berenson, 1957, p. 184 (Titian); Valcanover, 1960, II, p. 68 (doubtful attribution); Olsen, 1961, p. 94 (Palma il Giovane or Giuseppe Salviati); Valcanover, 1969, no. 373 (Titian); Pallucchini, 1969, p. 306, fig. 425 (Titian, *c.* 1555–1560).

97. **Sixtus IV** Plate 124

Canvas. 1·10×0·90 m.
Florence, Uffizi (in storage).
Titian and workshop.
About 1545.

The extraordinary power and breadth of conception in this imposing work are surely worthy of Titian, after the manner of a state portrait such as Sebastiano del Piombo's *Clement VII* in the gallery at Naples. One theory holds that Titian painted the picture in Rome and based it on Melozzo da Forlì's fresco now in the Vatican gallery (C. and C., 1878, Italian edition, II, p. 418). Another reasonable suggestion is that Titian's workshop supplied it as a companion piece to Titian's copy of Raphael's *Julius II* (Cat. no. 55), both of them having been in Urbino (see below).

Biography: Francesco della Rovere (1414–1484), a Franciscan, studied at Bologna, and rose to the top of the Franciscan hierarchy before being made cardinal in 1467. His reign as pope (1471–1484) was marked by constant political intrigues and wars. Allied first with the Sforza at Milan and the Spanish dynasty at Naples, he conspired with the Pazzi at Florence to overthrow Lorenzo dei Medici (1478), upon the failure of which he excommunicated Lorenzo and placed all Florence under an interdict (1478–1480). His interest in and his protection of the humanists of Rome, his construction of the Sistine chapel, and his patronage of the painter Melozzo da Forlì to a certain degree redeem a sordidly political regime.

Condition: Poorly preserved.

History: In the *guardaroba* at Urbino as Titian (Vasari (1568)-Milanesi, VII, p. 444); brought to Florence in 1631 by Vittoria della Rovere on her engagement to Archduke Ferdinand II dei Medici of Tuscany, the picture listed as author unknown (Gronau, 1904, p. 12).

Bibliography: See also above; C. and C., 1878, II, p. 418 (Titian); Gronau, 1904, p. 12 (workshop of Titian); Burchard, 1925, pp. 121–125 (Titian); Florence, Uffizi, 1927, p. 91, no. 744 (school of Titian); Fischel, 1924, p. 133 (Titian);

Suida, 1935, pp. 82, 171 (Titian); Tietze, 1936, II, p. 290 (Titian); Berenson, 1957, p. 185 (partly by Titian); Valcanover, 1969, no. 213 (not Titian); Pallucchini, 1969, p. 275, fig. 253 (workshop of Titian).

98a. **Sperone Speroni** Plate 104

Canvas. 1·00×0·785 m.
Treviso, Museo Civico.
Workshop of Titian.
1544.

The testament of Speroni, dated 1569 states that Titian had painted his portrait twenty-five years earlier, a fact which establishes the date of 1544. The inscription at the upper right gives his age in the same year: 'Aet Suae An xxxxIIII'. In spite of the excellent documentation of this portrait, the stiff, lifeless figure does not measure up to Titian's standards. Dressed in black with a grey fur collar, Speroni rests his arm on a green ledge and holds a golden clock in his right hand. His whole figure is silhouetted against a reddish-black background.

Biography: Sperone Speroni (1500–1588), writer and humanist influenced by Pietro Bembo, held the chair of logic in the University of Padua from 1528. He was widely known among the intellectuals, princes, and ecclesiastics of his day. His published dialogues included *Della Retoria, Dell'amore, Della dignità delle donne*, and *Delle lingue* (Guerrieri-Crocetti, 1936, p. 343; Fano, 1909).

Condition: Satisfactory.

Probable History: Giulia Speroni (daughter of Sperone); her son Ingolfo Conti; Canon Sperone Conti (Ridolfi (1648)-Hadeln, I, p. 192); Annibale Capodilista (Fiocco, 1954, p. 309); private collection, Venice (as Paris Bordone); Maineri Collection; acquired by the museum in 1954.

Bibliography: See also above; C. and C., 1877, II, p. 107 (lost); Fuchs, 1928–1929, pp. 621–633 (Titian); Fiocco, 1954, pp. 306–310 (Titian); Berenson, 1957, p. 190 (studio); Valcanover, 1960, I, pl. 165B (Titian); Menegazzi, 1964, pp. 299–302 (Titian, 1544); Valcanover, 1969, no. 244 (Titian, 1544); Pallucchini, 1969, p. 280 (Titian?, 1544).

98b. **Sperone Speroni, device of Lion and Cupid**

Canvas. 0·93×1·13 m.
Madrid, Alba Collection.
Venetian School.
About 1544.

The identification of the device of Sperone Speroni, consisting of a recumbent lion and a cupid, was made by means of the medal of Speroni by Francesco Segala, on the back of which the identical composition occurs (Fuchs, 1928–1929, p. 629). A smaller picture (0·64×0·82 m.) in a private collection at Trieste was originally proposed as the cover for Speroni's portrait (Fuchs, 1928–1929, pp. 621–633), but subsequently Fiocco demonstrated that the larger canvas in the Alba Collection corresponds approximately to the dimensions of the portrait and that the smaller example is a replica, which he describes as in the style of Padovanino.

The quality of neither version reveals Titian's own hand, as is indeed the case for the portrait itself. The cover and the copy of it may well be the handiwork of painters unconnected with Titian's workshop.

History: Purchased by the Duke of Alba in Venice in 1814 as Titian (Barcia, 1911, p. 133, no. 141).

Bibliography: Barcia, 1911, p. 133, no. 141 (Titian); Fuchs, 1928–1929, pp. 621–633 (Treviso version as Titian); Fiocco, 1954, pp. 306–310 (Alba picture as workshop of Titian).

99. Irene di Spilembergo (bust length) Plate 190

Canvas. 0·57×0·47 m.

New York, Private collection.

About 1559.

The theory that this study by Titian was made in preparation for the full-length portrait of Irene di Spilembergo by Pace and Titian in Washington (Cat. no. X–89) seems logical. On the other hand, Tietze and Tietze-Conrat preferred to consider the lady to be Giulia da Ponte, the mother of Irene, and thus to explain the close resemblance and the identical costumes in the two works. A document of 1540 indicates that Titian did paint the likeness of Giulia in that year (Muraro, 1949, pp. 87–88). Nevertheless, the distance of twenty years in date and the identity of features and costume in the two pictures make the Tietze theory difficult to accept.

History: Sedelmeyer, Paris; Quincy Shaw, Boston; Mrs. Graevne Haughton, c. 1948–1953; L. D. Peterkin, Andover; Steven Juvelis, Lynn (Massachusetts) (sale, London, Christie's, 30 June 1961; *APC*, xxxviii, 1960–1961, no. 5986).

Bibliography: L. Venturi, orally (Titian); Tietze and Tietze-Conrat, 1953, pp. 104–107 (portrait of Giulia da Ponte, by Titian, 1540); Pallucchini, 1969 (not listed); Valcanover, 1969, no. 583 (near Cesare Vecellio).

100. Jacopo Strada Plates 206, 207

Canvas. 1·25×0·95 m.

Vienna, Kunsthistorisches Museum.

Signed at the upper left: TITIANVS F

Documented 1567–1568.

For a discussion of the style and the subject matter of this painting, see the text, pages 48–49.

Condition: Somewhat darkened and dirty. The cartouche is a later addition.

Dating and the cartouche: The cartouche and its inscription at the upper right are clearly additions of the late sixteenth or early seventeenth century because of the late nature of the design. They appear in the print published by Teniers in 1660, pl. 92. The partly erroneous inscription, which has been restored, reads: JACOBVS DE STRADA CIVIS ROMANVS CAESS. ANTIQVARIVS ET COM. BELIC. AN: AETAT: LI: et C M.D. LXVI [Jacopo Strada, Citizen of Rome, Imperial Antiquarian, Minister of War, age 51, and year of Christ 1566]. Strada was never minister of war and the date 1566 is likewise wrong, since it is known that Strada was not in Venice at that time. Letters of Niccolò Stoppio to Johann Jacob Fugger refer to the portrait and place it definitely in the years 1567–1568, at the time Strada went to Venice with special permission of Emperor Maximilian II to negotiate the purchase of Gabriele Vendramin's antiques for Albrecht V of Bavaria (Zimmermann, 1901, pp. 849–854; Ravà, 1920, p. 180).

Biography: Born in Mantua of a Netherlandish family, Jacopo Strada (1515?–1588) became one of the most remarkably many-sided men of the whole sixteenth century: draughtsman, painter, goldsmith, scholar, architect, art collector, and antiquarian. He began collecting antique coins in his youth, and ultimately in the late 1550's he produced a two-volume work entitled *De consularibus numismatibus*. Toward the end of the fifteen-forties he left Italy for the north, journeying first to Augsburg, where he seems to have lived and studied in the house of Johann Jacob Fugger. Subsequently he visited Paris and Lyon, and associated with famous sixteenth-century scholars and collectors. In the early 1550's he acquired from Serlio himself the text and plates of the *Seventh Book of Architecture*. His own antiquarian masterwork on the Roman emperors, *Epitome thesauri antiquitatum hoc est imperatorum orientalium et occidentalium ex museo Jacobi de Strada Mantuano*, appeared at Lyon in 1553, and in the following year he was called to Rome to the service of Julius III, remaining there through the succeeding brief pontificate of Marcellus II. No doubt

it was at this time that he received the title 'Civis Romanus'. Strada's private library, extraordinary for that period, is said to have consisted of more than three thousand volumes in thirteen languages including Chaldean and Egyptian. Strada was working in Nürnberg as a goldsmith and painter for the Fuggers, when he succeeded in bringing himself to the attention of Archduke Ferdinand of Austria, brother of Emperor Charles V, and from 1557 his life was spent chiefly in the service of the Hapsburg emperors, Ferdinand I, Maximilian II, and Rudolf II. As imperial antiquarian he bought for them paintings and sculptures, jewels and other objects, as well as books (Stockbauer, 1874, pp. 53–69; Zimmermann, 1901, pp. 830–857; Schulz, 1938, pp. 145–147; Lhotsky, 1941–1945, pp. 160–163, 290–292; Verheyen, 1967, pp. 62–70).

History: Archduke Leopold Wilhelm, Vienna, Inventory 1659, no. 7 (Berger, 1883, p. LXXXVI); in all the imperial Inventories from that time; taken to the Belvedere Palace, Vienna, in 1780.

Bibliography: See also above; Vasari and Ridolfi (no mention); Teniers, 1660, pl. 92 (Titian); Stampart, 1735, pl. 20; Mechel, 1783, p. 21, no. 18; C. and C., 1877, II, pp. 369–371 (Titian); Engerth, 1884, pp. 370–372 (thorough account); Gronau, *Titian*, 1904, p. 277 (Titian, 1568); Suida, 1935, pp. 114, 181 (Titian, 1568); *Mostra di Tiziano*, 1935, no. 91 (Titian, 1567); Tietze, 1936, II, p. 317 (Titian, 1567–1568); Berenson, 1957, p. 192 (Titian, 1566); Klauner and Oberhammer, 1960, p. 145, no. 724 (Titian, 1567–1568); Valcanover, 1960, II, pls. 122–123 (Titian, 1567–1568); Pope-Hennessy, 1966, pp. 145–147 (Titian); Valcanover, 1969, no. 488 (Titian, 1567–1568); Pallucchini, 1969, p. 322, figs. 510–511; colour plate LVI (Titian, 1567–1568); Panofsky, 1969, pp. 80–81 (Titian, assisted by Emanuel Amberger).

101. **Clarice Strozzi** Plates 106–108, 110

Canvas. 1·15×0·98 m. Colour Plate

Berlin-Dahlem, Staatliche Gemäldegalerie.

Signed in capitals on the edge of the table: TITIANVS F

Dated on the tablet at the upper left in letters now virtually invisible: ANNOR II MDXLII.

In this portrait of a two-year old child feeding a biscuit to her dog, Titian achieved one of his most completely charming interpretations. The curly-haired blonde Clarice in a white dress wears pearls at the throat and wrist and a girdle of white, red, and green stones. The setting consists of a dark-green curtain, a reddish floor, wine-red drapery on the table, and through the open window a landscape of thick green trees with a solid blue sky above it. Two cupids playing on a sculptured frieze upon the table add a spirited note. The date of the picture is confirmed by Aretino's description of it in a letter dated 6 July 1542 (*Lettere*, edition 1957, I, p. 217).

Biography: Clarice Strozzi (1540–1581), aged two in this portrait, was daughter of Roberto Strozzi and Maddalena dei Medici and granddaughter of Clarice dei Medici. Her parents lived in exile at Venice from 1536–1542, but were in Rome in 1544. At the age of fifteen the girl's marriage to Cristofano Savelli of the noble Roman family was celebrated in the famous Villa at Bagnaia near Viterbo. She died on 11 March 1581 (biography reconstructed by Gronau, 1906).

Condition: Although slightly crackled, the paint is unusually well preserved.

History: Palazzo Strozzi, Rome, until the nineteenth century; shown in an exhibition in 1641 in S. Giovanni Decollato, Rome; bought in 1878 by the Berlin museum from the Strozzi palace, Florence (Gronau, 1906).

Bibliography: See also above; C. and C., 1877, II, pp. 67–68 (Titian); Gronau, 1906, pp. 7–12 (major account); Posse, Berlin, 1909, p. 171, no. 160A; Kühnel-Kunze, 1931, p. 483, no. 160A (Titian); Suida, 1935, pp. 86, 170 (Titian); Tietze, 1936, II, p. 284 (Titian); Berenson, 1957, p. 184 (Titian); Valcanover, 1960, I, pl. 166 (Titian); *idem*, 1969, no. 223 (Titian); Kühnel-Kunze, 1963, p. 111; Pallucchini, 1969, p. 277, fig. 266 (Titian, 1542).

COPY:

New York, Private Collection; canvas, 1·16×0·95 m. This excellent copy of the Berlin portrait follows the original by Titian very closely, although it differs markedly in the details of the landscape and lacks Titian's signature. The child and dog are accurately reproduced, but the red drapery at the right upon the table and the frieze of cherubs are more summarily painted. The dimensions of this picture are close to those of Lost Copies, no. 2 (see below).

LOST COPIES:

1. Florence, Lorenzo Magalotti, in 1707, copy by Antonio Lesma. Letters of Magalotti to Lorenzo Strozzi, 1706–1707 (Bottari, v, pp. 323–330; Gronau, 1906, pp. 11–12).
2. Paris, Duc de Choiseul; 45×33 *pouces* (about 1·14× 0·84 m.), sale, Paris, 1772 (Mireur, 1912, VII, p. 289; also Blanc, 1857, I, p. 198). The same picture was called 'Charles V in Infancy' when in the Choiseul Collection and that of the Prince de Conti in 1777 (Blanc, I, p. 375).

102. **Filippo Strozzi** (incorrectly called) Plate 200
Canvas. 1·15×0·89 m.
Vienna, Kunsthistorisches Museum.
Titian (?).
About 1560.

The black costume lined with lynx fur appears contemporary with Salvaresio's portrait of 1558 (Plate 199). Even considering its damaged condition, this work does not measure up to Titian's best, and the attribution to him must be regarded as hypothetical.

Biography: That Filippo Strozzi (1488–1538) is the man seen in this portrait, a suggestion first made by Storffer in 1720, is most improbable because he belonged to an earlier generation. Filippo was born in Florence, married Clarice dei Medici, and lived a somewhat turbulent life caught between numerous rival factions, the pope, Emperor Charles V, and Florentine politicians. He visited Venice in 1536, when Titian might have painted him, but he died in prison in the castle at Florence two years later (Niccolini, 1847).

Condition: Paint losses in the face; considerable crackle.

History: Archduke Leopold Wilhelm, Vienna, 1659, no. 5 (as by Tintoretto); Stallburg (Storffer, 1720, I, p. 269).

Bibliography: Teniers, 1660, pl. 95 (Titian); Mechel, 1784, p. 26, no. 40 (Filippo Strozzi, by Titian); C. and C., 1877, II, p. 426 (Titian, overpainted); Engerth, 1884, p. 364, no. 513 (Titian); Fischel, 1924, pl. 102 (Titian, 1540); Mayer, 1924, p. 185 (Titian, 1550); Suida, 1935, pp. 86, 171 (Titian, 1540); Tietze, 1936, II, p. 316 (Titian, 1540); Berenson, 1957, p. 191 (Titian; F. Strozzi died 1538); Valcanover, 1960, II, p. 68 (doubtful attribution); Klauner and Oberhammer, 1960, p. 143, no. 722 (Titian, *c.* 1560–1565); Valcanover, 1969, no. 339 (attributed); Pallucchini, 1969, p. 297, fig. 371 (Titian, *c.* 1550–1552).

COPY:
London, Count Seilern; panel, 0·224×0·17 m.; by David Teniers the Younger (Seilern, 1969, p. 29, pl. XIX).

103. **Gabriele Tadino** Plate 85
Canvas. 1·18×1·08 m.
Winterthur (Switzerland), Dr. Robert Bühler.
Titian (?).
1538.

Inscribed: GABRIEL TADINVS EQVES HIER^NVS PRIOR BAR^VLI CES. TOR^VM PREF^VS GEN^TIS MDXXXVIII.

The formula used for the composition is the same in the portrait of *Eleanora Gonzaga della Rovere* (Plate 70), but the details in Cat. no. 103 are unusually hard for Titian.

Biography: Gabriele Tadino (1480–1544) was a Venetian general, born in Martinengo. After studying medicine and military architecture, he entered the service of Venice in the war of the League of Cambrai. In 1522 he was one of the defenders of Rhodes against the Turks, where he was wounded. For a time he served under Charles V and became a great expert in artillery, reference to which is seen in the cannons in the landscape background of his portrait (*Dizionario enciclopedico italiano*, XI, 1960, p. 893).

Condition: Recently cleaned.

History: Conte Aldafrede; von Heyl Collection, Darmstadt (sale, Munich, Helbing, 28–29 October 1930, no. 143, as Titian); L. Bendit, New York.

Bibliography: See also History; Mayer, 1930, p. 482 (Titian); Suida, 1935, p. 172, pl. 187 (Titian); Tietze, 1950, p. 390 (Titian); Pallucchini, 1953, I, p. 179 (Titian); Berenson, 1957 (omitted); Valcanover, 1960, I, pl. 146B (Titian); Morassi, 1967, p. 139 (Titian); Valcanover, 1969, no. 189 (Titian, 1538); Pallucchini, 1969, p. 273, fig. 245 (Titian, 1538?).

RELATED PORTRAIT:
Lovere, Accademia Tadini; profile of Gabriele Tadini. *Bibliography:* C. and C., 1877, II, p. 437 (totally repainted; they believed it possibly by Titian); Lovere, 1929, no. 362 (Titian?).

Titian's Father, see: Gregorio Vecellio, Cat. no. 109.

Titian's Friend, see: Friend of Titian, Cat. no. 39.

104. **Titian's Self-Portrait** Plates 209, 213
Canvas. 0·96×0·75 m.
Berlin-Dahlem, Staatliche Gemäldegalerie.
About 1550.

In the psychological projection and the pictorial organization this *Self-Portrait* ranks among the artist's greatest. Of the numerous portraits of Titian only this and the profile in the Prado Museum are by the artist's own hand. The red-gold chain about his neck is the insignia of his knighthood, bestowed by Charles V in 1533. White

sleeves with brownish shadows against a black coat trimmed and lined with dark-brown fur, a black cap, together with a table of pale neutral green and a dark-green background constitute the principal elements. The hands and the sleeves appear surely to be unfinished and possibly also the beard.

Condition: Unfinished but well preserved.

Dating: See page 49 and note 178.

History: Casa Barbarigo a San Raffaele, Venice, in 1814; purchased from Barbarigo by Cicognara in 1814 and sold to Edward Solly of Berlin in 1816 (Malamani, 1888, II, pp. 112–114, 132–133); purchased by the Berlin Museum in 1821.

Bibliography: See also above; C. and C., 1877. II, pp. 60–62 (Titian); Bode, 1904, p. 396, no. 163 (Titian); Gronau, *Titian,* 1904, p. 286 (Titian, 1550); *idem,* 1907, pp. 45–49 (Titian, *c.* 1550); Posse, 1909, I, p. 173, no. 163 (Titian, *c.* 1550); Fischel, 1924, frontispiece (Titian, 1550); Kühnel-Kunze, 1931, p. 484 (Titian); Foscari, 1933, p. 248 (Titian, *c.* 1550); *idem,* 1935, pp. 16–18 (datable 1560); Suida, 1935, pp. 113, 181 (Titian 1562); Tietze, 1936, II, p. 284 (*c.* 1550); Berenson, 1957, p. 184 (Titian, late); Kühnel-Kunze, 1963, p. 112, no. 163 (Titian, *c.* 1560); Valcanover, 1960, II, pl. 98; *idem,* 1969, no. 443 (Titian, *c.* 1562); Pallucchini, 1969, p. 313, fig. 466 (Titian, *c.* 1562); Panofsky, 1969, p. 8 (Titian, *c.* 1550–1560).

ENGRAVINGS:
1. *Titian's Self-Portrait* (bust-length) (Plate 208); signed on the tablet held by the artist: 'In Venetia per Giovanni Brito intagliatore'; datable 1550. After a drawing or painting by Titian; mentioned in a letter and sonnet written by Pietro Aretino in July 1550. *Bibliography:* Aretino, *Lettere,* edition 1957, II, pp. 340–341; Mauroner, 1941, pp. 41–42, frontispiece; Foscari, 1935, fig. 40.
2. *Titian's Self-Portrait* (bust-length); 240×180 mm., signed by Agostino Carracci and dated 1587; Bologna, Pinacoteca Nazionale. Titian's age appears comparable to that of the Berlin portrait, but details of costume are not identical with any preserved version (Calvesi, 1965, no. 129). Plate 274

105. **Titian's Self-Portrait** Plate 1
Canvas. 0·86×0·65 m.
Madrid, Prado Museum.
About 1565–1570.

The half-length figure in profile, dressed in black, with a painter's brush in his right hand, is presented in a most sympathetic and completely unselfconscious manner. The colours, limited to a range of blacks and greys, are softly applied, most notably in the head.

Condition: Colours have darkened, particularly in the costume, in which some repairs in the canvas are detectable; cut down; cleaned in 1966.

Dating: It has been suggested that this *Self-portrait* is the one that Vasari saw in Titian's house in 1566, which the Florentine said had been finished four years earlier (Vasari (1568)-Milanesi, VII, p. 458; Allende-Salazar and Sánchez Cantón, 1919, pp. 80–81).

History: Probably from Rubens' collection, Inventory 1640, no. 4 (Rubens' Inventory: Lacroix, 1855, p. 270); apparently among the pictures purchased by Philip IV from Rubens' estate; Alcázar, Madrid, Inventory of 1666, no. 643, $1\frac{1}{2} \times \frac{3}{4}$ *varas* (1·25×0·626 m.), in Pasillo del Mediodía, 50 *ducados*; Inventory of 1686, no. 195, in Pasillo que llaman de la Madona (Bottineau, 1958, p. 147); Inventory of 1700, no. 44; Inventory 1734, not identifiable; New Palace, 1776, Cuarto del Rey (Ponz, 1776, tomo VI, Del Alcázar, 31); 1794 in the dining room; Prado Museum, 1821 (Beroqui, 1946, p. 171).

Bibliography: See also above; 'Inventario general', 1857, p. 138, no. 695; C. and C., 1877, II, pp. 62–63; Allende-Salazar and Sánchez Cantón, 1919, pp. 80–81 (Titian, from Rubens' estate); Fischel, 1924, p. 241 (*c.* 1570); Foscari, 1935, p. 18 (wrongly suggests that it was painted for Philip II); Suida, 1935, pp. 113, 155 (after 1570); Tietze, 1936, II, p. 299 (*c.* 1562); Beroqui, 1946, pp. 171–172 (Titian, late); Pallucchini, 1954, II, p. 139 (*c.* 1570); Berenson, 1957, p. 187 (Titian, late); Valcanover, 1960, II, pl. 128 (Titian, late); Prado catalogue, 1963, no. 407 (Titian, late); Valcanover, 1969, no. 476 (Titian, late); Pallucchini, 1969, p. 323, figs. 516–517 (Titian, 1568–1570).

Titian's Self-Portrait, see also: Cat. nos. X–92 to X–102 and Cat. nos. L–29 to L–33

106. **Titian's Self-Portrait (?)** Plate 210
Black ink on blue paper. 265×200 m.
Florence, Uffizi, Gabinetto delle Stampe e dei Disegni, no. 1661E.
About 1565.

The boldness of conception and freedom of handling of the pen suggest Titian in his late years. The seated elderly

man supports a large book on his right knee and in his raised left hand holds an object which appears to be a statuette of a woman, although it has been interpreted as a falcon. A wall behind the man ends at the left where a distant landscape is suggested. On the back of the sheet the same man is sketched in a relaxed seated position. This part of the drawing weakens the theory that the sheet represents a Self-Portrait of Titian, any resemblance to whose features is altogether hypothetical. The long golden chain, which is freely sketched over the chest, is one of the principal implications of a Self-Portrait, since the artist wears that kind of jewellery in the Berlin picture (Cat. no. 104, Plate 209).

Condition: The paper is torn and has some holes; water stained at the left.

Bibliography: Ferri, 1890, p. 255, no. 1661 (seated man by Titian); Hadeln, 1924, p. 48, pl. 15 (Titian; reverse drawing by another hand); Frölich-Bum, 1928, p. 195, note 51 (not Titian); Foscari, 1935, pp. 24–25, pl. 12 (Titian, Self-Portrait); Degenhart, 1937, pp. 277, 283, (Titian); Tietze and Tietze-Conrat, 1944, p. 315, no. A1903 (not Venetian and not sixteenth century); Pallucchini, 1969 (omitted).

107. **Titian's Self-Portrait with Orazio and Marco Vecellio** Plates 211, 212

(Allegory of Prudence).

Canvas. 0·756×0·686 m.

London, National Gallery.

About 1570.

See the text, p. 50, for a discussion of the style and colour of this picture.

Iconography: Inscribed at the top: EX PRAETERITO (From the past) over the head of the elderly Titian at the left; PRAESENS PRUDENTER AGIT (The present acts prudently) over the central head; NI FUTURĀ ACTIONĒ DE TURPET (Lest it spoil future action) over the young Marco Vecellio at the right. In Panofsky's brilliant analysis of the iconography of this picture he points out that the position of the inscriptions refers clearly to Old Age, Maturity, and Youth as represented by the three heads and that the entire picture is an *Allegory of Prudence*. The classical tradition of this symbolism was maintained by mediaeval Christianity, the major source being the pseudo-Seneca's *Liber de moribus*, the true author of which was a Spanish bishop, Martin of Bracara.

The convention of three heads united is fairly wide-spread

in western culture as a symbol of Prudence. The three animals, wolf, lion, and dog, first associated with the Egyptian god Serapis, are explained as the symbols of time, i.e. the past, present, and future, in Macrobius' *Saturnalia* c. 399–422 (Panofsky, 1955, p. 153; also Seznec, 1953, pp. 119–121). This device was revived by Petrarch in 1338 in his third canto of *Africa*.

Surely Titian became familiar with the tradition of the three human heads on a herm and the three animal heads on a standard in the woodcuts of the book *Hypnerotomachia Polyphili*, published by Aldus at Venice in 1499, a fact noted by Panofsky and repeated by Madlyn Kahr (1966, pp. 125–126). The probable direct source of Titian's adoption of the three animal heads originally associated with the Egyptian god Serapis (again established by Panofsky) was Giovanni Pierio Valeriano's *Hieroglyphica* published in 1556. Thus Titian combined two traditional symbols representing past, present, and future in placing the three human heads above the three animals. No other artist appears to have so combined them.

Again Panofsky deserves the credit for identifying the portraits as those of Titian and his family. The old man at the left is easily recognizable as the artist himself, so similar to *Titian's Self-Portrait* in the Prado Museum (Plate 1), although dramatized in a rather fierce way. That the black-bearded man in the centre is Orazio Vecellio, Titian's son (1525–1576), in his forties when the picture was painted, seems reasonable, as does Panofsky's suggestion that the youth is Marco Vecellio (1545–1611), a distant relative who lived in Titian's house. Since we have no certain portrait of this youth, the proposal is more speculative.

The original theory of Hadeln (1924) that the *Allegory of Prudence* was intended as a cover for another picture seems too trivial of purpose. It is rather the testament of a genius (Panofsky), a profoundly philosophical commentary on life (studies of the iconography by Panofsky and Saxl, 1926, pp. 177–181; Panofsky, 1930, pp. 1–35; Panofsky, 1955, pp. 146–168, the major account).

Condition: Somewhat darkened, but well preserved; cleaned in 1966 (Roberts, 1966, p. 490).

History: Crozat Collection, Paris, Inventory of 1740 (Stuffmann, 1968, p. 76, no. 157); Duc de Tallard, Paris, sale 1756 (Mireur, 1912, VII, p. 289, 'sujet allégorique'); Chevalier Menabuoni, Paris, in 1766, described as Julius II at the left, Alfonso d'Este in the centre and Charles V at the right! (Duvaux, 1873, pp. CCXCI–CCXCII, quotes Hébert's *Dictionnaire pittoresque et historique*); Lucien Bonaparte, Rome (offered London in 1815 by Christie's; sold by Stanley: Buchanan, 1824, II, p. 277, no. 109 and p. 292, no. 126; Graves, 1921, III, p. 211); Earl of Aberdeen, exhibited

at the British Institution, 1828, no. 14, with the identifica-
tion as above except that the elderly man at the left is
called Paul III (Graves, 1914, III, p. 1317); exhibited by the
Earl of Aberdeen at Edinburgh in 1883 (*loc. cit.*, IV, p. 2200);
Alfred de Rothschild, London, purchased in 1917 (London,
National Gallery, archives); Lady Carnarvon, London, 1918;
Francis Howard, London, before 1924 and until 1955; sale,
London, Christie's, 22 November 1955 (*APC*, XXXIII,
1955–1956, no. 941); thereafter in dealers' possession; gift
of David Koetser to the National Gallery, London, in 1966
(Thanks are due to Cecil Gould of the National Gallery for
his assistance in reconstructing the above history).

Bibliography: See also above; Hadeln, 1924, pp. 179–180
(Titian; first publication); Panofsky and Saxl, 1925, pp.
177–181 (Titian); Suida, 1935, p. 89 (Titian); Tietze, 1936,
I, p. 240, II, p. 293; *idem*, 1950, p. 378 (Titian, *c.* 1565);
London, 1950–1951, no. 209, pl. 31 (Titian); Berenson,
1957, p. 187 (great part by Titian); Valcanover, 1960, II, pl.
120; 1969, no. 449 (Titian, *c.* 1565); Pallucchini, 1969, p.
317, fig. 483 (Titian, *c.* 1565).

108. **Benedetto Varchi** Plate 83

Canvas. 1·17×0·91 m.

Vienna, Kunsthistorisches Museum.

Signed on the column at the right: TITIANVS F

About 1540.

The identification of the sitter, obviously a man of letters,
is based on a medal (Plate 84) by Poggini (Hill, 1920, pl.
XVI, no. 7); the resemblance is entirely reasonable, while
the date of the portrait logically falls within the years he
spent in Venice (1536–1540). Varchi in an entirely black
costume, with red and white at the cuff and a yellow book
in his right hand, is placed against a grey column. The mild
aristocratic and intellectual attitude of the man reveals
Titian's extraordinary understanding of human character.

Biography: Benedetto Varchi (1503–1565), a Florentine
historian and humanist, heir to a substantial fortune at the
death of his father, was able to devote himself exclusively
to letters. During the siege of Florence he fled to Bologna,
where he attended the coronation of Charles V in 1530,
but he returned to Tuscany in 1532 on the side of the Strozzi.
Later in 1536 he sought refuge in Venice with the Strozzi
family, then spent some time in Padua (1540) and Bologna
before he went back to Florence in 1543. A typical figure
of the Renaissance, he had a prodigious knowledge and was
a prolific writer of verse and prose. His major work, *Storia
fiorentina*, covering the period 1522–1528, remained un-
published until 1721 (Palmarocchi, 1935, pp. 991–992).

Condition: Excellent.

History: Archduke Leopold Wilhelm, Vienna, Inventory
1659, no. 8; Stallburg (Storffer, 1733, III, p. 154).

Bibliography: See also above; Teniers, 1660, pl. 88 (Titian);
Mechel, 1783, p. 25, no. 28; C. and C., 1877, II, p. 426
(Titian); Engerth, 1884, pp. 359–360; Gronau, *Titian*,
1904, p. 276 (Titian; uncertain if Varchi); *Mostra di Tiziano*,
1935, no. 44 (Titian, *c.* 1542); Suida, 1935, pp. 89, 172–173
(Titian; uncertain if Varchi); Tietze, 1936, II, p. 317 (Titian,
c. 1543); Wilde, 1938, p. 176, no. 177 (*c.* 1552–1554);
Berenson, 1957, p. 192 (Titian); Valcanover, 1960, II, pl.
38 (Titian, *c.* 1536–1543); Klauner and Oberhammer,
1960, p. 139, no. 716 (Titian, *c.* 1540–1543); Valcanover,
1969, no. 340 (Titian, 1550); Pallucchini, 1969, p. 294,
figs. 356–357 (Titian, *c.* 1550; not Varchi).

Marchese del Vasto: see Alfonso d'Avalos, Cat. nos. 9, 10.

109. **Gregorio Vecellio, Titian's Father** (presumed)
 Plate 45

Canvas. 0·65×0·58 m.

Milan, Ambrosiana Gallery.

About 1530.

The identification as Titian's father is supported by the
Inventory of 1618 (see below, History) and a statement in
the funeral oration of Francesco Vecellio, delivered by
Vincenzo Vecellio, that Titian painted his father's portrait
cum lorica (i.e. a leather cuirass) (Ticozzi, 1817, p. 321).
Although the sitter wears a red velvet vest over his pre-
sumably steel armour, the description is essentially accept-
able in relation to the Ambrosiana portrait, whereas the
idea that he might be Gian Giacomo dei Medici has nothing
to support it. Both psychologically and technically the
picture is worthy of Titian.

Biography: Gregorio Vecellio (*c.* 1455–1530), Titian's father,
married a woman named Lucia, by whom he had two
sons, Francesco (died 1560) and Tiziano, and two daughters,
Orsa (died 1550) and Caterina. He held various offices at
Cadore from 1508 to 1527 and apparently served in the
local army (Ticozzi, 1817, p. 7 and Appendix I; C. and
C., 1877, I, pp. 28–29; Ciani, edition 1940, pp. 440–448).

Condition: Heavily varnished, dirty; right hand damaged and
repainted.

History: Gift of Cardinal Federico Borromeo, 1618 (*Guida*

sommaria, 1907, p. 132, Titian's father dressed as a soldier, by Titian).

Bibliography: Cavalcaselle, 1891, p. 4 (as Gian Giacomo dei Medici, Marchese di Marignano, by Titian); *Guida sommaria*, 1907, p. 68, no. 35 and p. 132 (Titian's father by Titian); Gronau, 1907, pp. 135–136 (Gian Giacomo dei Medici by Titian); Fischel, 1924, p. 94 (Titian, 1530–1540); Berenson, 1932, p. 572 (Titian, unfinished); Suida, 1935, pp. 87, 160 (Titian); Tietze, 1936, II, p. 300 (Titian, *c.* 1535); Pallucchini, 1953, I, p. 173 (Titian, *c.* 1530); Galbiati, 1956, pp. 187, 266 (Titian); Berenson, 1957, p. 188 (Titian); Valcanover, 1960, I, pl. 134 (Titian, *c.* 1530); *idem*, 1969, no. 172 (Titian); dell'Acqua, 1967, fig. 88, colour reproduction; Pallucchini, 1969, pp. 265–266, fig. 205 (Titian, perhaps his father, *c.* 1530–1532); Panofsky, 1969, p. 2 (Titian's father by Titian).

110. **Vendramin Family** Plates 136–140

Canvas. 2·06 × 3·01 m. Frontispiece. Colour Plate
London, National Gallery.
About 1543–1547.

The rich red-velvet robes, lined in lynx, worn by the two major members of the Vendramin family establish a warm sumptuous tonality for the entire composition. The structure of the design, which is built upward in a series of steps, reaching a climax in the altar table, is one that was to have long repercussions in Venetian painting, especially in the work of Tintoretto and his followers.

The identification of this work with the picture described in the inventory of Gabriele Vendramin in 1569 has removed all doubt of the subject, which was formerly entitled the Cornaro family (Gronau, 1925, pp. 126–127, made the discovery). Further investigation of the genealogy of the Vendramin has established the identity of each person portrayed (Gould, 1959, pp. 118–119). The grey-bearded elderly man is Gabriele Vendramin, while Andrea kneels at the left, followed by his eldest, bearded son, Leonardo, and the group of three sons, who must be Luca, Francesco, and Bartolo. On the right side the three youngest children must be Giovanni, Filippo, and Federico, reading right to left, their attitudes expressive of the restlessness of little children; the smallest, Federico holds a white dog. Titian's understanding and deep humanity prevail here in the subtlest variations of pose, as the gravity of the older children is contrasted with the natural spontaneity of the youngest. It has been shown (Pouncey, 1938–1939, pp. 191–193) that the cross of crystal upon the altar is the same as that held in the hand of a *trecento* Andrea Vendramin in Gentile Bellini's *Miracle of the Holy Cross* (1500), a picture originally in the

Scuola di San Giovanni Evangelista (now in the Accademia at Venice). Since both Gentile Bellini and Titian were at pains to illustrate it, this cross, doubtless containing the presumed relic of the Holy Cross, must be the venerated reliquary which was preserved in the Scuola.

Dating: Gould has demonstrated by the ages of the members of the Vendramin family that the picture must have been started about 1543 and that it should have been finished before 1547, when both Andrea and his son Leonardo died.

Condition: Generally good, although the face of the boy in the centre of the left group has been retouched and the sky considerably repainted (full account of the condition by Gould, 1959, pp. 117–118).

History: Vendramin Family, Venice; on sale in Venice in 1636 as mentioned in a letter of 9 September from Lord Maltravers, son of Lord Arundel (Millar, 1955, p. 255, note 2; also Gould, 1959, p. 120, note 14); Sir Anthony van Dyck's collection, his inventory, *c.* 1644 (Müller-Rostock, 1922, p. 22); purchased by the Duke of Northumberland from van Dyck's estate in 1645 (Millar, 1955, p. 255); in the possession of the Dukes of Somerset and Northumberland in various residences and finally at Alnwick Castle, 1900–1929; purchased from the Duke of Northumberland by the National Gallery in 1929 (Gould, 1959, p. 119).

Bibliography: See also above; Waagen, 1854, I, p. 393 (Titian); C. and C., 1877, II, p. 303 (Titian, *c.* 1560); Cook, 1907, pp. 108–109 (Titian, 1560); Ravà, 1920, p. 177 (Vendramin Inventory, 1569, compiled by Jacopo Tintoretto and Orazio Vecellio); Suida, 1935, pp. 80, 173 (Titian, *c.* 1540–1550); Tietze, 1936, II, p. 294 (Titian, 1550); Berenson, 1957, p. 182 (Titian, before 1552); Gould, 1959, pp. 117–120 (definitive study); Morassi, 1964, pl. 26 (partial colour reproduction); Pope-Hennessy, 1966, pp. 277–280; Morassi, 1967, p. 143 (Titian); Valcanover, II, 1960, pl. 14 (Titian, 1547); *idem*, 1969, no. 285 (Titian, *c.* 1547); Pallucchini, 1969, pp. 118–119, 287–288, figs. 322–325 (Titian, *c.* 1547).

COPIES:
Several English copies are listed by Gould (1959, p. 119), but no earlier Italian versions [before 1636] have been recorded.

111. **Venetian Girl** Plate 194

Canvas. 0·85 × 0·75 m.
Naples, Gallerie Nazionali, Capodimonte.
About 1545–1546.

This charming young blonde girl, who has not yet been convincingly identified, wears a pale-pink brocaded dress and a transparent veil over her arm. She holds in her hand a large pear-shaped diamond pendant (often described as a pearl) on a gold rope and in her left ear hangs a garnet ear-ring. Neither of the suggestions that she might be Clelia Farnese (Cat. L–13) or Lavinia (Cat. nos. 59–61) can be taken seriously.

Condition: Rather worn; cleaned and restored in 1960 (Causa, 1960, pp. 61–62, no. 18).

History: Sent from Rome to Parma in 1662: 'ritratto di dama venetiana giovane mano di Titiano' (Filangieri di Candida, 1902, p. 269, no. 64); Palazzo del Giardino, Parma, Inventory 1680 (Campori, 1870, p. 236); probably sent to Naples in 1759 (Filangieri di Candida, 1902, p. 223).

Bibliography: C. and C., 1877, II, p. 474 (among lost pictures); Rinaldis, 1911, p. 156, no. 80 (Lavinia; workshop of Titian); *idem*, 1927, pp. 337–338, no. 135 (Lavinia by Titian, *c.* 1555); Dussler, 1935, p. 238 (workshop); Suida, 1935, pp. 112, 174 (Titian); Tietze, 1936, II, p. 302 (Titian, *c.* 1545); *Mostra di Tiziano*, 1935, no. 68 (Titian, *c.* 1546); Pallucchini, 1954, II, p. 27 (Titian, 1540's); Berenson, 1957, p. 189, no. 135 (Titian, Lavinia?); Valcanover, 1960, pl. 6 (Titian); *idem*, 1969, no. 265 (Titian); Pallucchini, 1969, p. 286, fig. 312 (Titian, *c.* 1546).

112. **Francesco Venier, Doge of Venice** Plates 184–185

Canvas. 1·13 × 0·99 m.

Lugano, Thyssen-Bornemisza Collection.

1554–1556.

The slightly stooped pose of the sick elderly Doge is partially concealed by the rich brocaded robes of gold against the rose curtain and the distant landscape in a work of great dignity and pictorial splendour. The handsome seascape visible through the window is very blue. Titian's official portrait of this Doge, done for the Sala del Gran Consiglio and paid for in 1555 (Lorenzi, 1858, p. 288, document 617), was destroyed by fire in 1577.

Biography: Doge Francesco Venier (1489–1556), a bachelor, noted for his frugal life and poor health, was nevertheless a good administrator. At the period when he held the office of Doge (1554–1556) he could walk only when supported by two men. His monumental tomb, designed by Jacopo Sansovino with sculpture by Alessandro Vittoria, is located in San Salvatore at Venice, the same church in which stands Titian's *Annunciation* (Wethey, I, 1969, Cat. no. 11; Mosto, 1966, pp. 319–323).

Condition: In a generally superior state.

History: Prince Trivulzio, Milan (it is said); acquired by Thyssen-Bornemisza in 1930.

Bibliography: See also above; C. and C. (unknown to them); Hadeln, 1930, pp. 492–494 (Titian); Suida, 1935, pp. 111, 172 (Titian); Tietze, 1936 and 1950 (omitted); Berenson, 1957, p. 187 (Titian); Heinemann, 1958, p. 108, no. 422 (Titian); Valcanover, 1960, II, pls. 50–51 (Titian); Hendy, 1964, pp. 113–114 (Titian); Valcanover, 1969, no. 381 (Titian, 1555); Pallucchini, 1969, p. 303, figs. 400–401 (Titian, *c.* 1554–1556).

113. **Young Englishman** (so-called) Plates 100, 101

Canvas. 1·11 × 0·93 m.

Florence, Pitti Gallery.

About 1540–1545.

Long known as the *Young Englishman* and sometimes as the *Duke of Norfolk*, the picture has also been called *Ippolito Riminaldi*, apparently a lawyer of Ferrara. However, the portrait identified as Riminaldi in the Accademia di San Luca at Rome (Cat. no. X–85) does not convincingly resemble the *Young Englishman*. Gronau (1904, p. 10) thought that the subject might be Guidobaldo II della Rovere of Urbino in 1538 (see Cat. no. 91), a proposal which no other writer has accepted. Also unconvincing was the attempt to identify the personality as Ottavio Farnese on comparison with a bust in the Metropolitan Museum (Philips and Raggio, 1953–1954, pp. 233–248).
In this indescribably beautiful and appealing work the artist relied on colour in the black costume with a touch of white at the collar and cuffs against the greenish-grey background. The picture ranks among the masterpieces of Renaissance art in the subtlety of organization and the psychological penetration of character.

Condition: Dry surface; small spots repaired years ago.

History: Brought to Florence by Vittoria della Rovere in 1631 on her engagement to Ferdinand II dei Medici; described in the Inventory as 'un uomo in abito all'antica' (Gronau, 1904, p. 10, note).

Bibliography: See also above; C. and C., 1877, II, p. 417 (among Titian's best); Gronau, *Titian*, 1904, p. 291 (Riminaldi by Titian, 1540–1545); *Mostra di Tiziano*, 1935, no.

41 (Titian, *c.* 1540); Suida, 1935, p. 89 (Riminaldi by Titian, *c.* 1545); Tietze, 1936, II, p. 289 (Riminaldi by Titian, *c.* 1540–1545); Jahn-Rusconi, 1935, pp. 304–305 (Titian); Berenson, 1957, p. 187 (Riminaldi by Titian); Valcanover, 1960, I, pl. 102 (unknown man, *c.* 1540–1545); Francini Ciaranfi, 1964, p. 44, no. 92. ; Valcanover, 1969, no. 245 (Titian, *c.* 1540–1545); Pallucchini, 1969, p. 280, figs. 283–284 (Titian, *c.* 1540–1545).

114. Young Lady, Portrait of Plate 17

Black crayon on greenish-brown paper. 420×265 mm.

Florence, Uffizi, Gabinetto delle Stampe e dei Disegni, no. 718E.

About 1512.

The extraordinary beauty of the draughtsmanship prevails despite the generally damaged condition of the sheet. Broad, almost monumental in conception, the drawing is related in figure style to the ladies in the frescoes at Padua (Wethey, I, 1969, Plates 139–140) and to *La Schiavona* in London (Plate 14). The black crayon is unusually dark, perhaps because of the soft absorbent paper, while the touches of white chalk on the face and neck have nearly disappeared. Any doubts about the attribution of this great drawing appear unjustified.

Condition: Damaged by water; numerous dark spots on coarse, badly faded paper, which was originally pale green but has turned brown.

Bibliography: Ferri, 1890, p. 254, no. 718 (Titian); Hetzer, 1920, p. 132 (not Titian); Loeser, 1922, pl. 2 (early Titian); Hadeln, 1924, p. 47, pl. 18 (Titian); Frölich-Bum, II, 1928, p. 195, no. 7 (Titian, *c.* 1515); Popham, 1931, p. 72, no. 262 (early Titian); Tietze and Tietze-Conrat, 1936, p. 183, *idem,* 1944, p. 315, no. A 1899 (Romanino); Pallucchini, 1969, p. 330, fig. 556 (Titian, *c.* 1515).

115. Young Man with Cap and Gloves Plate 20

Canvas. 1·10×0·94 m.

Garrowby Hall (Yorkshire), Earl of Halifax.

About 1512–1515.

The general colouristic effect is subdued, although the chestnut hair, the rose sleeves, neutralized yellow gloves, and white shirt provide contrast to the black costume. The head stands out with pictorial forcefulness, supported by the white area of the shirt, edged in red, and the serious intelligent face carries conviction and clarity of thought,

comparable with the somewhat more dramatic central figure of *The Concert* (Plate 10). In the background at the left the base of a pier is decorated with a mask-head and arabesques, while only a wall of dark grey appears at the right.

At the beginning of the century the Giorgionesque aspects of this picture impressed many critics, but as the early phase of Titian's portraiture has become more fully understood, his name has been firmly attached to this splendid work, particularly because of the strong psychological content.

Condition: Heavily varnished and so darkened that the cap and the background were virtually invisible until the cleaning and restoration in 1970.

History: Temple Newsam, Ingram family, first mention, Inventory 1808, no. 76 (Waagen, 1854, III, p. 334, as Martin Bucer by Titian); by inheritance to the present owner.

Bibliography: See also History; Cook, 1907, pp. 86–88, 152 (Giorgione); Gronau, 1908, p. 514 (early Titian); Holmes, 1909–1910, p. 73 (Titian); Fry, 1910, p. 36 (early Titian); L. Venturi, 1913, p. 175 (Palma il Vecchio); Hetzer, 1920, p. 127 (anonymous); Fischel, 1924, p. 281 (too undramatic for Titian!); L. Justi, edition 1926, II, pp. 331–332 (Giorgione?); Debrunner, 1928, pp. 116–127 (Lorenzo Lotto); Suida, 1935, pp. 33, 161 (Titian); Tietze, 1936, II, p. 293 (then London, Lord Irwin; Titian, *c.* 1520); *idem,* 1950, p. 379 (Titian); Richter, 1937, pp. 238–239 (follower of Giorgione, perhaps Palma); Phillips, 1937, pp. 82–83 (Giorgionesque Titian); Pallucchini, 1953, I, p. 101 (Titian); Berenson, 1957, p. 186 (Titian, *c.* 1520); Manchester, 1957, no. 62 (Titian); Valcanover, 1960, I, pl. 62 (Titian); Waterhouse, 1960, p. 39, no. 68 (Titian); Morassi, 1964, p. 18 (Titian); *idem,* 1967, p. 135 (Titian); Mariacher, 1968, p. 101 (not Palma); Valcanover, 1969, no. 64 (Titian, *c.* 1515); Pallucchini, 1969, p. 251, fig. 117 (Titian, *c.* 1516).

116. Young Man in a Red Cap Plate 22

Canvas. 0·823×0·711 m.

New York, Frick Collection.

About 1516.

The sumptuous decorative quality of this portrait is beyond dispute. Against the black mantle and black doublet the brown-white fur provides brilliance of pattern and contrast, to which the red cap with black ribbons adds further richness. The white shirt with round neck-line and the square neck of the doublet are skilfully managed in their design here as elsewhere in Titian's early portraits (see Plates 19, 20).

The attribution to Titian is widely accepted, although the blandness of expression has caused some critics to doubt that the great Venetian would endow anyone with so little personality. Possibly the smoothing process of restorers can partially account for that fact.

Identification of the youth has failed since he is obviously not Lorenzo dei Medici (1492–1519) as proposed in the nineteenth century, nor Charles, Duke of Bourbon (1490–1527), Constable of France (Cat. no. X–14), whose fame rests upon his infamous leadership in the sack of Rome in 1527 (*Frick Collection*, 1949, I, p. 257).

Condition: Minor losses on the edges, now retouched (*Frick Collection*, 1968, II, p. 251). The irregular grey parapet at the lower edge is a late addition.

Dating: The picture is stylistically close to the *Young Man in a Red Cap* (Cat. no. 117), which is inscribed with the date 1516 on the back.

History: Probably from a Florentine collection, since Carlo Dolci made a drawing after the portrait now in the Uffizi Collection (Bravo, 1967, p. 223) and also introduced the figure in the background of his *Martyrdom of St. Andrew* in the Pitti Gallery (Cipriani, 1966, p. 243). Paul Methuen, London; Edward Edgell and descendants, Frome (sale, London, Christie's, 24 June 1876, no. 122, bought in; sale, London, Christie's, 12 May 1906, no. 75); bought by Sir Hugh Lane, who owned it 1906–1911; Arthur Grenfell, 1911–1914 (sale, London, Christie's, 26 June 1914, no. 66, Lane rebought); Frick purchase from Lane in 1915 (see history reconstructed: *Frick Collection*, 1968, II, pp. 253–254).

Bibliography: See also above; Ricketts, 1910, p. 177 (Titian); Fischel, 1924, p. 279 (doubtful attribution); L. Venturi, 1933, pl. 511 (Titian); Suida, 1935, pp. 34, 185 (Titian); Tietze, 1936 and 1950 (omitted); Phillips, 1937, p. 158 (Titian); Longhi, 1946, p. 64 (Titian); Pallucchini, 1953, I,

p. 103 (major work by Titian); dell'Acqua, 1955, pl. 100 (Titian); Coletti, 1955, p. 62 (Giorgione); Berenson, 1957, p. 189 (Titian); Valcanover, 1960, I, pl. 56 (Titian); Morassi, 1964, p. 18 (early Titian); *idem*, 1967, p. 135 (early Titian); New York, *Frick Collection*, 1968, II, pp. 251–255 (exhaustive account); Valcanover, 1969, no. 67 (Titian, 1515); Pallucchini, 1969, p. 252, fig. 122 (Titian, 1516–1518).

117. **Young Man in a Red Cap** (head only) Plate 21
Panel, 0·20×0·162 m.
Frankfurt, Städelsches Kunstinstitut.
1516.

If the attribution of the Frick portrait of a *Young Man in a Red Cap* (Plate 22) is correct, the head in Frankfurt must be accepted as Titian's work also, in view of the close similarity in mood and in the style of painting. The violet-blue doublet and white shirt are subtly balanced against the red cap and brown hair. The quality of the picture is exquisite in its miniature-like delicacy.

Condition: Cut down on all sides, probably bust-length originally; small losses in the face and neck have not been retouched; an inscription on the back includes the date 1516.

History: Collection of Erasmus, Ritter von Engert, Vienna; acquired by Frankfurt in 1881.

Bibliography: Frankfurt, 1900, pp. 342–343, no. 43a (Titian); Ricketts, 1910, pp. 46, 180 (Titian); Fischel, 1924, p. 278 (doubtful attribution); Suida, 1935, pp. 34, 185 (Titian); Mayer, 1937, p. 306 (Titian, c. 1516); Pallucchini, 1953, I, pp. 104–105 (Titian); Berenson, 1957, p. 186 (Titian, 1516); Valcanover, 1960, I, p. 94 (doubtful attribution); Frankfurt, 1966, p. 120, no. 1881 (Titian); Valcanover, 1969, no. 73 (commonly attributed, 1516); Pallucchini, 1969, p. 252, fig. 121 (Titian, c. 1516).

APPENDIX

SCHOOL PIECES, DOUBTFUL AND WRONG ATTRIBUTIONS

The Appendix includes works sometimes attributed to Titian, but which are in the author's opinion by Giorgione, Palma il Vecchio, Palma il Giovane, Jacopo Bassano, Lambert Sustris, Giulio Licinio, Orlando Flacco, Federico Barocci, Girolamo Savoldo, Giovanni Cariani, Paris Bordone, Vincenzo Catena, Gian Paolo Pace, and anonymous painters of the sixteenth century.

X–1. **Giovanni Francesco Acquaviva d'Aragona** (full length, seated)

Canvas. 1·40 × 1·02 m.

Lucerne, Julius Böhler (1934).

Venetian School.

Mid-sixteenth century.

Despite an inscription, GIOVANNI AQUAVIVA DVCES ATRI ANNO 1554 and the so-called signature TITIANVS F., this work has not been widely accepted as Titian's. The extremely awkward pose, the incorrect scale of the head in relation to the body, and the bad drawing do not inspire an attribution to a great master in his maturity. The artist was probably North Italian (see a better work by G. B. Moroni, Venturi, 1929, p. 230). The identity of the sitter is also in doubt.

History: Ehrich Gallery, New York (1926); from a Polish Collection (?).

Bibliography: Hadeln, 1934, pp. 16–17 (Titian); Tietze, 1936, II, p. 295 (Titian; picture then in Lucerne); Hetzer, 1940, p. 166 (not Titian); Tietze, 1950, p. 381 (uncertain attribution); Berenson, 1957 (omitted); Valcanover, 1960, II, p. 67, pl. 157 (not Titian); *idem*, 1969, no. 344 (doubtful attribution); Pallucchini, 1969, p. 296, fig. 370 (probably Titian, c. 1551–1552); Dussler, 1970, p. 550 (not Titian).

Giovanni Francesco Acquaviva, see also: Cat. no. 1.

X–2. **Giulio Antonio Acquaviva d'Aragona, Duke of Atri.**

Canvas. 1·194 × 0·94 m.

Unknown location.

German School.

Sixteenth century.

Wrongly entitled 'Duke of Alba' in the sale, the picture is inscribed 'Julius Antonius Secundus de Acquaviva, 1538' and has a reference to a Carmelite church.

Biography: Son of Gianfrancesco Acquaviva, who died in 1527 without succeeding to the Dukedom of Atri, Giulio Antonio Acquaviva, Count of Conversano, was born towards the end of the fifteenth century. Already in exile in France in 1529, along with his son Giovanni Francesco (Cat. no. 1), he lost his title and lands of Atri, which were given by Charles V to an uncle, Giovanni Antonio Donato Acquaviva (1485–1554). Atri, today a town of twelve thousand inhabitants, is located north of Pescara in the Adriatic province of Teramo.

History: T. L. S. Cornwall-Legh, Abbington, sale, London, Sotheby's, 21 May 1935 (*APC*, XIV, 1934–1935, no. 4980, attributed to Titian, £290); Colonel Lord Joicey (sale, London, Christie's, 26 July 1946, no. 150).

Bibliography: Suida, 1934–1935, p. 101 (Titian); Suida, 1935, p. 84 (Titian; ruined by restoration); Tietze and Tietze-Conrat, 1936, p. 139 (not Titian).

X–3. **Duke of Alba in Armour** Plate 249

Canvas. 0·99 × 0·81 m.

Madrid, Palacio de Liria, Duke and Duchess of Alba.

Flemish School.

About 1560.

This half-length portrait is painted in a precise Flemish manner, which is entirely foreign to Titian's style and much nearer to that of Willem Key, whose portrait of the same duke, dated 1568, is in the Alba Collection in the Palacio de Dueñas at Seville. It is even doubtful that the composition reflects a prototype by the Venetian master. Another version of the same picture, somewhat less sharp in its details, belonged to the Duque de Huéscar at Madrid (Fischel, 1924, pl. 154). For the *Duke of Alba in Armour* painted by Titian, see Cat. no. L–1.

History: Said to have belonged to the Conde Duque de Olivares (died 1645) and since then in the Alba Collection (Barcia, 1911, p. 9); that picture of the Duke in armour, called an original by Titian in the Inventory *c.* 1645 (*loc. cit.*, p. 247, 1¼×1 *vara* (1·64×0·835 m.) must be regarded as lost.

Bibliography: Barcia, 1911, pp. 8–9 (Titian); Fischel, 1924, p. 155 (probably a copy); Suida, 1935, p. 109 (not Titian); Mayer, 1938, pp. 305–307 (close to Antonio Moro); Pita Andrade, 1965, pp. 268–269 (Titian, *c.* 1565).

X–4. **Duke of Alba in Black**
Canvas. 1·155×0·81 m.

Madrid, Palacio de Liria, Duke and Duchess of Alba.

Copy (probably not after Titian).

The theory that this mediocre canvas is Rubens' copy of a lost original by Titian is completely unjustified. Pieter de Jode's engraving of this same figure (illustration, Byam Shaw, 1967, p. 69), which is labelled as after Titian, is the only evidence that Titian ever invented this composition. We have proof only that Titian painted the Duke of Alba in *armour* (see Cat. no. L–1) and none at all of any other composition.

History: Acquired by the Albas in London in 1942.

Bibliography: Mayer, 1938, pp. 305–307 (probably after Titian; compares Jode's print); Beroqui, 1946, pp. 182–184 (Rubens after Titian); Charles V, 1958, p. 109, no. 123, pl. 99 (Rubens after Titian's original *c.* 1550); Pita Andrade, 1965, p. 268 (Rubens' copy, 1628).

SECOND COPY:
Oxford, Christ Church Gallery; canvas, 1·023×0·89 m. (C. and C., 1877, II, p. 466, Venetian School; Byam Shaw, 1965, pp. 68–69, copy of Titian).

X–5. **The Appeal** (Three Figures)
Canvas. 0·84×0·69 m.

Detroit, Institute of Arts (in storage).

Venetian School.

Sixteenth century.

A composition containing three figures is familiar enough in Venetian painting of the early sixteenth century, but the juxtaposition of three different styles of painting in one canvas is another matter. The theory that Titian painted the woman on the left, Giorgione the man, and Sebastiano del Piombo the woman at the right, has only an inscription on the back of the canvas to recommend it. The quality of the work is rather good, yet the picture has the appearance of an exercise in techniques. Schubring's identification of the characters as Medea, Jason, and Creusa is a wholly romantic theory.

Condition: In a rather bad state particularly the figure at the left. The pigment on the face is blistered and a hole in this section has been repaired. The sleeve and right wrist are extensively repainted.

History: Palazzo Sanchi, Bergamo, in 1777 (Valentiner, *Art in America*, 1926, p. 43); Count Schönborn, Pommersfelden until 1867; Duke of Oldenburg until 1923; purchased by Detroit 1926.

Bibliography: C. and C., 1871, p. 553 (Cariani); Morelli, 1891, II, p. 38 (Cariani); Borenius, 1913, p. 26 (Cariani); Mather, 1926, pp. 70–75 (a pastiche, *c.* 1600); Valentiner, 1926, pp. 62–65 (Titian, Giorgione, and Sebastiano del Piombo, *c.* 1508–1510); Detroit, 1926, no. 2; Valentiner, *Art in America*, 1926, pp. 40–45 (reply to Mather); Schubring, 1926–1927, pp. 35–40 (Titian, Giorgione, and Sebastiano del Piombo); Venturi, 1928, p. 462 (Cariani); Tietze, 1936 and 1950 (omitted); Suida, 1935, pp. 29, 153 (Titian, Giorgione, and Sebastiano del Piombo); Robertson, 1954, p. 25; *idem*, 1955, p. 276 (a pastiche); Suida, 1956, pp, 72–73 (Titian, Giorgione, and Sebastiano del Piombo); Berenson, 1957, p. 184 (Titian in part); Braunfels, 1964, pp. 25–27 (Sebastiano, Giorgione, Titian, *c.* 1540); Pallucchini, 1969, p. 238, figs. 52, 53 (Titian, Giorgione, and Sebastiano del Piombo); Pignatti, 1969, Cat. no. A10, pl. 203 (Palma il Vecchio?).

COPY:
Venice, Accademia; canvas, 0·80×0·72 m.; sixteenth-century copy (Moschini Marconi, 1962, p. 200, no. 346).

VARIANT:
Vienna, Mrs. Olga Schnitzler, *Woman Holding a Medal* by Vincenzo Catena; canvas, 0·62×0·56 m.; *c.* 1520; this figure repeats the woman on the right in *The Appeal* (Robertson, 1954, pp. 25, 52, pl. 20).

X–6. **Pietro Aretino**
Canvas. 0·58×0·465 m.

Basle, Kunstmuseum.

Moretto da Brescia.

About 1544.

Suida attempted unsuccessfully to establish this picture as Titian's first portrait of Aretino, c. 1527. Gombosi identifies it as the portrait that Aretino presented to the Duke of Urbino in 1544.

History: Bachofen-Burckhardt Collection, Basle.

Bibliography: Suida, 1939, pp. 113–115 (Titian); Dussler, 1942, p. 150 (anonymous); Gombosi, 1943, pp. 87, 91 (Moretto); Pallucchini, 1944, p. 67 (Sebastiano del Piombo); Berenson, 1957, p. 162 (Sebastiano del Piombo?).

Pietro Aretino, see also: Cat. nos. 5, 6.

X–7. **Ariosto**

Canvas. 0·60 × 0·50 m.

Ferrara, Casa Oriani (formerly).

Venetian School.

About 1520.

Since this item has been lost and the photographs are inferior, no safe opinion about the quality of the canvas can be ventured. The shoulder-length portrait in partial profile, which disappeared in World War II according to Signore Capra of the Ferrara Library, was first discovered in 1933 by Giuseppe Agnelli, then director of the Ferrara Library and attributed by him to Dosso Dossi (Agnelli, 1933, pp. 275–282). Very shortly thereafter Georg Gronau published an article arguing in favour of Titian, to whose style the work is more closely related than to Dosso Dossi's (Gronau, 1933, pp. 194–203). Various contemporary sources indicate that the Venetian artist painted the celebrated poet in addition to supplying the preparatory drawing for the woodcut in profile which appears in *Orlando Furioso*, edition of 1532 (Baruffaldi edition, 1807, pp. 250–253).

That the features of the Casa Oriani portrait are those of Ariosto there can be no doubt, and this model for the head is similar to that of the three-quarter-length picture in the Biblioteca Comunale at Ferrara.

Inasmuch as Ariosto's appearance is well known, the consensus among art historians is that the *Portrait of a Poet* given to Palma il Vecchio in the National Gallery at London also represents Ariosto, while the *Gentleman in Blue* (Cat. no. 40) was undoubtedly painted by Titian but the identity of the sitter is unknown. The same conclusion must be reached in regard to the *Ariosto* (so-called) at Indianapolis (Cat. no. 7).

Biography: Ludovico Ariosto (1474–1533), born at Reggio d'Emilia, one of the most celebrated poets of the Renaissance, passed most of his life at Ferrara, first attached to the entourage of Cardinal Ippolito I d'Este, 1503–1517, and thereafter in the service of Duke Alfonso I d'Este (Cat. no. 26). Despite his fame Ariosto reaped only modest personal rewards. He wrote numerous poems and plays both in Italian and Latin, but his fame rests upon the romantic epic *Orlando Furioso*, first edition 1516, complete edition 1532 (Sapegno, 1962, pp. 172–188).

Condition: Very dirty and worn according to photographs.

History: Gronau proposed the Casa Oriani portrait as the one which Ariosto's son Vittorio (or Giulio?) ordered to be sent to himself from Ferrara to Padua according to a letter of 1554. The same writer assumed that the picture went back to Ferrara, where it was mentioned in a letter of 1572 as 'a portrait by Titian from life' ('fece del naturale fatto per mano del Tiziano'). Both letters are in manuscript in the Ferrara Library (Agnelli, 1922, p. 86).

Bibliography: See also above; Solerti, 1904, pp. 465–476 (material on Ariosto iconography); Agnelli, 1922, pp. 82–98 (Ariosto iconography); *idem*, 1933, pp. 275–282 (Dosso Dossi); Gronau, 1933, pp. 194–203 (Titian); Suida, 1935 (omitted); Tietze, 1936, II, p. 288, fig. 94 (Titian, c. 1532); *idem*, 1950, p. 372 (Titian); Berenson, 1957 (omitted); Valcanover, 1960, I, p. 98 (doubtful attribution); Gibbons, 1968, p. 252 (copy); Pallucchini, 1969 (omitted).

COPY:

1. Ferrara, Biblioteca Comunale, Sala Ariostea; canvas, 1·07 × 0·87 m.; formerly Marchese Roberto Canonici, Ferrara, in the seventeenth century; Giuseppe Gatti-Casazza, 1905–1920; his gift to the library in 1920. *Bibliography:* Fischel, 1924, p. 280 (apparently this item, although Fischel locates it in the museum at Ferrara); Gibbons, 1968, p. 252, no. 151 (not related to Dosso Dossi).

X–8. **Barbarigo Gentleman** (so-called)

Canvas. 0·825 × 0·648 m.

Alnwick Castle, Duke of Northumberland.

Venetian School.

About 1525.

The stolid, dull nature of this utterly mediocre portrait can only be compared with the production of a minor painter at his most uninspired, perhaps Bernardino Licinio on comparison with this painter's portrait in Count Cini's collection at Venice (illustrations in Berenson, 1957, pls. 847, 852).

History: Aldobrandini Collection, Rome, probably the item catalogued as the portrait of a young man by Titian in the Aldobrandini Inventory 1603, no. 193; 1626, no. 95; before 1665, no. 193; and 1682, no. 356, in the last two cases as four *palmi* high, i.e. 0·89 m. (Onofrio, 1964, p. 204; Pergola, 1960, p. 431; *idem*, 1963, p. 77); purchased in 1856 from the Camuccini Gallery of Rome.

Bibliography: See also above; C. and C., 1877, II, p. 468 (Barbarigo Gentleman (?); not Titian; Morto da Feltre or Pellegrino da San Daniele); Waagen, 1857, p. 468 (Barbarigo male figure, 'empty in form', Titian); Gombosi, 1937 (not listed); Berenson, 1957, p. 123 (Palma il Vecchio); Newcastle-on-Tyne, 1963, no. 70 (Titian); Mariacher, 1968, p. 93 (not Palma); Pallucchini, 1969, p. 242, fig. 75 (Titian, *c.* 1512–1515).

X–9. **Bearded Old Man** (so-called Cardinal Pietro Bembo)

Canvas. 0·575×0·455 m.
Budapest, Museum of Fine Arts.
Jacopo Bassano.

The traditional theory that this work represents Cardinal Pietro Bembo, as portrayed by Titian, has been abandoned. Some doubts about the present attribution to Jacopo Bassano have arisen, yet the exceptionally high quality in execution and characterization is agreed.

Condition: Somewhat rubbed.

History: Lucien Bonaparte, Rome (Bonaparte, 1812, pl. 57; sale, London, 1816, Bembo by Titian; Buchanan, 1824, II, p. 278, no. 110); Duca di Lucca (sale, London, 1840–1841, Titian); Esterhazy Collection, Budapest, 1844, as Titian (Pigler, 1967, p. 42, no. 108).

Bibliography: See also History; Zampetti, 1957, p. 224 (Jacopo Bassano); Berenson, 1957, p. 16, no. 108 (Jacopo Bassano); Arslan, 1960, I, p. 334 (Bassanesque, not by Jacopo); Boschetto, 1963, pl. 9 (Savoldo); Garas, 1965, p. 24 (uncertain attribution to Bassano); Pigler, 1967, pp. 42–43, no. 108 (full account).

X–10. **La Bella di Tiziano**

Canvas. 0·95×0·80 m.
Lugano (Switzerland), Thyssen-Bornemisza Collection.
Palma il Vecchio.
About 1520–1525.

History: Archduke Leopold Wilhelm, Brussels and Vienna;

Sciarra Collection, Rome, in the nineteenth century, as Titian; Rothschild Collection, Château Ferrières (until 1959).

Bibliography: C. and C., 1877, I, pp. 66–67, II, p. 442 (Palma il Vecchio); Berenson, 1957, p. 125 (Palma il Vecchio, under Paris); Mariacher, 1968, pp. 74–75, no. 51 (Palma il Vecchio).

X–11. **Cardinal Pietro Bembo** (profile)

Canvas. 1·162×0·965 m.
Unknown location, European collection.
Copy?

The profile portrait of Bembo as an elderly man with long grey beard, datable 1547, resembles the medal of him attributed to Benvenuto Cellini. The late date, so obvious by the appearance of Bembo, is confirmed by Bonasone's print and the picture formerly in Court Borromeo's collection at Padua, which gives his age as seventy-seven (see below). There is another print of the same portrait by Enea Vico of Parma (Coggiola, 1914–1915, p. 498). The popularity of this portrait is attested by the several replicas of it and its reproduction in prints.

Probable history: Venice, Pier Gradenigo and Elena, Bembo's daughter; Venice, Cornelia Dolfin Gradenigo, descendant of the above, in 1790 (Coggiola, pp. 500, 502–503); Morelli, in his edition of Bembo's *Della istoria veneziana*, Venice, 1790 (preface, pp. XXXIX–XL), gives it as the source of Bartolozzi's print, which is used as the frontispiece (also Morelli in Michiel, edition 1800); Cornelia Gradenigo died in 1815; Natale Schiavoni, Venice, *c.* 1830; inherited by Conte Luigi Sernagiotto, who said about 1914 that it had been sold to England not long before (Coggiola, pp. 503–504). *Certain history:* Earl of Rosebery, Mentmore (private sale); Wildenstein Gallery, New York, 1952; Putnam Foundation, San Diego, California, *c.* 1955–1965.

Bibliography: See also above; C. and C., 1877 (see item, no. 5 below); Tietze, 1936 (omitted); Berenson, 1957, p. 190 (Titian); Valcanover, 1960, I, p. 101 (wrong attribution; confused history).

VARIANTS AND OTHER COPIES:
1. Milan, Count Luigi Bossi, in the early nineteenth century; copy of the profile portrait with the table included (Coggiola 1914–1915, p. 504; reproduced in a print in Roscoe and Bossi, 1817, p. 186).
2. Padua, Count Antonio Borromeo (formerly), profile portrait with the inscription PETRVS BEMBVS ANNVM AGENS LXXVII, identical to that on Bonasone's print

(Coggiola, 1914–1915, pp. 502, 505; probably a copy says Coggiola).

3. Pavia, Museo Malaspina, panel, 0·27×0·23 m. (Bernardini, 1901, p. 151); much repainted.

4. Pavia, Museo Malaspina, fresco crudely transferred to canvas, 0·83×0·67 m., much repainted (Suida, 1936, p. 281); provenance unknown; acquired later than 1914–1915, not known to Coggiola.

5. Unknown location, formerly Venice, Jacopo Nardi and descendants (Milanesi note in Vasari (1568)-Milanesi, VII, 1881, p. 455; C. and C., 1877, I, pp. 418–419: 'unmistakably . . . Titian', then in the studio of Vason; Coggiola in 1914–1915, pp. 486, 490, then had disappeared).

6. Venice, Libreria di San Marco; late poor copy on panel, 0·29×0·215 m., donation of Balì Farsetta in 1792 (Morelli-Frizzoni, 1884, p. 47); on the back of the panel is the name of Paolo Ramusio, son of Giambattista, who was a friend of Bembo (Coggiola, 1914–1915, pp. 506–513).

7. Venice, Museo Correr (in storage); panel, 0·26×0·20 m.; badly retouched (Coggiola, 1914–1915, p. 505).

8. Zurich, A. Martin; panel, 0·29×0·24 m.; replica, called an original by Suida (1936, p. 281, pl. ID; also Suida, 1935, p. 87); this item is doubtless one of those listed above as formerly in Milan or Venice.

PRINTS:

1. Bonasone in 1547 (Plate 256).
2. Enea Vico of Parma, about 1550 (Plate 257) (Bartsch, XV, p. 334, no. 242).
3. Bartolozzi print (1790) after the Gradenigo portrait (see above, History).
4. Print from Luigi Bossi's portrait, reproduced in Roscoe and Bossi, 1817 (see above, Copy no. 1).

Cardinal Pietro Bembo, see also: Cat. nos. 15 and 16.

X–12. **Antonio Galeazzo Bevilacqua** Plate 227

Canvas. 1·413×1·08 m.

Cleveland, Museum of Art.

School of Parma-Modena.

About 1565.

The portrait appears to be a work of the school of Parma-Modena probably to be dated about 1565, when the sitter was twenty-five. Mina Gregori first suggested orally to the Cleveland curator the names of Niccolò dell'Abbate or Girolamo Mazzola-Bedoli (1500–1569). Because of the age of the sitter, Mazzola-Bedoli is a good possibility. Certainly Berenson's attribution to Titian is totally unfounded.

Biography: The inscription on the book reads 'Antonio Galeazzo Bevilacqua di Verona, ramo di Ferrara, Marchese di Bismantova'. Exactly the same name in this same branch of the Bevilacqua di Verona appears in Litta's publication of Italian families (Bevilacqua di Verona, tavola v). This man, born in 1540, studied civil and canon law at Bologna in 1567. Later he went to Rome, where he became apostolic pronotary, and the vicar of the church of S. Maria in Via Lata. He died in Rome in 1584.

Bibliography: Berenson, 1957, p. 184 (Titian).

X–13. **Blonde Woman in a Black Dress** Plate 223

Panel. 0·595×0·445 m.

Vienna, Kunsthistorisches Museum.

Palma il Vecchio.

About 1520.

Most critics ascribe this handsome picture to Palma il Vecchio, surely the most reasonable conclusion, but Suida (1935) and recently the museum changed the attribution to Titian. The same woman appears seated at the right in Palma's *Bath of Diana* in the same museum (no. 606). The strong contrasts in colour values between the black dress, the white blouse, the flesh tones, and grey background are not characteristic of Titian, although the picture is one of extraordinary quality. Palma is revealed here under the strong influence of Titian's *Flora* and related works, yet the hard, coarse nature of this face cannot be paralleled in Titian's work.

Condition: Cleaned in 1959.

History: Stallburg (Storffer, 1720, I, p. 20, Palma il Vecchio); Charles VI (Stampart and Prenner, 1735, pl. 4, Palma il Vecchio).

Bibliography: See also above; Engerth, 1884, I, p. 230, no. 327 (Palma il Vecchio; wrongly said to have belonged to Queen Christina, i.e. a young woman in green, described in her Inventory of 1689: Campori, 1870, p. 341); Longhi, 1927 (not mentioned, contrary to the statements of later writers); Spahn, 1932, pp. 128–129 (Palma il Vecchio); Suida, 1935, pp. 32, 156, pl. 28A (Titian); Gombosi, 1937, p. 81 (Palma il Vecchio, 1517–1520); Berenson, 1957, p. 127, no. 142 (Palma il Vecchio); Klauner and Oberhammer, 1960, p. 132, no. 705 (Titian); Oberhammer, 1964, pp. 129–131 (Titian); Klauner, Oberhammer, and Heinz, 1966, p. 53, no. 116 (Titian); Mariacher, 1968, p. 111 (Titian); Valcanover, 1969, no. 61 (attributed to Titian); Pallucchini,

1969, p. 249, fig. 110 (Titian, *c.* 1515); Dussler, 1970, p. 550 (not Titian).

X–14. **Charles de Bourbon, Constable of France** (so-called)

Canvas. 1·00×0·76 m.

Bilbao, Marquesa de Feria.

Giampietro Silvio.

About 1520.

An engraving of this subject by Vorsterman (Plate 219) in the mid-seventeenth century carries an inscription with the name of the Constable of Bourbon and the authorship of Titian. The only other early reference to such a portrait is Tizianello's mention of it, also as in the collection of the Earl of Arundel (Tizianello, 1622, edition 1809, p. XIII). So far as portraits of Charles de Bourbon are concerned, the woodcut reproduced by Paolo Giovio (edition 1575, p. 281) has only the vaguest, if any, similarity to Vorsterman's print (Plate 219) and the Feria canvas. The identification of the sitter is highly problematic, but the painter is surely a minor imitator of Titian, Giampietro Silvio, on comparison with his signed picture of a *Gentleman* in Vienna (Wilde, 1934, p. 164).

Biography: Charles, Constable of Bourbon (1490–1527), was the son of Gilbert de Montpensier, Duke of Bourbon, and Chiara Gonzaga, and thus nephew of Francesco Gonzaga and Isabella d'Este (Cat. no. 27). After having ruled Milan and Burgundy under Francis I from 1515, he was denied the properties of his wife Susannah, who died in 1522. In anger he defected to Emperor Charles V, who appointed him imperial viceroy in Italy, where he led the mercenary troops in the sack of Rome, a universally condemned event, in which he lost his life (Paolo Giovio, edition 1575, pp. 281–284; Mariallac (*c.* 1600), edition 1836, pp. 124–184; Brantôme (1604), edition 1858, I, pp. 298–334).

Presumed History: Earl of Arundel (Tizianello, 1622, edition 1809, p. XIII); Arundel Inventory, 1655 (Cust, 1911, p. 286; Hervey, 1921, p. 489); Gaspar de Haro, bought in London in 1649; Duke of Alba, 1688 (Duke of Alba, 1924, p. 108); sold to Braulio Zubía, 1802; by inheritance to the Marquesa de Feria, Bilbao (history of Spanish ownership by Lorente Junquera, 1953, p. 165, illustrated).

Bibliography: See also above; C. and C., 1877, II, p. 475 (mention of Vorsterman's print and the Arundel portrait); Lorente Junquera, 1953, pp. 164–165 and errata sheet (Titian); Berenson, Suida, Tietze (omitted); Valcanover,

1960, I, pl. 219B (attributed to Titian); *idem*, 1969 (recently attributed).

VARIANT:
Lord Howard of Effingham (Lorente Junquera, 1953, p. 164, wrongly labelled as the Feria picture; photograph, London, Courtauld Institute).

X–15. **Bramante** (so-called)

Canvas. 0·95×0·71 m.

Unknown location.

Italian School.

About 1550.

Crowe and Cavalcaselle identified the man as Oderico Piloni on comparison with a portrait of him by Cesare Vecellio in the Villa Piloni near Belluno. A work of inferior quality.

Probable source: Rome, Borghese Collection; Bramante, 'cuadro di quattro palmi', i.e., 0.89 m.; Inventory, 1693, no. 212 (Pergola, 1964, p. 452).

History: Blockley, Lord Northwick, sale 26 July 1859, no. 1106 (bought in); Northwick catalogue, 1864, no. 9, as Bramante by Titian; Borenius and Cust, 1921, no. 69 (*Old Man* by Titian); Blockley, Northwick Park, E. G. Spencer-Churchill, sale 28 May 1965, no. 24 (as by Lorenzo Lotto).

Bibliography: See also History; C. and C., 1877, II, p. 460 (possibly Cesare Vecellio); Colvin, 1937, p. 87, illustrated (Titian); Manchester, 1957, no. 60 (Titian).

X–16. **Cardinal** (Jean du Bellay?)

Canvas. 0·463×0·375 m.

Sarasota, Ringling Museum of Art.

Roman School.

About 1550.

Bust-length figure, a mediocre work of the Roman school, is wrongly attributed to Titian. On comparison with a portrait in the Musée des Beaux Arts at Versailles (Salerno, 1968, fig. 105), the sitter may be Cardinal Jean du Bellay who lived at Rome in 1547–1550 and 1553–1560.

Bibliography: Suida, 1946, p. 141 (Titian, 1545–1546); Suida, 1949, p. 59, no. 59 (*sic*) (Titian).

X–17. **Cardinal**

Canvas. 1·11×0·91 m.

Lucerne, Private collection.

Roman School.

Sixteenth century.

History (as given by Pallucchini): exhibited at Leeds in 1868 (not listed in the catalogue); Winter Exhibition, London, Royal Academy, 1912, no. 112, lent by C. Brinsley Marlay as by Jacopo Bassano.

Bibliography: Pallucchini, 1969, p. 285, fig. 310 (Titian, *c.* 1546); Dussler, 1970, p. 550 (not Titian).

X–18. **Charles V** (half-length) Plate 243

Canvas. 0·97×0·76 m.

Naples, Gallerie Nazionali, Capodimonte

Workshop or school of Titian.

Sixteenth century.

The identification of the sitter remains questionable, but the proposal that Ferdinand I, the brother of Charles, is represented here seems even less persuasive. The head constitutes a weak variant of the *Charles V Seated* at Munich (Plate 145). That combined with the characterless black costume and the dark-red background only slightly relieved by a sunset sky adds up to a dull picture. A portrait of this sort seems to have served as model when the Zuccari brothers included the emperor in the historical murals of the Farnese family on the walls of the castle at Caprarola.

Condition: Darkened and heavily restored.

History: Unconvincingly identified as the portrait of Charles V that Titian presented to Ferrante Gonzaga in 1549 (C. and C., 1877, II, pp. 193–194), since no explanation is forthcoming as to how the picture could have passed to the Farnese Collection.
A large portrait of Charles V at Caprarola in the Inventory of 1626 (Naples, Archivio di Stato, Fondo Farnese, 1176–1177, folio 66) is repeated in the Inventory of 1668 (*loc. cit.*, folio 15ᵛ) and there given as 'lungo palmi sei largo quattro' (1·33×0·89 m.). The large size of the canvas seems to exclude that item as the work at Naples, especially since no artist is indicated.
The Naples portrait appears, as de Rinaldis suggested, to have been sent from Rome to Parma in 1662, Inventory no. 69: 'Un quadro in tela con il ritratto di Carlo 5 con un memoriale in mano e tosone, mano di Titiano' (Filangieri di Candida, 1902, p. 267, no. 12); Palazzo del Giardino, Parma,

Inventory 1680, 'un quadro alto braccia 1 on. 10½ largo braccia 1 on. 7½. Ritratto di uomo vestito di nero, berretta nera, piccolo collaro al collo, tosone d'oro; si vede la sola destra in cui ha una carta, di Tiziano' (Campori, 1870, p. 235).

Bibliography: See also above; Gronau, *Titian*, 1904 (omitted); Rinaldis, 1911, pp. 150–151, no. 131; 1927, pp. 334–335 (Titian); Fischel, 1924, p. 101 (Titian, much repainted, perhaps Ferdinand I of Austria); *Mostra di Tiziano*, 1935, no. 72 (Titian, *c.* 1533, an important work, perhaps Ferdinand I of Austria); Suida, 1935, p. 84 (Titian original, *c.* 1530–1533); Tietze, 1936, II, p. 302 (probably a copy); Berenson, 1957, p. 189 (Titian); Valcanover, 1960 (omitted); Molajoli, 1964, pp. 45–46, no. 31 (Titian); Valcanover, 1969, no. 323 (workshop; Ferdinand I); Pallucchini, 1969, pp. 127–128, 291, fig. 342 (workshop of Titian, *c.* 1549; perhaps Ferdinand I).

COPY:

Unknown location, panel, 36×28 inches (0·914×0·71 m.), Zetland sale, London, Christie's, 27 April 1934, no. 61; Milford sale, London, Sotheby's, 13 December 1950, no. 100, panel 37½×29¼ inches; said to have belonged to Marchesa Amalia Mancinforti-Spinelli of Ancona and later to Lady Tweedmouth.

X–19. **Charles V in a Brocade Coat**

Canvas. 1·12×0·96 m.

Milan, Private Collection.

Copy.

The poor quality of the picture excludes any possibility that it is an original by Titian, even though the description conforms to a work described by Ridolfi in 1648. The same wrong attribution at Verona is involved here.

History: Muselli Collection, Verona, 1648 (Ridolfi (1648)-Hadeln, I, p. 198); Muselli Inventory, 1662 (Campori, 1870, p. 183).

Bibliography: See also History; C. and C., 1877, II, p. 472 (among lost works); Suida, 1935, pp. 84, 168, pl. 135b (Titian).

OTHER EXAMPLES:

1. Milan, Castello (Suida, 1935, p. 168).
2. Vienna, Kunsthistorisches Museum, panel, 0·26×0·21 m., from Ambras Castle (Engerth, 1884, I, pp. 361–362; an inscription in Italian quoted by Engerth, on the back of the

panel, states that this example was taken by Nicolò Cochnier (*sic*) to R . . . (Rome?); Suida, 1935, p. 168, as a copy).

X–20. Charles V Seated as Holy Roman Emperor

Canvas, 1·61 × 1·06 m.

Milan, Private Collection.

Flemish School.

Sixteenth-seventeenth century.

A Flemish work entirely unrelated to Titian, it was published as the Italian's portrait of Charles done at Bologna in 1530 (Malaguzzi-Valeri, 1912, pp. 237–239).

Charles V, see also: Cat. nos. 20–22 and L–3—L–6.

X–21. Padre Giuliano Cirno

Paper. 0·38 × 0·28 m.

Milan, Brera.

Palma il Giovane.

Formerly attributed to Titian and identified as Sanmichele, the correct names of the man and the painter have been convincingly established by Tietze-Conrat.

Bibliography: C. and C., 1877, II, p. 440 (Bolognese School); Tietze-Conrat, 1946, pp. 378–382 (Palma il Giovane); Modigliani, 1950, p. 50, no. 181 (Palma il Giovane).

X–22. Clement VII

Canvas. 0·953 × 0·724 m.

Unknown location.

Italian School.

Seventeenth century (?).

A work of extreme mediocrity and badly preserved, not possibly by Titian (photograph in the Courtauld Institute, London). Vasari lists Clement VII among the famous men portrayed by Titian (Vasari (1568)-Milanesi, VII, p. 444).

Biography: Clement VII (Giulio dei Medici), pope from 1523 to 1534, was the son of Giuliano, the man murdered in the Pazzi conspiracy, His cousin Leo X elevated him to the rank of cardinal, and he subsequently succeeded Adrian VI as pope. His pro-French policy and his opposition to the imperial Hapsburg forces led to the sack of Rome in 1527. He was obliged to go to Bologna to crown Charles V as Holy Roman Emperor in 1530. Later, however, he swung back to the French party and arranged for the marriage of Catherine dei Medici to Henry of France a year before his death (Philips, 1910, pp. 485–486).

History: Amelot Collection; Orléans Collection, Paris, until 1792 (Dubois de Saint Gelais, 1727, p. 464; Couché, 1786–1788, II, pl. XIII, Titian); Marquess of Stafford (Stafford, 1808, p. 45, no. 37; 1818, II, no. 9, etching; 1825, p. 29, no. 52); by inheritance to Earl of Ellesmere, Bridgewater House, London (Bridgewater, 1907, no. 57); Earl of Ellesmere sale, London, Christie's, 18 October 1946, no. 159 (Titian).

Bibliography: See also above; Buchanan, 1824, I, p. 114 (Titian); Jameson, 1844, p. 131, no. 117 (Titian); Waagen, 1854, II, p. 32 (too feeble for Titian); C. and C., 1877, II, p. 88 (not Titian).

X–23. Admiral Tommaso Contarini

Canvas. 1·22 × 0·981 m.

Narbonne, Musée des Beaux-Arts.

Follower of Tintoretto.

About 1550.

The admiral represented here is Tommaso Contarini on comparison with the inscribed portrait in the William Rockhill Nelson Museum in Kansas City, by a follower of Tintoretto (Kansas City, 1940, fig. 7). The latter composition is nearly full length, whereas the close replica at Narbonne is slightly more than half length. The red drapery and the ruddy flesh tints reinforce the rather fine characterization, although the Narbonne version does not measure up to the quality of the work in Kansas City.

The former identification of the man at Narbonne as Sebastiano Venier has been changed recently in the museum to Tommaso Contarini, whose epitaph on his tomb in S. Maria dell'Orto at Venice gives his dates as 1488–1578. Formerly attributed to Titian, the Narbonne portrait is much closer to Tintoretto, and the date *c.* 1550 is suggested by the man's apparent age of about sixty.

Condition: Darkened but satisfactory.

History: Bequest of Yven to the museum in 1876.

Bibliography: Wickhoff, 1904, p. 117 (Titian); Barthomieu, 1923, p. 131, no. 449 (as Vincenzo Cappello by Titian; see my Cat. no. 17); Fischel, 1924, p. 210 (Sebastiano Venier

by Titian); A. Venturi, 1927, pp. 313–314, illustration (Tintoretto); Berenson, 1957 (not listed).

X–24. **Caterina Cornaro** (so-called)

Canvas. 1·24×0·82 m.

Vienna, Kunsthistorisches Museum.

Follower of Veronese (Antonio Badile?).

About 1560.

A mediocre work which has been attributed to various masters, mostly to Veronese, but which is too poor for him or for Titian, to whom Longhi and the Vienna museum now attribute it. The rigid pose, the large flat red area on the right side of the face, and the whole technique are inferior.

Bibliography: Storffer, 1730, II, p. 125 (Veronese); Mechel, 1783, p. 12, no. 42 (Veronese); Engerth, 1884, I, p. 414, no. 589 (Veronese); Wickhoff, 1893, pp. 136–138 (Antonio Badile); Longhi, 1927, pp. 216–220; also edition 1967, p. 242 (Titian); Vienna, 1938, no. 725 (G. A. Fasolo); Berenson, 1957, p. 139 (Veronese, early); Klauner and Oberhammer, 1960, p. 146, no. 725 (Titian); Valcanover, 1960, II, p. 73 (not Titian); *idem,* 1969, no. 498 (doubtful attribution).

Caterina Cornaro, see also:
Queen Caterina Cornaro, Cat. no. L–9.
La Schiavona, Cat. no. 95.
Venetian Girl, Cat. no. X–112, and related work, no. 2.

X–25. **Hernán Cortés**

Canvas. 0.585×0.47 m.

London, Lady Isabel Browne (formerly).

Anonymous. Sixteenth century.

The identity of the sitter in bust length has been securely established by Count Seilern, but the tentative attribution of the picture to Titian is not convincing. It rests primarily upon an inscription on George Vertue's engraving of 1724, in which the same figure is labelled 'Ex pictura Titiani'. In a photograph the portrait appears dry and mediocre (Browne sale, London, Christie's, 12 March 1948, no. 109, £21; anonymous sale, London, Christie's, 4 August 1950, no. 148, 8 guineas).

Bibliography: Seilern, 1969, pp. 11–14.

VARIANT:

London, Count Seilern; canvas, 0.975×0.765 m.; copy by Rubens in slightly more than half length. No doubt Rubens'

model was a Renaissance original, which, however, suggests Antonio Moro to a greater degree than Titian. *Bibliography:* Seilern, *loc. cit.*

X–26. **Courtesan** (so-called)

Panel. 0·317×0·241 m.

Los Angeles, California, Norton Simon Foundation.

Giorgione.

About 1505.

The title *Courtesan* for this little picture rests upon the costume, consisting of the undergarment (*camicia*) in low-cut disarray, over which she wears a scarf or stole of white decorated with blue and reddish stripes. The blue is repeated by the ribbon in her hair, loosely dressed with free strands on each cheek as in the portrait of *Laura* in Vienna and in the head of the girl of *The Tempest.* The garland of green leaves and tiny white flowers and the thin gold band with jewelled ornament on the centre of her forehead may indicate that the girl is in theatrical or pageant dress (see Mellencamp, 1969, p. 177).

No complete agreement has been reached among scholars as to whether Giorgione or Titian painted this so-called *Courtesan.* The close similarity to the girl in Giorgione's *Tempest* in Venice and some relationship to his *Laura* are compelling reasons in favour of Giorgione, whereas no such traits exist in Titian's early work. Pignatti's arguments in favour of Titian are based on pictures which other writers attribute to Giorgione, i.e. *Christ and the Adulteress* in Glasgow, or to his school, i.e. the *Madonna and Child* in Bergamo (Wethey, I, 1969, no. X–4; p. 174, no. X–18). Berenson, who in 1932 assigned the work to Titian, switched to Giorgione in 1957.

Condition: The figure has suffered greatly in the lower part of the breast and on the hand.

History: James Howard Harris, 3rd Earl of Malmesbury, London, 1876; William Graham, London, 1886; Prince Karl von Lichnowski (German Ambassador in London, 1912–1914), Kuchelna, Hultschin, Czechoslovakia; Sir Alexander Henderson, 1914; Paul Cassirer, Berlin; Sir Alfred Mond, 1st Baron Melchett, Romsey, Hampshire (died 1930); Sir Henry Mond, 2nd Baron Melchett, Sharnbrook, Bedfordshire; Duveen Brothers, New York, 1928; purchased by Norton Simon from Duveen in 1964.

Bibliography: Baldass, 1929, pp. 104–106 (Cariani); London, 1930, p. 207, no. 367 (Titian); Berenson, 1932, p. 575 (early Titian, then at Romsey); Mayer, 1932, pp. 376–377 (Giorgione); Richter, 1932, pp. 123–132 (Giorgione);

Suida, 1935, pp. 16, 162 (Titian); Richter, 1937, p. 226 (Giorgione); Tietze, 1940, no. 25 (Giorgione); Zampetti, 1955, p. 56, no. 24 (Giorgione); Berenson, 1957, p. 84 (Giorgione); Coletti, 1961, pl. 40 (Giorgione); Heinemann, 1962, I, p. 122, no. 217, fig. 552 (Rocco Marconi!); Gilbert, 1963, pp. 14–16 (Giorgione); Pignatti, 1969, p. 119, no. A14 (Titian); Pallucchini, 1969 (omitted).

X–27. **Francesco Donato, Doge of Venice** Plate 236
Canvas. 1·003 × 0·794 m.
San Diego (California), Fine Arts Gallery.
Copy or workshop of Titian.
About 1546–1553.

Francesco Donato, Doge of Venice in 1545–1553, was presumably portrayed by Titian after the artist's return from Rome in 1546, yet the present work hardly measures up to the master's standards. A letter of Aretino in Venice to Titian at Rome, dated January 1546, is interpreted as containing an oblique reference to painting a portrait of the new Doge Donato (*Lettere*, edition 1957, II, p. 131), who succeeded Pietro Lando after the latter's death in November 1545.

Biography: The long and distinguished career of Francesco Donato (1468–1553) included several appointments as ambassador, to Spain in 1504, to England in 1509, and to Florence in 1512. He held numerous posts in the Venetian government, yet his support of the arts and letters was equally significant. As Doge (1545–1553) he kept Venice at peace, and the public works on the Ducal Palace, the Mint, and the Library of St. Mark's consequently moved forward rapidly (Cicogna, 1824, I, pp. 60–62).

Condition: Satisfactory.

History: Lord Battersea, London; Sir Anthony de Rothschild, London; Misses Anne and Amy Putnam, San Diego; gift to the museum in 1941 (San Diego, 1960, p. 65).

Bibliography: See also above; Tietze-Conrat, 1946, p. 82, illustration (Titian, sketch); Suida, 1946, pp. 139–141 (Titian); Tietze, 1950, p. 396 (Titian); Berenson, 1957, p. 190 (Titian, 1546); San Diego, 1960, p. 65 (Titian); Valcanover, 1960, p. 53 (portrait of 1546 as lost), p. 65 (San Diego portrait as doubtful); Morassi, 1967, p. 143 (copy); Longhi, 1968, p. 63 (replica); Valcanover, 1969, no. 619 (attributed); Pallucchini, 1969, p. 115 (not Titian).

OTHER VERSIONS:
1. Florence, private collection; canvas, 1·11 × 0·87 m., nearly identical to the San Diego portrait (Longhi, 1968, p. 63, Titian).
2. Stockholm, Bukowski sale, April 1961, no. 184; canvas, 1·19 × 0·96 m., hard, poor copy (Courtauld photo); expertises by Gronau and Fiocco; earlier Paris, L. Birtschausky (1930), canvas, 1·25 × 0·90 m.

LOST PORTRAIT:
Venice, Sala del Maggiore Consiglio (destroyed 1577); payment to Titian 27 May 1547 (Lorenzi, 1868, p. 259).

X–28. **Gian Andrea Doria** (so-called)
Canvas. 2·00 × 1·04 m.
Florence, Contini-Bonacossi Collection.
Italian School.
Late sixteenth century.

The identification of the sitter as Gian Andrea Doria (1539–1606), a younger relative of the famous Andrea Doria (1466–1560), was made by Suida, and this mediocre canvas attributed to Titian. Suida's theory that this portrait commemorates the battle of Lepanto (1571) and was one of three painted by Titian for that purpose, the others being Philip II (Cat. no. 84) and the Turkish Potentate (Cat. no. X–106), even forces the reasonable boundaries of fantastic speculation (Suida, 1952, pp. 40–41).

History: Balbi di Piovera Collection, Genoa, until about 1950.

Bibliography: See also above; Suida, 1934, pp. 272–273 (Titian, 1571); Suida, 1935, pp. 102, 114, 182, pls. 284, 334 (Titian, 1571); Valcanover, 1960, II, p. 73 (doubtful attribution); *idem,* 1969, no. 591 (doubtful attribution); Pallucchini, 1969, p. 206 (perhaps by Giovanni Contarini).

X–29. **Elderly Man**
Canvas. 0·584 × 0·433 m.
England, Private Collection.
Modern forgery.

Bibliography: Borenius, 1942, pp. 133–134 (late Titian); Valcanover, 1960, II, p. 73 (wrong attribution); *idem,* 1969, no. 601 (wrong attribution).

X–30. **Elderly Patrician**
Canvas. 0·92 × 0·78 m.
Genoa, Palazzo Rosso.
North Italian School.
Sixteenth century.

This portrait of a man dressed in a reddish-black costume with fur cuffs and wearing a golden chain is too mediocre to be taken seriously, even by the museum, where it is labelled 'attributed to Titian'. Bonifazio Veronese might be a possible attribution.

History: Palace of Anton Giulio Brignole, called the Palazzo Rosso (Ratti, 1780, I, p. 252, Titian).

Bibliography: See also above; Grosso, 1932, p. 43 (school of Titian); Suida, 1935, p. 91, pl. 141 (Titian); Berenson, 1957, p. 186 (Titian?); Pallucchini, 1969, p. 223, fig. 671 (follower of Titian).

X–31. Isabella d'Este and Son (so-called)
Canvas.
London, Lord Melchett, Alfred L. Mond (formerly).
Paris Bordone (?).

Apparently the same composition as Cat. no. X–32. This item may be the picture sold in London, Puttick's, 22 June 1932; canvas, 0.99 × 0.863 m. (*APC*, XIA, 1931–1932, no. 4018).

Bibliography: Gronau, 1895, p. 435 (Pordenone); Luzio, 1900, p. 434 (mention); Berenson, 1957, p. 187 (copy of Titian).

X–32. Isabella d'Este and Son (so-called)
Canvas. 0.97 × 0.77 m.
Leningrad, Hermitage (in storage).
Paris Bordone.

She wears a green brocaded dress adorned with ribbons and a roll fur headdress. Another version in Vienna is given to Pietro della Vecchia: canvas, 1.03 × 0.84 m. (Engerth, 1884, I, pp. 386–387; Stampart, 1735, pl. 6 illustrated). Still other variants are listed by Crowe and Cavalcaselle, 1877, I, pp. 387–388.

Bibliography: C. and C., 1877, I, p. 387 (possibly an injured Titian); Somof, 1899, p. 28, no. III (Paris Bordone); Luzio, 1900, p. 433, illustrated; Leningrad, 1958 (not listed); Canova, 1965, p. 104, fig. 79 (Paris Bordone).

Isabella d'Este, see also: Cat. nos. 27 and L–11.

X–33. Cardinal Alessandro Farnese — Plate 130
Panel. 0.51 × 0.48 m.
Tivoli, Villa d'Este, Quadreria.
Roman School.
Sixteenth century.

The cardinal's red costume is set against a green curtain at the right and a brown background at the left. Nothing about this portrait suggests the hand of Titian, as the hard solid surfaces and the handling of paint are technically those of a Roman Mannerist. Carpegna suggested Perino del Vaga as the possible author, primarily because he worked for the Farnese family in decorating the Sala Paolina in the Castel Sant'Angelo. An attribution to Raphael appears on an eighteenth-century engraving by Rossi, subsequent to which Crowe and Cavalcaselle suggested the name of Titian. The writers who have accepted this proposal could never have seen the original painting. The pose of the head and the position of the hat are based directly upon Alessandro in *Paul III and Grandsons* (Plate 129).

Condition: The red *berretta* has been entirely repainted in a deeper colour than the cardinal's cape. Damage and inpainting are visible on the nose and beside the right eye. The moustache has been retouched as though with pencil. Numerous scars and scratches have been repaired, and a piece of wood about four centimetres broad at the top and two centimetres at the bottom has been added at the right side for the full height of the panel. Restored in 1954.

History: Gift of Prince Corsini in 1883 to the Galleria Nazionale, Rome; on loan at the Villa d'Este.

Bibliography: Milanesi, 1885, in Vasari (1568)-Milanesi, p. 447, note; C. and C., 1877, II, p. 90 (Titian); Gronau, 1929, p. 46 (Titian); Suida, 1935, pl. 150a (Titian); Tietze, 1936, II, p. 308 (Titian, 1543); Carpegna, *c.* 1955, p. 4 (perhaps Perino del Vaga); Berenson, 1957 (omitted); Valcanover, 1960, II, p. 64, pl. 148B (attributed); *idem*, 1969, no. 276 (doubtful attribution); Pallucchini, 1969, p. 286 (perhaps by Perino del Vaga).

Cardinal Alessandro Farnese, see also: Cat. no. 29.

X–34. Pierluigi Farnese — Plate 252
Panel. 0.99 × 0.76 m.
Naples, Royal Palace.
Roman School.
About 1540.

The solid, hard quality of the painting does not resemble Titian's work or the Venetian school in general. If not by a Roman painter, it might be the work of an artist of Parma, as previously proposed by Suida. Against a brown curtain Pierluigi stands, sword in the left hand and the baton of a commander in the right. His white moiré silk costume,

broad dark-sable collar and cuffs, and the black cap with white plume are painted with flourish and attention to details, none of which fit Titian's style.

Condition: Much darkened and somewhat dirty.

History: Presumably Palazzo Farnese, Rome; Palazzo del Giardino, Parma, Inventory, 1680, as Titian (Campori, 1870, p. 230).

Bibliography: C. and C., 1877, II, pp. 88–89 (Titian, 1543); Gronau, *Titian,* 1904, p. 137 (artist unknown); Clausse, 1905, pp. 121–127 (Titian, 1543); Rinaldis, 1911, p. 149 (Titian); *idem,* 1927, p. 333 (Titian); Longhi, 1925, pp. 48–50 (Titian); *Mostra di Tiziano,* 1935, no. 59 (Titian); Dussler, 1935, p. 238 (close to Sebastiano del Piombo and Parmigianino); Suida, 1935, p. 105 (Titian, *c.* 1535); Suida, 1936, p. 102 (Girolamo Bedoli Mazzola); Tietze, 1936, pp. 302–303 (not Titian); Berenson, 1957, p. 189 (Titian; restored); Valcanover, 1960, I, p. 104 (with wrong location; attributed); *idem,* 1969, no. 235 (still wrong location; commonly attributed); Pallucchini, 1969 (omitted).

COPY:
Rome, Castel Sant'Angelo, Hall of Psyche and Cupid, modern copy, size of the Naples picture.

Pierluigi Farnese, see also: Cat. nos. 30 and L–15.

X–35. **Vittoria Farnese** (so-called) Plate 263
Panel. 0·80×0·615 m.
Budapest, Museum of Fine Arts.
Italian School.
About 1550.

This extraordinarily handsome picture shows the lady dressed in a black gown with white partlet, holding her pale tan veil with her exquisitely drawn right hand, on the fourth finger of which is a ring with a sapphire gem. The left hand grasps the end of the long veil. In beauty of design and draughtsmanship and in elegance of interpretation this portrait ranks among the masterpieces of the Italian Renaissance. Nevertheless, its authorship has not yet been established. Berenson and Gombosi were the most ardent champions of Titian's authorship, yet the non-Venetian character of the design and painting technique is now widely acknowledged, and even the authorities of the Budapest Museum regard the work as anonymous. The recent suggestion that Lambert Sustris was the painter (Ballarin, 1968, pp. 246–247) offers another possibility, yet that German follower of Titian did not usually rise to such heights.

The identification of the lady as Vittoria Farnese stems from the fact that the panel formerly belonged to the Farnese Collection (see History), where the picture was given to Titian but the sitter was not named. Gombosi (1928, pp. 55–61) insisted upon Vittoria Farnese, comparing the Budapest portrait with a lady by Bronzino in the Uffizi at Florence, who is now considered to be unidentified, although formerly called Vittoria Colonna (*sic*). A certain portrait of Vittoria Farnese (*sic*) at Urbino, published by Gombosi, does not help solve the problem.

Another candidate, nominated by A. L. Mayer, is considerably less acceptable, that is, Clelia Farnese (1556–1613), natural daughter of Cardinal Alessandro Farnese (Cat. no. L–13). Her generation is too late to be associated with the Budapest portrait. Mayer called attention to the item cited in the lottery sale of Niccolò Renieri on 4 December 1666 (Savini-Branca, 1964, p. 99; also Segarizzi, 1914, p. 178, no. G4) as 'a most beautiful lady dressed as a widow, said to be Clelia Farnese ... by Titian'. That work fails to fit the situation on all points. It is most improbable that the Farnese family would have acquired the Budapest panel at that late date. Moreover, the lady is not dressed as a widow. The long veil appears frequently in Italian portraits from Raphael (*La Donna Velata* in Florence) through Bronzino, Pontormo, and the north Italian Moroni, but not commonly in Venice. A widow's veil was entirely different in arrangement, being drawn tightly under the chin and covering the breast in a fashion reminiscent of nun's garb (Vecellio, 1598, 'Delle vedove', p. 103).

Biography: Vittoria Farnese (1519–1602), the first child of Pierluigi Farnese (Cat. no. 30) and Girolama Orsini, was reared at Rome and considered a major prize for a matrimonial alliance. Nevertheless, she did not marry until 1547, becoming the second wife of Guidobaldo II della Rovere, Duke of Urbino (Cat. no. 91). The papacy had repeatedly tried to annex this state. Widowed in 1574 at the age of fifty-five, she remained adviser to her son Francesco until her death in 1602 (Clausse, 1905, p. 297).

History: Farnese Collection; on the back of the Budapest picture the large Farnese lily and the letters G. F. (Galleria Farnese) are stamped, thus establishing the provenance without any question; Palazzo Giardino, Parma, Inventory 1680: 'Un quadro alto braccia uno once 6, largo braccia 1 once 2 in tavola [about 0·682×0·65 m.], ritratto di donna vestita di nero con manto di vello che va acommodando vicino alle mamelle con la destra, in cui un anello, nella sinistra un facioletto di Tiziano'; Palazzo del Giardino, Inventory about 1700, no. 111; Inventory 1708, no. 355,

pictures at Colorno, a summer palace of the Farnese (last two inventories in Archivio di Stato, Parma, published by Gombosi, 1928, p. 57); the lack of further references in the Farnese inventories implies that the portrait was given away or lost when the collections were transferred to Naples in the eighteenth century; gift to Budapest of Count János Pálffy in 1912.

Bibliography: See also above; Térey, 1924, no. P. 86 (Scipione Pulzone); Berenson, 1926, pp. 153–162 (a lady by Titian, 1545–46); Gombosi, 1928, pp. 55–61 (Vittoria Farnese by Titian; lengthy study); A. Venturi, 1934, p. 780 (Scipione Pulzone); *Mostra di Tiziano*, 1935, no. 66 (Titian, 1545–1546); Suida, 1935, pp. 105, 169 (Titian); *idem*, 1936, p. 104 (not Vittoria Farnese; by Giuseppe Salviati); Norris, 1935, p. 128 (not Titianesque); Tietze, 1936, II, p. 285 (not Venetian); Pigler, 1937, p. 259 (Titian?); Mayer, 1937, p. 309 (Clelia Farnese by a Mannerist of Parma); Pallucchini, 1954, II, p. 27 (Parmese copy of Titian); Berenson, 1957, p. 184 (Titian, 1546); Valcanover, 1960, II, p. 64 (doubtful attribution); Garas, 1965, pl. 22 (north Italian, mid-sixteenth century); Pigler, 1967, p. 329, no. 4213 (Vittoria Farnese, north Italian, mid-sixteenth century); Dresden, 1968, pp. 62–63 (Italian School, mid-sixteenth century); Ballarin, 1968, pp. 246–247 (Vittoria Farnese by Lambert Sustris at Venice *c.* 1542); Valcanover, 1969, no. 585 (Vittoria Farnese?, doubtful attribution).

X–36. **Father and Son**
Canvas. 1·22×0·965 m.
Padua, Private Collection.
Giulio Licinio.
Dated 1552.

An inscription, now repainted, is said to have read J L F and to have included the date MDLII; other inscriptions 'Anno Aetatis XXX' and 'Aetatis S. VIII' must refer to the ages of father and son respectively. The interpretation of the letters as 'Giulio Licinio Fecit' remains hypothetical, since little is known of the portraiture of this minor master (Arslan, 1929, p. 194). Dr. Canova's attribution of the picture to Paris Bordone merits serious consideration, while Bologna's attempt to upgrade this unpleasant work to Titian has not been accepted.

Condition: Overcleaned about 1950; the letters J. L. F. were changed to T V F (Titianus Vecellio Fecit).

History: G. A. F. Cavendish Bentinck, London,; Clark sale, London, Sotheby's, 9 July 1922, no. 58; bought by Agnew & Co.; recent history unrecorded: Genoa(?).

Bibliography: See also above; Bologna, 1957, pp. 65–70 (Titian); Valcanover, 1960, II, pl. 154 (wrong attribution); Heinemann, 1963, p. 67 (Giulio Licinio, 1552); Canova, 1964, pp. 101–102, pl. 113 (Paris Bordone); Valcanover, 1969, no. 351 (attributed to Titian).

X–37. **Emperor Ferdinand I's Daughters**
Canvas. 1·27×1·17 m.
Henfield (Sussex), Henfield Place, Lady Salmond (1969).
Venetian School (?).
Mid-sixteenth century.

It is difficult to discover Titian's hand in this picture. In a letter written at Innsbruck on 20 October 1548 Titian promised to finish the portraits of Ferdinand's daughters within two days (C. and C., 1877, II, pp. 189–190, 503), but no evidence exists to determine the type of composition that he may have used. The references to Titian's portraits of Ferdinand's daughters in Mary of Hungary's Inventory of 1556 (edition 1856, p. 141, nos. 27–30) concern four separate canvases, yet it must be admitted that attributions in these inventories are not always reliable.

Possible history: The Inventory of 1561 of Charles V's possessions in the castle at Simancas includes a portrait of two daughters and one son of Ferdinand in a single canvas without mention of the painter (Beer, 1891, p. CLXXIII, no. 199). The description might apply to a version of the present composition.

Known history: Acquired in Italy by George Nathan, third Earl of Cowper, who placed it in his gallery at Panshanger, near Hertford (Waagen, 1854, III, p. 12); by inheritance to Baron Desborough (died 1945); by inheritance to his daughter Lady Salmond, since 1953.

Bibliography: C. and C., 1877, II, pp. 190–191 (mostly by Cesare Vecellio; repainted); Tietze, 1936, II, pp. 304–305, fig. 199 (tentative attribution, perhaps a copy); Pallucchini, 1954, II, p. 41 (workshop of Titian); Valcanover, 1960, II, p. 54 (school of Titian); Pallucchini, 1969, p. 223, fig. 676 (workshop of Titian).

X–38. **Girolamo Fracastoro** (so-called) Plate 271
Canvas. 1·01×0·80 m.
Verona, Museo Civico di Castelvecchio.
Orlando Flacco (Fiaco).
About 1555.

This portrait, after having been attributed to Lorenzo Lotto and to Giovanni Battista Moroni, first passed to Titian in Berenson's list of 1895, where it was identified as Ferdinand King of the Romans! The theory that the gentleman is Girolamo Fracastoro was ardently advanced by Schaeffer (1910, pp. 130–138) on comparison with prints and a medal. With even greater vigour Giuseppe Gerola (1910) rejected the identification by comparison with other certain portraits of the scientist, and his opinion prevails today. Furthermore, the belief in Titian's authorship has been widely doubted by nearly all recent writers save Berenson.

The attribution to Orlando Flacco by Dr. Lanfranco Franzoni of the Verona Museum is new. It convinces on comparison with Flacco's signed portrait of *Titian* in Stockholm (Plate 272).

Biography: Girolamo Fracastoro (1478–1553), scientist and writer, a fellow student of Copernicus, studied at Padua. His greatest claim to fame lies in his research on contagious diseases; in effect he is regarded as the founder of modern medicine in that field (Castiglioni and Calcaterra, 1932, pp. 829–830).

History: Bevilacqua Collection, Verona; Count Bernasconi, gift to the museum in 1871.

Bibliography: Vasari (1568)–Milanesi, VII, p. 455 (includes a portrait of Fracastoro by Titian); Ridolfi (1648)–Hadeln, I, p. 192 (repeats Vasari; Hadeln rejects the Fracastoro identification); Berenson, 1895 and 1906, p. 145, no. 51; Schaeffer, 1910, pp. 130–138 (Fracastoro by Titian); Gerola, 1910, pp. 1–9 (Titian); Treccia, 1912, p. 117, no. 51 (Titian?); Berenson, 1932, p. 576 (Titian); Suida, 1935, pp. 111, 174 (Titian); *Mostra di Tiziano*, 1935, no. 45 (Castracane gentleman by Titian); Tietze, 1936, II, p. 314 (uncertain attribution); Berenson, 1957, p. 191 (Gentleman, by Titian); Valcanover, 1960, I, p. 104; *idem*, 1969, no. 624 (not Titian); Pallucchini, 1969, p. 204, fig. 625 (Lorenzo Lotto); Franzoni, article in preparation according to the Verona director, L. Magagnato, in a letter of 18 December 1969 (Orlando Flacco).

X–39. Andrea dei Franceschi Plate 253
Canvas. 0·863×0·686 m.
Indianapolis, Clowes Foundation.
Venetian School.
About 1550.

Franceschi (1472–1551; see Cat. no. 34 for biography) appears here as a very old man with completely white hair and beard. This mechanical portrait surely has no suggestion of Titian's hand.

Condition: Considerably restored.

History: Collection of Major and Mrs. Bono, Florence.

Bibliography: Suida, 1956, p. 76 (Titian); Berenson, 1957, p. 184 (questioned); Indianapolis, Clowes, 1959, no. 55 (Titian); Valcanover, 1960, II, p. 66 (doubtful); *idem*, 1969, no. 157 (doubtful attribution); Pallucchini, 1969, p. 223, fig, 672 (follower of Titian).

Andrea dei Franceschi see also: Cat. nos. 34, 35, and X–103.

X–40. Franciscan Friar
Canvas. 0·66×0·572 m.
Bowood (Wiltshire), Marquess of Lansdowne.
Girolamo Romanino (?).
About 1550.

The turn of the head and its position against heavy white clouds suggest Romanino as the possible author of this fragment.

History: Sir Robert Price; exhibited at Agnews, London, in 1955.

Bibliography: Pallucchini, *Arte veneta*, 1953, p. 210 (Titian, about 1550–1560; fragment); Berenson, 1957, p. 184 (Titian); Valcanover, 1960, II, p. 69, pl. 167A (doubtful attribution); *idem*, 1969, no. 408 (recently attributed); Pallucchini, 1969, p. 313, fig. 467 (Titian, *c.* 1560–1565, fragment).

X–41. Franciscan Friar
Canvas. 0·844×0·746 m.
Melbourne, National Gallery of Victoria.
Venetian School.
Mid-sixteenth century.

Without seeing this picture, which looks very dull in a photograph, it would be hazardous to express a firm opinion as to authorship.

Condition: Badly preserved.

History: Purchased in Italy by Thomas Agnew and Sons; acquired by Melbourne 1924 (Hoff, 1961, p. 130).

Bibliography: Hadeln, 1924, p. 179 (Titian, *c.* 1550); Fischel, 1924, p. 219 (Titian, *c.* 1550); Suida, 1935, p. 174, pl. 207B (Titian); Tietze, 1936, II, p. 301 (Titian, *c.* 1550); Pallucchini, 1954, II, p. 55 (Titian, *c.* 1550); Berenson, 1957, p. 188 (Titian); Hoff, 1961, p. 130 (Titian); Valcanover, 1960, II, pl. 47B (Titian); Valcanover, 1969, no. 343 (Titian, 1551); Pallucchini, 1969, p. 297, fig. 372 (Titian, *c.* 1550–1552).

X–42. **Fugger Youth** (so-called) Plate 11
Panel. 0·695×0·528 m.
Munich, Alte Pinakothek.
Giorgione.
About 1510.

An inscription of uncertain date on the back of the picture, 'Giorgion de Castel Franco F, Maestro de Titiano', is partly responsible for the traditional attribution to Giorgione. It is also supported by Ridolfi's description of a *Fugger Youth* dressed in fox fur, side view in the act of turning, 'un tedesco con pelliccia di volpe in dosso in fianco in atto di girarsi'. A number of scholars have accepted the Munich picture as the work of Giorgione described by Ridolfi (Hadeln, I, p. 106 note 2; Richter, 1937, p. 229). The attempt to associate it with a *Self-Portrait* by Palma il Vecchio described by Vasari is wide of the mark (Milanesi edition, v, pp. 246–247; an idea advanced by Milanesi, *loc. cit.*, note I and also by Crowe and Cavalcaselle, 1871, II, p. 482). Nothing about the pose of this handsome youth suggests a painter, who traditionally would hold a brush or some other mark of his profession. Moreover, Palma (1480–1528) at the age of thirty would not have looked so young.

The belief that the Munich youth was a member of the famous Augsburg family of bankers, the Fugger, was also transmitted by Wenzel Hollar (Plate 218) in his engraving (1650) made when the panel belonged to the Antwerp collector, Van Werle. One copy is labelled 'Ritratto d'un Todescho di casa Fucharo'. Another copy of the print, however, carries a label 'Ritratto di Bonamico Buffalmaco'. Another reference by Vasari to a portrait in oil by Giorgione in his book of drawings of 'un tedesco di casa Fucheri' cannot be pertinent because of the small size of the drawing and the medium of the Munich composition (Vasari (1568)-Milanesi, IV, p. 99).

The style and energetic mood of the Fugger youth are remarkably like the *Bravo* in Vienna, there assigned to Titian, whereas Berenson considered both to be Palma il Vecchio's copies after Giorgione. Whatever one's opinion of authorship may be, Ridolfi's description corresponds exactly to the Munich portrait.

The greyish-brown fur coat, red sleeve, and long dark-brown hair of the young man, who holds gloves in his right hand, stand against a green background in the form of a stone wall. At the left is an arched doorway and at the upper right an oculus window, which recalls the fact that Titian's portrait of *La Schiavona* (Plate 13) had a half-oculus in that position, as recent X-rays reveal.

Condition: Various surface damage and crackle.

History: Van Werle Collection, Antwerp (engraved by Wenzel Hollar, *c.* 1650; see Parthey, 1853, no. 1367); Kurfürstliche Galerie, Munich (from 1748).

Bibliography: See also above; C. and C., 1871, II, p. 482 (Palma's *Self-Portrait*); Reber, 1890, p. 223, no. 1107 (Palma il Vecchio's *Self-Portrait*); Morelli, 1891, III, pp. 30–31 (Fugger portrait by Cariani); L. Venturi, 1913, p. 174 (Palma il Vecchio); L. Justi, 1925, II, pp. 336–342 (perhaps Giorgione); Venturi, 1928, IX, part 3, pp. 490–491 (Domenico Mancini?); Spahn, 1932, pp. 131, 174 (probably by Giorgione); Wilde, 1933, pp. 117–120 (Master of the Self Portraits); Suida, 1935 (omitted); Tietze, 1936 (omitted); Richter, 1937, p. 229 (follower of Giorgione); Zampetti, 1955, p. 122, no. 52 (Giorgione); Pergola, 1955, pl. 106 (anonymous); Berenson, 1957, p. 125, no. 524, pl. 684 (Palma il Vecchio after Giorgione); Munich, 1958, p. 41, no. 524 (Giorgione); Baldass and Heinz, 1965, p. 171, no. 32 (follower of Giorgione); Mariacher, 1968, p. 103 (not Palma); Valcanover, 1969, no. 610 (Palma il Vecchio); Pallucchini, 1969, p. 242, fig. 72 (Titian, *c.* 1512); Pignatti, 1969, p. 126, no. A32 (Fugger portrait by Titian); Dussler, 1970, p. 550 (Giorgione).

X–43. **Antonio Galli** (1510–1561)
Canvas. 1·075×0·84 m.
Copenhagen, Royal Museum of Fine Arts.
Federico Barocci.
About 1555.

Although this canvas bore a traditional attribution to Titian, the style proves it to be unquestionably the work of Barocci, as Olsen has clearly demonstrated.

Condition: Excessively restored.

History: (reconstructed by Harald Olsen, 1962): probably painted at Urbino about 1555; purchased by Clement XI, pope from 1700–1721; Orazio Albani, brother of the pope; Consul West, catalogue of 1807; purchased in 1809 from the West Collection by Copenhagen.

Bibliography: Spengler, 1827, no. 138 (Titian); Madsen, 1898, p. 296 (identified as Francesco Maria della Rovere); see Copenhagen, 1951, p. 316, no. 710 (Titian); Berenson, Suida, Tietze (omitted); Pallucchini, 1954, II, p. 117 (Titian, *c.* 1565); Valcanover, 1960, II, p. 68, pl. 163b (doubtful attribution to Titian); Olsen, 1961, p. 37 (Barocci); *idem,* 1962, pp. 101, 140–142 (Barocci); Valcanover, 1969, no. 442 (commonly attributed, 1562); Pallucchini, 1969, pp. 311–312, fig. 458 (Titian, 1561–1562).

X–44. **Gentleman with Gloves** Plate 214

Canvas. 0·87×0·73 m.

Ajaccio (Corsica), Musée Fesch.

Giorgionesque painter (Cariani?).

About 1515.

The classification of 1683 as in the manner of Giorgione is closest to the truth. Although the gloves recall Titian's *Man with the Glove* (Plate 29), the quality in general seems well below the master's.

Condition: Enlarged to 0·90×0·73 m.

History: Jabach Collection; Louis XIV, Le Brun's Inventory 1683, no. 50 (as manner of Giorgione); Inventory 1695; Hôtel d'Antin, Paris, 1715 (history by Bailly Engerand, 1899, p. 66); on loan from the Louvre to Ajaccio since 1956.

Bibliography: Suida, 1930, pp. 83–84 (early Titian); *idem,* 1935, pp. 34, 161 (early Titian); Zampetti, 1955, no. 77 (early Titian); Berenson, 1957, p. 183 (early Titian); Valcanover, 1960, I, p. 98, fig. 206A (doubtful attribution); Paris, 1966, p. 233 (full account as Titian by Pierre Rosenberg); Valcanover, 1969, no. 90 (commonly attributed, 1517–1520); Pallucchini, 1969, p. 258, figs. 167–168 (Titian, *c.* 1520–1522).

X–45. **Gentleman in a Beret**

Canvas. 0·58×0·45 m.

Besançon, Musée des Beaux-Arts.

Giorgionesque painter.

About 1515.

The quality of the picture is too pedestrian to merit its recent upgrading to Titian.

History: Dr. Rinecker, University of Würzburg (sale, Paris, 30–31 March 1868, no. 106, as school of Titian); Jean Gigoux, Paris, his gift to the Besançon Museum in 1896 (Paris, 1966, p. 233, no. 283).

Bibliography: Paris, 1966, p. 233, no. 283, illustrated (as Titian) Ballarin, 1965, p. 239 (Titian).

X–46. **Gentleman** (so-called Raphael)

Canvas. 0·825×0·645 m.

Geneva, Filiginetti Collection.

Italian School.

About 1515.

A mediocre picture, this portrait reveals no personal characteristics of Titian's art. The Central Italian formula explains the earlier identification of the sitter as Raphael, a theory now universally abandoned.

History: Supposedly Count Mexborough; Lady Saville, London (as given in Stockholm, 1962–1963, p. 92); Liechtenstein, private collection (sale, London, Christie's, 29 November 1968, no. 75).

Bibliography: Suida, 1935, p. 161, pl. 63b (an engraving of this picture, identified as a portrait of Raphael by Titian); Morassi, 1956, pp. 129–130 (Titian); Pallucchini, 1958, pp. 63–69, colour print (Titian); Valcanover, 1960, I, p. 97 (doubtful attribution); Stockholm, 1962–1963, pp. 91–92 (Titian); Nicolson, 1963, p. 31 (uncertain attribution); Valcanover, 1969, no. 92 (Titian, *c.* 1518–1520); Pallucchini, 1969, pp. 252–254, figs. 132–133 (Titian, *c.* 1518–1520).

X–47. **Gentleman with a Large Book**

Canvas. 0·978×0·825 m.

New York, Mrs. Rush H. Kress.

Giovanni Cariani.

About 1520.

History: Leuchtenberg Collection, Munich and St. Petersburg (1852–1903); Contini-Bonacossi Collection, Florence; acquired by Kress in 1929.

Bibliography: Zampetti, 1955, no. 97 (Cariani); Morassi, 1956, pp. 128–129 (early Titian); Berenson, 1957, p. 55 (Cariani); Valcanover, 1960, I, p. 93 (doubtful attribution to Titian); Heinemann, 1962, I, p. 145, no. 374 (Andrea Previtali, *c.* 1514); Shapley, 1968, pp. 168–169 (Cariani; full data as to history and attribution); Valcanover, 1969, no. 15 (uncertain attribution).

X–48. Gentleman
Canvas. 1·105×0·902 m.
Paris, Arthur Sachs.
Girolamo Savoldo.
About 1538.

According to A. L. Mayer the remains of Titian's signature and the date 1538 are discernible at the lower right. The style of the portrait does not appear to confirm that supposition but rather suggests Girolamo Savoldo, whose portrait of a *Knight* in the National Gallery of Art at Washington is very similar in general style, in colour, and in the handling of the brush (Shapley, 1968, p. 89, fig. 216). The rose curtain at the left and the oriental rug provide the major elements of colour against the black costume trimmed or lined with fur, and the light greenish wall behind.

Possible History: A portrait of a man said to have been signed by Titian, size 1·05×0·87 m., was in the collection of the Infante Sebastián Gabriel de Borbón at Pau (Catalogue, Pau, 1876, p. 76, no. 678). The size of the Sachs picture closely approximates that work.

Known History: Durlacher Gallery, New York, c. 1926.

Bibliography: Mayer, 1926, pp. 63–64, colour reproduction (Titian, 1538); L. Venturi, 1931, pl. 381; Berenson, 1955, p. 140 (Lotto); Howe, 1947, pp. 34–36 (Titian, c. 1533–1538).

X–49. Gentleman
Canvas. 0·96×0·77 m.
Unknown location.
Venetian School, about 1540.

An utterly mediocre picture.

History (according to Suida): Frohsdorf Castle, Austria (formerly); Prince Jaime, Madrid (formerly).

Bibliography: Suida, 1922, pp. 170–174 (Titian, c. 1530–1540); *idem*, 1935, pp. 91, 171, pl. 183a (Titian, c. 1530–1540).

X–50. Gentleman with an Astrolabe
Canvas. 1·028×0·908 m.
New York, Walter P. Chrysler, Jr.
Venetian School.
About 1540–1550.

Formerly attributed to Jacopo or Domenico Tintoretto, Suida changed it to Titian, followed by his daughter, Bertina Suida Manning.

History: Liverpool, Woolton Hall, Leyland Collection (sale, London, Christie's, 28 May 1892, no. 87, as Tintoretto); W. E. Darwin (sale, London, 25 June 1915, no. 66, as Tintoretto); bought by Sir Herbert Cook, Richmond; Cook Collection until 1954.

Bibliography: Brockwell, 1915, p. 180, no. 538 (Tintoretto); Manning, 1962, pp. 49–50 (Titian, c. 1540–1545).

X–51. Gentleman Plate 229
Canvas. 1·207×0·927 m.
New York, Metropolitan Museum of Art, Bache Collection.
Follower of Titian (Lambert Sustris?).
About 1545–1550.

This portrait of a gentleman in a black costume cannot seriously be considered as the work of Titian. The recent suggestion of Lambert Sustris (Ballarin, 1962), although perhaps not definitive, is far more satisfactory as a possibility.

History: Prince Giovanelli, Venice, until 1925; Sir Joseph Duveen, London; Frank P. Wood, Toronto (Freund, 1928, pp. 254–258); Bache Collection, New York, c. 1930–1944; bequest to the Metropolitan Museum in 1944.

Bibliography: Lafenestre and Richtenberger, about 1910, p. 317 (Titian; in Prince Giovanelli's palace); Ojetti, 1925, p. 133 (Titian); Detroit Exhibition, 1928, p. 17 (Titian); L. Venturi, 1931, pl. 385; 1933, pl. 522 (Titian); Suida, 1935, p. 167, pl. 184 (Titian); Duveen, 1941, pl. 158 (Titian); Bache Catalogue, 1937, p. 15 (Titian); Berenson, 1957, p. 189, no. 49.7.14 (Titian); Valcanover, 1960, II, p. 65 (wrong attribution); Ballarin, 1962, p. 77 (Lambert Sustris); *idem*, 1962–1963, p. 365 (Lambert Sustris); Valcanover, 1969, no. 612 (probably Lambert Sustris); Pallucchini, 1969 (omitted).

X–52. Gentleman with a Long Beard
Canvas. 0·983×0·742 m.
Kreuzlingen, Heinz Kisters.
Paris Bordone.
About 1550.

Impressive as this picture is, the style does not conform to Titian's methods. It should be compared with a portrait by Paris Bordone (Tietze, 1940, fig. 15 and Canova, 1965, p. 152).

Condition: Crackled, damaged by fire; the hands repainted.

History: Genoese Collection (supposedly); Julius Böhler, Munich, 1931, no. 49, still there in 1965 (*Apollo*, October 1965, advertisement).

Bibliography: Martini, 1957, pp. 62–64 (Titian); Valcanover, 1960, II, p. 65, pl. 153B (doubtful attribution); *idem*, 1969, no. 335 (attributed); Pallucchini, 1969 (omitted).

X–53. **Gentleman with a Dog**

Canvas. 1·03 × 0·762 m.

Chicago, John Maxon.

Venetian School.

About 1550.

History: Sir Watkins Williams-Wynn of Plas-yn-Cefn, St. Asaph, Flint, Wales (sale, London, Sotheby's, 30 June 1965, as Venetian School; *APC*, XLII, 1964–1965, no. 5047, £500).

Bibliography: See also above; Pallucchini, 1969, p. 298, fig. 377 (Titian, 1552–1554).

X–54. **Gentleman**

Canvas. 1·016 × 0·98 m.

Indianapolis, W. H. Thompson.

North Italian School.

About 1550.

This picture, wrongly attributed to Titian by Suida, is not Venetian.

Bibliography: Suida, 1934, p. 272, *idem*, 1935, p. 186, pl. 316 (Titian).

X–55. **Gentleman Seated**

Canvas. 1·29 × 0·98 m.

Florence, Pitti Gallery, Sala della Giustizia.

Venetian School.

Mid-sixteenth century.

Titianesque is the most that one can say about this picture.

Condition: In a dreadful state, smudged and dirty.

History: Collection of Ferdinand I dei Medici (died 1609).

Bibliography: C. and C., 1877 (not listed); Berenson, 1932, p. 570, no. 494 (Federico Gonzaga, late Titian); Suida, 1935, p. 91, pl. 328B (Titian); Jahn-Rusconi, 1937, p. 310, no. 494 (Titian); Francini Ciaranfi, 1956, p. 106, no. 494 (school of Titian); Berenson, 1957, p. 185, no. 494 (by typographical error called Diego Hurtado de Mendoza, whereas this picture is no. 215); Cipriani, 1966, p. 207, no. 494 (school of Titian); Pallucchini, 1969, p. 348, fig. 669 (follower of Titian).

X–56. **Gentleman in a Lynx Collar** Plate 250

Canvas. 0·81 × 0·68 m.

Madrid, Prado Museum.

Inscribed at the upper left: ANNO AETATIS XXXVII

Follower of Paolo Veronese.

About 1560.

The proposed identifications as Francesco Maria I della Rovere (1480–1538; see Cat. no. 89) or Giovanni Jacopo dei Medici were guesses and not especially convincing. Neither the quality nor the style is close to Titian and, even considering restorations, the drawing of the hand is exceptionally clumsy. Above all, the attention given to the lynx collar and the emphasis upon the texture are not consistent with Titian's method but rather Veronese's, as for instance in the portrait of Alessandro Contarini at Dresden (Posse, 1929, p. 126, no. 236).

Condition: Darkened but much improved after the cleaning of 1965.

History: Alcázar, Madrid, Inventory, 1666, no. 634; Inventory 1686, no. 184; Inventory 1700, no. 35, as Tintoretto (Bottineau, 1958, p. 145); not identifiable in the Inventories of 1734 and 1747; probably transferred from the Royal Palace to the Prado Museum in 1827.

Bibliography: C. and C., 1877, p. 446 (Tintoretto); Fischel, 1924, p. 292 (near Paris Bordone); Suida, 1935, pp. 91, 161, pl. 61b (Titian); Tietze, 1936 (not listed); Beroqui, 1946, p. 169 (Tintoretto); Berenson, 1957, p. 187 (Titian); Valcanover, 1960 (omitted); Prado catalogue, 1963, no. 413 (Titian).

X–57. **Gentleman**

Canvas. 0·94 × 0·737 m.

New York, Private Collection.

Venetian School.

Late sixteenth century.

Bibliography: New York World's Fair, 1940, pp. 19–20 (illustrated, as Titian).

X–58. **Gentleman with a Book**

Canvas. 0.743×0.568 m.
Indianapolis, Clowes Foundation.
Venetian School.
Early seventeenth century.

This dashingly painted work, in which the white highlights are freely applied, surely belongs to the end of the sixteenth or the early seventeenth century.

History: J. Seligmann, Paris and New York, 1937.

Bibliography: A. Venturi, 1937, p. 56 (late Titian); Tietze, 1940, no. 67 (probably by a follower); *idem*, 1950 (omitted); Berenson, 1957, p. 173 (apparently attributed to Tintoretto); Valcanover, 1960 (omitted).

Gentleman, see also: Cat. nos. 40–47.
 Also see:
 Fracastoro (so-called), Cat. no. X–38.
 Man, Cat. nos. 63–64 and X–72.
 Scholar, Cat. no. 96.
 Venetian Gentleman, Cat. nos. X–110, X–111.
 Young Englishman, Cat. no. 113.
 Young Man, Cat. nos. 115–117, X–118—X–122.

X–59. **Girl in a Fur Coat and Hat** Plate 265

Canvas. 0·97×0·75 m.
Leningrad, Hermitage Museum.
Workshop or Follower of Titian.
About 1540.

The perfunctory quality of this picture makes it more than doubtful that Titian had any share in it. The dark-green cloak with brown fur lining and the reddish-brown hat with white plumes have a foil in the dark green background and white shift, but the colours like the drawing are hard.
 The work should be compared with the original in Vienna (Plate 73).

Condition: Some crackle and repairs in the canvas; much repainted. The jewels in the hair indicate that the hat was added later, a fact confirmed by X-rays (Fomiciova, 1967, p. 61).

History: Crozat Collection, Paris, Inventory 1740 (Stuffmann, 1969, p. 77, no. 162, Titian); purchased by St. Petersburg in 1772.

Bibliography: C. and C., 1877, I, pp. 392–393 (Titian); Somoff, 1899, pp. 134–135, no. 105 (Titian); Gronau, *Titian*, 1904 (omitted); Liphart, 1912, no. 10 (Padovanino); Fischel, 1924, pl. 77b (Padovanino); Suida, 1935, p. 171 (perhaps not Titian); Tietze, 1936, II, p. 291 (Titian); Berenson, 1957, p. 187 (Titian); Leningrad, 1958, I, p. 189, no. 71 (Titian, *c.* 1530); Valcanover, 1960, I, pl. 141 (Titian); Fomiciova, 1960, pl. 27 (colour reproduction; Titian, *c.* 1534); Bordeaux, 1964, no. 27 (Titian); Fomiciova, 1967, pp. 60–61 (Titian); Valcanover, 1969, no. 178 (doubtful attribution); Pallucchini, 1969, pp. 270–271, fig. 228 (Titian, *c.* 1535–1537).

X–60. **Giulia Gonzaga Colonna** (so-called)

Canvas. 0·639×0·518 m.
Chicago, Art Institute.
Tintoretto (?).
About 1550.

The traditional identification of the sitter as the celebrated beauty, Giulia Gonzaga Colonna, is completely unjustified (for her biography see Cat. no. L–17). John Maxon of the Art Institute now attributes the painting to Tintoretto *c.* 1550.

History: Gift of Max and Leola Epstein, 1954.

Bibliography: Suida, 1935, p. 112 (Titian); Chicago, 1961, p. 451 (uncertain attribution to Titian); Pallucchini, 1969, fig. 675 (follower of Titian).

Giulia Gonzaga Colonna, see also: Cat. nos. L–17 and X–112.

X–61. **Antonio Grimani, Doge of Venice**

Canvas. 1·17×0·99 m.
Unknown location.
Venetian School.
About 1521–1523.

Berenson assigned this mediocre picture to Domenico Caprioli, but the known works of this master are considerably better than the Grimani portrait.

History: Palazzo Grimani, Venice, until 1871; Countess Mathilde Berchtold-Stratan, purchased 1871; Friedrich von Rosenberg, Vienna, 1873–1891; Catherine de Rosenberg, Vienna, 1895 (Cust, 1895, p. 211); Fischoff, Paris; Sedelmeyer, Paris, 1899 (sale, 1901, no. 76); Matthiesen sale, New York, American Art Association, 1902; Joseph

Pulitzer Collection, New York (sale, American Art Association, New York, 10 January 1919, no. 36); Walter Toscanini, New York, 1939.

Bibliography: C. and C., 1877, I, pp. 244–246 (Titian); L. Venturi, 1931, pl. 378 (Titian); Berenson, 1930, p. 91; *idem*, 1957, p. 52 (Domenico Caprioli).

VARIANTS AND COPIES:
1. London, Lord Rothermere; *Antonio Grimani, Doge of Venice*, canvas, 1·01×0·84 m., formerly Casa Giustiniani-Barbarigo, Padua (Ridolfi (1648)-Hadeln, I, p. 200; Selvatico, 1875, p. 14, seen in Padua, size 1·17×1·00 m.; see also C. and C., 1877, I, p. 244, probably from Titian's house; Rothermere, 1932, pl. 33).
2. Vercelli, Museo Borgogna; canvas, 1·086×0·89 m., half-length, behind a table, in an ermine cape; no curtain at the back; hard, poor quality; apparently from the Casa Morosini-Gattersberg, Venice, sale Paris, 1894 (Mireur, VII, p. 291; C. and C., 1877, I, p. 246, replica).

X–62. **Andrea Gritti, Doge of Venice** (profile)
Canvas. 0·92×0·79 m.
London, National Gallery.
Vincenzo Catena.
About 1523–1531.

Any suggestion of Titian is remote, and the attribution to Catena is now widely accepted. See Cat. nos. 50, 51.

History: Palazzo Contarini, Venice; Dr. Gilbert Elliot, Bristol; exhibited at the British Institution in 1863 (catalogue, p. 9, no. 53); John Ruskin, Brantwood, Coniston (called it Titian) *c.* 1864–1900; Mrs. Arthur Severn (by inheritance); Langton Douglas, London; Otto Gutekunst, 1917; presented by Mrs. Gutekunst to the National Gallery in 1947.

Bibliography: C. and C., 1877, I, p. 301 (in Ruskin's collection; no opinion); Hadeln, 1930, pp. 490–491 (Titian; wrongly considered it a fragment of a lost votive picture); Wilde, 1931, p. 96 (Catena); Dussler, 1935, p. 239 (not Titian); Tietze-Conrat, 1946, pp. 81–82 (undecided); Berenson, 1957, p. 187 (Titian, after Catena!); Gould, 1959, pp. 32–34 (Catena; gives complete history and bibliography); Robertson, 1954, cat. no. 49 (Catena); Valcanover, 1960, I, p. 100 (not Titian); Valcanover, 1969, no. 600 (wrong attribution).

COPY:
Cambridge, Fitzwilliam Museum; canvas, 1·04×0·762 m.,

three-quarter length in profile, this work is a replica of the portrait of Gritti by Catena in the National Gallery at London. *History:* Cotterel Collection, Florence; Holford Collection, London (sale, London, Christie's, 15 July 1927, no. 117). *Bibliography:* C. and C., 1877, I, p. 301, note (uncertain attribution); Mayer, 1937, p. 308, illustration (probably Titian's original); Robertson, 1954, p. 69 (perhaps shop of Tintoretto).

Andrea Gritti, see also: Cat. nos. 50–51.

X–63. **Group Portrait**
Canvas. 0·998×1·321 m.
Washington, National Gallery of Art (storage).
Venetian School.
About 1530.

Hadeln related the picture to the portraits in the *Pesaro Madonna* (Wethey, I, 1969, Cat. no. 55) dating it *c.* 1520. The badly constructed group of the cardinal in red and other figures in black is the work of a minor master.
On the back of a photograph in the National Gallery archives is a legend reading, 'Quadro di Tiziano rappresentante il Padre e due fratelli della Regina Cornaro. In segno di vera stima di gratitudine e amicizia all' onorato Suo Signore e amico Cav. J. Hamilton. Antonio Canova.'

History: Private collection, England; Colnaghi, London; Howard Young, New York, 1931; Timken Collection, New York; bequest to the National Gallery in 1959.

Bibliography: Hadeln, 1929, pp. 10–12 (Titian); L. Venturi, 1931, pl. 379 (Titian); *idem*, 1933, pl. 512 (Titian); Berenson, 1957 (omitted); Washington, 1965, p. 131, no. 1590 (attributed).

Group Portrait, see also:
 The Appeal, Cat. no. X–5.
 The Concert, Cat. no. 23.
 Three Figures, Cat. no. X–90.
 Titian, Andrea dei Franceschi, and 'Friend of Titian', Cat. no. X–103.

X–64. **Mathias Hofer**
Canvas. 1·21×0·88 m.
Duino (Trieste), Castello Nuovo, Principi della Torre e Tassi.
German follower of Titian (Lambert Sustris?).
Mid-sixteenth century.

In the only known photograph of this picture, it appears to be a work of extraordinary quality, although the style, so far as one can judge, looks Germanic. Efforts to study the original have been unavailing.

Biography: Mathias Hofer (died 1587) was the last of this family, which came originally from the Tyrol but settled in Gorizia, where they had the lordship of several villages. From 1547 Mathias held the captaincy of Duino, where the Hofer castle is still located (Manzano, VII, 1879, pp. 143, 145).

History: Said to be mentioned in an Inventory of 1620 as the work of Titian (Suida, 1935, p. 170).

Bibliography: Suida, 1935, pp. 86, 170, pl. 164 (Titian, *c.* 1535–1540); Ballarin, 1962–1963, p. 364 (Lambert Sustris?); Morassi, 1967, p. 139 (Titian); Pallucchini, 1969, p. 221 (Gian Paolo Pace?).

X–65. Johann Friedrich, Elector of Saxony, in Armour
Plate 247

Canvas. 1·29×0·93 m.
Madrid, Prado Museum.
Copy of original of 1550.

The presence of two portraits of Johann Friedrich in the Spanish inventories, one in armour and the other in black (Cat. no. 54), sometimes but not always specified as the work of Titian, creates problems of identification. The fact that copies of the same items also existed further complicates an already difficult situation.

The extremely mediocre quality of the Prado picture makes it difficult to believe that it could have issued from Titian's workshop. On the other hand, it may have been badly damaged in the fire of the Alcázar at Madrid in 1734 and thereafter extensively repainted. The suit of armour still exists in the Real Armería in Madrid (no. M 13).

Condition: Very dark and badly preserved.

History: The original picture was in Brussels, in Mary of Hungary's collection, which was shipped to Spain; listed in Inventory 1556, 1558 (Pinchart, 1856, p. 140, no. 9; also Pérez Gredilla, 1877, p. 251): a portrait of Johann Friedrich, 'when he was captured, armed, and wounded in the face, by Titian'; Inventory of El Pardo Palace, 1564, portrait of the Duke of Saxony, no artist specified (Calandre, 1953, p. 152); Inventory of El Pardo, 1582, 'Johann Friedrich of Saxony, who surrendered to the Emperor Charles V, Our Lord, in Germany, by Titian' (Calandre, 1953, p. 46); in March 1604

a fire in El Pardo Palace destroyed fifty portraits (Calandre, 1953, p. 70); since the Inventory of 1582 listed forty-five portraits and the loss seems to have been total, the original work by Titian may have been destroyed then.

A likely supposition is that a copy was in the Alcázar before 1604; Alcázar, Madrid, Guardajoyas, 1600, Duke of Saxony armed, $1\frac{1}{3}×1·02$ *varas* (1·11×0·85 m.), valued at the low price of 100 *reales*, no artist mentioned (Philip II, edition 1959, II, p. 233). This picture is probably the one still preserved in the Prado Museum (Prado catalogue, 1963, no. 533). Alcázar Inventory 1666, Pieza inmediata, no. 132, 'Duke of Saxony, armed, by Titian', $1\frac{1}{2}×1$ *varas* (1·25×0·835 m.), valued at 100 ducats of silver; Alcázar, Inventory 1686, Pieza donde Su Magestad Comía, no. 474, 'Portrait of the Duke of Saxony, armed, $1\frac{1}{2}×1$ *varas*, by Titian' (Bottineau, 1958, p. 294); Alcázar Inventory 1700, no. 256; Inventory 1734, after the fire of the Alcázar, several portraits are described individually merely as 'portrait of a man'; Inventory 1747, no. 26, 'portrait of a man armed, original by Titian' might be this picture; or Buen Retiro, 1747, no. 703, as Johann Friedrich by an unknown painter; probably sent to the Prado Museum in 1827.

Bibliography: See also above; Vasari (1568)-Milanesi, VII, p. 450 (painted when prisoner); C. and C., 1877, II, pp. 175–176, 181 (copy of Titian's lost portrait); Allende-Salazar and Sánchez Cantón, 1919, pp. 47–48 (copy); Suida, 1935, pp. 109, 173 (possibly a copy); Tietze, 1936, II, p. 299 (uncertain); Beroqui, 1946, pp. 92–94 (Titian's original); Braunfels, 1956, p. 207 (copy or workshop); Braunfels, 1965, p. 46 (workshop); Valcanover, 1960, II, p. 54 (copy of lost original); Pallucchini, 1969, p. 344, fig. 624 (perhaps a copy after Titian).

Johann Friedrich, see also: Cat. no. 54.

X–66. Knight of Malta (Pierre de Sales?)
Canvas. 0·60×0·51 m.
Paris, Louvre (reserves).
Paolo Farinati (?).
About 1560.

The white fur collar against the dark doublet and cloak is effective, yet both characterization and design fail to measure up to Titian's quality.

Condition: Darkened, heavily varnished; in bad condition.

History: Collection of Philippe de Noailles, duc de Mouchy; Leopold Wilhelm, Brussels (Teniers' picture, Prado, no. 1813).

Bibliography: Villot, 1874, p. 291, no. 475 (Titian); C. and C., 1877, II, p. 458 (close to Calisto da Lodi); Berenson, 1968, p. 125 (Paolo Farinati); Malta, 1970, no. 199 (Paolo Farinati).

ANOTHER VERSION:
Conspresières (Geneva); formerly at Château de Blonay, collection of Claude de Blonay in 1681.

X–67. **Lady with Pearl Necklace**
Canvas. 0·90×0·75 m.
Milan, Private Collection.
Bernardino Licinio.
About 1530.

The lady wears a brown dress trimmed with white fur against a red curtain as background. The former attribution of this portrait to Romanino was more acceptable than Pallucchini's recent repromotion of it to the rank of a Titian. The qualities of design and the stolid nature of the sitter come very close to the style of Bernardino Licinio (cf. Berenson, 1957, pls. 851, 853).

History: Said to have belonged to Lucien Bonaparte, Rome (in the sales catalogue two items are described as portraits of a lady by Titian; Buchanan, 1824, II, p. 290, no. 85, p. 291, no. 121); Morris Moore, London; purchased by Holford from Morris in 1849 as Titian; Holford Collection, Dorchester House, London, 1849–1927 (sale, London, Christie's, 15 July 1927, no. 90, as by Romanino; *APC*, VI, 1926–1927, no. 9783, £546); purchased by Rothschild Gallery, London; Detlev von Hadeln (died 1935).

Bibliography: C. and C., 1877, II, p. 461 (Venetian, not Titian); Benson, 1927, no. 77, pl. 71 (Romanino); A. Venturi, *L'Arte* 1928, pp. 199–200 (Pordenone); Pallucchini, 1969, p. 271, figs. 229–230 (Titian, *c.* 1535–1538); Dussler, 1970, p. 550 (not Titian).

X–68. **Lady, Portrait of**
Canvas. 1·00×0·73 m.
Private Collection.
Lambert Sustris.
About 1560.

Longhi attributes this portrait to Titian on comparison with the *Widow* in Dresden, which he gives to Titian also, whereas that picture is normally considered to be by Tintoretto (Posse, 1929, p. 115, Tintoretto; Berenson, 1957, p. 172,

no. 265A, Tintoretto). The recent suggestion of Lambert Sustris for the work under discussion has much to recommend it.

History: Duke of Richmond (Hailey, 1939, no. 140, then 44×36 inches); von Hadeln Collection (history according to Longhi).

Bibliography: See also History; Ballarin, 1962–1963, p. 366 (Lambert Sustris); Longhi, 1968, pp. 61–62, illustration (Titian).

Lady and Son, see Isabella d'Este and Son, Cat. nos. X–31, X–32.

X–69. **Pietro Lando, Doge of Venice**
Canvas. 1·168×0·99 m.
Glens Falls (New York), Louis Hyde Collection.
Inscribed: PETRVS LANDO VENETIAR DVX MDXLV
Copy, or modern imitation.

A picture of dubious quality, which has nothing to do with Ridolfi's reference to a picture at Venice in the Lando Collection showing two doges, Marco Antonio Trevisan and Pietro Lando walking together (Ridolfi (1648)-Hadeln, I, p. 192, Titian).

Biography: Pietro Lando (1462–1545), of a Venetian aristocratic family, held various administrative posts. He was 'provveditore' at Faenza and in Romagna, ambassador to Rome under Leo X, podestà of Padua in 1519 and 1535, and in 1528 captain general in the war of Naples. Doge of Venice from January 1539 to November 1545, he is chiefly known for having concluded a peace treaty in 1540 between Venice and Soliman the Great (Cicogna, I, 1824, pp. 167–169; Pavanello, 1932, p. 494).

History: A Grassi, Florence.

Bibliography: See also above; L. Venturi, 1933, pl. 519 (Titian).

X–70. **Lavinia as Matron** (so-called) Plate 197
Canvas. 1·17×0·92 m.
Vienna, Kunsthistorisches Museum.
Follower of Titian.
Sixteenth century.

In a dark-green dress and white bodice adorned with gold

ornaments, she holds a fan of feathers like a duster. The excessive dullness of this picture excludes any possibility of authorship by a great master. Moreover, Lavinia (1530–1561) in the later Dresden portrait (Cat. no. 61) is not particularly similar in features to this lady.

History: Archduke Leopold Wilhelm, Vienna, Inventory 1659, no. 12, as Tintoretto; Teniers, 1660, no. 91 (Titian).

Bibliography: See also above; C. and C., 1877 (omitted); Engerth, 1884, I, p. 370, no. 521 (Lavinia by Titian); Gronau, *Titian,* 1904 (omitted); Stix, 1913–1914, pp. 334–335 (Lavinia, by Titian's workshop); Fischel, 1924, pl. 124B (Lavinia, 1570, Titian); Baldass, 1924, p. 91 (Titian, 1560); Ozzola, 1931, pp. 171–172 (Marco Vecellio); Hadeln, 1931, pp. 84–85 (Titian); Suida, 1935, pp. 113, 174, pl. 204 (Titian, *c.* 1560); Tietze, 1936, II, p. 317 (workshop; quotes Wilde's opinion that it is a workshop piece); Pallucchini, 1954, II, p. 137 (workshop); Berenson, 1957, p. 192 (Titian); Valcanover, 1960, II, p. 69 (workshop); *idem,* 1969, no. 456 (workshop): Pallucchini, 1969, p. 318, fig. 486 (Titian, *c.* 1566).

X–71. **Lavinia** (so-called)

Canvas. 1·041×0·787 m.

Los Angeles, County Museum.

Venetian School.

About 1550.

The proposal that this figure is an ideal representation of Lavinia, Titian's daughter, does not carry much weight. Although a picture of pleasing quality, its relation to Titian does not appear immediate.

Condition: Much cleaned and restored.

History: Paul R. Mabury, Los Angeles, in 1936; bequest to the museum in 1939.

Bibliography: Richter, 1937, pp. 222–223 (Titian); Wescher, 1953, p. 22, no. 17 (Titian or workshop).

Lavinia, see also: Cat. nos. 59–61, X–112.

X–72. **Man with a Sword**

Canvas. 0·99×0·82 m.

Paris, Louvre (storage).

Jan Stephan von Calcar (?).

About 1540.

This three-quarter-length portrait has strength and conviction, but the presentation is unlike Titian nor does it seem to have the remotest connection with Tintoretto. Entirely dressed in black, he is a vigorous black-bearded man, who clasps a sword hilt in his right hand as he stands against a column. The Louvre picture must be by the same hand as the portrait of a musician in the Palazzo Spada at Rome (Zeri, 1954, pl. 31), in which the pose and architectural setting are identical. The attribution to Calcar, a north German follower of Titian, is debatable in both cases.

History: Marchese Sanese, Rome; purchased from him by Cardinal Mazarin, Paris; Louis XIV, Le Brun Inventory 1683, no. 49; Paillet, Versailles Inventory 1695; Hôtel d'Antin, Paris, 1715; Versailles Inventory, 1737 (Lépicié, 1752, p. 36); Hôtel de la Surintendance, 1760 and 1784 (Bailly Engerand, 1899, pp. 79–80).

Bibliography: See also above; Villot, 1874, p. 290, no. 474; C. and C., 1871, II, p. 290 (Pordenone); *idem,* 1877, II, p. 459 (Pordenone); Gronau, *Titian,* 1904, p. 285 (Titian); Suida, 1934–1935, p. 14 (Jan Stephan von Calcar); Fiocco, 1943 (omitted); Pallucchini, 1950, fig. 144 (Tintoretto); Berenson, 1957, p. 190, no. 1593 (Titian); Valcanover, 1960, I, p. 102 (Tintoretto).

X–73. **Giovanni dei Medici** (delle Bande Nere)

Canvas. 0·90×0·97 m.

Florence, Uffizi (in storage).

Gian Paolo Pace.

1545.

Because he was called to Rome by Paul III, Titian never carried out Aretino's request for a portrait of this *condottiere* (*Lettere,* edition 1957, II, pp. 106–107). This work of mediocre facture was painted by Gian Paolo (Pace) for Aretino to present to Duke Cosimo I dei Medici, son of the portrayed, whose death mask by Giulio Romano (see Cat. no. 86) served as a model (Aretino, *Lettere,* edition 1957, II, p. 116, November 1545).

Biography: Giovanni dei Medici (1498–1526), called Giovanni delle Bande Nere, was the son of Giovanni dei Medici and Caterina Riario Sforza. Orphaned in childhood, he was reared in the house of Jacopo Salviati, whose daughter he married. Their son was Cosimo I, the first grand-duke of Tuscany. Soldier of fortune, Giovanni organized the famous *Bande,* who twice, at the death of Leo X and of their captain, changed their white insignia to black. In the service now of the pope, now of the French, he was mortally wounded in 1526 near Mantua in the war of the League of Cognac.

13

During the last two years of his life Pietro Aretino (see Cat. no. 6) served as his secretary (Picotti, 1934, p. 698).

Condition: Darkened and dirty.

History: In the Medici Collection since 1545.

Bibliography: See also above; Vasari (1568)-Milanesi, VII, p. 445 (Titian; gift of Aretino); C. and C., 1877, I, pp. 315–316, II, pp. 133–134 (Titian); Gronau, 1905, pp. 135–141 (follower of Titian; the major study of the picture); Florence, Uffizi, *Catalogo*, 1926, p. 85 (school of Titian); Florence, Uffizi, *Catalogo... illustrato*, 1930, sala XVII, no. 934 (Titian); Suida, 1935 (not listed); Tietze, 1936 (not listed); Berenson, 1957 (not listed); Valcanover, 1960 (not listed); Camesasca, 1960, III, part II, pp. 394–395 (Pace); photographs: Alinari 1062, Anderson 9430.

X–74. Gerardo Mercator (so-called)

Canvas. 1·07×0·934 m.
New Haven, Yale University Art Gallery.
Gian Paolo Pace.
About 1550.

A weak picture, not even close to Titian's style or quality, it resembles the awkward poses and flat weak drawing of Titian's follower, Gian Paolo Pace (see Cat. nos. X–88, X–89). An inscription TITIANO (*sic*) on the globe and another on the table TITIANVS F and ANNO AETATIS SUE XXIV, are not to be regarded as signatures of the artist. Obviously the second part 'aged 24 ' must refer to the gentleman. The first 'signature' TITIANO is a form never used by the artist. The cleaning of 1961 improved the picture, which is close in style to Cat. no. X–73.
The globe is the basis for the belief that the man may be the famous cartographer Mercator (1512–1594), a Fleming whom Titian never saw. If he was really aged twenty-four at the time of the painting, the date would be 1536.

History: Charles I of England, supposedly; said to have been bought from Mr. Peter Oliver, a painter, as by Titian, 39× 38 inches (van der Doort, 1639, Millar edition 1960, p. 17); Lindenhurst, Philadelphia (catalogue, no. 23); Silbermann Gallery, New York, 1940; Rabinowitz Collection, Sands Point, Long Island; gift to Yale University in 1959.

Bibliography: Tietze, 1940, no. 66 (cautiously as Titian); L. Venturi, 1944, pp. 50–51 (Titian); *idem*, 1947, pp. 20–21 (Titian); Tietze, 1950, German edition, p. 396 (Titian); Pallucchini, 1953, I, pp. 206, 212 (Titian, 1541); Berenson, 1957 (omitted); Valcanover, 1960 (omitted); *idem*, 1969,

no. 221 (Titian); Seymour, 1961, pp. 32–33 (Titian); Pallucchini, 1969, p. 275, fig. 255 (Titian).

X–75. Giovanni Moro, Admiral (destroyed 1945)

Canvas. 0·83×0·67 m.
Berlin, Staatliche Gemäldegalerie (formerly).
Inscribed: JOANNES MAVRVS GENERALIS MARIS IMPERATOR MDXXXVIII
Dosso Dossi (?).

The attribution by Venturi and Berenson to Dosso Dossi is the more likely solution, although Felton Gibbons, the most recent authority on the Dossi, prefers Titian. The extremely heavy white highlights on the armour do not suggest Titian's style of painting, nor do the composition and the psychological content.

Biography: Since the inscription is posterior to the date of the portrait, its correctness is uncertain. Of the three men known to have been named Giovanni Moro in sixteenth-century Venice, one, the son of Leonardo, was a *podestà* of Brescia, died in 1546; another Giovanni Moro, son of Antonio, was elected captain general of Po in 1509, a date which seems too early; the third Giovanni, son of Damiano, was *podestà* at Crema in 1523 and at some time took charge of restoring the fortifications of Udine (Cicogna, 1830, III, pp. 15–16).

History: Purchased in Venice in 1841; destroyed in the Flakturm fire in 1945.

Condition: Badly damaged, restored in 1874; the inscription repainted before its destruction.

Bibliography: C. and C., 1877, II, p. 22 (Titian); Posse, 1931, I, p. 176, no. 161 (Titian); A. Venturi, 1900, p. 42 (attributed it to Dosso Dossi); Berenson, 1907, p. 208; 1932, p. 173; 1968, I, p. 110 (Dosso Dossi); Fischel, 1924, pl. 85 (Titian, 1537); Dr. Irene Kühnel-Kunze, 1931, p. 483, no. 161 (Titian); Tietze, 1936, II, p. 284 (Titian); Valcanover, 1960 (not listed); Gibbons, 1968, p. 250, no. 139 (Titian).

X–76. Domenico Morosini, Doge of Venice

Canvas. 1·05×0·955 m.
Vienna, Private Collection.
Modern.

Published by Poglayen-Neuwall as Titian's own copy of a portrait of Morosini (doge of Venice, 1148–1156) in the

Sala del Gran Consiglio which was destroyed by the fire of 1577; it has not been accepted by other writers.

Bibliography: Poglayen-Neuwall, 1927, pp. 61-63; photograph in the Courtauld Institute, London.

X-77. **Mulatto Boy**

Vienna, Private Collection.

Venetian School.

Sixteenth-seventeenth century.

Bibliography: Suida, 1934-1935, p. 102 (Titian).

X-78. **Andrea Navagero** (so-called)

Canvas. 0·79×0·686 m.

Detroit, Mrs. Edsel Ford.

Venetian School.

About 1525.

The hard technique and lack of psychological impact eliminate Titian as the author of this picture, which is closer to Paris Bordone. The style is also similar indeed to Cat. no. X-111. The identification of the man as Andrea Navagero is unacceptable because he does not resemble Navagero as painted by Raphael in the double portrait in the Doria-Pamphili Collection at Rome.

Biography: Andrea Navagero (1483-1529), son of an aristocratic Venetian family, studied in Padua and became one of the leading humanists of the first quarter of the sixteenth century. In Rome during the pontificate of Leo X (Giovanni dei Medici, 1513-1521), he became a friend of Raphael, Baldassare Castiglione (Cat. no. 19), Pietro Bembo (Cat. no. 15), and other luminaries of the period. In 1524 he set out on a diplomatic mission as representative of the Venetian state to Spain, where he was able to accomplish little other than to leave an interesting account of his travels. After his departure from Spain he died suddenly at Blois in May 1529 (Cicogna, 1853, VI, pp. 172-348).

History: Proposed as the portrait of a man in Cristoforo Orsetti's collection, Venice (Ridolfi (1648)-Hadeln, I, p. 201); the history of this picture has been confused with that of item no. 2 below (Gronau, 1937, pp. 93-94); Mr. and Mrs. Edsel Ford, Detroit.

Bibliography: See also above; Detroit, 1928, cat. no. 3; L. Venturi, 1931, pl. 377 (Titian); *idem*, 1933, pl. 520; Suida, 1935, pp. 32, 33, 161, plate 64a (early Titian); Tietze, 1936 (omitted); *idem*, 1950, p. 371 (early Titian); Gronau, 1937, pp. 93-101 (Titian); Berenson, 1957, p. 184 (Titian); Valcanover, 1960, I, p. 96 (doubtful attribution); *idem*, 1969, no. 70 (attributed, 1515); Pallucchini, 1969, p. 223, fig. 668 (close follower of Titian).

RELATED ITEMS:
1. Berlin, Palace of the Chancellor; portrait inscribed 'Andreas Navagero MDXXV' (Gronau, 1937, p. 97, copy).
2. London, Private collection, *Andrea Navagero* (so-called); canvas, 0·647×0·51 m.; bearded man in profile, Venetian School, *c.* 1530, photograph in the Courtauld Institute, London. Lord Brownlow's sale, 3 May 1929, no. 20, to Agnew and Company, London; said to have been purchased from the Contarini Palace in 1786; Sir Abraham Hume's collection (Hume, 1829, p. 66); by inheritance to Lord Brownlow, Belton House; later Edgar Kaufmann, New York. Note the confusion of this history with that of Cat. no. X-111.

X-79. **Cardinal Antoniotto Pallavicini** (so-called)

Plate 255

Canvas. 1·30×1·15 m.

Moscow, Pushkin Museum (in storage).

Roman School.

About 1530.

The identification of the sitter is open to doubt since he died in 1507, about a quarter of a century before the portrait was executed. It rests upon the inscription ANTONIVS PALLAVICINVS CARDINALIS S. PRASSEDIS on the picture, on the notation in Van Dyck's 'Italian Sketchbook', and on a print by Pieter de Jode. The attribution to Titian has been abandoned in recent years by everyone except Berenson, for the style is indeed nearer to that of Sebastiano del Piombo, particularly to the portrait of Cardinal Pole at Leningrad (Venturi, 1932, IX, part v, p. 77).

The engraving by Pieter de Jode was made when the picture belonged to Van Dyck (Mariette, *c.* 1720, edition 1858-1859, p. 328).

Biography: Antoniotto Pallavicini (1441-1507), born in Genoa of a noble family, was taken to Spain as a child but returned to Genoa in 1470. At Rome under the protection of the Genoese Cardinal Giovanni Battista Cybo he rose quickly in the ecclesiastical hierarchy, being made bishop of Orense, Pamplona, Nicosia, and Tournay. He became cardinal of Sant' Anastasia in 1489 and later of Santa Prassede (Ciaconius, 1601, edition 1677, III, pp. 130-131; Moroni, LI, 1851, pp. 49-50 contains errors). His tomb now in S. Maria del Popolo has an inscription on the sarcophagus with

the date of its erection in 1501 (ANTONIOTVS CARD. S. PRAXEDIS MORTEM PRAE OCULIS SEMPRE HABENS VIVENS SIBI POS. AN. MDI). The epitaph below gives the date of his death as 10 September 1507, and the year 1596 when the whole tomb and his remains were transferred from Old St. Peter's.

History: Possibly Sir Anthony Van Dyck's collection, Inventory 1644, no. 3 (Müller-Rostock, 1922, p. 22, no. 4); Crozat Collection, Paris, Inventory 1740 (Stuffmann, 1969, p. 77, no. 158 (Titian); purchased by Leningrad in 1772; on loan at Moscow from the Hermitage.

Bibliography: Van Dyck's 'Italian Sketchbook', 1622–1627, as Titian (Adriani, 1940, pl. 105); C. and C., 1877, II, p. 422 (Titian, *c.* 1545, influence of Michelangelo); Somof, 1899, p. 134, no. 102 (Titian); L. Venturi, 1912, p. 132 (Sebastiano del Piombo); Fischel, 1924, p. 290 (doubtful attribution); Venturi, 1932, IX, part 5, pp. 32–33 (Sebastiano del Piombo); Suida, 1935 (omitted); Dussler, 1942, no. 67 (doubtful attribution to Sebastiano del Piombo); Pallucchini, 1944, p. 124, note 49 (not Sebastiano del Piombo); Berenson, 1957, p. 186 (early Titian); Valcanover, 1960, I, p. 101 (near to Sebastiano del Piombo); *idem,* 1969, no. 598 (derivation).

X–80. **Cardinal Antonio Pallavicini** (so-called)

Canvas.

Berlin, Schlossmuseum (formerly; now lost).

Roman School.

About 1530.

In profile, seated against an architectural setting with open window at the left, Pallavicini is about the same age as in the portrait in Moscow (formerly Leningrad, Cat. no. X–79). The general style of the two works is also similar.

Bibliography: Van Dyck's 'Italian Sketchbook', 1622–1627 (Adriani, 1940, pl. 104v, Titian); Fischel, 1924, p. 291; Venturi, 1932, IX, part v, pp. 33–34 (Sebastiano del Piombo); Pallucchini, 1944, p. 124, note 49 (not Sebastiano del Piombo); Berenson, 1957 (omitted).

X–81. **Padre Onofrio Panvino** (so-called)

Canvas. 1·15×0·88 m.

Rome, Colonna Gallery.

Venetian School.

About 1540.

The attribution to Titian has been generally abandoned as well as the identification of the Augustinian monk as Onofrio Panvino (1529–1568), one of the most erudite men of his time and the author of many books on the history of Christianity, of the Church, of the Papacy, etc.

Bibliography: C. and C., 1877, II, pp. 419–420 (Titian); Fischel, 1924, p. 300 (Flemish school); Suida, Tietze, Berenson, Valcanover, Pallucchini (omitted by all).

X–82. **Nicholas Perrenot, Seigneur de Granvelle**

Plate 152

Canvas. 1·22×0·93 m.

Besançon, Granvelle Palace (on loan from the Musée des Beaux-Arts).

Replica or workshop (Lambert Sustris?).

About 1548.

In spite of the history of the picture, the hard enamel-like surface does not correspond to Titian's technique in 1548. It may have been carried out largely by one of Titian's Flemish or German assistants (Lambert Sustris?) or it may be a copy. Granvelle's black costume has a lining and a broad fur collar of dark grey, while a green cross of the Spanish military order of Alcantara is embroidered upon his doublet.

Biography: Chancellor Granvelle (1485–1550), having begun as a lawyer at Besançon, passed into the service of Marguerite of Austria, aunt of Charles V. He later became chancellor to the Emperor himself, accompanying him in many operations throughout the vast Hapsburg empire, and he died at Augsburg in 1550. His son, Cardinal Granvelle (see Cat. no. 77), had an even greater career under Charles V and Philip II (*Charles-Quint*, 1955, p. 67).

Condition: Cut down at the lower edge, thus eliminating part of the hand; some repairs in the cloak.

History: Granvelle Palace, Besançon, Inventory, of 1607; Monsieur Granvelle by Titian (Castan, 1867, p. 128, no. 173, 4 *pieds* × 3 *pieds* 3 *polces* (1·22×0·99 m.); no. 175, 3 *pieds* 6½ *polces*×2 *pieds* 14 *polces* (1·08×0·965 m.), both by Titian; p. 132, no. 201, 3 *pieds* 13 *polces* × 3 *pieds* (1·245× 0·965 m.), copy of Titian). The dimensions of all items above are so close to the preserved canvas that no safe conclusion can be drawn. Abbé Boisot bequeathed it in 1694 to the Benedictine monastery at Besançon, whose collection passed to the museum (Besançon, 1957, pp. 52–57).

Bibliography: See also History; C. and C., 1877, II, pp. 183–185 (literary references); Gronau, *Titian*, 1904, pp. 153, 282 (Titian); Ricketts, 1910, pp. 117, 179 (ruined); Fischel, 1924, pl. 157 (Titian); Peltzer, 1925, pp. 44–45 (Titian, at Augsburg); A. Venturi, 1934, p. 766 (attributed the picture to Scipione Pulzone, but such a theory is untenable on comparison with Pulzone's portrait of Cardinal Granvelle in the Musée des Beaux-Arts; see Bescançon, 1957, no. 52, pl. VII); Suida, 1935, pp. 109, 170 (much repainted); Tietze, 1936, II, p. 284 (undecided); Berenson, 1957, p. 184 (Titian); Valcanover, 1960, II, pl. 26 (Titian); Ballarin, 1962, p. 62 (Lambert Sustris); *idem*, 1962–1963, p. 364 (Lambert Sustris); Valcanover, 1969, no. 293 (commonly attributed); Pallucchini, 1969, p. 289, fig. 334 (Titian, 1548).

X–83. **Pope Pius IV** (1559–1565)

Canvas. 0·45×0·30 m.

Unknown location.

Roman School.

Mid-sixteenth century.

Extraordinarily mediocre in quality in spite of Longhi's high praise.

History: Giuseppe Brunati (dealer), Milan, *c.* 1918; Pinerolo, parish priest, *c.* 1945 (history given by Longhi).

Bibliography: Longhi, 1968, pp. 63–64, illustration (Titian, who copied it from another portrait).

X–84. **Archbishop Vincenzo (?) Querini**

Canvas. 1·07×0·876 m.

Location unknown.

Follower of Titian.

About 1550.

Inscribed: MONS QVERINI ARCIVESCOVO DI NIXIA E PARS. Although Titian was a friend of the Querini family and is known to have done the likeness of Elisabetta (Cat. no. L–26), no early reference to a portrait of the archbishop is known. Vincenzo Querini, who was archbishop of Retimo (Rethimenses) in Crete during the years 1537–1551 (Gams, 1931, p. 402), might be the sitter. On the other hand, no Querini bishop is listed at Nice or Parenzo, as indicated by the inscription on the picture.
The style and composition of the work suggest knowledge of the portrait of Filippo Archinto (Plate 162).

History: Von Kaulbach sale (Munich, Helbing, 29–30 October 1929, no. 171); Ehrich Gallery, New York (sale New York, Anderson Galleries, 2 April 1931, no. 65; also *APC*, X, 1930–1931, no. 2700, $20,500.00).

Bibliography: Fischel, 1924, p. 222 (doubtful attribution); Detroit, 1928, no. 14, illustrated (Titian); Suida, 1935 (omitted); Tietze, 1936 (omitted); Valcanover, 1960, *idem*, 1969 (omitted); Pallucchini, 1969 (omitted).

X–85. **Ippolito Riminaldi**

Canvas. 1·12×0·91 m.

Rome, Accademia di San Luca.

North Italian School.

About 1550.

Bequest of Baron Lazzaroni in 1934; a very mediocre work, beneath Titian's capacity. Another portrait with an inscription identifying a much older man as Ippolito Riminaldi, and dated 1543, also from the Lazzaroni Collection, does not appear to represent the same person, even if the inferior quality of the painting is discounted (Toesca, 1934–1935, p. 444). See also Cat. no. 113.

Bibliography: A. Venturi, 1928, p. 326 (Titian); Suida, 1935, p. 89 (Titian); Tietze, 1936, II, p. 289 (not Titian); Berenson, 1957, p. 190 (Riminaldi by Titian; repainted); Valcanover, 1960, I, p. 103 (doubtful); *idem*, 1969, no. 617 (attributed); Pallucchini, 1969, p. 223 (Orazio Vecellio).

X–86. **Guidobaldo II della Rovere, Duke of Urbino, with Page**

Canvas. 1·905×1·245 m.

Sarasota, John and Mable Ringling Museum.

Follower of Titian.

About 1560.

This full-length figure accompanied by a page at the left and a statue of a man holding antlers at the right shows no evidence of Titian's hand.

History: Paalen, Berlin, 1916; Julius Böhler, Munich.

Bibliography: Suida, 1949, p. 61, no. 60 (Titian and workshop).

X–87. **Guidobaldo II della Rovere, Duke of Urbino**

Canvas. 0·623×0·482 m.

New Haven, Yale University Art Gallery.

Italian School.

About 1545.

A mediocre picture in half-length which Gronau attempted to identify as Titian's portrait of the duke painted in 1545 (see Cat. no. 91).

History: Jackson Higgs (dealer), New York, in 1933; Mr. and Mrs. Charles Hickox's gift to Yale University in 1957 (*Bulletin of Associates in Fine Arts*, XXIII, 1957, p. 29).

Bibliography: Gronau, 1933, pp. 487–495 (Titian; with hitherto unpublished letters of 1545); Suida, 1935, pp. 49, 187, pl. 327 (Titian, 1545); Sangiorgi, 1969, pp. 25–27 (Titian).

X–88. Emilia di Spilimbergo Plate 195

Canvas. 1·22 × 1·07 m.

Washington, National Gallery of Art.

Gian Paolo Pace.

About 1560.

Unlike the companion picture of *Irene di Spilembergo* (Cat. no. X–89), the portrait of Emilia betrays no participation by Titian.

Documentation, *History,* and *Bibliography:* The same as for Cat. no. X–89.

X–89. Irene di Spilembergo Plates 196, 198

Canvas. 1·22 × 1·07 m.

Washington, National Gallery of Art.

Gian Paolo Pace, retouched by Titian.

1560.

The rigid pose and the dryness of execution bear out the documentary evidence that Titian merely retouched a mediocre work by Pace. One may assume that he tried to improve the face, but the landscape shows the most likely intervention of the master.

Biography: A poetess of a princely family, Irene died at the age of twenty (1539–1559). Her promise and premature death inspired a book of poems dated 1561, among the contributors to which was Torquato Tasso (Cicogna, II, 1827, p. 37; Maniago, 1819, p. 164).

Documentation: In a notice of 28 June 1560 it is said that Gian Paolo painted the portrait of Irene Spilembergo so badly that Titian himself retouched it (first published by Carreri in 1911; repeated by Venturi, 1911, p. 394; also by Muraro, 1949, p. 83; quoted by Tietze and Tietze-Conrat,

1953, p, 100; the sheet of p. 163 with the notice of 28 June 1560 is now lost, but there is no reason to doubt its validity. Lodovico Dolce in a sonnet of 1559 had urged Titian to paint Irene's portrait (quoted by Ricci, 1929, p. 262).

History: In Maniago Castle, Friuli (Maniago, 1819, pp. 88–90, 125–129, 279–281; exported in 1909 (Venturi, 1911, p. 394); bought by Duveen before 1916; Widener Collection, Philadelphia, 1916–1942; bequest to the National Gallery, 1942.

Bibliography: See also above; Vasari (1568)-Milanesi, VII, p. 455 (Titian's portrait of Irene); Ridolfi (1648)-Hadeln, I, p. 194 (follows Vasari); C. and C., 1877, II, pp. 300–303 (Titian); Berenson, 1916, p. 19 (Titian); Valentiner, 1923, pp. 162–163 (Titian); Fischel, 1924, pp. 208–209 (Titian and Pace); A. Venturi, 1928, p. 167 (not Titian); Ricci, 1929, pp. 260–264 (Pace and Titian; major article); Berenson, 1932, p. 574 (Titian); Gronau, 1932, p. 117 (Pace and Titian); Suida, 1935 (omitted); Duveen, 1941, pls. 161, 162 (Titian); Tietze and Tietze-Conrat, 1953, pp. 99–107 (Pace and Titian); Berenson, 1957, p. 192 (Titian); Camesasca, 1959, III, p. 396 (Pace); Valcanover, 1960, II, p. 70 (Pace); 1969, no. 633 (Pace); Pallucchini, 1969, p. 221, fig. 665 (Pace).

COPY:

Irene di Spilembergo as St. Catherine, unknown location; canvas, 1·156 × 0·94 m. Leinster sale, London, Christie's, 14 May 1926, no. 52 (eighteenth-century forgery-copy; Sir Abraham Hume bought it from Giovanni Sasso of Venice about 1800; see Hume, 1829, pp. 63–64, as from the Cornaro Palace, Venice); Lord Brownlow, sale, London, Christie's, 4 May 1923, no. 56.

Sultana, see: Cat. no. L–28.

X–90. Three Figures (Conversation)

Canvas. 0·735 × 0·77 m.

Alnwick Castle, Duke of Northumberland.

Venetian School.

About 1520.

The traditional attribution to Titian or Giorgione cannot be taken seriously, since this mediocre painting of figures dressed in costumes of *c.* 1510–1520 may even be a later imitation *c.* 1600. The best figure, the man in black in the centre, is definitely superior in mood to the rather wooden girl at the left and the boy in the red hat to the right.

History: Manfrin Collection, Venice, praised by Lord Byron; Camuccini Gallery, Rome; purchased by the duke in 1856.

Bibliography: C. and C., 1871, II, p. 162 (imitator of Titian); Alnwick Castle, Catalogue, no. 755 (Giorgione); Suida, 1935, pp. 29, 30, 158, pl. 33B (early Titian); Berenson, 1957, p. 183 (studio of Titian); Valcanover, 1960 and 1969 (omitted); Pallucchini, 1969 (omitted).

Three Figures, see also:
 The Appeal, Cat. no. X–5.
 The Concert, Cat. no. 23.
 Group Portrait, Cat. no. X–63.
 Titian, Andrea dei Franceschi, and 'Friend of Titian', Cat. no. X–103.

X–91. Titian's Mistress (so-called) Plate 266

Canvas. 0·974×0·711 m.

London, Apsley House.

School of Titian.

About 1550.

This portrait of a woman in three-quarter length shows her wearing a hat and revealing her nude left breast. She wears a dark red velvet cloak over the white undergarment. The face has a flushed look, which may be partially due to restoration. The quality of the painting is moderately high, little if any inferior to the well-known picture of the *Girl in a Fur Coat and Hat* in Leningrad (Cat. X–59).

Condition: The nude breast and chest were formerly covered discreetly with a pale grey veil, presumably added when the picture was in the royal palace at Madrid. The remains of this overpaint are clearly visible in the original picture, although barely discernible in the photograph. A restorer of the past century, in cleaning the canvas, scrubbed the surface excessively.

History: Royal Palace, Madrid, possibly one of four half-length portraits of women in the Antecamara del Rey (Ponz, 1776, VI, Del Alcázar, 31); captured by the Duke of Wellington with Joseph Bonaparte's baggage at Vitoria in 1813.

Bibliography: See also above; Wellington, 1901, I, p. 222, no. 92, illustration.

X–92. Titian's Self-Portrait (tondo)

Panel. 1·07 m. diameter.

Location unknown (formerly Kaufmann).

Copy.

Sixteenth century.

An original *Self-Portrait* by Titian in tondo belonged to the collection of Gabriele Vendramin according to the Inventory of 1569 (Ravà, 1920, p. 178). Gronau attempted to establish the present version as Titian's original from the Vendramin family, particularly because that composition included a figure of the Medici Venus in the background as does the example under discussion (Gronau, 1937, pp. 291–294). Despite his arguments the fact remains that we must be dealing with a copy, perhaps of that very original.

In 1666 a lottery sale of the collection of the French painter Niccolò Renieri (Regnier), who lived in Venice, included a tondo called an original *Self-Portrait* by Titian (Segarizzi, 1914, p. 178; Savini Branca, 1964, p. 99). This same picture, which also had a figurine of the Medici Venus in the background, is likewise recorded by Martinioni in 1663 (Sansovino-Martinioni, p. 377). Renieri, something of a dealer and a copyist of Titian, owned other pictures purportedly by the master. Our version, last traceable in the Kaufmann sale at Berlin in 1917, has a chance of being the one which Renieri sold in 1666. It surely cannot be regarded as Titian's original.

Known History: Collection of Marchese Brignole in the Palazzo Rosso, Genoa (Ratti, 1780, I, p. 252, Titian); Lord Malmesbury, London, exhibited at the British Institution, 1848 (Waagen, 1854, I, p. 417: a label on the back gave Brignole as the provenance and Sebastiano del Piombo as the painter in 1542); sale 1876 as Sebastiano del Piombo (Redford, 1888, I, p. 250, II, p. 253); Kaufmann Collection, Berlin (sale 4–5 December 1917, no. 59, as Sebastiano del Piombo).

Bibliography: See also above; Campori, 1870, p. 442 (Renieri inventory); C. and C., 1871, II, p. 360 (poor copy), edition 1912, p. 252 (Lord Malmesbury's picture, a poor copy); Richter, 1931, p. 167 (copy); *idem, Apollo,* 1931, pp. 339–343 (Sebastiano del Piombo); Gronau, 1937, pp. 291–294 (Titian, from the Vendramin Collection); Valcanover, 1960, II, p. 66 (not by Titian); *idem,* 1969, no. 584 (doubtful attribution).

X–93. Titian's Self-Portrait (half-length) Plate 273

Canvas. 1·142×0·94 m.

Washington, National Gallery of Art (in storage).

Copy.

Seventeenth century.

A false later inscription on the back of the plaque held by the artist reads: T. VECELLIUS P AET LXXXIV ANNO MDLXI. The association of this work with an engraving by Giovanni Britto (see Cat. no. 104, engraving no. 1) is not

justified. The quality of the lighting and the brushwork place the picture definitely in the full Baroque style of the seventeenth century, a time at which many forged Titians were produced. A statue of Venus in the left background distinguishes this example and also others formerly in private collections (Cat. nos. X–92, X–94).

Condition: Many small losses all over the surface of the black costume and the greyish-white statue of Venus in the left background.

False history: The following false history is given in the Paolini Catalogue: Renier Collection, Venice (this picture was round, see Cat. no. X–92); Catherine the Great of Russia, 1700; said to be her gift to Count Rackinsky, who took it to Melbourne.

Certain history: Paolo Paolini, New York, 1894–1924 (sale 10–11 December 1924, no. 116, $9,200); Van Dieman Gallery, New York, 1924; W. R. Timken, New York; bequest to the National Gallery, Washington, in 1959.

Bibliography: See also above; L. Venturi, 1931, pl. 389 (with incorrect history; Titian); *idem*, 1933, pl. 528; Mather, 1938, p. 20 (with wrong history of the picture; Titian); New York, World's Fair, 1939, pp. 188–189, no. 387 (with incorrect data); Washington, 1965, p. 131, no. 1591 (attributed).

X–94. **Titian's Self-Portrait** (half-length)

Canvas. 1·09×0·877 m.

Location unknown (formerly Ashburnham).

Copy.

Seventeenth century.

George M. Richter identified this picture with the one mentioned in Aretino's letter of 1550 and engraved by Giovanni Britto (Plate 208), but the print lacks the statue in the background and does not correspond in other details. The weak drawing of the hand and the absurd Venus are enough to eliminate Titian as the painter.

History: No early history is surely established; Earl of Ashburnham, before 1877 to 1931; Frank Sabin, London, 1931; Anonymous sale, Christie's, London, 20 July 1956, lot 51, bought by Klein, £262 (APC, XXXIII, 1955–1956, no. 4414).

Bibliography: Richter, 1931, pp. 161–168 (Titian, *c.* 1550; recently in Ashburnham Collection); Berenson, 1957, p. 183, pl. 1008 (late work of Titian).

A literary reference which corresponds to this type of portrait, although the attribution is unconfirmed, is as follows: Letter of April 1675 of Marco Boschini to Cardinal Leopoldo dei Medici, mentioning a picture in the collection of Cav^r Francesco Fontana in Venice and available for purchase, 'Un quadro di mano di Tiziano ove è dipinto il suo proprio ritratto, meza figura, il quale con una mano sta appoggiato sopra un quadretto e nell' altra mano tiene un toccalapsis, mostra voler disegnare, con dietro una statua della Venere de Medici fatta di bronzo, alto quarti 7, largo quarti 6 in circa' (Procacci, 1965, p. 98; apparently the same item in Campori, 1870, pp. 442–443).

X–95. **Titian's Self-Portrait** (half-length)

Canvas. 0·77×0·63 m.

Florence, Uffizi.

Copy.

Seventeenth century.

History: This picture was purchased in Antwerp in 1676–1677 by Cosimo III, Grand Duke of Tuscany (Gualandi, 1845, II, pp. 306–317).

Bibliography: C. and C., 1877, II, pp. 60, 62 (perhaps by Marco Vecellio); Cruttwell, 1907, p. 154, no. 384 (copy); Fischel, 1924, p. 163 (Titian, 1550); Richter, 1931, p. 167 (Titian); Foscari, 1935, pp. 28–29, fig. 16 (school work).

X–96. **Titian's Self-Portrait** (bust-length) Plate 272

Canvas. 0·62×0·52 m.

Stockholm, National Museum.

Copy by Orlando Flacco (Fiaco).

Signed: ORL. FIACO. VERO. F.

Late sixteenth century.

A rather mediocre, hard copy by Orlando Fiaco (Flacco, or Fiacco) of Verona (*c.* 1530–1591), a pupil of Torbido.

History: Giuseppe Caliari's collection, Venice, a portrait of Titian by Fiacco (Ridolfi (1648)–Hadeln, II, p. 121); Rudolf II at Prague, Inventory, *c.* 1598 (Perger, 1864, p. 106; Prague Inventory, 1621, no. 921 (Zimmermann, 1905, p. XL); captured and taken to Stockholm in 1648.

Bibliography: See also above; Sirèn, 1904–1905, pp. 60–61; Stockholm, 1928, p. 15.

X–97. **Titian's Self-Portrait** (bust-length)

Canvas. 0·50×0·42 m.

Milan, Ambrosiana Gallery.

Copy.

Sixteenth or seventeenth century.

History: Gift of Cardinal Federico Borromeo in 1618.

Bibliography: Guida sommaria, 1907, no. 41; Foscari, 1935, pp. 28–29, fig. 18 (school of Titian).

X–98. **Titian's Self-Portrait** (bust-length)

Panel. 0·51×0·42 m.

Vienna, Kunsthistorisches Museum (in storage).

Copy.

Seventeenth century.

Titian looks much younger here than in other portraits; therefore this canvas may reflect the *Self-Portrait* which Vasari saw in 1542 (Vasari (1568)-Milanesi, VII, p. 446). Crowe and Cavalcaselle suggested that Jacopo Strada might have sold the original painting to Vienna in 1567. However, the portraits of Titian, Michelangelo, Baccio Bandinelli, and Andrea del Sarto in the list of 1567 were anonymous (Stockbauer, 1874, p. 43).

History: Archduke Leopold Wilhelm, Vienna, 1659, no. 304; Stallburg (Mechel, 1783, p. 28, no. 49).

Bibliography: See also above; Teniers, 1660, pl. 52; C. and C., 1877, II, pp. 60–61 ('no trace of Titian's hand'); Engerth, 1884, p. 366, no. 516 (Titian); Fischel, 1924, p. 274 (copy); Foscari, 1935, pp. 29–31, fig. 17 (copy of an original *c.* 1533).

COPY:

By Teniers, formerly at Blenheim Palace, Duke of Marlborough; sale, 24 July 1886, p. 33, no. 98.

X–99. **Titian's Self-Portrait** (bust-length)

Canvas. 0·28×0·25 m.

Rome, Villa Borghese (in storage).

Copy.

Seventeenth century.

Similar to the Ambrosiana example (Cat. no. X–97).

History: First mentioned in the Inventory of 1700.

Bibliography: Pergola, 1955, I, p. 134, fig. 239.

X–100. **Titian's Self-Portrait** (bust-length)

Panel. 0·66×0·49 m.

Florence, Uffizi.

Copy.

Seventeenth or eighteenth century.

Said to have been stolen from the Vecelli family at Cadore and bought in 1733 by the Duke of Florence (Ticozzi, 1817, pp. 303–307).

Bibliography: See also above; C. and C., 1877, II, pp. 59–60 (copy); Cruttwell, 1907, p. 155, no. 384bis (copy); Fischel, 1924, p. 274 (copy); Foscari, 1935, pp. 28–29 (copy).

X–101. **Titian's Self-Portrait** (bust-length)

Panel. 0·63×0·51 m.

Hannover, Museum (formerly on loan).

Copy.

Eighteenth century.

A romanticized late version, which is treated with considerable freedom, it cannot possibly be the source of the woodcut used by Vasari in 1568 as proposed by Foscari (1935, p. 30, pls. 19, 33). On the contrary, it is copied from the woodcut. The present location of this item is unknown, for it has not been in Hannover since 1925, according to a recent letter from the director of the museum.

Bibliography: See also above; Braunschweig, 1905, no. 588 (copy, seventeenth century).

Titian's Self-Portrait, see also: Cat. nos. 104–107 and L–29—L–33.

X–102. **Titian's Self-Portrait with His Mistress** (so-called) Page 52

A painting of this subject listed in the Borghese Collection at Rome in the Inventory of 1693 (see below) may be the source of the drawing of the two figures in Van Dyck's 'Italian Sketchbook' (1622–1627, folio 109). Here the woman appears at the left and Titian at the right. An etching signed 'Titian. pinxit, Pauli fecit, A. Bonenfant excudit' repeats these figures and adds a skull at the left (illustrated by Tietze, 1936, I, pl. XXXI, p. 251).

Another print showing the figures in reverse has, on at least some examples, an inscription signed by Van Dyck dedicating it to Lucas van Uffel, a Flemish collector (illustrated by Fischel, 1924, p. 275).

The etching lacks any signature of the maker. Nevertheless, writers on Van Dyck and his activity as a print-maker have widely accepted the print as Van Dyck's own work (Carpenter, 1844, pp. 127–128; Hind, 1915, pp. 3, 103). Gronau (*Titian*, 1904, p. 231) adopted Cadorin's position that an original picture of the subject was in the van Uffel Collection in Antwerp and that Van Dyck made the print after it. However, the 'Italian Sketchbook' indicates that the artist saw it in Italy, where to be sure Lucas Van Uffel could have had a version during his residence in Venice (Vaes, 1924, pp. 178, 180).

Hourticq mistakenly believed that Van Dyck had originated the composition, using Titianesque elements. On the contrary, the now lost picture from the Borghese Collection must have been a pastiche or an outright forgery of about 1600, which Van Dyck mistook for an original by Titian (see Müller-Rostock, 1922, p. 22, no. 21). The composition is badly mis-scaled, and the whole idea of the lecherous old man and a stout young woman betrays no connection with Titian's mentality. It is, moreover, open to question whether the unsigned etching is properly attributed to Van Dyck himself.

The other etching (unreversed) signed by Pauli (1600–1639) and printed by Bonenfant (1598–1644) seems to have been copied and reprinted by Franz van der Wyngaerde (1614–1679). An example of this print exists in the Bibliothèque Nationale, Paris (Oeuvre de Titien, vol. v, pl. 54). An inscription is given in Latin on the Pauli etchings and its copies, while an Italian poem appears on the anonymous print attributed dubiously to Van Dyck. The contradictory nature of the legend supports the belief that the composition is apocryphal.

'Ecce viro quae grata suo est, nec pulchrior ulla:
Pignora coniugii ventre pudica gerit.
Sed tamen an vivens, an mortua, picta tabella
Haec magni Titiani, arte notanda refert'.

English translation:
'Behold a woman pleasing to her husband, nor is any other fairer than she.
In her womb the chaste woman bears the pledges of wedlock.
Yet be she alive or be she dead, this painted panel
Represents [her] through the remarkable skill of the great Titian'.
[Translation by Dr. Berthe Marti]

Italian version:
'Ecco il belveder! ô che felice sorte
Che la fruttifera frutta in ventre porte
Ma ch' ella porte, ô me vita et morte piano
Demonstra l'arte del magno Titiano'.

Inscription on Italian version:
'Al molto illustre, magnifico et osseruandis^mo Sig^r il Sig^r Luca van Uffel, in segno d'affectione et inclinatione amoreuole, como patrone et singularis^mo amico suo dedicato il vero ritratto del unico Titiano'.

Ant. Van Dyck.

Various scholars have made rather non-serious proposals about the subject matter: Crowe and Cavalcaselle that Titian painted a Self-Portrait with his daughter Lavinia; Mario Brunetti that the woman might have been Titian's anonymous mistress of the fifteen-forties when the artist's illegitimate daughter, Emilia, was born *c.* 1548 (see Wethey, I, 1969, p. 14, note 74); Cadorin saw in the gesture of Titian the affectionate touch of the future grandfather. That the lady is pregnant seems clearly indicated by the verses, and in the Latin version the old man is her husband.

Bibliography: Mariette (1748–1758) edition 1858–1859, x, p. 329 (a painting by Titian, preserved in a print by Van Dyck and another published by Bonenfant); Cadorin, 1833, p. 79, note 119 (Titian and Lavinia, preserved in Van Dyck's print); Carpenter, 1844, pp. 127–128 (Titian and His Mistress by Van Dyck); C. and C., 1877, II, pp. 138–139; Lafenestre, 1886, pp. 261, 268 (illustrated as Van Dyck after Titian).

Hourticq, 1919, pp. 232–234; Fischel, 1924, p. 275 (a late pastiche); Brunetti, 1935, pp. 175–184; Tietze, 1936, I, p. 251, pl. xxxi (Pauli after Van Dyck's copy of Titian); Goldscheider, 1937, p. 23 (etching by A. Pauli); Adriani, 1940, pp. 70–71 (after an original painting by Titian in the Van Uffel Collection at Venice).

PAINTINGS OF THE SUBJECT:

1. London, James Morrison (formerly); canvas, $35\frac{1}{2} \times 31\frac{1}{2}$ inches (0.92×0.80 m.) (Waagen, 1857, p. 110; C. and C., 1877, II, p. 139, note). Previously London, Lord Radstock, 35×20 inches; sale, London, Christie's, 12 May 1826, no. 50, bought by Captain Gillam (Graves, 1921, III, p. 211).

2. Borghese Collection, Rome; panel, 4 *palmi* square (*sic*), i.e., 0.89 m., Inventory, 1693, no. 458, Titian (Pergola, 1965, p. 204). Despite the fact that this item is said to be on panel, it may be the same as the above, no. 1. The Borghese picture is probably the one seen by Van Dyck ('Italian Sketchbook', 1622–1627, folio 109).

PRINT (VARIANT):

Boston, Museum of Fine Arts; the head of Titian alone; signed 30 March 1661 by Jan Thomas of Ypres (1613–1673) (H. P. R., 1948, p. 90).

X–103. Titian, Andrea dei Franceschi, and the Friend of Titian Plate 275

Canvas. 0·805×0·93 m.

Hampton Court Palace (formerly Windsor Castle).

Follower of Titian.

Late sixteenth century.

This picture was X-rayed in 1957, revealing for the first time in several centuries the third head at the right. As far back as 1639, in the catalogue of the collection of Charles I made by van der Doort, the work had been a double portrait cited as 'Titian and a Venetian senator'. Crowe and Cavalcaselle first suggested that it be called 'Titian and Andrea dei Franceschi'. The features of the youngest of the men at the right are now identifiable, since he appears in the portrait known as the *Friend of Titian*, now in the De Young Memorial Museum at San Francisco (Cat. no. 39). This compilation of portraits from Titian's workshop remains a mystery as to authorship. A Venetian follower of the artist is the most likely solution. Certainly St. John Gore's suggestion that Titian painted the central figure does not convince. Further complications were added by the revelation in the X-rays of the head of a bearded elderly man painted twice, once upright and secondly in a lateral position on this reused canvas. Sir Anthony Blunt's comparison of it with a Bassanesque head (sold at Christie's on 1 February 1924, no. 4) further removes the whole problem from Titian's own immediate environment.

Condition: Cleaned and restored by Mr. Buttery in 1957.

History: Gonzaga Collection, Mantua, sold to Charles I of England: 'Three heads in one picture' mentioned in a letter written at Venice, 13 June 1631, to Thomas Cary from Daniel Nys (Sainsbury, 1859, pp. 336–337; Braghirolli, 1881, p. 38, note 3; Luzio, 1913, pp. 165–166); Collection of Charles I, 'The Picture of Tichian himself painted by himselfe and his friend by. In a reed velvett venicia senators' (van der Doort, 1639, edition Millar, 1960, p. 16, no. 11); Charles I, Inventory 1649, LR 2/124, folio 164, no. 21; in 1650 sold to J. B. Gaspar for £112 after Charles' execution (Harley MS., no. 4898, folio 504, no. 234, 'Titian and Aretino').

Bibliography: See also History; Waagen, 1854, II, p. 481, no. 41; C. and C., 1877, II, pp. 64–65 (as a work of the early seventeenth century recalling Odoardo Fialetti); Poglayen-Neuwal, 1927, pp. 66–70 (a pastiche); Berenson, 1927, pp. 232–233 (workshop); *idem*, 1947, p. 30 (workshop); *idem*, 1957, p. 186 (Titian); St. John Gore, 1958, pp. 351–352 (the major study of the picture): Pallucchini, 1969, p. 294 (workshop).

LOST COPY:

Rome, Palazzo Falconieri, in the eighteenth century, 'tre ritratti in un quadro... di Tiziano' (Venuti, 1745, I, p. 313; 1766, p. 230).

COPIES (with only Titian and Andrea dei Franceschi): 1. Cobham, Kent, Cobham Hall (C. and C., 1877, II, p. 65); sale, 22–23 July, 1957, no. 320, obviously after 1627. 2. Hardwick Hall, Derbyshire; after 1627; two figures only; canvas, 1.142×1.12 m. (Gore, 1969, p. 244).

OTHER VERSIONS:

See single portraits of Franceschi in Detroit, Washington, and Indianapolis (Cat. nos. 34, 35 and X–39).

X–104. Titian and Francesco Zuccato (del Mosaico)

Canvas. 0·97×0·885 m.

Location unknown.

Copy after Titian.

About 1600.

Although the quality of this copy is superior to the common run, it has not been seriously considered in modern times to be an original. No photograph of it is available for publication here.

History: Casa Ruzzoni, Venice (Ridolfi (1648)-Hadeln, I, p. 200, described the picture as by Titian); Vitturi Collection, Venice, c. 1740–1744; Thomas M. Slade, Rochester, England, c. 1744–1790 (Buchanan, 1824, I, p. 328); Lord Darnley, Cobham Hall, 1790–1925 (Waagen, 1838, III, p. 381, by Titian, from the Vitturi collection); Darnley sale, London, Christie's, 1 May 1925, no. 82, £336; Frank T. Sabin, London, 1931; Fischer, Lucerne, sale 29 November 1950, no. 1711; Fischer and Co., Lucerne, in 1955; Anonymous sale, London, Christie's 18 March 1955, no. 156, £846, to D. A. Martin.

Bibliography: See also History; Waagen, 1854, III, p. 19, feeble copy, wrongly states that it came from the Orléans Collection; C. and C., 1877, II, pp. 64–65 (copy of the seventeenth century); Richter, 1931, pp. 161–168 (beyond doubt by Titian, 1540).

X–105. Marcantonio Trevisan, Doge of Venice Plate 237

Canvas. 1·00×0·865 m.

Budapest, Museum of Fine Arts.

Workshop of Titian.

About 1553.

Titian's own replica of a lost votive portrait, destroyed in the fire of 1577, is the usual evaluation given to this canvas, but the quality is far from inspired. Aretino's praise of Titian's portrait of the Doge Trevisan in November 1553 (*Lettere*, edition 1957, II, p. 433) makes one wonder whether he was referring to another picture.

Biography: Marcantonio Trevisan (*c.* 1475–1554), of an illustrious Venetian family, held the office of Doge (1553–1554) for only one year before his death; he did not want the post, perhaps because of his age, but his relatives and friends forced him to accept it (Cicogna, 1834, IV, p. 566; Mosto, 1960, pp. 254–259).

Condition: Well preserved.

History: Said to have come from the Sampieri Collection, Bologna (not listed in that collection by local guide books); Samuel Festetics, Vienna, until 1859; Dr. F. Sterne, Vienna (died 1886); H. O. Miethke, Vienna; gift of Count János Pálffy to the museum in 1912 (Pigler, 1967, I, p. 698).

Bibliography: C. and C., 1877, II, pp. 226–227 (Titian's own replica); Hadeln, 1930, p. 492 (workshop of Titian); Suida, 1935, pp. 74, 173 (Titian); Tietze, 1936, II, p. 285 (doubtful attribution); Berenson, 1957, p. 184 (Titian); Valcanover, 1960, II, p. 69 (doubtful attribution); Garas, 1965, no. 20 (Titian, 1553); Pigler, edition 1967, I, p. 698, no. 4223 (Titian; with full bibliography); Ballarin, 1968, p. 254 (workshop); Valcanover, 1969, no. 362 (doubtful attribution); Pallucchini, 1969, p. 299, fig. 381 (Titian, 1553–1554).

X–106. **Turkish** (Oriental) **Potentate**

Canvas. 1·52 × 1·09 m.

Venice, Italico Brass.

French School (?).

Eighteenth century

The *Turkish Potentate* suggests the ultimate in sophistication and worldly splendour, the slender, elegant, black-bearded subject presented in a setting and seated on a bench which seems to have little precedent in Italian Renaissance painting. Cellini in 1961 (pp. 465–469) first called attention to the fact that the jewellery and turban are unmistakably of the eighteenth century. By comparison with portraits in the Seraglio Museum in Constantinople, he suggested that the sitter is Abdul Hamid I (1725–1789), an identification which carries conviction, since despite the deceptiveness of beards, a physical resemblance actually seems to exist between the Brass and Seraglio faces.

Suida (1952, pp. 40–41), who first published the portrait,

called him Selim II (1524–1575) who in 1566 succeeded his father Soliman the Great (Cat. no. L–27), and he at the same time attributed the canvas to Titian. Even more speculative was his suggestion that *Philip II* (Cat. no. 84) and the so-called *Gian Andrea Doria* (Cat. no. X–28) were companion pieces celebrating the Christian victory at Lepanto in 1571. The total disparity in sizes of all three was overlooked by Suida. The last two measure 3·25 × 2·74 m. and 2·00 × 1·04 m. respectively. Berenson accepted Suida's attribution but without explanation changed the sitter to Muhrad III (1546–1595), son of Selim II and his favourite wife, Cecilia Baffo Venier (Spagni, 1900, pp. 141–348). However, Muhrad was described in contemporary Venetian dispatches as grey-eyed and blond-bearded, as well as short and corpulent (Rossi, 1953, pp. 438–439). There the matter has stood until the present, when, examining the evidence, the author can find no substantial traits in the portrait to suggest the hand of Titian or of anyone else in the sixteenth century.

A tentative attribution to the French school seems likely for several reasons. The portrait itself suggests a sophisticated point of view that seems essentially French. Furthermore, several artists of the French school spent considerable time in Constantinople in the eighteenth century, among them van Mour (Thieme-Becker, XXV, 1931, p. 202), Liotard (Vollmer, 1929, pp. 263–264), and Favray (Vollmer, 1915, pp. 310–311). In addition the favourite wife of Abdul Hamid I, the identification suggested by Cellini, was Aimée Dubucq de Rivery, a cousin of the Empress Josephine. She had been kidnapped by Turkish pirates on her way from school in France to her home in Martinique and presented to the Sultan by the Bey of Tunis (Blanch, 1954, chapter III).

Bibliography: Suida, 1935, pp. 102, 116, pl. 285 (Selim II by Titian); Berenson, 1957, p. 191, pl. 1010 (Muhrad III by Titian); Cellini, 1961, pp. 465–469 (Abdul Hamid I, by a painter of the eighteenth century); Valcanover, 1960, II, pl. 106 (Titian); *idem*, 1969, no. 623 (doubtful attribution).

X–107. **Two Young Princes**

Canvas. 1·27 × 0·97 m.

Tivoli, Villa d'Este, Quadreria.

Roman School (?).

About 1580.

An altogether charming picture, it cannot be associated with the Venetian school or with Titian, to whom it was traditionally assigned. Both children are dressed in grey against a rose-coloured curtain. In addition to the sword held by the older boy, they carry flowers, and the younger wears a coral

necklace with a pendant, on which appears the Madonna in half-length.

Condition: Slashes in the canvas have been repaired.

History: Gift of Prince Corsini in 1883 to the Galleria Nazionale, Rome, as by Titian; lent by the gallery to the Villa d'Este.

Bibliography: C. and C., 1877, II, p. 442 (Sons of Charles V; seventeenth century); *Mostra del 1500*, Florence, 1940, p. 151 (manner of the Zuccari); Bologna and Causa, 1952, no. 86 (unknown painter, late sixteenth century); Carpegna, 1955, no. 20 (Roman school); photographs: Alinari 7234, Anderson 1239.

X–108. **Pomponio Vecellio** (so-called)

Canvas. 1·073 × 0·86 m.

Kreuzlingen, Heinz Kisters.

Cariani (?).

About 1530.

The youth in a black costume, trimmed with dark fur, grasps the hilt of a sword with his left hand and rests his right upon a helmet, as he stands silhouetted against a greyish-green background. The identification of the sitter as Titian's son, who was a priest, is quite illogical.

Condition: Somewhat restored; grey underpaint is visible in the face and hands.

History: Steinmeyer Collection, Lucerne, 1922; Reinhardt Galleries, New York, 1928; J. Böhler, Munich, 1950; Kreuzlingen, Dr. Friedrich Flick.

Bibliography: Gronau, 1922, pp. 60–68 (Titian, *c.* 1550); Detroit, 1928, no. 6 (Titian, 1535–1540); Suida, 1935, pp. 87, 174 (Titian); Tietze, 1936, II, p. 295 (Titian; as in Lucerne); Tietze, 1950, p. 381 (Titian); Berenson, 1957 (omitted); Heinemann, 1967, p. 212 (Young Man, by Titian, *c.* 1550); Valcanover, 1960 and 1969 (omitted); Pallucchini, 1969, (omitted).

X–109. **Venetian Gentleman** Plate 215

Canvas. 0·76 × 0·64 m.

Washington, National Gallery of Art.

Giorgionesque Painter.

About 1510.

The letters vvo upon the parapet came to light during the cleaning of the picture in 1962, thus adding another example of those puzzles whose meaning remains to be deciphered (see note 56). The Giorgionesque formula has generally been recognized by all critics, i.e. the parapet in the foreground and the figure in black silhouetted against the grey background. However, the right hand originally held a dagger hilt, which was subsequently changed to a scroll and still later to the present handkerchief. It is assumed that the book and parapet were added during these modifications. The first design of the composition is therefore difficult to imagine.

The present state of the portrait strikes this writer as disagreeable for several reasons: the strange uncomfortable tilt of the head, the wall-eyed countenance, and the generally coarse features, added to the contradictory tilt of the parapet, which confuses the space. Arguments in favour of Titian's authorship are usually based upon the similarity of the composition to that of *La Schiavona* and of the *Gentleman in Blue*, both in London (Plates 14, 3). But both of these works have an adroitness of organization which the Washington picture so distressingly lacks. Only a minor artist could be responsible for this picture, so thoroughly unpleasant both in form and content.

Condition: Restored in 1962 by Modestini removing old repaint that had transformed the view of Venice through the window. The background and parapet have suffered extensive losses of paint, which have been filled in.

History: William Graham, London (sale, London, Christie's, 10 April 1886, no. 450, Giorgione); Henry Doetsch, London (sale, London, Christie's, 22 June 1895, no. 48, Licinio); George Kemp, Lord Rochdale, Beechwood Hall, Rochdale (Giorgione); Henry Goldman, New York, before 1920 (Titian); Duveen Brothers, New York (Titian); Kress Collection, acquired 1937; in the National Gallery, Washington, since 1941 (history compiled by Shapley, 1968, pp. 178–179).

Bibliography: See also above; Berenson, 1897, pp. 275–281 (copy after Giorgione); *idem*, 1901, pp. 82–84 (copy of lost Giorgione); Cook, 1905–1906, p. 338 (Giorgione); L. Venturi, 1913, p. 366 (Sebastiano del Piombo); Valentiner, 1922, pl. 5 (Titian); L. Venturi, 1931, pl. 374; *idem*, 1933, pl. 505 (Titian); Berenson, 1932, p. 573 (early Titian); Suida, 1935, pp. 15, 155 (Titian); Tietze, 1936, II, p. 303; *idem*, 1950, p. 403 (early Titian); Duveen, 1941, pl. 153 (Titian); Washington, 1941, p. 79, no. 369 (Giorgione and Titian); Richter, 1942, pp. 151–152 (Giorgione and assistant); Berenson, 1957, p. 192 (early Titian); Valcanover, 1960, I, pl. 2 (early Titian); Pallucchini, 1962, pp. 234–237 (Titian);

Morassi, 1967, p. 135 (early Titian); Shapley, 1968, pp. 178–179 (Titian; complete study and bibliography); Pallucchini, 1969, pp. 233–234, figs. 16–17 (Titian, *c.* 1508–1510); Pignatti, 1969, pp. 112–114, no. 31 (Giorgione, *c.* 1510).

X–110. Venetian Gentleman (so-called Ariosto) Plate 216
Canvas. 0·502 × 0·451 m.
New York, Metropolitan Museum, Altman Collection.
Giorgionesque painter.
About 1510.

The condition of the picture is such that an attribution to either Giorgione or Titian is altogether hypothetical, the present agreement of several Italian critics in favour of Titian notwithstanding.

Condition: Dry and rubbed surface; cut down on all sides with the right hand partly eliminated.

History: Grimani Collection (?), Venice; Walter Landor, Florence, 1864; Countess of Turenne, Florence; Benjamin S. Altman, New York; bequeathed to the museum in 1913 (history by Wehle, 1940, p. 189).

Bibliography: Bode, 1913, pp. 225–234 (Giorgione); Gronau, 1921, p. 88 (probably by Giorgione); Berenson, 1932, p. 233 (Giorgione); Suida, 1935, p. 157 (Titian); Tietze, 1936 (omitted); Richter, 1937, p. 230, no. 53 (Palma il Vecchio, 1508–1510); Wehle, 1940, p. 189 (Giorgione or Titian); Duveen, 1941, no. 151 (Giorgione); Berenson, 1957, p. 84 (Giorgione); Valcanover, 1960, I, pl. 32; *idem*, 1969, no. 37 (Titian); Mariacher, 1968, p. 103 (Titian); Pallucchini, 1969, p. 233, fig. 15 (Titian, *c.* 1508–1510); Pignatti, 1969, p. 127, no. A35 (early Titian).

X–111. Venetian Gentleman (so-called Contarini) Plate 251
Canvas. 0·94 × 0·70 m.
São Paulo (Brazil), Museum of Art.
Venetian School.
About 1525.

The identification of the sitter as a member of the Contarini family, made by the São Paolo Museum, has not been established. This picture has been incorrectly associated with a portrait from the Contarini Palace at Venice (Hume, 1829, p. 66), which is really Cat. no. X–78, Related Item, no. 2.

Incorrect History: Sir Abraham Hume, London; Lord Alfred Hume, London; Lord Brownlow, Belton House, Grantham, Lincolnshire (history by Bardi, 1954, p. 28).

Certain History: Wildenstein Gallery, New York, *c.* 1930–1950; purchased by São Paulo, 1950.

Bibliography: See also above; L. Venturi, 1931, pl. 384; *idem*, 1933, no. 520 (Titian, *c.* 1550); Suida, 1935, pp. 86, 172 (Titian, *c.* 1540); Bardi, 1954, p. 28 (Titian); Berenson, 1957, p. 190 (Titian); Bologna, 1957, pp. 65, 69 (Titian); Pallucchini, 1969, p. 223, fig. 667 (follower of Titian).

X–112. Venetian Girl (formerly called Giulia Gonzaga Colonna) Plate 268
Canvas. 0.98 × 0.74 m.
Washington, National Gallery of Art (Kress Collection).
Imitator of Titian.
Sixteenth century.

In this extremely weak portrait a young woman wears a light-green boudoir gown sewn with pearls over the long white *camicia* or undergarment. The informality of dress does not necessarily indicate a courtesan, but rather a girl with attributes of an apple and wreath of flowers which must have a mythological or romantic literary significance. Below are listed other portraits, similar in pose, with different attributes.
Although the Washington picture has been accepted as a work of Titian by some writers, the quality in no way measures up to his standard. Mrs. Shapley in her monumental catalogue of the Kress Collection leaves no doubt of her rejection of their opinions.
The proposal to identify the woman in this picture as Lavinia, Titian's daughter, or as Giulia Gonzaga Colonna are totally without foundation (see also Cat. nos. X–60 and L–17.

History: George Wilbraham, London, exhibited at the British Institution, 1829, no. 161, as *Lavinia* by Titian (Graves, 1914, III, p. 1317); G. F. Wilbraham, exhibited at the Royal Academy, 1883, no. 191, as *Catherine Cornaro* by Titian (Graves, p. 1322); Major H. E. Wilbraham, exhibited at the Burlington Fine Arts Club, London, 1914, no. 19, as a *Lady* by Titian; Kress acquisition 1938; Duveen, 1941, no. 155, as *Giulia Gonzaga Colonna* by Titian; since 1941 in the National Gallery of Art, Washington (history reconstructed by Shapley, 1968, pp. 186–187).

Bibliography: See also above; Fischel, 1924, p. 318, no. 176 (not Titian); Hadeln, 1931, p. 86, note (follower of Titian); Suida, 1935, pp. 112, 173, pl. 197 (Titian; wrongly located in the Mellon Collection); Tietze, 1936 and 1950 (omitted); Pallucchini, 1954, II, pp. 63–64 (Titian, overcleaned); Berenson, 1957, p. 192, no. 403 (Titian); *Kress Collection* 1959, pl. 194 (Titian); Valcanover, 1960, II, p. 69, pl. 165

(doubtful attribution); Shapley, 1968, pp. 186–187 (not Titian; thorough account); Valcanover, 1969, no. 374 (attributed); Pallucchini, 1969, pp. 137, 301, fig. 394 (Titian, *c.* 1550–1555).

RELATED WORKS OF THE VENETIAN SCHOOL, LATE SIXTEENTH CENTURY:

1. Dresden, Staatliche Gemäldegalerie; *Girl with a Vase,* canvas, 0.995×0.87 m. *Bibliography:* Fischel, 1924, p. 176 (imitator of Titian); Posse, 1929, p. 88, no. 173 (workshop of Titian); Suida, 1935, pp. 112, 172, pl. 189b (Titian); Berenson, 1957, p. 184, no. 173 (late Titian, repainted).
2. London, Duke of Wellington; *Girl Holding a Crown of Roses* (Plate 267), canvas, 1.03×0.746 m.; follower of Titian; from the Royal Palace, Madrid; captured by Wellington with Joseph Bonaparte's baggage in the Peninsular War at Vitoria in 1813. *Bibliography:* Hume, 1829, p. 67 (Titian's daughter by Titian); C. and C., 1877, II, p. 58, note (follower of Titian); Wellington, 1901, I, pp. 202–203 (as *Catherine Cornaro* by Titian). Klara Garas has proposed that the portrait of a woman holding a crown in the Ludovisi Inventory of 1633, no. 17, was presented to Philip IV of Spain and has ended in the Wellington Collection. Her argument that the man with a clock was its companion and that the two were identified in Spain as *Titian and His Wife* is not convincing (Garas, 1967, p. 340, notes 17–19). My Cat. no. 58, Plate 161, *Knight with a Clock,* is the male figure and the other item is lost.
3. Milan, Private Collection; *Girl with Crown of Flowers. Bibliography:* Suida, 1935, p. 112 (Titian).
4. Vienna, Kunsthistorisches Museum, in storage; *Young Woman with a Weasel,* canvas, 0.86×0.65 m. *History:* Archduke Leopold Wilhelm (Teniers, 1660, pl. 94). *Bibliography:* Engerth, 1884, I, p. 374, no. 527 (school piece); Hadeln, 1931, p. 86, note (Vienna, in storage, school piece); Suida, 1935, p. 112 (Titian, wrongly cited as in Scandinavia).
5. Washington, Robert Guggenheim (destroyed by fire); *Girl with a Cat,* canvas, 0.952×0.762 m.; formerly Lord Leconfield, Petworth (Collins Baker, 1920, p. 130); Agnew and Co., New York and London. *Bibliography:* Detroit, 1928, no. 16, illustrated (Titian); Shapley, 1968, p. 186 (follower of Titian).

X–113. **Verdelotto and the Singer Ubretto** (presumed)

Canvas. 0·87×1·02 m.

Berlin, Staatliche Gemäldegalerie (formerly; destroyed in 1945).

Sebastiano del Piombo.

About 1510.

The celebrated Flemish composer Verdelot, known in Italy as Verdelotto, is presumed to have been shown here with Ubretto, a singer also attached to St. Mark's in Venice. Vasari's reference to a picture of this subject (Vasari (1568)-Milanesi, V, pp. 565–566) as the work of Sebastiano, then in the house of Francesco San Gallo at Florence, has given rise to the theory that he meant Titian's famous *Concert* (Cat. no. 23) in the Pitti Gallery, which, however, includes three figures, not two. More reasonably it has been identified by Sydney Freedberg as this double portrait formerly in Berlin.

Bibliography: Posse, 1913, I, p. 182, no. 152 (Venetian School, *c.* 1515–1525); Longhi, 1927, edition 1967, p. 241, fig. 202 (Titian, *c.* 1518–1520); Berenson, 1957, p. 184 (copy of an early work by Titian); Valcanover, 1960, I, p. 97, pl. 205B (doubtful attribution); Freedberg, 1961, pp. 337, 374, fig. 459 (Sebastiano del Piombo, *c.* 1510).

X–114. **Andreas Vesalius** (so-called)

Canvas. 1·30×0·98 m.

Florence, Pitti Gallery.

Venetian School.

Sixteenth century.

Although the condition of this portrait has so deteriorated that no safe opinion can be given, the style appears closer to Bassanesque realism than to that of Titian.

Biography: Andreas Vesalius (1514–1564), a Fleming by birth, became celebrated for his research on human anatomy, a subject which he taught at the universities of Padua, Pisa, and Bologna. In spite of the patronage of Charles V and Philip II, he barely escaped condemnation by the Inquisition. That this portrait does not represent Vesalius has been definitely established (Spielmann, 1925, pp. 36–38).

Condition: Covered with old thick varnish; very dark.

History: Bequeathed by Ferdinando dei Medici; attributed to Titian in the Medici Inventories.

Bibliography: C. and C., 1877, II, p. 418 (not Titian); Suida, 1935, pp. 91, 172, pl. 191 (Titian); Tietze, 1936 (omitted); Jahn-Rusconi, 1937, p. 304 (Titian); Berenson, 1957, p. 185 (Titian, repainted); Valcanover, 1960, II, p. 66 (doubtful attribution); Francini Ciaranfi, 1964, p. 40, no. 80 (Titian); Cipriani, 1966, p. 74, no. 80 (Titian); Valcanover, 1969, no. 594 (doubtful attribution); Pallucchini, 1969, p. 223, fig. 670 (follower of Titian).

X–115. **Violante** (so-called) Plate 222

Panel. 0·645×0·51 m.

Vienna, Kunsthistorisches Museum.

Palma il Vecchio.

About 1520.

The brilliant blue dress, white vest, and golden-brown sleeve
achieve a vivid colour composition combined with gleam-
ing blonde hair, which has blue shadows. Although con-
sidered by Titian in the seventeenth century, the attribution
to Palma il Vecchio has prevailed until Longhi, Suida, and
Pallucchini decided to return the authorship to Titian, a
view which the Vienna Museum has accepted.

The luscious blonde girl, who has two violets (*viola*) tucked
in her bosom, has been thought to be the same person who
reclines in the centre of Titian's famous mythological
picture the *Andrians* (Prado Museum). In the latter case a
violet appears in the same intimate spot and close by Titian's
signature is inscribed on a ribbon, a fact which initiated
the theory that Violante was Titian's mistress (Ridolfi
(1648)-Hadeln, I, p. 159). Boschini in 1660 first put into
print what may have existed earlier in legend that the girl
was Palma il Vecchio's daughter (Boschini (1660)-Pallu-
cchini, p. 402). Nevertheless, this aspect of the story has no
historical basis since Palma never had a daughter (Molmenti,
II, 1911, p. 162).

Condition: Cut down as compared with the print of 1660
(Teniers, pl. 194).

History: Bartolomeo della Nave, Venice, until 1636 (as by
Titian; purchased by Feilding, British ambassador to Venice,
in 1638; Duke of Hamilton, London, 1638–1649 (Water-
house, 1952, pp. 5–8, 15, no. 29); Archduke Leopold
Wilhelm, Vienna, Inventory 1659, no. 242: 'la bella gatta
genannt' (Palma il Vecchio).

Bibliography: See also above; Ridolfi (1648)-Hadeln, I,
p. 168 ('la gattina' by Titian); Teniers, 1660, pl. 194 (Palma
il Vecchio); Storffer, 1733, III, p. 9; Stampart, 1735, pl.
8; Mechel, 1783, p. 76, no. 34; Engerth, 1884, p. 228, no.
323 (Palma il Vecchio); C. and C., 1871, edition 1912,
III, p. 374 (Palma il Vecchio); Gerstfeldt, 1910, pp. 373–376
(Palma il Vecchio); Longhi, 1927, p. 220, also reprint,
1967, p. 238 (Titian); Suida, 1935, pp. 32, 159 (Titian,
1513–1514); Tietze, 1936 (omitted); Wilde, 1938, p. 125,
no. 137 (Palma il Vecchio); Longhi, 1946, p. 25 (Titian);
Klauner and Oberhammer, 1960, p. 133, no. 706 (Titian);
Valcanover, 1960, I, pl. 55; *idem*, 1969, no. 55 (Titian);
Oberhammer, 1964, pp. 128–131 (Titian); Mariacher, 1968,
p. 111 (Titian); Pallucchini, 1969, p. 249, figs. 108–109

(Titian, *c.* 1515–1516); Panofsky, 1969, p. 15 (not Titian);
Dussler, 1970, p. 550 (Palma).

X–116. **Violinist** (Battista Ceciliano?) Plate 221

Canvas. 0·99×0·818 m.

Rome, Galleria Spada.

Venetian School.

Early sixteenth century.

This highly mediocre picture, in a wretched state of preserva-
tion, does not merit Titian's name. Although Vasari records
the subject as by Orazio Vecellio, the latter's work would be
much later in date and style, i.e. at Rome in 1545–1546.
Three-quarter length in a black costume with white vest
and grey gloves, the musician turns toward the spectator,
his long chestnut hair falling over his shoulders. A desk with
a white scroll is barely visible in the background. The
letters C A on the table have been interpreted as a mono-
gram of Battista Caeciliano.

Condition: Very badly preserved.

Bibliography: Vasari (1568)-Milanesi, VII, p. 448 (portrait
by Orazio); C. and C., 1877, II, p. 442 (Orazio Vecellio);
Hadeln, 1911, p. 72 (early Titian); Suida, 1935, pp. 33, 161,
pl. 62b (Titian); Tietze, 1936 (not listed); Berenson, 1957
(not listed); Zeri, 1952, pp. 144–145, no. 194 (Titian;
unfinished); Zampetti, 1955, no. 76 (Giorgionesque Titian,
c. 1510–1515); Valcanover, 1960, I, pl. 59 (Titian); *idem*,
1969, no. 89 (Titian, 1515–1520); Pallucchini, 1969, p.
250, figs. 115–116 (Titian, *c.* 1516); Dussler, 1970, p. 550
(not Titian).

X–117. **Warrior**

Canvas. 0·94×0·737 m.

Unknown location.

North Italian School.

Inscribed at upper right: MDXLV

A mediocre effort, well below Titian's standard.

History: Chiesa Collection, Milan (sale, New York, Ameri-
can Art Galleries, 22–23 November 1927, no. 117); pur-
chased by W. M. Loring.

Bibliography: Longhi (1927), edition 1967, p. 242, pl. 203
(Titian).

X–118. **Young Man**

Canvas. 0·69×0·52 m.

Los Angeles (California), Norton Simon Foundation.

Giorgionesque painter.

About 1512.

History: Hermann Eissler Collection, Vienna, 1924; Duveen, New York, 1926; Bache Collection, New York, *c.* 1931–1940; Duveen, New York, sold to Norton Simon, 1964.

Bibliography: Suida, 1922, p. 169 (Titian); Vienna, Sezession Galerie, 1924; L. Venturi, 1933, no. 494; Suida, 1935, pp. 32, 157 (early Titian); Richter, 1937, p. 230, no. 55 (Giorgionesque); Phillips, 1937, p. 143 (copy of Giorgione); Baltimore, 1942, no. 13 (Giorgione); Zampetti, 1955, p. 74, no. 32 (Giorgionesque, perhaps Titian); Berenson, 1957, p. 84 (Giorgione); Valcanover, 1960, I, p. 93 (doubtful attribution to Titian); Zampetti, 1968, no. 82 (uncertain attribution to Giorgione); Valcanover, 1969, no. 65 (near Titian); Pallucchini, 1969 (omitted); Pignatti, 1969, pp. 119–120, Cat. no. A15, fig. 179 (Titian?).

X–119. **Young Man in a Large Hat**

Panel. 0·522×0·41 m.

Vienna, Kunsthistorisches Museum (in storage).

Giorgionesque painter.

About 1510–1520.

The similarities to Giorgione and Titian lie in the composition and in the position of the fingers upon the parapet. This same position occurs in Giorgione's *Youth* in Berlin (Plate 2) and Titian's *La Schiavona* in London (Plate 14).

Bibliography: Engerth, 1884, p. 170, no. 241 (Giorgione); Baldass, 1955, pp. 193–200 (early Titian); Berenson, 1957, p. 194, pl. 936 (Francesco Vecellio); Baldass, 1957, p. 106 (Titian); Klauner and Oberhammer, 1960 (not listed); Baldass and Heinz, 1965, p. 173, pl. 69 (Titian).

X–120. **Young Man with a Dagger**

Canvas. 0·972×0·772 m.

Chatsworth, Duke of Devonshire.

Cariani.

About 1515–1520.

A weak portrait, far beneath Titian's standard.

Bibliography: Cook, 1905–1906, pp. 343–344 (Cariani);

14

Longhi (1927), edition 1967, pp. 240–241, fig. 201 (Titian, *c.* 1515); Suida, 1935, pp. 33, 161, pl. 63 (early Titian); Berenson, 1957, p. 54 (Cariani); Valcanover, 1960, I, p. 101 (doubtful attribution to Titian).

X–121. **Young Man** Plate 226

Canvas. 0·965×0·793 m.

Chatsworth, Duke of Devonshire.

Van Dyck after Titian (?).

About 1625.

This elegant youth dressed in black is silhouetted against a darkish background. His strong, clear features and blonde hair are relieved against the white collar and gold chain. In his left hand he holds a black cap and in his right the hilt of a sword or dagger.

The records at Chatsworth note a wide variety of attributions by visiting scholars. The most popular in recent years is Tintoretto, yet 'Van Dyck after Titian' advanced by Charles Loeser and H. Horner has much to recommend it. The figure has a charm and tenderness more in the spirit of the great Fleming.

Condition: Generally dark; one damaged section to the right of the head; otherwise in good condition.

History: At Chatsworth since the eighteenth century as Titian (Dodsley, 1761, II, p. 226).

Bibliography: See also above; C. and C., 1877 (omitted); Strong, 1901, pl. 7 (Titian); Berenson, 1932, p. 558 (Tintoretto); Suida, 1935, pp. 90, 171 (Titian); Tietze, 1936, II, p. 286 (Titian, *c.* 1530); Berenson, 1957, p. 171 (Tintoretto, early); Valcanover, 1969, no. 599 (not Titian); Pallucchini, 1969 (omitted).

Young Woman, see: Blonde Woman in a Black Dress, Cat. no. X–13.

X–122. **Youth, Praying** (fragment)

Canvas. 0·63×0·49 m.

Genoa, Palazzo Bianco.

Venetian School.

Sixteenth century.

Also attributed to Veronese and Francesco Bassano.

History: Collection of the Duchess of Galliera, Genoa.

Bibliography: Grosso, 1931, p. 145 (Francesco Bassano); Suida, 1934–1935, p. 102 (Titian).

X-123. **Cardinal Francesco Zabarella** (1360–1417)

Fresco. 2·80×0·72 m.

Padua, Palazzo Liviano, Sala dei Giganti.

Paduan School, mid-sixteenth century.

An old mistaken attribution, it has strangely been maintained by a few critics.

Bibliography: Brandolese, 1795, p. 178 (Titian); Fiocco, 1947, p. 293 (Titian); Berenson, 1957, p. 189 (Titian); Valcanover, I, 1960, p. 102 (doubtful attribution); Grossato, 1966, pp. 209–211 (Gualtiero?).

LOST WORKS

L-1. **Duke of Alba in Armour**
1549.

Biography: Fernando Alvárez de Toledo (1507–1582), Duke of Alba, one of the most prominent military leaders under Charles V, engaged in the campaign against the Turks in Hungary, in the assault on Tunis, and in the battle of Mühlberg. After holding office as viceroy of Naples in 1555–1558, he was sent by Philip II to the Netherlands, where he acquired lasting ill-fame for his cruel repression of the Protestants (1567–1572). Because of reverses there, Alba fell into disfavour, but Philip later placed him in charge of the conquest of Portugal (1580–1582), at the conclusion of which he died.

History: Aretino's sonnet (1549) on Titian's portrait of the duke of Alba (partially quoted by Crowe and Cavalcaselle, 1877, II, p. 427; in full in Aretino, *Poesie*, edition 1930, II, p. 239, no. 60) places the execution of the original at Augsburg in 1549. Aretino does not state precisely what the composition was, but the words 'L'imagine tremenda della guerra' surely refer to a portrait in armour. The portrait of the Duke of Alba in armour by Titian: Inventory of Mary of Hungary, Brussels, 1556 (armado ecepto la cabeza con una banda, por el hombro, colorado; Pinchart, 1856, p. 141, no. 26); Inventory, Cigales, 1558 (Beer, 1891, p. CLXIV, no. 79); El Pardo Palace, Inventories 1564 and 1582 (Calandre, 1953, pp. 152 and 46, no. 16); destroyed by fire in 1604 (*loc. cit.*, p. 70).

COPY BY RUBENS (lost):
Rubens' copy of Titian's portrait of the Duke of Alba must have been painted in 1603, since the original perished in the El Pardo fire in 1604 (Pacheco, 1638, edition 1956, I, p. 153, as painted in 1628). The copy by Rubens is mentioned in his Inventory of 1640 (edition Lacroix, 1855, p. 271, no. 53).

POSSIBLE PENDANT COMPOSITION (lost):
A portrait identified as the Duchess of Alba by Titian in the Alcázar Inventories (Bottineau, 1958, p. 154: Inventory 1666, no. 587, Inventory 1686, no. 264, and Inventory 1700, no. 71) may be a wrong attribution and a wrong identification.

Duke of Alba, see also: Cat. nos. X–3, X–4.

Duchess of Bavaria, see: Cat. no. L–24, Collection of Mary of Hungary.

Nicole Bonvalet, see: Cat. no. L–18.

L-2. **Cameria as St. Catherine** Plate 269

Canvas. 1·025×0·765 m.

London, Count Antoine Seilern.

Follower of Titian.

After an original about 1552.

The late Professor Johannes Wilde recently published Count Seilern's new acquisition, *Cameria as St. Catherine*, a picture which had remained unnoticed in the last sixty-five years or more. Although Wilde classified it as an original by Titian, the smooth brushwork does not correspond to the master's style in the mid-century. The weak drawing of the hands and the generally dry handling of her red dress with a green leaf design and her long white veil are farther removed from the autograph work of Titian than the *Venetian Girl* in Washington (Plate 268). It is interesting that we now apparently have reflections of both the Sultana Rossa (Plate 270) and her daughter, whose portraits Vasari described as displaying most beautiful headdresses ('acconciature bellissime'). Cameria's headgear is virtually identical to the long veil built upon the head like the sail of a ship and embellished with pearls and precious stones which is illustrated in a woodcut in Cesare Vecellio's costume book of 1598 (p. 372) and identified as 'Favourite of the Turk' ('Favorita del turco'). The close-fitting dress with long sleeves and buttons down the front corresponds to another costume illustration also called 'Turkish woman' ('donna turca') in Nicolas de Nicolay, *Le navigationi et viaggi fatti nella Turkia* (edition Venice, 1580, p. 63).
These references, kindly pointed out to me by Dr. Emma

Mellencamp, indicate that Titian made use of authentic costume drawings when he devised the originals, but resorted to his imagination so far as the faces were concerned. All of these fanciful portraits of women have a family resemblance of an ideal nature, for they cannot be said to represent specific individuals (Plates 266–270).

The identification of the girl in Count Seilern's picture as Cameria is due to Georg Gronau's article of 1903 (p. 136). The shoulder-length portrait in the Uffizi at Florence labelled *Cameria Sol: II Filia* (Cameria, daughter of Soliman II) corresponds exactly in details of costume and headdress to Count Seilern's picture. This small portrait, painted by Cristofano dell' Altissimo, is part of the series copied from Paolo Giovio's gallery of famous people for Cosimo I dei Medici during the years 1552–1564 (see Schaeffer, 1907, pp. 352–353). The much inferior miniature from Ambras Castle, now in the Vienna Museum, also records the head and shoulders but in a summary and inexact way. In this case the lady is identified as the sultan's wife: 'Dulmelia Silcar: Solimani Turc: Imp: Uxor' (illustrated by Kenner, 1898, p. 130, no. 17).

Someone other than Titian must have been responsible for the addition of the over-large and clumsy wheel which turns Count Seilern's picture into a St. Catherine. The situation corresponds exactly to the *Caterina Cornaro as St. Catherine* in the Uffizi (Wethey, I, 1969, Cat. no. 97, Plate 168), where a copyist changed an ideal portrait into a saint by the addition of her attribute. The two paintings are stylistically unrelated.

Documentation: Vasari reported that Titian painted a portrait of Cameria, daughter of Soliman I, and another of her mother, the Sultana Rossa (Vasari (1548)-Milanesi, VII, p. 456). The same information is repeated by Ridolfi in 1648 (Ridolfi-Hadeln, I, p. 194). See also Cat. no. L–28.

Condition: Apparently well preserved.

History: Baron Riccardi, according to the sales catalogue of the Walter's collection; Dr. A. Walter, Naples, sale Munich, 4 June 1896, no. 108, pl. XXXIII; sale Berlin, 1899; Katherine Schratt, Vienna (history as given by Gronau, 1903, p. 136, and by Wilde, 1969, p. 4).

Bibliography: See also above; Gronau, 1903, p. 136 (classified the Seilern picture as Titianesque; not illustrated); Wilde, 1969, pp. 4–6, cat. no. 331 (as an original by Titian, *c.* 1555).

VARIANTS:

1. Aschaffenburg Gallery; *Cameria,* canvas, 0·965×0·80 m. (Wilde, 1969, p. 5, fig. 5).

14*

2. Bergamo, Galleria dell'Accademia Carrara; *Sultana* (not exhibited); the costume and headdress are essentially the same but not identical in details as in Cat. no. L–2. Since the wheel of St. Catherine is missing, the right hand rests against the skirt. Formerly attributed to Tintoretto (Gronau, 1903, p. 136, Taf. IVa); Wilde, 1969, fig. 6.

3. England, Private Collection; *Cameria.* The lady wears the same costume and headdress as the *Cameria* in Count Seilern's Collection; the wheel is wanting but a landscape is visible through a window at the left (*Country Life,* vol. 125, 26 February 1959, p. 422, illustrated as Caterina Cornaro).

4. Print by Pieter van der Heyden, published by H. Cock; head and shoulders only (Hollstein, 1949, IX, p. 32, no. 2; illustrated by Wilde, 1969, fig. 4).

Portraits of Charles V in Armour

In Spain alone there must have been three or four portraits of *Charles V in Armour* by Titian. One of them showed the Emperor in full armour, an unsheathed sword in hand (Cat. no. L–3). Another, *Charles V Armed, with Baton,* in the collection of Mary of Hungary in Brussels in 1556, was brought to Spain in 1558 and destroyed by fire in El Pardo Palace in 1604 (Cat. L–4, 1533). Charles took still another to Yuste when he retired in 1556 (Original, 1548), there paired with the *Empress Isabella* wearing pearls (Cat. no. 53). That picture passed eventually to the palace (Alcázar) in Madrid, where it appeared in 1600 and later (Cat. no. L–5), and was destroyed in the fire of 1734. Another *Charles V Armed, with Baton* by Titian is listed in the Inventory of Philip II, 1600 (edition 1956, p. 405, no. 489) as 'un retrato del Emperador, nuestro señor de medio cuerpo con un baston en la mano de mano de Ticiano que tiene de alto una vara y ochava y de ancho una vara menos ochava' (0·939×0·731 m.). This item makes no further appearance in the royal inventories. A fifth *Charles V Armed* in the collection at Simancas (Valladolid) in 1561 may well be identical with the *Charles V with Drawn Sword* (Cat. no. L–3).

L–3. **Charles V with Drawn Sword** (three-quarter-length) About 1530.

The portrait of *Charles V with Drawn Sword* is known through Rubens' copy (Plate 48) and two prints, one by Pieter de Jode after Rubens. The other engraving (*c.* 1617–1618?), by Lucas Vorsterman (Plate 49), appears to follow another, now lost, rendering by the great Fleming, who altered the head to represent Charles a few years older (see also Burchard, 1950, p. 31). Giovanni Britto's woodcut (Plate 50) in half-length presents a youthful face and changes the placement of the sword, resting on the right shoulder,

and the positions of both arms, modifications which Titian himself may have introduced in the form of a drawing supplied for the specific use of Britto (Mauroner, 1941, p. 40, fig. 27, as 1532; Müller-Hofstede, 1967, p. 42, dates the print *c.* 1540). Yet the possibility does remain that Titian painted two different canvases representing Charles holding the sword unsheathed. As for the date, it is impossible to be certain whether this composition originated in 1530 or 1533, for there can be little doubt that Titian produced more than one likeness of the Emperor in armour during these two visits to Bologna. The engraved portrait by Barthel Beham, dated 1531 (Plate 46), corresponds in cut of beard and features to Britto's print and Rubens' copy (Plates 50, 48).

The armour worn in these pictures is the same in all cases as well as in the Zambeccari bust by Rubens (see below, copy no. 3), which appears to be a later restudy by the Fleming, perhaps at Madrid in 1628, romanticizing Charles' features (Müller-Hofstede, 1967, p. 45, fig. 6, as Rubens, *c.* 1625). The disk at each shoulder is the most prominent feature which distinguishes this suit from that worn in 1548 (Plate 142, Cat. no. 21).

History: Simancas, Castle, Inventory of Charles V, 1561, 'un retrato de su magestad en una tabla armado en blanco [meaning steel] y dorado de mano de Ticiano' (Beer, 1891, p. CLXXIII, no. 196). Since no sword is mentioned, this suggestion is not final. From a negative point of view, it can be said that the picture with the sword did not come from Yuste, nor is it in Mary of Hungary's Inventories. Therefore it may have been sent to Valladolid during the lifetime of the Empress Isabella (died 1539).

Probably brought to El Pardo after the fire of 1604, since it is not in the earlier Inventories; El Pardo Palace, Sala de la Antecamara, Inventory 1614–1617, page 3 after folio 2: 'Otro retrato del emperador de medio cuerpo Carlo quinto armado con una espada desnuda en la mano y la celada encima del bufete'; Alcázar, Madrid, 'Pieca en que su Magestad negocia en el quarto bajo de verano', Inventory 1636, folio 31: same description as above with further details 'una celada con plumas a la mano izquierda sobre un bufete de carmesí con tuson de armar [*sic*] sobre la gola es de mano de Ticiano'. Sometime after 1636 and before the Inventory of 1666 it must have been removed to another palace. Thereafter it disappeared.

Bibliography: See also above; Vasari (1568)-Milanesi, VII, p. 440 (portrait in armour at Bologna in 1530; another portrait on second trip to Bologna); Gian Giacomo Leonardi in a letter written at Venice 18 March 1530 told the Duke of Urbino that Charles V was slandered by the story that he paid Titian only one ducat for his portrait (Gronau,

1904, p. 13); Justi, 1889, p. 184, no. 35 (certainly not from Yuste as here suggested, since in that picture Charles carried a baton, see Cat. no. L–5); Allende-Salazar and Sánchez Cantón, 1919, p. 32 (mentioned only); Glück, 1937, pp. 169–171 (published copies of the lost portrait with the sword); Cloulas, 1964, pp. 214–219 (Vorsterman and Britto prints reflects Titian's portrait of 1530; she accepted Ridolfi's story of equestrian portrait but now rejects it); Müller-Hofstede, 1965, pp. 116–117; Müller-Hofstede, 1967, pp. 38–46 (identified the portrait with a sword as Titian's first of Charles V).

COPIES:

1. England, Private collection; copy by Rubens, three-quarter-length, canvas, 1·18×0·915 m., 1603 (Plate 48). This copy could have been made by Rubens during his visit to Spain in 1603 or at Mantua in 1603–1608, if the Duke of Mantua owned a version by Titian himself. *Possible History:* In Rubens' Inventory 1640 (English edition, 1859, p. 237, no. 52), 'Emperor Ferdinand with a sword in his hand'. This confusion between Charles V and his brother Ferdinand I occurs frequently. *Bibliography:* Burchard, 1950, pp. 28–32, no. 26 (first publication as Rubens' work, datable 1603); Müller-Hofstede, 1965, pp. 116–117 (Rubens, 1603); *idem,* 1967, pp. 38–47 (Rubens, 1603, after Titian of 1530).

2. Hamburg, W. Willy Streit; a copy, with the sword omitted, similar to but inferior to copy no. 1, above (Glück, 1937, p. 170, fig. 180). Other related pictures of lesser quality are among the photographs of the Courtauld Institute in London and of the Frick Art Reference Library in New York.

3. Unknown location; the Zambeccari portrait, formerly attributed to Titian and later to Rubens, canvas, 0·723× 0·61 m. (Plate 53). This handsome portrait is Rubens' version *c.* 1628 after the *Charles V with Drawn Sword* by Titian which he had first copied in 1603. Reduced to bust-length with the sword eliminated and an older face, this adaptation by the great Fleming is the finest of all in quality. *History:* Zambeccari Palace, Bologna (Gatti, 1803, p. 99, Titian); seen there before 1850 by Crowe and Cavalcaselle, who considered the canvas to be Titian's sketch from life in 1533 (C. and C., 1877, I, p. 367, note); M. A. Gualandi, Bologna, sold before 1854 to an Englishman (*loc. cit.*); George Pretyman, Orwell Park, near Ipswich (Waagen, 1854, III, p. 440, Titian); Orwell Park sale, London, Christie's, 28 July 1933, no. 26, to V. Block, £682, 28½× 24 inches (*APC,* XII, 1932–1933, no. 5711); Amsterdam, Goudstikker Gallery, 1933–1940; Berlin, H. W. Lange, Auctioneer, 12 December 1940, no. 159, illustrated in catalogue. *Bibliography:* See also History; Giordano, 1842, pl. 1, Charles V; Burchard, 1933, no. 44 (Rubens); Scharf, 1935, p. 259 (Rubens); Glück, 1937, pp.

168–170 (Rubens, 1603); Burchard, 1950, p. 30 (Rubens); Müller-Hofstede, 1967, pp. 45–46 (Rubens, *c.* 1625).

L–4. Charles V in Armour with Baton

Original no. 1.

Brussels and Cigales, Collection of Mary of Hungary.

1533 (?).

History: Charles V Armed, with Baton, by Titian, paired with the *Empress Isabella* by Guillermo (Scrots): Inventory of Mary of Hungary 1556 (Pinchart, 1856, p. 140, nos. 17 and 18); the same items at Cigales in 1558 (Beer, 1891, p. CLXIV, nos. 70 and 71, no artists mentioned); on Mary's death her collection passed to Philip II; El Pardo Palace, Madrid, Inventories 1564 and 1582 (Calandre, 1953, p. 152, pp. 43 and 44); destroyed in the fire of 1604 (Calandre, 1953, p. 70). At El Pardo it must have been paired with Titian's *Empress Isabella Seated Dressed in Black* (Cat. no. L–20), since that picture was destroyed at the same time.

L–5. Charles V in Armour with Baton

Original no. 2.

Brussels and Yuste, Collection of Charles V

1548.

History: Inventory of Charles V at Brussels, 1556 (Gachard, 1855, p. 92; described simply as 'Charles Armed'); Inventory at Yuste 1558, paired with Isabella (Cat. no. 53) (Sánchez Loro, 1958, p. 507, no. 410); probably the 'Carlos V Armado con un baston en la mano' in the Inventory of Princess Juana in 1573 (pp. 363–364, no. 33), paired with Isabella wearing pearls (Cat. no. 53); Alcázar, Inventory 1600, *Charles V Armed, with Baton*, paired with Empress Isabella wearing pearls, Titian not cited, lent to the widowed Empress María (died 1603), then living in a palace adjoining the Descalzas Reales in Madrid (Philip II Inventory, edition 1956, pp. 254–255); Alcázar, Madrid, 1633, Charles V and a pendant of Isabella by Titian (Carducho, edition 1933, p. 108); Alcázar, Galería de Mediodía, Inventory 1636, folio 18v, two half-length portraits, 'Carlo quinto armado en la mano un baston y sobre un bufete la celada', paired with Isabella wearing pearls here called copies of Titian! No sizes given.

In 1666 the portrait of Charles V is separated for the first time from that of the Empress (see Cat. no. 53), a very strange thing which must have happened in the rebuilding and redecoration of several rooms in the palace under Velázquez's direction, beginning in 1652 (Palomino, 1724, edition 1947, p. 918). Alcázar, Galería de Mediodía, Inventory 1666, no. 576, valued at 250 ducats, the same large sum as the evaluation of *Philip II in Armour* (Cat. no. 78); Inventory, 1686, no. 254, Emperor Charles by Titian, $1\frac{1}{2} \times 1$ *varas* ($1 \cdot 25 \times 0 \cdot 835$ m.); Inventory, 1700, no. 65 (Bottineau, 1958, p. 153); in the Galería del Mediodía, destroyed in the Alcázar fire in 1734.

PRESERVED COPY:

Escorial, Sala de Audiencias, Apartments of Philip II, canvas, $1 \cdot 87 \times 1 \cdot 41$ m., copy by Pantoja de la Cruz (Plate 238), signed 'Juan Pantoja de la+Mayestatis Philippi 3 Camerarius Pictor Faciebat Madriti 1599' (Plate 238).

In a cartouche in the lower centre appears the inscription, 'Carolo V aetatis suae XXXXVII MDXXXXVII'. The inscription leaves no doubt that we have here an accurate copy of the lost portrait painted by Titian at Augsburg in 1548 (not 1547 as the inscription reads), undoubtedly the version that Charles took to Yuste. The setting includes a green marble balustrade in front of the three-quarter-length figure, which looks as though it were a piece of sculpture. The balustrade and the window at the left are enlargements by Pantoja de la Cruz and surely were not part of Titian's lost original. The armour is identical with that worn by Charles V in the equestrian portrait (Plate 141), while the head, although less care-worn in appearance, corresponds to *Charles V Seated* (Plate 145). Beinert's theory (1956, p. 198) that no original by Titian existed because it is not mentioned in Titian's letter to Granvelle in 1548 (Zarco del Valle, 1888, p. 222) carries no conviction in the light of the inventories of the Spanish royal collections (see above). On the other hand, the existence of a similar portrait of Ferdinand I, Charles' brother, in armour, seems to be proved by documentary references (Müller-Hofstede, 1967, pp. 51–52).

Bibliography: Kusche, 1964, p. 166, no. 40 (Pantoja's copy of the Yuste portrait).

FULL-LENGTH VARIANTS BY PANTOJA DE LA CRUZ (1553–1608):

These two pictures belong to an extensive series of copies made by Pantoja to replace the losses in the fire at El Pardo Palace in March 1604, when the entire portrait gallery of notables was destroyed.

1. Escorial, Library, canvas, $1 \cdot 88 \times 1 \cdot 02$ m., signed at the left 'Juan Pantoja de la+eius traductor 1608'. This (Plate 240) is an enlargement of Titian's original in three-quarter-length known in the foregoing copy by Pantoja (Plate 238). The poor drawing of the legs and the incorrect scale of the low table at the right betray the hand of a minor master such as Pantoja. The portrait is virtually identical to the next item below. *Bibliography:* Kusche, 1964, no. 42 (with full data).

2. Toledo, Museo de Santa Cruz, lent by the Ministerio de Educación Nacional, canvas, $1 \cdot 84 \times 1 \cdot 095$ m.; signed 'Juan

Pantoja de la+eius traductor 1605'. To the dark armour and white hose are added the brighter colours of the red-plumed helmet and the red table covering. *Bibliography:* Charles V, 1958, p. 103, no. 111, pl. 24; Kusche, 1964, no. 41 (full data).

OTHER COPIES (*Charles V in Armour with Baton*, three-quarter-length; original of 1548):

1. Augsburg, Schloss Babenhausen, Fugger-Babenhausen Collection; canvas, 1·18×0·95 m., dated 1548; mediocre German copy. Charles V wears the Mühlberg armour, made in 1544 (see Cat. no. 21). *Bibliography:* Fischel, 1924, p. 284 (copy of Titian); Wilczek, 1929–1930, p. 240 (copy after Titian's portrait of 1530); Suida, 1935, pp. 79, 106 (copy of Titian, 1530 or 1533); Tietze, 1936, II, p. 283 (copy of Titian, 1530); Beinert, 1946, pp. 8–9 (suggests the painter Christopher Amberger; Mühlberg armour dated 1544); Braunfels, 1956, p. 199 (suggests Emmanuel Amberger as the painter); Valcanover, 1960, I, p. 83 (copy of Titian, 1530); Müller-Hofstede, 1967, pp. 48, 88–89 (exhaustive account; copy of portrait of 1548 since the armour is dated 1544); Valcanover, 1969, under no. 144 (could be a copy of the portrait of 1530).

2. Barcelona, Palace of Justice; *Charles V in Armour with Baton* (Plate 239) by Felipe Ariosto, 1587–1588; in a series of Spanish rulers (Viñaza, 1889, pp. 33–34).

3. Cracow, Czartoryski Museum; panel, 1·05×0·83 m., Flemish copy, datable 1548–1556, when the original was in Brussels.
Bibliography: Glück, 1937, p. 173; Bialostocki and Walicki, 1957, no. 156 (Antonio Moro); Müller-Hofstede, 1967, pp. 48–49 (mediocre Flemish copy).

4. Detmold, Wilfried Goepel; canvas, 1·15×0·895 m., copy by Rubens, *c.* 1603–1604 (Müller-Hofstede, 1967, pp. 47–58; first publication).

5. London, St. James Palace, Lord Chamberlain's office; mediocre copy; probably the picture in Charles I's collection (van der Doort, 1639, Millar edition, 1960, pp. 25, 230); Charles I's sale, 1649 (Harley MS., no. 4898, folio 301, no. 213). There is also a second copy with an older face.

6. New York, Edward Fowles; canvas, 1·105×0·89 m., school of Rubens; formerly Paris, Prince Orloff, until 1936 (Glück, 1937, p. 172; Müller-Hofstede, 1967, p. 47, fig. 7; data from Mr. Fowles, letter of July 1969).

VARIANT:
Mantua, Ducal Palace; *Charles V in Armour* (half-length), late sixteenth century. The inferior quality of this copy without the baton, in which Charles has white hair, eliminates any possibility that it is the portrait Titian presented to Ferrante Gonzaga, governor of Milan (letter of 8 September 1549, published by Ronchini, 1864, reprint, p. 11; C. and C.,

1877, II, pp. 193–194, English translation); *Bibliography:* Beinert, 1956, p. 10 (copy); Braunfels, 1956, p. 199 (identified as a copy of the portrait sent by Titian to Ferrante Gonzaga in 1549).

LOST PORTRAITS OF CHARLES V (types unspecified):
1. The portrait Titian promised to Ferdinand I of Austria, brother of Charles, in 1534 must have been a replica of one of those for which Charles posed at Bologna in 1533 (Voltelini, 1890, p. XVIII, no. 6313).

2. Besançon, Granvelle Collection; an original portrait of Charles V by Titian, which was copied in the Netherlands; the copy was stolen but later recovered in bad condition and taken to Prague to Ferdinand I by the painter Jacopo Strada (letter of 26 January 1557 in Voltelini, 1890, p. CLXIX, no. 7246; see also Zimmermann, 1901, pp. 837–838). No such item appears in the Granvelle Inventory at Besançon in 1607, only a portrait of the Emperor by 'an old master' (Castan, p. 134, no. 218).

3. Mantua, Gonzaga Collection, 1533–1536. We have no hint as to the type of composition, although it was surely a replica of a portrait executed at Bologna in 1533. *Documents:* 10 March 1533, Bologna; in Titian's letter to Federico Gonzaga, the artist promises to send him a copy of the Emperor's portrait which he is taking to Venice (C. and C., 1877, I, pp. 456–457; Braghirolli, 1881, pp. 25–26). 27 April 1536: Federico Gonzaga invited Titian to come to Mantua and bring the portrait of the Emperor (Gaye, 1840, pp. 262–263). 30 April 1536: Benedetto Agnello announces to Federico Gonzaga that Titian will deliver the portrait of the Emperor (C. and C., *loc. cit.*, p. 458; Braghirolli, 1881, p. 30).

4. Parma, Palazzo del Giardino; 1680, 'Ritratto di Carlo V assai giovane armato di ferro, viene da Tiziano, braccia 2 × braccia 1 once 9'(1·288×1·12 m.) (Campori, 1870, p. 270).

5. Rome, Galerie Fesch; 'Charles V, full length, armed, with red beard', 1·728×1·016 m. (Fesch catalogue, 1845, II, no. 233). Undoubtedly a wrong attribution to Titian.

6. Rome, Cardinal Savelli (formerly Bologna); Inventory 1650, 'Ritratto di Carlo V palmi 4 (0·89 m.) in circa di Tiziano' (Campori, 1870, p. 165).

7. Urbino, Ducal Palace, della Rovere collection; portrait of Charles V, ordered in 1539, and a second large portrait of the Emperor, both last cited in the della Rovere Inventory of 1631. *Bibliography:* Vasari (1568)-Milanesi, VII, p. 444 (Charles V young); Gronau, 1904, pp. 6, 10, document XXXVII.

L–6. **Charles V and the Empress Isabella**

Canvas. 1·14×1·664 m.

Documented 1548.

In Rubens' copy of Titian's lost picture (Plate 151) both the Emperor and the Empress are dressed in black, in her case relieved by the white partlet and puffs in the sleeves. The red velvet table cover and the deeper red damask curtain supply the same sort of colour contrast as in the composition of *Charles V Seated* (Plate 145). The landscape view, in this instance seen through the curtains, is another familiar aspect of Titian's art. As for the portraits, that of Charles corresponds closely to the *Charles V Seated*, a work painted in the same year at Augsburg. The Empress, however, her hands resting upon the table, wears a costume similar to that of the lost portrait (Plate 150) of 1544–1545, which Charles had brought to Augsburg to have the nose retouched (Cat. no. L–20). The white partlet and the coiffure, on the other hand, more closely approximate the portrait still in Madrid (Plate 147).

Iconographically the double portrait representing man and wife has ample precedent in Renaissance art, most familiar in Lorenzo Lotto's *Marsilio and His Bride* in Madrid and the *Family Portrait* in London, as well as in other paintings and sculptures (Scharf, 1935, p. 265; Müller-Hofstede, 1967, pp. 75–76).

History: On 1 September 1548 Titian in a letter to Cardinal Granvelle promised to send in six days this double portrait as well as the *Empress* alone (Plate 147) and *Charles V on Horseback* (Plate 141); shipped from Brussels in 1556 on Charles' retirement to Yuste (Pinchart, 1856, p. 229); Inventory 1558 at Yuste after Charles' death; inherited by Philip II (Sánchez Loro, 1958, p. 507, no. 409); probably taken to Aranjuez, since it does not appear in the Alcázar Inventory of 1600, nor at El Pardo in the early description of 1564 or the Inventory of 1582; later at El Pardo for a few years, undoubtedly to refurnish the palace after the fire of 1604 (see below, Inventory 1636); Alcázar, Madrid, 1626, 'Carlo V con la moglie ambidue in una stessa tela e meze figure' (Cassiano del Pozzo, folio 122); Inventory 1636, Alcázar, 'pieca en que duerme su magestad en el cuarto bajo de verano', folio 36v, described as 'Un lienzo de 5 pies de largo ... el emperador Carlo V y su muger vestidos de negro las manos sobre un bufete carmesí y las de ellas juntas ... de Ticiano que se truxo de la Casa Real del Pardo'. After 1636 this picture disappears from the extant royal inventories. The statement that Titian's original was destroyed in the fire of the Alcázar, Madrid, in 1734 is an error of Mayer, who did not consult the Spanish Inventories (1934, pp. 296–298). (The mistake is repeated by various writers including the editor of the exhibition catalogue, Charles V, 1958, p. 108, no. 121). This double portrait must have been given away to a favourite by Philip IV or transferred to another palace such as that at Aranjuez and later destroyed.

Bibliography: See also History; C. and C., 1877 (not mentioned); Mayer, 1934, pp. 296–298; Scharf, 1935, pp. 259–266; Tietze, 1936, II, p. 295 (under London, Frank Sabin; inaccurate information).

COPY BY RUBENS: (Plate 151):
Madrid, Duke and Duchess of Alba, canvas, 1·14×1·664 m. This accurate reproduction supplies an excellent idea of Titian's original. Probably copied on Rubens' visit to Madrid in 1628.

History: Rubens' Inventory, 1640, no. 51 (edition 1855, p. 271; Sainsbury, 1859, p. 237; Denucé, 1932, p. 58); sale of Charles I of England, 1649–1650, as by Titian (LR 2/24, folio 9v; Harley MS. no. 4898, folio 140, no. 49; Cosnac, 1885, p. 414: 'Charles V empereur et l'impératrice sa femme par Tissian £30').
It was Rubens' copy for the following reasons: the double portrait does not appear in van der Doort's catalogue of Charles I's collection in 1639; therefore it must have been purchased at Rubens' sale. Charles I could not have acquired Titian's original from Philip IV after 1639, subsequent to the mention in the Alcázar Inventory of 1636 (see above), after which the picture disappears from Spain. Such negotiations between England and Spain were carried on only when Prince Charles visited Madrid in 1623. Philip IV purchased a large number of pictures from Rubens' sale, but not the double portrait because he still owned Titian's work. Rubens' copy was exhibited by P. H. Howard at the British Institution in London in 1847 (Catalogue, 1847, p. 8, no. 19, Rubens after Titian); it reappeared at London, Christie's, Anonymous sale, 23 September 1934 (*APC*, XIIIA, 1933–1934, no. 2823); acquired by the Duke of Alba, Madrid, in 1936.

Bibliography: See also above; Mayer, 1934, pp. 296–298 (Rubens' copy, 1603); Scharf, 1935, pp. 259–266 (Rubens' copy, 1603); Glück, 1937, p. 174 (Rubens' copy, 1603); Sánchez Cantón, 1948, pp. 114–115 (Rubens' copy, 1628); Charles V, 1958, p. 108, no. 121 (Rubens, 1603); Müller-Hofstede, 1967, pp. 74–76 (Rubens, 1628); Pallucchini, 1969, p. 343, fig. 620 (Rubens after Titian).

L–7. Christina of Denmark, Duchess of Milan and Lorraine

Biography: Christina (1522–1590), the daughter of Isabella of Austria and Christian II of Denmark, and a niece of Charles V, married first in 1534 Francesco II Sforza, Duke of Milan. He died a year later, and in 1541 she married Francis I, Duke of Lorraine (Cartwright, 1913).

History: Collection of Mary of Hungary, Inventory, Brussels, 1556 (edition Pinchart, 1856, p. 140, no. 7); Mary of Hungary, Inventory, Cigales, 1558 (Beer, 1891, p. CLXIII, no. 60); El Pardo Palace, Madrid, Inventory, 1564; 1582, no. 32; the portrait gallery of El Pardo was destroyed by fire in 1604 (Calandre, 1953, pp. 152, 46, 70).

SECOND LOST VERSION:

Cremona, Mario Amigone in 1585; sent to Archduke Ferdinand of Florence in 1604; attributed to Titian (Gaye, 1840, III, p. 531; Cartwright, 1913, pp. 96–97).

RELATED WORK:

Oberlin, Allen Memorial Art Museum; panel, 0·71×0·557 m., signed by Michiel Coxie, dated 1545, it may be based on Titian's lost portrait (Rose, 1963, pp. 29–51; Stechow, 1967, pp. 39–40).

L–8a. Francisco de los Cobos

Canvas. 1½ *varas* square (1·25 m.)

About 1542.

On 9 July 1542 Diego Hurtado de Mendoza, the Spanish ambassador in Venice, wrote to Cobos that Titian had not been paid but without further explanation, so that he may have referred to a picture delivered to Charles V (Hurtado de Mendoza, edition 1935, pp. 100–101). It may be, however, that Titian's lost portrait of Cobos himself was involved. The mediocre picture with Cobos' name inscribed in the collection of a descendant does not suggest any connection with a lost original by the Venetian master (Allende-Salazar and Sánchez Cantón, 1919, pp. 42–44; Keniston, 1959, fig. 18).

Biography: Francisco de los Cobos (*c.* 1477–1547), one of the major Spanish ministers of Charles V from 1522 until his death, played an important role in international politics. His biography has been reconstructed in a definitive form in a recent monograph (Keniston, 1959).

History: Portrait of Cobos by Titian: Alcázar, Madrid, Inventory 1666, no. 649; Inventory 1686, no. 215; Inventory 1700, no. 50 (Bottineau, 1958, p. 148), then in the passage next to the Galería del Mediodía; destroyed in the Alcázar fire in 1734.

L–8b. María de Mendoza, wife of Francisco de los Cobos

Canvas. 1·¼×1·00 *varas* (1·04×0·835 m.)

Perhaps a wrong attribution.

History: Portrait of Cobos' wife by Titian: Alcázar, Madrid, Inventory 1666, no. 602; Inventory 1686, no. 278; Inventory 1700, no. 89 (Bottineau, 1958, p. 157); destroyed in 1734.

L–9. Queen Caterina Cornaro

The name of Caterina Cornaro has been attached to various portraits which have no reasonable basis for their acceptance. One of the most thorough studies of the iconography of the lady (Schaeffer, 1911, pp. 12–19) straightened out the situation many years ago. Yet few writers have paid any heed. The former Queen of Cyprus appears among the spectators, wearing a crown, on the left side of Gentile Bellini's *Miracle of the Holy Cross* (Accademia, Venice), but the best likeness is that by the same artist in the Museum of Fine Arts, Budapest. Both Vasari (1568-Milanesi, VII, p. 98) and Ridolfi (1648-Hadeln, I, p. 126) report that Giorgione portrayed her, while Ridolfi alone (I, p. 198) describes a picture of Titian's early period in which she was presented as a widow: 'con la maniera stessa retrasse la regina Caterina Cornaro in abito vedovile campeggiando tra nere spoglie il candore delle carni'.

Biography: Caterina Cornaro (*c.* 1450–1510), daughter of Marco Cornaro, a Venetian patrician, married in 1472 Giacomo II Lusignano, king of Cyprus, who died a year later. She abdicated in 1489 leaving the island to the Venetian state, which bestowed upon her the city of Asolo, where she held court thereafter. Pietro Bembo's *Gli Asolani* (1505), a romantic poem eulogizing her court, is her chief claim to fame.

COPIES:

The following copies may to some degree reflect a lost portrait by Titian.

1. Hatfield House (England), Marquess of Salisbury; canvas, 1·12×0·864 m., mediocre copy; photograph in the Courtauld Institute, London.

2. London, Holford Collection (formerly); as by Gentile Bellini; canvas, 1·18×0·953 m. (Benson, 1924, pp. 48–52); Holford sale, 15 July 1927, no. 23.

3. Nicosia, Cyprus, National Museum; canvas, 1·18× 0·96 m. (Plate 220). An extra veil has been added later over the neck.

4. Treviso, Conte Avogadro degli Azzoni (Molmenti, 1911, II, p. 490).

Caterina Cornaro (so-called), see also: Cat. no. X–24.
 Also see:
 La Schiavona, Cat. no. 95.
 Venetian Girl, Cat. no. X–112 and related work, no. 2.

Caterina Cornaro as St. Catherine, see:
Wethey, I, 1969, Cat. no. 97, Plate 168.

Dorothea of Denmark, Countess Palatine, see:
Cat. no. L–24, Collection of Mary of Hungary.

L–10. **Alfonso I d'Este, Marquis and Duke of Ferrara**

Painted for Ferrara; payment made 20 July 1535; completed in 1536.

Bibliography: Campori, 1874, p. 604; Aretino's letter of 6 January 1538 mentions the portrait (*Lettere*, edition 1957, I, p. 112); C. and C., 1877, I, pp. 410–411.

COPIES:

1. Florence, Pitti Gallery, Sala di Ulisse; canvas, 1·545× 1·23 m. (Plate 225). Wearing a doublet of plum colour with bright red-brocaded sleeves, Alfonso d'Este rests his hand upon a cannon. Around his neck is the broad gold collar decorated with golden conch shells of the Royal Order of St. Michael of France, conferred by Louis XII in 1502 (Giustinian, 1692, pp. 771–780). All critics have regarded the portrait as a copy of Titian. It was attributed by Morelli and Tietze to Dosso Dossi and to Girolamo da Carpi by Crowe and Cavalcaselle and Berenson. The latter is more likely since it lacks the sumptuous technique of Dosso. *Bibliography:* Morelli, 1897, p. 217 (Dosso Dossi); Fischel, 1924, p. 72 (copy of Titian); Gronau, 1928, pp. 238–239 (copy of Titian); Berenson, 1932, p. 255 and 1968, p. 189 (Girolamo da Carpi); Suida, 1935, p. 162 (copy of Titian); Gronau, 1936, p. 69, perhaps a copy of the lost Titian, Inventory 1631, no. 346; Jahn-Rusconi, 1937, p. 311 (copy); Francini-Ciaranfi, 1956, p. 122, no. 311 (workshop of Dosso Dossi); Cipriani, 1966, p. 226, no. 311; Gibbons, 1968, p. 256 (copy of Titian).
2. New York, Jacob Heimann (formerly), canvas, 1·257× 1·098 m.; in the photograph this item shows Alfonso dressed in a brocaded cloak lined with sable, resting his right arm upon a cannon. He does not wear the collar of the Order of St. Michael, but otherwise the figure closely repeats that of the picture in Florence (see above, copy 1). *Bibliography:* A. Venturi, 1933, p. 390, fig. 9, then in the Foresti Collection, Milan (Titian); Ferrara, Catalogo, 1933, p. 195 (Titian); Tietze, 1940, no. 63 (Titian's original).

LOST COPY BY RUBENS (type unknown):
Portrait of Alfonso d'Este after Titian, Rubens' Inventory, 1640 (edition Lacroix, 1855, p, 271, no. 58). Rubens must have made this copy in Spain either in 1603 or 1628.

L–11. **Isabella d'Este in Red**

Canvas. 36× 29 inches (0·914× 0·737 m.)
London, Collection of Charles I (formerly).

The description as three-quarter-length in red velvet eliminates the possibility that this is Titian's work now in Vienna, in which she wears black. Neither can it have been Rubens' copy also now in Vienna, since that picture appears in Rubens' own Inventory of 1640.

History: Charles I's collection (van der Doort, 1639, Millar edition, 1960, p. 39, no. 10); Charles I's sale, London, May 1650, no. 193 (Cosnac, 1885, p. 417).

Bibliography: See also above; Engerth, 1884, I, pp. 356–357.

RUBENS' COPY: (Plate 231)
Vienna, Kunsthistorisches Museum; canvas, 1·02× 0·82 m., datable *c.* 1600–1601. *History:* Rubens' Inventory 1640, no. 56 (Lacroix, 1855, p. 271); Archduke Leopold Wilhelm, Vienna, 1659, no. 183. *Bibliography:* Engerth, II, 1884, edition 1892, pp. 400–401 (Rubens' copy made at Mantua *c.* 1600–1601 after the lost picture by Titian which later passed to Charles I's collection (see above); Rooses, 1890, IV, pp. 199–200, no. 972 (Rubens after Titian).

ANONYMOUS COPY:
Paris, Comtesse de Voguë, formerly Léopold Goldschmidt, Paris, 1903. *Bibliography:* Hamel, 1903, pp. 104–106 (proposed as Rubens' copy of Titian; said to have been bought by Goldschmidt from England); Fischel, 1924, p. 297 (copy); Suida, 1935, p. 82 (perhaps Titian); Tietze, 1936, I, pl. xxvb, II, p. 306 (probably a copy); Tietze and Tietze-Conrat, 1936, p. 139, note 12 (copy); Tietze, 1950, fig. 310 (copy).

L–12. **Alessandro Farnese**

One of the pictures taken from the Palace of Capodimonte by the French in 1799 and recovered in Rome in 1800 was the 'Ritratto di Alessandro Farnese, di Titiano' (Filangieri di Candida, 1902, p. 303, no. 11). It probably represented Alessandro Farnese (1545–1580), son of Ottavio Farnese and Margaret of Austria, rather than the cardinal, who in these inventories is always called Cardinal S. Angelo.

L–13. **Clelia Farnese**

Despite seventeenth-century references to a portrait of Clelia Farnese (1556–1613) by Titian, the late date of her birth just about eliminates the possibility that the artist ever saw or portrayed her. Neither Vasari nor Ridolfi reports that he included her among his likenesses of the

Farnese family. The reportedly beautiful daughter of Cardinal Alessandro Farnese, educated by her aunt Vittoria Farnese (Cat. no. X–35) at Urbino, Clelia became the wife of Giovanni Giorgio Cesarini, who died in 1585. She subsequently married Marco Pico of Sassuolo (Gigli, 1608–1670, edition 1958, p. 27; Drei, 1954, p. 128).

A portrait of her is recorded as by Titian in the Farnese Inventory at Parma in 1680 (Campori, 1870, p. 208: 'br. 1¼ d'oncia ×9 once', i.e. 0·705×0·483 m.). It is unlikely to be the same item in Renieri's collection at Venice (panel, '5½×4⅓ quarte') entered in a lottery in 1666 (C. and C., 1877, II, p. 471; Segarizzi, 1914, p. 178; Savini-Branca, 1964, p. 99). On the other hand, a portrait of Clelia, said to be by Titian, half-length with a most beautiful hand, which was for sale at Rome just previously in 1663, was approximately the same size as the Renieri item ('5 quarti× 4 quarti'; Ruffo, 1916, p. 169).

Another portrait of Clelia, qualified as after Scipione Pulzone ('1½ pies × 11 pouces', i.e. 0·46×0·28 m.), appears much earlier in 1607 in the Granvelle Palace at Besançon (Castan, 1867, p. 131, no. 190).

For the mistaken identification of Clelia as the lady of the so-called *Vittoria Farnese* at Budapest, see Cat. no. X–35.

L–14. Ottavio Farnese

Portrait painted by Titian at Rome in 1545–1546 (Vasari (1568)-Milanesi, VII, p. 447).

Biography: Ottavio Farnese (1524–1586), second son of Pierluigi Farnese (Cat. no. 30) and grandson of Paul III (Plates 127, 128), married Margaret of Austria (Cat. no. L–23), natural daughter of Charles V, and ultimately succeeded his father as duke of Parma four years after Pierluigi's murder in 1547. Alessandro Farnese, his son by Margaret of Austria, succeeded him but passed all of his reign in Flanders, as regent for Spain from 1579 to 1592 (Villari, 1910, pp. 183–184).

L–15. Pierluigi Farnese and Paul III

'Un quadro alto br. 3 on. 6, largo br. 2 on. 6 in tavola. Ritratto di Paolo III a sedere sopra carega di velluto ... alla destra il Serṁo Pier Luigi in piedi vestito di nero trinato d'oro con spada e mano sopra il fianco, di Tiziano' (Campori, 1870, p. 237).

L–16. Emperor Ferdinand I

Brussels, Collection of Mary of Hungary, later in the royal collections in Madrid.
1548.

Only one original of this work, which Titian painted at Augsburg in 1548, is recorded. Three-quarter-length in armour, Ferdinand I rests his right hand upon the helmet placed upon a table (Plate 248). The four copies listed below appear to repeat accurately the original, which was lost in the fire of the Alcázar in 1734 together with a vast quantity of other works of art. Pieter de Jode's engraving, labelled Ferdinand I, must instead represent *Charles V with Drawn Sword* (Cat. no. L–3). The original was praised by Aretino in a sonnet of 1550 (*Lettere*, ed. 1957, II, p. 341); also mentioned by Christopher Amberger who copied it (Beinert, 1946, p. 16).

Biography: Ferdinand of Austria (1503–1564), the brother of Charles V, was born and educated in Spain, where he remained until 1518. Charles, having fallen heir to the Spanish crown, sent his popular younger brother to Flanders to avoid a dispute over his succession, but in 1521 provided for him by granting him several archduchies and duchies of upper and lower Austria. In 1526 Ferdinand secured the election of himself as King of Bohemia on the death of his brother-in-law, Louis II. After the abdication of Charles V, he became Holy Roman Emperor, while his nephew Philip II inherited the Spanish dominions and the Netherlands.

History: Mary of Hungary's Inventory, 1556, Ferdinand in armour, the head uncovered (Pinchart, 1856, p. 140, no. 13); Cigales, Mary of Hungary's Inventory, 1558 (Beer, 1891, p. CLXIV, no. 66); Madrid, Princess Juana's Inventory, 1573, Emperor Ferdinand, half length in armour, his hand resting on his helmet, 1⅛×1 *varas* (0·97×0·835 m.) (Juana, Inventory, edition 1914, p. 368, no. 72; this item may be the copy still extant in the Descalzas Reales rather than Titian's lost original); Alcázar, Madrid, Inventory 1600, on loan to the Empress Maria (died 1603) at the Descalzas Reales, same description as in 1573 (Philip II, 1600, edition 1956–1959, II, p. 256, no. 405); Alcázar, Madrid, Galería del Mediodía, Inventory 1666, no. 605; Alcázar, Inventory 1686, no. 281, 1½ *varas* high (1·25 m.); Alcázar, Inventory 1700, no. 92 (Bottineau, 1958, p. 157); destroyed in the fire of 1734, since no further record is known. It hung at that time in the Galería del Mediodía.

Bibliography: See also History; Vasari (1568)-Milanesi, VII, p. 450 (Titian's portrait of Emperor Ferdinand); C. and C., 1877, II, pp. 187–188 (note); Beinert, 1946, p. 16 (a letter of Christopher Amberger at Augsburg, 1548, states that he had copied Titian's portrait of Ferdinand).

COPIES (of portrait of Ferdinand I):
1. Augsburg, Schloss Babenhausen, Fugger-Babenhausen

Collection; German copy, sixteenth century; inscribed: FERDINANDVS D. G. ROMA. IMP. ANNO 1548 (Beinert, 1946, p. 6; Müller-Hofstede, 1967, pp. 50–51, fig. 10).

2. Madrid, Descalzas Reales; canvas. 0·99×0·85 m., copy after Titian (Tormo, 1944, pp. 7–9).

3. Toledo, Museo de Santa Cruz (Plate 248); canvas, 1·12× 0·90 m.; on loan from the Prado Museum, Madrid. *Bibliography:* 'Inventario general', Prado, 1857, p. 196; Allende-Salazar and Sánchez Cantón, 1919, pp. 48–49 (copy); Suida, 1935, pp. 106, 187, pl. 327 (copy); Prado catalogue, 1945, no. 453 (copy); Charles V, 1958, p. 113, no. 135, pl. 55 (copy).

4. Venice, Donà dalle Rose Collection (formerly); (photographs, Soprintendenza alle Gallerie, Venice, no. VC 68 and no. S.G.V. 190).

L–17. Giulia Gonzaga Colonna.

Paolo Coccapani, bishop of Reggio, Inventory *c.* 1640, 'Il ritratto della signora Giulia Gonzaga di mano di Titiano' (Campori, 1870, p. 148).

In 1542 Ippolito Capilupi, bishop of Fano, nunzio at Venice, wrote to Giulia Gonzaga at Naples that he had her portrait by Titian. Her reply, dated 25 April 1542: '... Del guadagno, che ha fatto d'un mio ritratto, io non so quanto mi debba rallegrare, perciocchè essendo della bellezza che scrisse, non deve essere di naturale...' (Amante, 1896, p. 145, who copied the letter from G. B. Intra, *Di Ippolito Capilupi e del suo tempo*, Milan, 1893, p. 49).

Biography: Giulia Gonzaga Colonna (*c.* 1513–1566), daughter of Ludovico Gonzaga of Sabbioneta and Francesca Fieschi, was married at fourteen to Vespasiano Colonna, count of Fondi, a widower past forty years of age. At her husband's death in 1528 she remained in control of her little state of Fondi, to which were attracted a host of intellectuals and artists. Her beauty was so renowed that in July 1534 Khaired-din (Barbarossa), the famous Turkish corsair, assaulted Fondi by night in the hope of capturing her and sending her as a present to the Sultan Soliman the Great. The following year Giulia withdrew permanently to Naples, and there she died in 1566 (Quazza, 1933; Amante, 1896).

Giulia Gonzaga Colonna, see also: Cat. nos. X–60 and X–112.

L–18. Mme Granvelle, Nicole Bonvalot, wife of Chancellor Nicolas Perrenot

Canvas. 3 *pieds* 6½ *polces*× 2 *pieds* 14 *polces* (*c.* 1·079× 0·965 m.) Besançon, Granvelle Palace (formerly).

The portrait was listed in the Granvelle Inventory of 1607 as by Titian.

Bibliography: Castan, 1867, p. 218, no. 173.

COPY:
Another portrait appears in the Granvelle Inventory of 1607 as a copy after Titian (Castan, 1867, p. 132, no. 201).

RELATED WORK?
A portrait identified as Nicole Bonvalot is now in the Walter P. Chrysler Collection at Provincetown, Massachusetts, there attributed to Tintoretto. Perhaps Amalia di Alberti sale, London, Christie's, 22 July 1955, canvas, 1.016× 0.84 m. (*APC*, XXXII, 1954–1955, no. 4320).

L–19. Diego Hurtado de Mendoza
1540–1541.

Vasari refers to the portrait as painted in 1541, full-length, and a very beautiful figure (Vasari (1568)-Milanesi, VII, p. 445). It was thought to exist still in the Infantado Palace at Guadalajara, when Carderera referred to it in 1841 (Carderera, 1841, p. 232), but the present location of this picture is unknown. A half-length portrait illustrated by Espasa-Calpe, *Enciclopedia universal ilustrada*, vol. XXVIII, 1925, p. 754, does not seem to be a work by Titian as far as can be judged from the inadequate reproduction. The engraving in *El parnaso español*, Madrid, IV, 1770, clearly is based upon this same painting.

For the portrait in the Pitti Gallery, wrongly identified as Hurtado de Mendoza, see Cat. no. 52.

Biography: Diego Hurtado de Mendoza (*c.* 1506–1575), member of a great Spanish family, enjoyed a long diplomatic career, beginning with his appointment as ambassador to England in 1537. He transferred to Venice in 1539–1546 at a time when he became much involved with the political aspects of the Council of Trent. In 1547 his appointment as ambassador to the papacy took him to the court of Paul III. Having fallen from royal favour because of the loss of Siena, of which he had been governor in 1548–1552, Hurtado de Mendoza returned to Spain. From 1569 until his death in 1575 he lived in virtual exile at Granada, devoting himself to literature.

His major poetic work is the *Fábula de Adonis* (Venice, 1553), a characteristically Renaissance composition influenced by Vergil, Ovid, and Lucretius. *La Guerra de Granada*, written during his retirement, was not published until 1627. The attribution to Diego Hurtado de Mendoza of the celebrated picaresque novel *Lazarillo de Tormes*

has not been definitively established. His invaluable collection of Greek, Latin, and Arabic manuscripts, which he acquired in Italy, he bequeathed to the king, and they form part of the nucleus of the great Escorial library (González Palencia and Mele, 1941–1943; Padre Gregorio de Andrés, 1964, pp. 235–323).

History: Letters of 1 May 1540 and 29 January 1541 from Diego Hurtado de Mendoza at Venice to Francisco de los Cobos, minister of Charles V, refer to the portrait as in preparation (Vázquez and Rose, 1935, pp. 33, 63).

Bibliography: See also above; Aretino sonnet in Aretino, *Poesie*, edition 1930, II, p. 218; Ridolfi (1648)-Hadeln, I, p. 169 (quotes Aretino's poem on Hurtado de Mendoza's portrait); López Sedano, *El parnaso español*, Madrid, 1770, III, pp. V–VI; IV; IX, p. VI; Carderera, 1899, pp. 229–232; Foulché-Delbosc, 1910, pp. 310–313 (major study); Allende-Salazar and Sánchez Cantón, 1919, pp. 50–52; González Palencia, 1941, I, pp. 226–232 (literary sources).

L–20. Empress Isabella Seated, Dressed in Black

Plate 150

Canvas. No dimensions.

El Pardo Palace, Madrid (destroyed 1604).

Documented 1544–1545.

This lost portrait of *Empress Isabella* dressed in black, holding roses in her right hand, with an imperial crown placed in a window-like opening at the upper right, has been identified as the picture which Titian delivered in 1545. A letter written by Pietro Aretino to Charles V, dated at Venice 5 October 1544 (*Lettere*, edition 1957, II, pp. 26–28), describes the composition sufficiently to establish this identification and to distinguish it from the preserved canvas of the *Empress Isabella* wearing pearls (Plate 147). Much confusion had existed between the two works until the problem was resolved by Pedro Beroqui as early as 1925 in an article overlooked by writers on Titian (Beroqui, 1925, pp. 259–266; reprinted 1946, pp. 61–66). On 17 April 1545 Charles V wrote to Diego Hurtado de Mendoza in Venice asking if the Empress's portrait had been finished (Cloulas, 1967, p. 204, unpublished hitherto). At Busseto in 1543, when Charles V and Paul III met for discussions, the Emperor had given Titian a portrait by another artist, possibly Seisenegger, a work which Aretino characterized as by a trivial master ('di trivial pennello', *Lettere*, edition 1957, II, pp. 9–11, letter of July 1543; Beroqui, *loc. cit.*). Aretino, as previously stated, described the picture in October 1544, and in the following month he again praised it in a letter to Bernardo Navagero (*loc. cit.*, pp. 30–31). Almost a year

later on 5 October 1545 Titian wrote to the Emperor that he had delivered the picture to Diego Hurtado de Mendoza (Cloulas, 1967, pp. 204–205; C. and C., 1877, II, pp. 103–104, 501, with wrong date). On 8 December 1545 Titian wrote from Rome reminding the Emperor that he had previously delivered his own portrait of the Empress as well as the model 'qualtro che mi fu dato da lei per essempio' (Beroqui, *loc. cit.*, Cloulas, 1967, p. 207, note 3; further details about this letter in my Introduction, note 38).

At Ghent Charles informed his ambassador on 30 October 1545 (Cloulas, 1967, p. 207) that he was not entirely satisfied with the nose (!), but that he would have no other man touch the canvas and that on a future trip to Italy he would take it to Titian for retouching. At Augsburg on 21 October 1547 Charles returned to this subject of correcting the portrait of the Empress (Cloulas, 1967, p. 208), so it can be assumed that the artist did retouch the nose during his stay at Augsburg in 1548.

The puzzle as to who painted the model which Titian followed has not been resolved. Since Seisenegger did visit Spain in 1538–1539 before Isabella died (Löcher, 1962, p. 11) and Jan Vermeyen was there in 1536 (Boon, 1940, pp. 78–80), both are reasonable candidates, although William Scrots is another possibility, even if he never visited Spain, because Mary of Hungary owned a portrait of the Empress painted by him, listed in her inventory of 1556 (Pinchart, 1856, p. 140, no. 18, 'hecho por el maestro Guillermo'). A handsome likeness of the Empress by a Flemish painter, sometimes attributed to Scrots, in the National Museum at Posen, Poland (Plate 233) does bear some resemblance to the work by Titian, which is known in Peter de Jode's print (Plate 232) and recorded in the painted copies listed below.

History: See also above; Charles V's Inventory at Brussels, 18 August 1556, a portrait of the Empress by Titian in addition to a second portrait, which was a pendant to *Charles V Armed*. This pair was taken to Yuste (see Cat. no. L–5). The single item must have been the likeness showing the Empress in black with roses in her lap (Gachard, 1855, II, p. 92); undoubtedly taken to El Pardo Palace, Madrid; Inventories, El Pardo, 1564 and 1582 (Calandre, 1953, pp. 152, 43–44); destroyed by fire on 13 March 1604 (*loc. cit.*, p. 70).

Bibliography: See also above; C. and C., 1877, II, pp. 103–105 (they confused the portrait with the extant one in the Prado Museum, Cat. no. 53); Gronau, 1903, pp. 281–285; Roblot-Delondre, 1909, pp. 435–454 (suggested a model by Sânchez Coello who was born in 1532!); Allende-Salazar and Sánchez Cantón, 1919, p. 35; Glück, 1933, pp. 207–208 (confused it with the portrait in the Prado Museum,

see Cat. no. 53); Beroqui, 1925, pp. 259–266 and 1946, pp. 61–64 (first solved the problem of the two portraits); Suida, 1946, pp. 148–149, fig. 1 (proposed as model the Scrots portrait formerly in the Emile Gavet Collection, Paris); Bialostocki, 1954, pp. 109–115 (published the portrait at Posen); Bialostocki and Walicki, 1955, no. 157 (Scrots?); Valcanover, 1960, I, p. 89 (reference to Aretino's letter of October 1544); *idem*, 1969, no. 242; Panofsky, 1969, pp. 185–186 (original lost); Pallucchini, 1969, pp. 121–122 (lost).

PRINT (Plate 232):

Pieter de Jode (1606–1674), print signed 'P. de Jode excud. Ticianus pinxit'; engraved after Rubens' copy (see below, Lost Copy).

EXTANT COPIES:

1. Charlecote Park, Warwickshire; panel, 1·092×0·914 m.; in ruinous condition, obscured by mould; from Charles I's collection, monogram 'c R 459' on the back; purchased by Charles from Nathaniel Garret, 'Some roasees in her right hand . . .' (van der Doort, 1639, Millar edition, 1960, p. 24, no. 11); sold after his execution, 'l'Imperatrice, femme de Charles-Quint, habillée en noir, sans collet, tenant de sa main droit des roses, de la gauche un livre, et au dessus, la couronne imperiale' (Cosnac, 1885, p. 338); Stanley Collection (dates unknown); purchased by George Lucy from Stanley in 1835 for £23.10.6 (Charlecote archives); 1969, Gore, p. 242 (copy of Titian).
2. Madrid, Marqués de Santo Domingo; canvas, 1·07× 0·84 m.; formerly Altamira and Madrazo Collections (Madrazo, 1856, no. 275; Charles V, 1955, no. 136; Charles V, Toledo, 1958, p. 121, no. 160, pl. XIV).
3. New York, Hispanic Society; canvas, 1·035×0·85 m., hard weak copy possibly identical with No. 4, below; acquired in 1923.
4. Unknown location, formerly Florence, private collection; from the Pepoli Collection, Bologna, later sold at Munich (Gronau, 1903, pp. 282–283).
5. Unknown location, formerly Louise Roblot-Delondre, Paris (Plate 150); sale Paris, Hôtel Drouot, 13 March 1914, no. 8, panel, 1·10×0·98 m., said to have belonged to the Marqués de Salamanca at Vista Alegre until 1875 (Roblot-Delondre, 1909, pp. 438–454, illustrated; no such picture in the Salamanca sales of 1867 and 1875).

LOST COPY:

Rubens' copy, Inventory 1640 (edition 1855, p. 271, no. 50; also Sainsbury, 1857, p. 237, no. 49). Rubens must have painted this copy in 1603 on his first visit to Spain, since the original was destroyed the following year.

L–21. **Agostino Landi**

Letters of 1539 refer to a portrait (Ronchini, 1864, p. 129). Conte Agostino Landi, later Prince of Val di Taro (died 1555), became one of Charles V's Italian allies (Carotti, 1933, p. 491).

L–22. **Cornelia Malaspina**

Documented 1530.

On 12 July 1530 Titian wrote to Federico Gonzaga, duke of Mantua, that he had not been able to see Cornelia at Bologna because she was ill and had gone to Novellara, but that he could do her likeness from another artist's portrait.
Titian's picture of her was shipped from Mantua to Francisco de los Cobos on 26 September 1530 (C. and C., 1877, I, pp. 342–346, 447–449).

Biography: Cornelia Malaspina, a tall and very beautiful young woman, was a lady-in-waiting to Countess Isabella dei Pepoli of Bologna. Francisco de los Cobos, the powerful secretary to Charles V, met her at Bologna at the time of the Emperor's coronation in February 1530. He fell madly in love with her and carried on a correspondence until her death in 1541, although he apparently saw her only once again, in May 1536. Meantime, she married Pietro dei Vecchi of Reggio in April 1533, by whom she had five children. Her biography has been reconstructed by Hayward Keniston from the letters of the entourage of Cobos and the lady (see below). Her relationship to the Cybo-Malaspina family of Massa and Carrara, if any, is seemingly nowhere touched upon (see Cat. no. 91, History).

Bibliography: C. and C., 1877, I, pp. 342–346, 447–449; Keniston, 1959, pp. 133, 136–142; Pallucchini, 1969, p. 57 (mention).

L–23. **Margaret of Austria, Duchess of Parma** (Madama d'Austria)

Panel.

Parma, Farnese Collection (formerly).

Biography: Margaret of Parma (1522–1586), the illegitimate daughter of Charles V by a Flemish woman, was brought up in Flanders by her aunts Margaret of Austria and Mary of Hungary, (Cat. no. L–24), who were successively regents of the Netherlands. First married in 1536 to Alessandro dei Medici, claimant to the duchy of Florence, she was widowed a year later at the age of fifteen. After three years her father married her off, also for political reasons, to Ottavio Farnese

(Cat. no. L–14). They succeeded to the duchy of Parma and Piacenza in 1551. A woman of masculine abilities like her aunts, she was named regent of the Netherlands by her brother Philip in 1559, but because of the rising storm of discontent against the Inquisition and Spanish despotism, she resigned her post in 1567 to the Duke of Alba (Cat. no. L–1) and retired to Italy (Villari, x, 1910, pp. 183–184; 'Margaret of Austria', xvii, 1910, pp. 703–704).

History: Picture shipped from Rome to Parma, Inventory 1662, no. 56, 'Un ritratto di Madama d'Austria testa e busto in tavola, di Titiano segnato n. 107' (Filangieri di Candida, 1902, p. 260); Palazzo del Giardino, Parma, Inventory 1680, 'Un quadro alto on. 10, largo 8, in tavola. Una testa di Margarita d'Austria con velo bianco in testa e doppia collana di perle al collo, di Tiziano' (Campori, 1870, p. 227); the picture cannot be traced thereafter.

L–24. Queen Mary of Hungary

The existence of a portrait by Titian in Mary of Hungary's own collection has given rise to the theory that various preserved works reflect Titian's prototype, particularly the canvas at Ambras Castle showing the queen in widow's garments (Glück, 1934, p. 194) and a similar three-quarter-length figure against a curtain with architectural detail to the right in the Musée des Arts Décoratifs in Paris (Plate 264). Another copy in tondo (0·90 m.) is in the Rÿksmuseum, Amsterdam (Amsterdam, 1960, cat. no. 148).

Biography: Mary of Hungary (1505–1558), daughter of Philip the Fair and Joanna the Mad, and sister of Charles V, was engaged as a child to Louis, heir to the Hungarian throne. Married in 1521, she was widowed five years later when the young king died in battle. Her main occupation for the rest of her life was to serve as regent of the Netherlands (1531–1556). She retired in the year Charles abdicated, took her possessions to the castle of Cigales near Valladolid, and died there two years later.

History: Inventory of Mary of Hungary, Brussels, 1556 (Pinchart, 1856, p. 139, no. 5, by Titian); Cigales, 1558 (Beer, 1891, p. CLXIII, no. 58, by Titian); the only portrait of her at El Pardo Palace in 1582 was by Antonio Moro (Calandre, 1953, p. 47), therefore it cannot be assumed that Titian's portrait of her was destroyed in 1604; a likeness of Mary of Hungary in Philip II's collection in Madrid was valued at the low price of one-hundred *reales*, a fact which does not suggest a work by Titian (Alcázar, Inventory 1600, edition 1956, p. 243, no. 266); on the other hand, the

same inventory includes a picture of her husband, Louis II of Hungary, said to be by the hand of Titian and valued also at one-hundred *reales* (Alcázar, Inventory 1600, edition 1956, II, p. 247). Since no portrait of King Louis (died 1526) appears in Queen Mary's Inventory of 1556 or anywhere else in Spain, this attribution must be an error. Perhaps Titian's name should have been attached to the Queen's portrait in the Inventory of 1600 instead of to the King's. In any event her name disappears from the Alcazar Inventories thereafter.

Bibliography: See also above: Vasari (1568)-Milanesi, VII, p. 450 (Titian's portrait of Queen Mary); Glück, 1934, pp. 194–196; Suida, 1934, pp. 277–278; Suida, 1935, pp. 107, 186, pl. 326; Mauceri, 1935, p. 166 (copy at Bologna).

Collection of Mary of Hungary at Brussels in 1556

It is more than doubtful that Titian could have carried out all twenty portraits listed in Mary of Hungary's collection in addition to two of Charles V (Cat. nos. 21, L–4) during his stay of eight and one-half months at Augsburg in 1548 and again in 1550–1551. No more than a design and some retouching could have been his share in each, with the major part assigned to assistants.

In a letter of 28 August 1553 Mary of Hungary wrote to Francisco de Vargas, the Spanish ambassador at Venice, that she had received some pictures from Titian, but that the *Tantalus* and the *Seven Children of Ferdinand I* still had not arrived (Cloulas, 1967, p. 221). The Brussels (1556) and Cigales (1558) Inventories include four canvases of four daughters of King Ferdinand (Pinchart, 1856, p. 141, nos. 27–30; Beer, 1891, p. CLXIV, no. 80), suggesting that Titian never delivered the total of seven. On the other hand, Princess Juana's estate had eight (!) portraits of daughters of Emperor Ferdinand, artist unnamed, rather certainly not all by Titian (Juana, Inventory 1573, p. 372, no. 108, $1\frac{1}{2}\times$ $1\frac{1}{12}$ *varas*, i.e. $1\cdot25\times0\cdot904$ m.; no artist is mentioned anywhere in this Inventory).

The following portraits, described as by Titian, in the collection of Mary of Hungary, were lost in 1604: the widowed Duchess of Bavaria, Duke Maurice of Cleves armed, Dorothea, Countess Palatine sister of the Duchess of Lorraine, Philibert-Manuel Duke of Savoy, and Christina of Milan and of Lorraine (Cat. no. L–7). A picture of the last mentioned by Michael Coxie in the Museum at Oberlin College may possibly reflect Titian's lost prototype (Rose, 1963, pp. 29–51). All five of these works appear in the Brussels Inventory in 1556 (Pinchart, 1856, p. 140, nos. 7, 8, 11, 12, 16) and in the Cigales Inventory of 1558 (Beer, 1891, pp. CLXIII–CLXIV, nos. 60, 61, 64, 65, 69). They next turn

up with Titian's name attached in the Inventory of El Pardo Palace in 1582 (Calandre, 1953, p. 46, nos. 10, 29, 31, 33, all by Titian). We have therefore every reason to assume that they went up in flames in the fire of 13 March 1604, as stated by the contemporary, León Pinelo (edition 1931, pp. 67–68; also Calandre, 1953, p. 70).

The gallery of notables in the Palace of El Pardo was destroyed by a fire which ravaged but did not completely ruin the entire building. It must be remarked that the year was not 1608, an error introduced by Vicente Carducho in 1633 (edition 1933, p. 110, corrected by Sánchez Cantón) and repeated by Crowe and Cavalcaselle (1877, II, p. 177 and p. 319, note), who were also confused by the similarity of the name El Pardo to that of the Prado Museum. This mistaken date was repeated by Justi (1889, p. 185) and by nearly all subsequent writers outside of Spain.

Other notables who are mentioned in Mary of Hungary's collection in 1556 and 1558, but not included in the El Pardo gallery in 1582, must have been placed in other royal residences such as those of the Alcázar at Madrid, at Aranjuez, at Toledo, or at Valladolid. The disappearance of the inventories of these palaces results in numerous lacunae in the history of many pictures. Information about the other lost items attributed to Titian in Brussels (1556) are discussed separately, i.e. *Mary of Hungary* (Cat. no. L–24), *Emperor Ferdinand I* (Cat. no. L–16), the *Duke of Alba* (Cat. no. L–1), *Johann Friedrich in Armour* (Cat. no. X–65), and *Charles V in Armour* (Cat. no. L–4). About the Duchess of Bavaria, daughter of Emperor Ferdinand I, her brother the Archduke Ferdinand in Armour, and Maximilian II, King of Bohemia, we have no reliable information after 1558 and 1582, although Suida has unconvincingly proposed a work in the Staatsarchiv at Vienna as being related to the last mentioned portrait by Titian (Suida, 1936, p. 281, pl. IIB). More likely the portrait of *Maximilian II* was by Antonio Moro since a work so attributed appears in the El Pardo Inventory of 1582 (Calandre, 1953, p. 47).

Alvise Morosini, see: Cat. no. L–35.

L–25. Philip II (type unknown)

1. *Philip II*, begun at Milan in December 1548 and praised by Aretino in a sonnet of February 1549 (*Lettere*, edition 1957, II, p. 277; sonnet reprinted by Ridolfi (Ridolfi (1648)-Hadeln, I, p. 183).

The original was shipped from Venice by Juan de Mendoza to Philip in Flanders on 9 July 1549, according to a letter of that date (Cloulas, 1967, p. 212). At that time Mendoza stated that Titian was retouching two copies of this same picture and that they would also be forwarded to Flanders. This first portrait of 1549 may have been the one sent to Mary Tudor in November 1553 in connection with the negotiations which ended in her marriage to Philip. In this version the prince wore a blue cloak trimmed in white fur (*Calendar*, XI, 1916, p. 384; Cloulas, 1967, p. 218, no. 2, who formerly associated the picture of 1553 (Cat. no. 83) with this transaction, whereas the letters make it clear that Philip looked younger than he did in 1553. See my text, page 42).

On 19 November 1553 at Brussels Mary of Hungary wrote to Renard, the Emperor's ambassador in London, that she was lending Philip's portrait, so that it could be shown to Mary Tudor, but with the explanation that the portrait was three years old and that Titian's pictures had to be viewed from the distances ('le desir qu'elle avoit de veoir la portraicture dudict sieur prince, que nous en envoyons avec ceste, une faicte de la main de Titiano il y a trois ans, jugée par tous selon qu'il estoit lors, fort naturelle. Vray est que la poincture s'est un peu gastée par le temps et en l'apportant dois Ausbourg ici; si est-ce qu'elle verra assez par icelle sa ressemblance, la voyant à son jour et de loing, commes sont toutes les poinctures dudict Titien que de près ne se recognoissent' (Granvelle, 1843, IV, p. 150).

Philip's portrait was returned to Mary of Hungary on 29 November 1553, according to the English Queen's letter of the previous day, in which she remarked that she would be even happier to see Philip himself: 'Mais encore plus volentiers veroit elle la vive image' (Renard to Charles V: Gachard and Piot, 1882, pp. 223–224).

The same portrait may be the one which Philip sent to his aunt on 16 May 1551—not the portrait in armour but the second item, which he states has been damaged in the varnish: 'El otro le a dannado un poco al barniz aunque no en el gesto y esto se podra allá adreçar y la culpa no es mia sino de Ticiano' (Voltelini, 1890, p. LV, no. 6443; Beroqui, 1946, p. 116, note 3; Cloulas, 1967, p. 213).

This picture does not appear in the Inventory of Mary of Hungary made in Brussels in 1556 nor in the second one compiled at Cigales in 1558. It may be that Philip II himself took it to Spain. If so it might be the portrait inventoried in the gallery of El Pardo palace near Madrid in 1564 and 1582, and destroyed in 1604 (Calandre, 1953, pp. 44, 70, 152).

2. *Philip II*, presumably a replica of number 1 above, destined for Granvelle, according to letters between Titian and the cardinal dated 28 April and 6 October 1549 and 22 March 1550 (Zarco del Valle, 1888, pp. 227–229).

Philip II, see also: Cat. nos. 78–84.

L–26. **Elisabetta Querini Massola**

Elisabetta Querini (died 1559) and her husband Lorenzo Massola commissioned Titian's *Martyrdom of St. Lawrence*, now in the Gesuiti at Venice (Wethey, I, 1969, Cat. no. 114). Her lost portrait by Titian (*c.* 1543) has been theoretically identified in a print by Giuseppe Canale (1725–1802), the late date of which leaves doubt as to its reliability. Moreover, the medal of the lady by Danese Cattaneo (Gallo, 1935, p. 165) does not bear a close resemblance to the other portraits despite the difficulty in comparing the different media. She was reputed to be a woman of extraordinary beauty, another fact which belies the identification of her in these so-called portraits.

A nude woman, attributed to Titian and purported to be 'La Donna di Giovanni della Casa', as cited by Vasari, $4 \times 4\frac{1}{2}$ *palmi*, i.e. 0.89×1.00 m. (Campori, 1870, p. 141), obviously could not have been Elisabetta Querini.

History: The Querini portrait was praised in a sonnet (Aretino, *Poesie*, edition 1930, II, p. 222) and a letter by Aretino in October 1543 (*Lettere*, edition 1957, II, pp. 11–12); Pietro Bembo's letter of 3 August 1544 to Girolamo Querini mentions a picture of Elisabetta Querini in the house of Monsignore Giovanni della Casa at Rome (Gallo, *op. cit.*; also Bembo, edition 1743, II, pp. 265–266).

Bibliography: Vasari (1568)-Milanesi, VII, p. 456 (Titian's portrait of a beautiful lady beloved by Giovanni della Casa); Ridolfi (1648)-Hadeln, I, pp. 176, 198 (quotes Aretino's sonnet on the portrait of Elisabetta Querini Massola; Ridolfi includes the poem on the same portrait written by Monsignore della Casa who owned it, but he thought they were different pictures and different ladies); C. and C., 1877, II, p. 48 (reference to the print); Gallo, 1935, pp. 158–166 (major account); Valcanover, 1969, nos. 234 and 258 (lost portrait).

COPIES: (corresponding to Giuseppe Canale's print):
1. Paris, Louvre; canvas, 1.10×0.90 m. *Bibliography:* Villot, 1874, p. 71, no. 111 (school of Veronese); Gronau, 1922, pp. 61–63 (copy of Titian); Suida, 1935, pp. 90, 171, fig. 182 (copy of Titian); Berenson, 1947, pp. 35–36, fig. 36 (copy of Tintoretto).
2. Rome, Villa Borghese; canvas, 1.01×0.78 m. *Bibliography:* Gronau, 1922, pp. 61–63 (copy of Titian); Fischel, 1924, p. 287 (copy of Titian); Longhi, *Precisioni*, 1928, p. 186 (copy after Titian's Elisabetta Querini); Pergola, 1955, p. 128, no. 232 (as Marietta Tintoretto's *Self Portrait*).

L–27. **Soliman the Great, Sultan of Turkey**

Biography: Soliman the Great (1496–1566), the Ottoman sultan, ascended the throne in 1520 and kept western Europe and its leaders Charles V, Ferdinand I, Clement VII and Paul III in a state of constant alarm. Constantinople became a great intellectual centre during his reign (Rossi, 1936, p. 76).

1. **Profile Portrait for Mantua** (1538)
The original in profile by Titian must have been the work mentioned by Benedetto Agnello in a letter of 23 August 1538 to Duke Federico Gonzaga as having been done from a medal, i.e. in profile (C. and C., 1877, II, pp. 23–24, 498–499; Braghirolli, 1881, pp. 66–67; also Donati, 1956, pp. 219–223). In the Mantuan Inventory 1627: 'un ritratto di Selim rè dei Turchi' nella loggietta verso el giardino del paviglione', no artist mentioned (D'Arco, 1857, II, p. 167).
Suida published a profile likeness of Soliman as Titian's original, although the quality does not support his theory (Suida, 1935, pp. 86, 183, pl. 301; *idem*, 1936, p. 281, illustration). Then in the collection of E. Marinucci at Rome (1935), and presumed to have come from the collection of Paolo Giovio, this small canvas (0.725×0.61 m.) was sold at Christie's, London, 24 March 1961, no. 39, and purchased by Agnew for £7350 (*APC*, XXXVIII, 1960–1961, no. 3427).

2. **Portrait for Mantua** (1569).
In a letter dated in Venice, 7 March 1569, Bishop Ippolito Capilupi of Fano wrote to Cardinal Ercole Gonzaga of Mantua that he was sending a small picture (*quadretto*), a portrait of the Turk by Titian (Gualandi, 1856, III, pp. 20–22). Mario Brunetti (1935, p. 124) assumed that this item was an equestrian portrait.

3. **Portrait for Urbino** (1539).
A portrait of Soliman was painted for Urbino in 1539 (Gronau, 1904, pp. 10, 20; 1936, pp. 65, 95). Vasari reported having seen it at the della Rovere court (Vasari (1568)-Milanesi, VII, p. 444) and Ridolfi in the next century listed it among the portraits of famous men by Titian but without mentioning the owner (Ridolfi (1648)-Hadeln, I, p. 192). Last cited in the Urbino Inventory of 1631 as a picture of Soliman II (Gronau, *op. cit.*, p. 10).

4. **Equestrian portrait.**
In a letter of 20 September 1578 Niccolò Barbarigo writing from Constantinople to the Signoria of Venice remarked that he once saw in Titian's house an old neglected portrait of *Soliman on Horseback* (Brunetti, 1935, p. 123). Nothing further is known of this lost work by the great master.
The only equestrian portrait of Soliman by Titian that

survives is the figure with a large turban among the spectators on the right side of Titian's *Christ Before Pilate* at Vienna (Wethey, I, 1969, Plate 91; Gould, 1969, pl. 35).

L–28. **Sultana or Queen of Persia** (perhaps Rossa)

Titian announced to Prince Philip of Spain in a letter of 11 October 1552 that he was sending a portrait of the 'Queen of Persia'. Philip's acknowledgement, dated 12 December 1552, states that the picture has not yet arrived (C. and C., 1877, II, p. 218; Zarco del Valle, 1888, p. 231; Cloulas, 1967, pp. 215–216). Mme Cloulas questions whether the canvas ever reached Spain since it is not traceable in the royal Inventories.

Vasari reported that the artist did a portrait of Rossa (or Rosselana), the favourite wife of Soliman I, at the age of sixteen (Vasari (1568)-Milanesi, VII, p. 456) and added that Titian also painted her daughter Cameria (repeated by Ridolfi (1648)-Hadeln, I, p. 194).

Cameria's name does not occur in other references during Titian's own lifetime, so that it can not be confidently assumed that her portrait in the collection of notables in the Uffizi Gallery reflects a prototype by Titian (Gronau, 1903, pl. IVb, as after Titian; see also Cat. no. L–2). In the case of portraits such as these, since Titian never saw the sitters in the flesh, he had to follow a medal or another artist's work as the model. Because Rossa would have been sixteen about 1520, these portraits of 1552 would have clearly been ideal representations.

On 3 August 1559 García Hernández wrote Philip that he would send a small picture by Titian 'una Turca o Persiana hecho a su fantasia' (C. and C. 1877, II, pp. 277, 515; Cloulas, 1967, pp. 238–239).

Ponz saw a *Sultana* (Ponz, 1776, VI, Boadilla y Villaviciosa, 6; edition 1947, p. 561), which is classified as in the style of Titian, in the palace of the Conde de Chinchón at Villaviciosa.

PRESUMED COPY AFTER TITIAN:

Sarasota (Florida), John and Mable Ringling Museum of Art; canvas, 0·98×0·76 m. (Plate 270); follower of Titian. The crown and peaked headdress with a veil constitute a westerner's conception of a Turkish Sultana (Vecellio, 1598, p. 459, called Persian). It is true that the peaked headdress was used in Near Eastern costume of this period. A rose tucked in the lady's bosom could be a play on words, and imply that she was intended to be an ideal representation of the Sultana Rossa. Other Venetian portraits, loosely related to Titian, repeat the major elements of the Sarasota composition, but without the headdress.

The weasel, held in the lady's hand, is also present in the *Venetian Girl* in Vienna (Cat. no. X–112, copy 4). *History:* Said to have come from the Riccardi Palace, Florence, and thereafter from Lucien Bonaparte's collection in Rome (Buchanan, 1824, II, p. 278, no. 112); Farrer, London, 1843, sold to Holford; Holford Collection, London, 1843–1927 (Waagen, 1857, p. 101, Holford Collection, by Titian); Holford sale, London, Christie's, 15 July 1927, p. 116, no. 23; Julius Böhler, Munich; Howard Young, New York; purchase by Ringling c. 1930. *Bibliography:* See also above; C. and C., 1877, II, p. 58 (follower of Titian); Gronau, 1903, pp. 132–134 (workshop of Titian); Fischel, 1924, p. 176 (Titian); Benson, 1927, I, p. 30, no. 51, illustrated (Titian); Hadeln, 1930, p. 85 (Titian); Suida, 1935, pp. 86, 177, pl. 233b (Titian); Suida, 1949, p. 59, no. 58 (Titian); Berenson, 1957 (omitted); Valcanover, 1960 and 1969 (omitted).

LITERARY REFERENCE:

In a letter of 29 January 1569 Niccolò Stoppio, an agent of the Duke of Bavaria in Venice, asserted to Johann Jacob Fugger that Jacopo Strada (Cat. no. 100) had withheld a beautiful *Pomona* by Titian for himself and had sent the Duke of Bavaria a much less handsome portrait of a *Persian Lady* (Zimmermann, 1901, pp. 850–851).

L–29. **Titian's Self-Portrait**

A *Self-Portrait* by Titian sent to Charles V in March 1550 (Zarco del Valle, 1888, p. 230) might conceivably be the one located in the Galería del Mediodía in 1666, no. 598, '1 vara (0·835 m.) de alto y un pié de ancho'; Inventory 1686, no. 274; Inventory 1700, no. 85 (Bottineau, 1958, p. 156). It was doubtless destroyed in the fire of the Alcázar in 1734. Cat. no. 105 is another later picture.

L–30. **Titian's Self-Portrait Holding a Portrait of Prince Philip**

1552.

History: Sent to Philip II on 11 October 1552 (letter of Francisco de Vargas to Philip: Zarco del Valle, 1888, p. 231; Cloulas, 1967, p. 214); El Pardo Palace, Madrid, Inventory 1564 (Calandre, 1953, p. 152); El Pardo, 1582, Argote de Molina describes it: 'Ticiano, pintor el más excelente de su tiempo, natural de Venecia, cuyo retrato se ve teniendo en sus manos otro con la imagen del rey D. Felipe' (Argote de Molina, edition 1882, IV, chapter IV; also Calandre, 1953, pp. 46, 62). Destroyed by fire 13 March 1604 (Calandre 1953, pp. 70–72).

Bibliography: See above; Ridolfi (1648)-Hadeln, I, p. 180.

L–31. Titian's Self-Portrait (half-length)

Madrid, Pompeo Leoni, Estate of, Inventory 1609 (see: Leoni, 1934, p. 111).

L–32. Titian's Self-Portrait (tondo)

Venice, Gabriele Vendramin, 1569 (see Cat. no. X–92).

L–33. Titian's Self-Portrait (half-length)
Panel, 0·18×0·14 m.

Titian, aged about fifty, wearing a small cap, is seated behind a table. He is garbed in a heavy cloak, with a gold chain at the neck, and he places the left hand on his knee, while his right hand holds a paper. A composition that resembles this work is reproduced in a drawing at Chatsworth (Foscari, 1935, pl. 13).

History: Orléans Collection, Paris (Dubois de Saint Gelais, 1727, p. 462: 'Bois 5½×5⅓ pouces, barbe blanche, bonnet noir'; Couché, Paris, 1786–1808, I, pl. 1); Earl of Carlisle (Buchanan, 1824, I, p. 112, no. 1); exhibited at the British Institution in 1829 (Graves, 1914, III, p. 1317).

Bibliography: See above; Waagen, 1854 and 1857 (not listed).

Titian's Self-Portrait, see also: Cat. nos. 104–107 and Cat. nos. X–92—X–104.

L–34. Francisco de Vargas
1553.

Vargas' portrait was included in the *Trinity* (*Gloria*) at his own request according to Titian's letter of 10 September 1554 to Charles V (C. and C., 1877, II, p. 508; also Cloulas, 1967, p. 224). The artist suggested that Vargas' head could be painted over, if the Emperor preferred. No further information is forthcoming from the documents, and it is my own opinion that Vargas (Plate 246) may be the dark-bearded man who faces the spectator at the upper left, just at the feet of the Madonna. This head of a man about forty stands out like a portrait, just as the members of the royal family do at the upper right.

A theory that Vargas is to be seen in the guise of Job, the bearded man on the right side at the left of Titian's profile, was advanced a century ago (C. and C., 1877, II, p. 235). Recently this idea was further refined by the modification that Vargas' features were eliminated and replaced by those of Job (von Einem, 1960, p. 90; accepted by Cloulas, 1967, p. 224, note 5). Although absolute proof is wanting, it seems more logical that the bearded man and the woman beside him are intended as Adam and Eve (Wethey, I, 1969, p. 165). Panofsky appears to have accepted the identification as Job but not to have seen a portrait here (1969, p. 66, note 21).

Aretino's letter of October and November 1553 refers to Titian's portrait of Vargas and contains also the writer's sonnet dedicated to it (Aretino, *Lettere*, edition 1957, II, pp. 433, 435). It would seem that Aretino refers to an individual portrait of Vargas rather than to his inclusion in heaven in the *Trinity*. Crowe and Cavalcaselle held the same opinion (1877, II, p. 227).

Biography: Francisco de Vargas (*c.* 1500–1566), born either at Toledo or Madrid, had an important role as a Spanish representative at the Council of Trent. From 1552 to 1558 he held the post of ambassador at Venice, followed by an assignment to Flanders in 1559, and shortly afterwards was appointed Spanish ambassador to the Holy See, 1559–1563. He was said to be a learned man of lofty spirit, well versed in theology and canon law, and interested in history and antiquity. He returned to Spain in December 1563, retiring soon thereafter to the Jeronymite monastery of La Sisla near Toledo, where he died and was interred in 1566 (Constant, 1909, pp. 359-385).

ADDENDUM

L–35. Alvise Morosini
1561.
A receipt dated 6 December 1561 acknowledged the payment of 350 ducats for the portrait. This item was called to my attention by Charles Hope. *Bibliography:* Ammann, 1962, no. 559, p. 297, lot 611.

PLATES

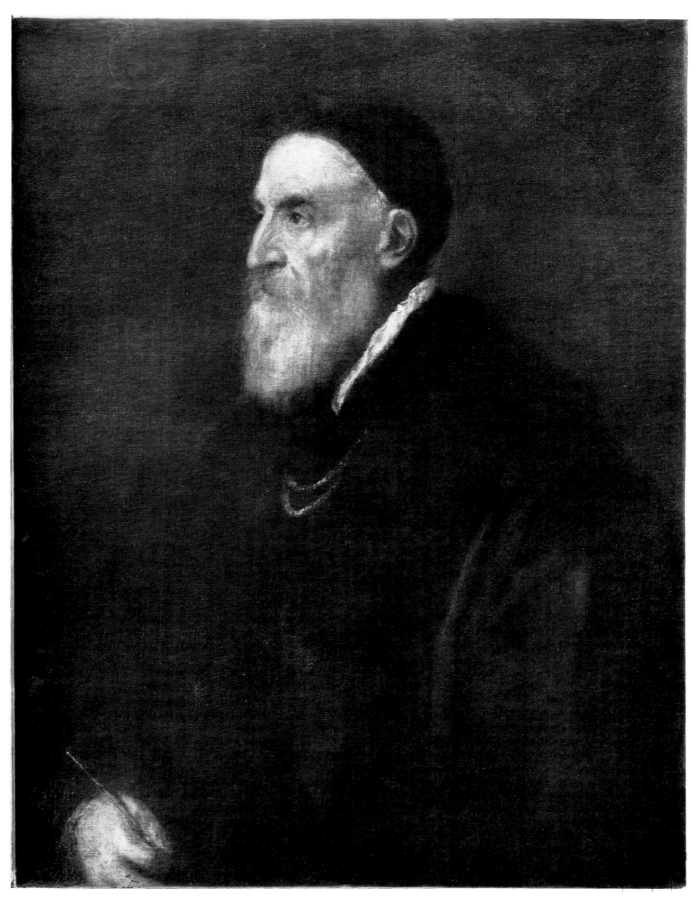

1. Titian: *Self-Portrait*. About 1565–1570. Madrid, Prado Museum (Cat. no. 105)

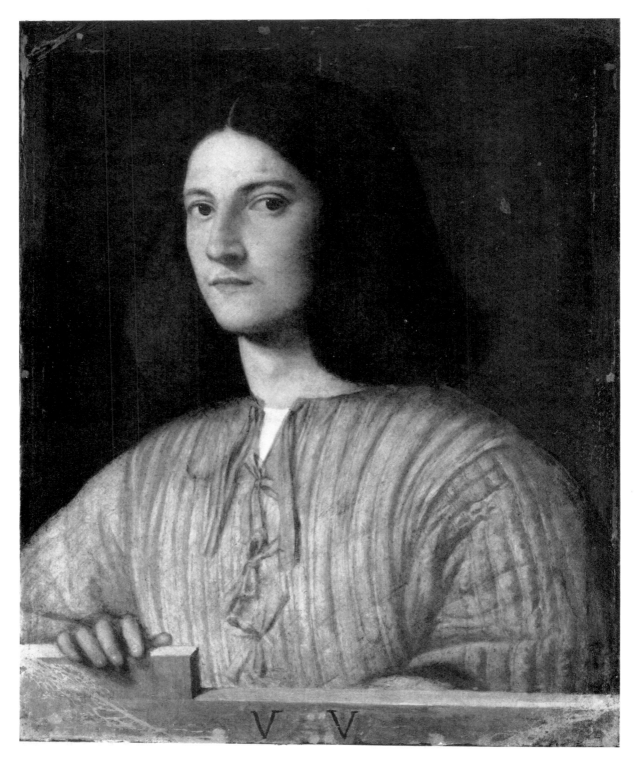

2. Giorgione: *Youth*. About 1504–1506. Berlin–Dahlem, Staatliche Gemäldegalerie

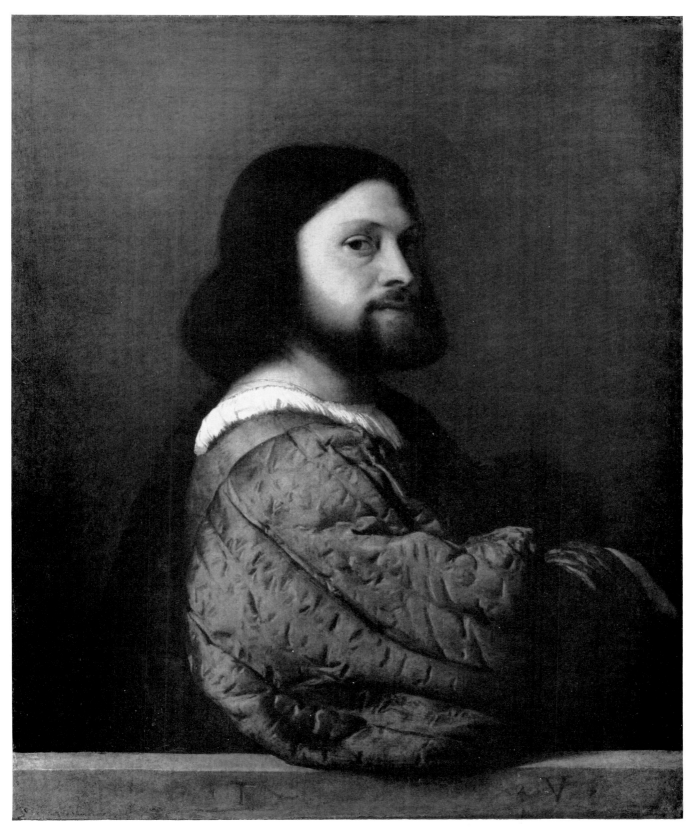

3. Titian: *Gentleman in Blue* (so-called *Ariosto*). About 1512. London, National Gallery (Cat. no. 40)

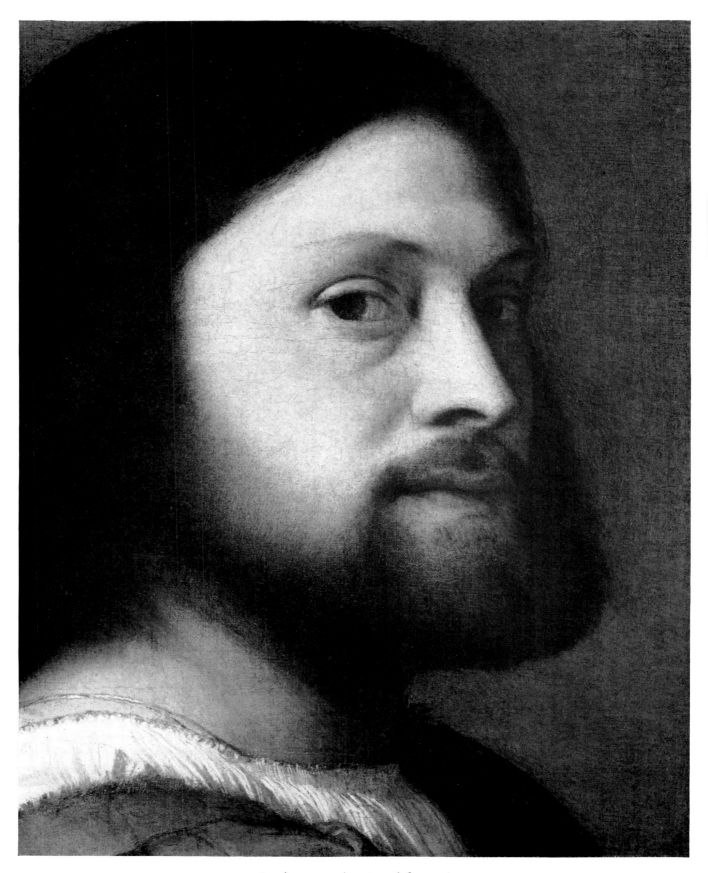

4. *Gentleman in Blue*. Detail from Plate 3

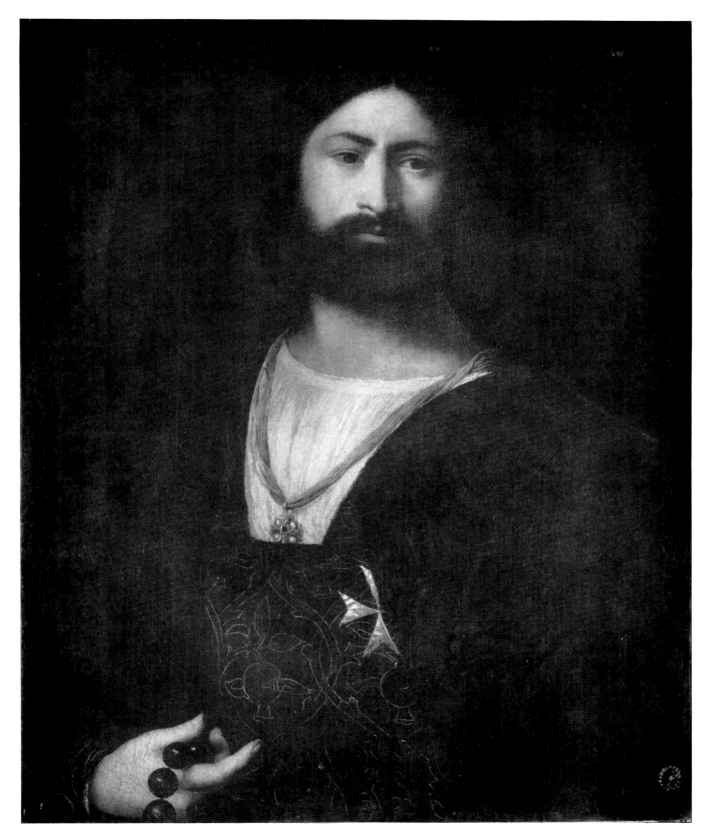

5. Titian (?): *Knight of Malta*. About 1510. Florence, Uffizi (Cat. no. 56)

Jesus

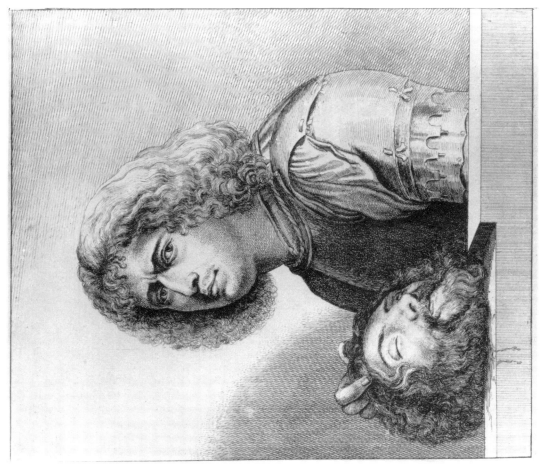

7. Hollar engraving after Giorgione's *Self-Portrait as David*. London, British Museum

6. Giorgione: *Self-Portrait*. About 1510. Brunswick, Museum

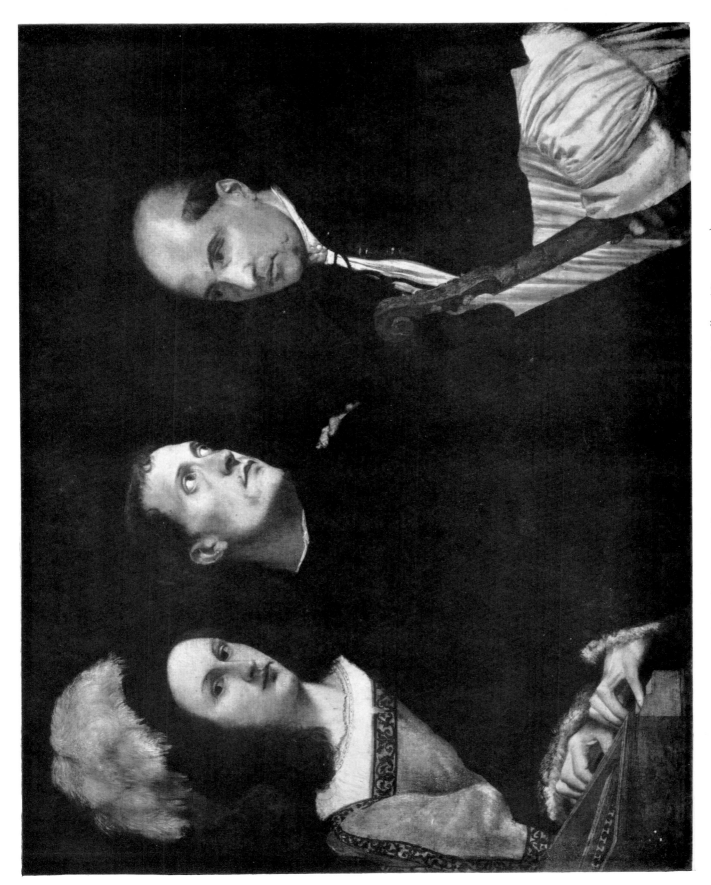

8. Titian: *The Concert.* About 1510–1512. Florence, Pitti Gallery (Cat. no. 23)

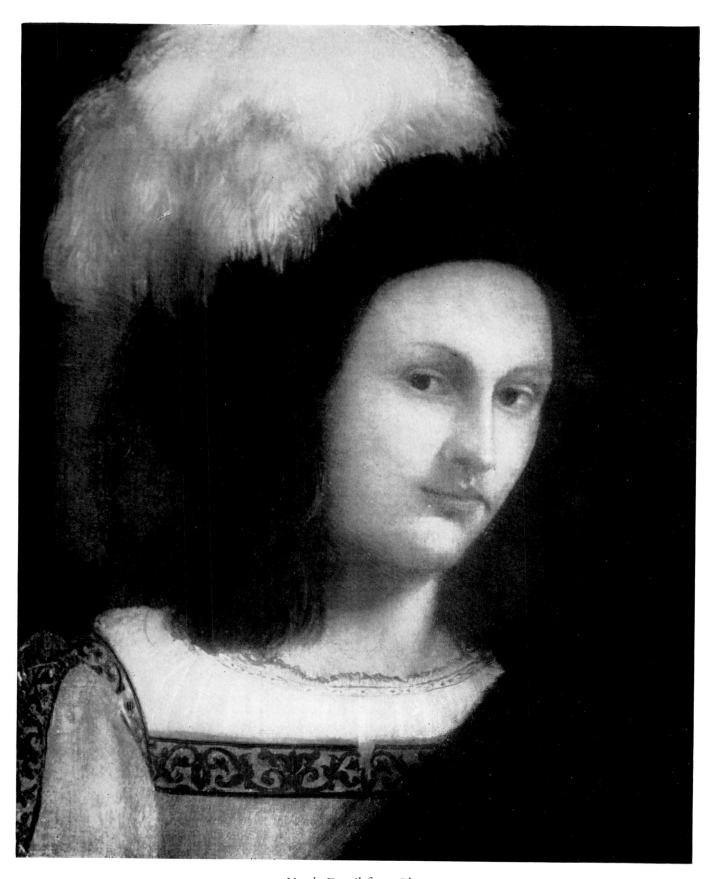

9. *Youth*. Detail from Plate 8

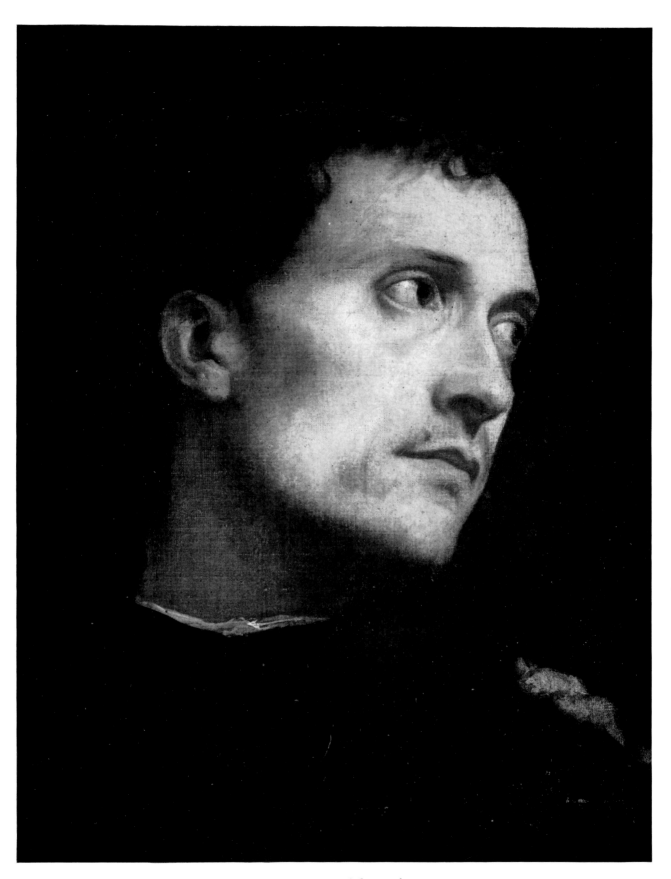

10. *Musician*. Detail from Plate 8

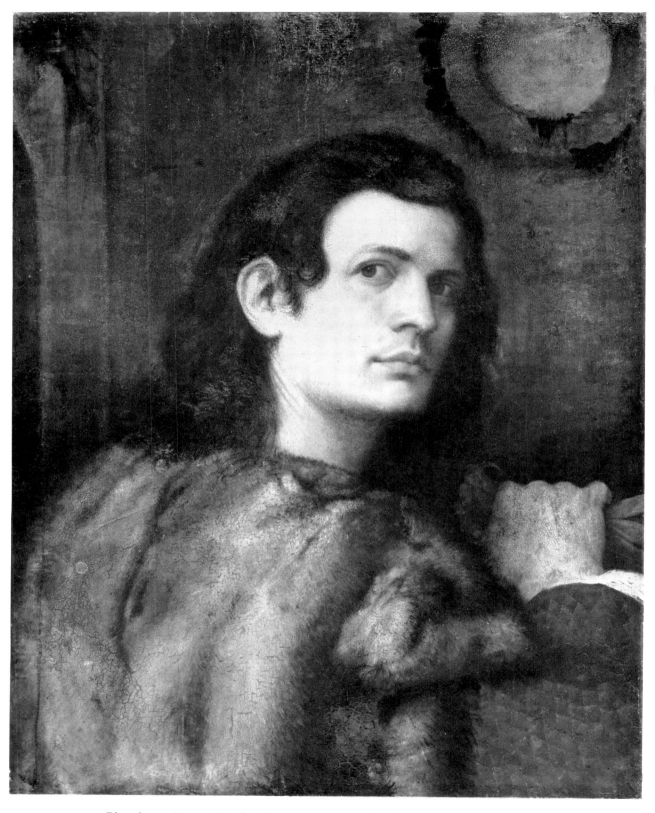

11. Giorgione: *Fugger Youth*. About 1510. Munich, Alte Pinakothek (Cat. no. X–42)

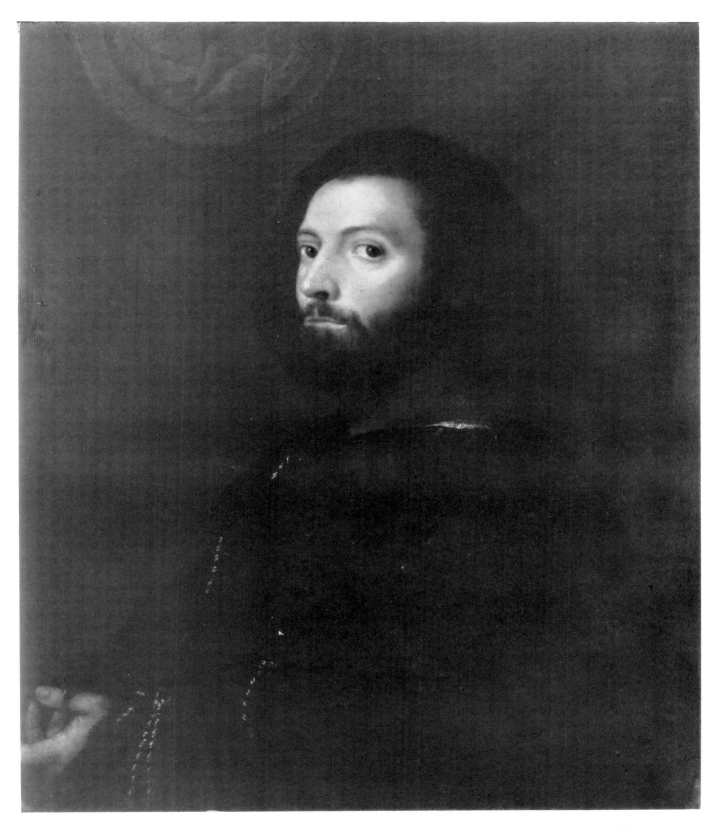

12. Titian: *Gentleman with Flashing Eyes*. About 1512. Ickworth, Bury St. Edmunds, National Trust
(Cat. no. 41)

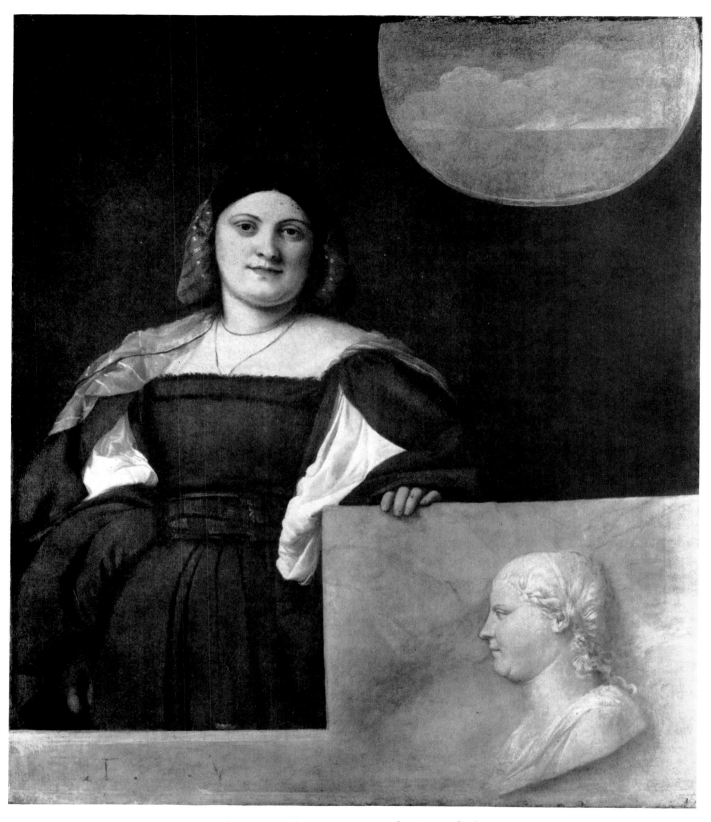

13. Titian: *La Schiavona*. During cleaning; cf. Plate 14

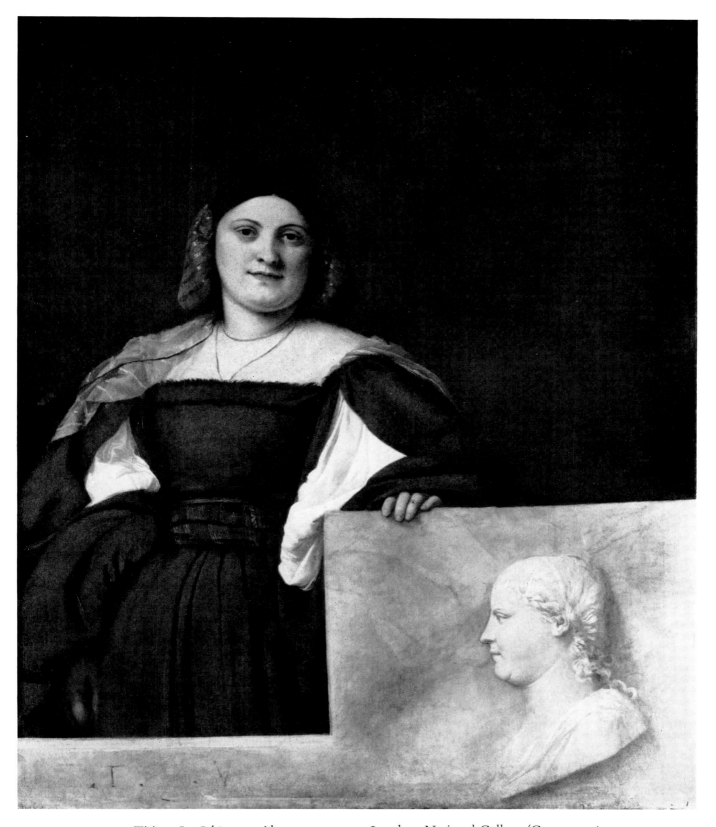

14. Titian: *La Schiavona*. About 1511–1512. London, National Gallery (Cat. no. 95)

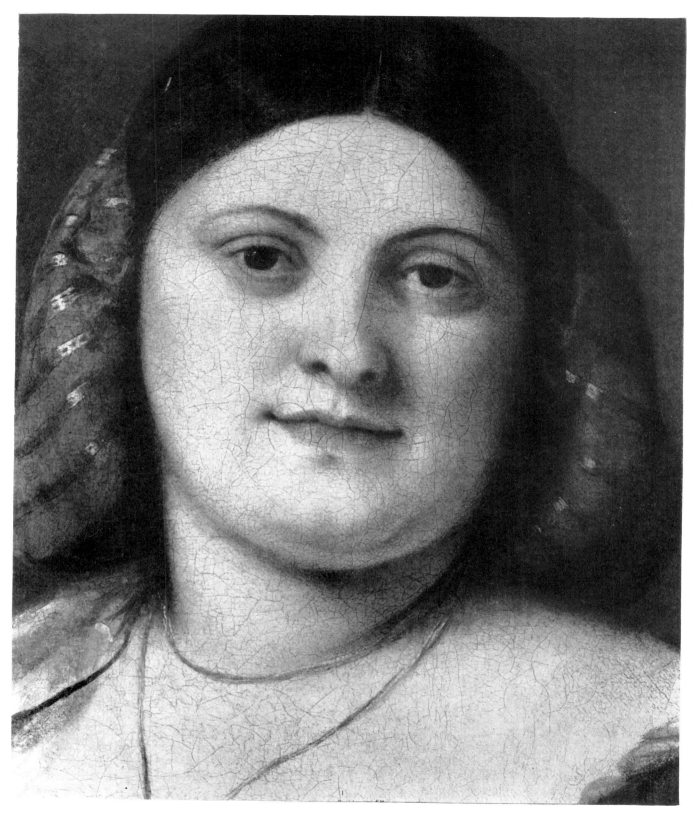

15. *Head of La Schiavona*. Detail from Plate 14

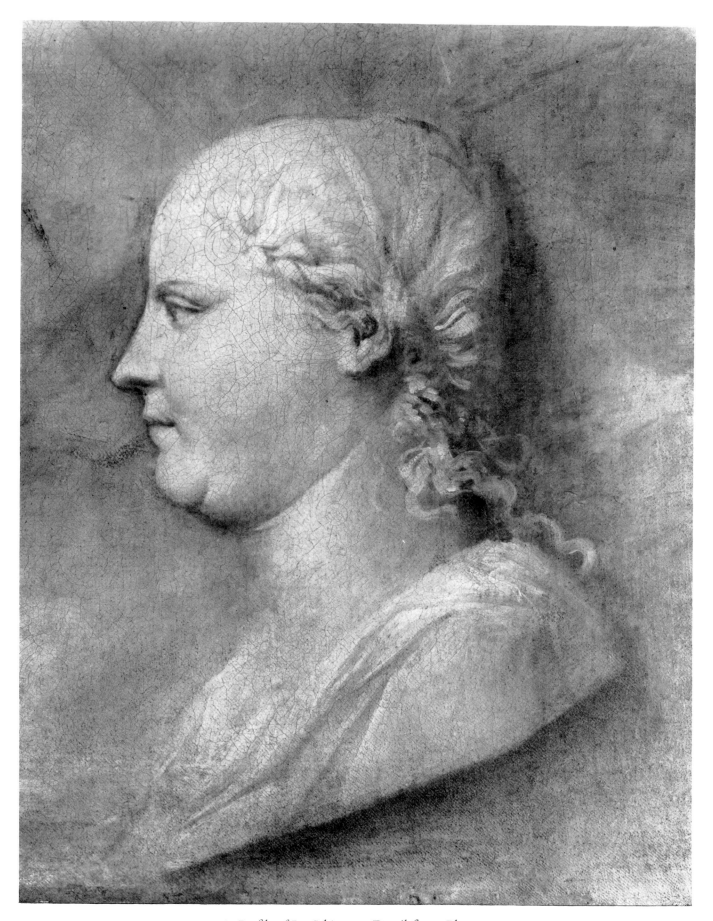

16. *Profile of La Schiavona*. Detail from Plate 14

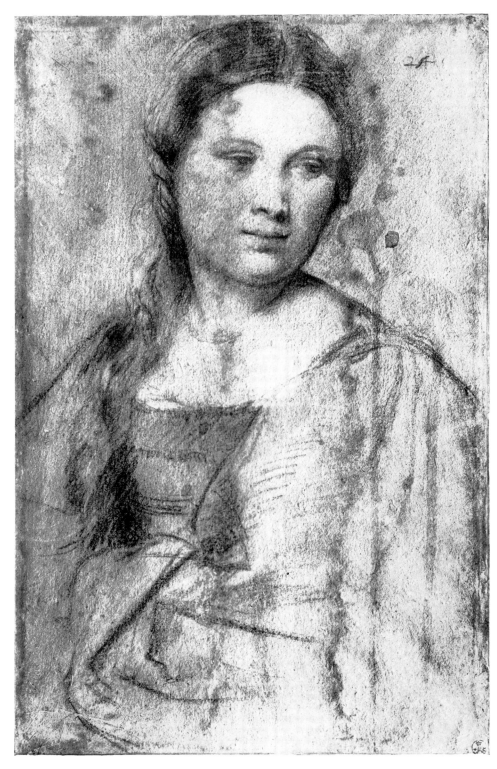

17. Titian: *Young Lady* (drawing). About 1512. Florence, Uffizi (Cat. no. 114)

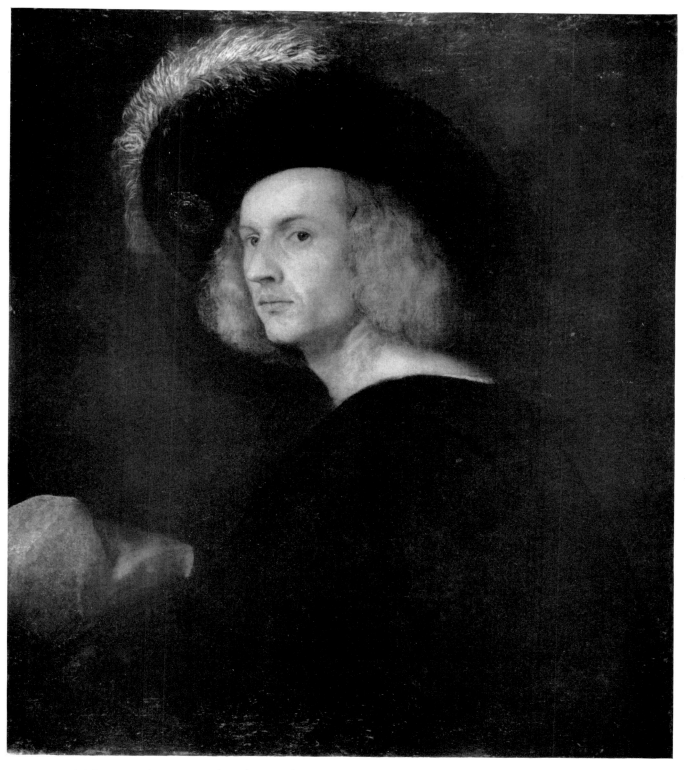

18. Titian: *Gentleman in a Plumed Hat*. About 1515. Petworth House, on loan from H.M. Treasury
(Cat. no. 42)

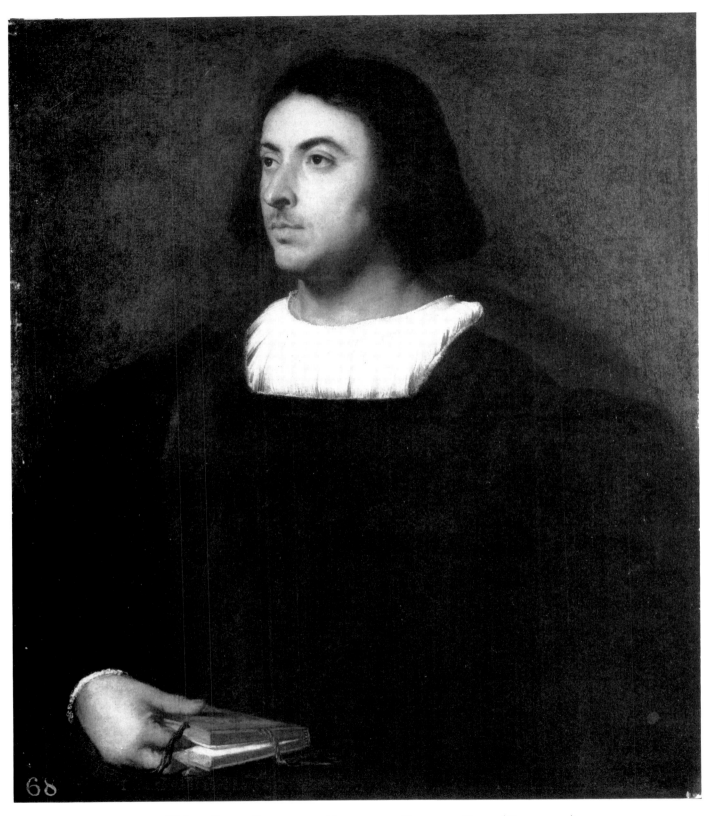

19. Titian: *Jacopo Sannazzaro*. About 1512. Hampton Court (Cat. no. 93)

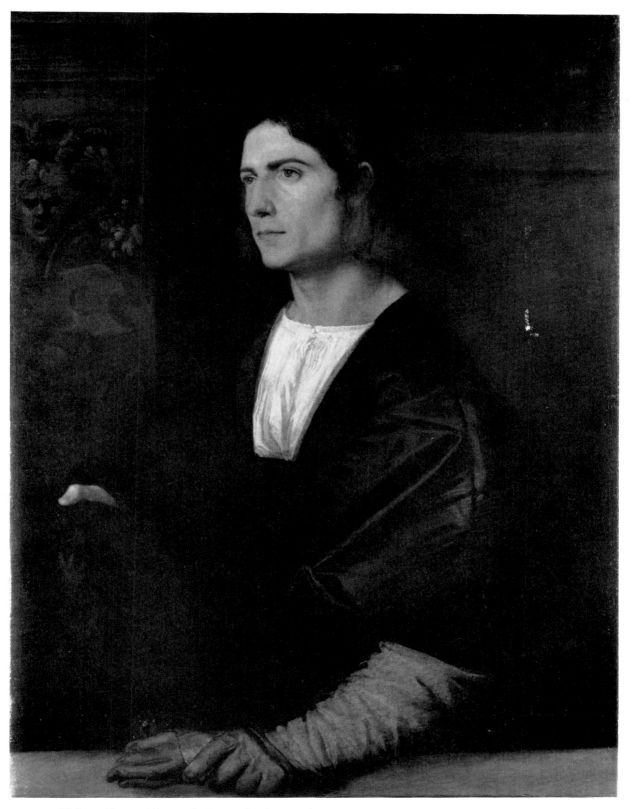

20. Titian: *Young Man with Cap and Gloves*. About 1512–1515. Garrowby Hall, Earl of Halifax
(Cat. no. 115)

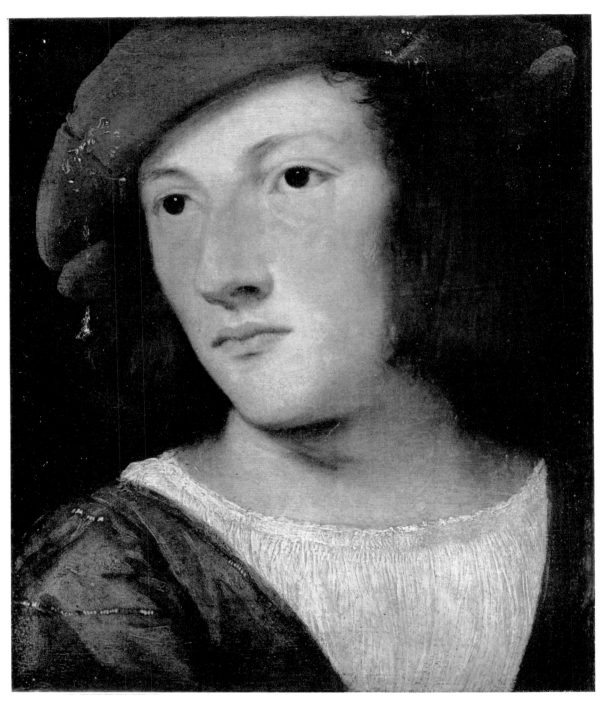

21. Titian: *Young Man in a Red Cap*. 1516. Frankfurt, Städelsches Institut (Cat. no. 117)

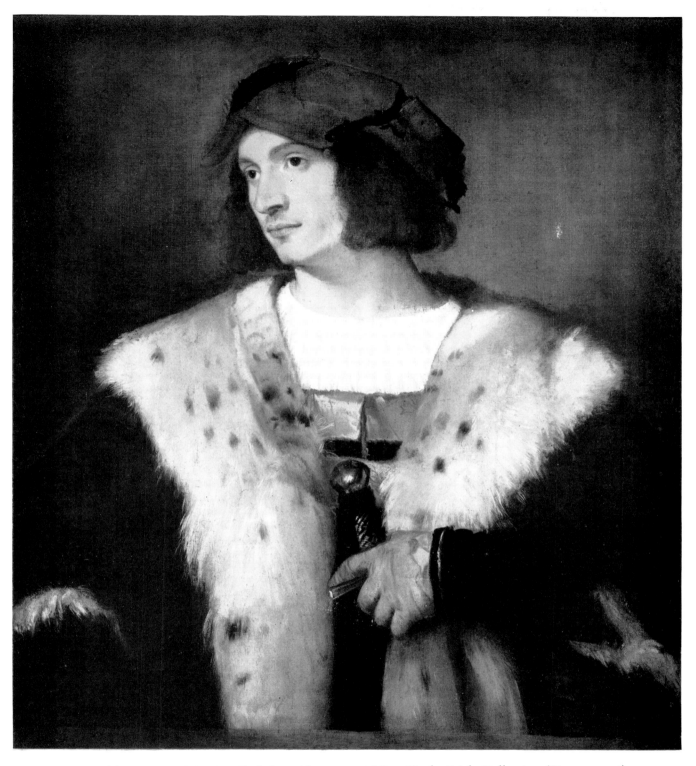

22. Titian: *Young Man in a Red Cap*. About 1516. New York, Frick Collection (Cat. no. 116)

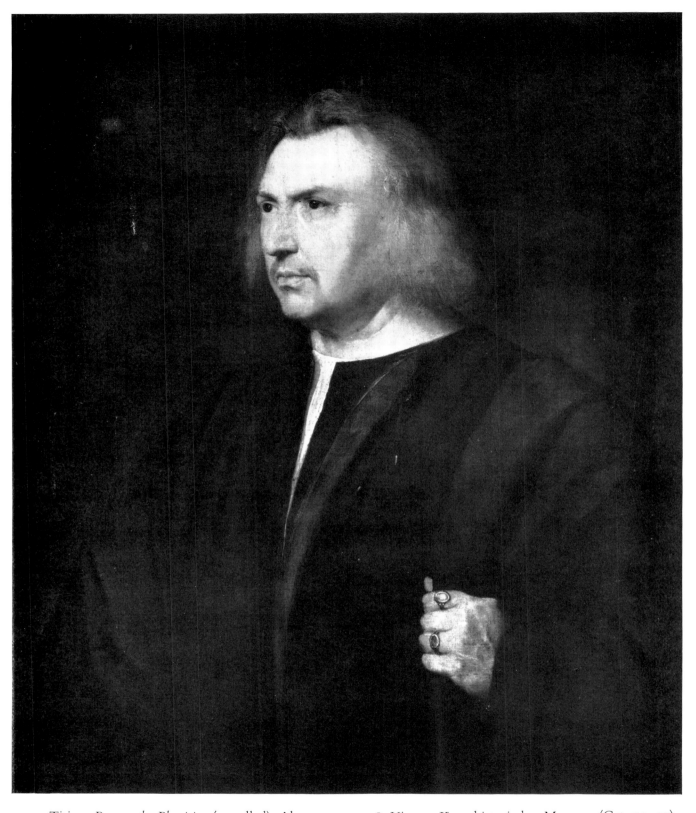

23. Titian: *Parma, the Physician* (so-called). About 1515–1518. Vienna, Kunsthistorisches Museum (Cat. no. 70)

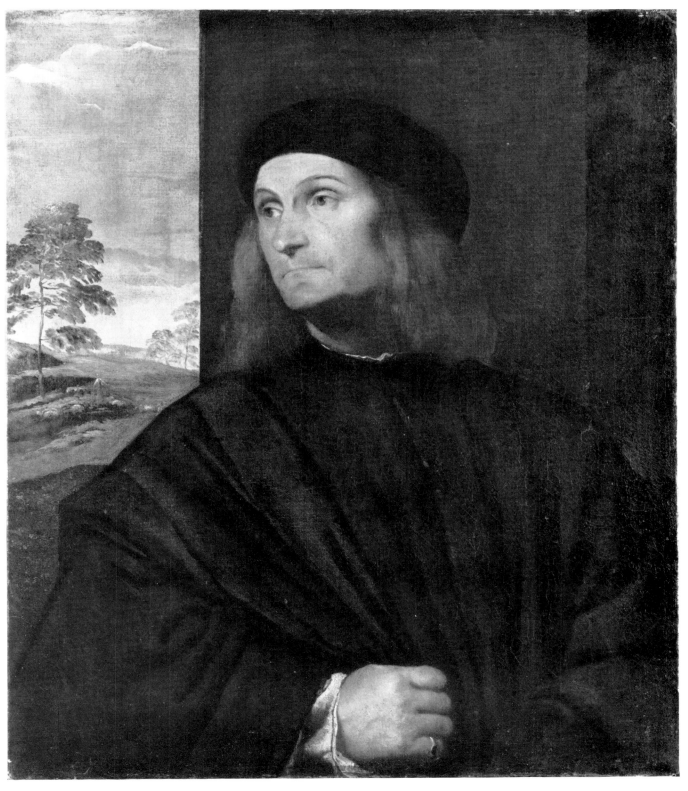

24. Titian: *Gentleman in a Black Beret*. About 1515–1518. Copenhagen, Royal Museum of Fine Arts
(Cat. no. 43)

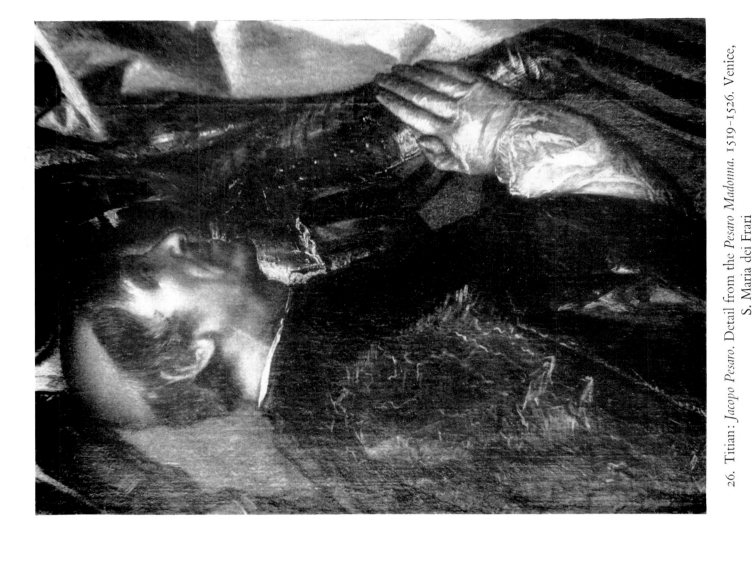

26. Titian: *Jacopo Pesaro*. Detail from the *Pesaro Madonna*. 1519–1526. Venice, S. Maria dei Frari

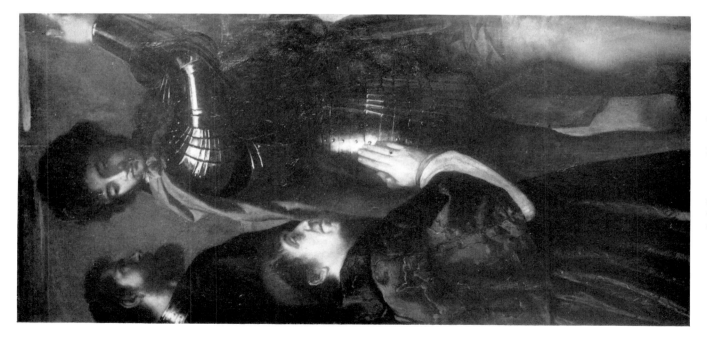

25. Titian: *Altobello Averoldo and Patron Saints*. Detail from the *Resurrection Altarpiece*. 1522. Brescia, SS. Nazaro e Celso

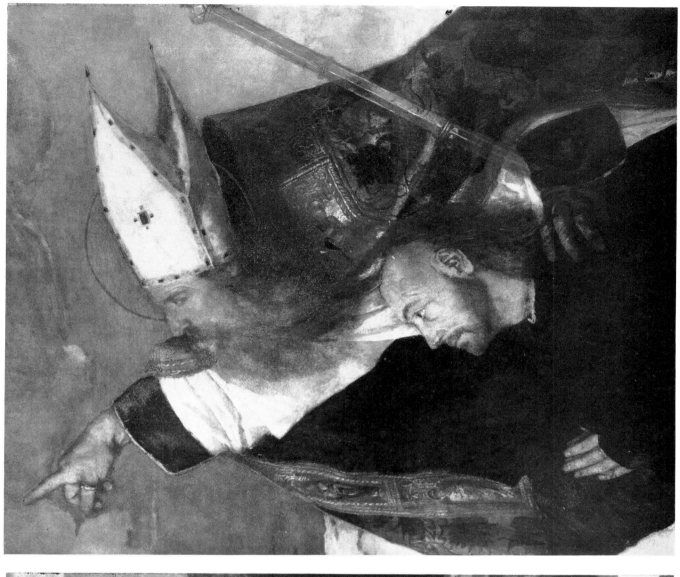

28. Titian: *Alvise Gozzi and St. Aloysius*. Detail from *Madonna and Saints*. 1520.
Ancona, Museo Civico

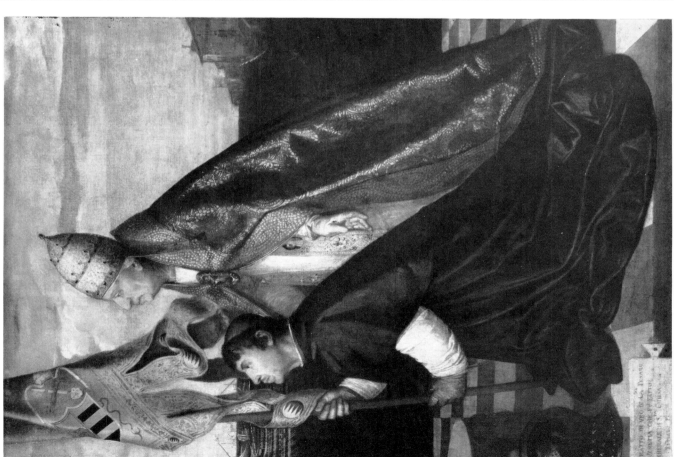

27. Titian: *Alexander VI and Jacopo Pesaro*. Detail from *St. Peter Enthroned*.
About 1512. Antwerp, Musée des Beaux–Arts

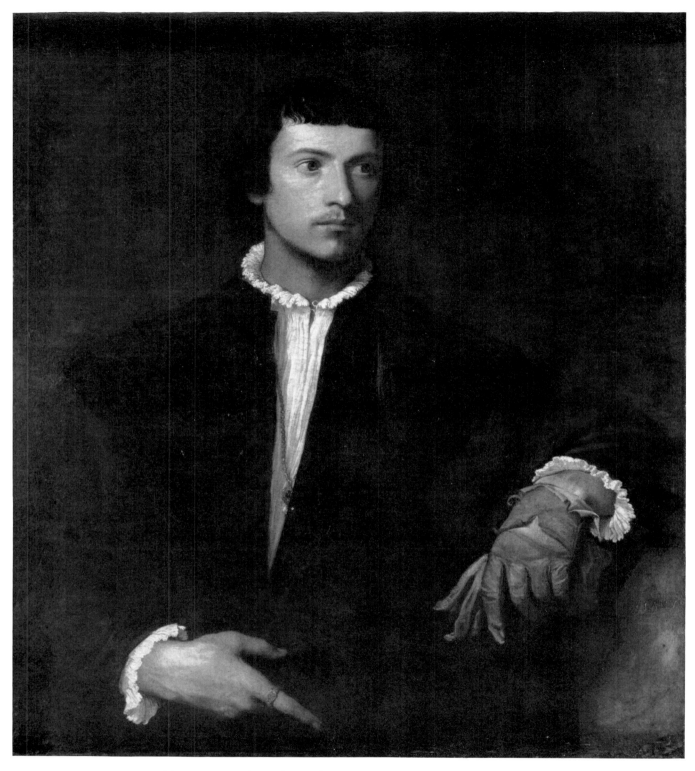

29. Titian: *Man with a Glove*. About 1520–1522. Paris, Louvre (Cat. no. 64)

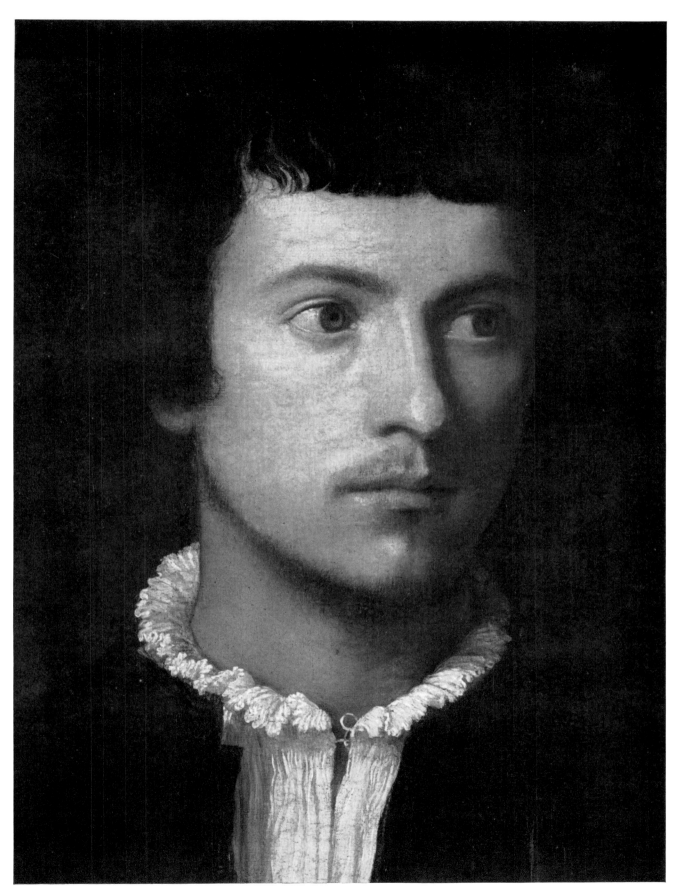

30. *Man with a Glove*. Detail from Plate 29

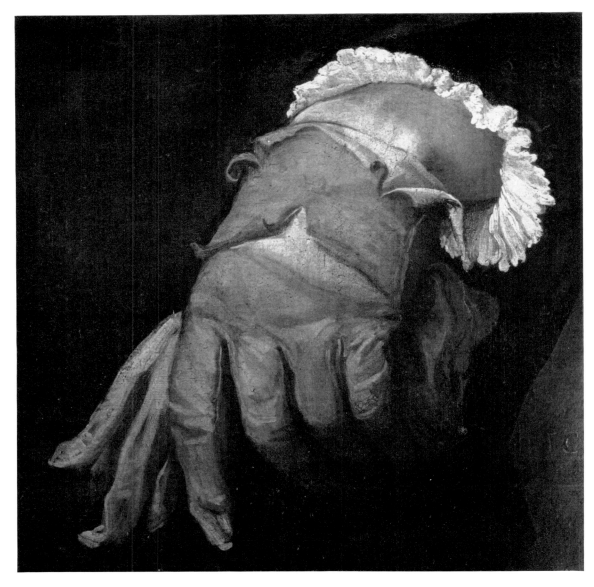

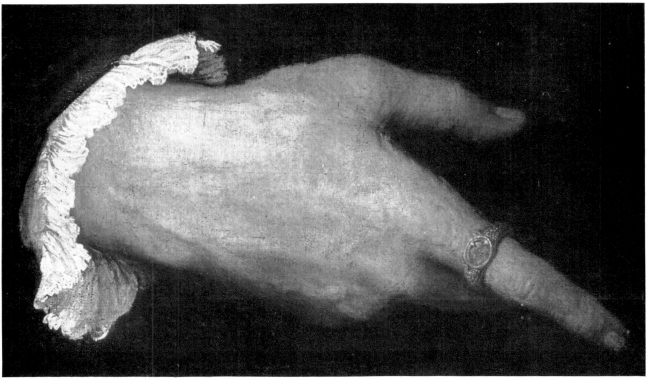

31–32. *Man with a Glove*. Details from Plate 29

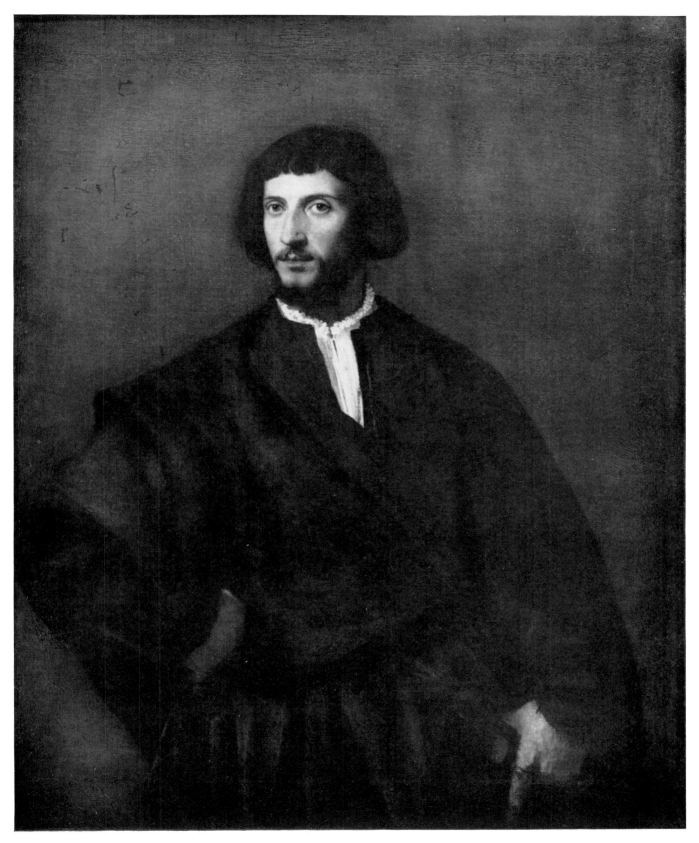

33. Titian: *Gentleman*. About 1520–1522. Paris, Louvre (Cat. no. 44)

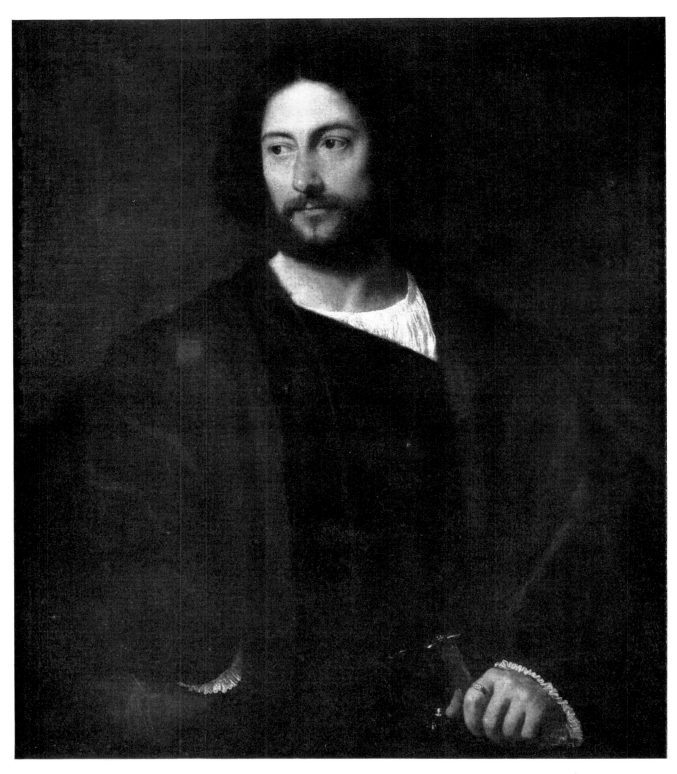

34. Titian: *Gentleman*. About 1520–1522. Munich, Alte Pinakothek (Cat. no. 45)

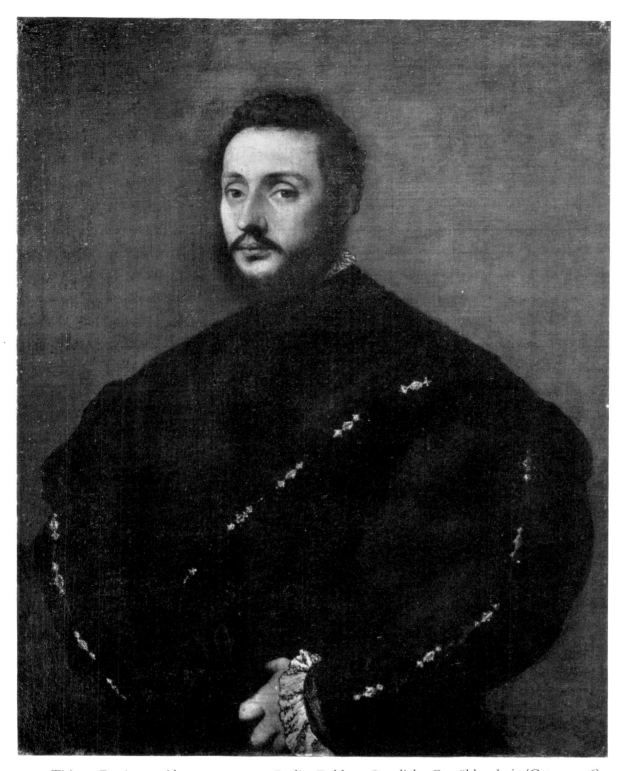

35. Titian: *Gentleman*. About 1525–1530. Berlin–Dahlem, Staatliche Gemäldegalerie (Cat. no. 46)

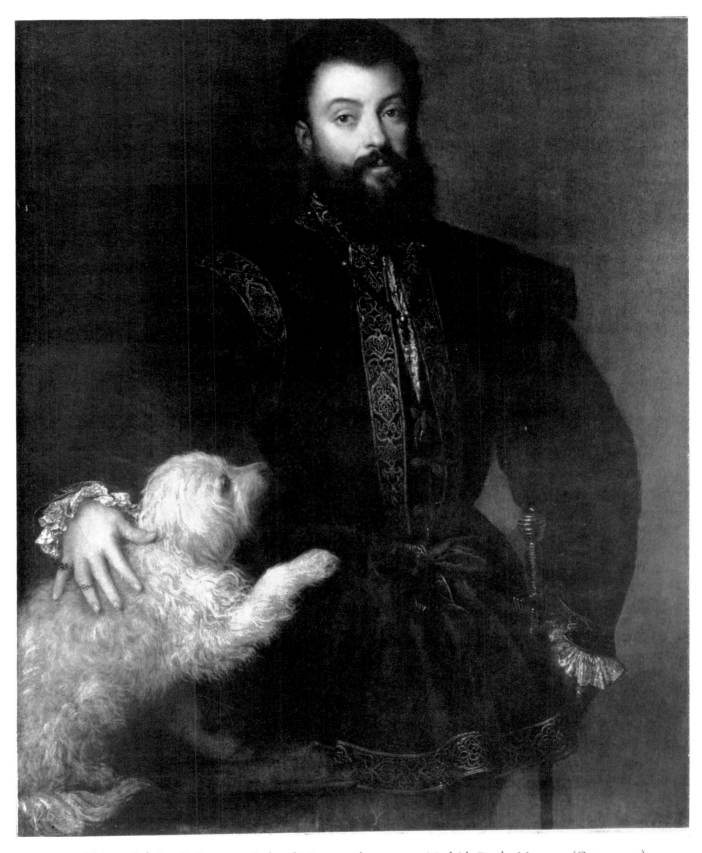

36. Titian: *Federico II Gonzaga, Duke of Mantua*. About 1523. Madrid, Prado Museum (Cat. no. 49)

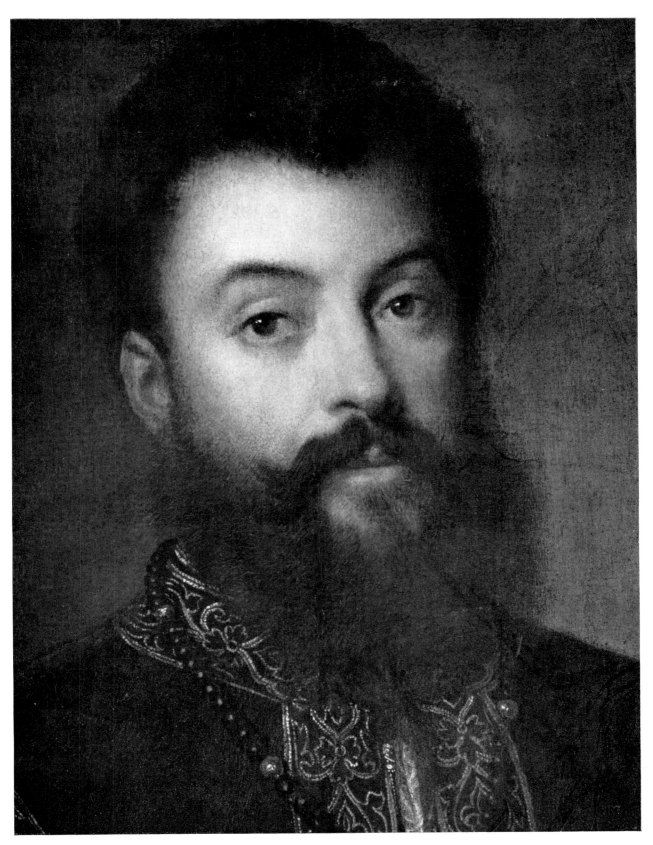

37. *Federico II Gonzaga*. Detail from Plate 36

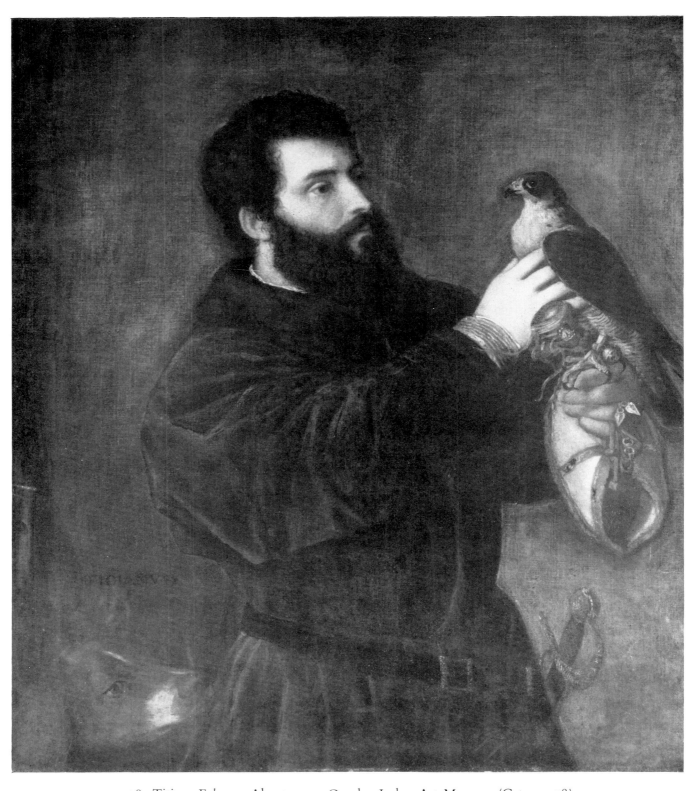

38. Titian: *Falconer*. About 1520. Omaha, Joslyn Art Museum (Cat. no. 28)

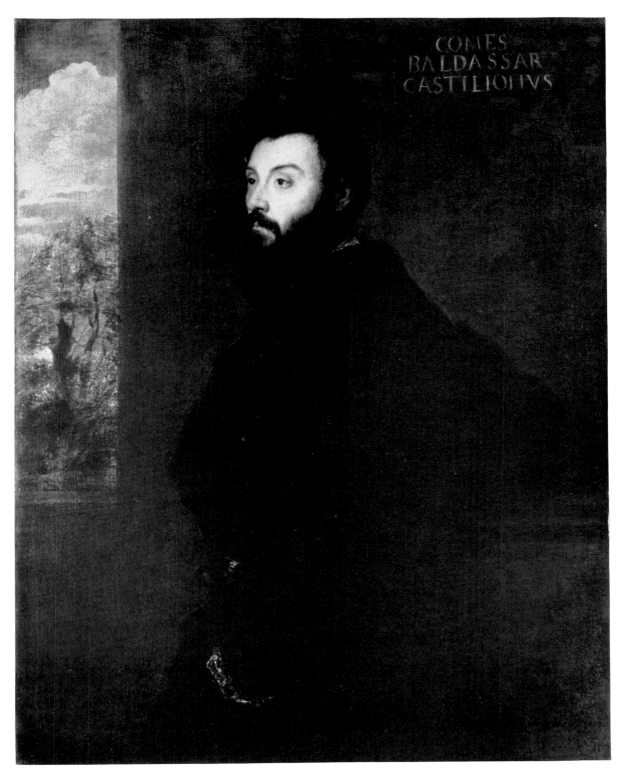

39. Titian: *Baldassare Castiglione*. 1523. Dublin, National Gallery of Ireland (Cat. no. 19)

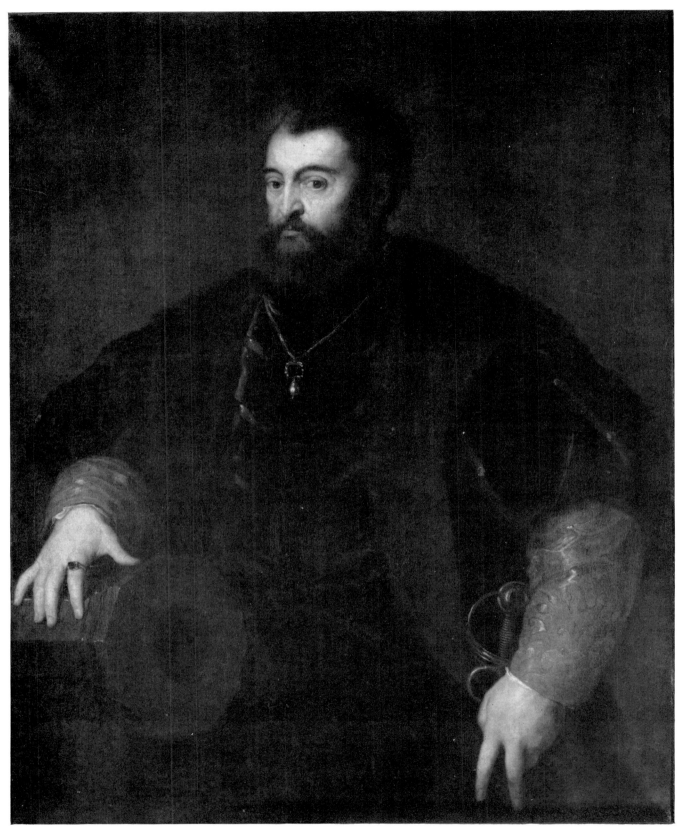

40. Titian: *Alfonso I d'Este, Marquess and Duke of Ferrara*. About 1523–1525. New York, Metropolitan Museum of Art (Cat. no. 26)

Sir Francis Beacon

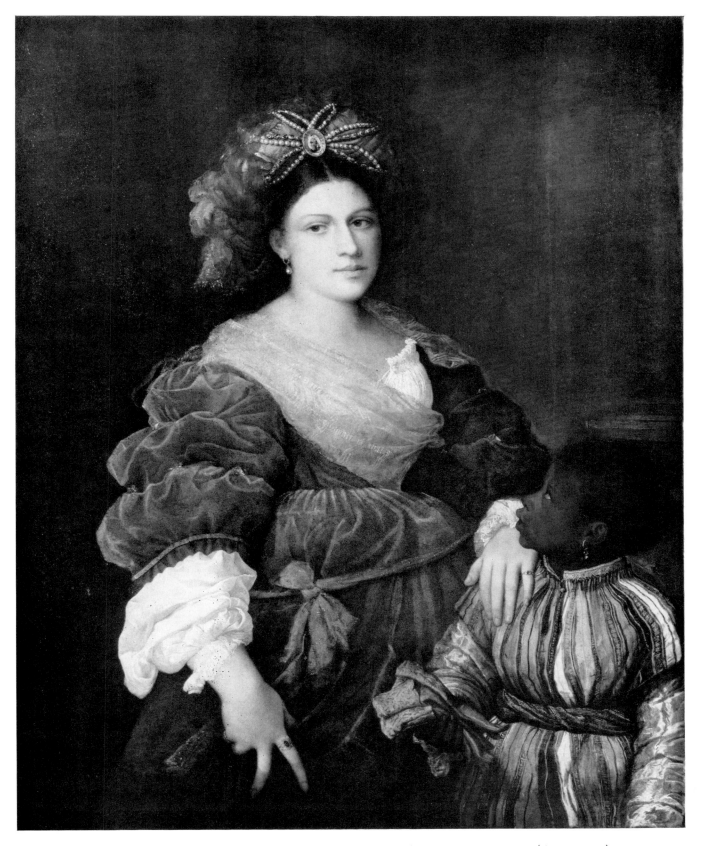

41. Titian: *Laura dei Dianti*. About 1523–1525. Kreuzlingen, Heinz Kisters (Cat. no. 24)

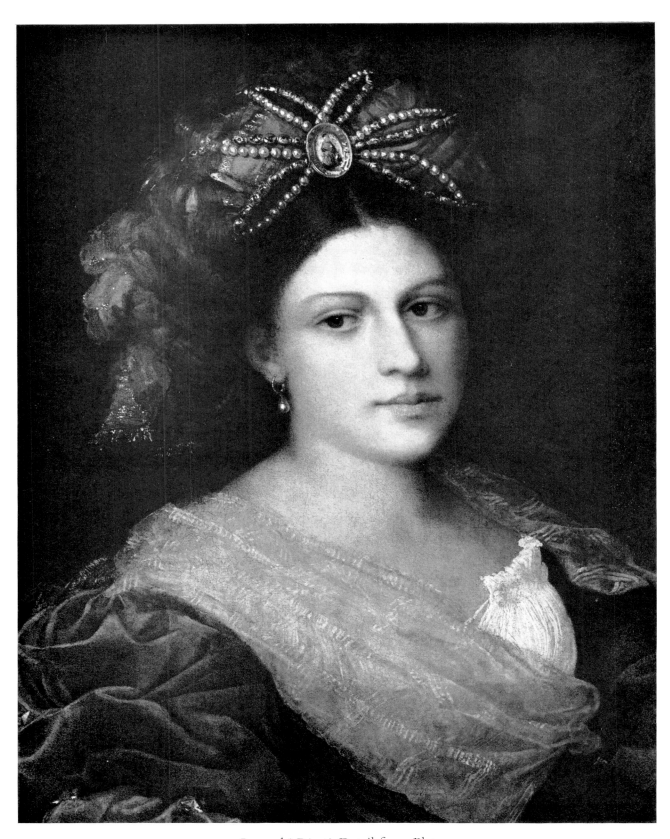

42. *Laura dei Dianti*. Detail from Plate 41

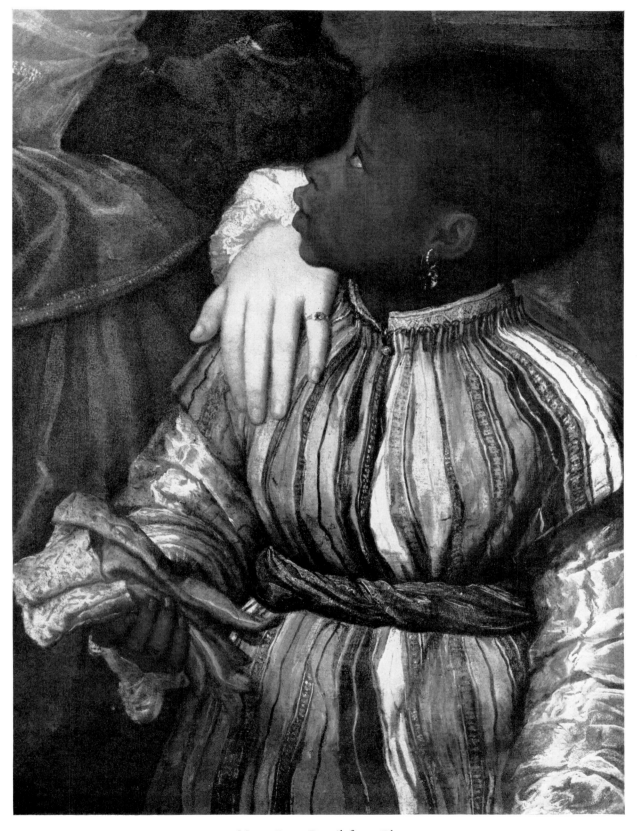

43. *Negro Page*. Detail from Plate 41

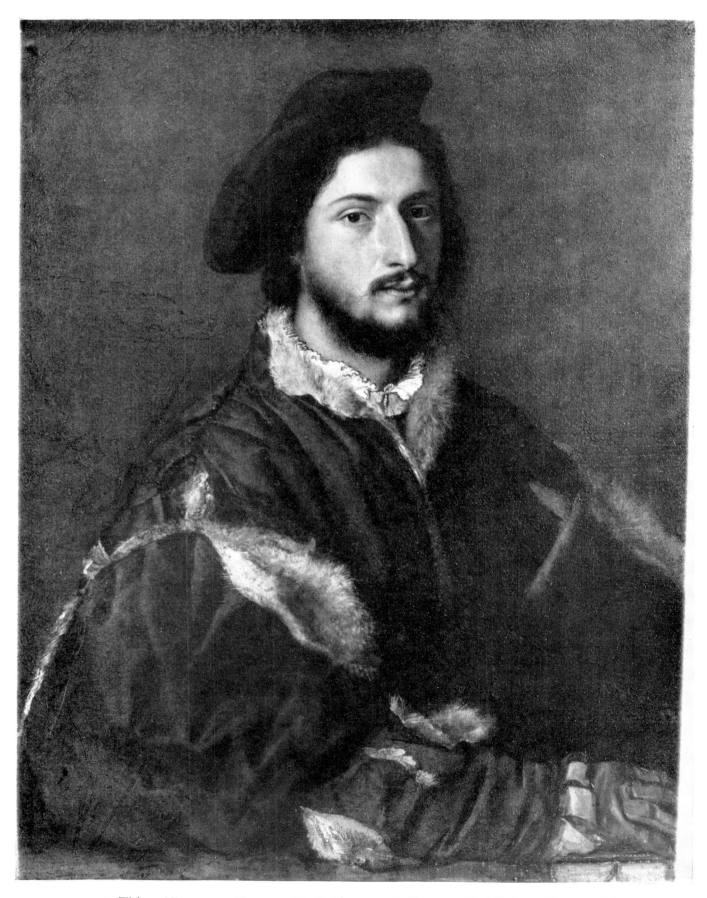

44. Titian: *Vincenzo or Tommaso Mosti*. About 1526. Florence, Pitti Gallery (Cat. no. 67)

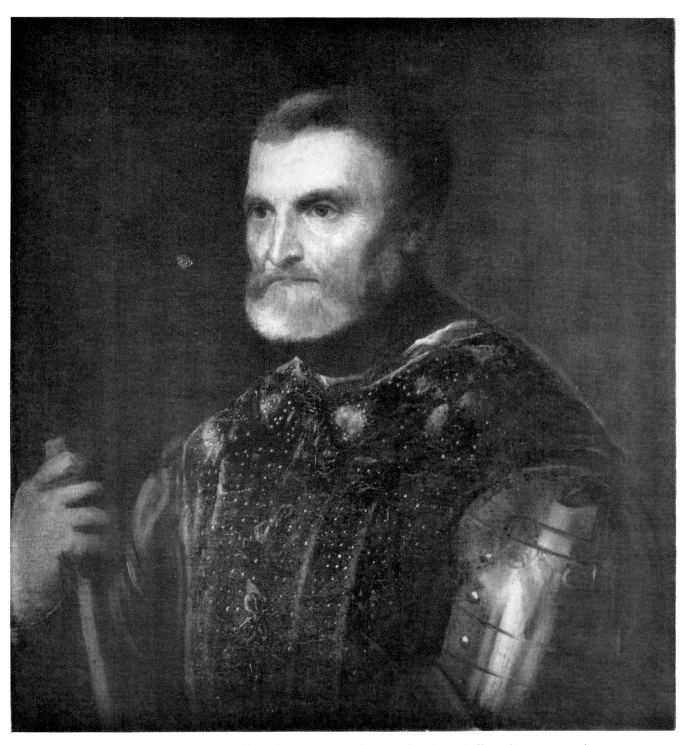

45. Titian: *Gregorio Vecellio*. About 1530. Milan, Ambrosiana Gallery (Cat. no. 109)

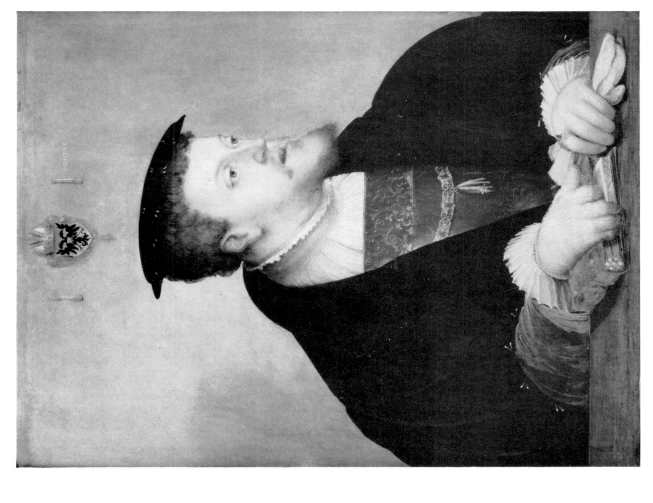

47. Christoph Amberger: *Charles V*. 1532. Berlin–Dahlem,
Staatliche Gemäldegalerie

46. Barthel Beham: *Charles V* (engraving). 1531. Madrid,
Biblioteca Nacional

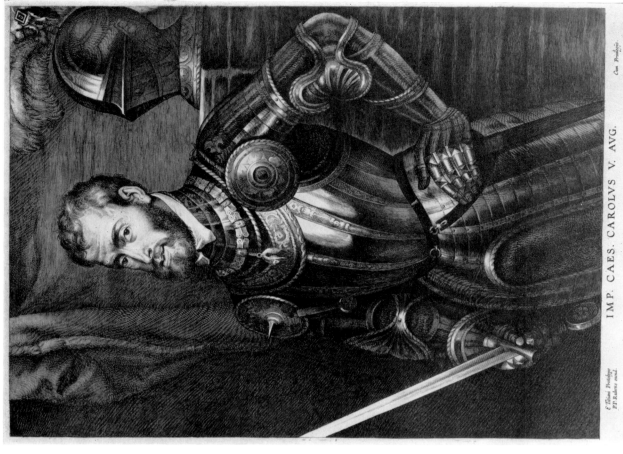

IMP. CAES. CAROLVS V. AVG.

E Titiani Prototypo
P.P. Rubens excud.

Cum Privilegijs.

49. Vorsterman's engraving after Rubens: *Charles V with Drawn Sword.*
Amsterdam, Rijksmuseum

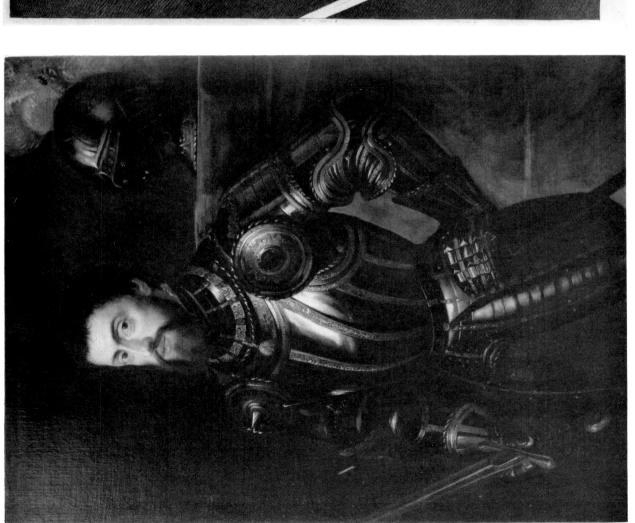

48. Rubens after Titian: *Charles V with Drawn Sword.* 1603. England,
Private Collection (Cat. no. L–3, copy 1)

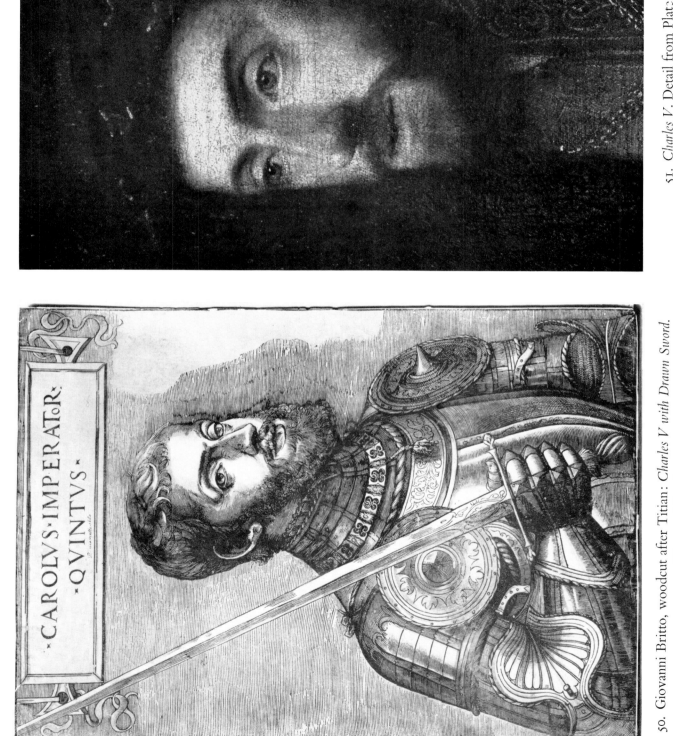

50. Giovanni Britto, woodcut after Titian: *Charles V with Drawn Sword.*
Vienna, Albertina

51. *Charles V.* Detail from Plate 55

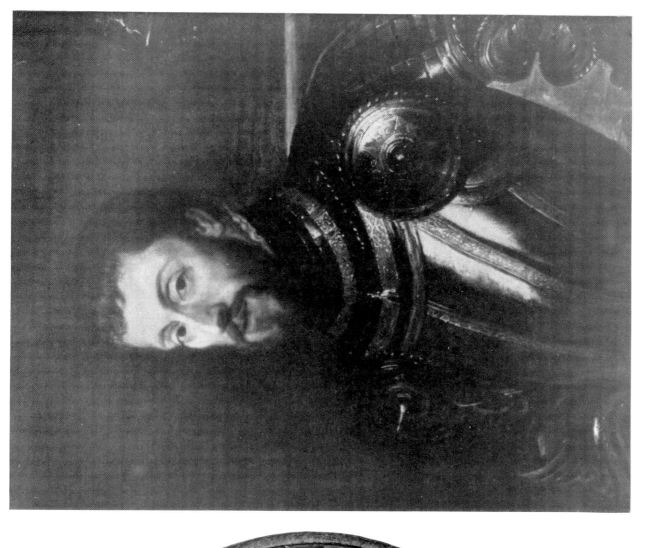

53. Rubens after Titian: *Charles V with Drawn Sword*. 1628. Unknown location (Cat. no. L–3, copy 3)

52. Alfonso Lombardi: *Charles V*. 1533. Geneva, Erich Lederer

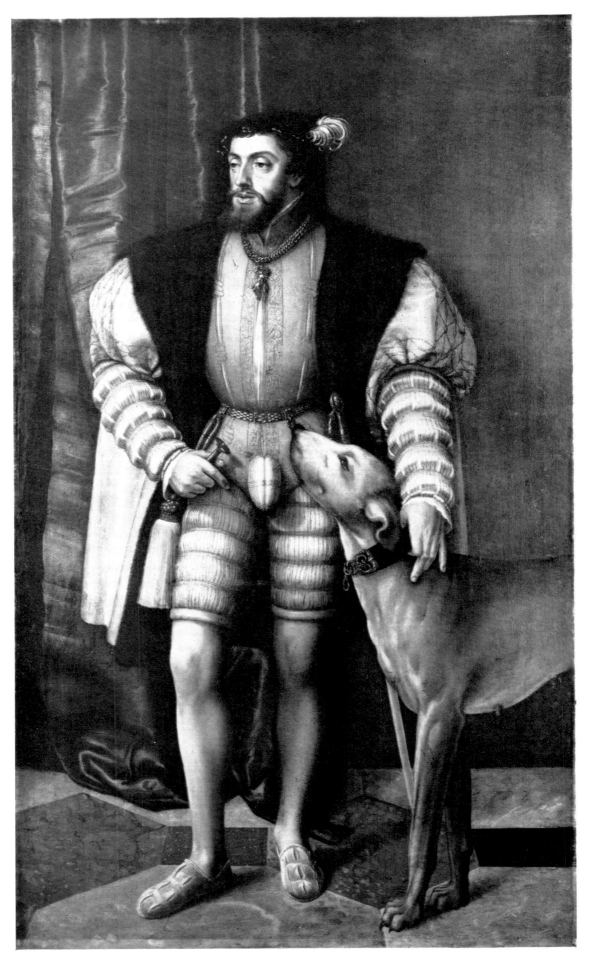

54. Jacob Seisenegger: *Charles V with Hound*. 1532. Vienna, Kunsthistorisches Museum

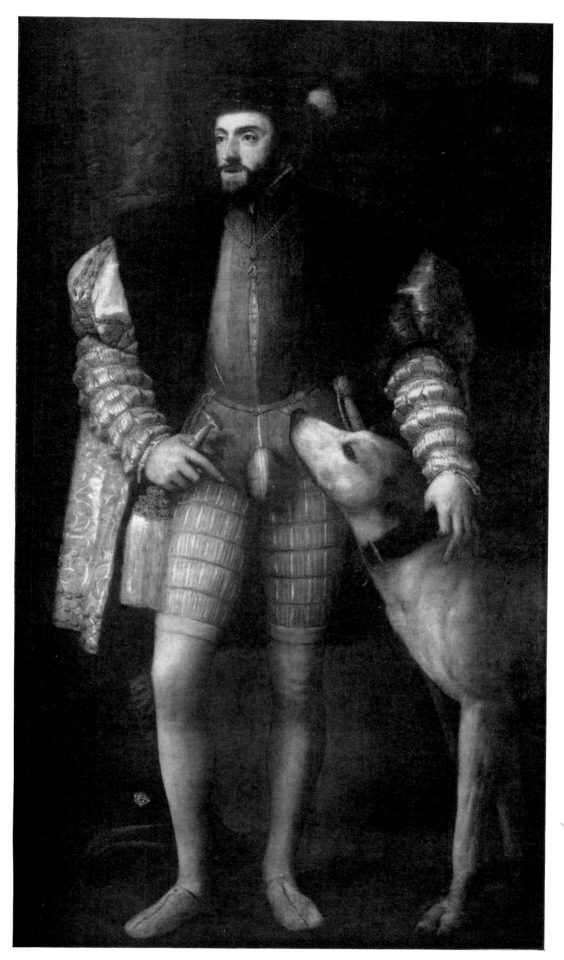

55. Titian: *Charles V with Hound*. 1533. Madrid, Prado Museum (Cat. no. 20)

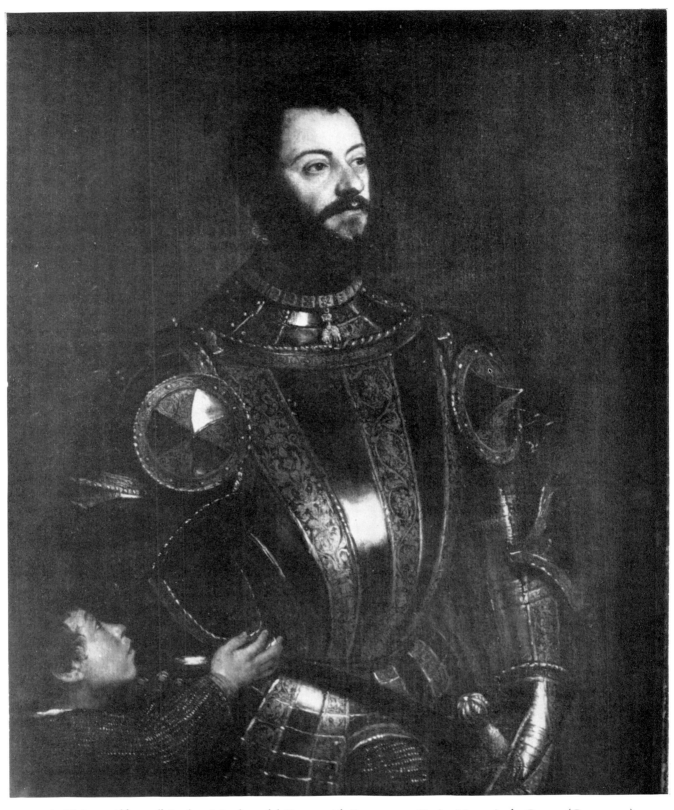

56. Titian: *Alfonso d'Avalos, Marchese del Vasto, with Page*. 1533. Paris, Marquis de Ganay (Cat. no. 9)

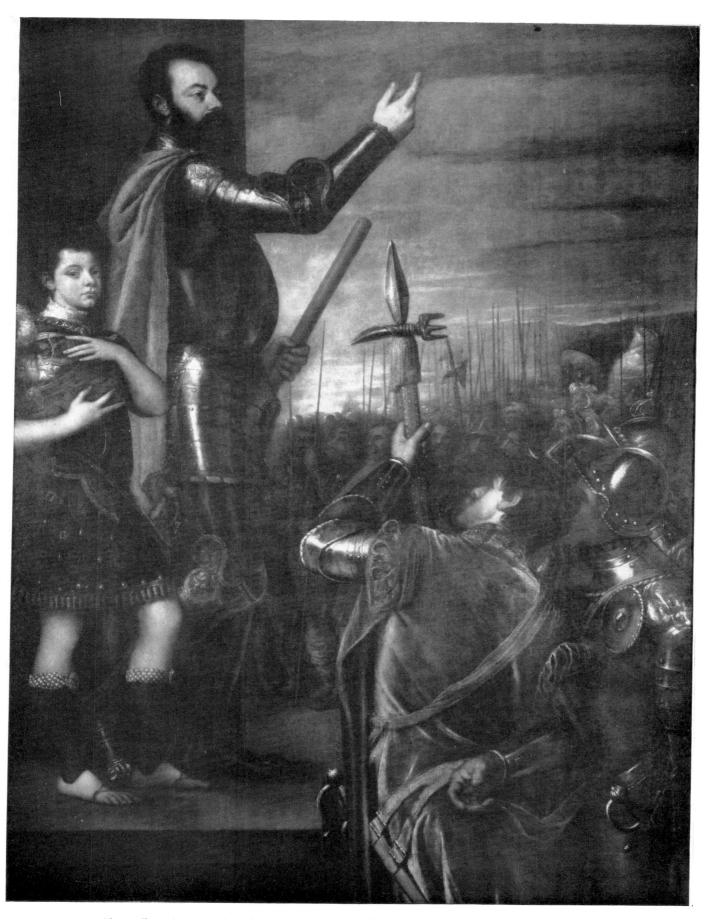

57. Titian: *Alfonso d'Avalos, Marchese del Vasto, Allocution of.* 1539–1541. Madrid, Prado Museum (Cat. no. 10)

59. *Alfonso d'Avalos*. From Titian's *Christ Before Pilate*. 1543. Vienna, Kunsthistorisches Museum

58. *Alfonso d'Avalos*. Detail from Plate 57

60. Titian: *Diego Hurtado de Mendoza* (wrongly called).
About 1530–1535. Florence, Pitti Gallery (Cat. no. 52)

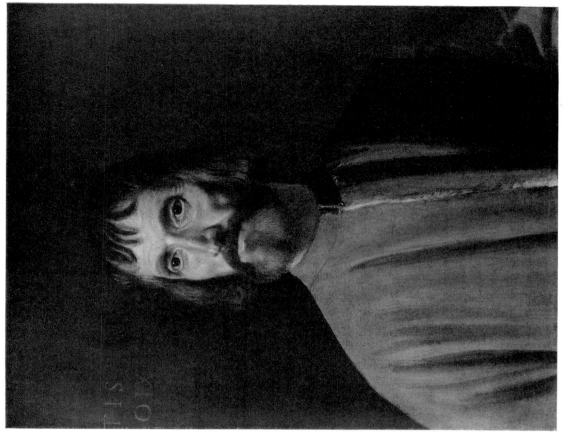

61. Workshop of Titian: *Andrea dei Franceschi*. About 1532.
Washington, National Gallery of Art, Mellon Collection
(Cat. no. 35)

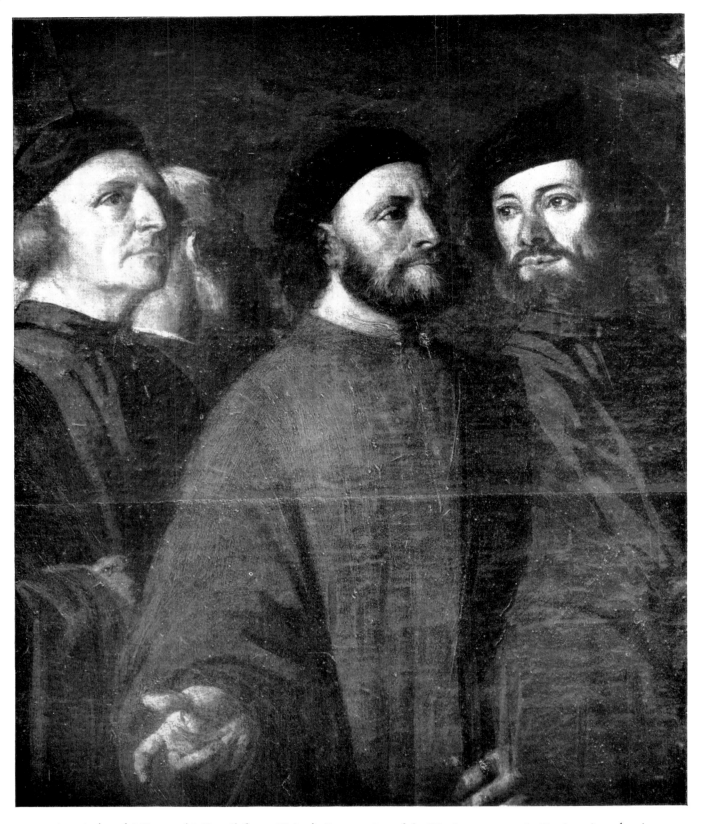

62. *Andrea dei Franceschi*. Detail from Titian's *Presentation of the Virgin*. 1534–1538. Venice, Accademia

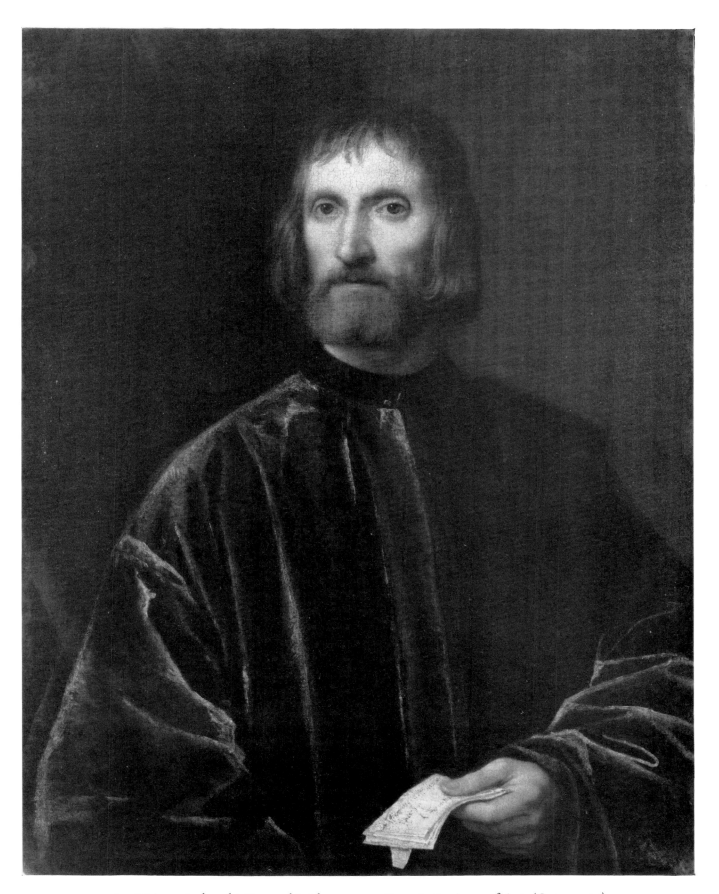

63. Titian: *Andrea dei Franceschi*. About 1532. Detroit, Institute of Arts (Cat. no. 34)

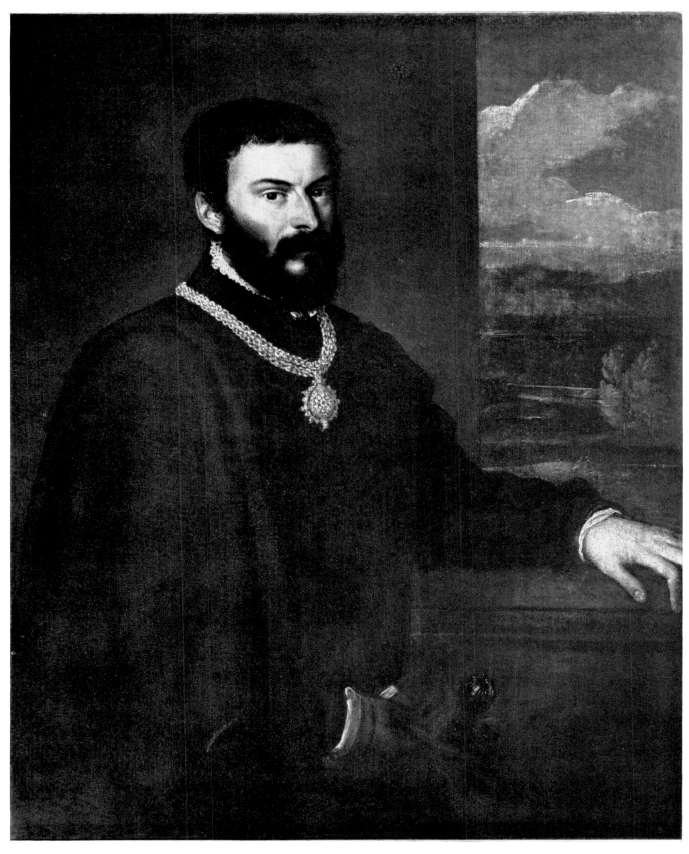

64. Titian: *Count Antonio Porcia*. About 1535. Milan, Brera Gallery (Cat. no. 85)

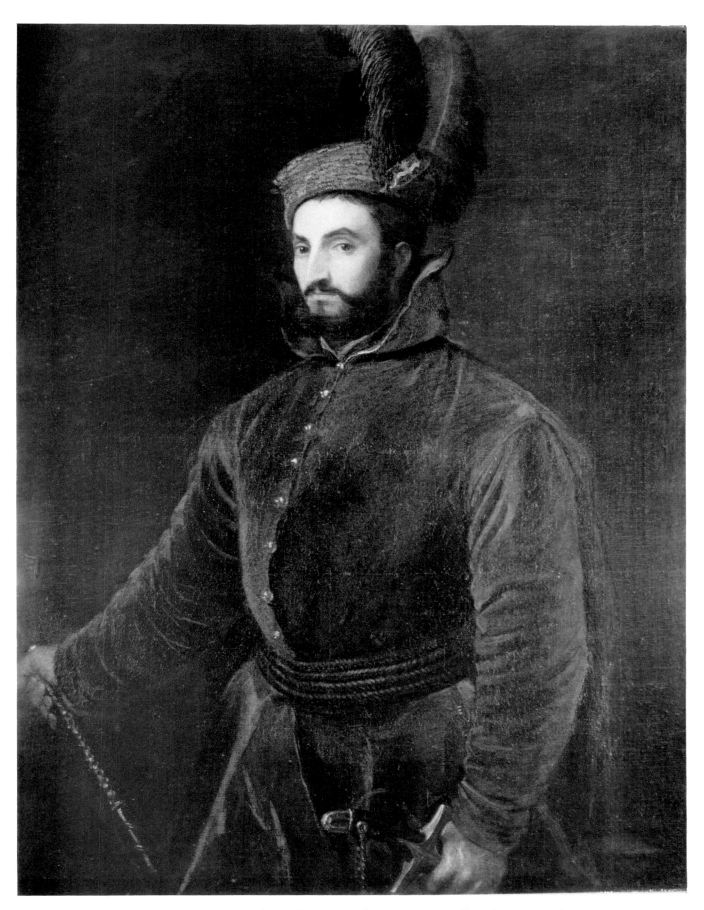

65. Titian: *Ippolito dei Medici*. 1533. Florence, Pitti Gallery (Cat. no. 66)

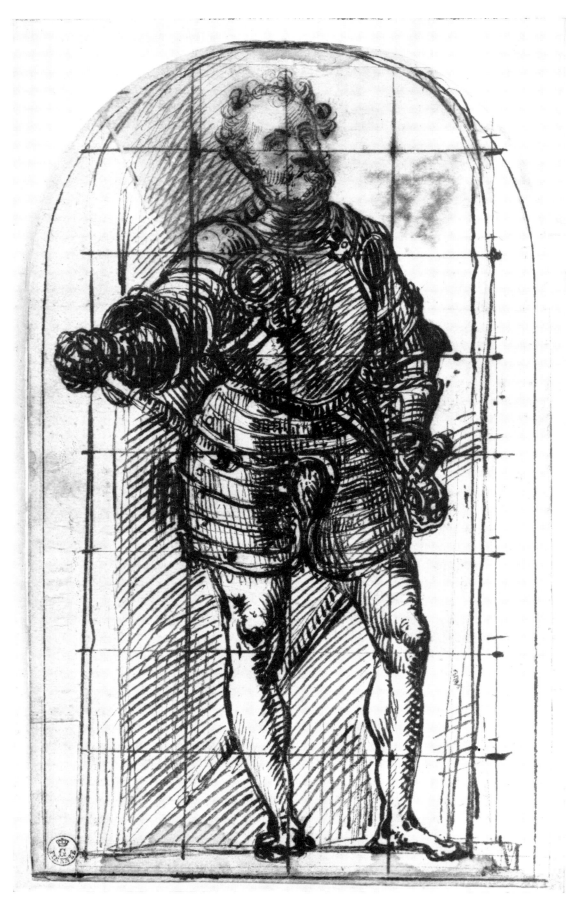

66. Titian: *Francesco Maria I della Rovere, Duke of Urbino* (drawing). About 1536.
Florence, Uffizi (Cat. no. 88)

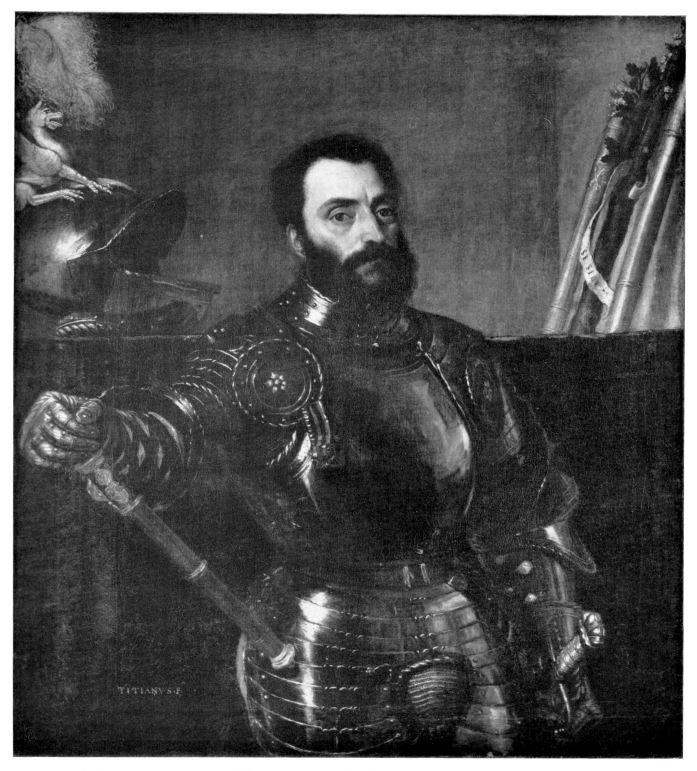

67. Titian: *Francesco Maria I della Rovere, Duke of Urbino*. 1536–1538. Florence, Uffizi (Cat. no. 89)

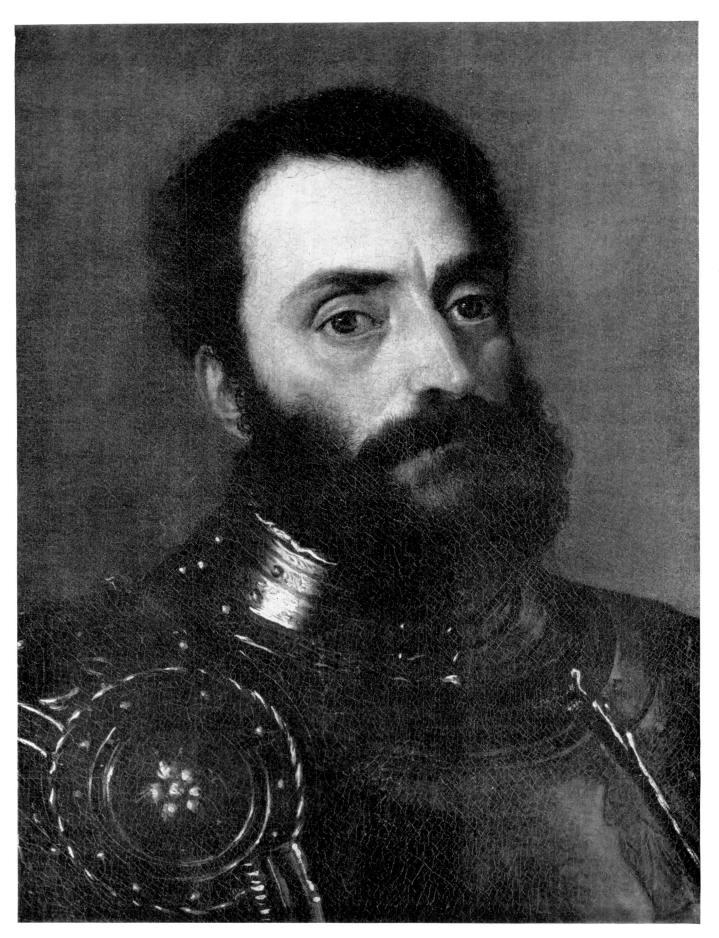

68. *Francesco Maria I della Rovere, Duke of Urbino*. Detail from Plate 67.

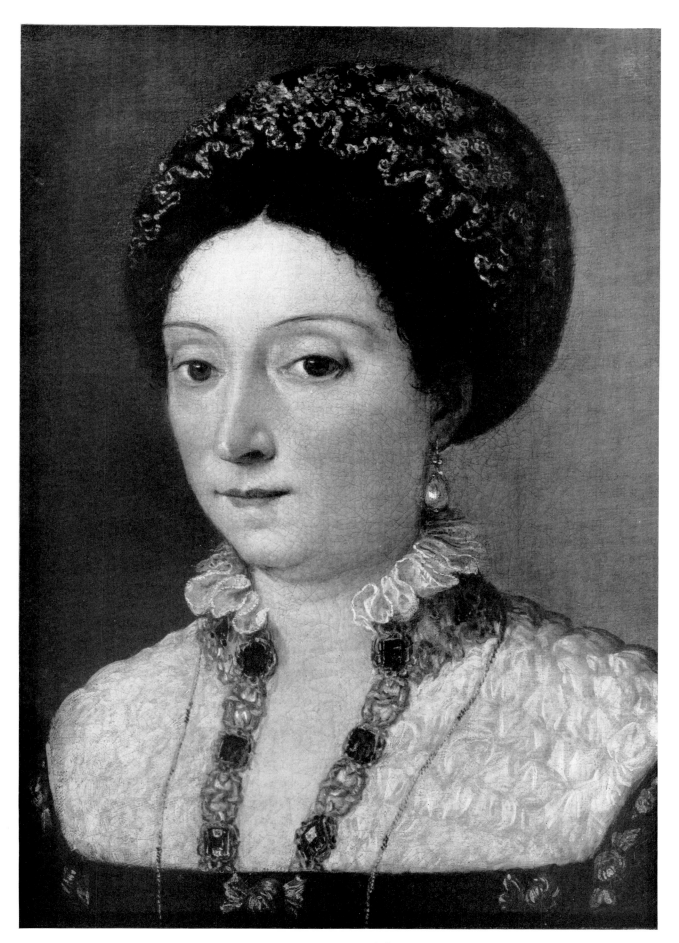

69. *Eleanora Gonzaga.* Detail from Plate 70

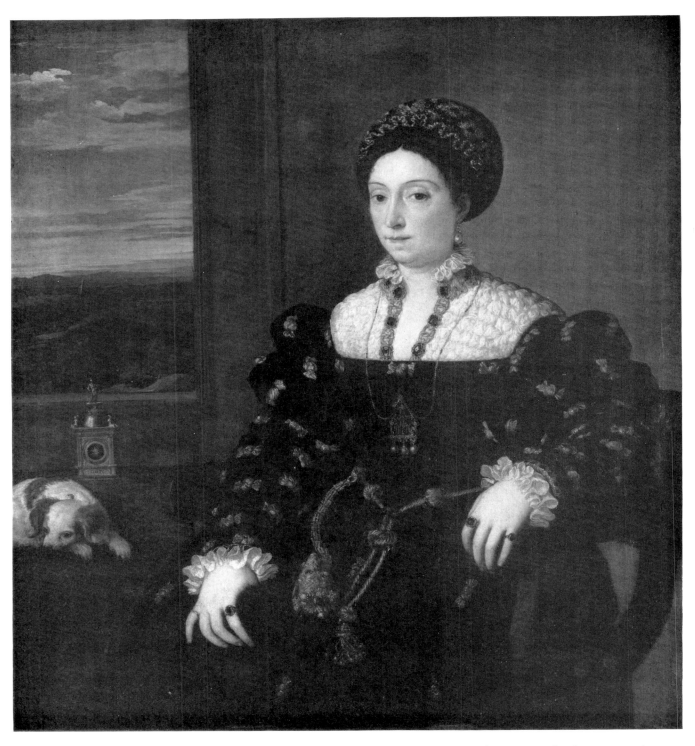

70. Titian: *Eleanora Gonzaga della Rovere, Duchess of Urbino.* 1536–1538. Florence, Uffizi (Cat. no. 87)

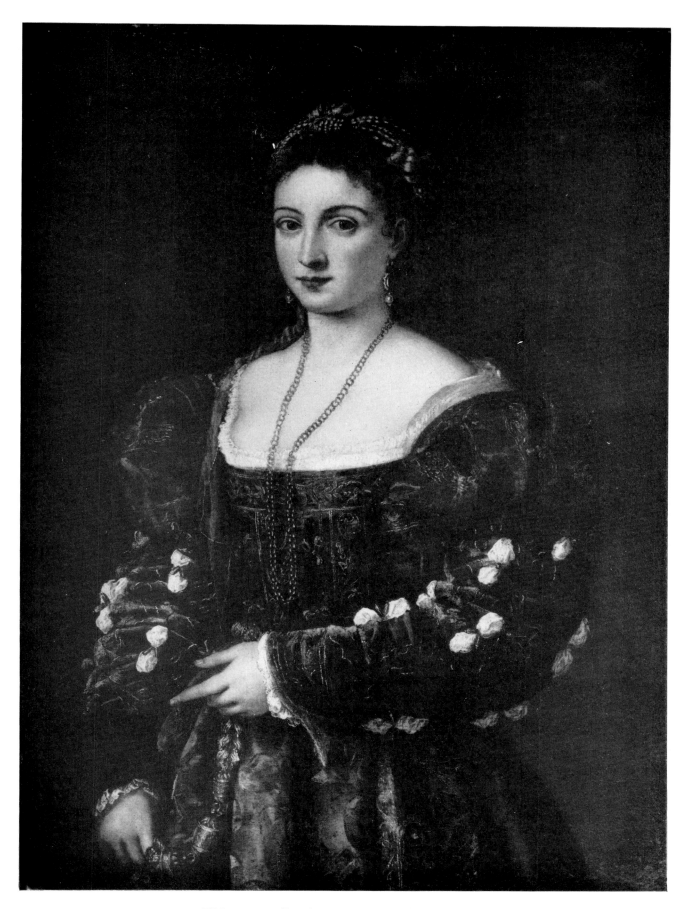

71. Titian: *La Bella*. Florence, Pitti Gallery (Cat. no. 14)

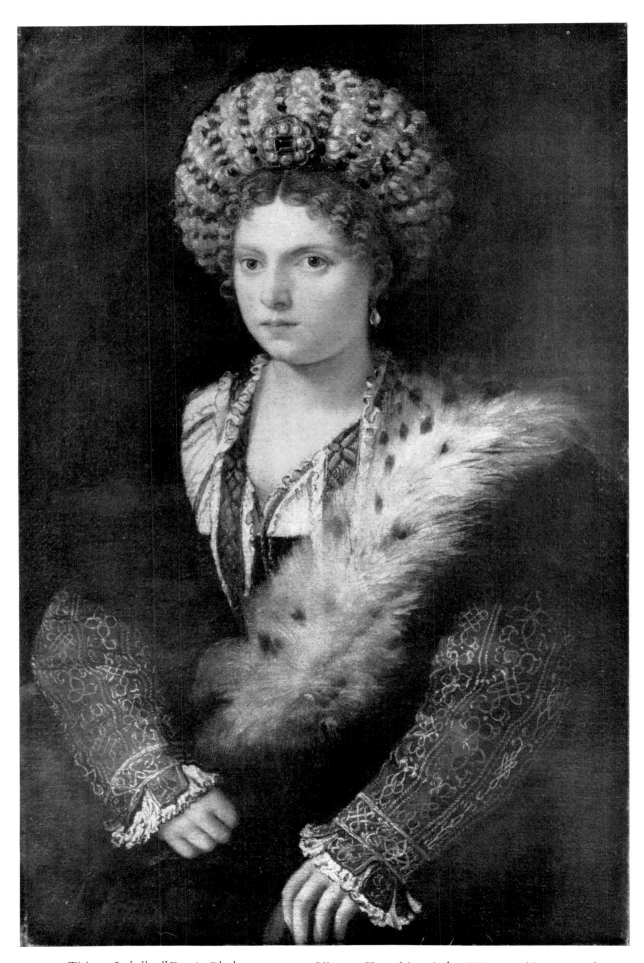

72. Titian: *Isabella d'Este in Black*. 1534–1536. Vienna, Kunsthistorisches Museum (Cat. no. 27)

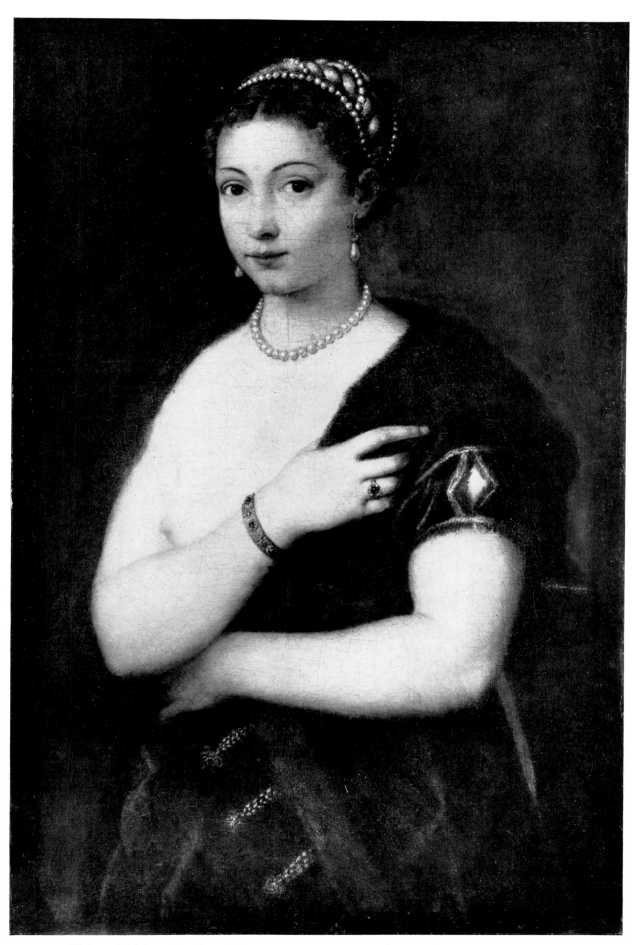

73. Titian: *Girl in a Fur Coat*. About 1535. Vienna, Kunsthistorisches Museum (Cat. no. 48)

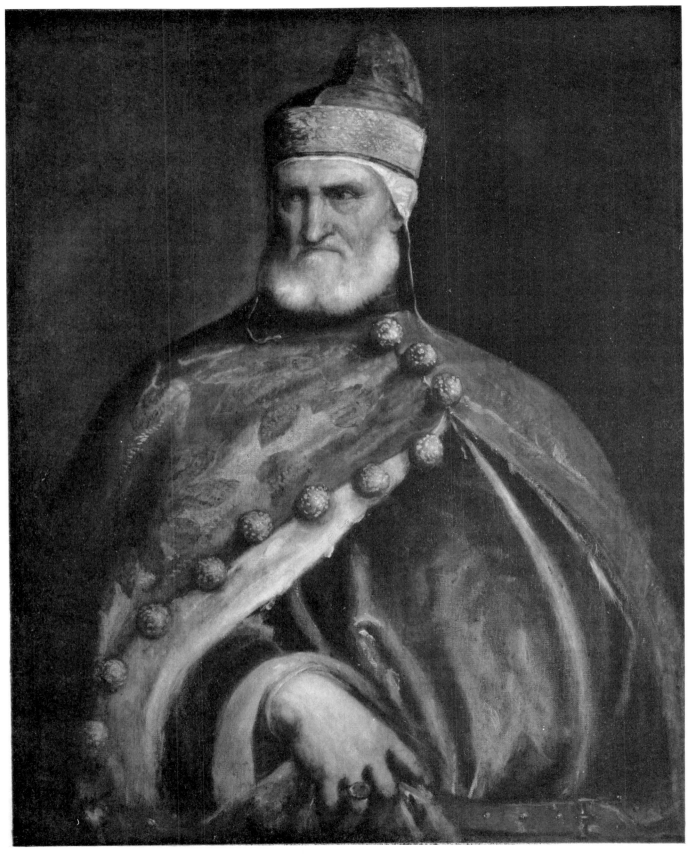

74. Titian: *Doge Andrea Gritti*. 1535–1538. Washington, National Gallery of Art, Samuel H. Kress Collection (Cat. no. 50)

75. *Andrea Gritti*. Detail from Plate 74

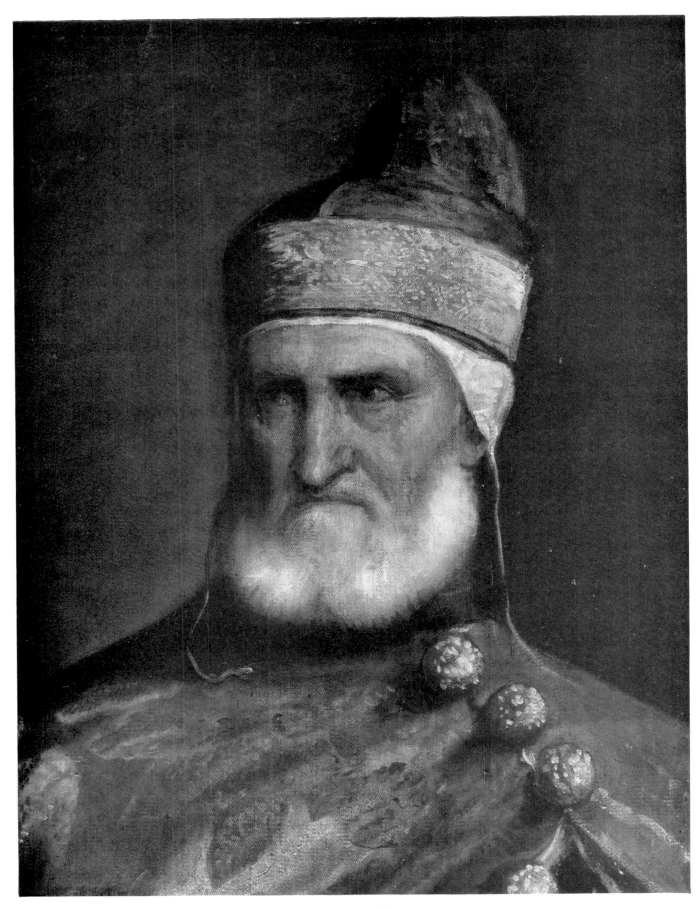

76. *Andrea Gritti*. Detail from Plate 74

77. *Andrea Gritti*. Detail from Plate 74

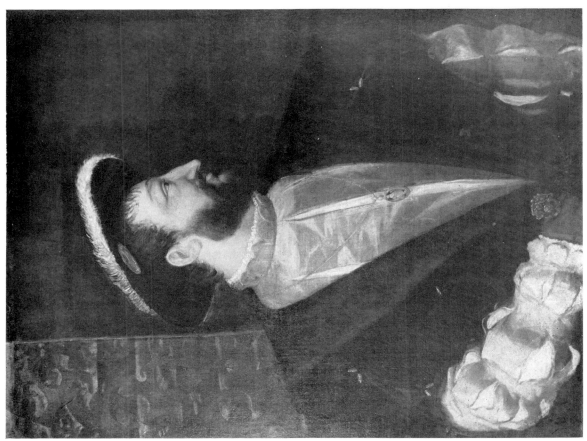

79. Titian: *Francis I*. 1539. Paris, Louvre (Cat. no. 37)

78. Titian: *Francis I* (sketch). About 1538. Leeds, Harewood House, Earl of Harewood (Cat. no. 36)

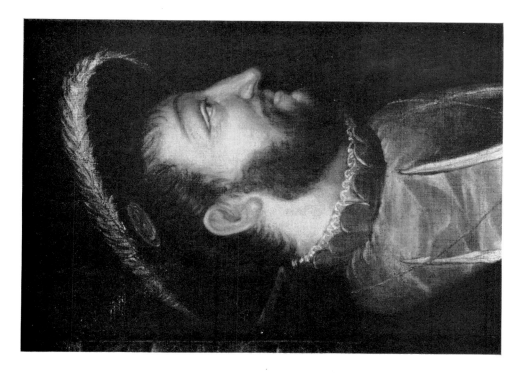

81. *Head of Francis I.* Detail from Plate 80

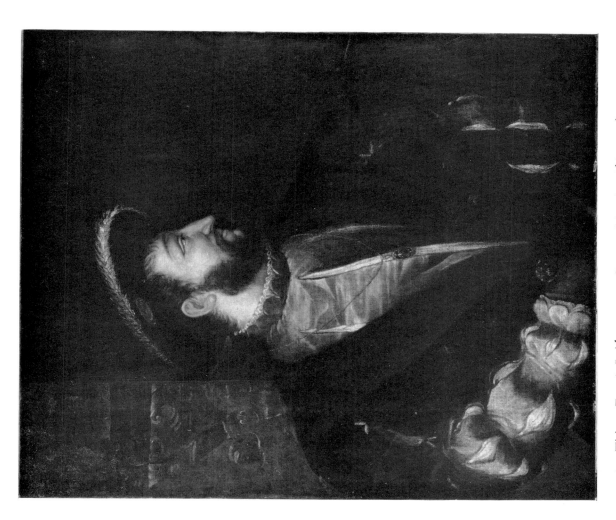

80. Titian: *Francis I.* About 1539. Geneva, Maurice Clément de Coppet
(Cat. no. 38)

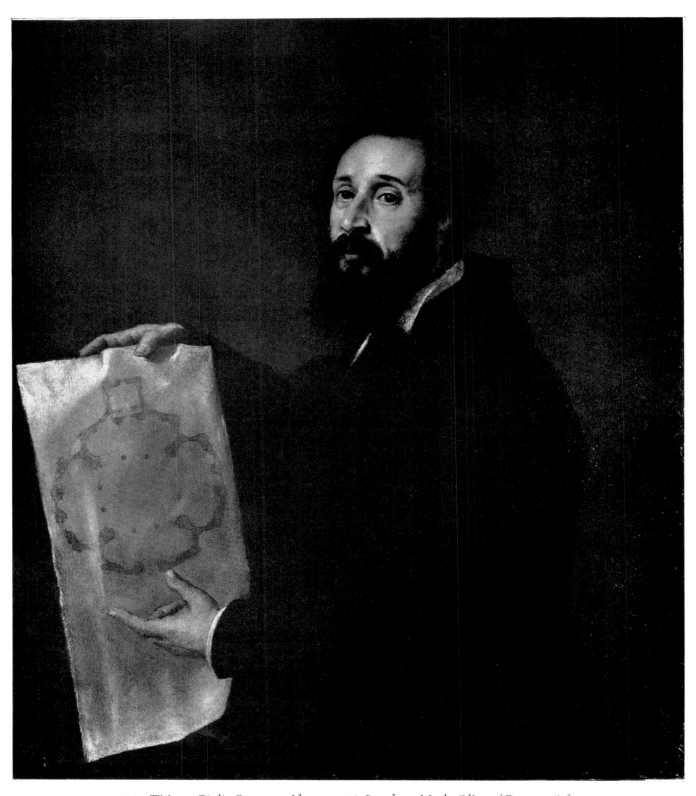

82. Titian: *Giulio Romano*. About 1536. London, Mark Oliver (Cat. no. 86)

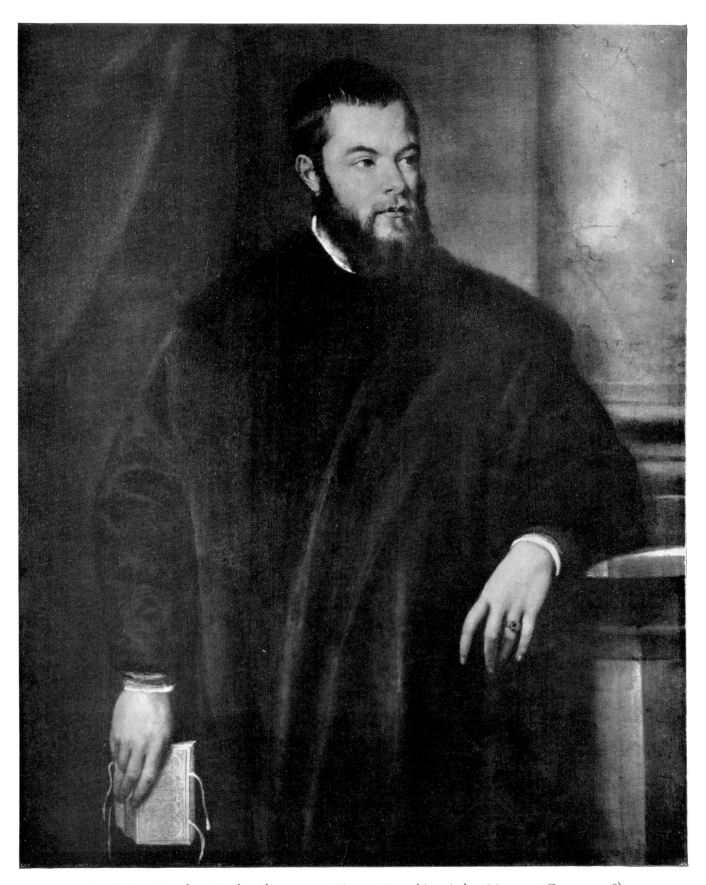

83. Titian: *Benedetto Varchi*. About 1540. Vienna, Kunsthistorisches Museum (Cat. no. 108)

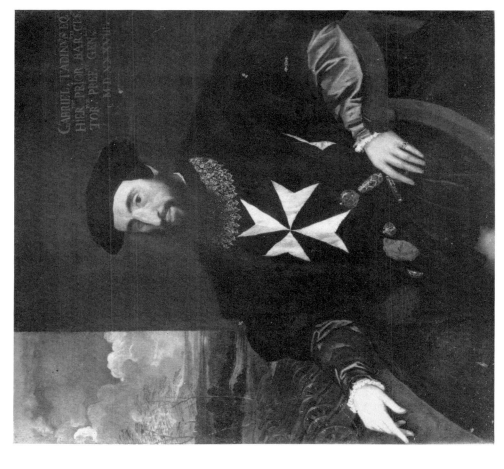

85. Titian (?): *Gabriele Tadino*. 1538. Winterthur, Dr. Robert Bühler
(Cat. no. 103)

84. Domenico Poggini: *Benedetto Varchi*. Medal.
Washington, National Gallery of Art,
Kress Collection

87. Titian (?): *Knight of Santiago*. 1542. Munich, Alte Pinakothek (Cat. no. 57)

86. Workshop of Titian: *Giacomo Doria*. About 1540–1545. Luton Hoo, Wernher Collection (Cat. no. 25)

88. Titian: *Vincenzo Cappello*. About 1540. Washington, National Gallery of Art, Samuel H. Kress Collection
(Cat. no. 17)

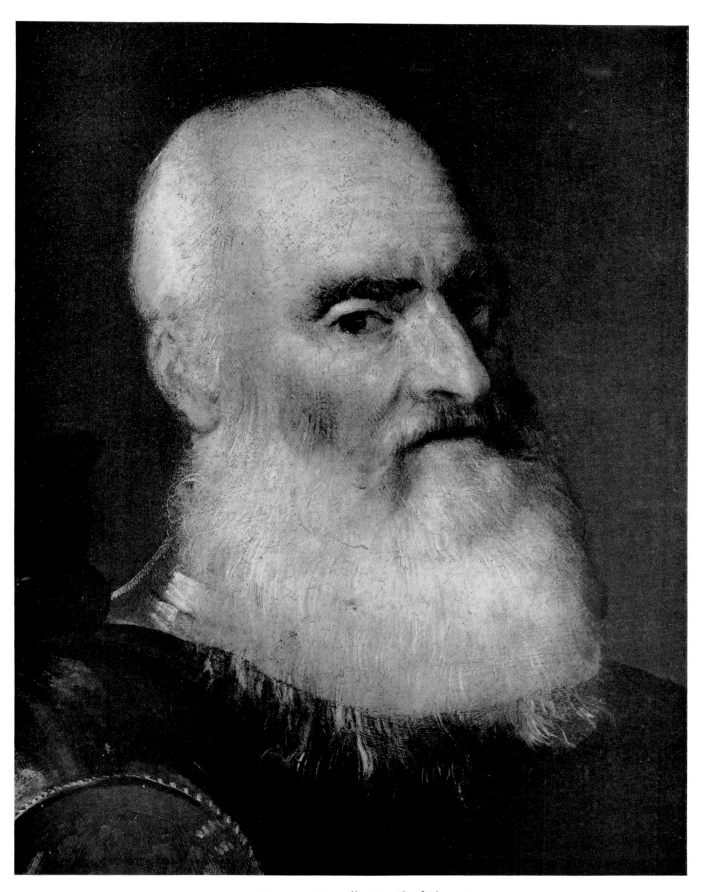

89. *Vincenzo Cappello.* Detail of Plate 88

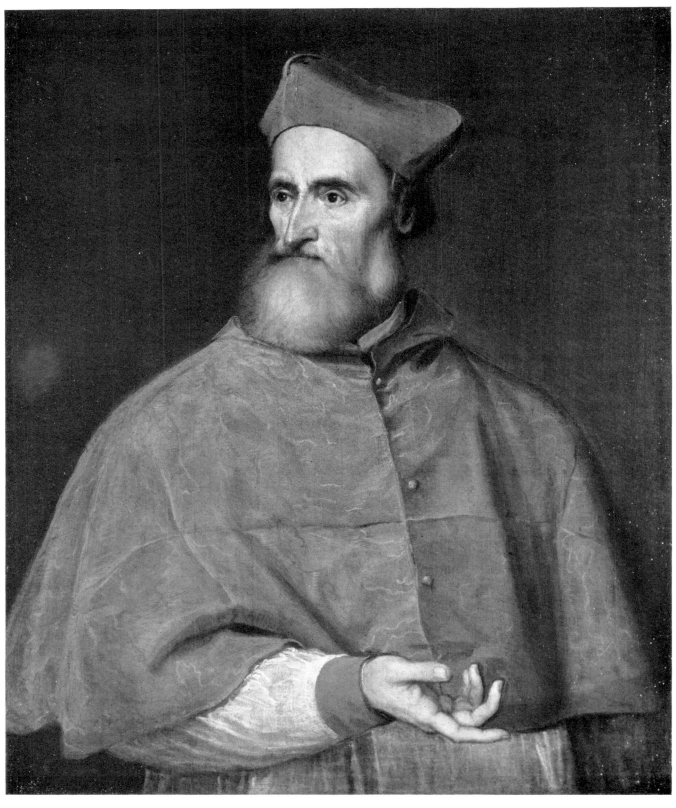

90. Titian: *Cardinal Pietro Bembo*. About 1540. Washington, National Gallery of Art, Samuel H. Kress Collection
(Cat. no. 15)

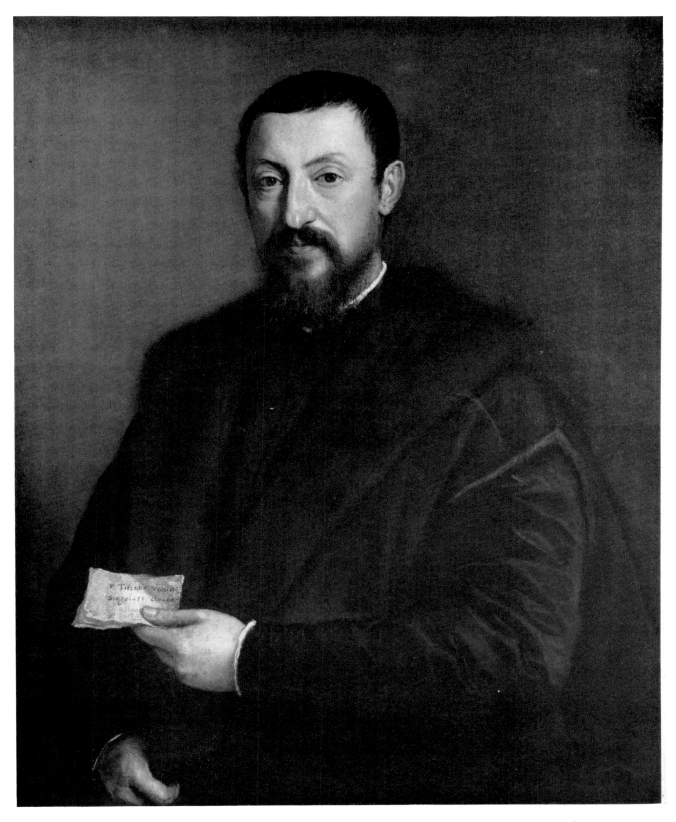

91. Titian: *Friend of Titian*. About 1540. San Francisco (California), De Young Memorial Museum, Samuel H. Kress Collection (Cat. no. 39)

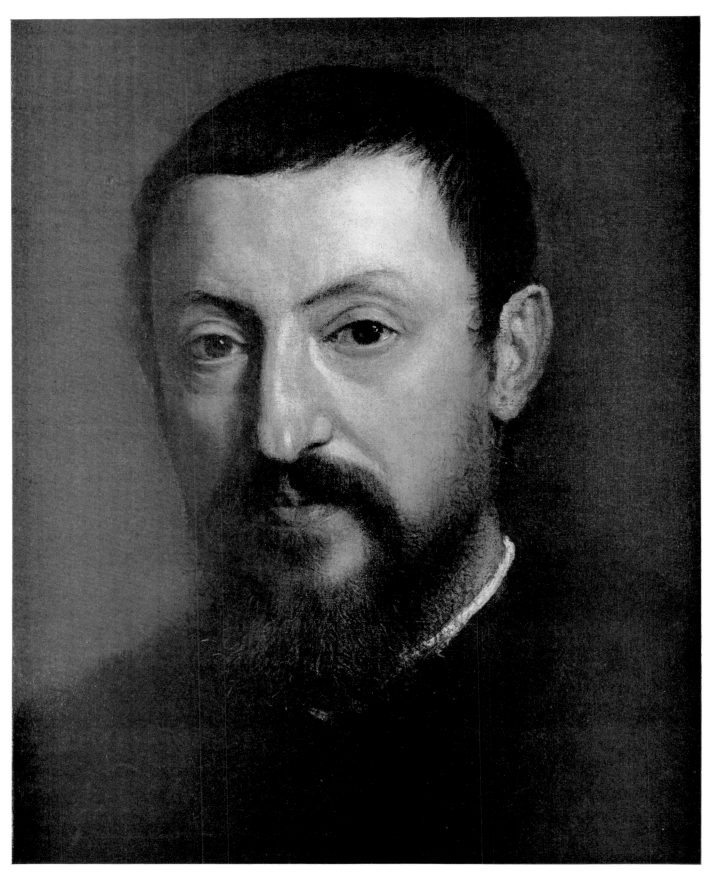

92. *Friend of Titian*. Detail from Plate 91

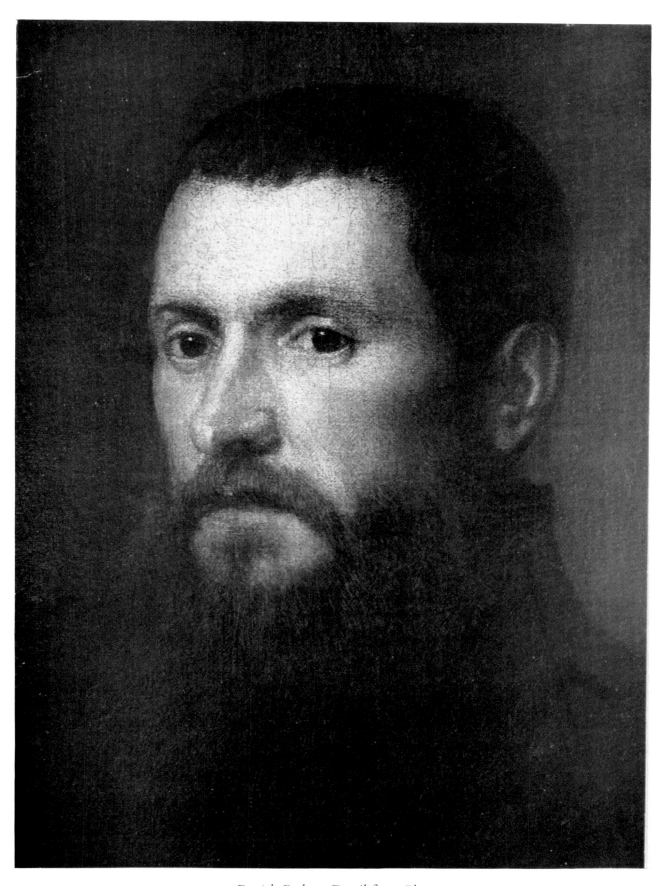

93. *Daniele Barbaro*. Detail from Plate 94

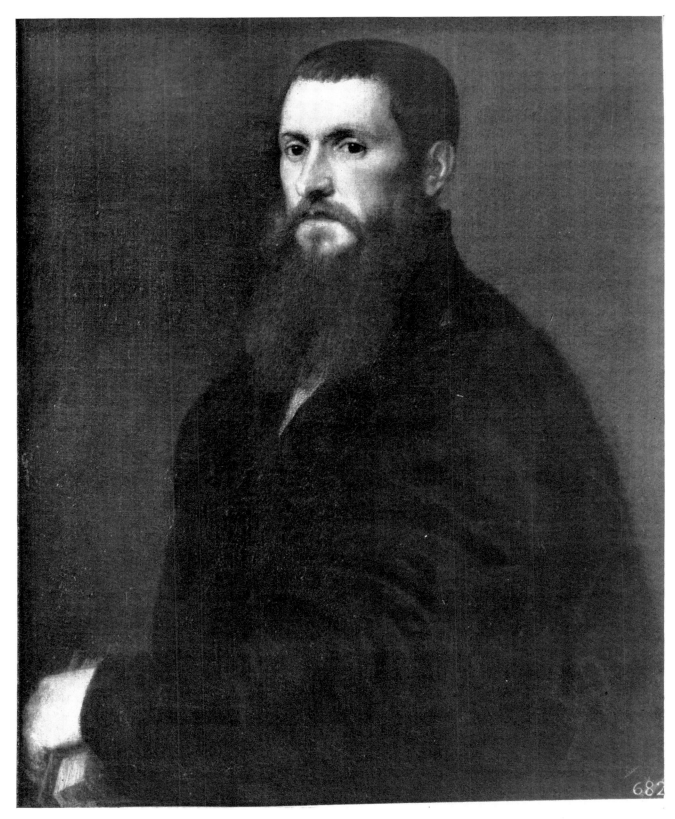

94. Titian: *Daniele Barbaro*. About 1545. Madrid, Prado Museum (Cat. no. 12)

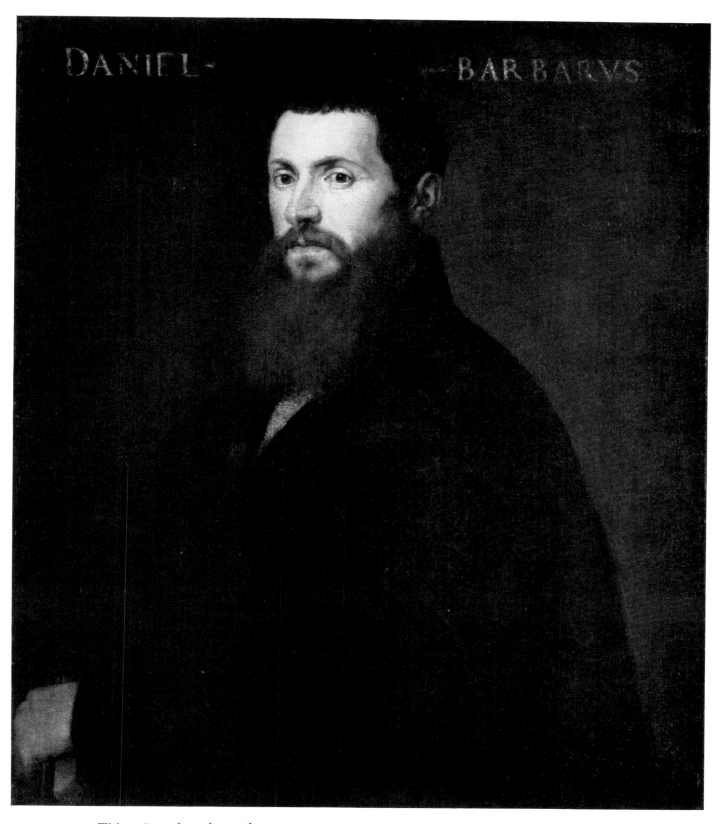

95. Titian: *Daniele Barbaro*. About 1544–1545. Ottawa, National Gallery of Canada (Cat. no. 11)

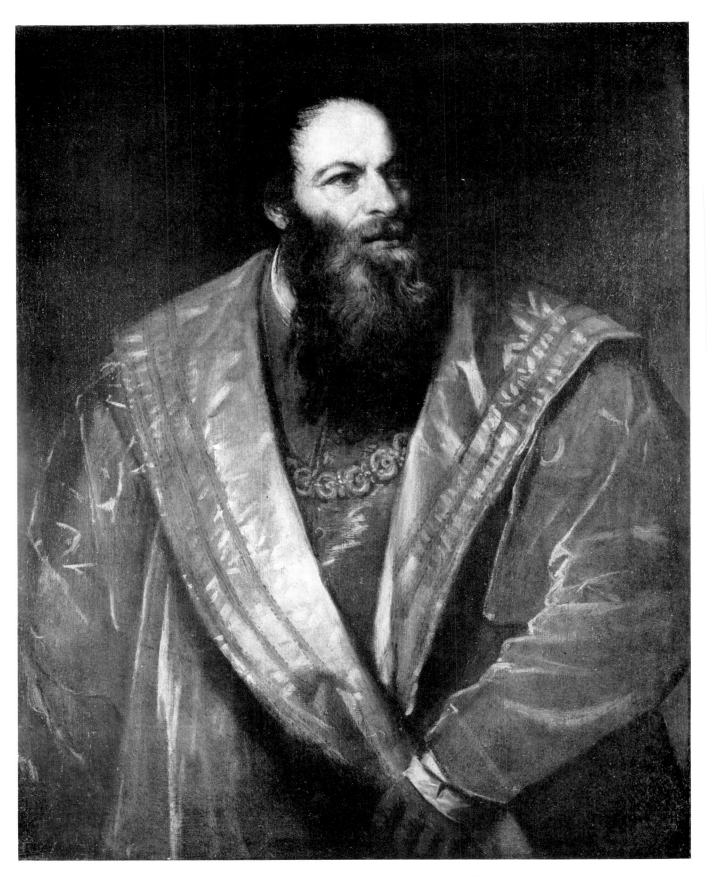

96. Titian: *Pietro Aretino*. About 1545. Florence, Pitti Gallery (Cat. no. 5)

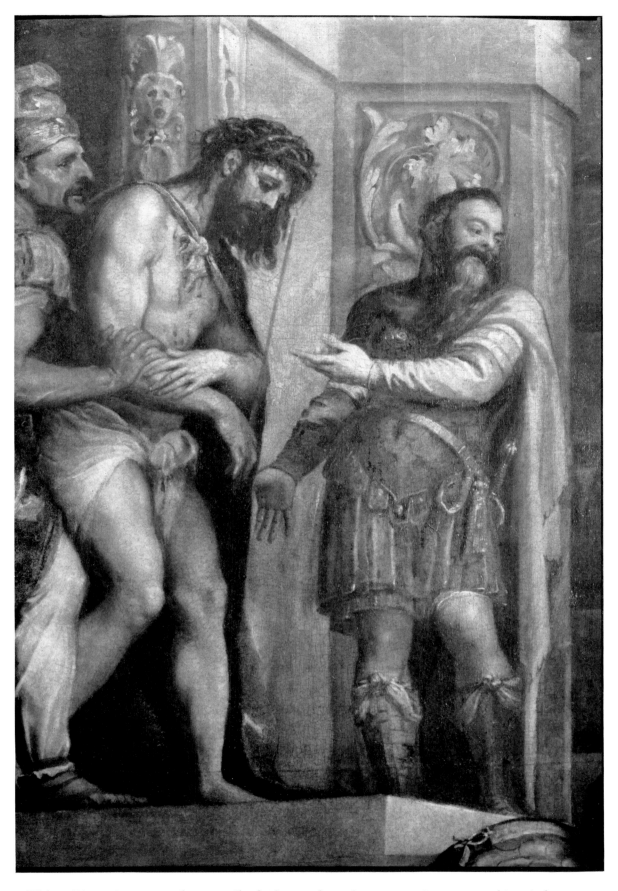

97. Titian: *Pietro Aretino as Pilate*. Detail of *Christ Before Pilate*. 1543. Vienna, Kunsthistorisches Museum

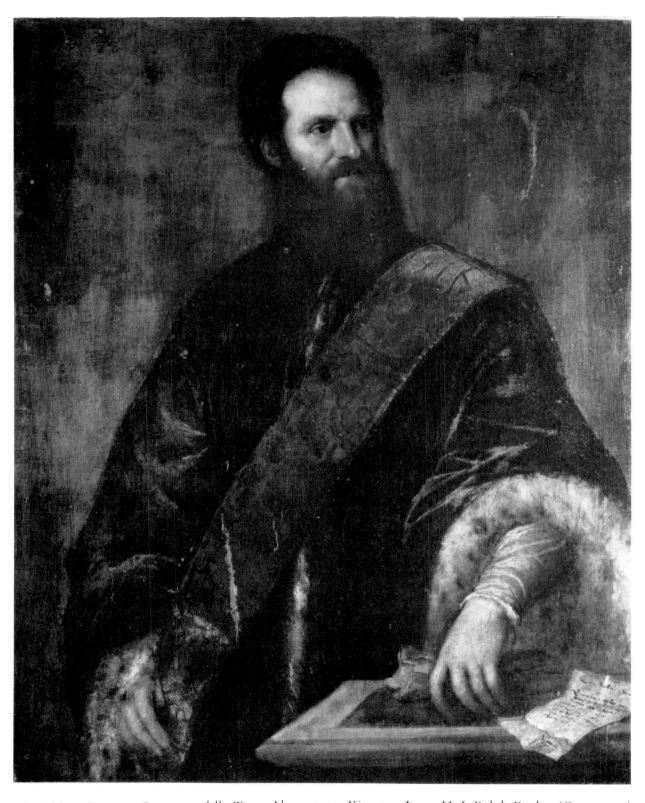

98. Titian: *Francesco Savorgnan della Torre*. About 1545. Kingston Lacy, H. J. Ralph Bankes (Cat. no. 94)

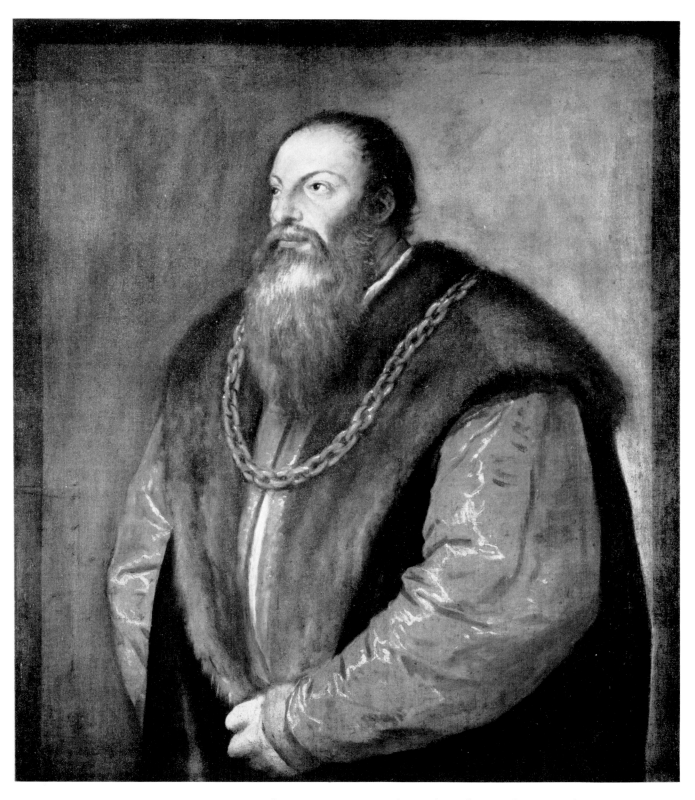

99. Titian: *Pietro Aretino*. About 1548. New York, Frick Collection (Cat. no. 6)

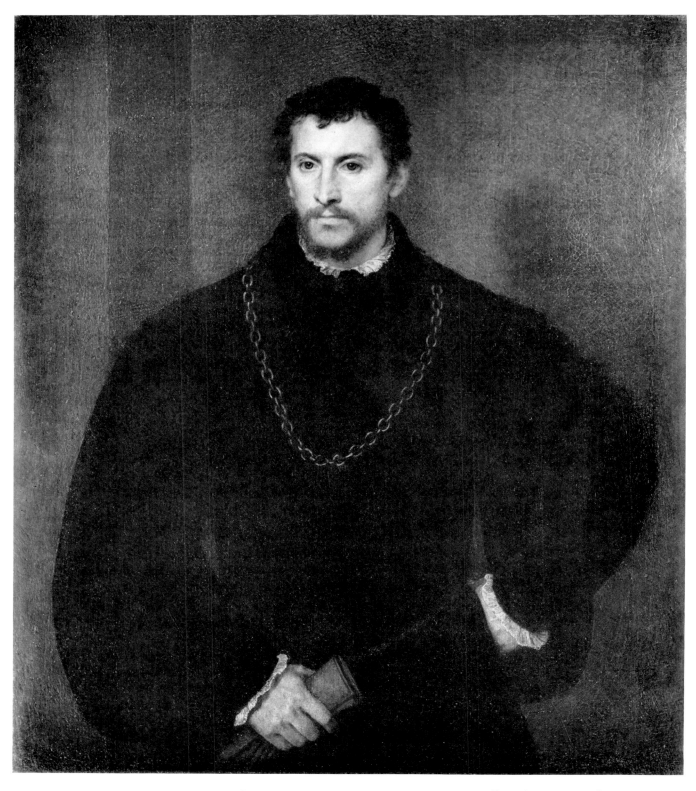

100. Titian: *Young Englishman*. About 1540–1545. Florence, Pitti Gallery (Cat. no. 113)

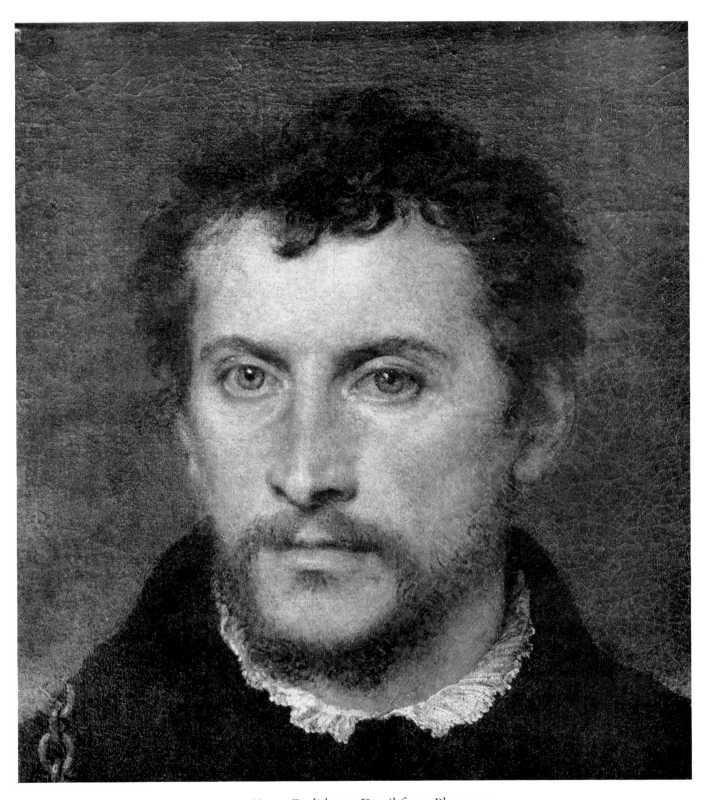

101. *Young Englishman*. Detail from Plate 100

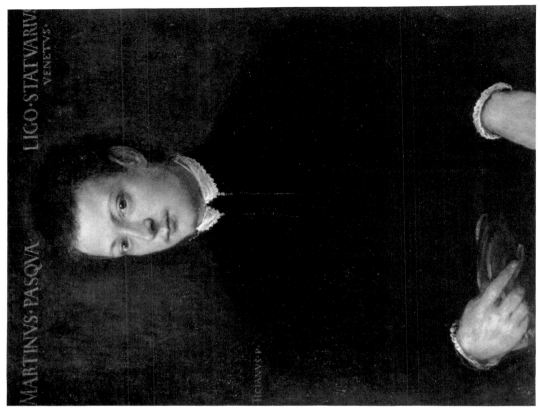

102. Titian: *Seigneur d'Aramon*. 1541–1542. Milan, Castello Sforzesco (Cat. no. 3)

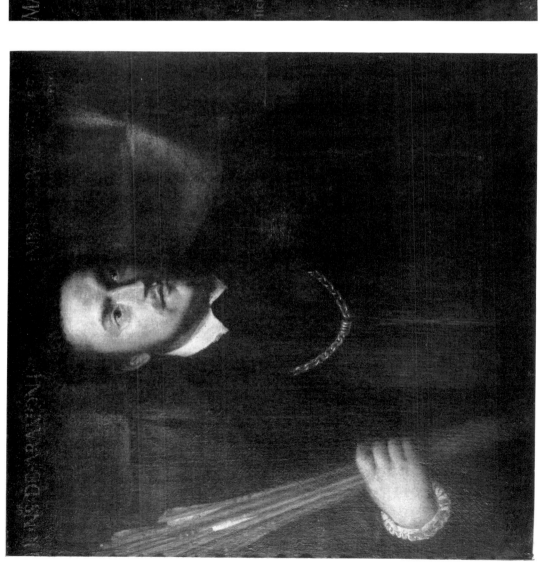

103. Titian and workshop: *Martino Pasqualigo*. About 1545–1546. Washington, Corcoran Gallery, Clark Collection (Cat. no. 71)

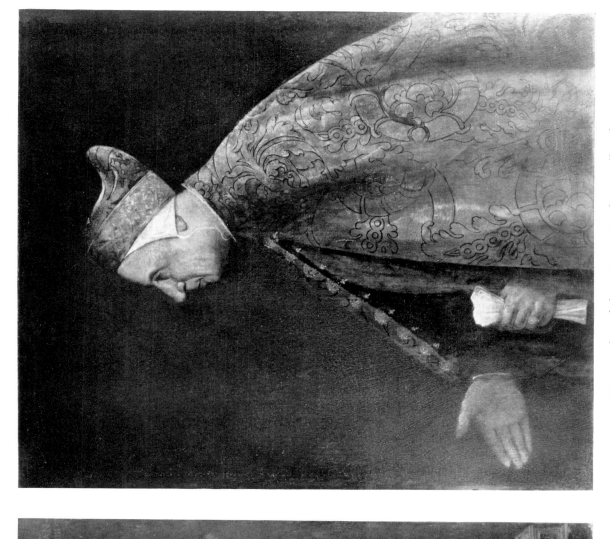

105. Titian and workshop: *Doge Niccolò Marcello*. About 1542.
Rome, Pinacoteca Vaticana (Cat. no. 65)

104. Workshop of Titian: *Sperone Speroni*. 1544. Treviso, Museo Civico
(Cat. no. 98)

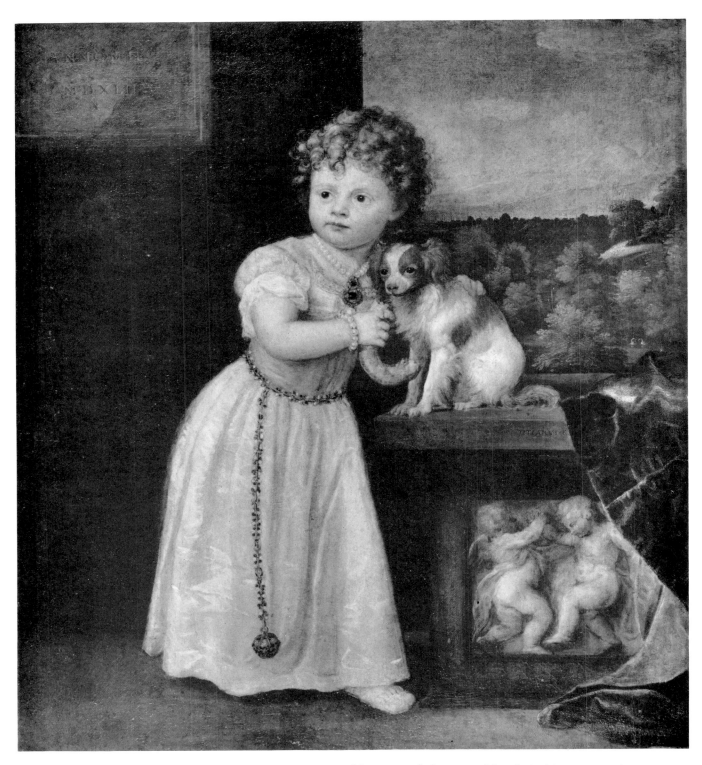

106. Titian: *Clarice Strozzi*. 1542. Berlin–Dahlem, Staatliche Gemäldegalerie (Cat. no. 101)

Tamsin.

107. *Landscape*. Detail from Plate 106

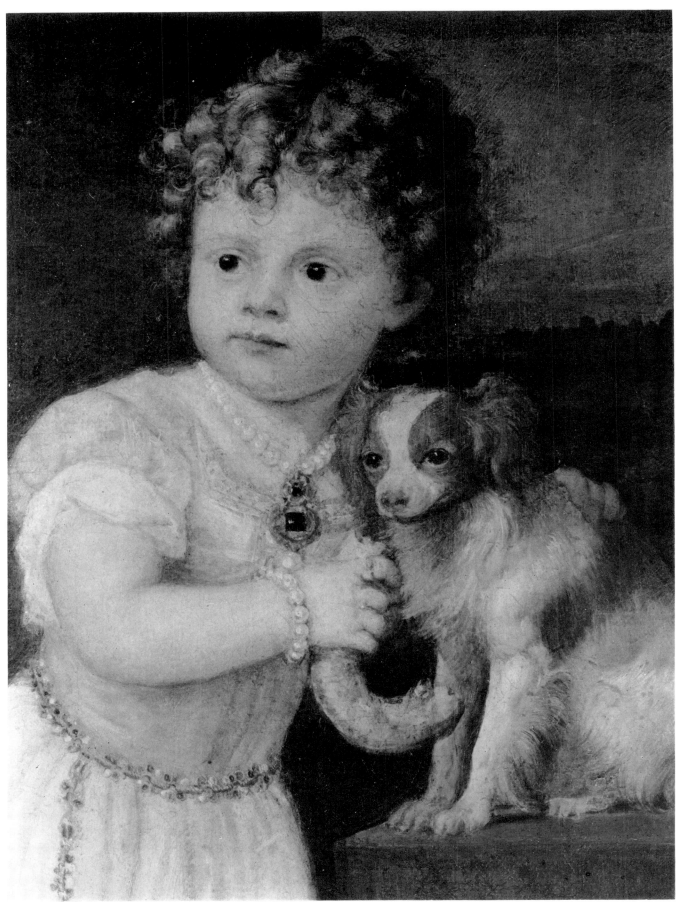

108. *Clarice Strozzi*. Detail from Plate 106

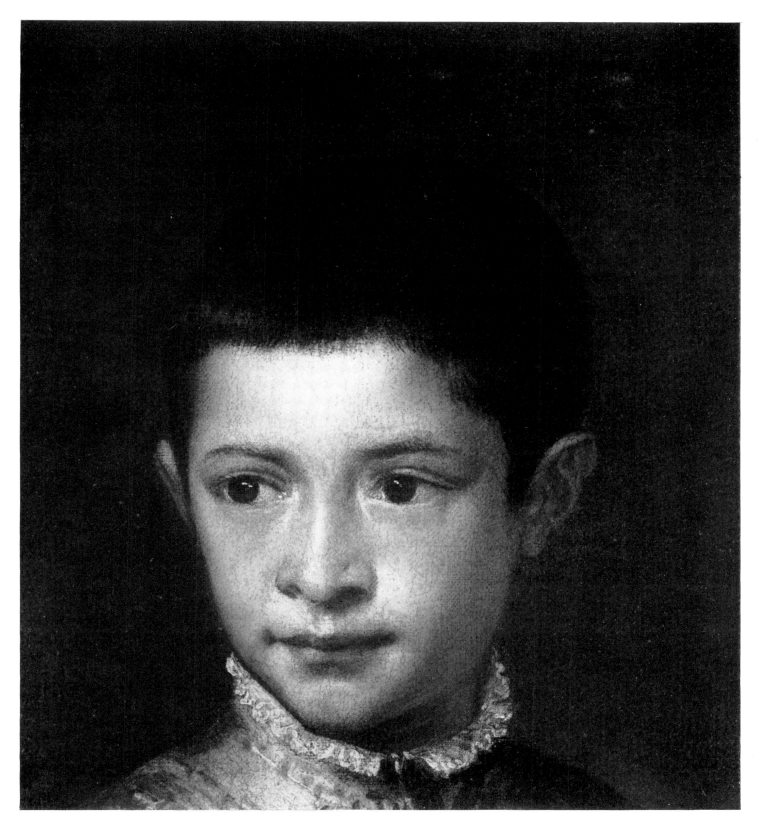

109. *Ranuccio Farnese*. Detail from Plate 113

110. *Dancing Putti.* Detail from Plate 106

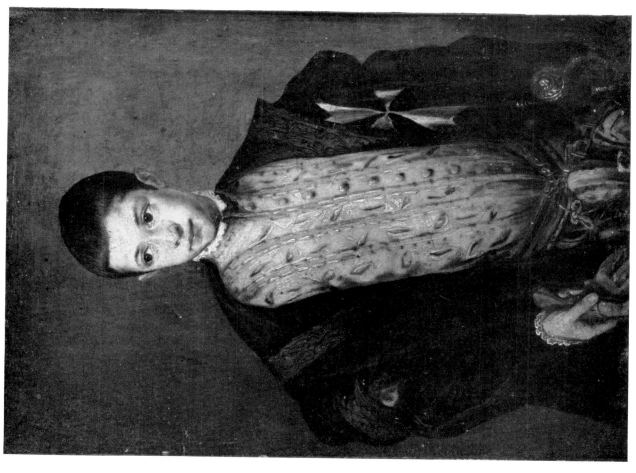

112. Francesco or Giuseppe Salviati after Titian: *Ranuccio Farnese*. About 1550.
Berlin–Dahlem, Staatliche Gemäldegalerie (Cat. no. 31, copy 1)

111. Titian (?): *Gentleman with a Book*. About 1540. Boston, Museum of Fine Arts
(Cat. no. 47)

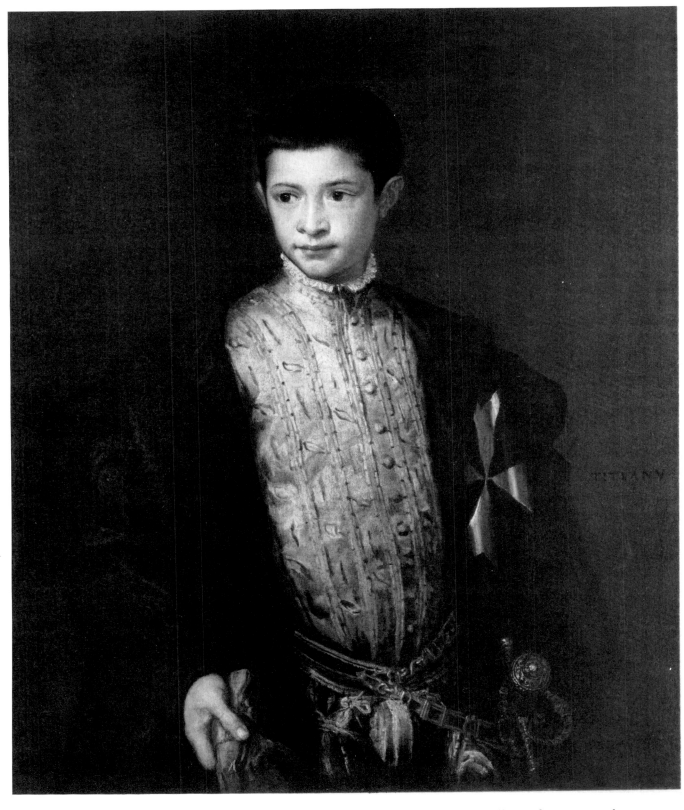

113. Titian: *Ranuccio Farnese as Knight of Malta*. 1542. Washington, National Gallery of Art, Samuel H. Kress Collection (Cat. no. 31)

114. *Ranuccio Farnese*. Detail from Plate 113

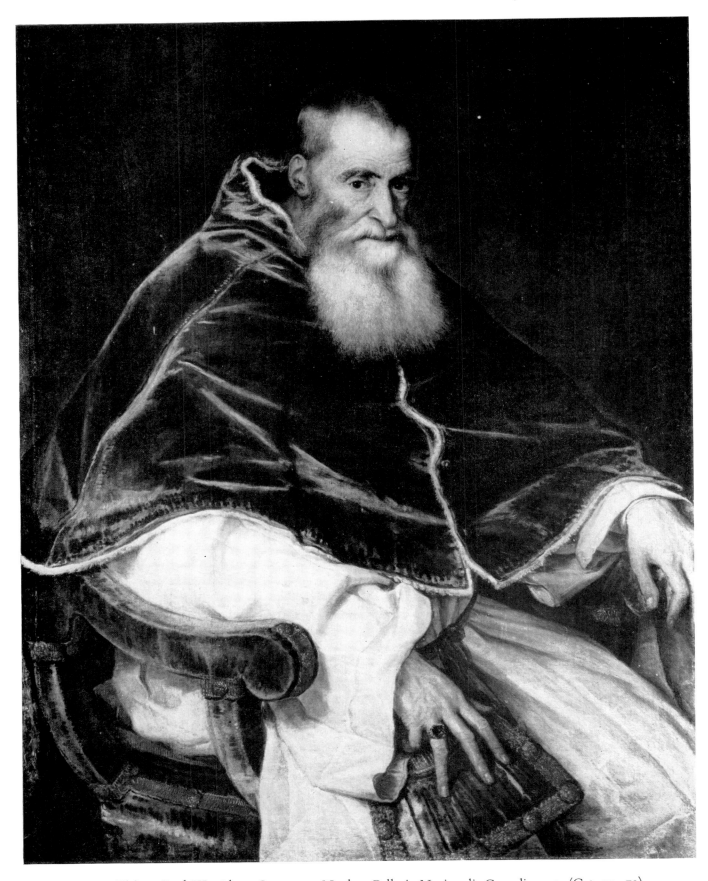

115. Titian: *Paul III without Cap*. 1543. Naples, Gallerie Nazionali, Capodimonte (Cat. no. 72)

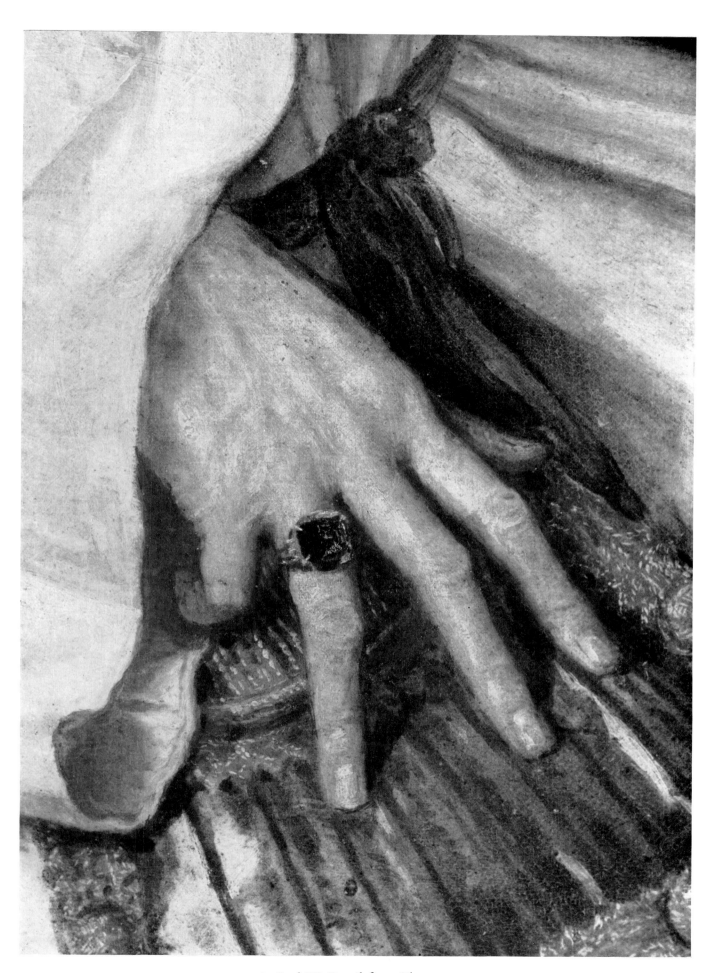

116. *Paul III*. Detail from Plate 115

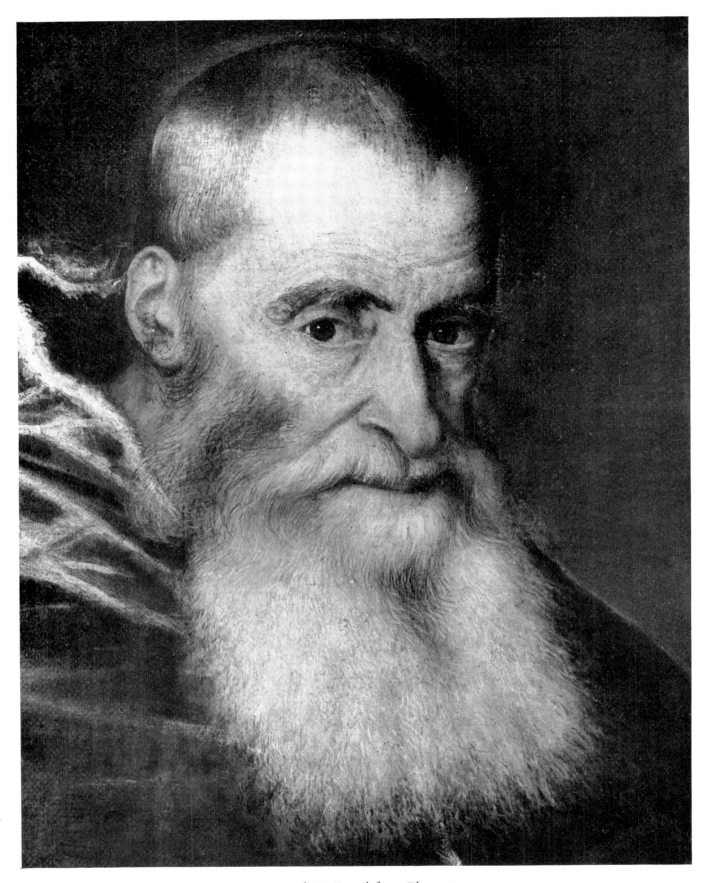

117. *Paul III*. Detail from Plate 115

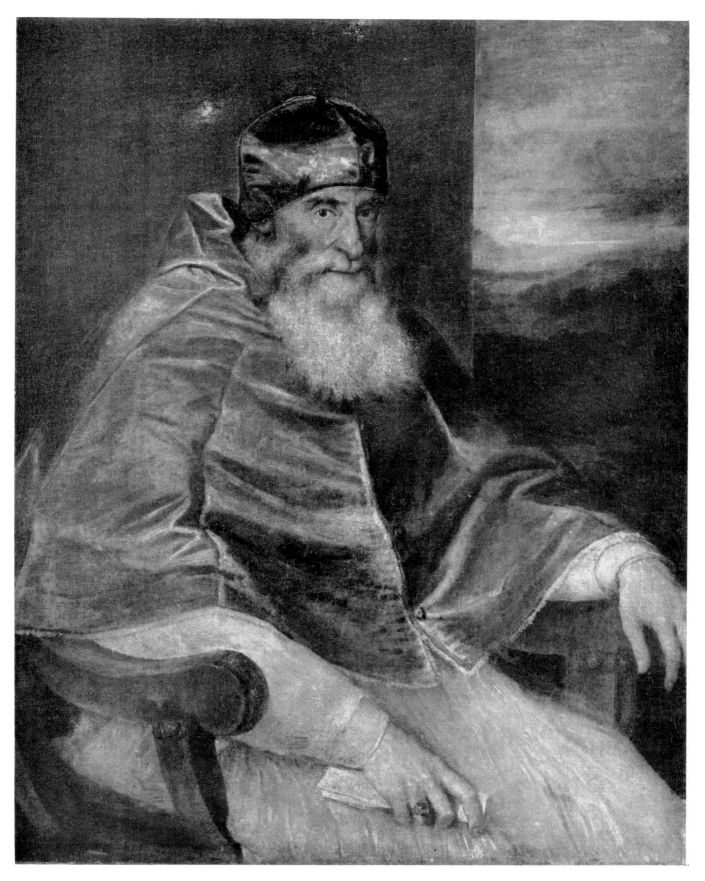

118. Titian: *Paul III with Cap* (damaged). 1545–1546. Naples, Gallerie Nazionali, Capodimonte (Cat. no. 73)

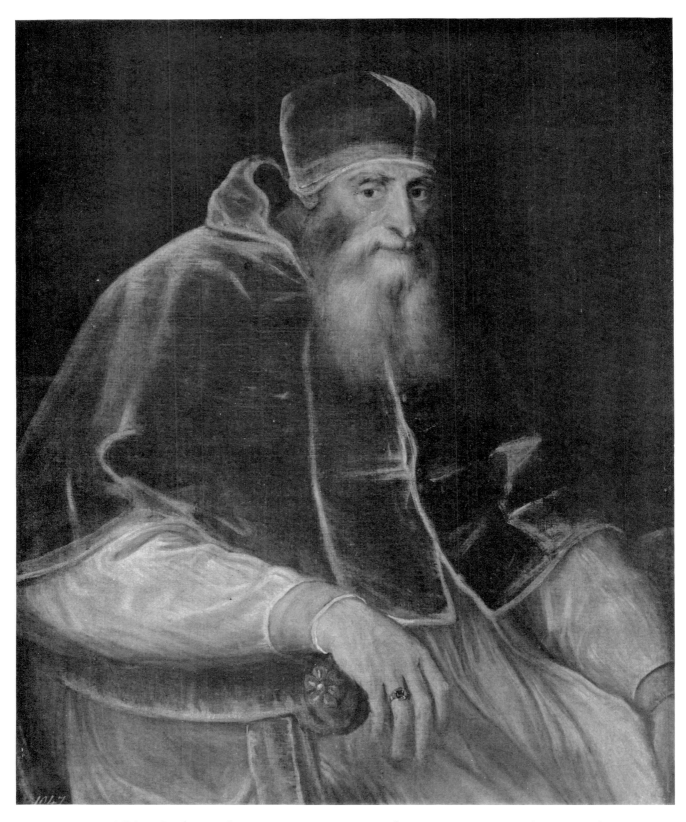

119. Titian: *Paul III with Cap*. 1545–1546. Leningrad, Hermitage Museum (Cat. no. 74)

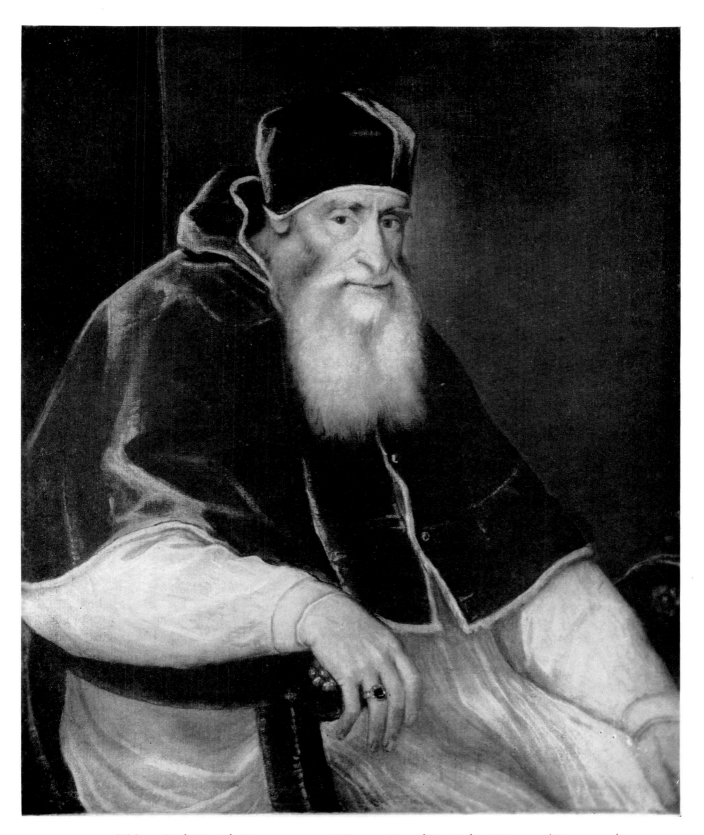

120. Titian: *Paul III with Cap.* 1545–1546. Vienna, Kunsthistorisches Museum (Cat. no. 75)

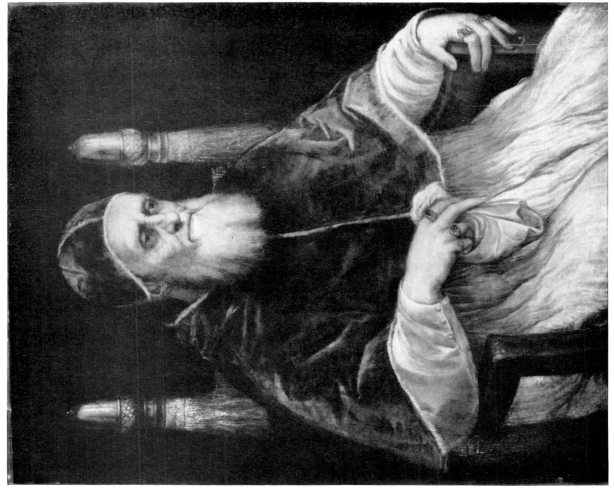

122. Titian after Raphael: *Julius II*. 1545–1546. Florence, Pitti Gallery (Cat. no. 55)

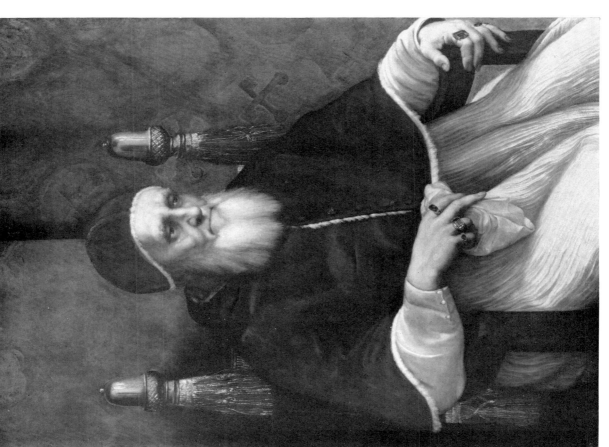

121. Raphael: *Julius II*. 1512. London, National Gallery

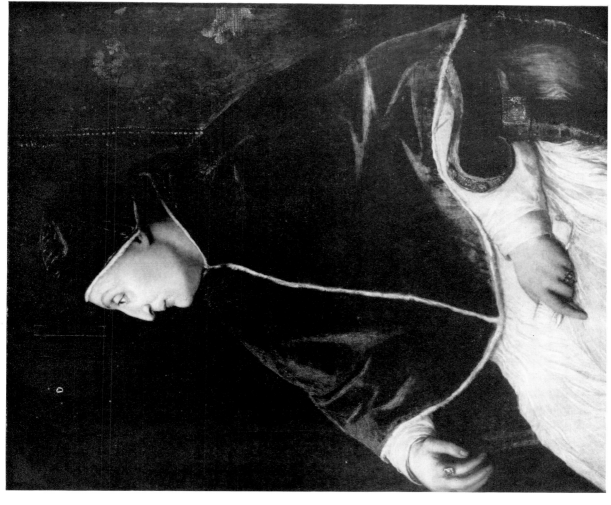

124. Titian and workshop: *Sixtus IV*. About 1545. Florence, Uffizi (in storage)
(Cat. no. 97)

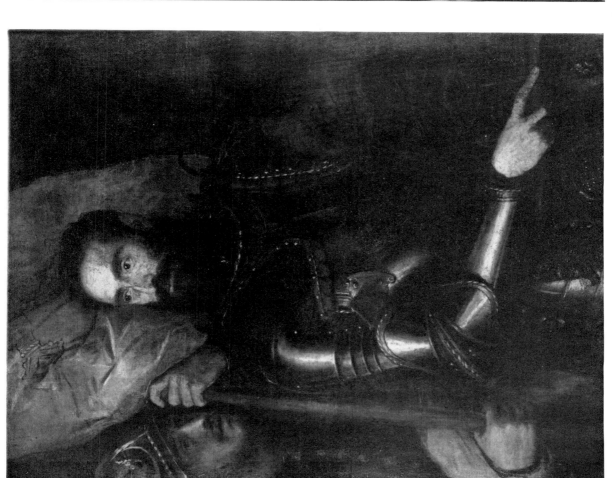

123. Titian: *Pierluigi Farnese and Standard Bearer* (damaged). 1546.
Naples, Gallerie Nazionali, Capodimonte (Cat. no. 30)

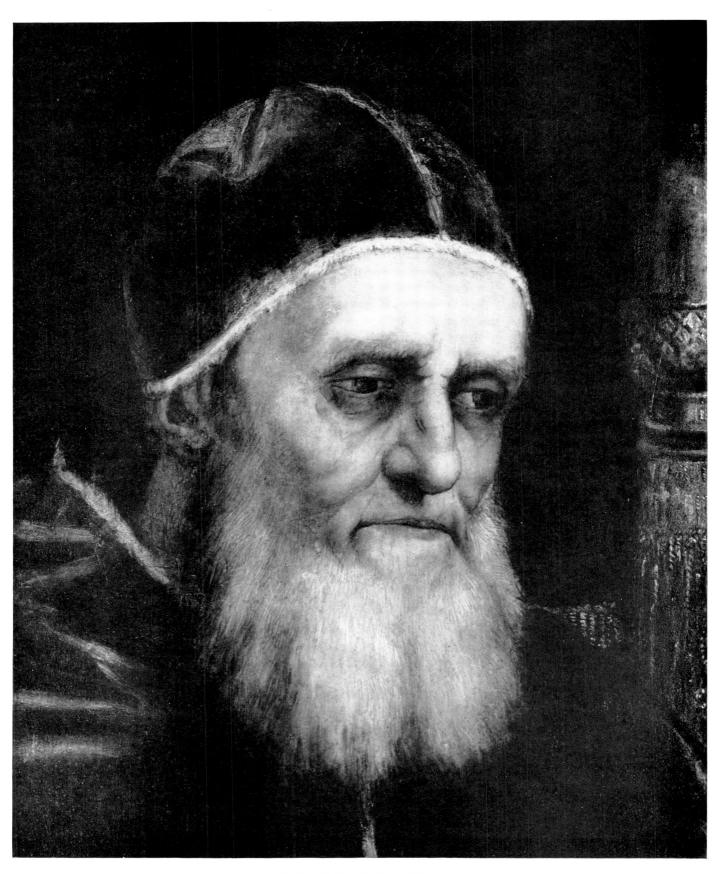

125. *Julius II*. Detail from Plate 122

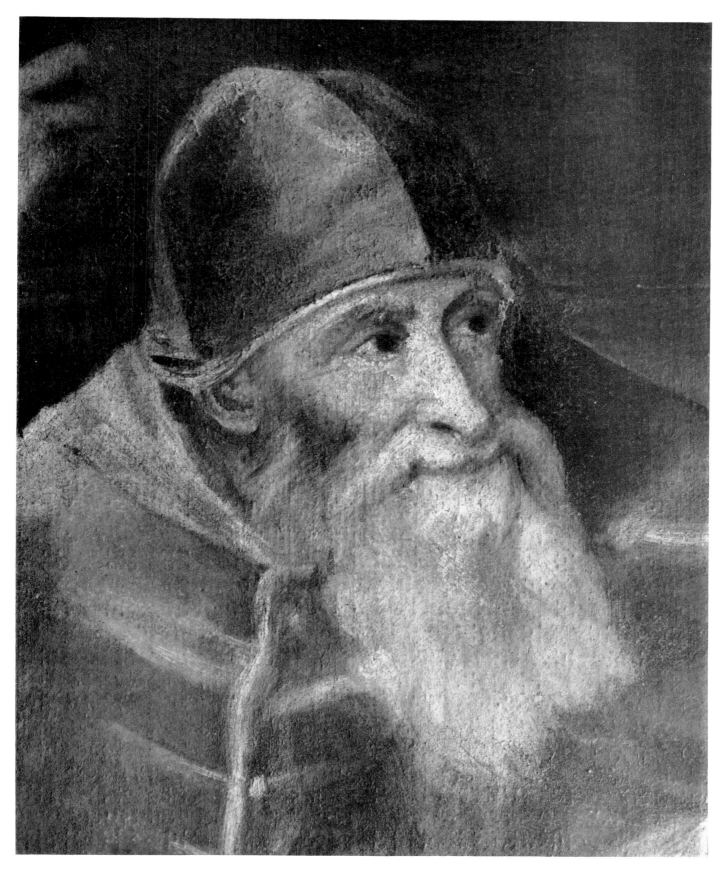

126. *Paul III*. Detail from Plate 127

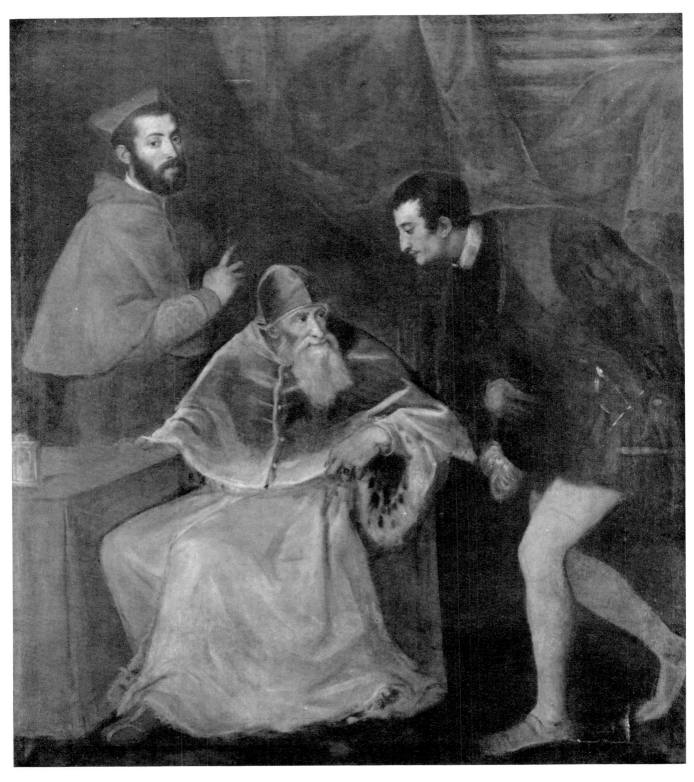

127. Titian: *Paul III and Grandsons*. 1546. Naples, Gallerie Nazionali, Capodimonte (Cat. no. 76)

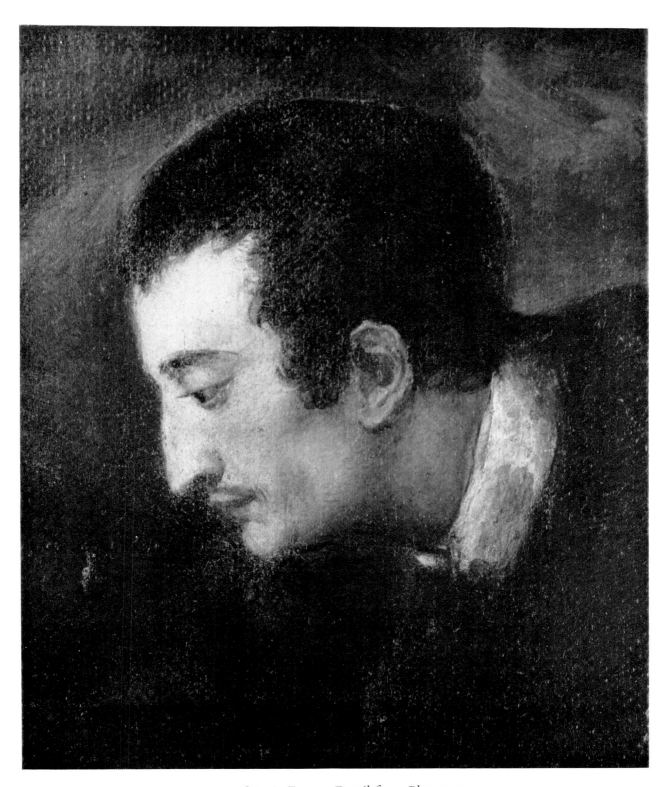

128. *Ottavio Farnese*. Detail from Plate 127

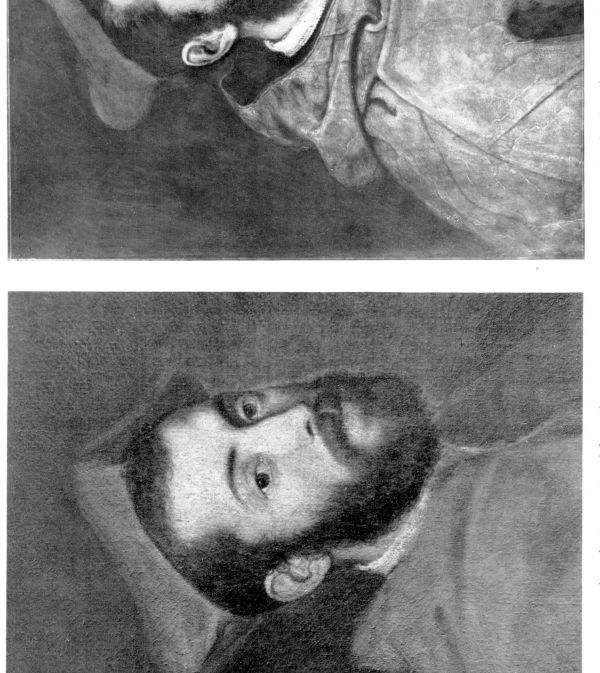

130. Roman School: *Alessandro Farnese*. Sixteenth century. Tivoli, Villa d'Este, Quadreria (Cat. no. X-33)

129. *Alessandro Farnese*. Detail from Plate 127

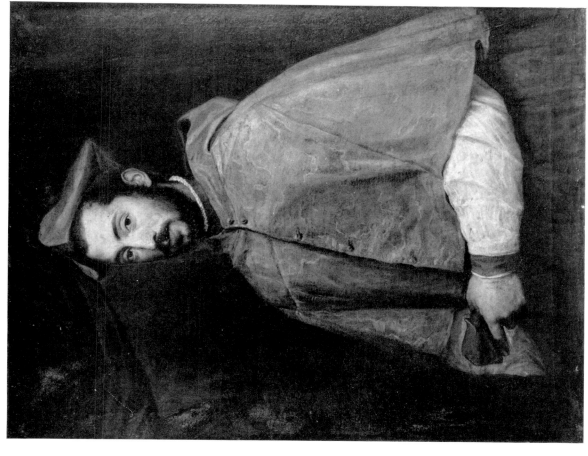

132. Titian: *Alessandro Farnese.* 1545. Naples, Gallerie Nazionali, Capodimonte (Cat. no. 29)

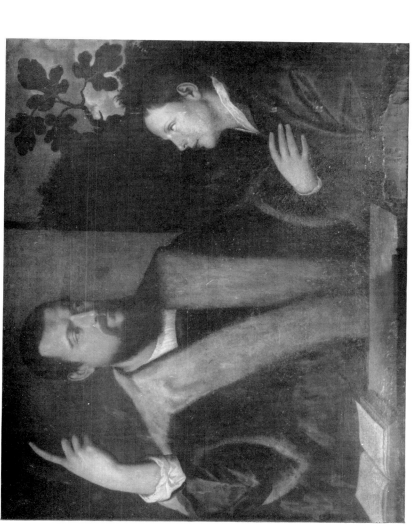

131. Copy of Titian: *Francesco Filetto and Son.* Before 1660. Ankara, German Embassy (Cat. no. 33, copy 1)

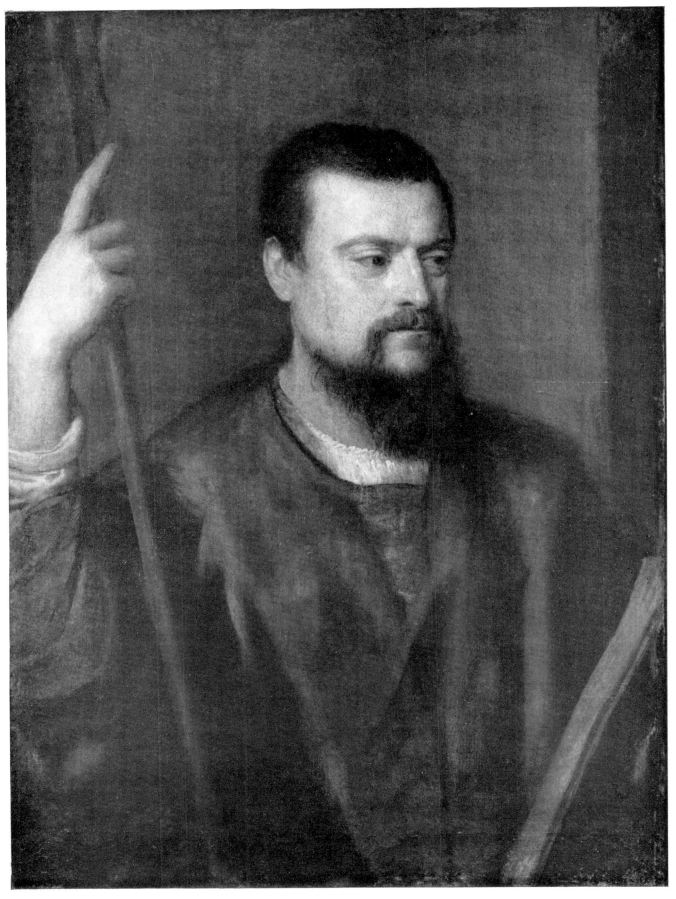

133. Titian: *Filetto*. About 1538–1540. Vienna, Kunsthistorisches Museum (Cat. no. 33)

Confucius

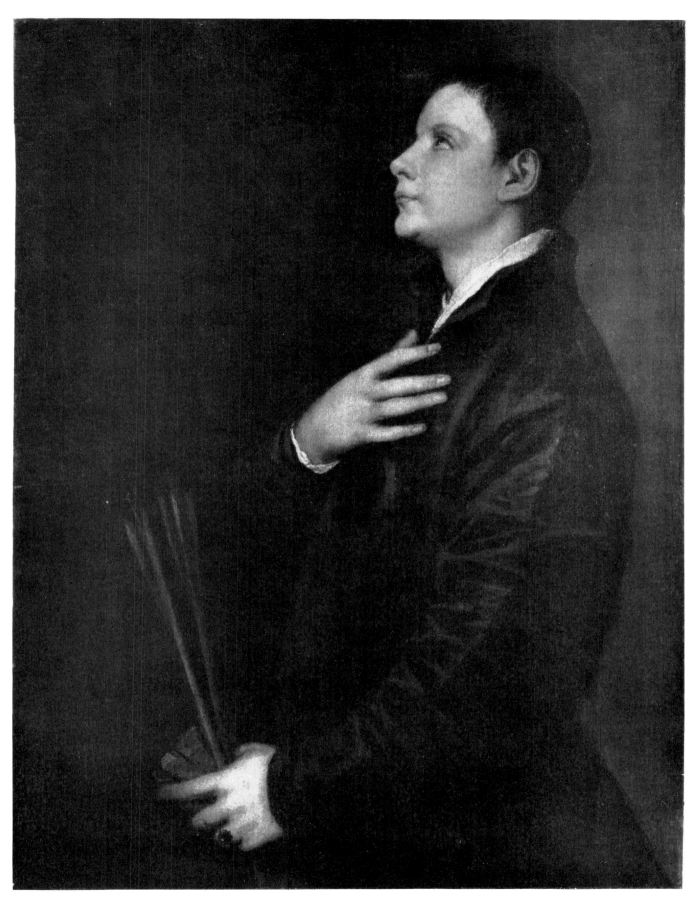

134. Titian: *Filetto's Son*. About 1538–1540. Vienna, Kunsthistorisches Museum (Cat. no. 33)

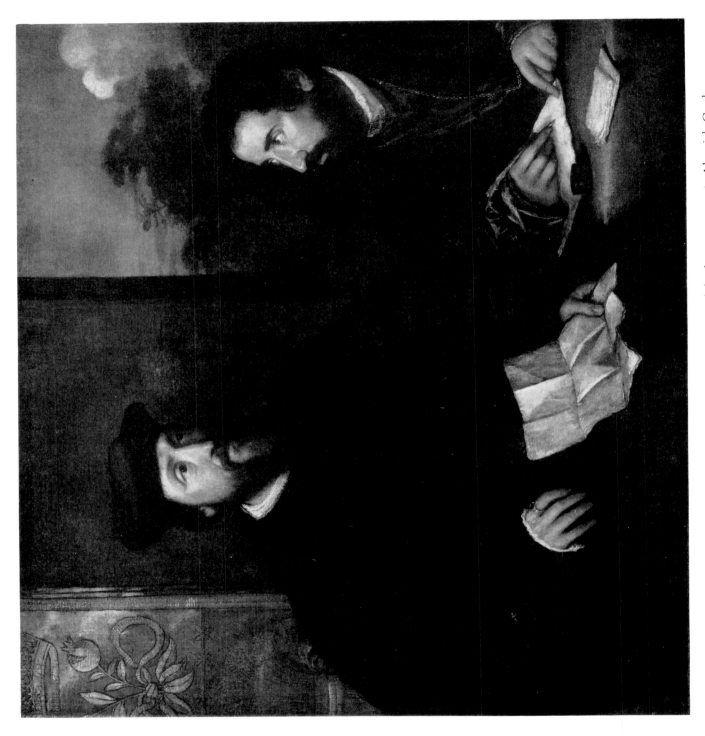

135. Titian: *Georges d'Armagnac and His Secretary Guillaume Philandrier*. 1536–1538. Alnwick Castle, Duke of Northumberland (Cat. no. 8)

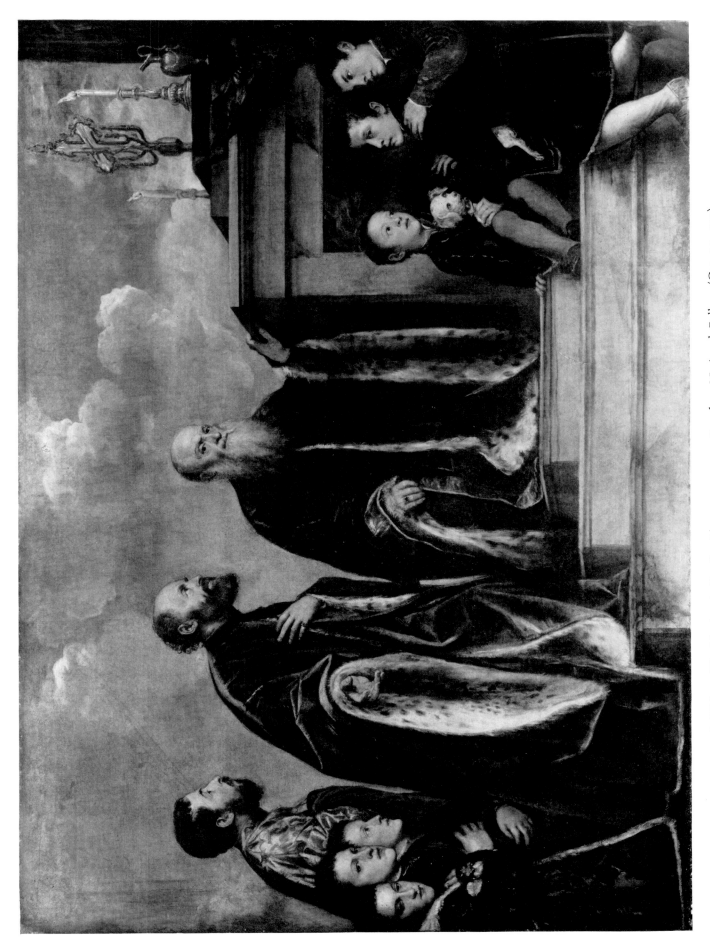

136. Titian: *The Vendramin Family*. About 1543–1547. London, National Gallery (Cat. no. 110)

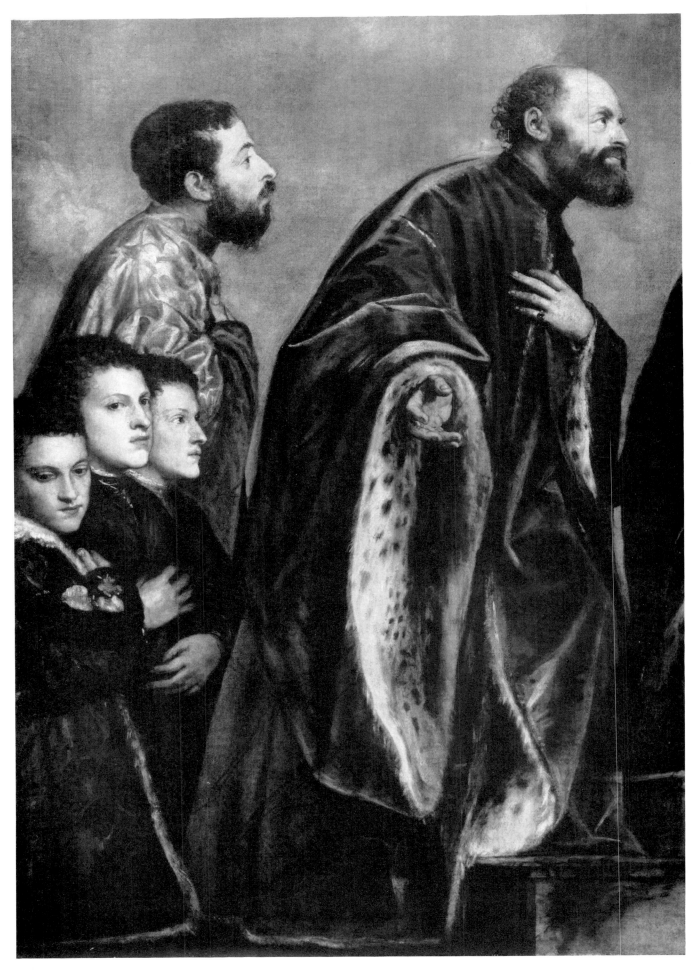

137. *Andrea Vendramin and His Son*. Detail from Plate 136

138. *Reliquary of the Holy Cross.* Detail from Plate 136

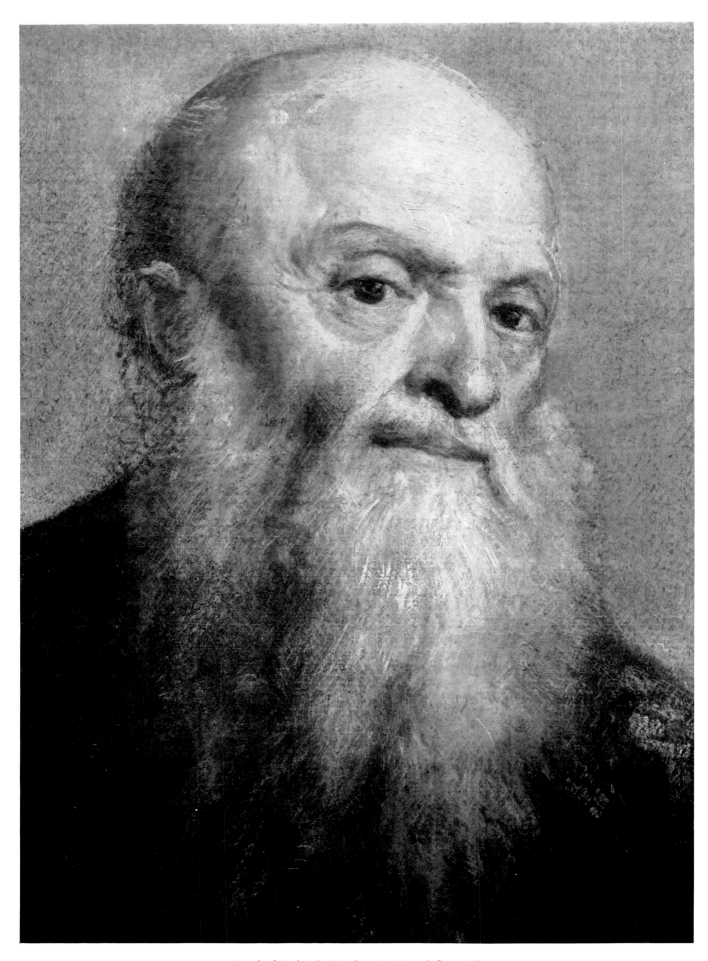

139. *Head of Gabriele Vendramin*. Detail from Plate 136

140. *Hand of Gabriele Vendramin.* Detail from Plate 136

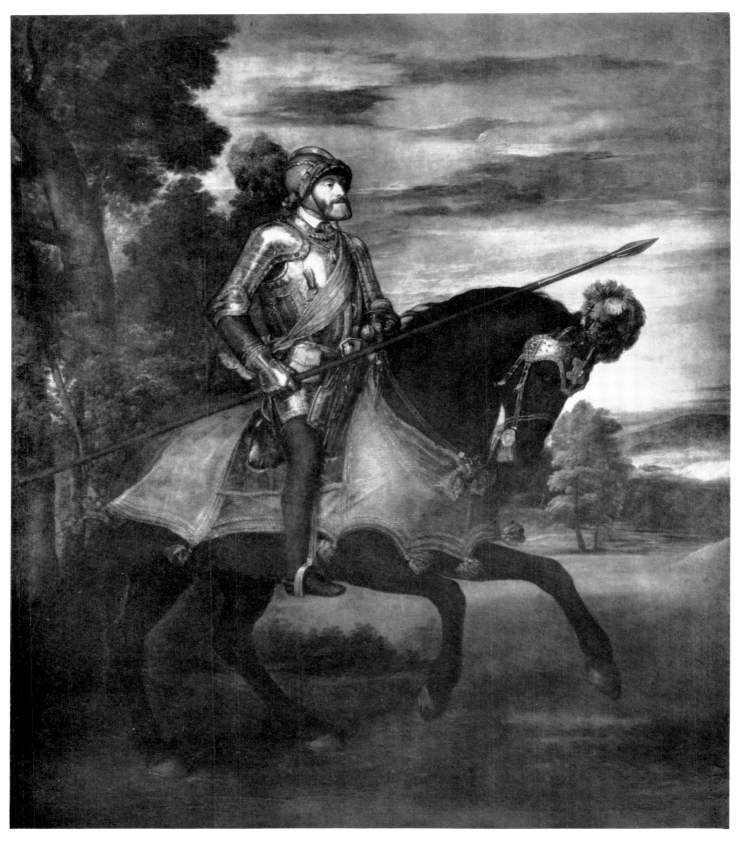

141. Titian: *Charles V at Mühlberg*. 1548. Madrid, Prado Museum (Cat. no. 21)

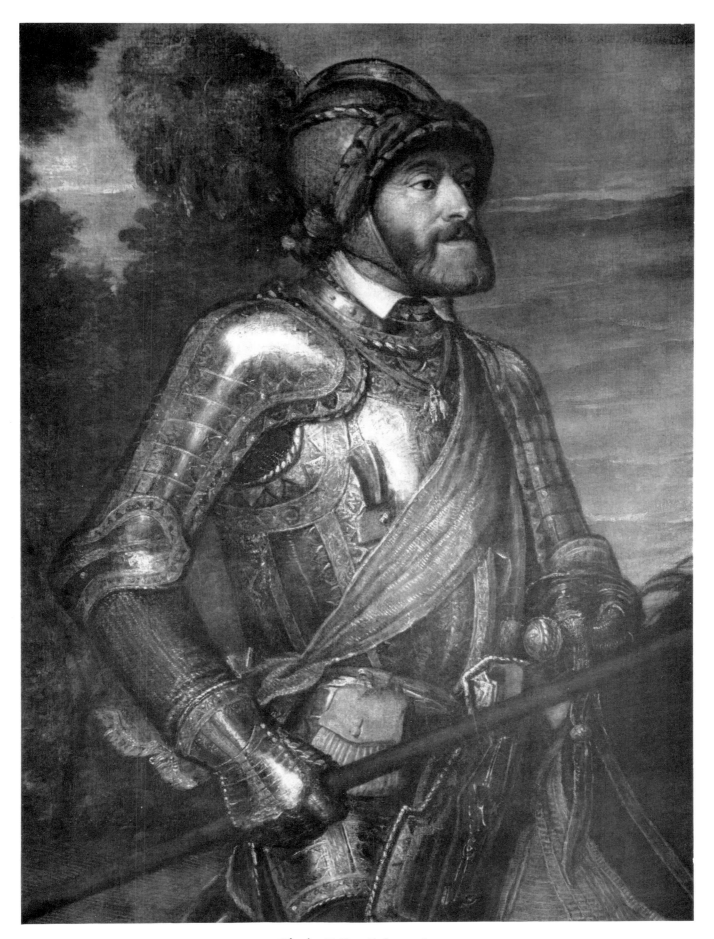

142. *Charles V*. Detail from Plate 141

143. *Horse*. Detail from Plate 141

144. *Landscape*. Detail from Plate 141

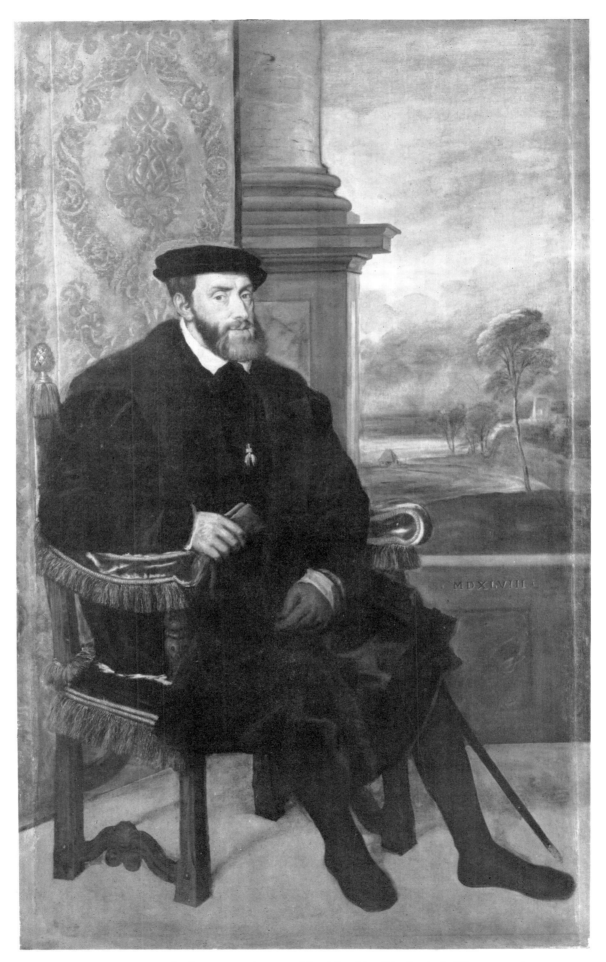

145. Titian: *Charles V Seated*. 1548. Munich, Alte Pinakothek (Cat. no. 22)

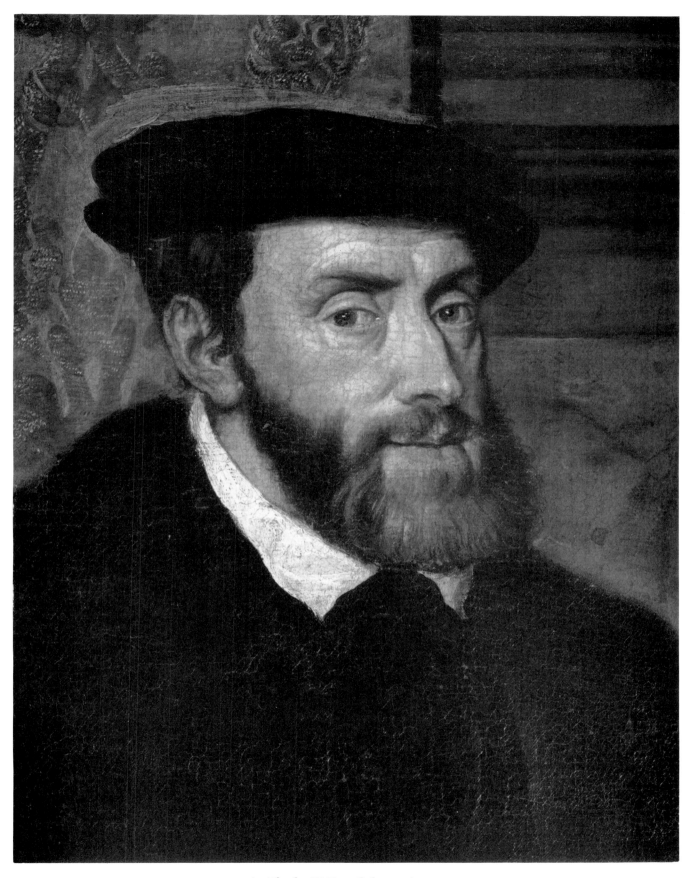

146. *Charles V.* Detail from Plate 145

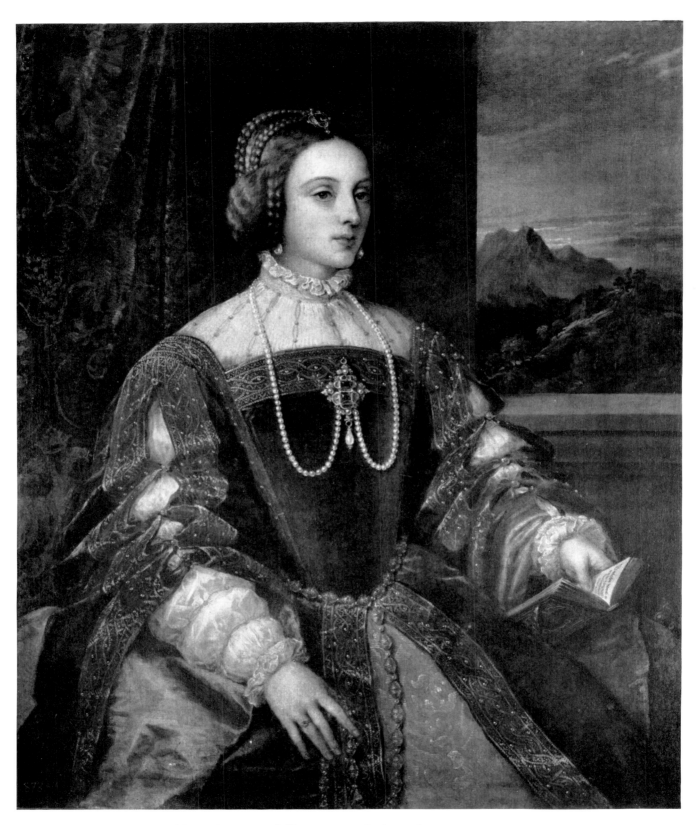

147. Titian: *Empress Isabella*. 1548. Madrid, Prado Museum (Cat. no. 53)

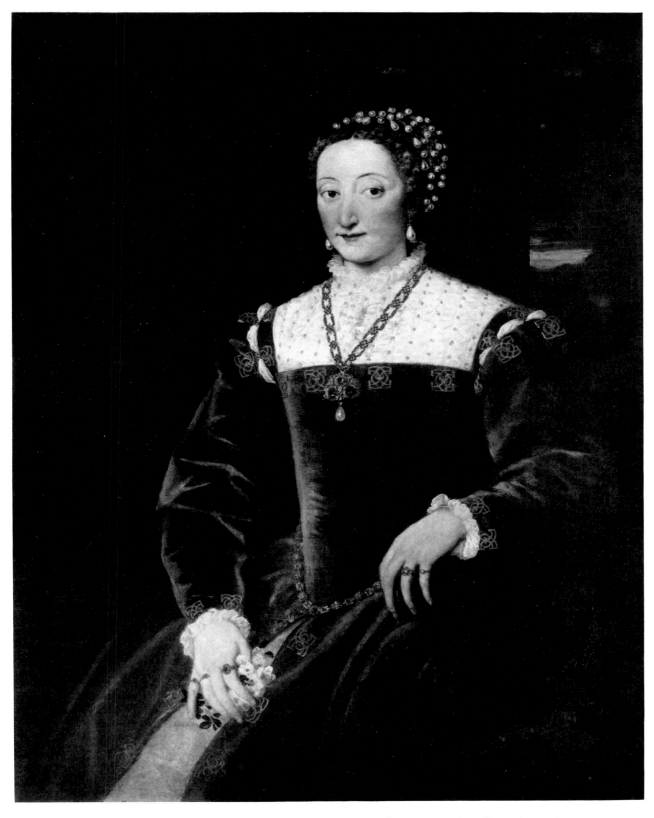

148. Titian: *Giulia Varano, Duchess of Urbino.* 1545–1547. Florence, Pitti Gallery, State Apartments
(Cat. no. 90)

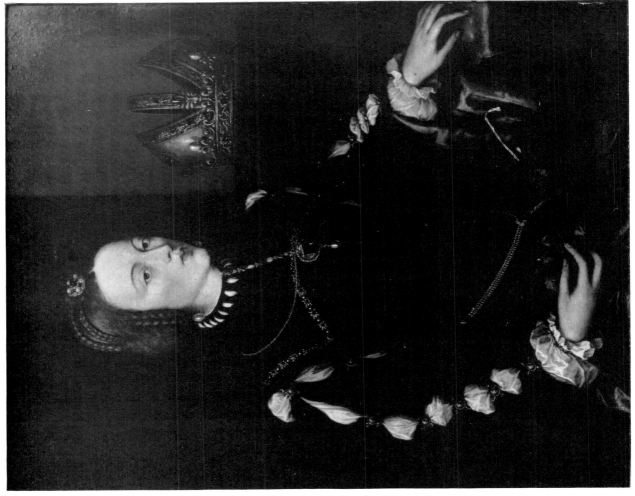

150. Copy of Titian: *Empress Isabella* (1544–1545). Paris, Roblot–Delondre (formerly) (Cat. no. L–20, copy 5)

149. Titian: *Empress Isabella.* Detail from Plate 147

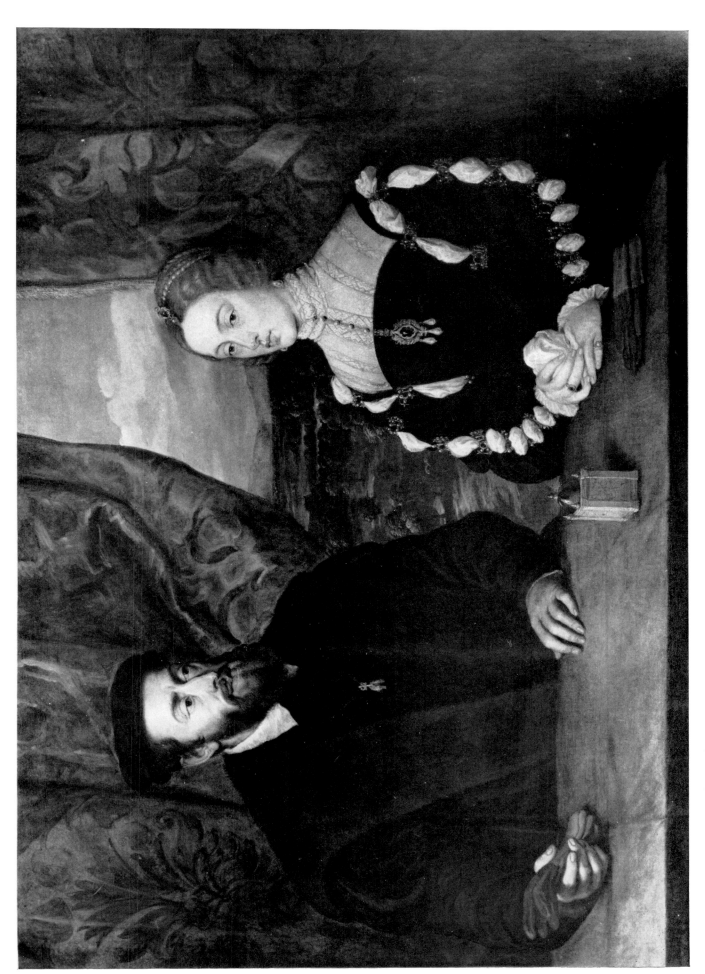

151. Rubens after Titian: *Charles V and Empress Isabella* (1548). Madrid, Duke and Duchess of Alba. (Cat. no. L–6, copy)

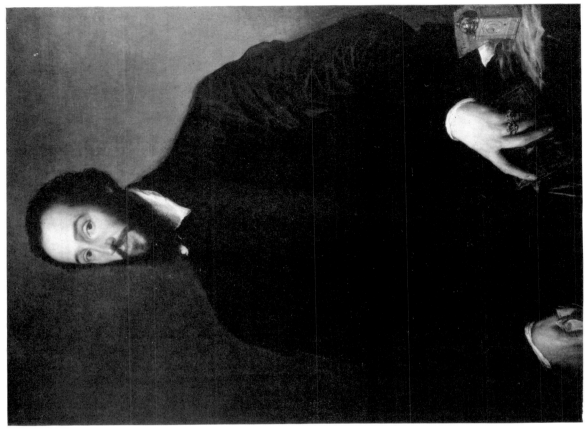

153. Titian and workshop: *Antoine Perrenot, Cardinal Granvelle*. 1548.
Kansas City, William Rockhill Nelson Gallery (Cat. no. 77)

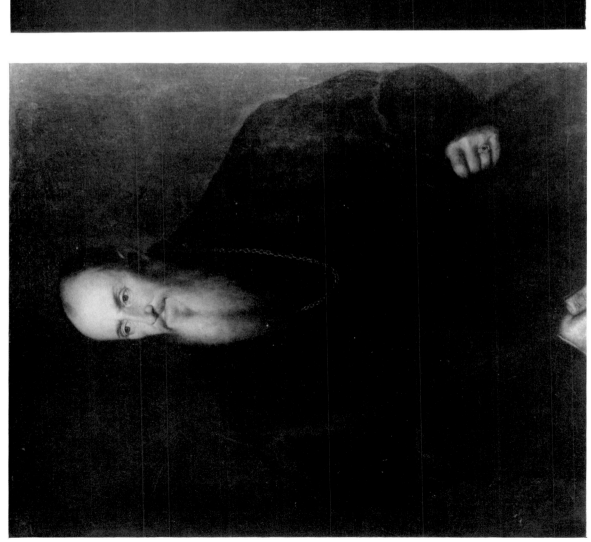

152. Workshop of Titian (Lambert Sustris): *Nicholas Perrenot, Seigneur de Granvelle*.
About 1548. Besançon, Granvelle Palace (Cat. no. X–82)

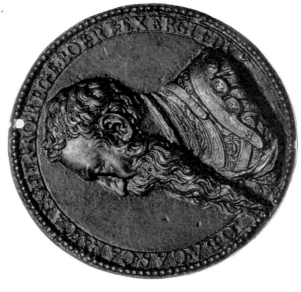

155. Annibal: *Giovanni Battista Castaldo*. Medal. Washington, National Gallery of Art, Samuel H. Kress Collection

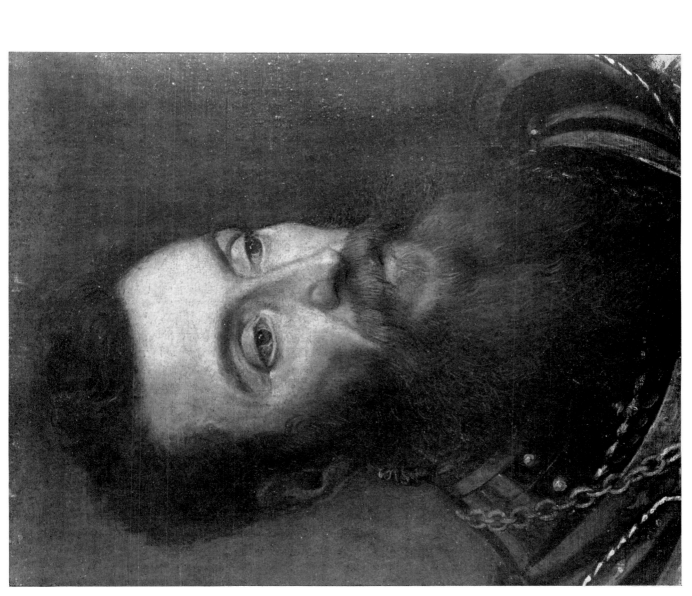

154. *Giovanni Battista Castaldo*. Detail from Plate 156

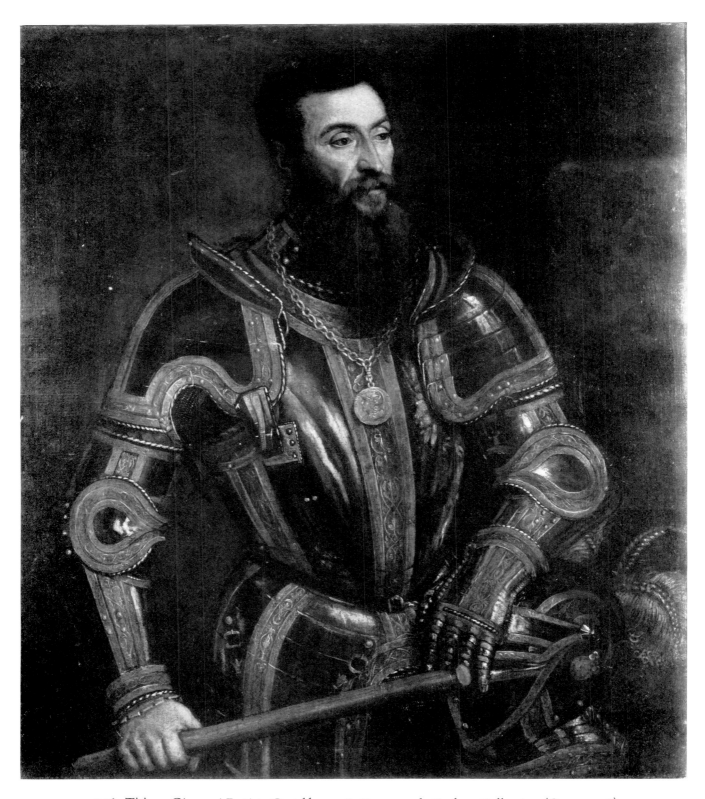

156. Titian: *Giovanni Battista Castaldo*. 1548. Dortmund, Becker Collection (Cat. no. 18)

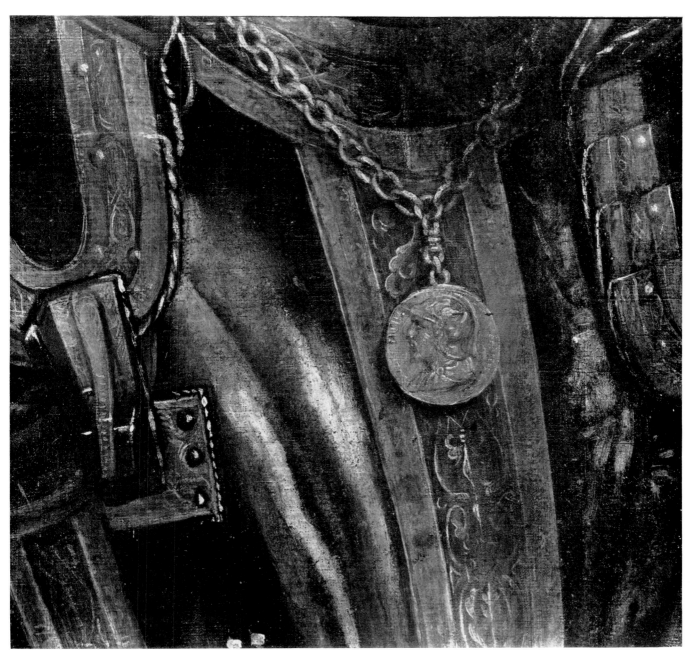

157. *Castaldo's Armour*. Detail from Plate 156

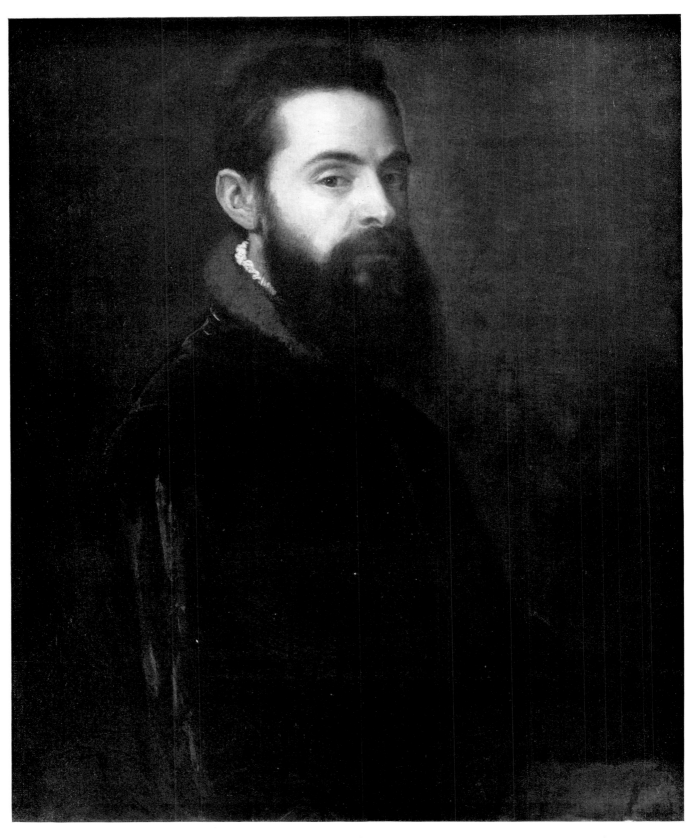

158. Titian: *Antonio Anselmi*. 1550. Lugano, Thyssen–Bornemisza Collection (Cat. no. 2)

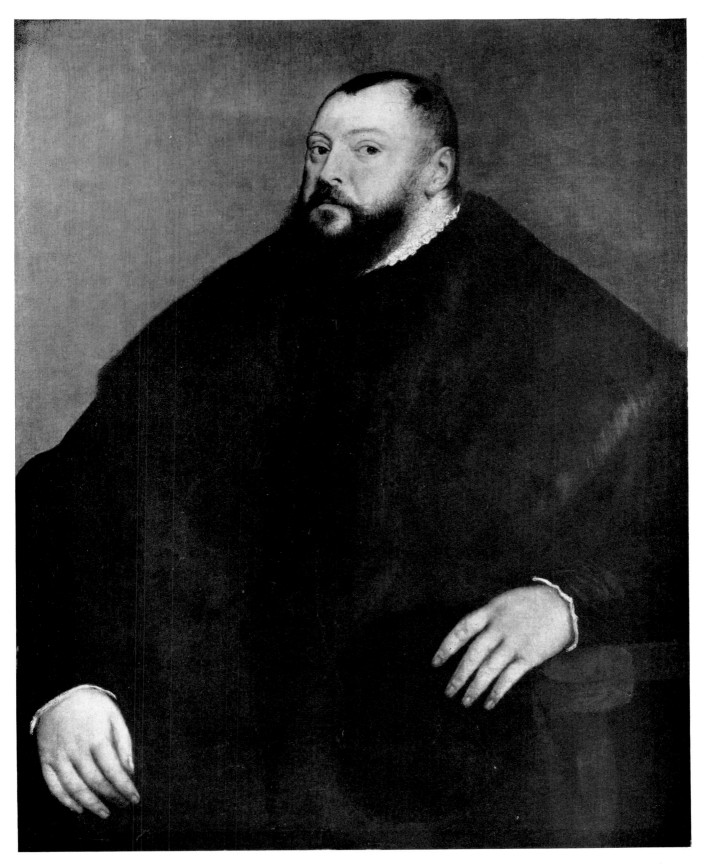

159. Titian: *Johann Friedrich of Saxony*. 1550–1551. Vienna, Kunsthistorisches Museum (Cat. no. 54)

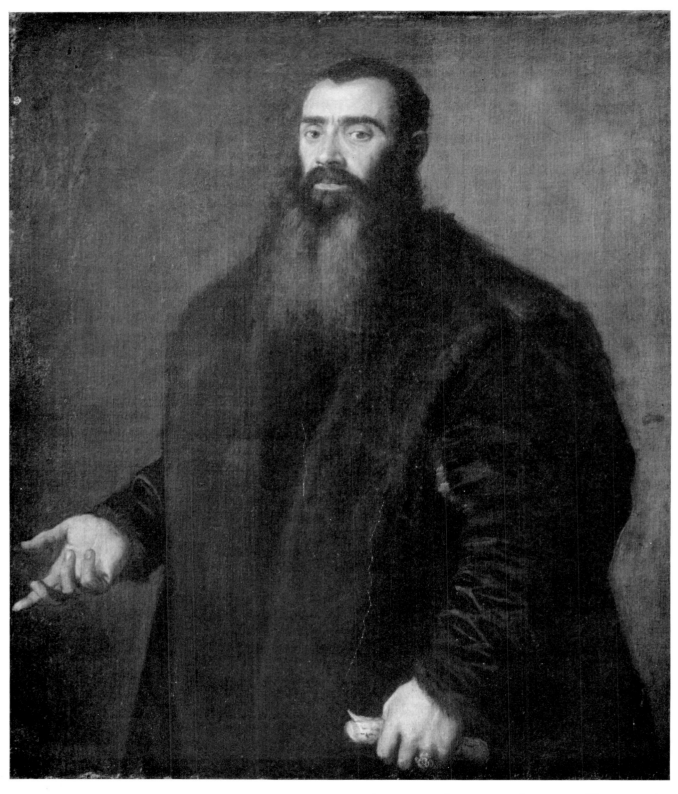

160. Titian: *Scholar with a Black Beard*. About 1550. Copenhagen, Royal Museum of Fine Arts (Cat. no. 96)

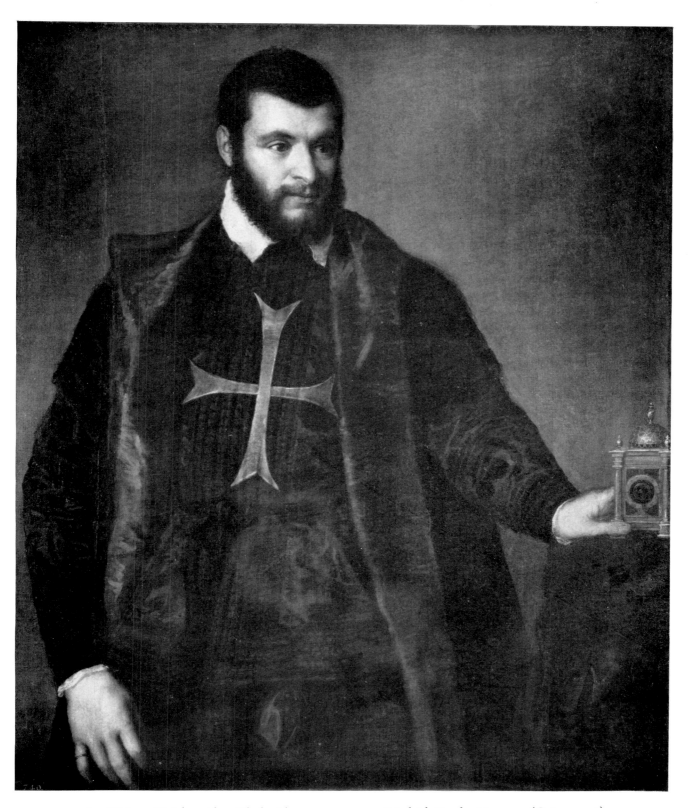

161. Titian: *Knight with a Clock*. About 1550–1552. Madrid, Prado Museum (Cat. no. 58)

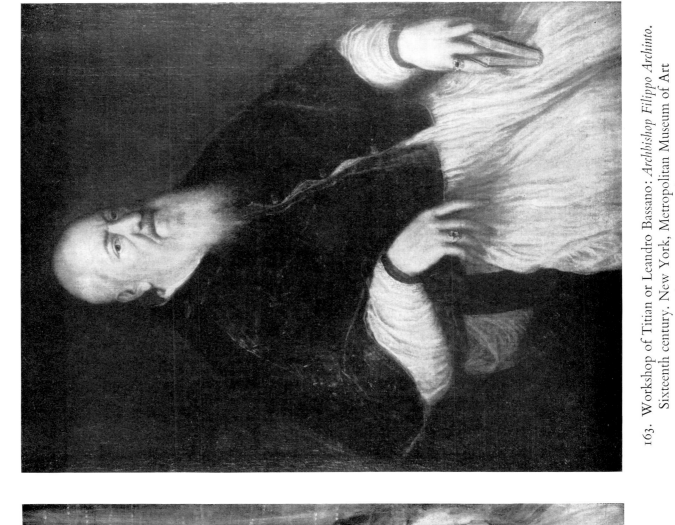

163. Workshop of Titian or Leandro Bassano: *Archbishop Filippo Archinto.*
Sixteenth century. New York, Metropolitan Museum of Art
(Cat. no. 4, variant)

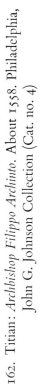

162. Titian: *Archbishop Filippo Archinto.* About 1558. Philadelphia,
John G. Johnson Collection (Cat. no. 4)

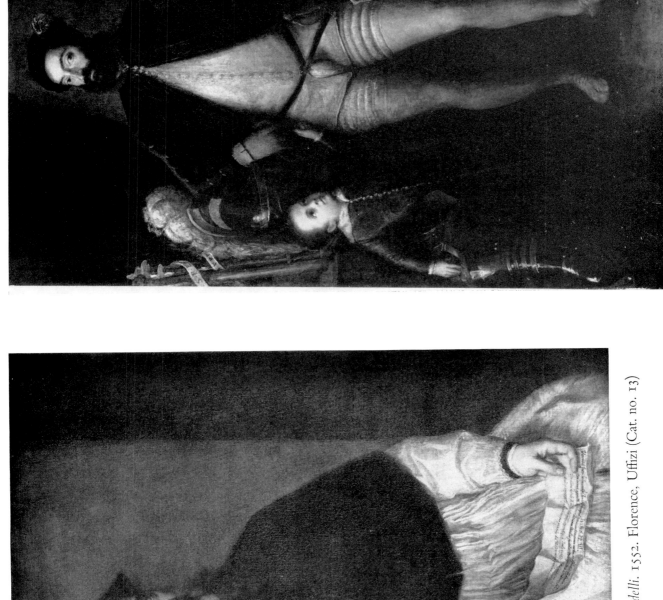

165. Titian: *Guidobaldo II della Rovere and His Son.* 1552.
Location unknown (Cat. no. 91)

164. Titian: *Bishop Ludovico Beccadelli.* 1552. Florence, Uffizi (Cat. no. 13)

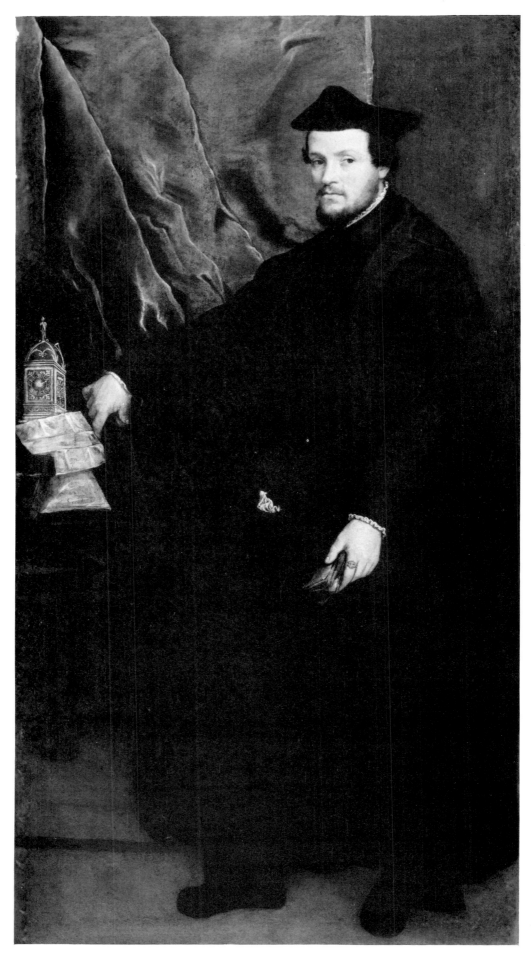

166. Titian: *Cardinal Cristoforo Madruzzo*. 1552. São Paulo, Museum of Art
(Cat. no. 62)

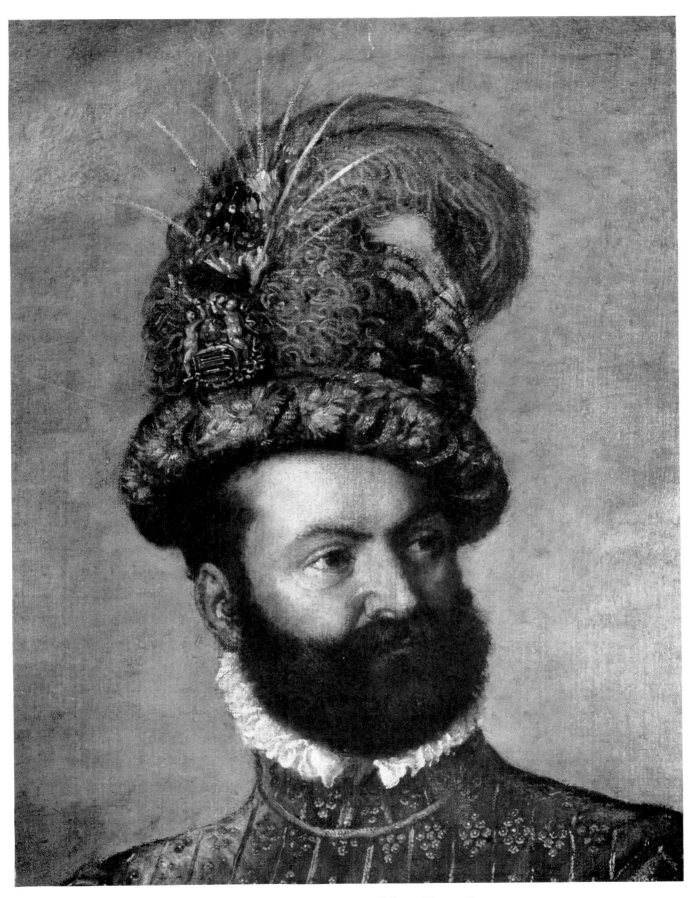

167. *Giovanni Acquaviva.* Detail from Plate 168

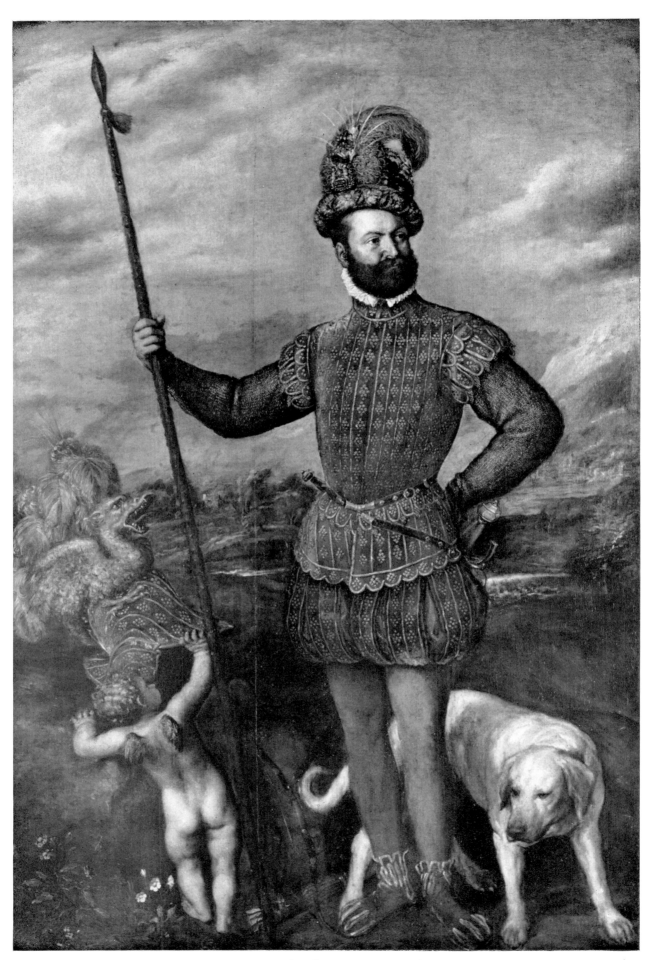

168. Titian: *Giovanni Acquaviva, Duke of Atri*. 1552. Cassel, Gemäldegalerie (Cat. no. 1)

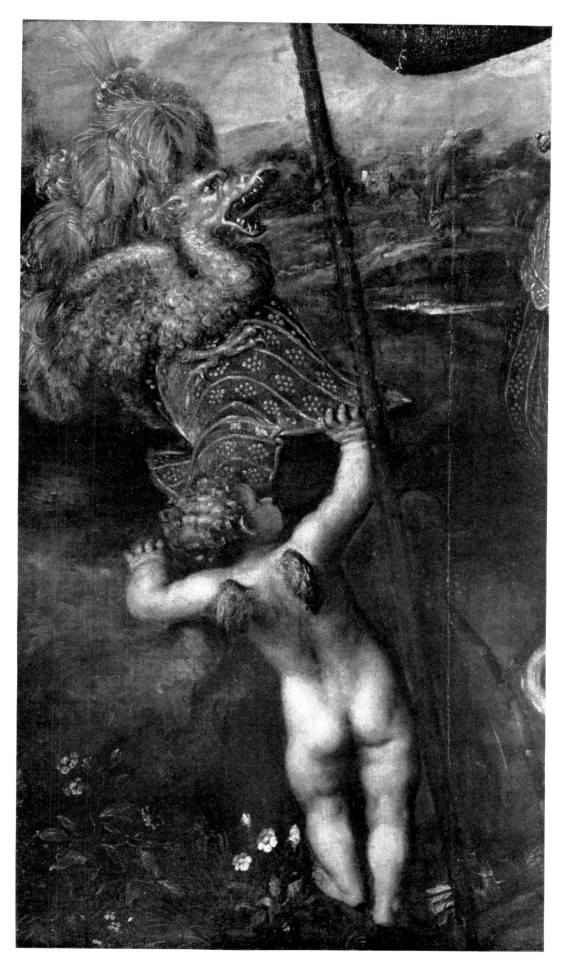

169. *Escutcheon of Giovanni Acquaviva*. Detail from Plate 168

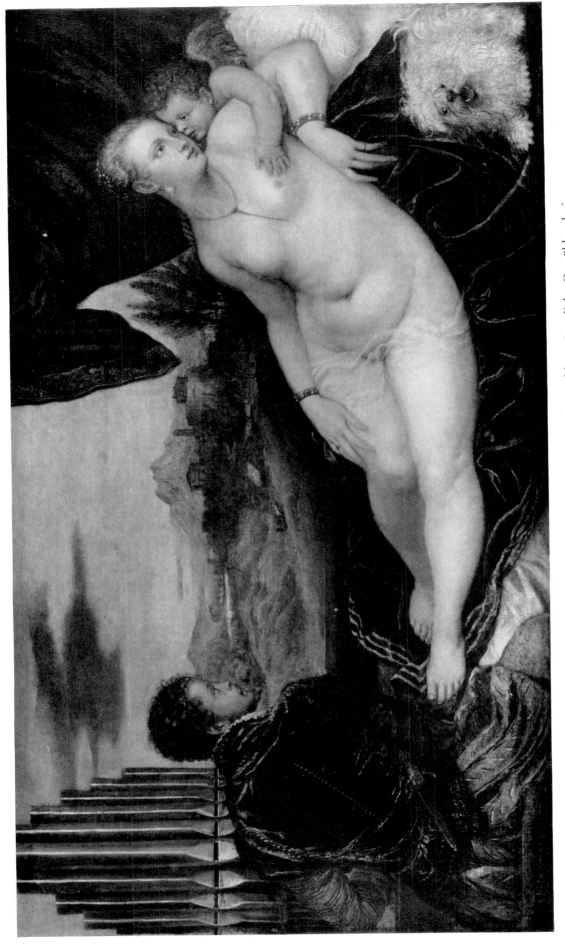

170. Titian: *Venus with Philip II as Organist.* 1548–1549. Berlin–Dahlem, Staatliche Gemäldegalerie

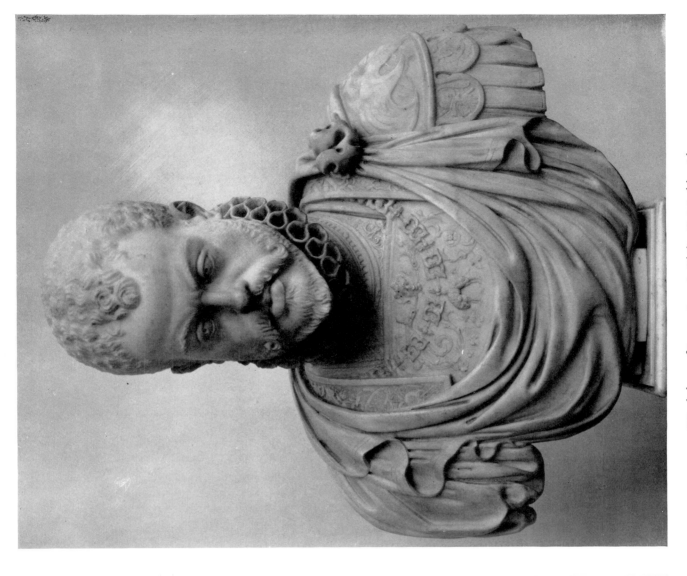

171. *Philip II as Organist.* Detail from Plate 170

172. Workshop of Leone Leoni: *Philip II.* Marble. About 1551. New York, Metropolitan Museum of Art

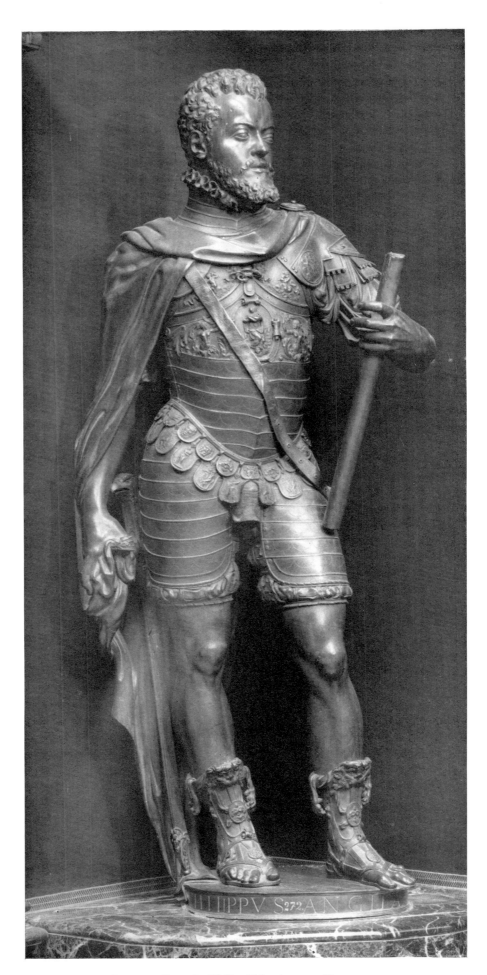

173. Pompeo Leoni: *Philip II in Armour.* Bronze. 1551.
Madrid, Prado Museum

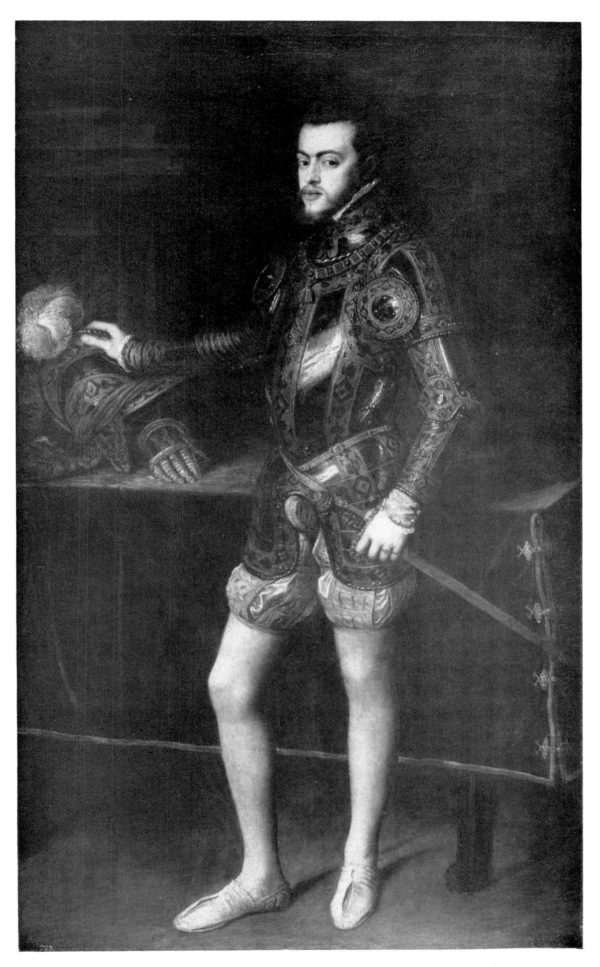

174. Titian: *Philip II in Armour*. 1550–1551. Madrid, Prado Museum (Cat. no. 78)

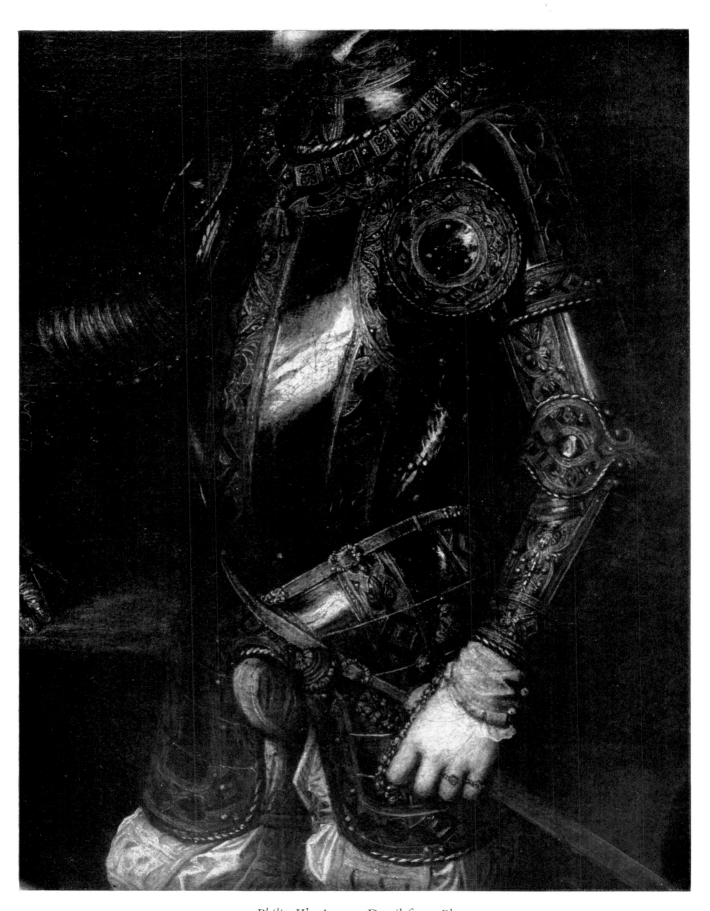

175. *Philip II's Armour.* Detail from Plate 174

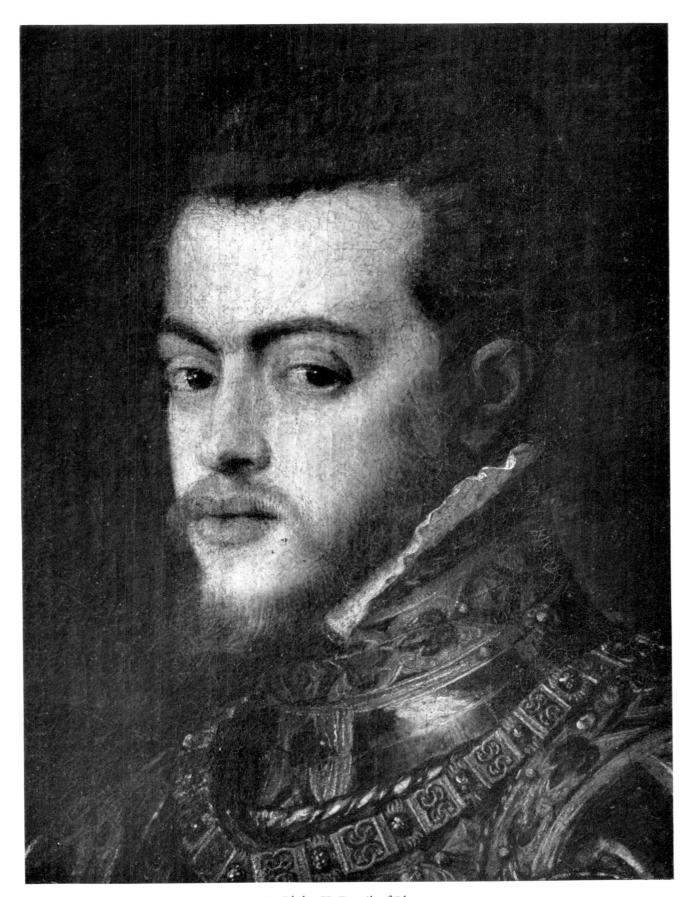

176. *Philip II*. Detail of Plate 174

178. Titian: *Charles V, Philip II, and the Royal Family. Detail of the Trinity (La Gloria).*
1554. Madrid, Prado Museum

177. *Workshop of Titian: Philip II.* 1553. Madrid, Prado Museum
(Cat. no. 83)

180. Titian and workshop: *Philip II*. About 1554. Florence, Pitti Gallery (Cat. no. 80)

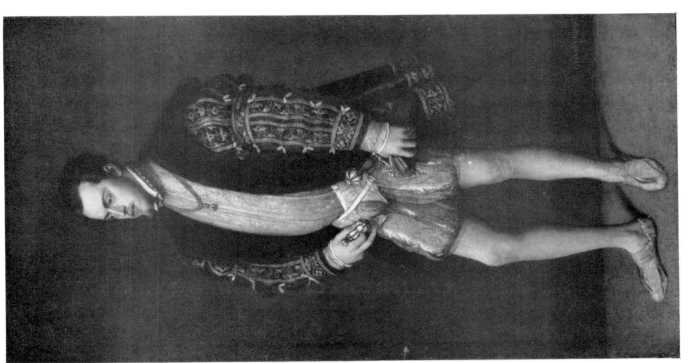

179. Titian and workshop: *Philip II*. About 1554. Naples, Gallerie Nazionali, Capodimonte (Cat. no. 79)

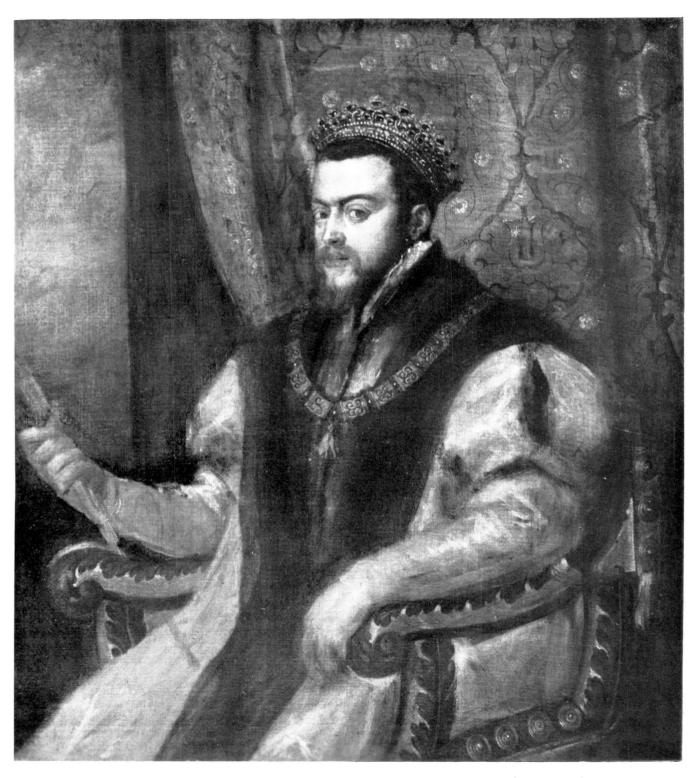

181. Titian: *Philip II, Seated with Crown*. Cincinnati, Art Museum (Cat. no. 81)

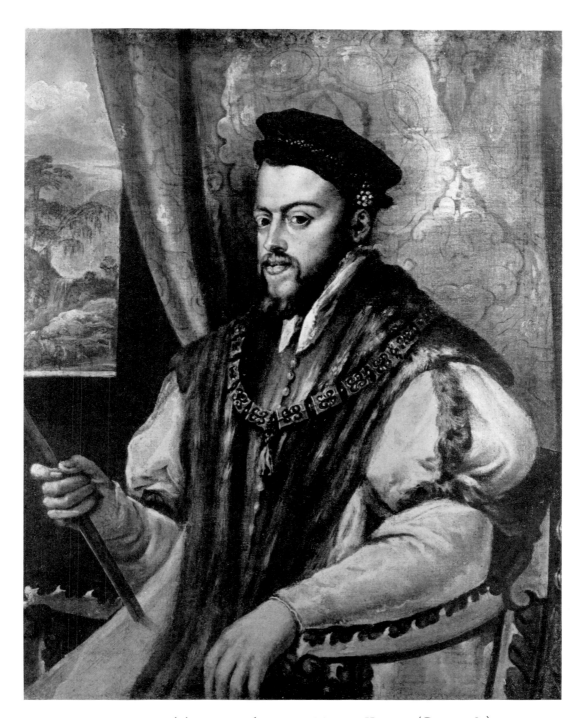

182. Titian: *Philip II, Seated*. Geneva, Torsten Kreuger (Cat. no. 82)

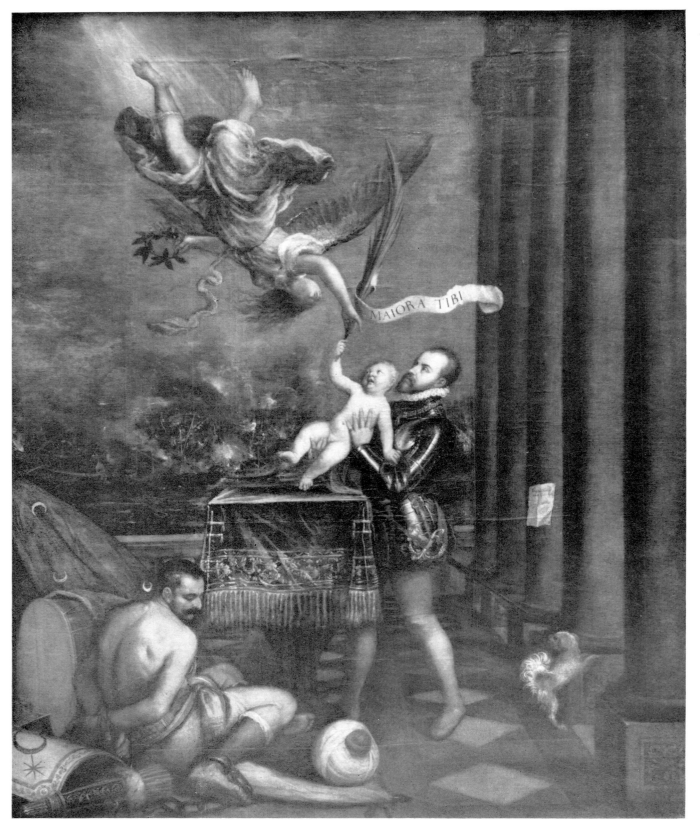

183. Titian and workshop: *Philip II, Allegorical Portrait* (*Allegory of Lepanto*). 1573–1575. Madrid, Prado Museum
(Cat. no. 84)

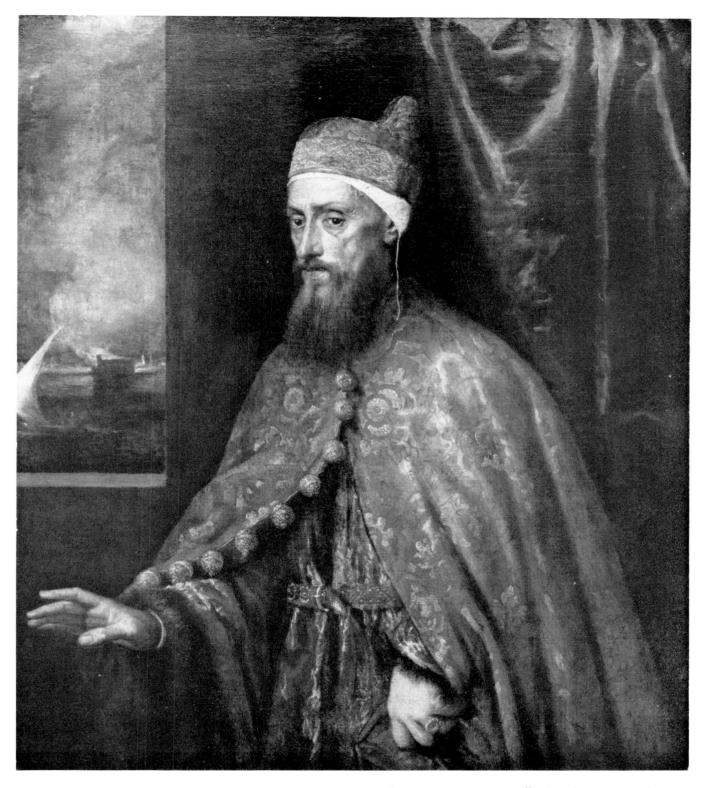

184. Titian: *Doge Francesco Venier*. 1554–1556. Lugano, Thyssen–Bornemisza Collection (Cat. no. 112)

185. *Landscape*. Detail from Plate 184

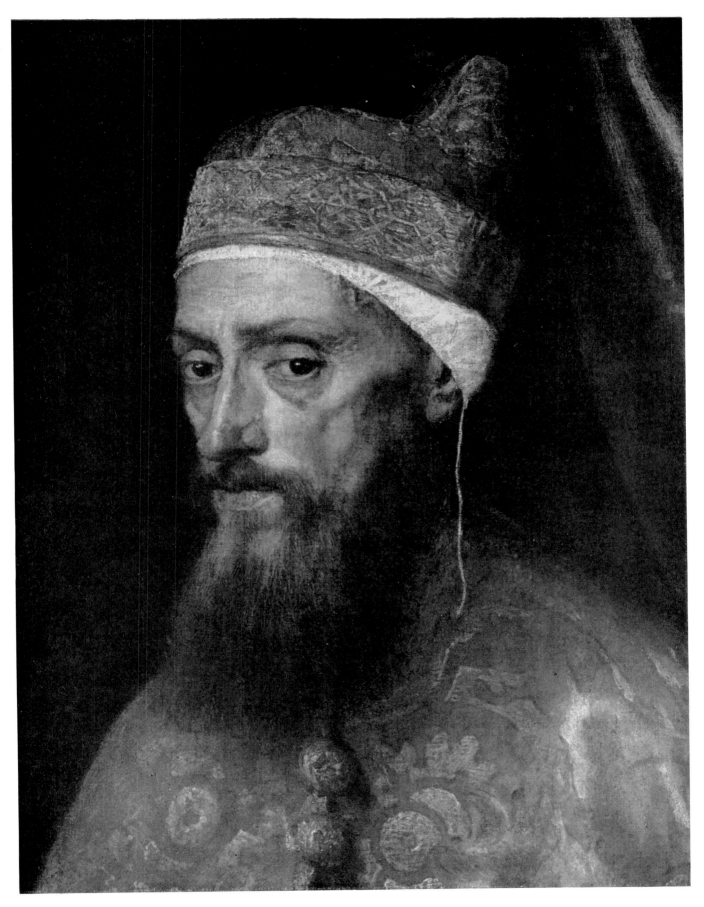

186. *Francesco Venier*. Detail from Plate 184

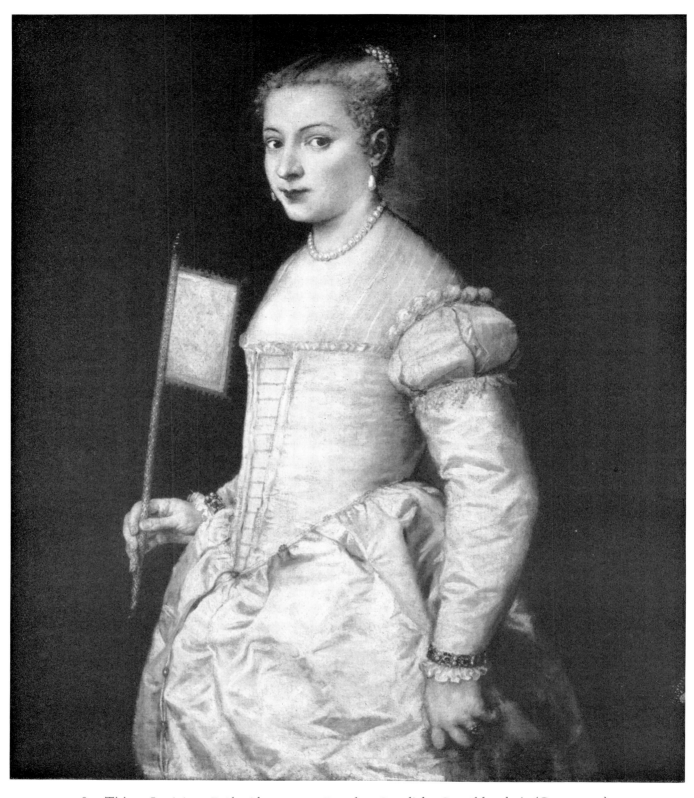

187. Titian: *Lavinia as Bride*. About 1555. Dresden, Staatliche Gemäldegalerie (Cat. no. 59)

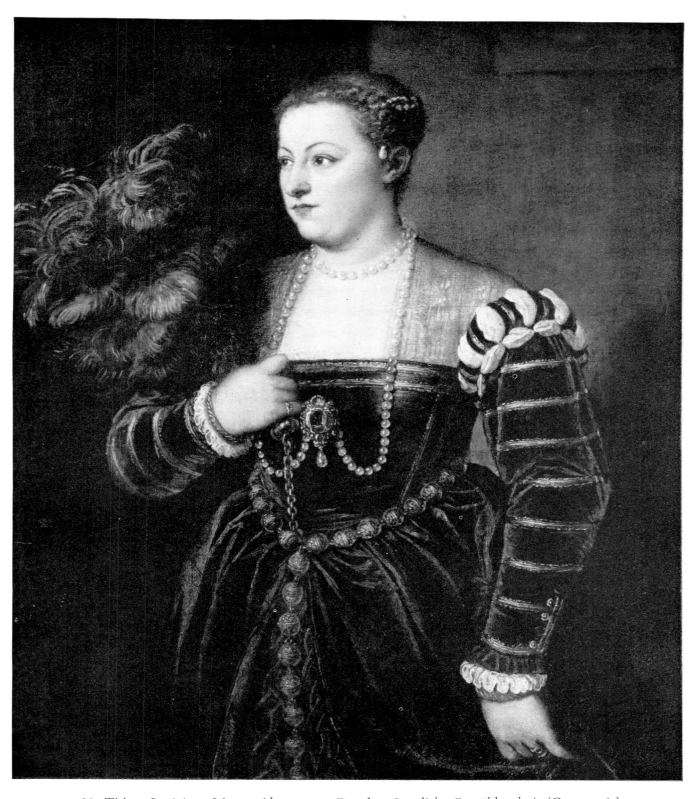

188. Titian: *Lavinia as Matron*. About 1560. Dresden, Staatliche Gemäldegalerie (Cat. no. 61)

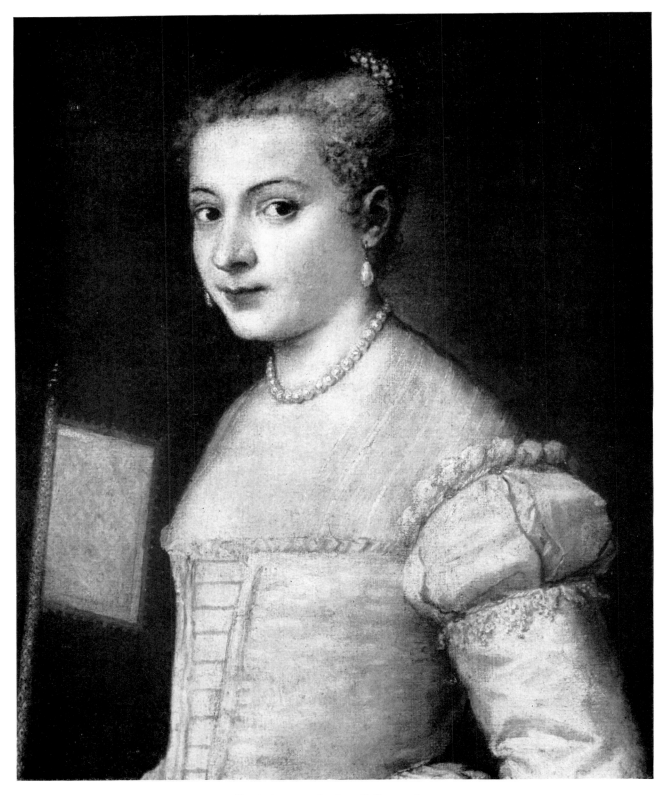

189. *Lavinia as Bride*. Detail from Plate 187

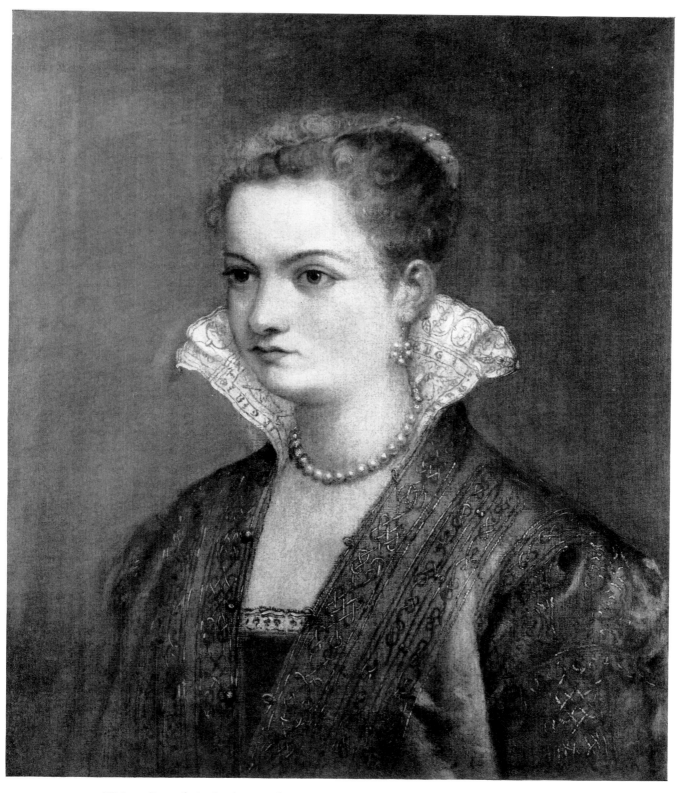

190. Titian: *Irene di Spilembergo*. About 1559. New York, Private Collection (Cat. no. 99)

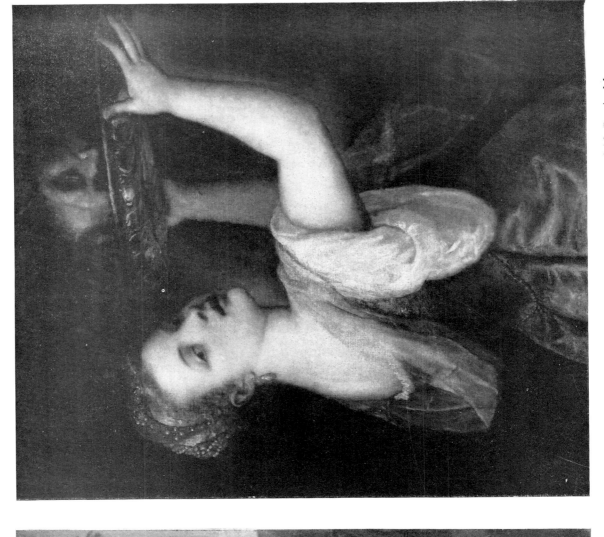

191. Titian: *Lavinia with a Tray of Fruit (Pomona?)*. About 1555.
Berlin-Dahlem, Staatliche Gemäldegalerie (Cat. no. 60)

192. Titian: *Lavinia as Salome*. About 1550–1555. Madrid, Prado Museum
(Cat. no. 60, variant 3)

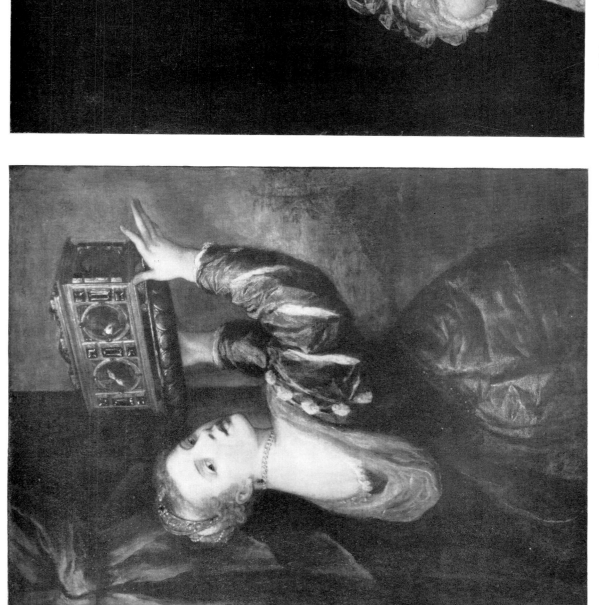

193. Follower of Titian: *Lavinia with a Casket*. Sixteenth century.
London, Mrs. Abbott (Cat. no. 60, variant 1)

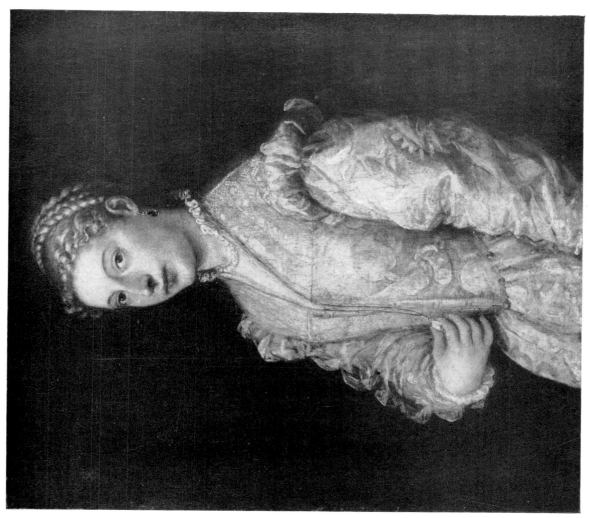

194. Titian: *Venetian Girl*. About 1545–1546. Naples, Gallerie Nazionali,
Capodimonte (Cat. no. 111)

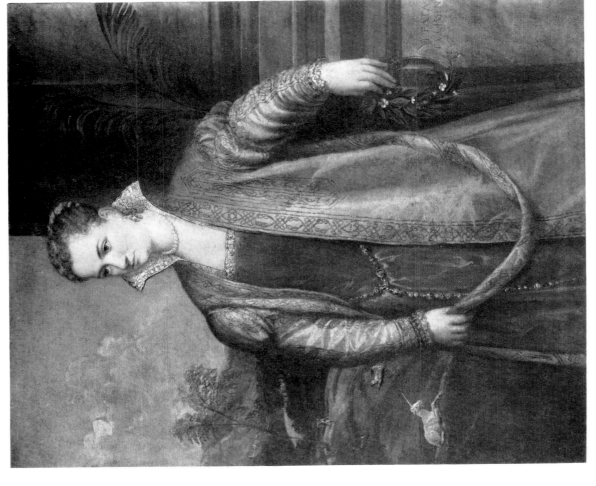

196. Gian Paolo Pace and Titian: *Irene di Spilembergo*. About 1560.
Washington, National Gallery of Art (Cat. no. X–89)

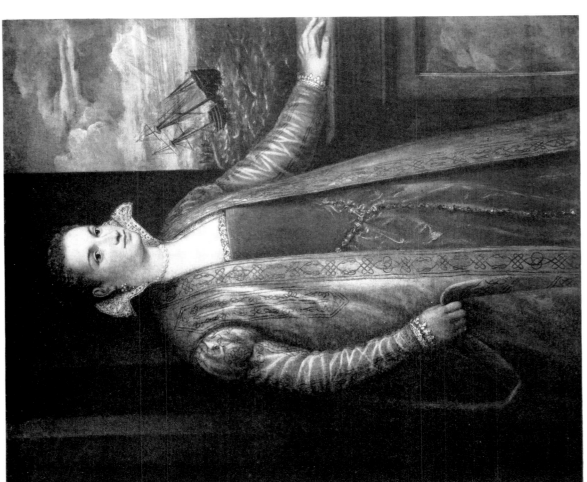

195. Gian Paolo Pace: *Emilia di Spilembergo*. About 1560. Washington,
National Gallery of Art, Widener Collection (Cat. no. X–88)

198. *Landscape.* Detail from Plate 196

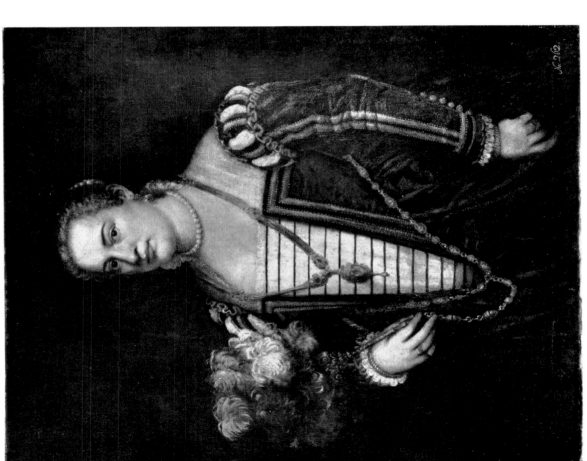

197. Follower of Titian: *Lavinia as Matron* (so-called). Sixteenth century. Vienna, Kunsthistorisches Museum (Cat. no. X–70)

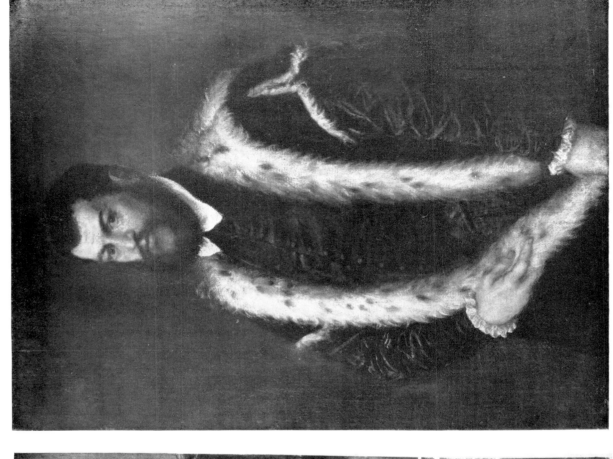

200. Titian (?): *Filippo Strozzi* (incorrectly called). About 1560.
Vienna, Kunsthistorisches Museum (Cat. no. 102)

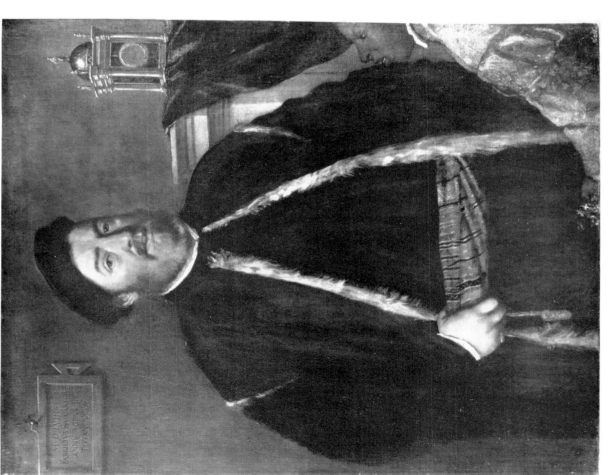

199. Titian: *Fabrizio Salvaresio*. 1558. Vienna, Kunsthistorisches Museum
(Cat. no. 92)

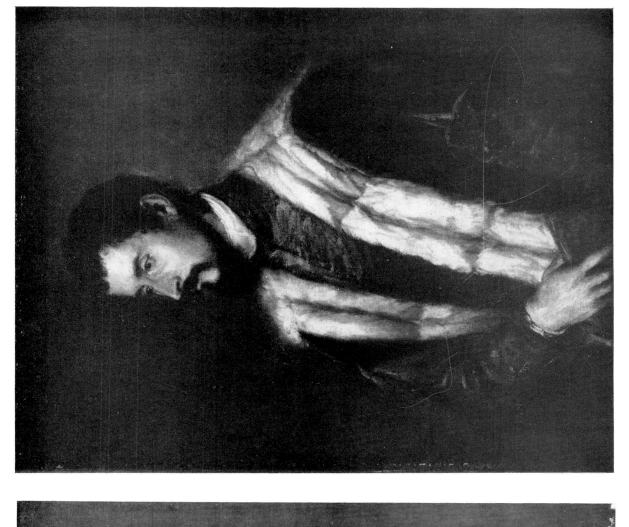

202. Titian: *Niccolò Orsini* (so-called). 1561. Baltimore, Museum of Art
(Cat. no. 68)

201. Titian: *Man with a Flute*. About 1560–1565. Detroit, Institute of Arts
(Cat. no. 63)

203. *Clock*. Detail from Plate 199

204. *Landscape*. Detail from Plate 205

205. Titian: *Antonio Palma*. 1561. Dresden, Staatliche Gemäldegalerie (Cat. no. 69)

206. Titian: *Jacopo Strada*. 1567–1568. Vienna, Kunsthistorisches Museum (Cat. no. 100)

207. *Jacopo Strada*. Detail from Plate 206

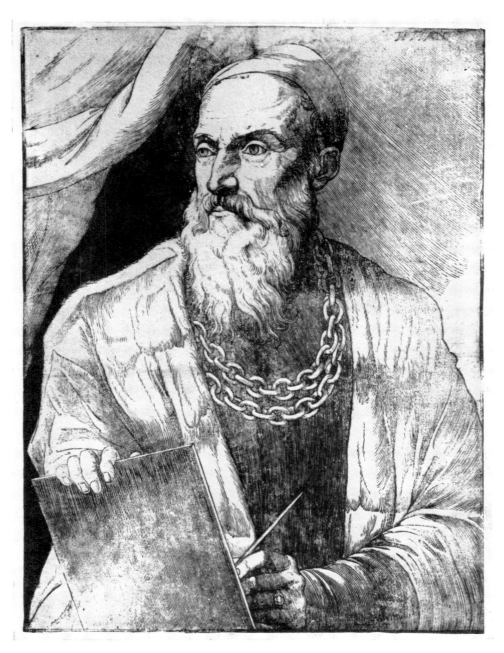

208. Giovanni Britto: *Titian* (engraving). 1550. London, British Museum
(Cat. no. 104, engraving 1)

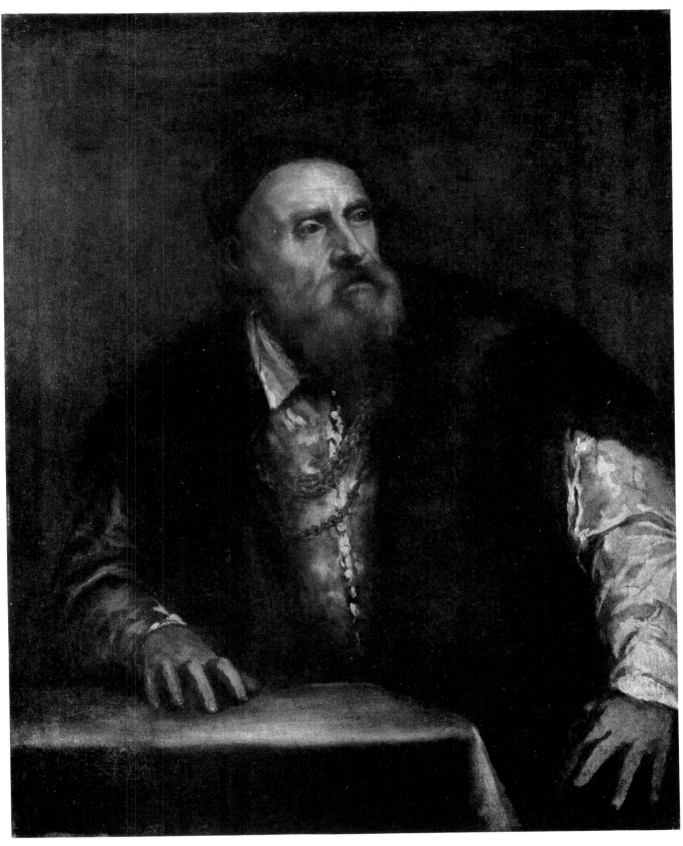

209. Titian: *Self-Portrait*. About 1550. Berlin–Dahlem, Staatliche Gemäldegalerie (Cat. no. 104)

210. Titian: *Self-Portrait* (?). Drawing. About 1565. Florence, Uffizi (Cat. no. 106)

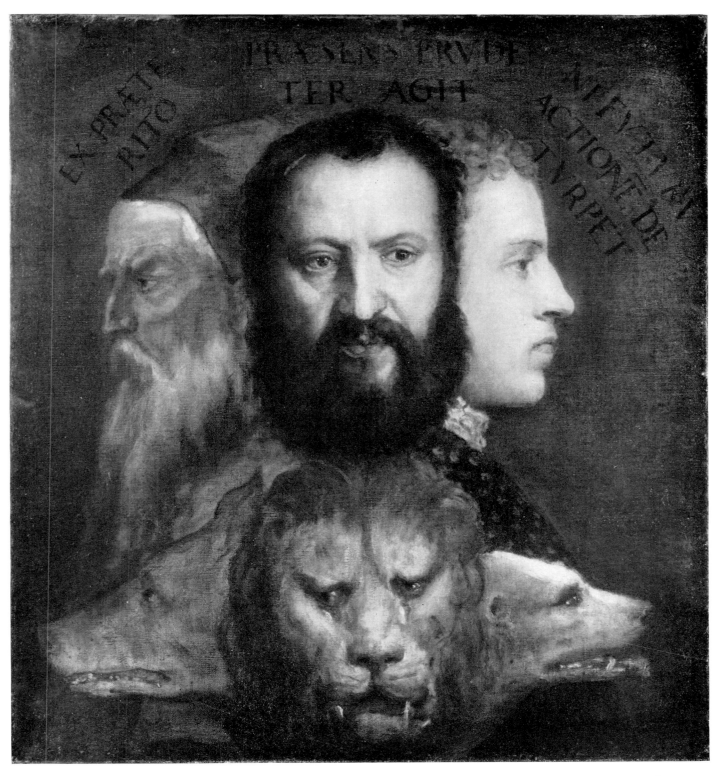

211. Titian: *Triple Portrait: Titian, Orazio Vecellio, and Marco Vecellio.* About 1570. London, National Gallery
(Cat. no. 107)

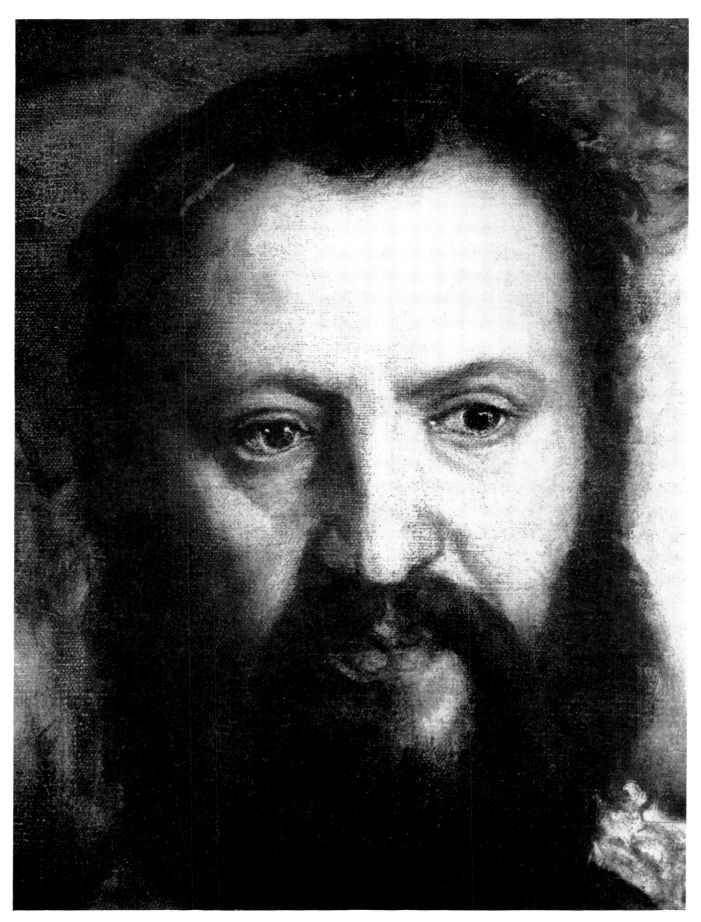

212. *Orazio Vecellio*. Detail from Plate 211

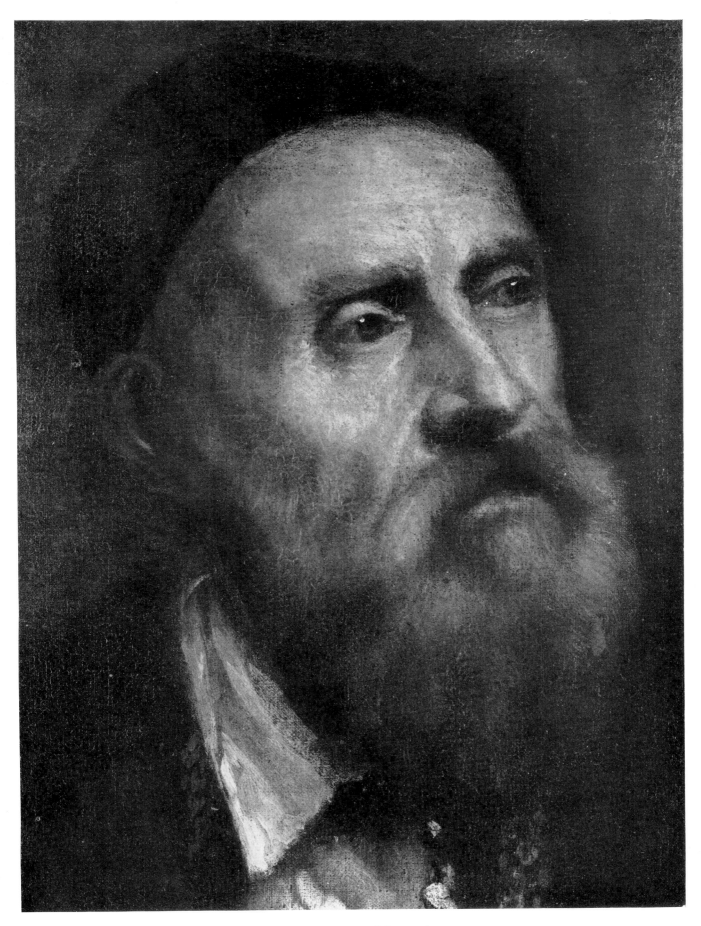

213. *Self-Portrait*. Detail from Plate 209

APPENDIX

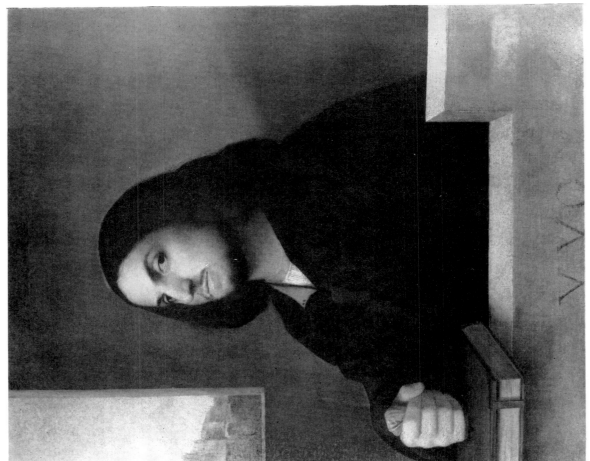

215. Giorgionesque painter: *Venetian Gentleman*. About 1510.
Washington, National Gallery of Art, Samuel H. Kress Collection
(Cat. no. X-109)

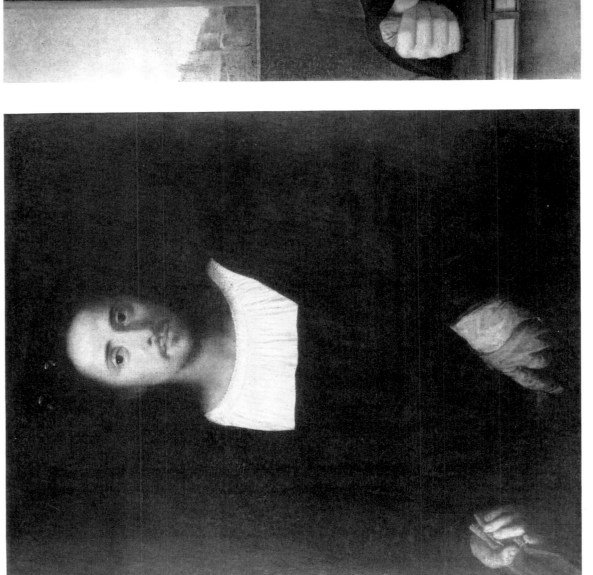

214. Giorgionesque painter: *Gentleman with Gloves*. About 1515.
Ajaccio, Musée Fesch (Cat. no. X-44)

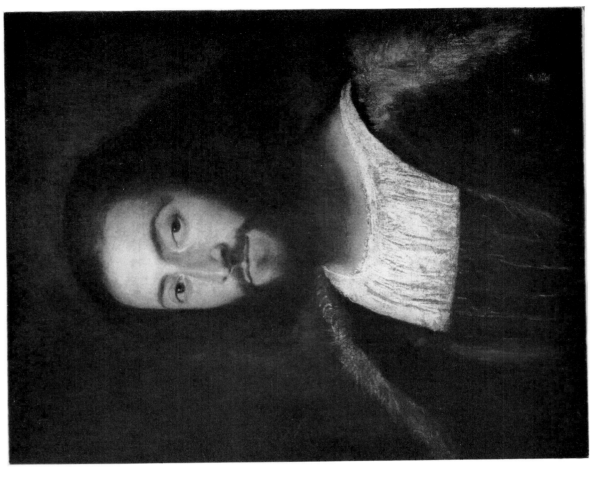

217. Titian: *Ariosto* (ruinous condition). About 1512. Indianapolis,
Indianapolis Museum of Art (Cat. no. 7)

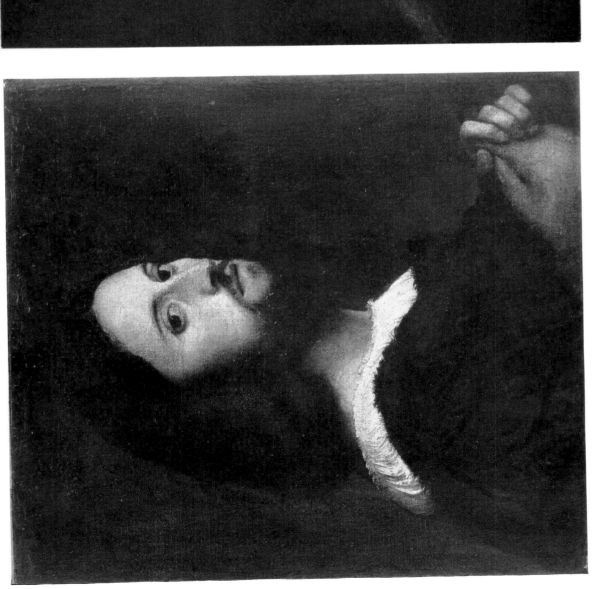

216. Giorgionesque painter: *Venetian Gentleman* (so-called *Ariosto*). About 1510.
New York, Metropolitan Museum of Art, Altman Collection (Cat. no. X–110)

219. Lucas Vorsterman after G. P. Silvio (c. 1520): *Charles de Bourbon.* Engraving. Seventeenth century. (Cat. no. X–14)

218. Wenzel Hollar after Giorgione: *Fugger Youth.* Engraving. Amsterdam, Rijksmuseum (Cat. no. X–42)

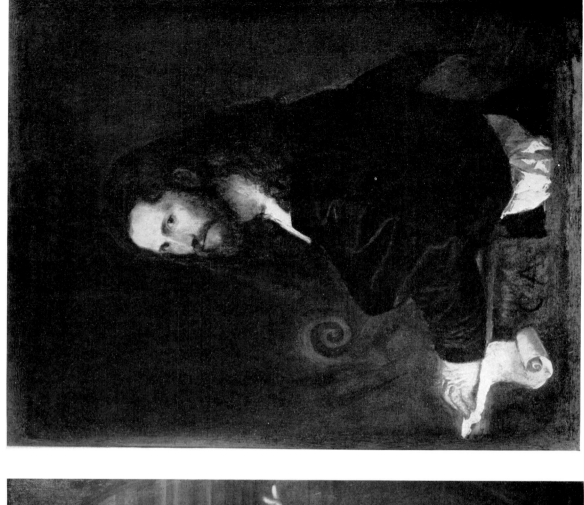

221. Venetian School: *Violinist*. Early sixteenth century. Rome,
Palazzo Spada (Cat. no. X–116)

220. Variant after Titian (?): *Queen Caterina Cornaro*. Sixteenth century.
Nicosia, Cyprus, National Museum (Cat. no. L–9, copy 3)

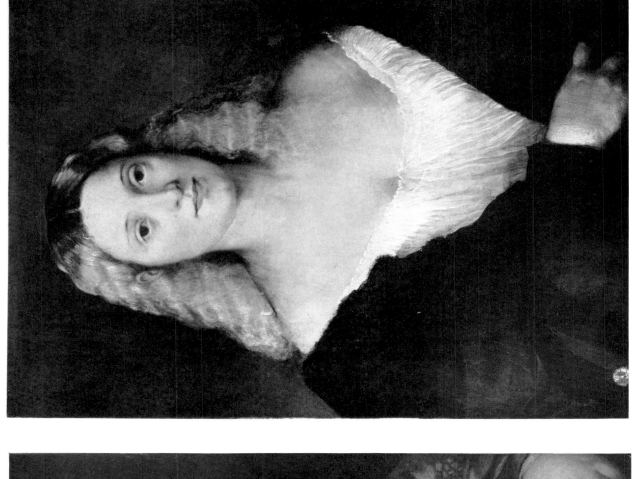

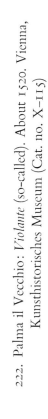

223. Palma il Vecchio: *Blonde Woman in a Black Dress*. About 1520. Vienna, Kunsthistorisches Museum (Cat. no. X–13)

222. Palma il Vecchio: *Violante* (so-called). About 1520. Vienna, Kunsthistorisches Museum (Cat. no. X–115)

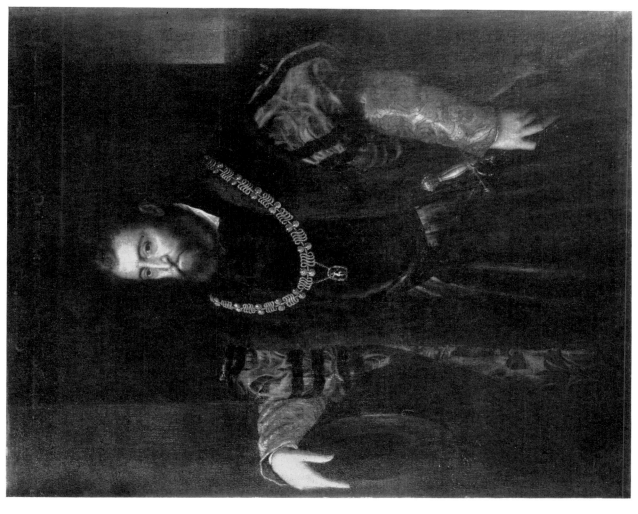

225. Girolamo da Carpi after Titian of 1535: *Alfonso d'Este*. Florence, Pitti Gallery
(Cat. no. L–10, copy 1)

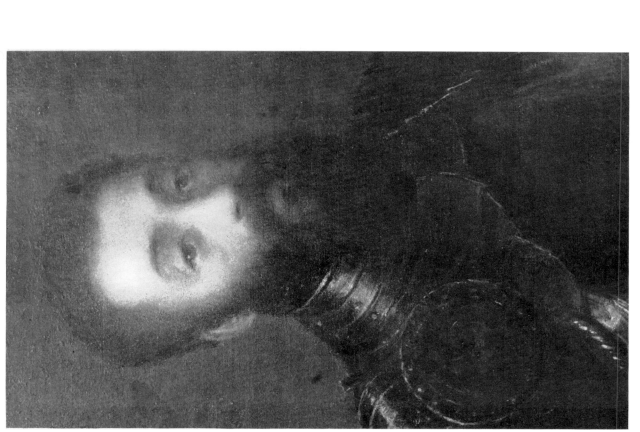

224. Copy of Titian: *Federico Gonzaga in Armour*
(original 1529–1530). Madrid, Duke and Duchess of Alba
(Cat. no. 49, under Literary Reference 1)

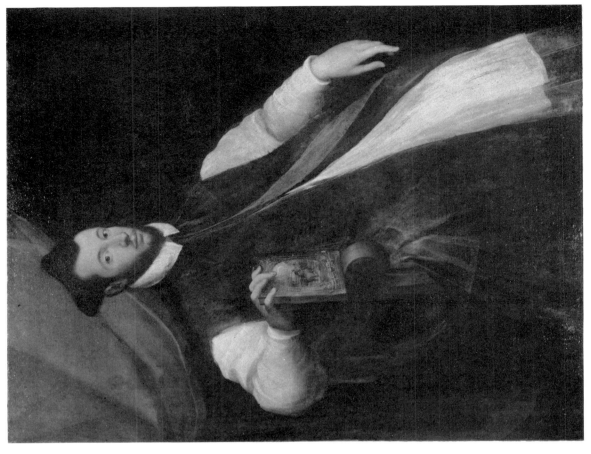

227. School of Parma–Modena: *Antonio Galeazzo Bevilacqua*. About 1565.
Cleveland, Museum of Art (Cat. no. X–12)

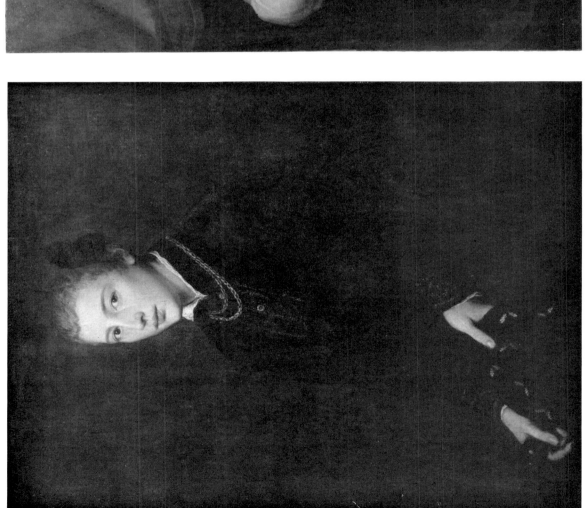

226. Van Dyck after Titian (?): *Young Man*. About 1625. Chatsworth,
Devonshire Collection (Cat. no. X–121)

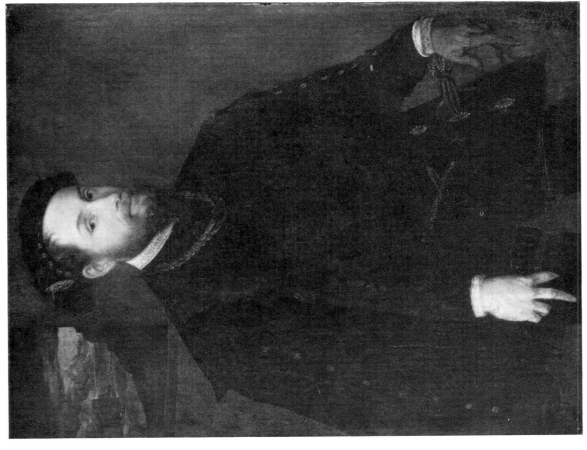

229. Follower of Titian: *Gentleman*. About 1545–1550. New York, Metropolitan Museum of Art (Cat. no. X–51)

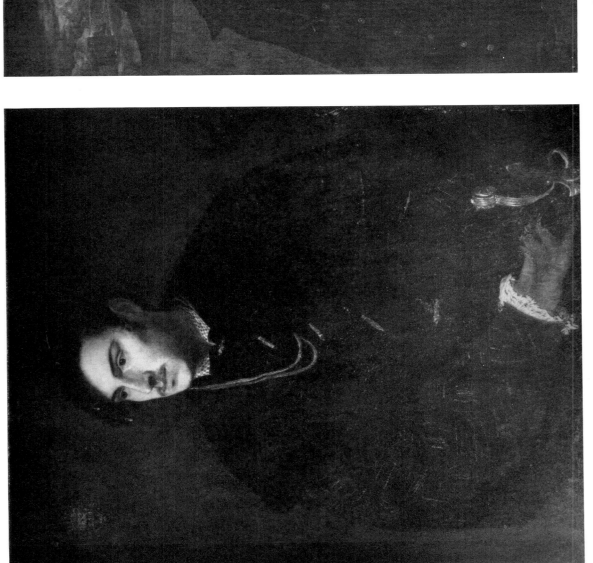

228. Titian (?): *Farnese Gentleman* (so-called). About 1526. Pommersfelden, Schönborn Collection (Cat. no. 32)

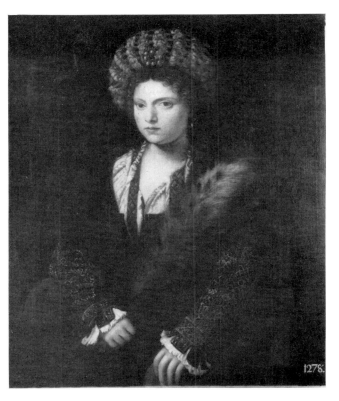

230. Copy of Titian: *Isabella d'Este* (cf. Plate 72).
Córdoba, Museo de Bellas Artes (Cat. no. 27, copy)

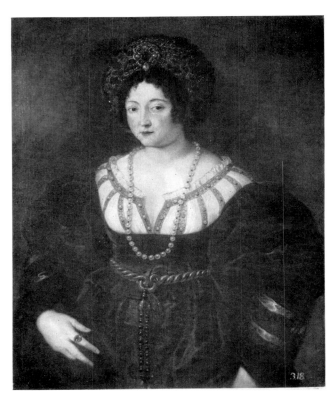

231. Rubens after Titian: *Isabella d'Este*.
About 1601. Vienna, Kunsthistorisches Museum
(Cat. no. L–11, copy)

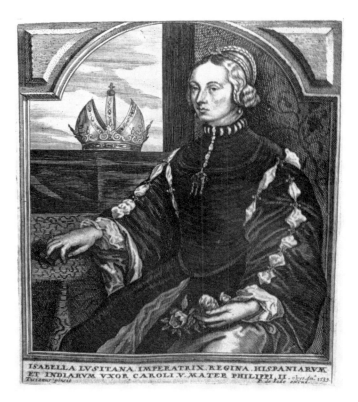

232. Pieter de Jode's engraving after Rubens' copy
of Titian: *Empress Isabella Seated, Dressed in Black*
(Cat. no. L–20, print)

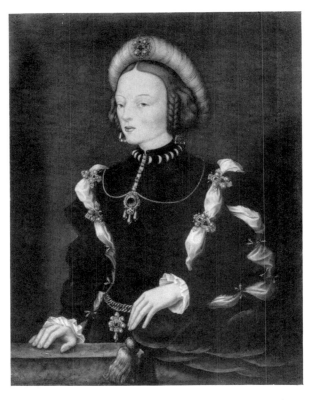

233. William Scrots (?): *Empress Isabella*.
Sixteenth century. Posen (Poland),
National Museum

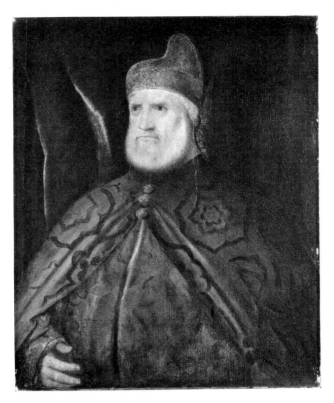

234. Workshop of Titian: *Doge Andrea Gritti.*
About 1535–1538. New York, Metropolitan
Museum of Art (Cat. no. 51)

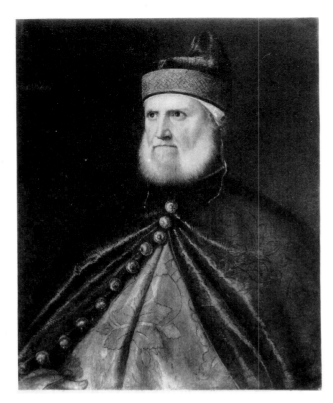

235. Workshop of Titian: *Doge Andrea Gritti.*
About 1535. Kenosha (Wisconsin), Margaret
Allen Whitaker (Cat. no. 51, variant)

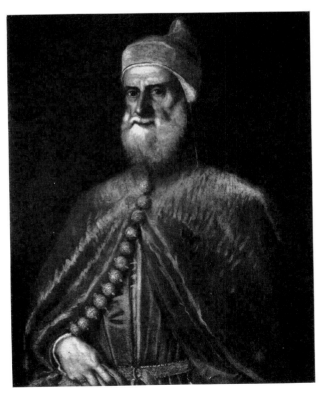

236. Workshop or copy of Titian: *Doge
Francesco Donato.* About 1546–1553. San Diego
(California), Fine Arts Gallery (Cat. no. X–27)

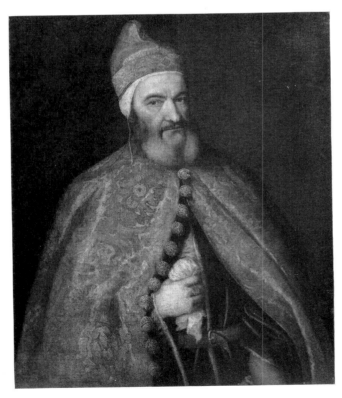

237. Workshop of Titian: *Doge Marcantonio Trevisan.*
1553. Budapest, Museum of Fine Arts
(Cat. no. X–105)

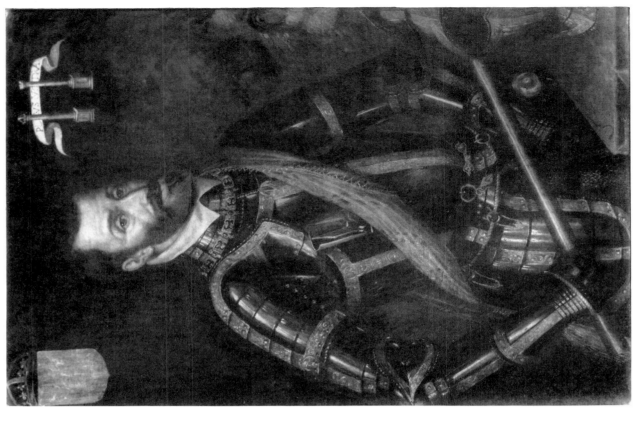

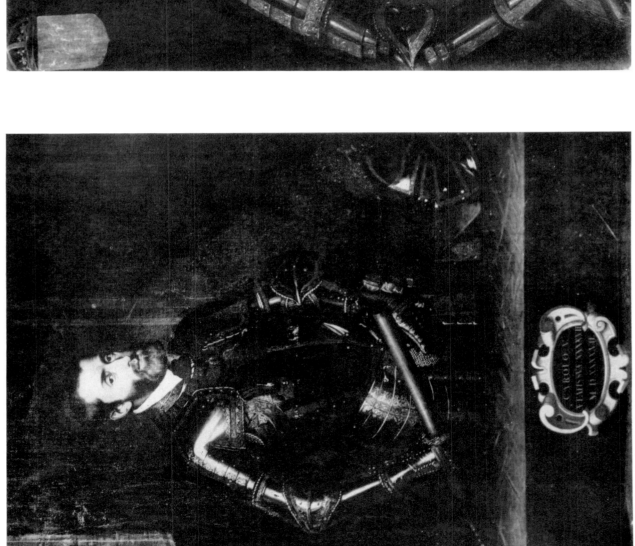

239. Felipe Ariosto after Titian: *Charles V in Armour with Baton*. 1587–1588. Barcelona, Palace of Justice (Cat. no. L–5, other copies, 2)

238. Juan Pantoja de la Cruz after Titian: *Charles V in Armour with Baton*. 1599. Escorial, Monastery (Cat. no. L–5, preserved copy)

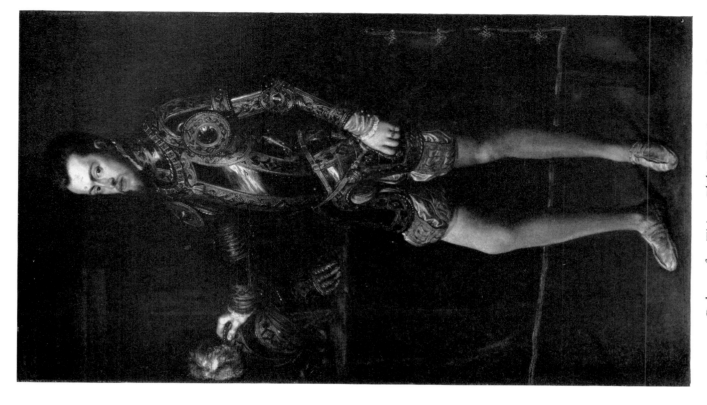

241. Rubens after Titian: *Philip II in Armour*. 1628.
Chatsworth, Devonshire Collection (Cat. no. 78, copy 1)

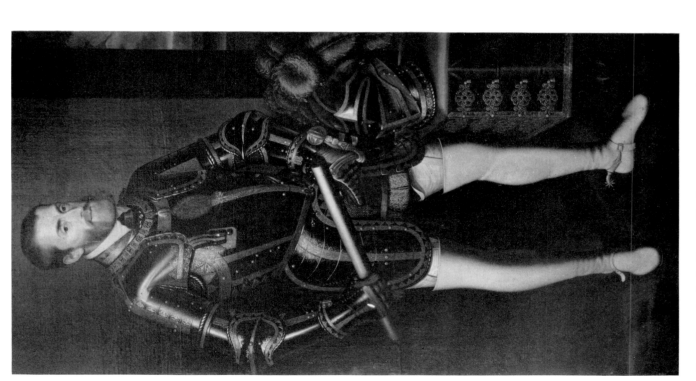

240. Juan Pantoja de la Cruz: *Charles V in Armour with Baton*. 1608.
Escorial, Monastery (Cat. no. L–5, full length variant 1)

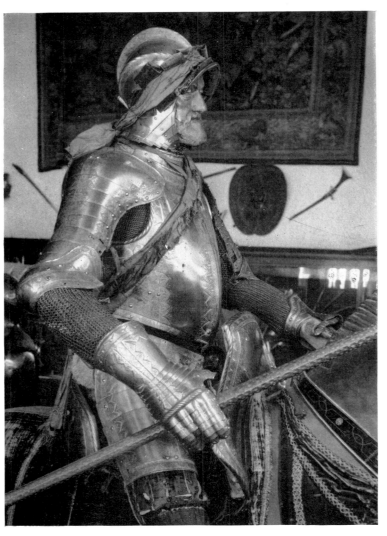

242. Desiderius Colman: *Armour of Charles V*. 1544.
Madrid, Royal Palace, Armoury

243. Workshop or school of Titian: *Charles V*.
Sixteenth century. Naples, Gallerie Nazionali,
Capodimonte (Cat. no. X–18)

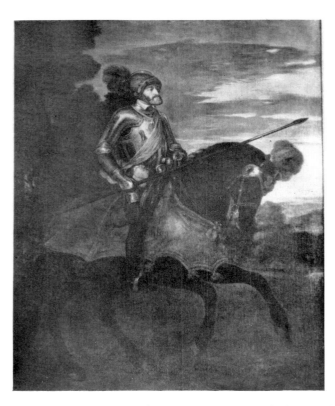

244. Copy of Titian: *Charles V at Mühlberg*. Toledo, Duchess
of Lerma (Cat. no. 21, copy 3)

245. Lambert Sustris: *Erhart Vöhlin*. 1552.
Cologne, Wallraf–Richartz Museum

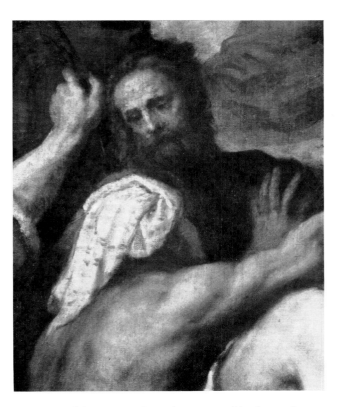

246. Titian: Francisco de Vargas (?), from the *Trinity*. 1554. Madrid, Prado Museum (Cat. no. L–34)

247. Copy of Titian: *Johann Friedrich in Armour*. Date of original: 1550. Madrid, Prado Museum (Cat. no. X–65)

248. Copy of Titian: *Emperor Ferdinand I*. Date of original: 1548. Toledo, Museo de Santa Cruz (Cat. no. L–16, copy 3)

249. Flemish School: *Duke of Alba in Armour*. About 1560. Madrid, Duke and Duchess of Alba (Cat. no. X–3)

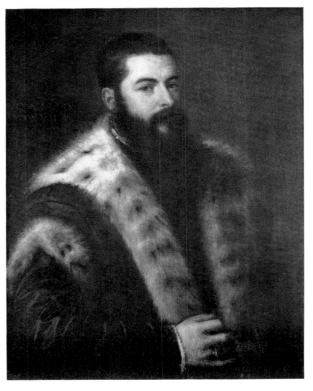

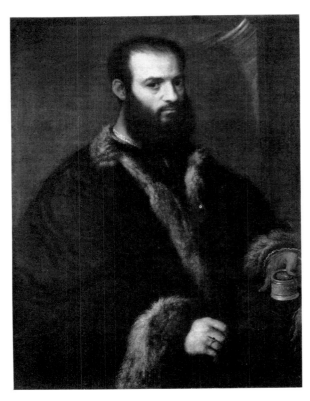

250. Follower of Paolo Veronese: *Gentleman in Lynx Collar*. About 1560. Madrid, Prado Museum (Cat. no. X–56)

251. Venetian School: *Venetian Gentleman (so-called Contarini)*. About 1525. São Paulo (Brazil), Museum of Art (Cat. no. X–111)

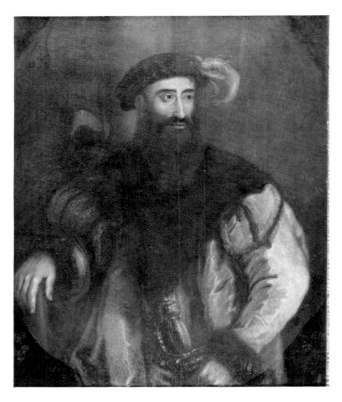

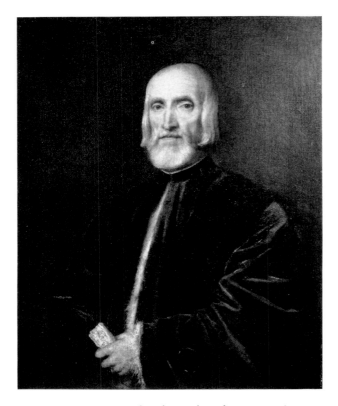

252. Roman School: *Pierluigi Farnese*. About 1540. Naples, Royal Palace (Cat. no. X–34)

253. Venetian School: *Andrea dei Franceschi*. About 1550. Indianapolis, Clowes Foundation (Cat. no. X–39)

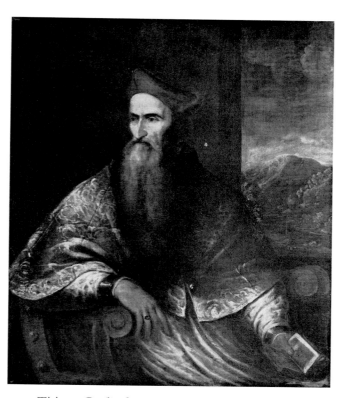

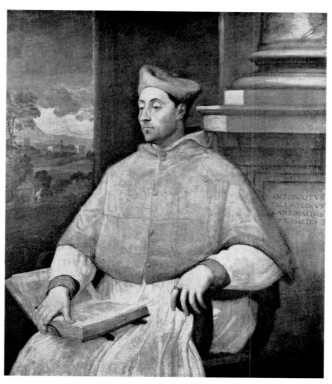

254. Titian: *Cardinal Pietro Bembo* (ruinous). 1545–1546.
Naples, Gallerie Nazionali, Capodimonte
(Cat. no. 16)

255. Roman School: *Cardinal Antoniotto Pallavicini*.
About 1530. Moscow, Pushkin Museum (in storage)
(Cat. no. X–79)

256. Bonasone after Titian: *Cardinal Pietro
Bembo*. Engraving. 1547. Rome, Accademia
dei Lincei (Cat. no. X–11, print)

257. Enea Vico after Titian: *Cardinal Pietro
Bembo*. Engraving. About 1550. London,
British Museum (Cat. no. X–11, print)

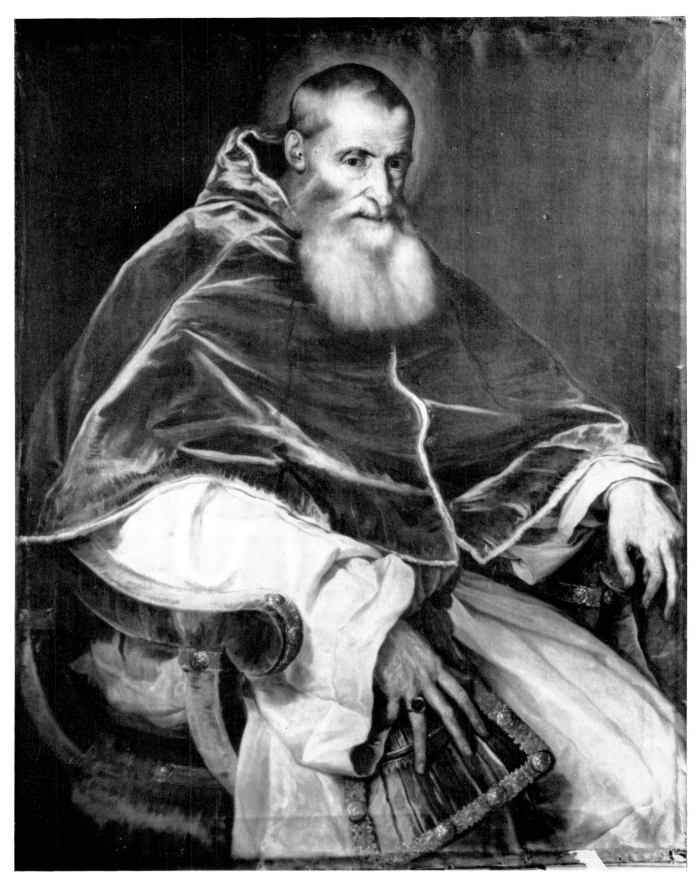

258. Workshop of Titian: *Paul III without Cap*. About 1550. Toledo, Cathedral, Sacristy (Cat. no. 72, copy 12)

259. Beverly Hills, Gene Kelley (Cat. no. 72, copy 3)

260. Rome, Palazzo Spada (Cat. no. 72, copy 7)

261. Rome, Palazzo Venezia (Cat. no. 72, copy 8)

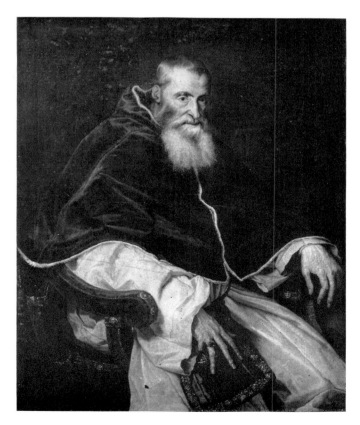

262. Rome, Palazzino di Pio IV (Cat. no. 72, copy 9).

Copies of Titian's *Paul III without Cap*. Sixteenth century

264. Copy of Titian: *Mary of Hungary*. Date of original: 1548. Paris, Musée des Arts Décoratifs (Cat. no. L–24)

263. Italian School: *Vittoria Farnese* (so-called). About 1550. Budapest, Museum of Fine Arts (Cat. no. X–35)

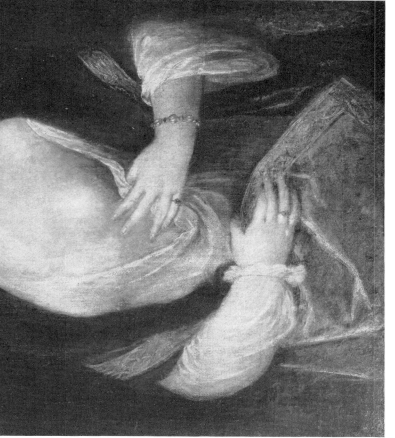

266. School of Titian: *Titian's Mistress* (so-called). About 1550.
London, Apsley House, Wellington Museum (Cat. no. X–91)

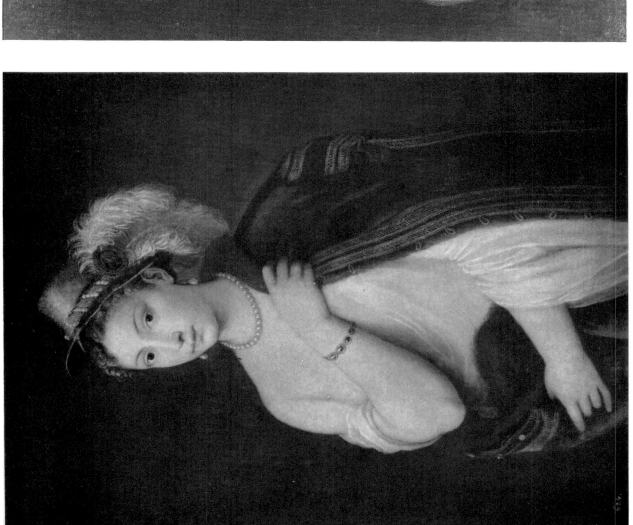

265. Workshop or Follower of Titian: *Girl in a Fur Coat and Hat*. About 1540.
Leningrad, Hermitage (Cat. no. X–59)

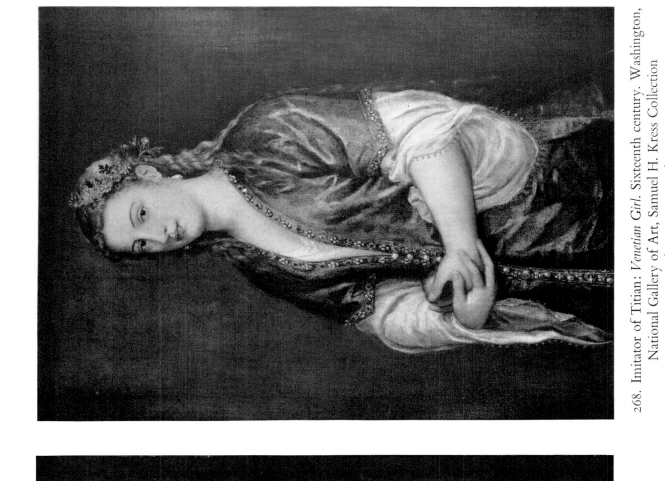

268. Imitator of Titian: *Venetian Girl*. Sixteenth century. Washington, National Gallery of Art, Samuel H. Kress Collection (Cat. no. X-112)

267. Follower of Titian: *Girl Holding a Crown of Roses*. Sixteenth century. London, Duke of Wellington (Cat. no. X-112, Related Works, 2)

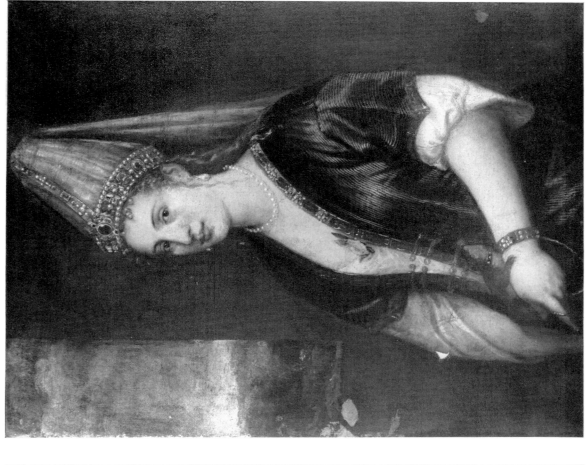

270. Copy after Titian: *Sultana*. Date of original: about 1552. Sarasota, John and Mable Ringling Museum of Art (Cat. no. L–28)

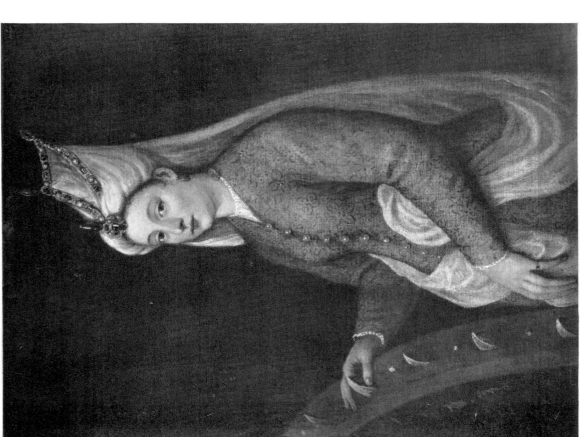

269. Follower of Titian: *Cameria as St. Catherine*. Date of original: about 1552. London, Count Antoine Seilern (Cat. no. L–2)

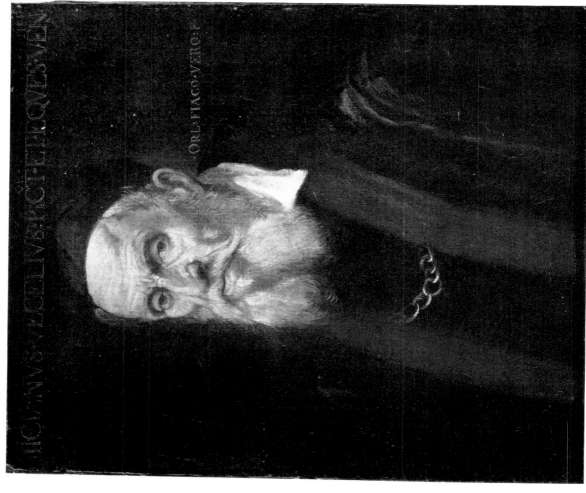

272. Orlando Flacco: *Titian*. Late sixteenth century. Stockholm, National Museum
(Cat. no. X–96)

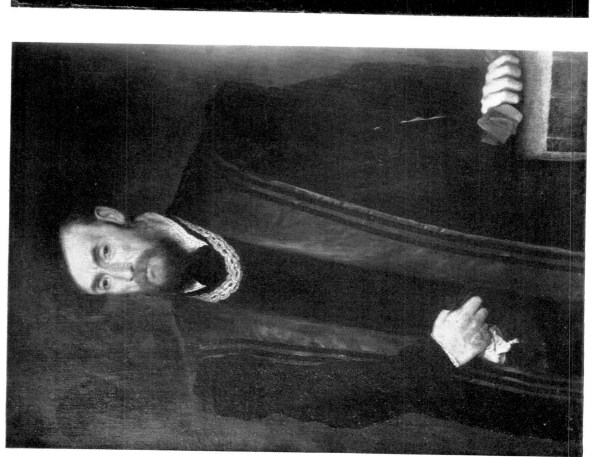

271. Orlando Flacco: *Girolamo Fracastoro* (so-called). About 1555.
Verona, Museo Civico (Cat. no. X–38)

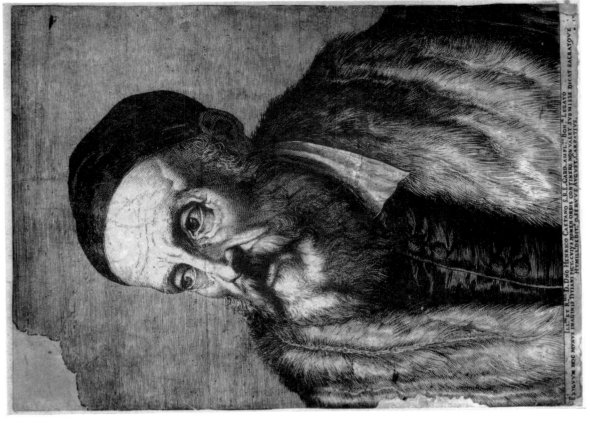

274. Agostino Carracci: *Titian's Self-Portrait*. Engraving. 1587. Bologna, Pinacoteca Nazionale (Cat. no. 104, engraving, no. 2)

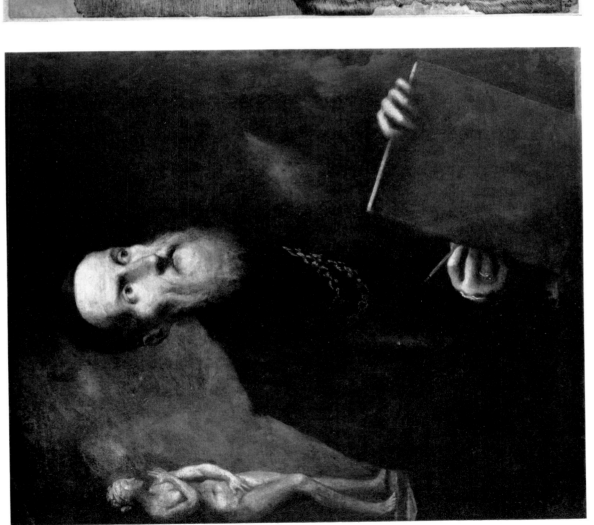

273. Copy of Titian: *Self-Portrait*. Seventeenth century. Washington, National Gallery of Art, Timken Collection (Cat. no. X–93)

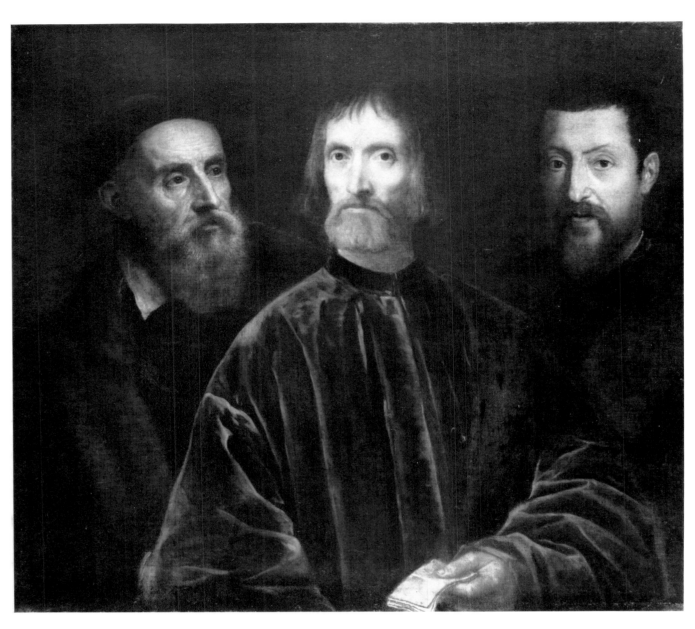

275. Follower of Titian: *Titian, Andrea dei Franceschi, and the Friend of Titian*. Late sixteenth century. Hampton Court Palace, Royal Collection (Cat. no. X–103)

INDEX

This Index is divided into two parts: an Index of Names and Subjects and an Index of Places. The latter starts on p. 419. Numerals refer to pages unless otherwise specified.

INDEX OF NAMES AND SUBJECTS

INDEX OF PLACES